Mastering

the Art
of Painting

MASTERING

Francisco Asensio Cerver
Ilse Diehl ## THE ART OF PAINTING

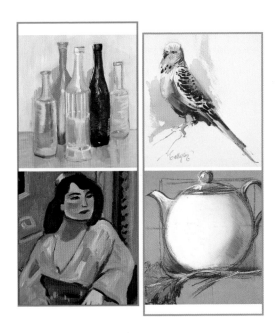

h.f.ullmann

Mastering the Art of Painting
© 2009 for this English edition: Tandem Verlag GmbH
h.f.ullmann is an imprint of Tandem Verlag GmbH

Acrylic Painting for Beginners:
© Tandem Verlag GmbH
h.f.ullmann is an imprint of Tandem Verlag GmbH
Authors: Ilse Diehl and Markus Hederer, Mainz
Expert advice: Gerd Stegner, Mainz
Paintings, drawings, graphics: Ilse Diehl, Mainz and Dagmar Ropertz, Ober-Olm
Photography: Markus Hederer, Mainz
Editing and production: Markus Hederer, Mainz
Design and production: K.Design, Wiesbaden
Original title: Acrylmalerei für Einsteiger
Translation: Rae Walter in association with First Edition Translations Ltd, Cambridge, UK
Editing: Lin Thomas in association with First Edition Translations Ltd, Cambridge, UK

Watercolors for Beginners:
Copyright © Atrium Group 2003
Text Copyright © Atrium Group 2003
Artwork and Commissioned Photography Copyright © Atrium Group 2003
Managing editor, text, layout, and typesetting: Arco Editorial, S.A.
Original title: Acuarela para principiantes, Francisco Asensio Cerver
Illustrations: Vicenç Badalona Ballestar
Photographs: Enric Berenguer
Translation from Spanish: Harry Paul Carey
English language editor: Peter Starkie

Oil Painting for Beginners:
Copyright © Atrium Group 2003
Text Copyright © Atrium Group 2003
Artwork and Commissioned Photography Copyright © Atrium Group 2003
Managing editor, text, layout, and typesetting: Arco Editorial, S.A.
Original title: Pintura al óleo para principiantes, Francisco Asensio Cerver
Illustrations: Vicenç Badalona Ballestar
Photographs: Enric Berenguer
Translation from Spanish: Mark Lodge
English language editor: Maia Costas

Pastels for Beginners:
Copyright © Atrium Group 2003
Text Copyright © Atrium Group 2003
Artwork and Commissioned Photography Copyright © Atrium Group 2003
Managing editor, text, layout, and typesetting: Arco Editorial, S.A.
Original title: Pintura al pastel para principiantes, Francisco Asensio Cerver
Illustrations: Vicenç Badalona Ballestar
Photographs: Enric Berenguer
Translation from Spanish: Harry Paul Carey

Cover Design: Simone Sticker

Printed in Slovakia

ISBN 978-3-8331-5516-1

10 9 8 7 6 5 4 3 2 1
X IX VIII VII VI V IV III II I

If you like to stay informed about forthcoming h.f.ullmann titles, you can request our newsletter by visiting our website (www.ullmann-publishing.com) or by emailing us at: newsletter@ullmann-publishing.com.
h.f.ullmann, Im Mühlenbruch 1, 53639 Königswinter, Germany
Fax: +49(0)2223-2780-708

ACRYLIC PAINTING FOR BEGINNERS

WATERCOLORS FOR BEGINNERS

OIL PAINTING FOR BEGINNERS

PASTELS FOR BEGINNERS

Authors: Ilse Diehl, Markus Hederer

Acrylic Painting
for Beginners

Drawings and paintings: Ilse Diehl, Dagmar Ropertz
Photographs: Markus Hederer

Materials

For beginners, one of the advantages of painting with acrylics is that you don't need much in the way of materials. Just a few paints, a brush, a support (the surface to be painted on), and a jar of water, and you're ready to start. The basic equipment is presented on the following pages.

Detailed instructions on the best way to use paints, brushes, and so on will be given in later chapters. It is important to get to know the materials and their characteristics, accessories, and aids in order to be able to achieve all the desired effects.

ACRYLIC PAINTS

Welcome to the colorful world of acrylic paints! You don't know anything about painting yet? Then you've made the right choice with acrylics! They're easy to use, simple and clean to handle, flexible, waterproof, and durable. The best way to learn about their characteristics is by practicing and experimenting. What's more, acrylic paints adhere very well to all kinds of surfaces: fabric, paper, card, fiberboard, wood, and plastic, and to almost any support material or decorative object. You can already see that your imagination can have free rein.

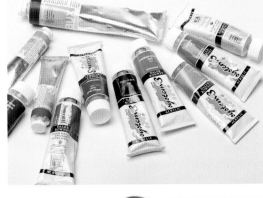

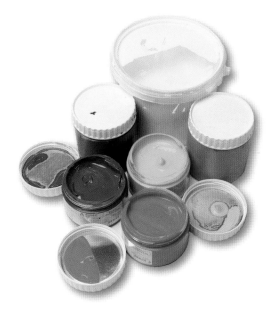

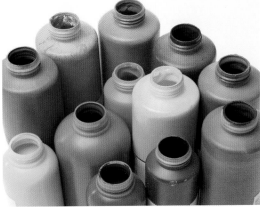

Acrylic paints come in various types of container: tubes, plastic bottles, or plastic tubs. There are also variations in color quality, i.e. the proportion of pigment. There's a distinction between top quality artist's colors and good quality school or studio paints.

SOFT AND HEAVY-BODY

Acrylic paints come not only in different containers and with different pigment contents, they also come in different consistencies. They can be divided into soft-body paints, which usually come in plastic bottles and flow out under light pressure, and what are known as heavy-body paints, which have a consistency similar to butter. These usually come in tubes or, if they are particularly firm, in plastic tubs.

For soft-body paint you usually use a brush, whereas heavy-body paints are often applied with a palette knife. In between these, anything goes, because you can mix all the different consistencies without any problem.

Tip
Note that heavy-body paints take longer to dry. This is important when you want to add the next layer of paint, so you don't get any unwanted mixtures. Also, you should store your painting to dry in such a way that the colors can't run unintentionally.

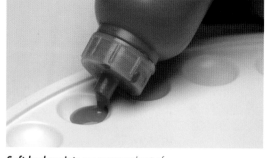

Soft-body paints are squeezed out of the plastic bottle. Palettes with wells are perfect for holding the paint and preparing it for mixing. They prevent the colors from inadvertently running into one another. Alternatively, you could use yogurt pots, disposable plastic plates or similar.

Scoop heavy-body paints out of the tub with a palette knife and mix either on a palette or directly on the support.

The great advantage of all kinds of acrylic paints is that they can be mixed together—regardless of quality, pigment content, and consistency.

ACRYLIC PAINTS FROM PIGMENTS

Pigments are colorants of either organic or inorganic origin. Unlike dyes, pigments are not soluble and therefore need a medium such as oil or acrylic resin. Organic pigments are obtained from plants and animals; inorganic pigments come from earth, minerals, and metals. The pigments we use for painting today are almost exclusively synthetic (artificially produced). Pigments are sold in the form of fine powders, irrespective of their origin or method of production. With the help of some acrylic additive, you can produce your own paints without difficulty. To get you further into the subject of paints, on pages 14 and 15 we will show you the best way to do this.

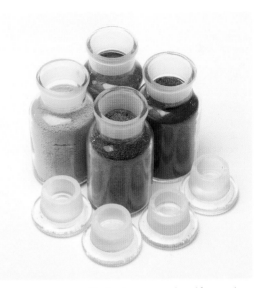

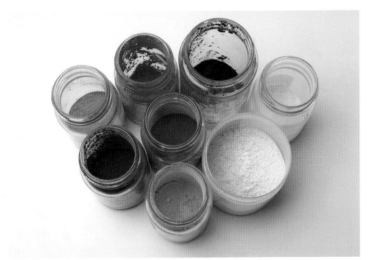

Plant colors are produced from such things as beets, Japanese blue algae, wild saffron, and stinging nettles. These natural extracts give brilliant colors but they are inclined to fade in the light.

As well as natural pigments there are also synthetic pigments produced by chemical processes. These also include pure white pigments (here titanium white) and effect pigments, which create changing shades of color depending on how the light falls on them.

Various pigments at a glance: three earth pigments on the right, synthetically produced blue, yellow, red, green, and violet pigments, and three plant colors, two of them on the left.

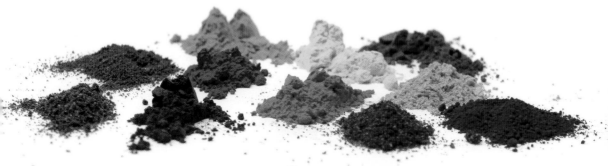

MAKING YOUR OWN ACRYLIC PAINTS

In order to turn the various pigments into usable acrylic paints, you must mix them with a binder in a suitable container and stir them together to make them into paints. For this you will need your chosen pigment, an acrylic binder, mortar and pestle, and possibly a thickener. You should also have either an empty tube or an opaque container with a lid at the ready for storing your paint. A spatula or a miniature dough scraper is the best thing for getting the paint out of the mortar. Now go through the following step by step.

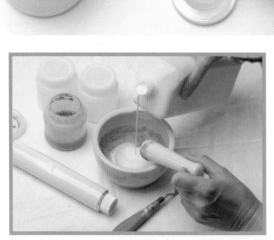

1 Put equal quantities of pigment and acrylic binder in the mortar.

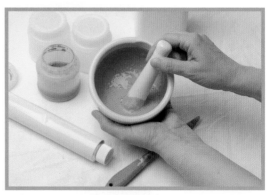

2 Stir to a smooth paste with the pestle.

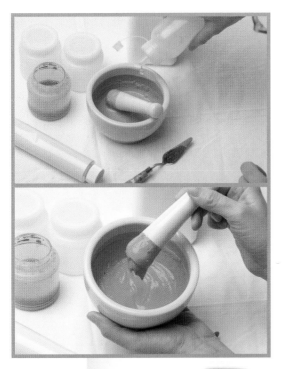

3 If the paint has become too runny, add more pigment if you want to keep the intensity of the color or add a little thickener. Thickener will make the color more transparent and eventually make a heavy-body paint.

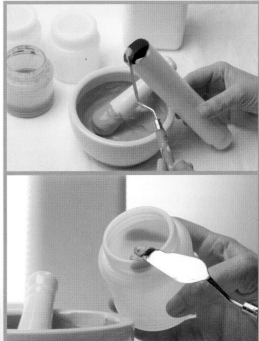

4 Transfer the finished paint to a tube or an opaque container with a lid. Adding a thin layer of water before closing will prevent the paint from drying out.

5 When the tube is full, fold the end over several times. Then you will be able to get the paint out in suitable amounts.

MEDIUMS

Classic mediums are used to change the color in a particular way: thinning it—for example with water—, thickening it and giving it more body, lengthening the drying time with retarders, and many others.

In addition, there are mediums that produce all kinds of effects when mixed with the paint or applied afterward. The paint becomes shinier, rougher, acquires light effects, glimmers and glistens, becomes more transparent or duller, etc. etc. These mediums are called texture gels. They are much used in modern experimental painting, when objects such as threads, strips of paper, and shells are being worked into the painting.

1 Before—after: in this case, a medium that dries transparent and shiny.

2 A smooth texture gel was mixed with the paint, thin layers of orange color, to bring out the structures.

3 Extra rough texture gel. The texture gel was mixed with the paint and applied on top of the paint.

4 Gold sparkle gel was applied on top of the paint.

5 Super-heavy gel paste applied on top of the paint.

Mediums and their effects

Medium	Use/effect
Retarder	Prevents the paint from drying too quickly and makes it possible to work longer with the current color. This makes it easier to create color flows.
Thickener	Gives body to fluid paints to give thicker cover.
Transparent medium, drying shiny	The medium is mixed with the paint. The color becomes shinier.
Heavy medium, drying white	The medium is mixed with the paint. The color becomes shinier.
Dull drying medium	The medium is mixed with the paint. The color becomes duller.
Smooth texture gel	Thick, heavy application, surface smooth to shiny, can be modeled.
Rough texture gel	Thick, heavy application, surface rough, can be modeled.
Extra-rough texture gel	Thick, heavy application, surface very rough, can be modeled.
Gel with gold sparkles	Thick, lightweight application, surface shiny and glittery.
Gel with hologram glitter	Thick, lightweight application, surface shiny and glittery.
Shiny varnish	Smooth application with brush, shiny paint surface.
Extra-heavy gel	Thick, lightweight application, paint surface shiny with structure.

BRUSHES, PAINTING KNIVES ETC.

Painting starts when paint is applied to a ground. In acrylic painting, various implements are used for this purpose. First and foremost among them is, of course, the brush, the classic artist's tool. But that is not enough. The different paint consistencies alone make it sensible and necessary to have other equipment. This includes a great variety of knives and all kinds of sponges, even items of window-cleaning equipment, if it's a question of experimentation—not to mention your own ten fingers, which are of course perfect for applying paint.

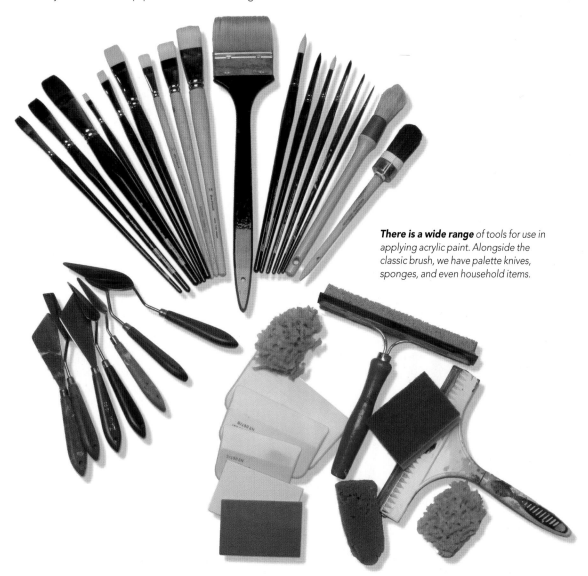

There is a wide range *of tools for use in applying acrylic paint. Alongside the classic brush, we have palette knives, sponges, and even household items.*

BRUSHES FOR COVERING LARGE SURFACES

Basically there are three occasions for using brushes with which you can quickly cover a large surface with paint.

1. An initial application for laying out a picture (page 41 ff.)
2. Applying a toned ground (imprimatura)
3. Experimental and expressionist painting.

The brushes used for covering large surfaces are either very broad or thick and round with many bristles.

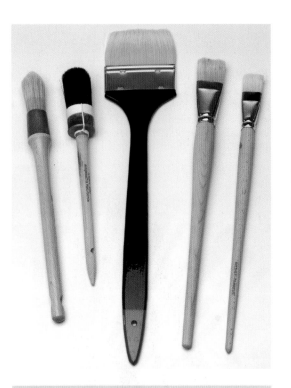

BRUSHES FOR ORDINARY PAINTING

In this case, almost exclusively flat brushes are used. The bristles are either natural hair or, especially for acrylic painting, made of artificial fibers such as nylon or perlon. Either way a long handle is important, because a long lever helps you to get the right sweep. It also makes it easier to keep a suitable distance from the support. These brushes can be used to apply all paints, of all consistencies.

Medium sized, flat brushes with long handles can be used for all purposes and are the tools most commonly used.

FINE BRUSHES

Fine round brushes are particularly important for the finish—the final application—highlights, fine lines, branches and lots more. And even though, as a beginner, you probably shouldn't be thinking of it, there is no better tool for signing your paintings.

The paintbrush is one of the earliest human inventions—not only for artistic expression but also more particularly as a tool for craftsmen.

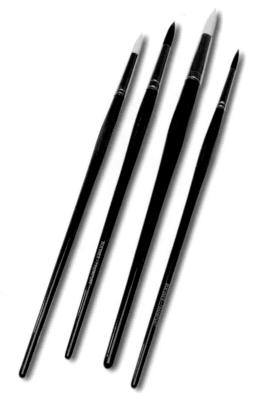

Fine brushes are usually round and have an elegantly tapering point.

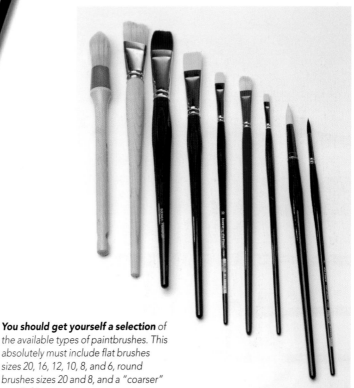

You should get yourself a selection of the available types of paintbrushes. This absolutely must include flat brushes sizes 20, 16, 12, 10, 8, and 6, round brushes sizes 20 and 8, and a "coarser" one (left).

PROTECTION FOR BRUSHES

Make sure when buying a round brush that it has a plastic sheath that you can put over the head of the brush after drying. This will help to keep its shape so you will get lasting pleasure from this valuable tool.

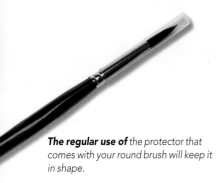

The regular use of the protector that comes with your round brush will keep it in shape.

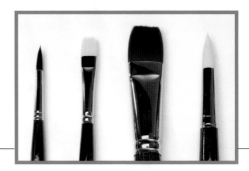

Lay the brushes flat to dry so water doesn't penetrate the handle.

TRYING OUT BRUSHES

To familiarize yourself with paints and brushes, you should try out both in various combinations. Start by using a simple acrylic painting block as a ground. That way you will learn how what amount of paint works with which brush and what options you have, for instance if you don't just draw a line with a brush but also dab sometimes. This will soon give you a good idea of all the different ways each brush can be used.

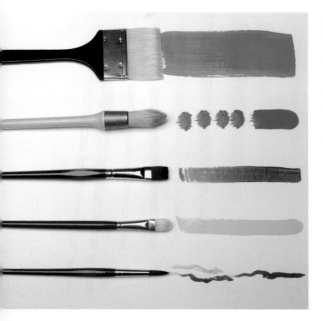

Try out all the different brush shapes. The choice of color doesn't matter to start with. But be sure to vary the amount of water you mix with the paint, so you get to know the effect of different paint consistencies.

Painting knives

Alongside brushes, knives are the tools most often used for applying paint. There are even some artists who prefer to use knives and don't use brushes at all.

Painting knives come in a number of different versions. Plastic or rubber knives are widely used for painting with acrylics, as well as traditional palette knives with metal blades and wooden handles. If buying the latter, go for good quality knives that will not rust.

Knives are especially good for applying structure pastes and heavy-body paints. They make it possible to create particularly attractive special effects.

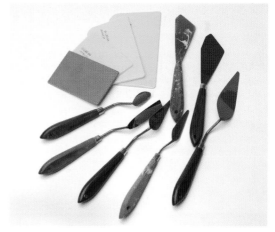

Painting knives at a glance: one model in rubber, three in yellow plastic, and a whole variety in metal with wooden handles.

Sponges have a wide variety of uses—including painting, and even a humble sponge scouring pad can be used for more than just cleaning pans.

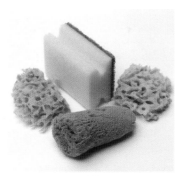

Sponges

You can use sponges for applying paint to a large area, deliberately smudging paint in order to achieve an intentional effect, and for dabbing on various designs.

All kinds of natural and household sponges can be used.

Trying out knives and sponges

To familiarize yourself with painting knives and sponges, do the same as you did with brushes and paints. Use various different knives to apply different amounts of heavy-body paints to a simple acrylic painting block, and use a sponge to apply all kinds of ordinary acrylic paint as well.

While knives are good for applying large quantities of strong colors, sponges produce rather more delicate effects.

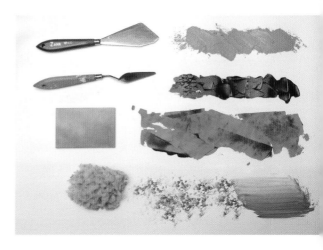

Supports

Acrylics can be used to paint on so many different surfaces that you can use almost anything you fancy as a support. A "support" simply means the surface you paint on. In fact, any surface can be a support, a fate regrettably suffered by many walls. Beginners in acrylic painting will naturally be attracted at first to conventional supports. These include:

• Acrylic painting blocks,
• Artist's boards
• Stretched canvases
• Wood.

Artist's boards are usually laminated with cotton fabric and are already primed. You can work directly onto the surface and also stand them on an easel. They come in a wide range of shapes and sizes.

Acrylic painting blocks are distinguished by the use of very thick paper that hardly wrinkles even when very wet. The sheets are glued together so they can't blow away, but when your painting has dried, it can be easily detached from the block.

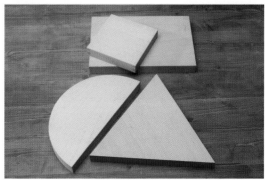

Wood is one of the oldest, most traditional supports. Now available in new, more attractive shapes, wood has been enjoying something of a renaissance as a support for painting. Triangular, semicircular, rectangular, and square blocks are pretty and look expensive.

Stretched canvases are among the most popular supports. There is an incomparable range of shapes and sizes, and their great advantage is that, when you have finished, you can hang your work directly with no need for a frame.

PRIMING WOOD

Whatever the support, be it canvas, cotton or wood, it is important to prime it before starting to paint. This prevents the support from absorbing too much paint and making work unnecessarily difficult for you. In addition, a light-colored base coat increases the luminescence of the colors and thus has a positive influence on the overall effect of the picture. A good base coat also makes the piece more durable.

We use a wooden support to show you how to apply a coat of primer. For acrylic paintings, use a white emulsion paint (often called acrylic gesso) for the outer surface. Apply the paint in two thin, even coats, using a broad, flat brush. Make sure the first coat has dried before applying the second.

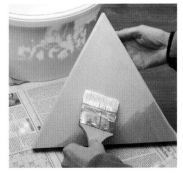

Tip
For a particularly fine primer coat, when the first coat has dried, rub it with fine sandpaper, apply the second coat, and rub down again when this has dried.

To prime wood apply two thin, even coats of white emulsion.

Advice
You don't have a palette or a disposable plate to hand? No problem: cover an ordinary plate with aluminum foil and mix your paints on that. The good thing about this is that, at the end of the session, you let the remains of the paint dry and throw them out with the foil.

A plate,
a piece of aluminum foil, and your palette is ready to use!

PALETTES

Before applying paint to the support, it is often advisable to mix them first in order to achieve the desired shade. For this purpose, artists and craftsmen have for centuries used a palette—a plate on which they can do just that. Nowadays you can find all sorts of palettes, but it is definitely an advantage if it is the same color as the support. In most cases, that means a white palette. In addition, it is useful to have a palette with wells for acrylics, so you can work safely with paints that may be runny.

A plastic palette with wells is best for fluid paints. Heavy-body paints can be mixed on disposable palettes. Disposable plates covered with cellophane make a cheap alternative.

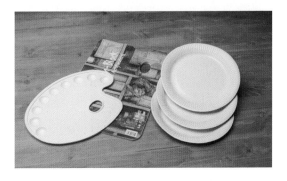

Scaling aids

If you want to copy a picture as a subject for your painting, you can use a grid to transfer the contours to your support with the correct proportions. This process is described in detail on pages 34 and 35. The equipment you need consists of a sheet of paper, a ruler or tape measure, string, scissors, and masking tape.

Scaling aids
at a glance.

Easels

An easel makes it easier to work on a picture. You can set it to the height and angle that best suits your method of working at any time. This means you can virtually eliminate problems caused by too great a difference between the level of the picture and that of the subject.

Easels come in many different sizes and price ranges. When buying, be guided mainly by the size of the support on which you want to paint. A second important aspect is maximum stability. To guarantee this, you should not hesitate to buy the best you can afford.

Wooden easel
that will safely take pictures
up to 47 inches (1.20 m).

Stay clean!

Acrylic paint dries quickly—often too quickly! A spot on the carpet, your best skirt or new sweater will not come out once it has dried. So there's only one thing for it: prevention! Protect yourself, your clothing, and your rooms from spots of paint by covering your workspace and wearing working clothes rather than anything smart. Fresh spots on smooth surfaces can be wiped off quickly with paper towels. On fabrics, the only thing that helps is to wash them out quickly.

Small ways to combat big spots: working clothes, protective film, and paper towels.

Color theory

The number of different colors seems to be infinite, yet all bright colors are based on the three primary colors yellow, cyan, and magenta. When two of these are mixed together, a secondary color is produced. However, if you really want to be able to produce all colors, you also need the achromatic (or neutral) colors black and white. If you experiment you will find out which mixtures produce which colors and be able to create your own palette.

THE PRIMARY COLORS

The three primary colors are yellow, cyan, and magenta. They are distinguished by being absolutely pure. This means that yellow contains only yellow and no trace of any other color. This is also true of cyan, a pure blue, and for magenta, which is a pure shade of red. By mixing them in the appropriate proportions, you can theoretically produce all other chromatic colors.

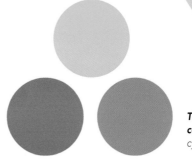

The three primary colors: yellow, cyan, and magenta.

THE SECONDARY COLORS

Secondary colors are made by mixing two primary colors in the proportion of 50:50. Yellow and cyan make green, yellow and magenta a reddish orange, and cyan and magenta mix to produce violet. If you alter the proportions in the mixture, the shades of the secondary color will also be altered. So with secondary colors you can already cover a broad spectrum of different colors. To try this out and get a good grasp of color mixes, you should treat yourself to paints in the primary colors and combine them to your heart's content.

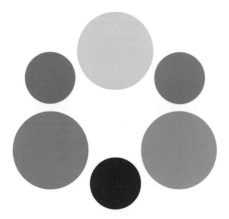

The mixing of each pairing of primary colors produces a secondary color. Yellow and cyan give green, yellow and magenta make an orange-red, and cyan and magenta produce violet-blue.

Try making different shades of secondary colors to get a feel for color mixing.

COMPLEMENTARY COLORS

There is one more important term in color theory: complementary colors. On a color wheel of primary and secondary colors, the secondary color lying opposite a primary color is its complementary color. This means that the secondary color green is the complementary color of the primary color magenta, orange-red is the complementary color of cyan, and violet-blue is the complementary color of yellow.

This knowledge, which may at first seem purely theoretical, is in practice much used in painting. The reason is that, when it's a question of making colors look bright and/or achieve maximum contrast, applying two complementary colors next to one another is a tried and tested method. This is not only true of primary colors and secondary colors that are a precise 50:50 mix, it also works for all the shades on the color wheel. You find the complementary color of any color by drawing a straight line from it through the center of the circle to the opposite side.

One more thing: if you mix two complementary colors together, the result is warm tones of brown and gray.

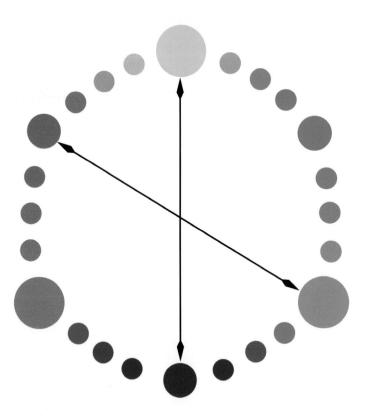

Tip
When looking for a complementary color, you can also be successful if you paint a large enough area of paper, hold the result up in front of a white wall, and stare at it for about two minutes. If you then remove the paper and look at the white background wall, you will see the complementary color you are looking for.

A color wheel with the primary colors yellow, cyan, and magenta, plus the secondary and complementary colors. If you mix two primary colors, the result is always the complementary color of the third primary color. Also, you can find the complementary color of a complementary color by drawing a straight line from it through the center of the circle to the opposite side.

Colors are especially bright and effective when they are applied next to their complementary colors. For example, orange-red appears most intense when surrounded by cyan blue.

THE MOST IMPORTANT COLORS FOR ACRYLIC PAINTING

To be honest, there are probably no painters who mix all their colors just from the three primary colors and the achromatic colors black and white. It simply would not be practical, especially as there are countless paints available from which you can easily mix the most frequently used shades.

Using ready-made acrylic paints also has the advantage that, if you particularly like bright colors, you can instantly get hold of, say, a strong orange that might easily look a little dirty if you had mixed it yourself. You will soon see that, after a few attempts, you will "home in" on a selection of colors from which you will create your personal palette. For beginners, we suggest a basic set of colors for acrylic painting.

One more thing to note: the three primary colors yellow, cyan, and magenta, as presented in color theory, come from the world of computing and in practice they are not nearly so widespread in painting. As primary colors for your own acrylic painting, it would be better to use cadmium yellow light or chrome yellow, ultramarine, and vermilion. Their brightness remains unsurpassed.

COLOR NAMES

The colors shown here, which can of course be bought, constitute a recommended basic kit for acrylic painting. These are:

- **Titanium white**
- **Cadmium yellow light**
- **Vermilion**
- **Dark madder**
- **Ultramarine**
- **Prussian blue**
- **Chromium oxide green fiery**
- **Umber**
- **Burnt Sienna**
- **Light ocher**
- **Black**

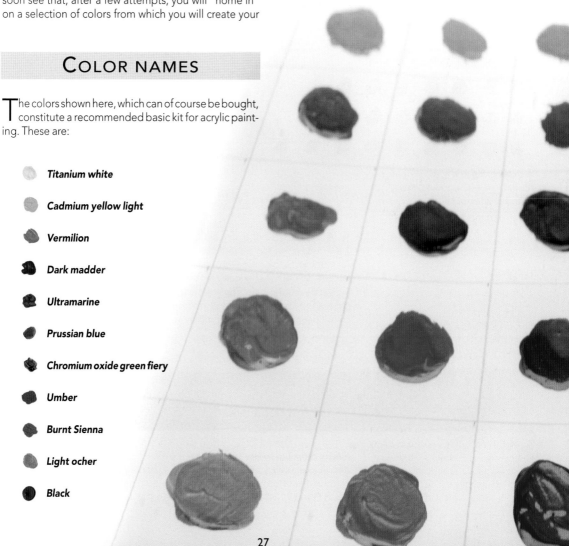

CREATING A COLOR-MIXING GRID

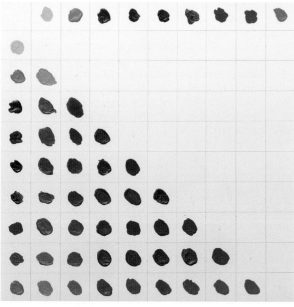

A color-mixing grid from the paints in the basic kit. Mix your own personal color grid from your paints.

As a first exercise in color mixing, draw a regular grid on an acrylic block and apply your eleven colors, each in its own square, horizontally along the top edge and vertically down the left side. Then, working downward, mix each of the colors in the top row about 50:50 with those from the left row, either on a palette or on a plate covered with aluminum foil, preferably with a paintbrush. Transfer the result to the appropriate "intersection field," which will give you a collection of mixed colors in the form of a triangle—your first color mixing grid. It will show you what shades it is possible to create by mixing the paints in your basic kit.

MIXING SHADES

Mixing paints in the proportion 50:50 is only one possibility. You can produce many more shades by mixing two colors in different proportions. Take, for instance, vermilion and ultramarine. As you add more blue to the mixture, the shade changes from the violet of the 50:50 mixture to an increasingly strong violet-blue. The greater the proportion of red, the more the shade changes to a reddish purple. Try mixing shades with all paints in various combinations to make all kinds of different things happen!

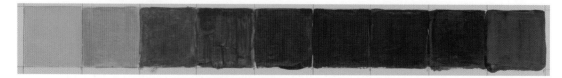

Mixing cadmium yellow and ultramarine. In seven stages, more and more blue was added to the yellow on the left. The far right field is 100 percent ultramarine.

LIGHTER AND DARKER TONES

In addition to the mixing of two bright colors, lightening with white and darkening with black are two other important methods when it comes to producing intentional mixtures of paint. Start in the same way by creating various color grids.

This is how it works: Apply a color in the middle of the scale. To lighten, add more and more white. The tone will become lighter until it reaches white. You darken the color by adding black. The tone becomes darker until it reaches black.

So you see, by mixing shades of color and lightening or darkening them you can create an enormous range of every color imaginable and give free rein to your imagination.

> ### *Advice*
> *Warm and cold colors can have an enormous influence on the mood of a picture. This plays a particularly important part in landscape painting.*

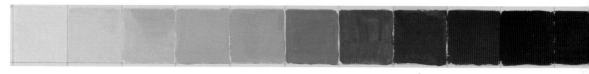

Lightening and darkening vermilion: *The color at the center of the scale was mixed with more and more white on the left, and more and more black on the right.*

WARM COLORS

The warm colors include all red tones through orange to yellow and through reddish violet and brown to ocher. They are mixed from all the red and yellow colors on the color wheel. To tone down warm colors, blue from among the cold shades can be mixed with them. Lightening and darkening play an equally significant role.

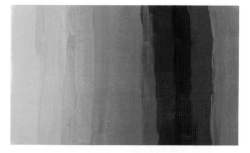

Warm colors, *set beside one another and mixed from the eleven acrylic paints recommended on page 27.*

COLD COLORS

The cold colors include all shades of blue, through turquoise to green. They are mixed from all the blue and yellow shades on the color wheel. To brighten cold colors, red from among the warm shades can be mixed with them. For instance, a cold violet can result from the right mixture of blue and red. As with the warm colors, lightening and darkening help to increase the selection of colors.

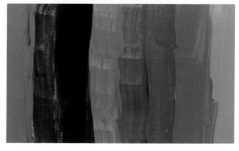

Cold colors, *set beside one another and mixed from the eleven acrylic paints recommended for beginners on page 27.*

COLOR EFFECTS AND MEANINGS

As well as the various effects colors may have, they have always conveyed a wide variety of meanings. As a rule, the colors used by an artist flow perfectly into the picture without further assistance. On the other hand, it can be an advantage to know the qualities attributed to a color and use them intentionally from time to time. With this in mind, we will now present the major colors and the properties that are generally associated with them.

Blue is cool. It's the color of the sky and the sea and conveys calm, trust, peace, dutifulness, beauty, and longing. However, blue also stands for dreaminess, coldness, neglectfulness, and melancholy.

Yellow is the color of the sun. It conveys light, happiness, and joy, and stands for knowledge, wisdom, reason, and logic. Dirty yellow tones have negative associations such as illness, deception, vindictiveness, ambition, danger, pessimism, egoism, miserliness, and envy.

Violet is a dignified color. It is associated with inspiration, magic, mysticism, and art. It is considered unusual and flamboyant and is also associated with piety, penitence, and self-sacrifice. The negative effects of violet are pride, arrogance, and immorality.

Green is the color of vegetation, of woods and meadows. Green is calming and stands for generosity, reliability, harmony, normality, hope, and the renewal of life.
However, it also has negative connotations such as envy, indifference, stagnation, and tiredness.

Cyan, also known as turquoise, is the fresh color of the sea on a sunny day. It is associated with alertness, consciousness, spiritual openness, and clarity. On the other hand, cyan can seem very cool and distant and evoke a feeling of emptiness.

Magenta is gentle and means idealism, gratitude, involvement, order, and sympathy.
However, snobbishness, arrogance, and dominance are also linked to magenta.

White as ice and snow…purity, clarity, innocence, and solemnity are associated with white, as well as peace, ease, and cleanliness.
On the other hand, white is also unapproachable; it stands for cool reserve, vulnerability, sterility, and capitulation.

Red is the color of fire. It arouses attention, is full of energy and vitality, and stands for love, passion, and sexuality. Red is aggressive and agitating. It means anger, rage, brutality, blood, war and, not least, the color of the devil.

Gray is a cloudy sky on a gloomy day. Perfect neutrality, caution, restraint, willingness to compromise, dignity, and devotion are closely associated with gray.
Gray is not very striking and may appear boring and monotonous. Uncertainty and depression are gray, as are bewilderment and decay.

Orange is the color of sunsets and symbolizes optimism and a zest for life. It is a sign of open-mindedness, sociability, youthfulness, health, and self-confidence.
Orange also conveys irresponsibility, obtrusiveness, and dissipation.

Black is dark, without light, the color of night.
It means sorrow, impenetrability, immutability, fear, and secrecy, as well as anxiety, emptiness, seclusion, and death.
However, black can also appear dignified and stands for respect and ceremony.

LOCAL AND APPARENT COLOR

Local color can be defined as a pure-toned color—uninfluenced by light and shade and without the addition of black or white. It also means the true color of an object. A tomato is red, a banana is yellow, the sky is blue, a leaf is green, an orange is orange, and so on. That's how children, for example, paint their pictures, giving everyday objects their typical colors.

By contrast, local color plays a subordinate role in naturalistic painting. Here what is known as apparent color—the color that the artist perceives an object, a figure, or a part of the landscape to be—is much more important. It depends very much on the conditions, particularly the way the light falls and how it is reflected. The picture of a stream (below left) illustrates the various apparent colors of the water.

Apparent colors are also influenced by their immediate surroundings. If, for example, a banana is lying next to a tomato, the reflection of its yellow color will cause part of the tomato to appear orange, while the reflection of the red color will turn parts of the banana orange. In this case, the apparent color is influenced by a reflection color.

APPLYING PAINT

We are now returning slowly but surely from theory to practice. Back on page 12, we presented paints of different consistencies—soft and heavy-body. These different consistencies make it possible to apply paint in a variety of ways, enabling you to achieve many interesting and attractive effects.

Application can be divided into
• Impasto (thick)
• Opaque (flat)
• Glazing (transparent).

Impasto appears thicker and cruder, and makes it easier to work objects into the surface. Applying the paint flat and opaque is probably the most frequently used technique and is very similar to traditional oil painting. Glazing is very delicate and is similar to watercolor technique, but has the advantage that the paints don't fade so readily and, most importantly, they don't smear when wiped.

In practice impasto painting is most often done with a knife, but it is also possible to use a brush. Opaque colors are usually applied with a brush, but you can use a knife. For glazing, a brush or a sponge is recommended.

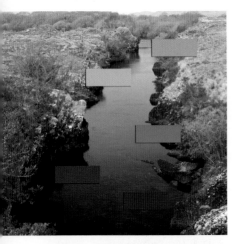

*Various **apparent colors** of the water in a stream, depending on the way the light falls and how it is reflected. On the left, the apparent colors are picked out again.*

***Different types of application** in vermilion: impasto, opaque, and transparent.*

Ideas and subjects

2

You want to paint, and subjects are as plentiful as sand on the seashore, only…which ones are right for you and what best suits the way you go about things? It's very important to keep your eyes open and collect everything you see that interests you and looks like a suitable subject for a painting. It might be examples of other paintings, but it could also be a stone or a shell picked up on the beach that you later paint, or attach to the picture using thick impasto, or draw inspiration from in some other way.

FINDING MOTIFS

The word motif is related to the idea of motivation, something that gets you going. So a motif is always something that motivates you to paint a picture, something that attracts and inspires you. The obvious reason for painting is surely to depict something you yourself like, and something you can handle in an artistic manner.

When searching for suitable subjects for your paintings, you will soon strike it lucky if you leaf through books—such as coffee-table books—look at your own photos, rummage through postcards, gaze at posters, or simply wander through the countryside or a picturesque town.

Tip
Start an "ideas collection," in which you gradually store everything you come across. You can also start a folder or a file to hold notes, photos, sketches, press-cuttings, and much more.

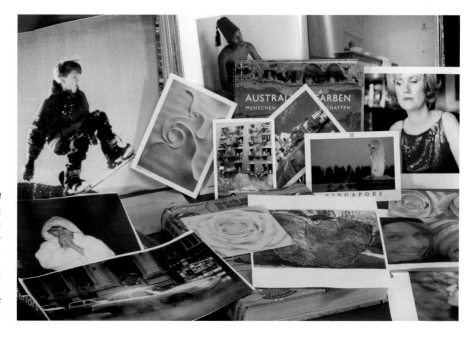

You can find many good ideas for your pictures in your immediate surroundings. Books, postcards, or your own photos will provide masses of material.

TWO-DIMENSIONAL, THREE-DIMENSIONAL

Painting a picture usually means setting it out on a flat surface, and as a rule, the result is two-dimensional. The obvious conclusion is that copying two-dimensional originals is the most appropriate thing for beginners. So before you set about trying to capture complicated spa-tial (three-dimensional) arrangements on canvas, it would be better to start with two-dimensional models: pictures from books, photos, postcards etc., as described on the previous page. However, because the original you are copying will rarely be the same size as your canvas, you need a way of keeping the proportions correct when trans-ferring the content of the picture. Over the centuries the grid has proved to be the ideal method for this purpose.

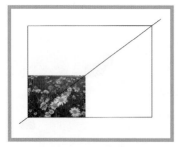

Use a grid to transfer the original onto the support in the correct proportions.

GRIDS

There are two stages to the grid method for transfer-ring the contents of a picture:
1. Checking your selected original to see if it can be enlarged directly to fit the support you have available. This is the case if the diagonal of the support has the same slope as that of the original. However, it may happen that the diagonal of the original has a steeper or shallower gra-dient than that of the support. In either case, you can adjust them by adding to or subtracting material from the original.

Example 1

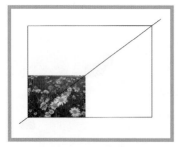

The diagonals of the original and the support are identical, so you can transfer the picture directly.

Example 2

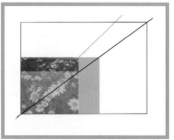

The diagonal of the original is stee-per. You can adjust to match either by leaving out parts of the original to reduce the height or by adding subject matter to the width.

Example 3

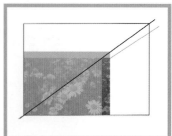

The diagonal of the original is shal-lower. You can adjust to match either by leaving out parts of the original to reduce the width or by adding subject matter to the height.

2. Once the proportions of the original and the support match, you create grids on the original and the support in the same proportions. Then you transfer the content of each square of the original to the corresponding square on the support, and thus keep the contents in the correct proportions.

Now we will show you step by step how you can transfer an original, in this case a photo, to the support, with the help of scissors, string (thread), ruler, pencil, and masking tape.

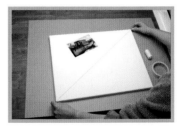

1 To check whether your chosen section of the original will—when enlarged in proportion—fit the support, stretch a thread diagonally from the top right to the bottom left of the support.
Fix the thread at the corners with a little masking tape.

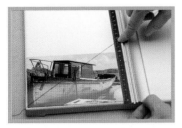

2 Now place your original in the bottom left hand corner of the support so the edges match. In this case, the original is not high enough, so it must be extended by adding to the upper and lower parts of the design. With a ruler, measure the distance from the lower edge of the picture to the appropriate place on the diagonal of the support. This measurement corresponds to the height of the extended original. The breadth of the original is already known.

3 Transfer the measurements of the extended original to a piece of paper and cut out.
Stick your original to the paper, then sketch in a few lines extending the design.

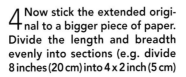

4 Now stick the extended original to a bigger piece of paper. Divide the length and breadth evenly into sections (e.g. divide 8 inches (20 cm) into 4 x 2 inch (5 cm)

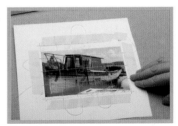

sections = divide by 4) and mark with a pencil. To divide into squares, stretch threads across it vertically and horizontally, and fix with masking tape.

 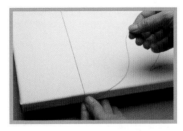 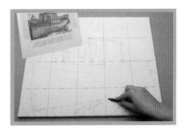

5 Divide the breadth and height of your support into the same number of squares as your extended original and mark the points with a pencil.

6 To divide into squares, stretch threads across it vertically and horizontally, and fix with masking tape.

7 Now transfer the content of each square of the original proportionally to the corresponding square on the support. This will create a preliminary sketch.

SKETCHES

Painting directly from a three-dimensional model almost from life is pretty difficult. And anyway, who always has their painting materials with them just when an interesting subject crops up? That's when it can help to have a sketch of something you later want to paint captured with a few quick strokes on a sketchpad. Also, this is a way to make a three-dimensional object into a two-dimensional pattern that will be easier for you to turn into a picture, for reasons already discussed.

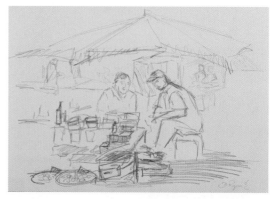

Scene in a weekly market *in a small turkish town. The two men are deep in conversation as they wait for customers. In this pencil sketch, the goods for sale were also captured in some detail. Market parasols in the background, a few stalls, and hints of people complete the sketch.*

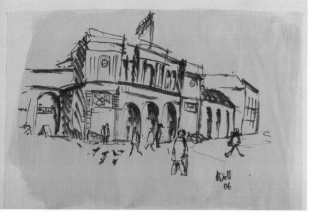

This is an architectural sketch, *in this case a station in a large city in Germany. It was made on waste paper, which had previously been given a coat of acrylic paint. It was done in felt pen, and quickly captured the structure of the building, the movement of the people hurrying by, and the tranquil elements.*

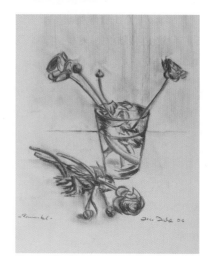

This sketch consists of three cut flowers from a florist, *and a glass vase filled with water. The various elements were sketched in charcoal on drawing paper. Attention was paid to how the light falls from the top right, to try to achieve a three-dimensional effect in the painting that was later elaborated from it.*

Categories and subjects

There are many reasons for painting pictures, and even more subjects. But because people crave order—especially in the case of art historians—they have naturally grouped different types of painting into a kind of filing system. This has produced what could be described as two filing cabinets with various drawers: cabinet 1—the category or genre, with drawers such as landscape, still life, and architecture; cabinet 2—the subject matter, with drawers such as mythology, nature or politics.

CLASSIFYING A PICTURE

The answer to the question "What does the picture show?" is one of the most important criteria for classifying pictures. It is a question of the subject of the picture.

Well-known and important genres are landscapes, figures, plants, animals, still life, and architecture. However, in each of these drawers there are a few, let's call them record cards, each of which contains a further subdivision. Taking plants as an example, we could mention "botanical studies," "flower pieces," "gardens," and "vegetables."

Ideally a picture can be clearly categorized, but quite often the boundaries are fluid, for example when animals are moving through a beautiful landscape.

You will learn more about individual genres and their subgroups from page 51 on.

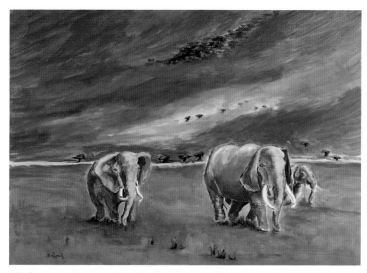

Elephants on the move through a breathtaking African landscape. In this picture the boundaries between animal and landscape painting are blurred.

Advice

Filing systems are there to provide an overview and help you to find your way around, but for the painter and his creativity they are not in any way binding. So there is no need to "paint yourself into" a category or decide on one too quickly. Remain versatile until you have found your own style.

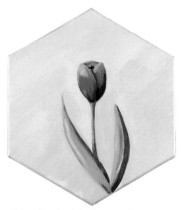

This tulip clearly belongs in the "plants" category and is a subject from the subcategory "flower pieces."

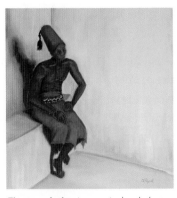

Figure painting is a particular challenge for every painter. It's about understanding the proportions of the human body and depicting them correctly—one of the more difficult tasks.

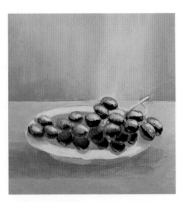

A simple still life, composed of the elements plate and fruits. Composition plays a special part in still life painting, so for beginners it's best to have just a few elements.

Beautiful areas such as these are to be found in southwest Ireland. Landscape is one of the most popular subjects in painting—possibly an expression of man's close attachment to nature.

The categories "architecture" and "landscape" in one picture. La Roque Gageac is one of those villages in southwest France, strung out along the Dordogne in an exciting river landscape that can literally be described as picturesque.

SUBJECT MATTER

A second important way of classifying pictures is division according to subject matter or the answer to the question "What does the picture express?" Typical subjects in painting are religion, war, social matters, mythology, history, sport, technology, nature, the arts, science, and politics. Anyone who paints a picture on a recognizable theme will generally have a message to convey. In most cases this is done through the subject of the painting.

There is no doubt that classification by type is more helpful to the beginner than classification by subject. It requires a certain degree of skill to get to the heart of the meaning of a subject, but you will soon get the idea.

Fun with colors

On the foregoing pages we showed you some typical subjects, but before you start restricting yourself to specific categories, we'd like to suggest a slightly different way of getting into acrylic painting. We turn our backs on the representational and allow color to create its own effects. So don't be afraid of the blank, white canvas—you have color at hand! Apply generously with brush, sponge, and palette knife, and you can easily produce attractive and decorative paintings. And you will be in very good company!

TIME TO START PAINTING

At last it's time to start painting. But don't rush into it headlong. Prepare your workplace carefully beforehand. Protect the table and floor from paint-splashes. Wear comfortable clothing that you're not intending to wear anywhere smart again, so it won't matter if it gets splashed. Then get together the materials you want to use. These must include paints, brushes, palette, a jar of water, and a rag for wiping the brushes. A roll of paper towels will also come in very handy. Depending on whether you're going to paint on an easel or on the table, place your chosen support on it.

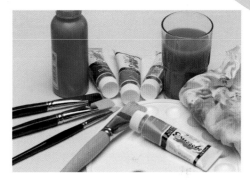

Perfectly prepared: paints, brushes, palette, a jar of water, and—last but not least, a rag.

Applying the color energetically with a broad brush and cadmium yellow mixed with a little water.

PLENTY OF PAINT ON A LARGE AREA

There's no reason to sit brooding over a white canvas. Take your first steps in acrylic painting by covering large areas with generous quantities of paint. Take one of your favorite colors, possibly thinned with a little water, and a broad, flat brush—and start covering the canvas with the shade of your choice.

Work with big sweeping movements. It makes you feel good, because you don't have to bother about shapes or other details—and it also gives you quite a feel for the materials you're dealing with. You'll see: in no time at all, the canvas will be covered with paint and the first picture will basically be finished.

Advice

There is a saying in the world of painting that is particularly helpful to those people who are prone to doubts about their work. It goes, "every picture is finished at every stage of its creation." There's also a popular saying: "less is often more."

A picture in yellow – *finished, even at this stage.*

Squares and rectangles in toning colors *make an effective contrast to the bold sweep of color in the background.*

COMBINING COLORS

A liberal covering of paint doesn't have to be limited to one color. It is fine to use two or three colors that go well with one another and combine them together with relish.

You don't always have to use a brush either. From your generous selection of tools, you can take a household sponge, mix the paints beforehand, and then boldly go ahead. Spread the colors over the canvas one after the other, perhaps in the form of a wave, until all the white areas are covered.

Apply two different *shades of blue to the canvas with a household sponge.*

ADDING ACCENTS

Every picture may be finished at every stage of its creation, but that shouldn't prevent anyone from adding attractive accents. Why not use shapes and colors to add contrast to an extensive area of paint? Hard-edged geometric shapes make an effective contrast to round off the sweeping curves of the first coat of color. This can be achieved by covering parts of the surface with masking tape that will be pulled off later after the paint has been applied.

So be brave and apply plenty of paint to a large area, give your imagination free rein, and create an attractive picture with a personal touch with relatively little effort.

Color without form

In the first picture we paint, we are not interested in specific shapes but in the liberal application of paint to large areas. The basis is a covering coat laid on with a broad brush. After that, a second and third color are dabbed on and smeared with a sponge. There is no need for a preparatory drawing to lay out the composition. Structures created by dabbing and smearing are only partly planned.

Materials

Stretched canvas 24 x 28 inches (60 x 70 cm); flat brush no. 80; natural sponge; jar of water; cotton cloth or paper towels; palette; colors: cadmium yellow light, light ocher, and vermilion

 Cadmium yellow light

 Light ocher

Vermilion

1 Put cadmium yellow onto your palette, dip the brush in water, and thin down the paint a little. Begin applying paint from top to bottom. It should start by being quite thin and be put on in several coats.

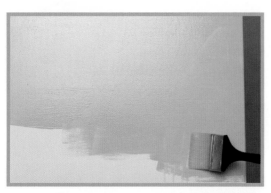

2 Use swift, sweeping, energetic brush strokes to be sure you apply the paint evenly. Take care to cover the canvas completely with paint.

3 Allow the first coat to dry, then add a second and third as required. The end result should be a rich, even shade of color.

4 On your palette, mix a little light ocher into the cadmium yellow and add enough water to make the paint quite runny. Dip a moistened natural sponge in the paint and dab it on the canvas.

Tip
Don't completely fill the brush with paint; take it up gradually in smaller portions. This will assure even application.

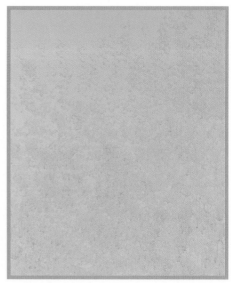

5 By dabbing the canvas from the bottom (with more paint) to the top (with slightly less), you will have created a progression. Leave the result to dry.

6 Now mix vermilion with the light ocher and cadmium yellow. Don't add any more water. The new color will be slightly less runny. Dip a moistened natural sponge in it and dab it on the canvas.

Tip
After smearing, always take a couple of steps back to consider the result and get fresh inspiration.

7 Now use the sponge to smear the wet paint in places of your choice to give a pattern to the whole picture and create extra effects.

8 Work with greater freedom and energy in the upper parts of the painting.

9 The lighter patches in the center of the picture were created by first washing out the sponge and squeezing it out before smearing. This technique can be used to remove paint from selected areas. The end result is an expressive and dynamic picture created from three colors.

SUMMARY

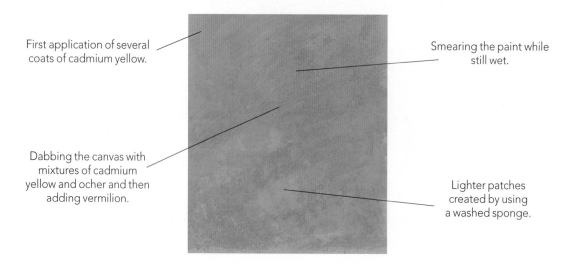

First application of several coats of cadmium yellow.

Smearing the paint while still wet.

Dabbing the canvas with mixtures of cadmium yellow and ocher and then adding vermilion.

Lighter patches created by using a washed sponge.

A picture in red

Rich, cheerful colors also dominate our second picture which, like "color without form," contains no specific objects. But unlike the first painting, here the second covering coat is given a structure by means of the brush marks. Horizontals and verticals determine the directions.

Applying a darker red and painting over it produces interesting figures, or more precisely "color solids."

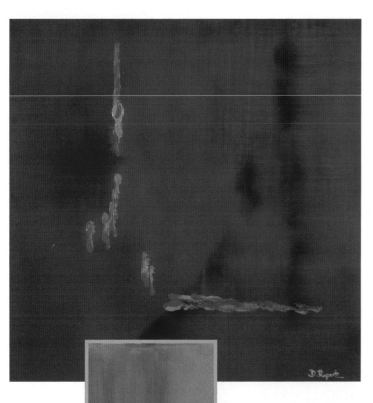

Materials

Stretched canvas 20 x 20 inches (50 x 50 cm); flat brushes nos. 80, 12; jar of water; cotton cloth or paper towels; palette; colors: vermilion, crimson, dark madder, and chrome yellow

Vermilion

Crimson

Dark madder

Chrome yellow

1 Put vermilion on your palette, dip your brush in the water, and thin the paint a little with it. Start applying paint from top to bottom. It should be fairly thin to begin with.

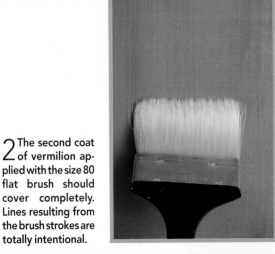

2 The second coat of vermilion applied with the size 80 flat brush should cover completely. Lines resulting from the brush strokes are totally intentional.

3 Paint streaks in crimson in a few places, using a narrower brush and much thicker paint.

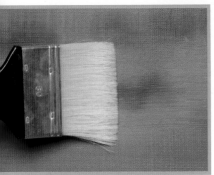

4 Then paint over these places again with the broad brush both horizontally and vertically. Depending on the direction of the brush strokes, blurred figures will appear, which can also be described as "color solids."

5 Break up the crimson by overpainting with madder, which is darker. Brighten lighter patches by applying more vermilion.

6 Now paint over these places again with the broad flat brush vertically, horizontally, and also diagonally in order to achieve even more attractive effects.

Tip
Starting no later than with the second coat, work "wet into wet"—so avoid letting the paints dry before starting the next application.

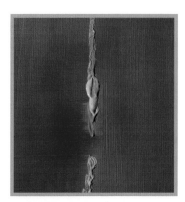

7 With a narrow flat brush, add accents in very thick chrome yellow and vermilion.

8 The contrasts in the painting are created by the various colors, their different tonal values, and also the direction (horizontal, vertical, or diagonal) and the way in which the paint was applied. Dark colors retreat into the background, while bright colors are more striking. The very thick impasto also heightens the effect.

SUMMARY

Second total cover with vermilion. Lines appear as a result of the brush strokes.

Apply crimson and dark madder, and overpaint horizontally and vertically.

Add accents in chrome yellow and vermilion, applied very thickly.

Various color solids are formed.

Accents in blue

Plenty of paint and strong lines are also the basis for the third painting in the "fun with colors" series. The essential difference from the two previous works is that the first application is both complete and final.

Tangible forms now have a part to play—light and dark waves in the first coat and more significantly through the addition of dark blue accents in hard shapes that contrast with the waves.

Materials
Stretched canvas 20 x 16 inches (50 x 40 cm); household sponge; palette knife; jar of water; cotton cloth or paper towels; palette; colors: Prussian blue, chromium oxide green fiery, titanium white, and ultramarine; additive: glossy, heavy gel masking tape

 Prussian blue

 Chromium oxide green fiery

 Titanium white

 Ultramarine

1 On your palette, mix Prussian blue, chromium oxide green fiery, and a lot of white to make turquoise. Apply the paint to the canvas with a household sponge, wiping with diagonal wavy movements. Leave enough space at the top right and bottom left to add a different shade.

2 Now add a little ultramarine to the mixture and fill the top and bottom of the canvas in the same way.

3 The first coat is finished. The contrasts between light and dark tones of blue in the wave-forms are very beautiful.

5 On your palette, mix a quantity of ultramarine paint with the glossy heavy gel additive in the proportion of approximately 50:50. Pick up the mixture with a palette knife and spread it over the open areas.

4 Measure the areas where you want to place the accents and stick enough masking tape around them to protect the other part of the painting.

6 The heavy mixture means the paint you have applied will be quite solid and the spreading movements will create fine reliefs.

7 Now pull off the masking tape one piece at a time. Don't wait until the paint dries, as then you risk pulling it off with the tape.

8 A wonderful symphony in blue has been created with simple means. The attraction lies in the contrast between the motion of the background and the strong, hard lines of the angular accents.

SUMMARY

First stage of the background cover in turquoise waves in the middle of the painting.

Second stage of the background cover with a darker blue at the top and bottom.

Accents: heavy paint applied with a palette knife.

Straight lines are left behind when the tape is removed.

Still life

Ever since people in ancient times began painting pictures, the depiction of lifeless objects has been a favorite subject. In the Baroque period in the 17th and 18th centuries, still life was at its height. Constrained by strict rules of composition, it was carefully cultivated and developed to the peak of perfection. For newcomers to painting, still life is a very good way to approach the representation of objects.

DECIDE THE DEGREE OF DIFFICULTY FOR YOURSELF

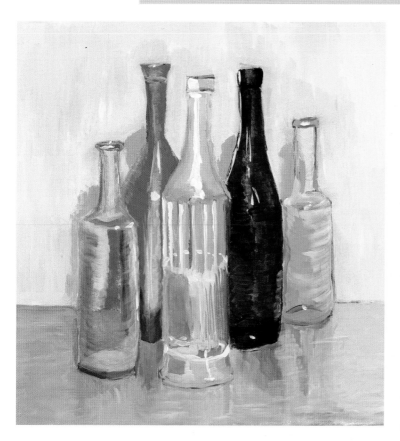

The objects depicted artistically in a still life are inanimate and motionless. Some of them were once living (fruit, vegetables, animals); others were not (bottles, bowls, chairs etc.). Still life is very suitable for beginners, because the painter can determine the degree of difficulty for himself. The best way to begin is with an object that can be lit more or less from all sides, turn it this way and that, move it hither and thither, until you find the best arrangement. Then sketch the object before actually painting it. Gradually, as your confidence grows, the time will come for arranging a number of things in interesting groups.

A still life of five bottles placed centrally. The degree of difficulty in this case is already a bit higher. Apart from the outsides of the bottles, in two cases their transparency is also depicted.

OBJECTS WITH MEANING

Still life paintings have survived from Greek and Roman times. These were probably mainly for decorative purposes. The baroque age (1600–1790) is considered to be the golden age of the still life, when Dutch and Flemish artists in particular left their mark on the genre. Their aim was to convey, through the objects they painted, a symbolic hidden message that would give the beholder food for thought. For example, broken pots, bowls, and glasses were a symbol of earthly vanity, while the fading lights of oil lamps or candles referred to the passing of time and the inevitable eternal darkness of death. Grapes stood for Jesus Christ; the egg was a symbol of the resurrection. So the messages associated with the objects in these paintings had a marked religious content, and there were many more of these symbolic objects than are mentioned here.

However, around 1760, the still life was relieved of this heavy burden of symbolic meaning. From then on it was art for art's sake, for the sake of esthetics. The objects were now only used to convey color and form, which took over the leading role again.

Candle, skull, musical instrument, and shells are typical of the objects that carried messages in baroque still lifes. This picture from the year 2006 is an exercise that looks back to the old masters.

ARRANGEMENT AND COMPOSITION

No matter what period they come from, the same consideration has always been of outstanding importance: adherence to the rules of composition. For example, among the Netherlandish painters of around 1600, the components of a still life always had to be a vertical axis, a horizontal axis, and a spatial axis that reaches out into the room.

There are many options in composition. Incidentally, the word compose comes from the Latin "componere," meaning to put together. In painting, it's a matter of putting the elements together in a way that creates harmony, so that the positioning of an element or the arrangement of several is attractive. It's all about tension and balance.

An apple placed on two cloths, lying on a table. The main motif is to be found in the golden section, which gives the picture a particular tension.

Advice

To familiarize yourself with composition, we recommend that you study old master paintings, look at them in museums, sketch them, and transfer their structure into your own works.

COMPOSITION OPTIONS

First of all: compositional rules apply not only to still life but to every painting. However, it is true to say that composition plays a special part in still life.

At this point we want to present the most important kinds of composition.

- Central composition: the main motif is placed in the center of the picture.
- Triangular composition: the main motif or the elements form a triangle.
- Golden section: the golden section is created where a

horizontal and a vertical axis cross and are extended to around two thirds of the surface.

These three are the main options, but by no means the only ones. Objects standing next to one another (serial composition) can look just as attractive as a well-judged distribution composition.

Central composition. The main motif is in the center of the picture. It radiates peace, but can also appear boring.

Triangular composition. The main motif or the elements form a triangle. This type of composition was widespread in sacred art.

Golden section. Theoretically it is found in four places in a picture, at the intersection of straight lines dividing the picture into unequal rectangles in a proportion of approximately 8:13. The main motif or the majority of the elements are placed on or close to one of the four intersection points.

A painting that follows none of the rules of composition looks arbitrary, and is often irritating as well.

Special
Preliminary sketch

If you want to achieve good results in representational painting, a preliminary sketch on the support is very important. It will allow you to fix the outlines and contours of the still life, landscape, figure etc. that you will be painting later. When you work on it with paint, these are important clues for keeping the proportions and the details of the content correct. Preliminary sketches have the additional advantage that you can go on correcting them until you are satisfied all the details are right.

You can either transfer the content from an original using the grid method as described on pages 34–35, or draw freehand on the support.

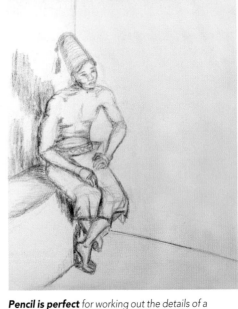

Pencil is perfect *for working out the details of a figure.*

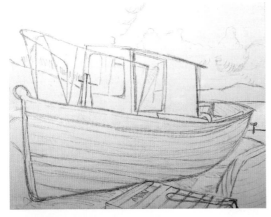

A graphite stick is good for transferring *the content of a picture using a grid, and also for freehand drawing.*

Fine lines, but almost impossible to erase: *a preliminary drawing in red chalk. The lines will mix with the first application of acrylic paint.*

FROM PENCIL TO PAINTBRUSH

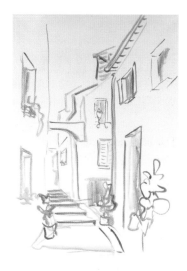

There are various drawing implements that can be used to make a preliminary sketch. We would like to introduce you to five of them here.

- Pencil: the most frequently used drawing implement for sketches and, of course, preliminary drawings. It is important that the pencil should be soft, for instance "b" or "2b". Advantages: it can always be rubbed out to make corrections, and the outlines are fine.
- Graphite stick: next to pencil, the most important drawing implement for grid transfers. It is softer than pencil and the lines are a bit thicker. Both can, of course, also be used for freehand drawing.
- Red chalk: similar to a graphite stick in covering strength. A red chalk drawing looks more delicate, but is almost impossible to rub out. The lines will mix visibly with thin applications of acrylic paint. This can produce attractive effects and has the advantage that the contours fade and the design becomes freer.
- Natural charcoal: wood that has been turned into charcoal is very soft and very good for freehand drawing. You can make corrections by wiping it off and drawing over it again. In a preliminary sketch, you can already determine light and shade. Charcoal must be fixed with a special charcoal and pastel fixative from a spray can, preferably in several thin coats, until no more will rub off.
- Paintbrush: more experienced artists can also make preliminary sketches with a brush. The outlines are painted delicately with acrylic paint thinned with a lot of water. Use a single color for this, or two at most.

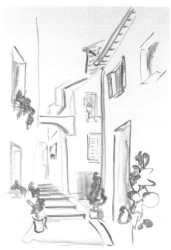

In a preliminary sketch using a brush, it's important to outline the contours with verve and capture the essentials. The lower picture shows the first color added in green.

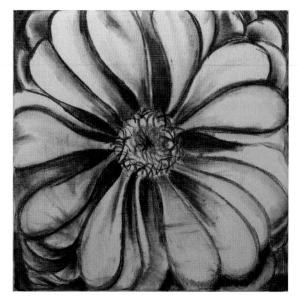

Drawn freehand with charcoal, the light and shade values (chiaroscuro) are already determined.

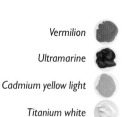

Plate of grapes

A plate filled with black grapes gives you an easy start in this genre. The objects are arranged symmetrically, the light falls from the top right and determines the values of light and shade. The arrangement is in the category of central compositions. In this picture, only four colors are used, from which all the necessary shades are mixed. This makes the plate of grapes a very good practice exercise for getting the right colors.

Materials
Stretched canvas 12 x 12 inches (30 x 30 cm); pencil; graphite stick; fixative; flat brush no. 8; jar of water; cotton cloth or paper towels; palette; colors: vermilion, ultramarine, cadmium yellow light, and titanium white

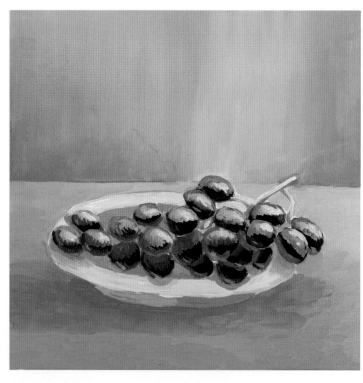

Vermilion

Ultramarine

Cadmium yellow light

Titanium white

Advice
Always begin your picture with the main subject, for the preliminary drawing, when you start painting, and even more when it comes to the finishing touches. The most important always comes first—it makes the picture more alive.

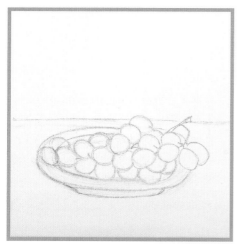

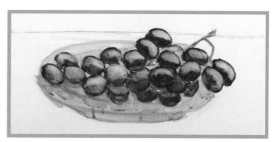

1 Make a preliminary drawing of the plate and the grapes in fine pencil and then thicken the lines with the graphite stick. Spray the graphite layer with fixative. Take care that some of the grapes overlap one another, not all lying separately.

2 Mix the vermilion and ultramarine to a violet shade. Thin the paint with a lot of water and paint the grapes. Clean the brush with water and gently wipe it dry. Now use the brush to take off some of the wet paint from the top halves of the grapes. The lighter patches will give an impression of three-dimensionality. For the stalks, mix cadmium yellow light with ultramarine, which gives a fresh green. For the plate, mix titanium white with a little cadmium yellow light, a very small amount of vermilion, and a trace of ultramarine. This gives a very pale shade of beige to gray.

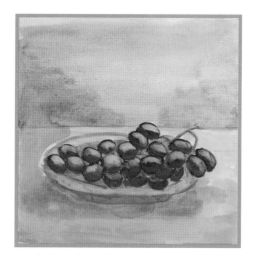

Tip

So far, we have applied the paint as a glaze (transparent). It is worth considering whether to give the painting a further glazing coat to finish with. This is entirely a matter of the artist's taste. We have decided to paint it opaque.

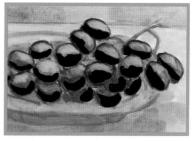

3 Block in the table in a pale orange, mixed from cadmium yellow light, a little vermilion, and titanium white. Give the shadow under the plate a violet tint. That way you create a little contrast between the colors, which produces a three-dimensional effect. Block in the background with the pale violet shade and the delicate yellowy orange as well.

4 Mix ultramarine with a very little vermilion to give a violet blue, but this time without adding any water, and paint the bottom halves of the grapes.

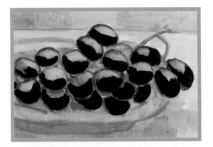

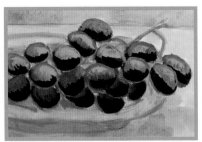

5 Add a little more vermilion to the violet blue to make a reddish violet. Break up the top edge of the violet blue a little with this color and mix the two.

6 Now mix titanium white into the violet and paint the upper side of the grapes. Blur the transition between the dark and light violet tones.

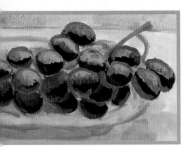

7 To add slight contrasts, paint the underside of one or two grapes with a mixture of cadmium yellow light, a little ultramarine, and titanium white. Use this light, fresh green for the stalks as well.

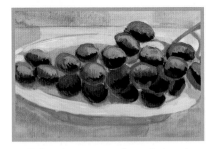

8 Paint the upper edge of the plate with a light beige, mixed from titanium white, a very little cadmium yellow light, and a trace of vermilion. Paint the light parts of the edge of the plate and leave out the areas shaded by the grapes.

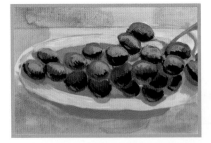

9 The color of the shadow falling on the plate is mixed as follows: into the beige you used for the edge of the plate, mix a little more vermilion and cadmium yellow light, and to make it darker a little ultramarine. This gives a slightly faded beige-gray.

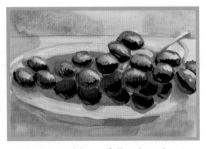

10 Now add carefully placed points of light and shade. With a little titanium white and ultramarine you can create more spatial depth.

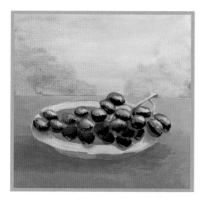

11 From cadmium yellow light, vermilion, and a little titanium white mix the color for the table, a bright orange, which you apply flat. You make the color for the shadow of the plate with the same orange, with less titanium white, and a little ultramarine. The brush strokes should be horizontal.

12 The background is made up of two mixtures of color: the sides of a very pale violet and the middle above the curve of the grapes of a very pale cadmium yellow light. The brush strokes should be vertical.

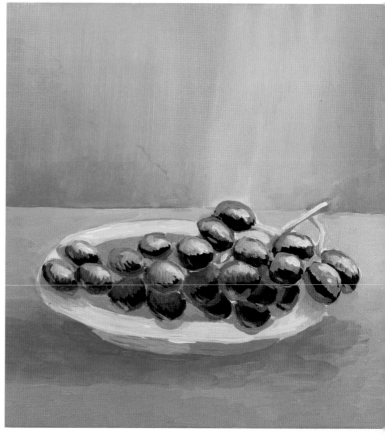

SUMMARY

Grapes: create the three-dimensional effect with layers of violet, green, white, and a little light blue.

Background of two color mixtures and vertical brush strokes.

Shadows of the grapes with a slightly faded beige-gray.

When painting the table, the brush strokes are horizontal.

Step by step
Apple

Our second still life picture is a simple subject. It shows an apple positioned on two cloths on a table. It uses the golden section to introduce tension into the picture. A light source illuminates the fruit from above left. The subject makes it possible to concentrate on the details of the apple. The cloths and the table are painted flat.

Materials
Stretched canvas 12 x 12 inches (30 x 30 cm); graphite stick; fixative; flat brush no. 10; round brush size 6; jar of water; cotton cloth or paper towels; palette; colors: crimson, vermilion, chrome yellow, cobalt blue, black, ultramarine, titanium white, light ocher, Vandyke brown, and raw umber.

Crimson

Vermilion

Chrome yellow

Cobalt blue

Black

Ultramarine

Titanium white

Light ocher

Vandyke brown

Raw umber

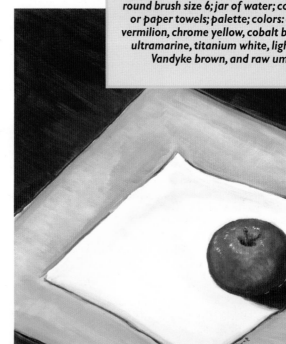

1 When making the preliminary drawing, pay attention to the circular shape of the apple and the position of the stalk in the hollow. Also draw in both the shadow of the stalk and the apple. This already produces a three-dimensional effect. Complete the preliminary drawing with the outlines of the cloths.

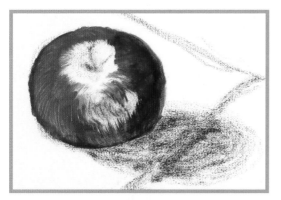

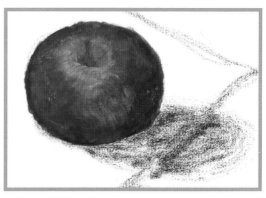

2 Mix a red shade from crimson and vermilion. Paint the body of the apple following the natural rounded shape of the fruit with the flat brush. Every now and then, use the two shades of red separately.

3 Add a green tone, by mixing chrome yellow, a little cobalt blue, and a trace of vermilion, and paint in volume the parts that are still white. Don't use just one mixture, but sometimes add a little more chrome yellow and sometimes a little more cobalt blue.

4 The shadow cast by the apple is an element of the painting in its own right. For the shadow on the white cloth, mix titanium white with black, a little ultramarine, and a trace of crimson. For the ocher-colored cloth, use a mixture of light ocher and Vandyke brown, plus some cobalt blue and a little ultramarine. Next, block in the two different shadow areas with the appropriate colors.

Give the side of the apple away from the light some of the shadow color for the white tablecloth to represent the mutual reflections of the apple and the cloth.

Advice

Shadows are special pictorial elements in painting. To get the right color for the shadows, we have the following rule: mix a darker shade of the local color with its complementary color and a little ultramarine.

An example: the local color of a tomato is vermilion. For the shadow, you take a darker red, crimson for example, mix it with the complementary color of the local color, which is a turquoise green, and add a trace of ultramarine.

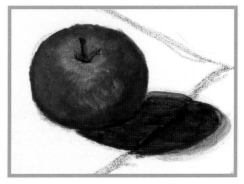

5 Now paint the smaller cloth in titanium white and a little light ocher, and the larger one in light ocher with a little titanium white, applying the paint flat. Paint over the graphite of the preliminary drawing to create the edges of the shadows.

6 Block in the table in the background with Vandyke brown and raw umber.

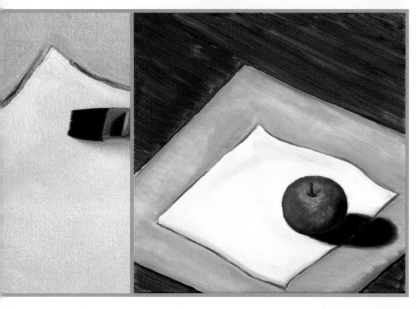

7 Now go over the surfaces of the cloths with the same colors in a thicker consistency.

8 Darken their outlines by painting them in raw umber with a flat brush.

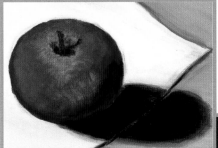

9 Finish off the apple and darken the shadows in the hollow, and the shadow cast by the stalk.

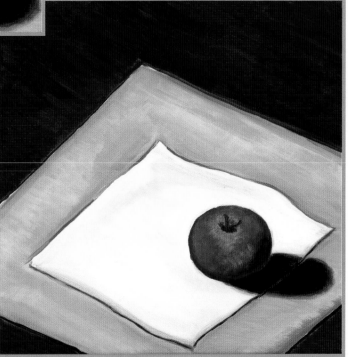

10 Paint over the background again with the mixture of Vandyke brown and raw umber.

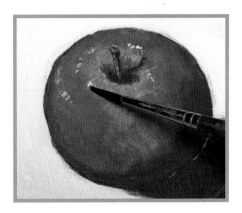

11 Using the round brush and titanium white, add high-lights to the stalk and the body of the apple.

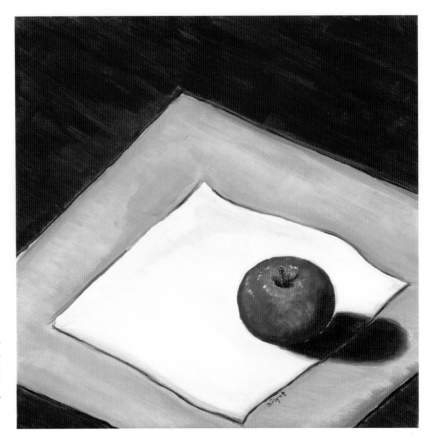

12 Although this still life only consists of a single main element, the work needed to bring out small details offers interesting challenges.

SUMMARY

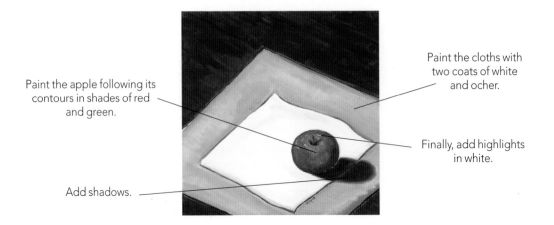

Paint the cloths with two coats of white and ocher.

Paint the apple following its contours in shades of red and green.

Finally, add highlights in white.

Add shadows.

Light and shade

Our still life creates the interplay of light and shade using a stepladder and two chairs. With this kind of subject, you can capture everyday life in an artistic way—the content of a still life doesn't always have to consist of classic objects. The shadows on the floor and wall offer a new challenge after the exercise with the apple. Of course the background is not left completely white but is given structure by the careful painting of the shadows.

Materials

Stretched canvas 24 x 32 inches (60 x 80 cm); graphite stick; flat brush no. 10; round brush size 6; jar of water; cotton cloth or paper towels; palette; colors: Vandyke brown, titanium white, crimson, black, and ultramarine

 Vandyke brown

Titanium white

Crimson

Black

Ultramarine

1 The preliminary sketch using a graphite stick already shows all the objects. No fixative is used. A single source of light means that the shadows fall at slightly different angles.

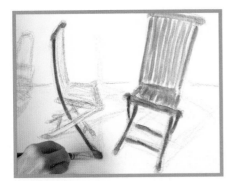

2 Paint the outlines of the chairs in Vandyke brown. Where the chair legs cross, take care to leave gaps in the parts that go behind and only paint those in front in full.

3 To block in the stepladder, paint over the graphite with a wet brush and titanium white.

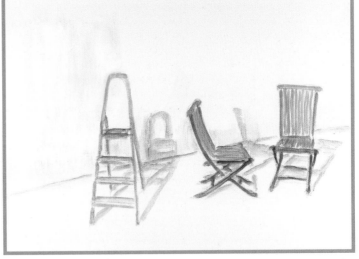

4 Block in the shadows of the chairs and the stepladder by painting over the preliminary sketch with a wet brush.

5 The first application of color for the chairs, stepladder, and shadows is complete. The graphite of the preliminary drawing is incorporated in the same way for the floor and wall.

6 Paint the floor and wall with titanium white rather more completely, working the graphite in further.

7 Block in the plastic parts of the stepladder with a glazing of crimson.

8 Paint the chairs in more detail, using mixtures of Vandyke brown and black.

9 The painting after the floor, wall, and chairs have been painted in detail and the stepladder blocked in.

10 Put in the details of the stepladder in impasto, using crimson for the plastic parts and titanium white on the light areas, and add highlights. Then put in the detail of the darkest bits with a mixture of Vandyke brown and black.

11 Now it's the turn of the darkest bits of the chairs, also with a mixture of Vandyke brown and black.

12 To finish off the shadows, mix black, titanium white, and a trace of ultramarine.

13 Lastly, finish off the floor and walls between the shadows and the objects with titanium white, with a little black mixed in.

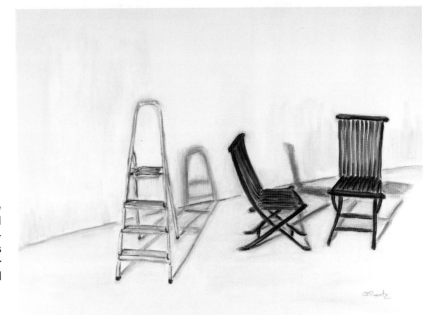

14 Paint the large areas of floor and wall with the same mixture. The brush strokes should be vertical for the wall and horizontal for the floor.

SUMMARY

The depiction of the shadows creates an impression of space.

Detailing the lightest and darkest parts.

Red parts as spots of color.

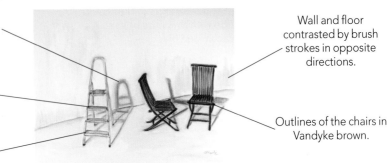

Wall and floor contrasted by brush strokes in opposite directions.

Outlines of the chairs in Vandyke brown.

Five bottles

Four of the five bottles in our next still life were actually transparent in the original arrangement. In order not to set the degree of difficulty too high, only two are depicted as transparent. Painting bottles involves one or two particular skills. The most important is to get their curves onto the support in the correct perspective (page 65).

To do this, you block in cylindrical objects with opening or closing circles and ellipses, depending on the perspective.

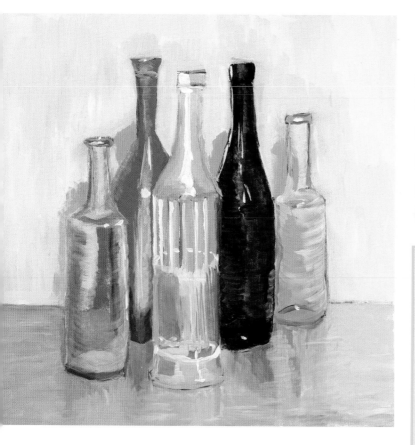

 Light ocher

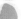 Ultramarine

 Cadmium yellow light

 Vermilion

 Chromium oxide green fiery

Titanium white

Materials
Stretched canvas
20 x 20 inches (50 x 50 cm);
natural charcoal; fixative;
flat brush no. 12; jar of
water; cotton cloth or
paper towels; palette;
colors: light ocher, ultrama-
rine, cadmium yellow light,
vermilion, chromium oxide
green fiery, and titanium
white

1 Before you start the preliminary drawing, arrange the bottles and make a sketch in order to establish the proportions and perspective. For each bottle, first draw a cylinder and its central axis. Draw the ellipses representing the bottom, body, and neck of the bottle around this midpoint.

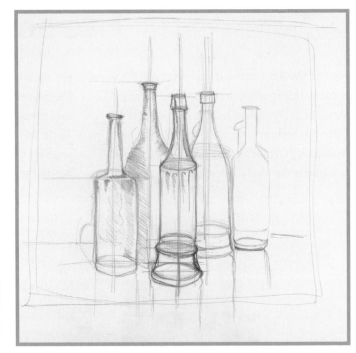

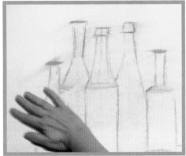

2 Transfer the sketch to the support in charcoal. Rub out the first versions with the flat of your hand and keep drawing the outlines until you are satisfied with the result.

3 Block in the shadows as part of the charcoal sketch. You can put in shadows by rubbing with your fingers. Spray the sketch with fixative several times, until no more charcoal rubs off.

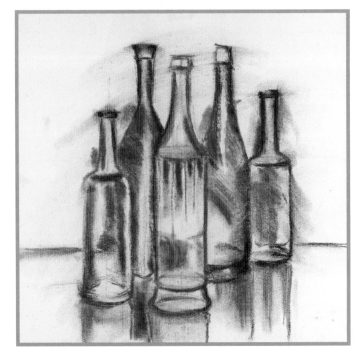

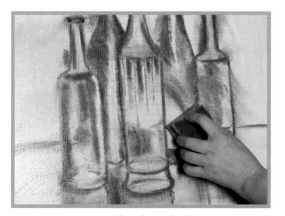

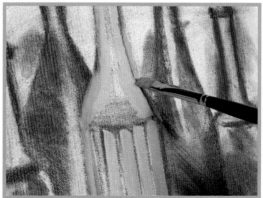

4 With a household sponge, apply light ocher thinned with a lot of water. This kind of application is called imprimatura.

5 Begin with the bottle at the front. Mix a bluish-gray shade from cadmium yellow light, vermilion, ultramarine, and titanium white, and paint the first parts of the bottle following its structure.

6 Add a little more ultramarine to the mixture and paint the areas where the blue of the other bottles shines through. Use titanium white to put in the lightest accents on the bottles.

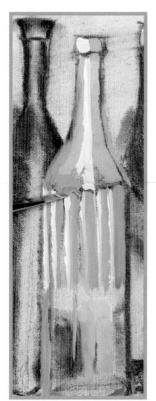

Advice

A wash (or imprimatura) completely covers the support and gives the picture a background color. Depending on your intentions, it may harmonize with the major colors, but it can also be in contrast to them.

7 Paint the second bottle that is just to the right of the first in pure ultramarine, following its contours. For the left-hand half, darken the blue by adding black.

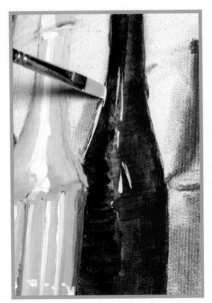 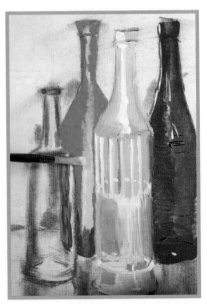

> **Tip**
>
> *To get the exact shade for the two outer bottles, add a little chromium oxide green fiery to the mixture of titanium white and ultramarine.*

8 Finally, put in highlights with titanium white.

9 The blue of the second bottle from the left shines through the bottle on the far left. When you paint this bottle, use some of its color, a mixture of ultramarine and titanium white, in the first bottle as well.

10 When you have finished all the bottles, paint the table with a mixture of titanium white, light ocher, and a little vermilion. You can capture the reflection of the bottles in the surface of the table by using vertical brush strokes and the colors of each of the bottles.

11 For the background, use light ocher mixed with titanium white. The shadows of the bottles on the wall are a special part of the picture. Mix the appropriate color from light ocher, with less titanium white than before, and add a little blue—the complementary color of ocher—and a hint of ultramarine as usual.

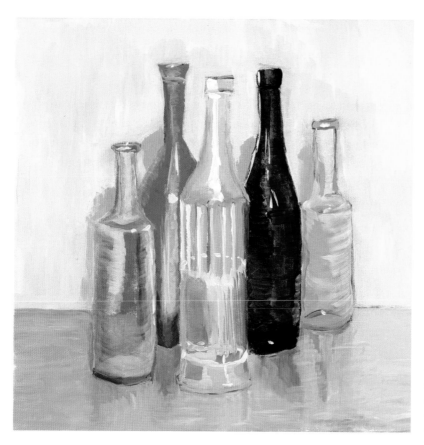

12 A very expressive still life has been created with five bottles. The color contrast between ocher and blue gives a pleasant, fresh effect that is not at all cold, despite the large amount of blue.

SUMMARY

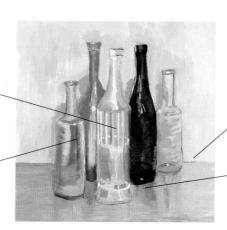

Paint the bottles following their contours or structure.

Bring out the transparency of a bottle.

Vertical brush strokes for the reflections; horizontal brush strokes for the tabletop.

Reflections and shadows enhance the three-dimensional effect.

Step by step
Basket of vegetables

A still life with objects that are classic for this genre is the last work in our series. However, the various vegetables aren't conveying any kind of message, they're just arranged and painted for their own sakes. Various shapes and different colors make the picture very complex and offer quite a challenge. All the same, their soft curves allow plenty of freedom in the way they are represented.

Materials
Stretched canvas 20 x 28 inches (50 x 70 cm); graphite stick; fixative; flat brush no. 12; round brush size 6; jar of water; cotton cloth or paper towels; palette; colors: light ocher, Prussian blue, chromium oxide green fiery, vermilion, dark madder, titanium white, and ultramarine

Light ocher

Prussian blue

Chromium oxide green fiery

Vermilion

Dark madder

Ultramarine

Titanium white

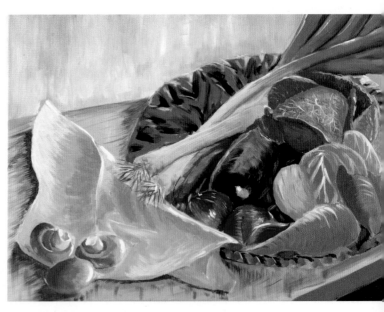

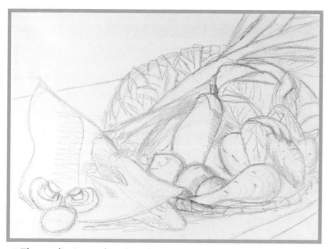

1 The preliminary drawing shows the true proportions and distribution of the vegetables. Draw with a graphite stick, then spray with fixative until no more rubs off.

2 mix a green from light ocher, Prussian blue, chromium oxide green fiery, and a little vermilion. Use this to block in the darkest areas, e.g. the savoy and the tops of the leeks. Then add titanium white to the mixture to produce a lighter green.

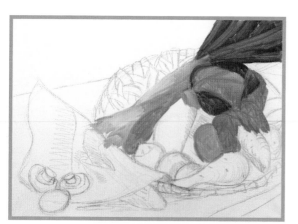

3 The green vegetables have been blocked in. The brush strokes already follow the form and contours at this stage. Leave spaces on the leaves to add the veins later (step 11).

4 With a mixture of vermilion and dark madder, block in the onions. For the sweet potatoes, add a little titanium white. Paint these vegetables with brush strokes that follow the contours.

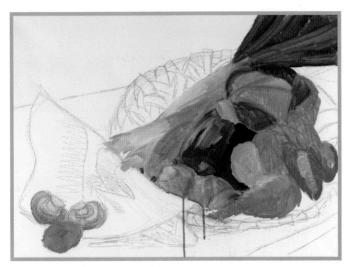

Tip

For very dark areas of a picture, mix what is known as a classic black from Prussian blue, dark madder, and chromium oxide green fiery.

5 From vermilion, Prussian blue, and a very little light ocher, mix a grayish violet and block in the eggplant. Add highlights in titanium white. For the mushrooms, use a light brown shade, mixed from light ocher, Prussian blue, vermilion, and a lot of titanium white.

6 To paint the folds of the cloth, mix light ocher and titanium white, and break it up with a little dark madder. Darken the color in stages by adding a trace of Prussian blue each time.

7 Block in the basket with light ocher, Prussian blue, and vermilion. Follow the structure of its surface with your brush strokes.

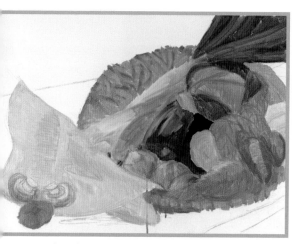

8 The elements in the foreground are now blocked in. The lighter areas of the basket were produced by adding titanium white to the original mixture (step 7).

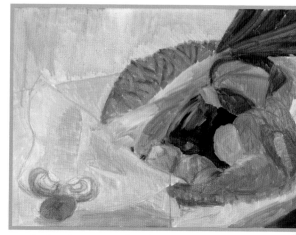

9 Block in the background with a mixture of titanium white, a little dark madder, and a little Prussian blue. The table was given a first coat of titanium white with a little Prussian blue to add contrast to the picture.

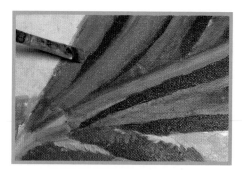

10 Now finish off the vegetables, with the same colors as when blocking in, but with a buttery consistency. Begin with the darkest areas, for instance on the leeks, and gradually lighten the tone by adding more titanium white.

11 Finish the leaves with brush strokes following the contours. You previously left spaces for the veins of the leaves.

Tip
Vary the shades of green by changing the proportions of the individual colors light ocher, titanium white, vermilion, and Prussian blue.

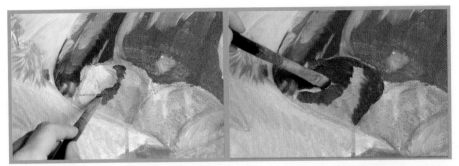

12 Next, finish the onions with vermilion, following their structure. Then add dark madder. For the lighter areas in the middle, mix the madder with some titanium white. The colors are still wet. Using a flat brush with no paint, draw fine lines from dark to light and vice versa. This will produce the typical structures of a red onion.

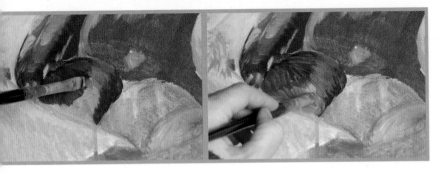

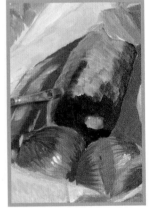

13 Work with the color mixture for the eggplant (step 5) in a buttery consistency, following the contours. For the lighter areas you again add titanium white. The lightest areas consist of pure titanium white.

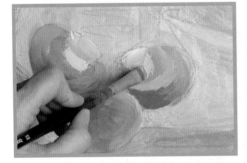

14 Finish the mushrooms in the same mixture as for blocking in (step 5). Begin with the darkest areas and gradually lighten the tone by adding more titanium white. Create the structure of the mushrooms by drawing the flat brush without paint from light to dark and vice versa.

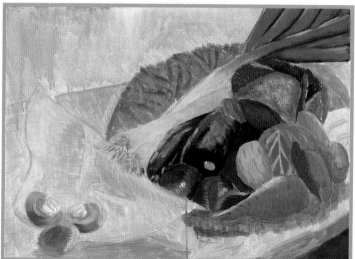

15 The vegetables are fin-
ished.

16 To finish the cloth, use the
color mixture as in step 6, in
a buttery consistency. The direc-
tion of your brush strokes depends
on how the cloth is lying.

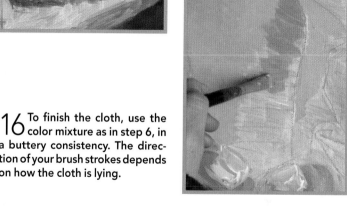

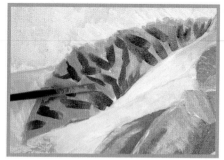

17 Now finish the basket with the color
mixture from step 7, following the
structure. Gradually lighten the tone by
adding more titanium white.

18 With a mixture of titanium white, and
a little dark madder and ultramarine,
finish off the background, using vertical
brush strokes. The light violet echoes the
violet of the eggplant.

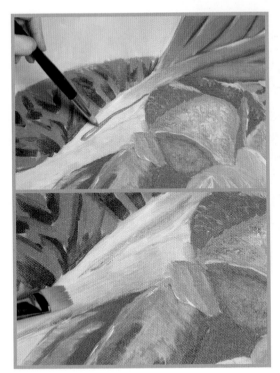

19 After the picture has been completely finished in thick paint, we pick out the important points in dark and light. For the dark green of the leeks, use the color mixture from step 2, thinned with water, and the round brush. Lastly, smear the paint with a dry flat brush.

20 Put in the highlights with titanium white, using the round brush. This gives you an additional opportunity to emphasize the finer structures.

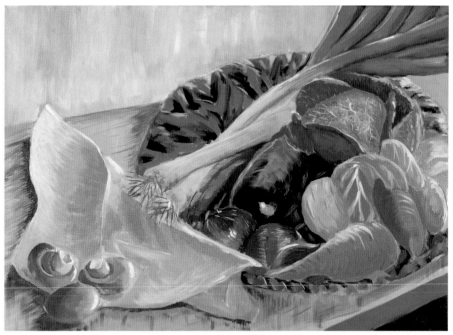

21 The color coat on the table has been completely painted over, with the color for the basket (step 7), plus titanium white and the addition of light ocher as necessary. The brush strokes correspond to the diagonal view of the table. Work from light to dark, and finish by emphasizing the darkest and lightest areas once more to give the whole thing more depth.

SUMMARY

Paint the vegetables with smooth surfaces following their contours.

Paint the darkest areas with classic black.

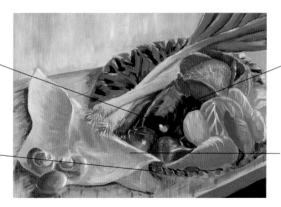

Paint the basket and vegetables with rough surfaces following their structure.

Light and shade enhance the three-dimensional effect.

Plants

6

Plants are living things—so the most important difference from the still life genre is immediately obvious. The enjoyment of nature, trees, bushes, grasses, flowers, and so on is a great source of motivation for a painter to turn to plants. In fact, you will not find that greens and browns predominate, because the multiplicity of flowers offers a feast of color, as do the changing seasons. The countless different shapes and structures will provide you with an extra challenge.

IN A GREEN SHADE

Green is, of course, a color, but how many shades of green are there? The answer is simple: it's actually impossible to count them. Yet the various greens are the most important colors when it comes to plants. This is because the chlorophyll used by plants for photosynthesis in order to stay alive is green. However, the local color plays a subordinate role in perception. The many shades are produced mainly by the effects of light and shade, brightness and darkness. Leaves that are the same shade of green may take on a vast number of apparent colors, from almost black to something approaching white. It's true that plants are green—but how green?

Green is also considered to be the most difficult color in painting. We have paid tribute to that by devoting a special page to green (page 98).

Trees are also green—that's obvious. But that's not the whole story. They delight us with their many different shapes, the structure of their bark, their grandeur, and their vital energy. So it is not surprising that they are among the favorite subjects for painters when it comes to the theme of "plants."

The leaf of a plant is green —but how green? Tonal values ranging from almost white to nearly black are possible.

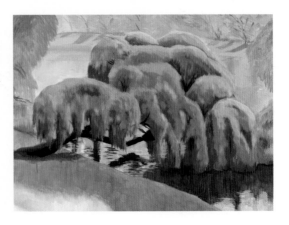

A splendid weeping willow bows down into the water.

VARIETY OF FORM

Lovers of form get their money's worth from plants. The curving leaves of a tulip are simple and elegant, while its slender stalk rises straight up and merges into a beautiful calyx. This flower, which came to Europe via Persia, was considered a luxury in the Middle Ages and was valued more highly than gold or precious stones. If you examine one closely, you can understand why.

Plants en masse have quite a different effect. At first glance, you can only get an overall impression of a meadow full of wild flowers and grasses. The details only become apparent when you take a second look, and you see "individuals," each one, without exception, raising its head proudly toward the sun.

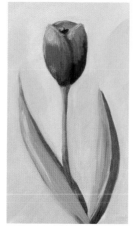

Simple, clear, and elegant: *the tulip's beauty is captivating.*

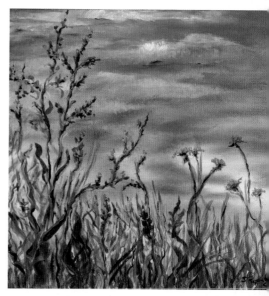

Grasses and flowers *in a summer meadow.*

EVERYTHING IS COLORFUL!

Being eye-catching is a way of getting ahead in life, and it works for flowers. They make use of a whole palette of striking colors in shades of red, yellow, and blue in order to catch the attention of the insects that will guarantee their propagation. Their magnificent and exciting shapes also make them a feast for the eye—particularly for painters. A beautiful, brightly colored flower makes an ideal subject. Small wonder, then, that flowers are always top of the pops.

The sunflower *was once worshiped by the Incas as an image of their god.*

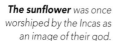

Special
First things first!

In representational painting, the usual order of events is: preliminary drawing, first application of paint watery, second application impasto, then emphasizing the darkest, and finally the lightest areas. But if you want to paint vivid pictures, you should follow one more rule, right from the start of the preliminary drawing. This rule says: "Begin with the most important thing, with what is in the foreground, what matters to you!" This is not necessarily the same for every painter.

A picture conveys the artist's idea, and his intention will only come to life if he has worked on the main element right from the start. That way the objects and other elements in the picture will have the intended effect and give the painting clarity and power.

FROM FOREGROUND TO BACKGROUND

Concentrating on the foreground, the important elements of the picture, and sticking to the correct order for blocking in and adding detail will help you to avoid typical mistakes, such as blocking in the entire sky and only then adding trees that reach up into the sky. The result is that the colors of the trees mix with those of the sky, not just in the literal sense, but also because the colors overlie one another and thus lose some of their strength and brilliance. Structures from a different set of brush strokes show through. In short, what should stand out appears faded and dull. The quality of the picture is reduced.

To show you the correct procedure, we have chosen an example; a few ivy leaves against a wall. We want the ivy to dominate the foreground and the wall to be merely the background, so this is how we proceed.

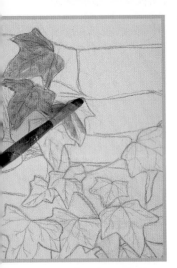

1 After the preliminary drawing—which began with the ivy—start by blocking in the green of the ivy leaves.

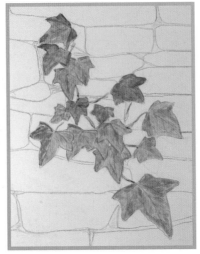

2 The foreground is blocked in with the first color.

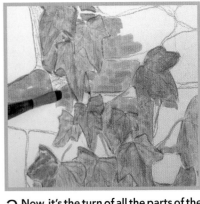

3 Now, it's the turn of all the parts of the background immediately adjacent to the foreground, including any shadows.

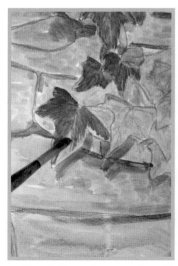

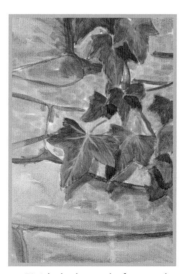

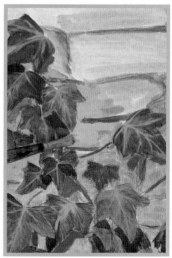

4 Now follows the second application, with the brush strokes following the leaf structures.

5 Finish the leaves before applying the second coat to the background.

6 Begin the second application to the background, immediately next to and between the leaves.

7 Emphasizing the darkest areas and putting in highlights increases the brilliance of the foreground and makes the leaves stand out even more from the background.

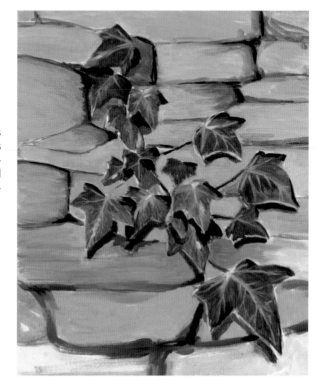

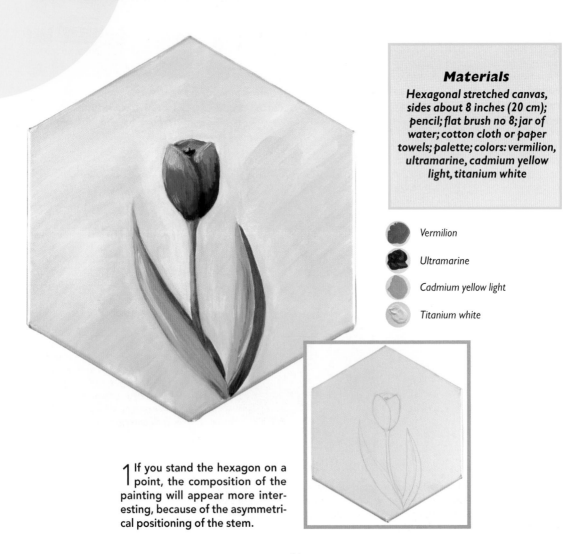

Step by step
An elegant tulip

Painting a tulip is a great way to start on the subject of "plants." Firstly, its simple beauty offers great esthetic pleasure, and secondly, its forms are easy to reproduce. Incidentally, did you know that there was once a period of "tulipomania?" In Holland in the 1730s, three tulip bulbs were once worth as much as an entire house. The dream of riches collapsed, but the beauty of the tulip remains.

Materials
Hexagonal stretched canvas, sides about 8 inches (20 cm); pencil; flat brush no 8; jar of water; cotton cloth or paper towels; palette; colors: vermilion, ultramarine, cadmium yellow light, titanium white

Vermilion

Ultramarine

Cadmium yellow light

Titanium white

1 If you stand the hexagon on a point, the composition of the painting will appear more interesting, because of the asymmetrical positioning of the stem.

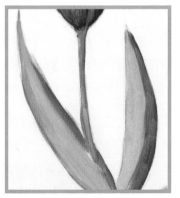

2 With a mixture of vermilion, ultramarine, and a little titanium white, block in the lower edges of the petals in violet. Paint the main areas of the flower in vermilion, and the tips of the petals in cadmium yellow light.

3 Block in the stem and leaves with a mixture of cadmium yellow light, ultramarine, and titanium white for light areas. For darker parts, mix a little vermilion into the green.

4 At the center of the flower, paint the pistil in a dark violet, mixed from vermilion and ultramarine. Block in the background with plenty of titanium white and a little vermilion and ultramarine, using diagonal brush strokes.

Tip

Apply the second layer of paint wet-into-wet, i.e. immediately after the first. After applying the yellow, clean the brush in water and dry it gently. Then drag it over all three colors, following the shape of the flower, so the colors mingle a little, creating a fluid transition from one to the other.

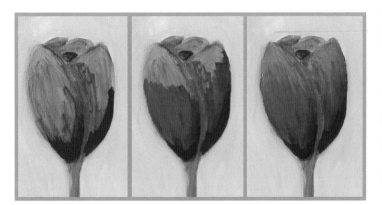

5 Second application with thicker paint. Begin with the lower edges of the petals, using the same violet as for blocking in. After that, it's the turn of the main parts of the petals in vermilion, while the tips are finished off with cadmium yellow light.

6 Paint the petal at the back in more detail and finish the darkest parts of the calyx.

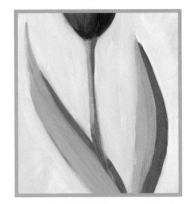

7 Finish the light areas of the leaves with the same color mixture as for step 3 but with thick paint. Do the same for the darkest parts, but using less titanium white.

8 Finish the background wet-into-wet with a lot of titanium white and a little ultramarine, cadmium yellow light, and vermilion. Stick to the same diagonal brush strokes you used for blocking in. With titanium white, put in the highlights on the flower and the leaves.

SUMMARY

Paint the calyx wet-into-wet and smear.

Background with diagonal brush strokes.

Contrast the color of the leaves and the stem.

Add highlights in titanium white.

Sunflower

Brought back from America by Spanish seafarers, the sunflower has long since become an important agricultural and decorative plant. The challenge—and the pleasure—of painting it consist in capturing the individual nature of a sunflower and transferring it to the canvas. With its strong colors, large flower head, and generously filled seed head, it symbolizes life and fertility. It radiates friendliness and seems somehow human.

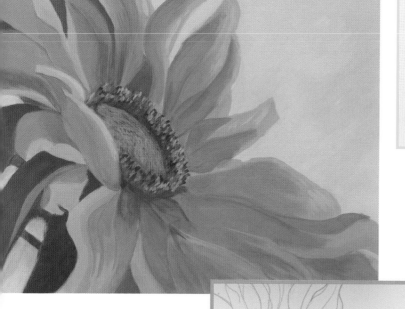

> ## *Materials*
> *Stretched canvas 24 x 32 inches (60 x 80 cm); graphite stick; fixative; flat brushes nos. 18 and 32; jar of water; cotton cloth or paper towels; palette; colors: cadmium yellow light, vermilion, ultramarine, chromium oxide green fiery, titanium white*

Cadmium yellow light

Vermilion

Ultramarine

Chromium oxide green fiery

Titanium white

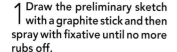

1 Draw the preliminary sketch with a graphite stick and then spray with fixative until no more rubs off.

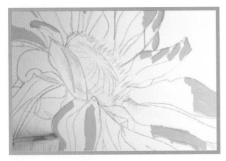

2 First application using cadmium yellow light. Block in the lightest parts of the petals.

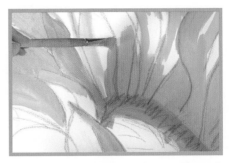

3 Add a very little vermilion to the cadmium yellow light to give a light orange. Use this to block in the darker parts of the petals and the edge of the seed head.

Tip

Keep adding vermilion to create a bright orange. For the leaves in the shadow, mix a little ultramarine into the orange.

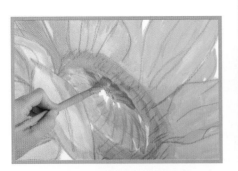

4 Block in the seed head in a green mixed from cadmium yellow light and ultramarine. For darker areas, add a little chromium oxide green fiery.

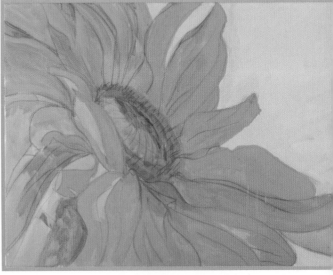

5 Block in the dark green of the stem with the same mixture as for the seed head, and the background in titanium white with the addition of a very little ultramarine.

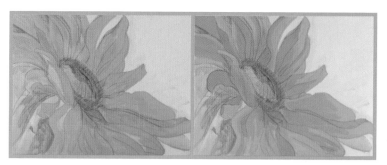

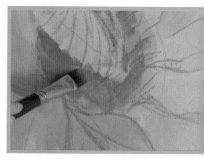

6 Finish the petals with a second coat, first with cadmium yellow light, then, as described in step 3, with the addition of more and more vermilion.

7 Mix a little ultramarine with the dark orange and finish the edge of the seed head with the brush strokes, following the structure.

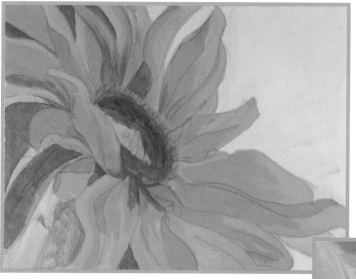

9 Paint the light part of the seed head with a mixture of cadmium yellow light and ultramarine.

8 With the same mixture as in step 7, paint the petals that are in shadow and the dark area of the seed head.

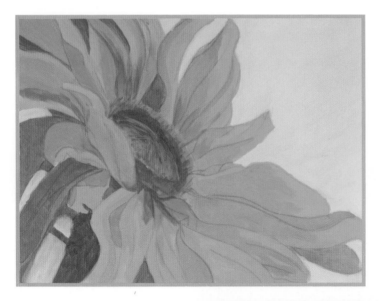

10 The second, impasto, coat is complete. You can repeat it as often as you think necessary, so the paint covers better and the painting acquires greater depth and intensity of color.

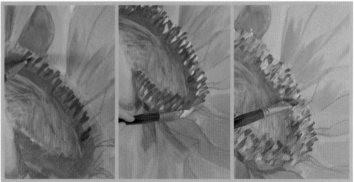

11 Now finish off the other elements of the seed head one by one, working from dark to light. Begin with the mixture from step 7, but with a higher proportion of ultramarine. Then it's the turn of titanium white, and finally a few dabs of cadmium yellow light.

12 With the mixture from step 11, emphasize the darkest areas.

13 Add highlights in titanium white, broken with a trace of cadmium yellow light.

14 Finish the background using thick titanium white and a little ultramarine. This includes all the major light patches near the stem.

SUMMARY

For petals in shadow, add a little ultramarine to the orange.

Petals in cadmium yellow light, with gradually increasing amounts of vermilion.

Very pale blue of the background contrasting with the petals.

Seed head painted following the structure.

Colorful flower meadow

The wide variety of different species is an important characteristic of a lush flower meadow. Countless different grasses grow side by side, competing for sunlight. Poppies, marguerites, dandelions, daisies, buttercups, and many other flowers offer spots of color from all parts of the spectrum. Depending on the viewpoint and the weather, a dramatic sky can add particular accents. The painter's task is to create an interesting composition from the many details.

Materials

Stretched canvas 12 x 12 inches (30 x 30 cm); pencil; fixative; household sponge; flat brushes nos. 10 and 18; round brushes sizes 4 and 8; jar of water; cotton cloth or paper towels; palette; colors: chrome yellow, vermilion, Prussian blue, titanium white, crimson, ultramarine, cadmium yellow light, black

 Chrome yellow

 Vermilion

 Prussian blue

 Titanium white

 Crimson

 Ultramarine

Cadmium yellow light

 Black

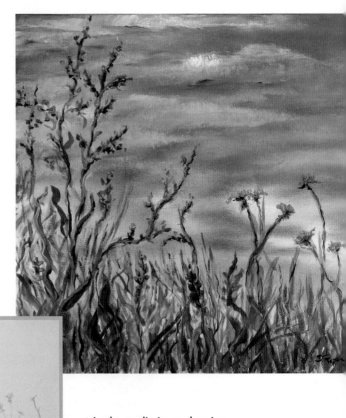

1 In the preliminary drawing, pencil in the outlines of the most important plants. Spray with fixative until no more rubs off.

2 With a household sponge, apply a thin, watery mixture of chrome yellow and vermilion. This wash gives the picture a warm background color.

3 Block in the grasses and flower stems with various mixtures of chrome yellow, vermilion, and Prussian blue, lightened with titanium white as required.

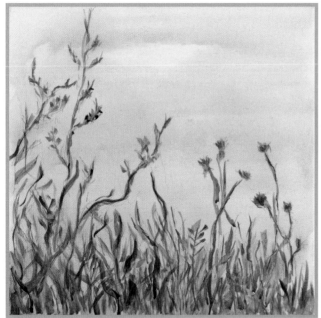

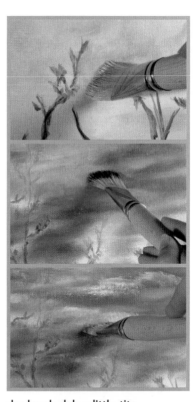

4 With the background wash and the first layer of color on the grasses and flowers, this phase is completed.

5 Paint the sky in three phases. Begin with a mixture of titanium white and a little Prussian blue. Then add a little more Prussian blue and a little crimson to the mixture to produce a blue with a hint of violet. Finally, with a very dry brush dab a little titanium white onto the sky. The background wash should be allowed to shine through in places.

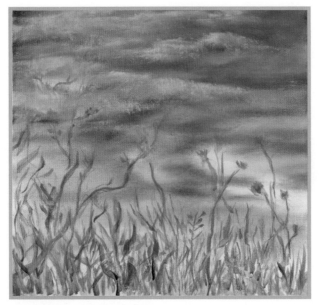

6 Now you have finished blocking in the sky as well as the plants.

7 Finish the grasses using the same colors as for step 3. You can also add ultramarine and cadmium yellow light to the mixture.

Ultramarine, vermilion, and cadmium yellow light *picked up on the brush and applied without mixing.*

8 In this step, finish off the flowers with chrome yellow and vermilion. For this—without taking it too far—you can also use the technique described on the left, i.e. using the two colors unmixed on the brush.

9 Darken the greens of steps 3 and 7 with black to emphasize the darkest parts of the flowers and grasses.

10 Add the final accents by painting the light parts of the flowers and grasses with an opaque mixture of chrome yellow and a little vermilion, and in selected places with pure chrome yellow or vermilion.

11 Add a few more flowers and grasses until you get the desired three-dimensional effect. Then finish the sky with titanium white, Prussian blue, a little vermilion, and a little chrome yellow.

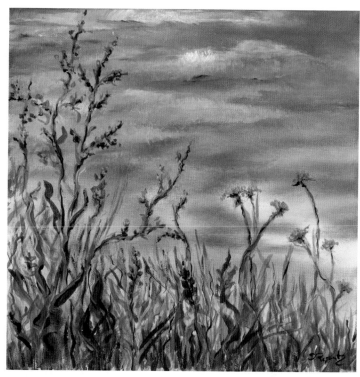

SUMMARY

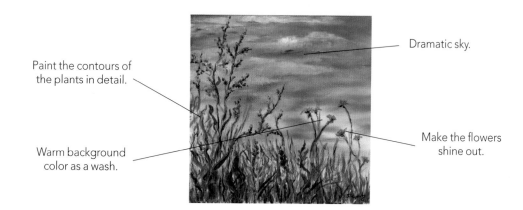

Paint the contours of the plants in detail.

Warm background color as a wash.

Dramatic sky.

Make the flowers shine out.

Special
Shades of green

When it's a question of mixing colors for painting, greens are among the more difficult. If you experiment with using a green straight from the tube or the jar to paint a whole area of a tree, a bush, or a meadow, you will soon discover that the green looks unnatural. So to create natural-looking shades of green, you should mix them from other colors.

BLUE AND YELLOW

Before you start mixing greens, set out all the blue and yellow paints you have. After all, according to color theory, blue and yellow make green.

The yellows used in this book are primary yellow, cadmium yellow light, chrome yellow, and light ocher. The blues are ultramarine, cobalt blue, and Prussian blue.

Now you can—and should—lay out a color grid as described on pages 28 and 29 with greens mixed from the different blues and yellows.

If you now feel prompted to ask why you should buy any green paints at all, the answer is simple: to mix them with other colors to produce (more) natural shades of green. So you should add mixtures of chromium oxide green fiery and chromium oxide green opaque to the blues and yellows and their mixtures on your color grid.

A view of the Gardens of Eyrignac in the South of France—photo and painting.

AND RED AS WELL!

To make greens produced by mixing look even more natural, you often need to "break" them by adding a red. In this way you can get more warmth into the green and also produce shades that tend toward brown.

Greens are often broken using vermilion, which hardly seems likely when you consider what a bright red it is. However, other shades of red are also used, ranging from crimson and madder to reddish browns such as burnt sienna.

And of course you can darken or lighten any shade with black or white (page 29).

To illustrate this topic, we have taken a photo of a park as a model and turned it into a painting. Here are a few examples of how we went about mixing the colors.

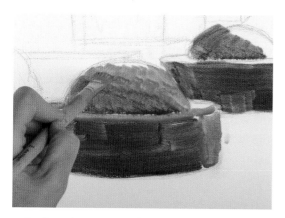

1 Darken chromium oxide green opaque with black for the dark parts of the hedges. For the light areas, mix chromium oxide green opaque and light ocher.

2 For the fresh green of the lawns, mix primary yellow and cobalt blue.

3 For the dark parts of the trees on the left, mix Prussian blue and light ocher, and break the green with a touch of vermilion. For the lighter parts of the trees, add cobalt blue and primary yellow to the mixture.

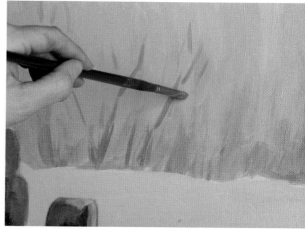

4 The color for the trees in the background is mixed from Prussian blue, titanium white, and a little light ocher.

Weeping willow by the lake

For those of us who live in temperate regions, vegetation without trees is unimaginable. With their combination of roots, trunks, branches, twigs, leaves, and sometimes fruits, trees are among the most impressive plants we know. The weeping willow in our picture really exists in a park in **Brussels**. In a strange way it has bent down almost into the water, as though it wanted to drink from the little lake. It makes a fantastic subject for artists, which we have captured on canvas in 16 steps.

Materials

Stretched canvas 24 x 32 inches (60 x 80 cm); graphite stick; flat brush no. 18; round brush size 6; jar of water; cotton cloth or paper towels; palette; colors: chromium oxide green opaque, titanium white, cadmium yellow light, light ocher, vermilion, ultramarine, Prussian blue, chromium oxide green fiery, dark madder

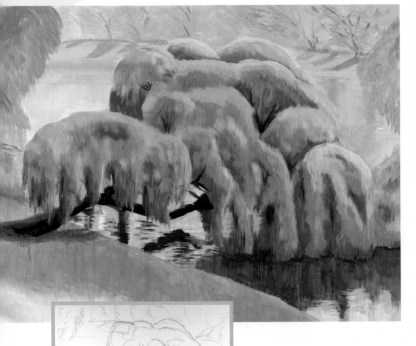

Chromium oxide green opaque

Titanium white

Cadmium yellow light

Light ocher

Vermilion

Ultramarine

Prussian blue

Chromium oxide green fiery

Dark madder

1 Draw the outline of the tree in graphite stick, but don't spray with fixative. The reflections and shadows can already be seen, as well as indications of the background.

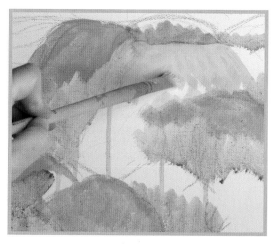

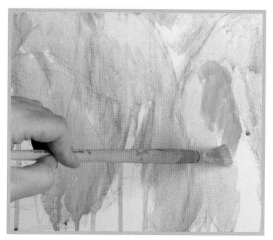

2 Block in the darkest parts of the crown of the tree with chromium oxide green opaque. For the lighter parts, gradually add more titanium white.

3 Add a little cadmium yellow light to the lightest green mixture and use it to block in the yellowish areas of the treetop and the grass.

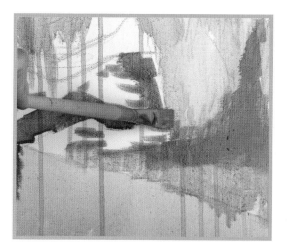

4 For the darkest areas of water underneath the tree, use a mixture of Prussian blue, light ocher, and a little vermilion.

5 For the tree trunk, use a mixture of Prussian blue, chromium oxide green fiery, and dark madder. Paint with brush strokes following the structure.

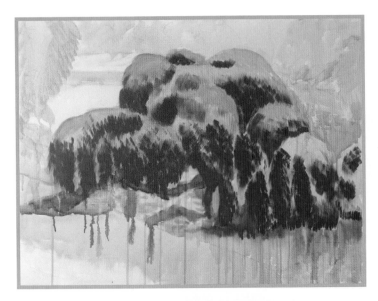

6 Emphasize the darkest parts of the crown by dabbing with a mixture of chromium oxide green opaque and vermilion. Block in the background in delicate shades of green mixed with a lot of water. The lightest, pale blue reflections in the water are created with a mixture of titanium white and a little Prussian blue.

7 After adding detail to the dark parts of the crown, use a mixture of chromium oxide green opaque with a little ultramarine and titanium white to finish the lighter parts. Dab on the paint with the brush following the structure of the crown. The spots should be closer together in the darker parts. Put a few dark spots in the light areas and vice versa. The lightest mixture consists of ultramarine, cadmium yellow light, a little chromium oxide green opaque, and titanium white. Using a dry brush and a very little titanium white, add stripes to all the areas painted in lighter shades of green.

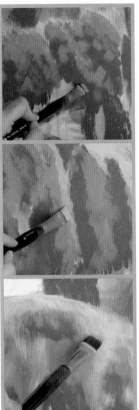

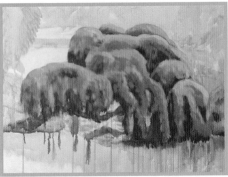

8 The crown of the tree is finished.

Tip
Create the effect of different distances through the changing shades of green. In this case, the farther away something is, the lighter the shade of green (through the addition of white) and the more blue you add.

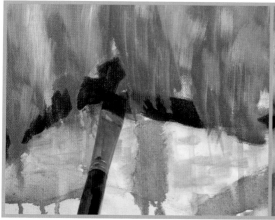

9 With the mixture of colors from step 5 but in a buttery consistency, add detail to the trunk. Paint any visible branches in the same color.

10 Paint the dark reflections of any downward hanging branches with vertical brush strokes. Use a mixture of Prussian blue, light ocher, and a little vermilion.

Tip

Still water is usually painted with horizontal brush strokes, whereas vertical brush strokes are used for reflections. You can create a sense of movement by adding delicate diagonals with a fine brush.

11 Paint the lighter reflections with horizontal brush strokes. For these you need titanium white with a very little Prussian blue, and also pure titanium white.

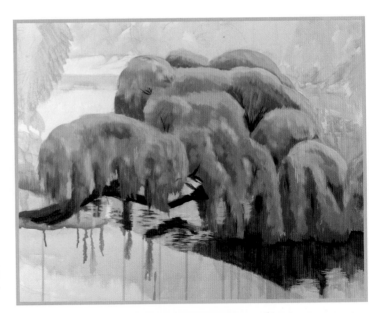

12 The trunk, branches, and their reflections are now finished.

13 Finish painting the grass using chromium oxide green opaque, cadmium yellow light, a little titanium white, and a touch of vermilion. For the shadows under the trunk, mix Prussian blue and light ocher, with traces of titanium white, cadmium yellow light, vermilion and, as for all shadow colors, a hint of ultramarine.

14 Paint the trees at the sides in shades of very pale green and turquoise. Use the mixtures you already know for these, but with a larger proportion of blue and much more white. Finish their reflections in pale green and pale blue, by means of horizontal brush strokes. For the most distant background, add a little Prussian blue to titanium white and dab on with the brush.

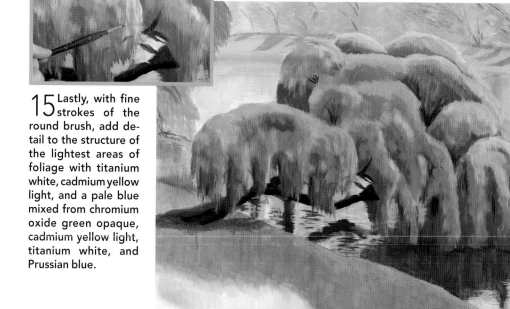

15 Lastly, with fine strokes of the round brush, add detail to the structure of the lightest areas of foliage with titanium white, cadmium yellow light, and a pale blue mixed from chromium oxide green opaque, cadmium yellow light, titanium white, and Prussian blue.

16 After adding the highlights, give the background more structure by hinting at the trunks and branches of other trees. Add shadows to the far side of the lake.

SUMMARY

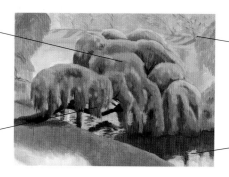

Dab in shades of green with a brush.

Trees at the side and in the background painted in less detail.

Fine stripes bring out the structure of the leaves.

Movement of the water shown by horizontal brush strokes.

Landscape

Our surroundings, the world in which we live, make a deep impression on us. We feel compelled to give artistic expression to the emotions they create within us by turning them into a picture and painting a landscape. "Landscape painting" means the depiction of scenery that may be the result of natural or human activity, or a mixture of both. The subject of a picture may be a natural landscape, but it could also be parkland, a townscape, an industrial landscape, or many other things.

FROM MINOR MATTER TO SUBJECT MATTER

Landscape painting, where the depiction of the world around us is an important subject, only really began in the late Middle Ages. Before that, the depiction of landscape in art was rarely of more than secondary importance. The only purpose of sketchily drawn buildings or countryside was to put the foreground figures in context.

It was only when people's view of nature changed—when the world was no longer the perishable stage through which they had to pass in order to achieve eternal happiness on the other side—that contemporary artists began to make an effort to capture and represent reality through accurate observation and view the landscape with a new, esthetic eye. Of course this also included attempting to depict the world in three dimensions and to capture the atmosphere and the particular phenomena produced by various times of day. Artists began to make systematic studies of different perspectives and developed their skills further through the use of brilliant

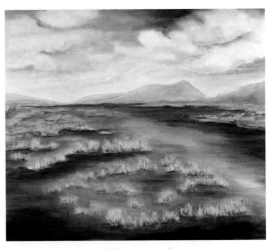

A lake scene with interesting cloud formations.

color, subtle gradations of tone, and a new awareness of how best to use the effects of light and shade to create a sense of space, and to depict luminescent and atmospheric phenomena.

Figures and mythological stories were gradually sidelined, and the landscape became the actual subject of the picture—until the first purely landscape painting entirely without figures appeared some time around 1522. Of course architecture and figures continued to appear in landscape painting, and the landscape became the setting for mythological and historical scenes.

A WIDE RANGE

In the 17th century, when art made its way into the houses of the Dutch middle classes, there was a big demand for landscape paintings. The genre rapidly expanded into mountain, woodland, coastal, and river landscapes, fantasy and topographical landscapes, seascapes, winter landscapes, etc. These works were distinguished by their technical excellence in matters of tonal nuances, aerial perspective, and diverse effects of light. However, where matters of color selection are concerned, from time to time there was a vogue for monochrome paintings in blues, greens, and earth colors.

With the 19th century came a new trend in landscape painting. Lighter and brighter colors became increasingly important, while the interest moved from the subject to the method. The arrangement of forms and colors on the two-dimensional surface of the canvas became the focus of attention. The picture ceased to be a depiction of reality and became a reality in itself.

However, the painting of romantic landscapes intended to arouse emotions continued to flourish. With the advent of the Impressionists it became light and airy. They painted out of doors; the colors flowed into one another. The perception of things became more important than their meaning.

Interesting landscape with an idyllic village and a river in the background.

A morning landscape just after sunrise.

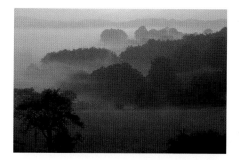

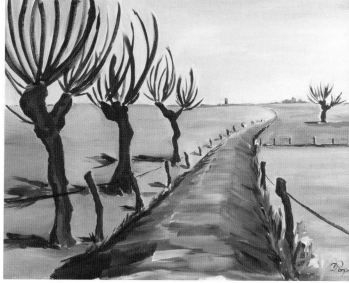

Monochrome landscape in shades of brown.

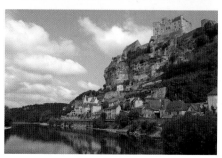

Archetypal landscape in the style of a postcard.

Special
Clouds

You rarely see a landscape without clouds. For one thing, cloudless days are a rarity, at least in temperate regions. And for another, a beautiful cloud formation is what makes a sky really interesting. The combination of clouds and the rays of a low sun always produces dramatic effects. From the point of view of composition, clouds can always be introduced into a painting in order to balance the distribution of the subject matter and add a little extra weight in a particular area. Clouds are a subject in their own right, and are always painted first when blocking in a sky.

1 After making a preliminary sketch, block in the clouds with burnt sienna, ultramarine, and titanium white, thinned with plenty of water. Be sure to follow the contours of the clouds with your brush right from the start.

COLOR, TECHNIQUE, FORMS

If you want to paint clouds in the best possible way, three considerations are particularly important:
1. The choice of colors
2. The correct brush strokes
3. Painting following the shapes.

For fair-weather clouds, paint the darker areas using a mixture of burnt sienna and ultramarine. For heavy rain clouds, use raw umber and Prussian blue. Of course you will need plenty of titanium white to make the tones lighter. Depending on the weather and the time of day, many other colors may be added, for instance yellow, orange, and violet.

Using a brush, you start by applying the dark colors, and then mix them with lots of titanium white, painting in semicircles and following the shapes of the clouds. This will produce the effect of a typical cumulus cloud.

The series of pictures on this double page is intended to show you how best to go about painting clouds.

2 The clouds have been blocked in first as the most important element in the picture.

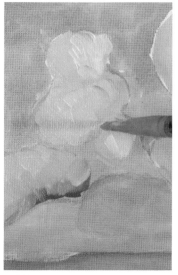

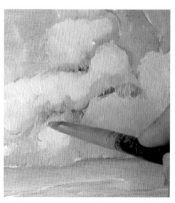

3 Using the wet-into-wet technique (good for soft transitions), concentrate on one section of a cloud at a time. First apply a stripe of the dark color in a thick consistency, then a lot of titanium white on top, and mix the colors with semicircular movements of your brush.

4 If you still have a light-colored mixture on your brush, you can use it to start a new section of cloud and add the dark color afterward.

5 More distant clouds will be darker at the transition point with paler areas on top and at the front. To achieve this, dab paint on the darker areas of each cloud and work over them with titanium white.

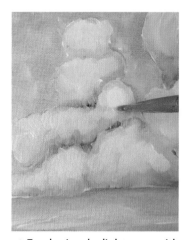

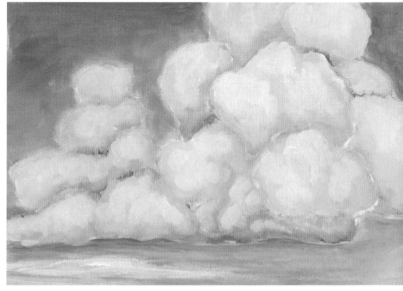

6 Emphasize the light areas with increasing amounts of titanium white. Heightening the contrast between light and dark tones will make the clouds more three-dimensional.

7 Lastly, when the paint has dried, go over it once more with titanium white to bring the white areas even more into the foreground.

Dramatic sky

No two clouds are the same. An occasional look at the sky will confirm this. Anyone who takes up landscape painting will also have to press the clouds and their many different shapes into service. There are just 4 families of clouds, with 10 genera, 14 species, 9 subspecies, plus 9 special forms. As you can see, clouds are a real challenge for the painter, as well as making the sky a specific element of the picture requiring special attention.

Materials

Stretched canvas 24 x 32 inches (60 x 80 cm); household sponge; red chalk; flat brushes nos. 20 and 32; jar of water; cotton cloth or paper towels; palette; colors: vermilion, chrome yellow, titanium white, ultramarine, burnt sienna and crimson

Vermilion

Chrome yellow

Titanium white

Ultramarine

Burnt sienna

Crimson

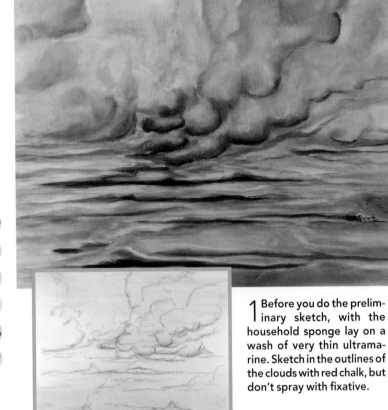

1 Before you do the preliminary sketch, with the household sponge lay on a wash of very thin ultramarine. Sketch in the outlines of the clouds with red chalk, but don't spray with fixative.

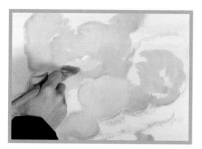

2 Block in the clouds with mixtures of vermilion, chrome yellow, and titanium white, using semicircular brush movements.

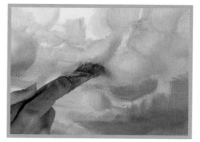

3 Block in the dark areas in vermilion only, with slightly thicker paint and a fairly dry brush.

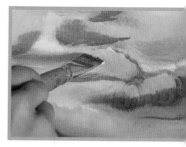

4 Emphasize the dark areas with a violet shade mixed from ultramarine and vermilion. The addition of titanium white produces a lighter shade.

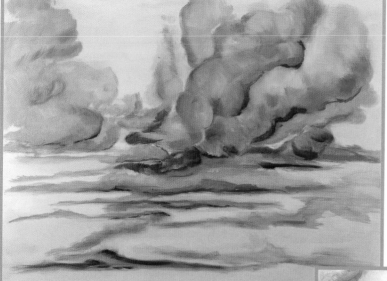

5 The whole picture after step 4.

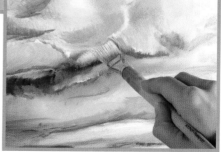

6 Emphasize the lightest areas with titanium white.

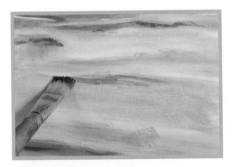

7 With the wash as your starting point, darken the lower half of the sky with ultramarine and a trace of burnt sienna.

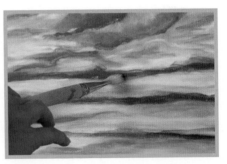

8 Put in the detail of the dark clouds with a thick mixture of ultramarine and crimson.

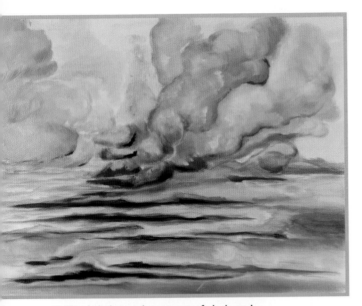

9 The heightened contrast of dark and light creates an amazing sculptural effect.

10 Using a dry brush with a thin mixture of titanium white, chrome yellow, a little vermilion, and a little burnt sienna, paint over selected areas of cloud to create a "smoky" effect.

11 Paint the light areas with a mixture of titanium white and a little chrome yellow.

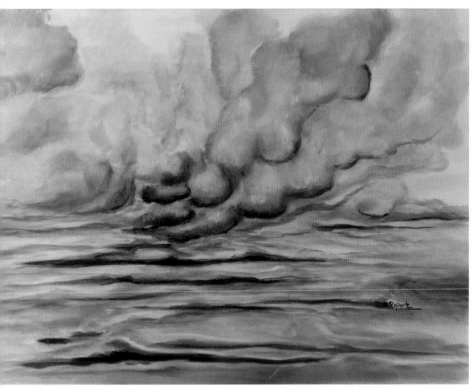

12 The painting is finished. The darkest areas have been emphasized with a mixture of ultramarine and crimson.

SUMMARY

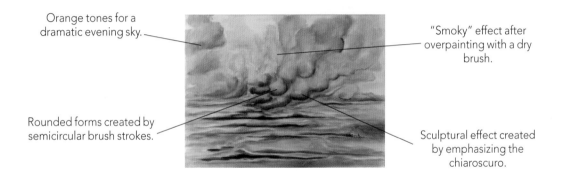

Orange tones for a dramatic evening sky.

"Smoky" effect after overpainting with a dry brush.

Rounded forms created by semicircular brush strokes.

Sculptural effect created by emphasizing the chiaroscuro.

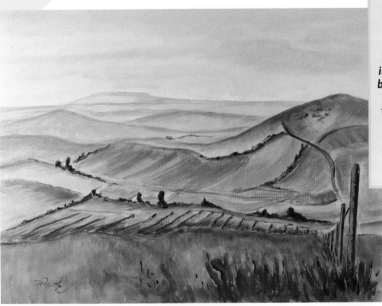

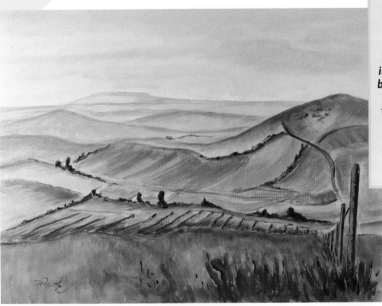

Step by step
Warm and cold

At one end of the rich spectrum of colors you have the warm colors. These are all the red shades, through orange to yellow and through red-violet and brown to ocher. The cold colors include all the blue shades through turquoise to green. In order to try out the different color ranges and gain experience, a good exercise is to paint the same (landscape) picture first in warm, then in cold colors. We will show you how to create it in warm colors and then compare it with the picture in cold colors.

Materials
Stretched canvas 24 x 32 inches (60 x 80 cm); pencil; flat brushes nos. 6, 14, and 20; jar of water; cotton cloth or paper towels; palette; colors: vermilion, dark madder, chrome yellow, and raw umber

 Vermilion

 Dark madder

 Chrome yellow

 Raw umber

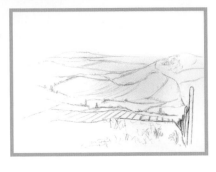

1 Pencil in the contours of the landscape, paying particular attention to the details in the foreground.

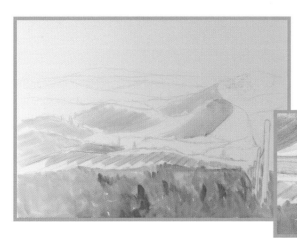

2 Block in the field in the foreground in vermilion. Do not hesitate to apply the paint a little more thickly at this stage. Block in the fields in the middle and background in vermilion as well, but much more delicately.

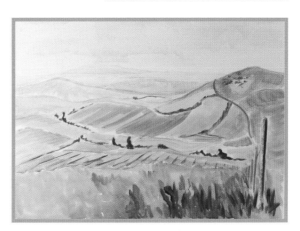

3 Pick out the field edges, meadows, the shadowy side of the fence posts, and the road strongly in dark madder.

4 Paint the background fields in different strengths of dark madder thinned with water. Follow the structure of the fields with your brush strokes. Sketch in the most distant background (hills and sky) with very dilute dark madder.

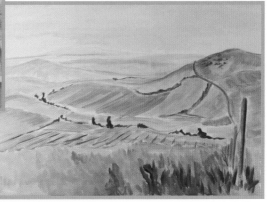

5 Block in the sunlit sides with thin chrome yellow. In some places you will be painting over surfaces you have already painted.

6 In the background and foreground delicate shades of yellow will also appear.

7 Using raw umber, add the dark accents in the foreground. These include the shadowy areas on the fence posts, the paths between the fields, and the meadow grasses.

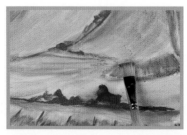

8 The farther away parts of the landscape are, the more you lighten and dilute the raw umber. Here it is best to use a dry brush.

9 Emphasize the red areas with another coat of vermilion, especially those in the foreground. Sketch a few clouds in the sky in vermilion.

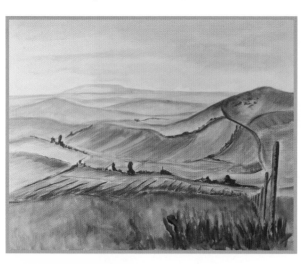

10 Emphasizing the dark areas with raw umber and adding more vermilion has given the picture more depth.

11 Put in the final accents in dark madder.

Tip
Instead of using a ready-made brown, you can mix warm shades of red with a cool green to give a warm shade of brown.

LANDSCAPE IN COLD COLORS

However, you can also paint the same picture in cold colors. For this we used titanium white, cobalt blue, ultramarine, Prussian blue, chromium oxide green fiery, chromium oxide green opaque, and crimson. Although crimson actually belongs with the warm colors, it is used here to make a cool violet when mixed with a blue.

The cold colors create a wintery but nevertheless appealing mood.

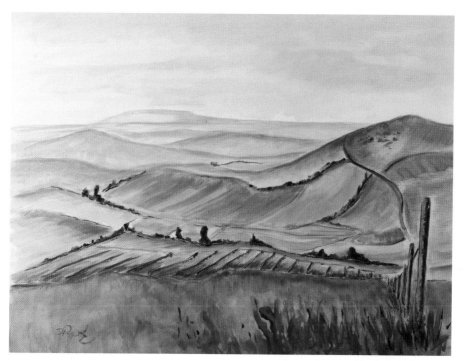

12 View of Essenheim, using only warm colors.

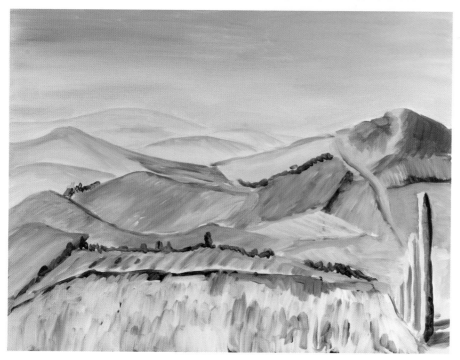

View of Essenheim *painted only in cold colors.*

Irish landscape with lake

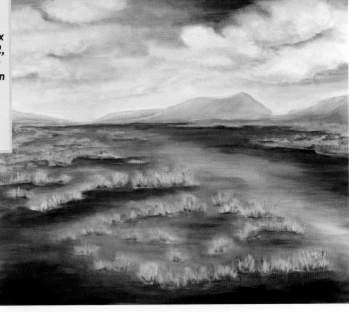

Ireland is rightly known as the Emerald Isle. This is chiefly due to the abundant rainfall. Before it flows out into the sea, the water collects in many small lakes, with occasional big tufts of grass protruding above the surface. An area of low pressure creating rapidly changing weather and skies plays its part in allowing us to create beautiful patterns in brief moments of bright sunlight against a background of gently rolling hills. Our picture was painted in southern Ireland at the Skellig ring in County Kerry.

Materials

Stretched canvas 24 x 28 inches (60 x 70 cm); red chalk; flat brushes nos. 12, and 18; jar of water; cotton cloth or paper towels; palette; colors: Prussian blue, light ocher, burnt sienna, titanium white, ultramarine, cadmium yellow light, and black

 Prussian blue

 Light ocher

 Burnt sienna

 Titanium white

 Ultramarine

 Cadmium yellow light

 Black

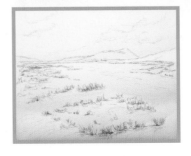

1 The preliminary sketch in red chalk is not sprayed with fixative but partly painted into the first application of color. You should already pay attention to the structure of the grasses in the water and their correct proportions. Draw the contours in the foreground clearly; in the middle and background they should be increasingly unclear.

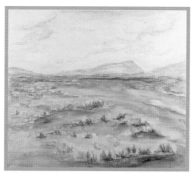

2 Block in the first layer of color for the water, the hills, and the sky in thin Prussian blue.

3 Use light ocher for the grasses, the edge of the bank, and part of the clouds. Mix a green from light ocher and Prussian blue, diluted with a lot of water. Use this to block in the water in front of the tufts of grass, the meadow on the left, and parts of the hills.

4 Use burnt sienna for the dark areas of the grasses and the shoreline.

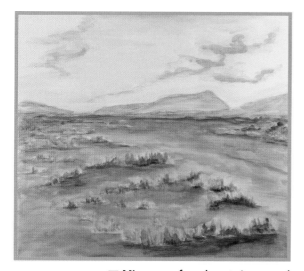

Tip

First set the line of the horizon in your landscape. Decide whether you want to give more importance to the scenery or the sky. Pictures that have the horizon in the middle often appear boring.

5 Mix a gray from burnt sienna and Prussian blue, thinned and therefore made paler with a lot of water, and paint parts of the water, the hills, and the sky.

6 Add detail to the water by applying Prussian blue with horizontal brush strokes. Pick out the light patches with titanium white, which you will then overpaint with Prussian blue. Paint the detail of the grasses and the lake edge with burnt sienna and light ocher.

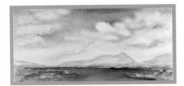

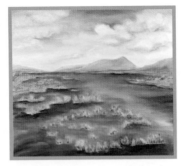

7 For the sky, use Prussian blue and titanium white applied side by side and painted into one another using horizontal brush strokes. For the clouds, use a mixture of burnt sienna and ultramarine, overpainted with a lot of titanium white.

8 Finish the mountains and landscape in a green mixed from cadmium yellow light, Prussian blue, and titanium white. Make the color stronger in the foreground and increasingly blue and pale in the background.

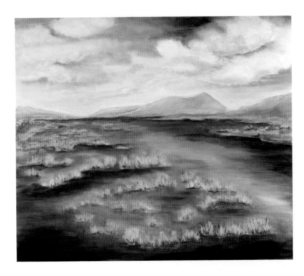

9 Paint the fine detail of the grasses in light ocher, burnt sienna, and titanium white. Detail the reflections in the water with Prussian blue, darkened with a little black.

10 Emphasize the darkest and lightest areas of the painting and add accents in cadmium yellow light, black, burnt sienna, and the green from step 3.

SUMMARY

Set the horizon.

Aerial perspective: The mountains in the background become increasingly blue and pale.

Determine the structure and proportions of the grasses.

Light patches on the water by brushing Prussian blue and titanium white together on the canvas.

Step by step

Monochrome landscape

In a world full of color you can easily have too much of a good thing, so it's not surprising that there are artistic movements that concentrate on painting in a single color. There is no doubt that monochrome paintings have a particular appeal and a very special atmosphere. They look purist, simple, and beautiful. The landscape we show you here was painted using a single brown, plus the neutral colors white and black.

Materials

Stretched canvas 24 x 32 inches (60 x 80 cm); pencil; flat brushes nos. 12, 18, and 28; jar of water; cotton cloth or paper towels; palette; colors: Vandyke brown, titanium white, and black

 Vandyke brown

 Titanium white

 Black

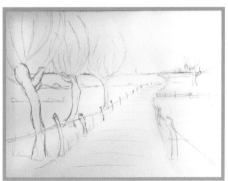

1 Draw the outlines of the landscape in pencil. At the same time, establish the horizon and note the perspective of the road and the trees and fence posts that get smaller toward the background.

2 Put Vandyke brown and black on your palette and paint the trees in brown and black. Omit the usual first application of paint and work with thick paint straight away.

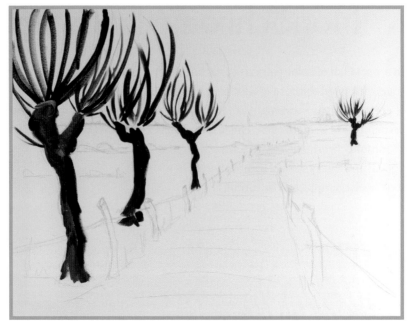

3 The trees are finished.

4 Now it's the turn of the fence posts. Paint them in Vandyke brown and black, and add titanium white, so you can use your brush strokes to give them volume.

5 Paint the road wet-into-wet with thinner paint in all three colors.

6 Using the same technique as for step 5, but with much more titanium white, paint the meadow areas to the left and right of the road. Add in the shadows of the trees and fence posts.

7 Using all three colors, with Vandyke brown and black predominating, paint the grasses and bushes at the roadside.

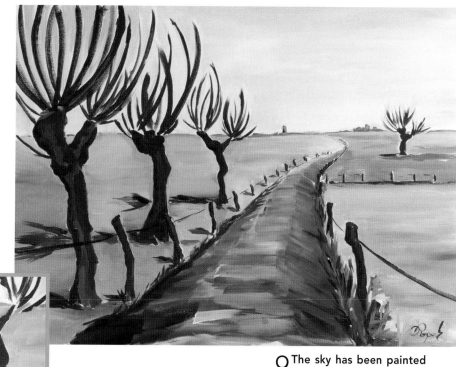

8 Give emphasis to the darkest areas using black and the lightest with titanium white.

9 The sky has been painted pale and cloudless using a lot of titanium white—a little darker at the top and lighter toward the horizon. The line of the horizon has been slightly darkened.

SUMMARY

Paint applied impasto straight away.

Pale, cloudless sky using a lot of titanium white.

Main color Vandyke brown, using only white and black to lighten or darken it.

Perspective aided by rows of trees and fence posts.

8

Architecture

Architectural painting is concerned with the artistic treatment of buildings created by man, ranging from the simplest hut to the skyscraper. One of the reasons why buildings are so interesting is that, throughout the ages, the people who built them always tried to make them visually attractive as well as functional. Visitors to foreign cities and the artists who capture them with brush and paint find them equally fascinating. And subjects abound, often right outside your own front door.

PERSPECTIVE

Pictures, especially of buildings, only begin to look interesting when the painter has the skill to create an impression of space on the two-dimensional canvas, i.e. to depict three-dimensional objects in their correct perspective. The Ancient Greeks, and even more so the Romans, understood how to use perspective to represent three-dimensional space. After that, this skill fell into neglect for a time. Until the end of the Middle Ages, the dominant concept was perspective of importance, which meant that the size of the figures and objects depicted was determined by their importance in the picture, whereas their spatial relationship was of no significance. In the mid 15th century, at the time of the Renaissance, artists rediscovered perspective and developed it into central perspective as we know it.

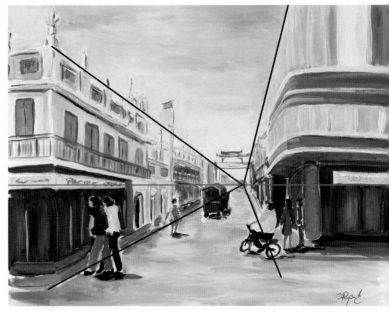

Central perspective *with one vanishing point.*

VANISHING POINTS

Perspective is indispensable for the representation of three-dimensional space in a picture. All the imaginary or visible lines in the picture lead to one or more vanishing points. Central perspective is the simplest and most effective way of representing space. It has a single vanishing point, where all the lines leading into the depth of the space must meet. The picture you can see on this page has been created and painted in accordance with this principle.

If the standpoint of the viewer

124

moves from the center of a building or group of buildings to the side, a second vanishing point is created, because each set of horizontal lines at the sides of, for instance, a house, which are in reality parallel, runs to its own vanishing point at either side of the corner. As central perspective with a single perspective is also known as "one-point perspective," it is logical that this latter kind should be called "two-point perspective."

The picture of the bar on this page uses two vanishing points.

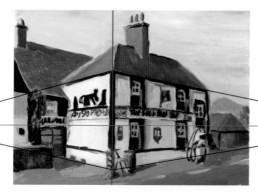

The horizontal lines of the building lead to two vanishing points.

No visible vanishing point, two dimensions.

Tip

Start by photographing the architecture you want to paint from different angles, without angling the camera upward or downward. The result is always a good basis for getting the correct perspective.

PICTURE LAYOUT

Anyone responsible for the layout of a picture, whether photographer or painter, must always take perspective and vanishing points into consideration if they want to create eye-catching spatial effects. To put it another way: choosing the number and posi-tion of vanishing points are two of the essential tasks when designing a picture. This is because the vanishing points enable you to create a sense of movement and spatial depth. You can use them to add accents and bring objects into the line of vision.

One vanishing point

A street scene on the island of Mauritius is our starting point for discussion of the phenomenon of central perspective with a single vanishing point. All the lines leading back into space, which are in reality parallel, run together and meet at a point on the horizon that you have previously set at eye level. The crucial horizontals are the street and the buildings. The figures are also involved in the depiction of perspective.

Materials

Acrylic block 20 x 32 inches (50 x 64 cm); pencil; flat brushes nos. 12 and 18; round brushes sizes 4 and 8; jar of water; cotton cloth or paper towels; palette; colors: titanium white, black, ultramarine, cobalt blue, chrome yellow, light ocher, raw umber, vermilion

Titanium white

Black

Ultramarine

Cobalt blue

Chrome yellow

Light ocher

Raw umber

Vermilion

1 In the preliminary pencil drawing, fix your chosen vanishing points and get all the elements of the picture in perspective.

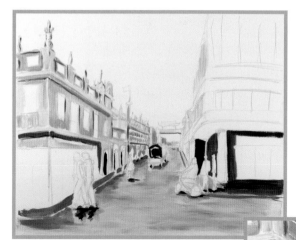

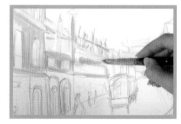

2 All the colors in this picture are painted thick from the start and applied side by side. Begin by painting the buildings and streets in mixtures of titanium white, black, and ultramarine blue.

3 Pay attention to the bright and shady sides. Paint the bright sides in shades right through to pure white, whereas the shady sides should become almost black.

4 With a mixture of chrome yellow, cobalt blue, and titanium white, paint things like the shutters and the balcony railings in a fresh turquoise.

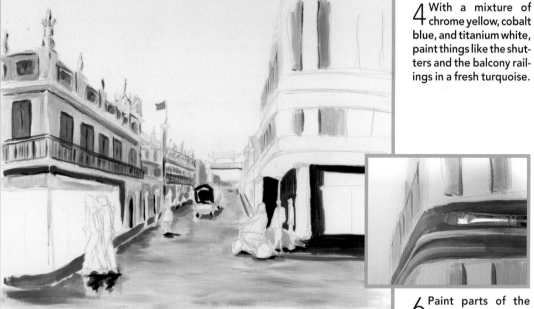

5 For shady areas use a little less titanium white, adding a trace of ultramarine instead.

6 Paint parts of the buildings and streets and a few of the people using a mixture of titanium white, light ocher, and raw umber.

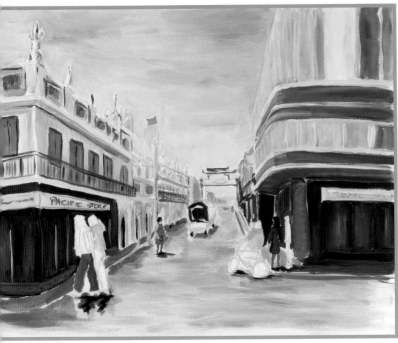

7 The sky and some parts of the buildings were painted with a mixture of ultramarine and cobalt blue, lightened with titanium white. For darker areas, add black to the mixture of blues.

8 Emphasize the dark accents with black. This includes both people and vehicles.

9 Using a dry brush, paint lines in black or with a mixture of light ocher and black.

10 Where appropriate, use a mixture of light ocher and vermilion to add accents to the buildings.

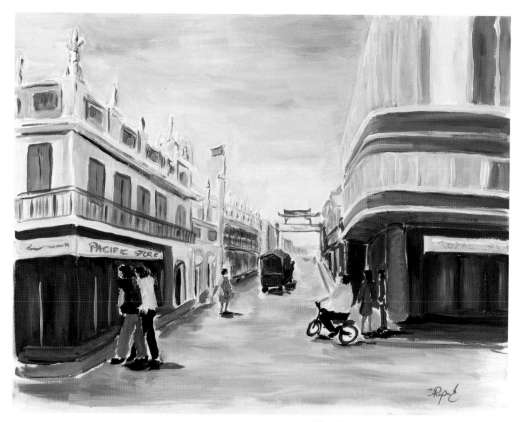

11 Sketch in the faces and arms of the figures in light ocher. Add accents to their clothing with a mixture of light ocher and vermilion.

SUMMARY

Fix the horizon and vanishing points.

Darkest parts in the foreground, getting paler toward the background.

Get all the elements of the picture into perspective.

Apply the paint thickly from the start, with the colors side by side.

Two vanishing points

As soon as the viewer is no longer standing centrally in front of a building or group of buildings so that their walls are no longer parallel to him and he is looking at a corner, a second vanishing point is created (page 125). This example of a bar in Ireland, a kind of filling station for both people and vehicles, offers you a very good opportunity to practice perspective with two vanishing points. It is also interesting to note that—as with many paintings of single buildings—the vanishing points lie beyond the edge of the canvas.

Materials
Stretched canvas 12 x 12 inches (30 x 30 cm); pencil; flat brushes nos. 2, 6 and 10; jar of water; cotton cloth or paper towels; palette; colors: titanium white, ultramarine, cadmium yellow light, vermilion, Prussian blue, chromium oxide green fiery, dark madder, black

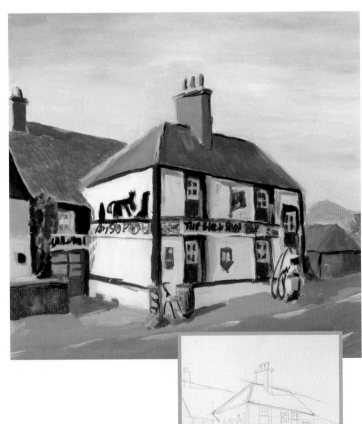

Titanium white	
Ultramarine	
Cadmium yellow light	
Vermilion	
Prussian blue	
Chromium oxide green fiery	
Dark madder	
Black	

1 In the preliminary pencil drawing, extend the lines leading to the vanishing points a little.

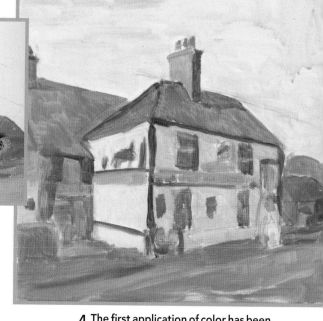

2 Mix a brown from ultramarine, cadmium yellow light, and vermilion. For the lighter parts of the house wall add titanium white and water. A little more ultramarine is needed for blocking in the shadows.

3 Block in the roof of the small neighboring hut to the right with vermilion. For the orange of the front, add a little cadmium yellow light, and for the shadow add ultramarine as before.

4 The first application of color has been completed. All the browns have been painted with the mixture from step 2. The wall of the neighboring house to the left was blocked in using a mixture of cadmium yellow light and titanium white, and the sky with very dilute ultramarine.

5 Add detail to the front wall of the house using a pale gray mixed from titanium white, a little Prussian blue, chromium oxide green fiery, and a little dark madder. For the shadows, add a little ultramarine.

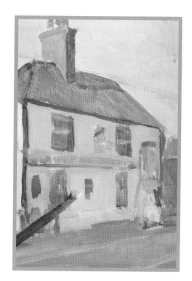

6 Paint the barrel and the chair in the foreground in shades of gray. Use a little black as well for the darkest parts of the barrel.

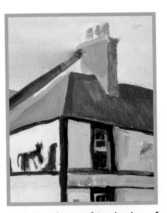

7 Mix a dark brown from ultramarine, cadmium yellow light, vermilion and black and use this to paint the detail of the beams, the window frames, and the paintings on the wall of the house.

8 Paint the roof in shades of gray. Add a little ultramarine for the shady side. For the bright side of the chimney, add more titanium white.

9 For the signboards, use vermilion broken with a little ultramarine, plus spots of titanium white. The inn sign between the windows has been blocked in with a mixture of vermilion, cadmium yellow light, and titanium white.

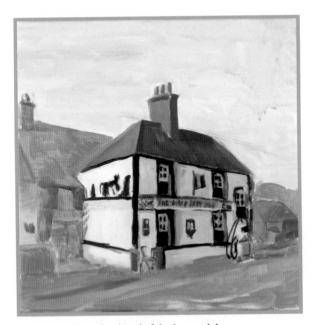

11 Finish the detail of the neighboring house in shades of green, yellow, gray, and blue.

10 Complete the detail of the bar and the objects in front. Paint the writing on the sign above the door in gray and the pictures on either side of the text with dabs of different colors.

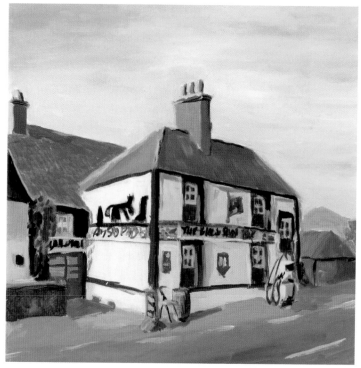

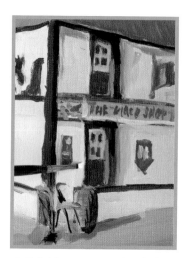

12 Add accents to the darkest and lightest spots.

13 The grays for the street were produced from the mixture in step 5, adding a little cadmium yellow light for the sidewalk close to the house. The sky has been finished using titanium white, ultramarine, and a very little Prussian blue.

SUMMARY

Emphasize the lightest and darkest areas.

Fix the horizon and the two vanishing points.

Heighten the sense of space through the use of light and shade.

Paint the objects in the foreground in detail.

Step by step
Alley in Menton

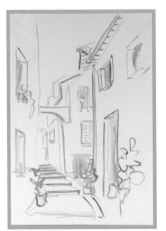

Menton is a picturesque town in the South of France, or to be more precise, on the Côte d'Azur not far from the Italian border. It always pays to stroll through the narrow streets, sketchbook in hand, in search of suitable subjects. You can be lucky at any time. The preliminary study for this picture was done one lovely September afternoon. Of course, one-point perspective is also used in this painting.

Materials

Stretched canvas 28 x 20 inches (70 x 50 cm); round brush size 10; flat brushes nos. 22 and 18; jar of water; cotton cloth or paper towels; palette; colors: burnt sienna, chrome yellow, cobalt blue, raw umber, ultramarine, light ocher, and black

Burnt sienna

Chrome yellow

Cobalt blue

Raw umber

Ultramarine

Light ocher

Black

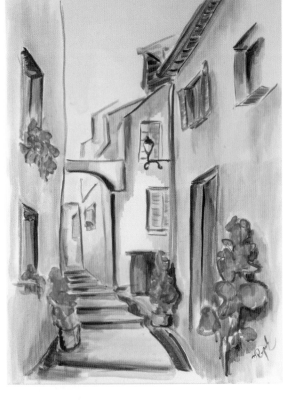

1 Make the preliminary sketch with a round brush and burnt sienna.

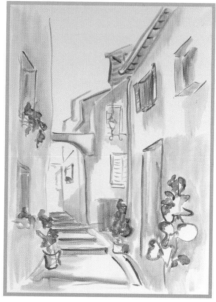

2 All the colors are applied transparent one after the other. Start with a green mixed from chrome yellow and cobalt blue, with a touch of burnt sienna.

3 Paint the shadow areas—the sun is coming from the left—in a gray mixed from raw umber and cobalt blue.

Tip

It is quite possible that the paint will run a little as you apply it. This does not matter, as long as it doesn't run too much, but be careful when adding water to the paint.

4 Paint the sunlit walls and steps in light ocher. Brush this color over the shadows as well.

5 Add accents to the darkest parts with black, applied more thickly. Mix in more water and emphasize the shadowy areas.

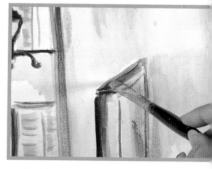

6 Emphasize the bright parts of the buildings with a mixture of chrome yellow and light ocher.

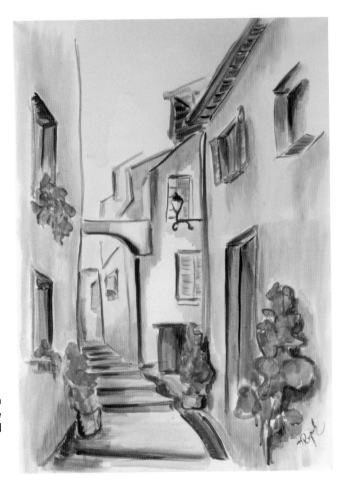

7 Paint the sky with a very dilute mixture of cobalt blue and ultramarine.

SUMMARY

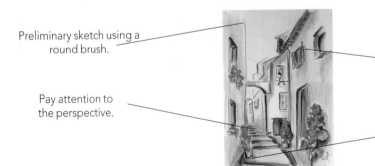

Preliminary sketch using a round brush.

Colors applied transparent and in turn.

Pay attention to the perspective.

Light and shade heightens the sense of three-dimensionality.

Holiday memories

For many people, holidays are the times of the year they most look forward to. Every year we get the urge to leave home for a couple of weeks, either to head for distant shores or to see and experience something new in our own country. We are left with happy memories, which fortunately are quite slow to fade, especially if they have been captured in a picture. For people like you who have taken up painting, holiday memories are an ideal subject for a painting. You will be painting something you enjoy!

FROM ONE PICTURE TO ANOTHER

When people are away on holiday, they sometimes wish they had a kind of computer hard disk in their brain so they could store all the beautiful pictures they encounter every day and reproduce them at will—or better still print them out. It's a bit easier for people with camcorders or cameras, but even they can't capture everything. However, if you're a painter, you will carry your sketchbook with you all the time on holiday, and that gives you one advantage over all the optical and electronic gear. With a couple of strokes you can fix the image you still have in your head in your sketchbook in enough detail to be able to transfer it to canvas at your leisure.

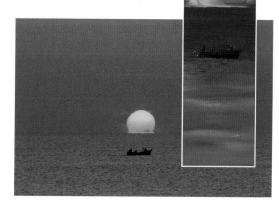

From landscape to portrait format. The photo of a sunset became the subject of a painting in an unusually tall, thin format.

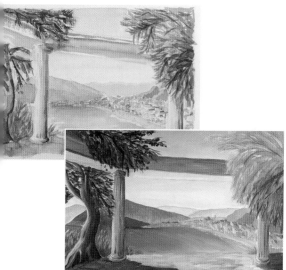

Sketched on the spot and painted in watercolor, this bay on the Aegean coast of Turkey was painted in acrylics back home.

Step by step
Sunset

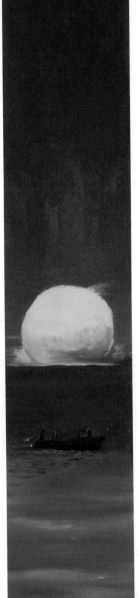

Is there anything more romantic than a sunset over the sea? Tastes differ, but the tourists who flock to west-facing shores every evening to enjoy this natural spectacle do not travel in vain. And if a fishing-boat happens to pass this way as well, the idyll is complete. You can see from the photo on page 137 that the subject of the picture we're about to paint really existed and is not merely the product of our imagination.

 Cadmium yellow light

 Vermilion

 Dark madder

 Ultramarine

 Chromium oxide green fiery

 Prussian blue

 Titanium white

1 The preliminary pencil drawing is kept very simple. All you need to do is sketch the outlines of the boat and the sun.

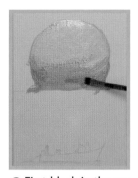

2 First block in the sun with cadmium yellow light in the upper part of the picture. Use vermilion for the lowest quarter circle. Where it is even darker, overpaint with a little dark madder. All these colors should be thinned with water.

3 Mix a dark gray from ultramarine, vermilion, and cadmium yellow light, and block in the boat.

4 Now we work from top to bottom. Block in the sky in a violet mixed from ultramarine and vermilion. Gradually add more blue as you get closer to the sun.

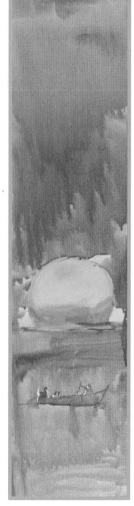

5 For blocking in the sea, add a little cobalt blue to the mixture from step 4, which will give a bluer shade of violet.

6 The first application is complete. The colors have run into one another a bit, but that is not a problem. After all, blocking is "only" the basis for the final painting.

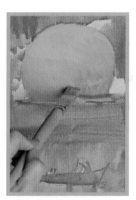

7 Finish painting the sun, first with cadmium yellow light, then with vermilion. Blur the colors wet-into-wet.

8 Add the dark accent to the setting sun in dark madder. Here again, blur the edges with a dry brush.

9 To finish the boat, mix a classic black from chromium oxide green fiery, Prussian blue, and dark madder.

10 Using the mixture from step 4 but without adding water, finish the sky with regular, vertical brush strokes.

11 Finish the sea using the mixture from step 5 and horizontal brush strokes. Around the boat, use a narrower brush, still with horizontal brush strokes. Lighten the shade of blue with a little titanium white toward the foreground.

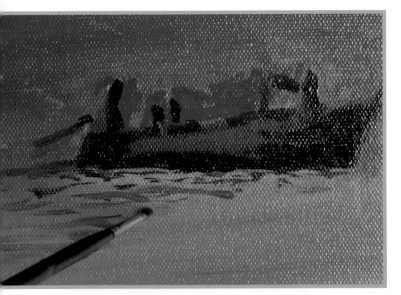

Tip

You can repeat the second coat on the sea and sky several times until you are satisfied with the result. Allow the paint to dry in between each coat.

12 Paint the dark patches and reflections in the water with the dark blue sea mixture and classic black respectively.

13 Emphasize the light spots delicately with titanium white.

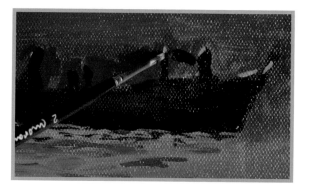

14 Paint highlights on the boat with a mixture of cadmium yellow light and titanium white.

15 Add accents to the setting sun with cadmium yellow light, vermilion, and dark madder, sometimes slightly mixed.

16 Sparingly added highlights in titanium white heighten the romantic atmosphere. The orange shades of the sun are contrasted with the violet of the sky and the sea.

SUMMARY

Gradually changing shades of violet in the sky.

Blur the red accents at the edges.

Boat in classic black.

Blue of the sea lightened with titanium white.

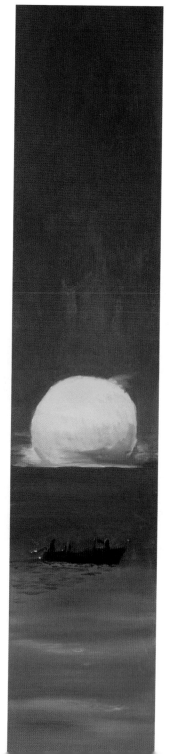

Step by step
Boat

It is worth occasionally taking time to explore the areas close to your holiday resort on foot. The slower tempo will open your eyes to all kinds of interesting things to the left and right of the path. We were struck by this beached boat, which we came across along with a few others abandoned beside a bay. It seemed to be waiting for the moment when it would get back into the sea.

Materials

Stretched canvas 16 x 20 inches (40 x 50 cm); graphite stick; fixative; flat brushes nos. 6 and 20; jar of water, cotton cloth or paper towels; palette; colors: cobalt blue, light ocher, burnt sienna, titanium white, Prussian blue, chromium oxide green fiery, dark madder, cadmium yellow light, vermilion, and ultramarine

 Cobalt blue

 Light ocher

Burnt sienna

Titanium white

Prussian blue

 Chromium oxide green fiery

 Dark madder

 Cadmium yellow light

 Vermilion

 Ultramarine

1 The preliminary sketch was completed using the grid method (pages 34 and 35). Use a graphite stick and spray with fixative until no more will wipe off.

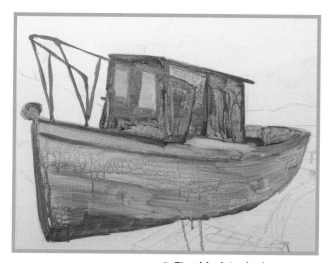

2 First block in the boat, using cobalt blue, light ocher, burnt sienna, and mixtures of these diluted with water.

3 Block in the boat and the crate in the right foreground in titanium white mixed with a very little chromium oxide green fiery, Prussian blue, and dark madder. Add more blue for the shady side.

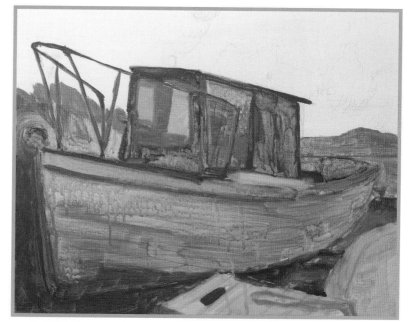

4 Block in the hill in the background in light ocher and a mixture of light ocher and ultramarine.

5 The cliff in the right background has been blocked in with light ocher, ultramarine, and a little dark madder. For the sea, we used a mixture of Prussian blue and titanium white. The ground in front of the boat and to the right is mainly burnt sienna mixed with ultramarine.

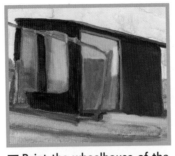

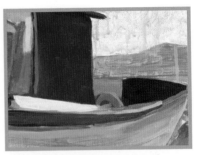

6 Block in the sky with cobalt blue mixed with ultramarine and thinned with a lot of water. For the clouds, use burnt sienna mixed with ultramarine and a lot of water.

7 Paint the wheelhouse of the boat in burnt sienna mixed with a little cobalt blue. For the darker areas add more blue, and for lighter parts mix in titanium white.

8 Finish the darkest parts of the inside of the stern with a mixture of Prussian blue, and burnt sienna. Add titanium white for the decking to its left. The board in the sun has been painted with pure titanium white.

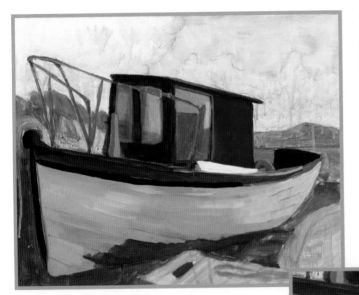

9 For the forward part of the hull, mix titanium white with a little Prussian blue; for the after part use titanium white, light ocher, and burnt sienna. Blend the two mixtures in the middle. Follow the line of each plank with your brush strokes. Paint the darkest parts of the upper edge of the boat in burnt sienna mixed with a little Prussian blue and the darkest parts of the hull in cobalt blue, light ocher, and a little titanium white.

10 Mix a classic black from Prussian blue, chromium oxide green fiery, and dark madder to paint the darkest patches underneath the boat.

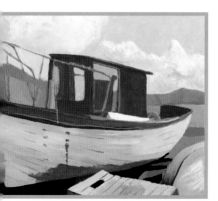

11 Finish the background using the same color mixtures as for steps 4, 5, and 6, but in a buttery consistency and adding titanium white for the sky and clouds. Add more detail to the hull, the crate, and the upturned dinghy.

12 Paint the railings in burnt sienna.

13 Add highlights in titanium white.

14 The grass around the boat has been painted in various shades of green, mixed from cadmium yellow light, ultramarine, and a touch of vermilion, sometimes lightened with titanium white.

SUMMARY

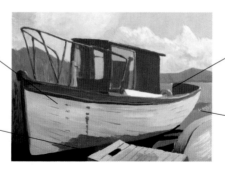

Brush strokes following the planks.

Light and shade emphasize three-dimensionality.

Darkest areas in classic black.

Add highlights in titanium white.

Step by step
Aegean bay

Why do we humans always feel drawn to the sea and the shore? Even lovers of the countryside and mountains sometimes feel at home there. Is it because all our distant ancestors came from the sea? Whatever the reason, a picturesque spot beside a bay always delights the eye. Artists especially should linger a while to soak in its beauty and to keep the memory alive by first sketching it and then capturing it on canvas with paint and brush.

Materials

Stretched canvas 20 x 28 inches (50 x 70 cm); pencil; fixative; flat brushes nos. 6, 10, and 28; jar of water, cotton cloth or paper towels; palette; colors: light ocher, burnt sienna, Prussian blue, cadmium yellow light, chromium oxide green fiery, vermilion, cobalt blue, and titanium white

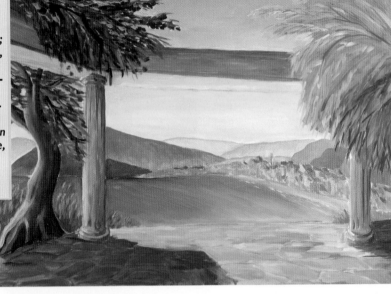

Light ocher

Burnt sienna

Prussian blue

Cadmium yellow light

Chromium oxide green fiery

Vermilion

Cobalt blue

Titanium white

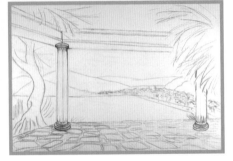

1 The preliminary drawing in pencil includes all the essential elements. The columns framing the bay are particularly eye-catching.

2 The first blocking in has been done with light ocher, burnt sienna, Prussian blue, and mixtures of these three colors, all thinned with plenty of water. Broadly speaking, they represent the primary colors yellow, red, and blue.

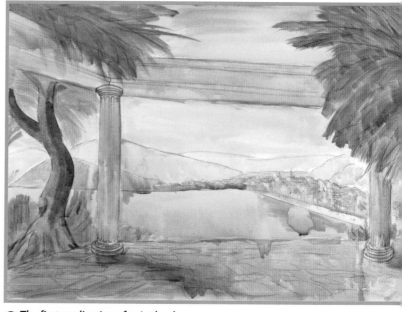

3 The first application of paint has been completed. The shadows are already blocked in, whereas the stone paving is painted in only two dimensions.

4 Next put in the detail of the columns, using a mixture of light ocher and Prussian blue for the shady side. For the light areas, mix light ocher and titanium white. Your brush strokes should follow the structure of the columns.

5 Work on the paving stones with the same mixtures as for the columns, using horizontal brush strokes. For the cracks between them, add burnt sienna. Your brush strokes should follow the direction of the cracks.

6 Mix burnt sienna and Prussian blue and paint the darkest parts of the tree on the left. Add titanium white for the lighter parts. Follow the structure of the bark with your brush.

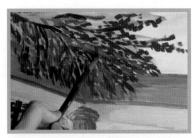

7 Greens! For the leaves of this tree, mix all kinds of greens, for example from light ocher and cobalt blue, and dab the colors on side by side. Use titanium white to lighten the various mixtures.

8 The foreground is complete, apart from the tree on the right.

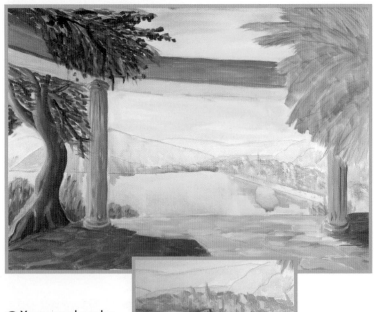

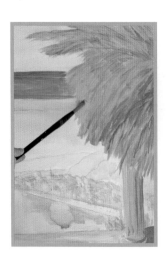

9 You can make paler shades of green, for instance using cadmium yellow light and cobalt blue. Finish the tree on the right with these, dabbing the paint on with your brush.

10 Paint the town beside the bay with dabs of many different colors. Use light ocher, titanium white, vermilion, and a gray mixed from Prussian blue, burnt sienna, and titanium white.

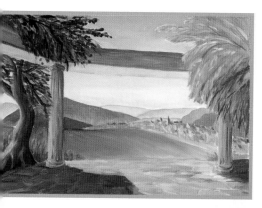

11 The sea has been finished with a mixture of Prussian blue, cobalt blue, a very little chromium oxide green fiery, and titanium white. The mountains are painted in shades of green, getting blue and paler into the distance.

12 Add the lightest spots—here the crests of a few waves— in titanium white.

13 The sky has been finished using a mixture of Prussian blue, cobalt blue, and titanium white. It gets paler toward the horizon, turning almost to a pale orange mixed from titanium white with a little vermilion and light ocher. Show the sky shining through the trees to left and right with spots of pale blue.

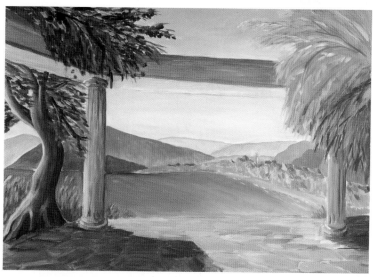

SUMMARY

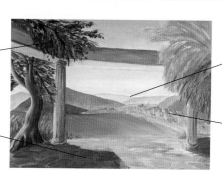

Leaves of the left-hand tree in various shades of dark green.

Light and shade on the tree and the ground create three-dimensionality.

Aerial perspective with sky and mountains paler closer to the horizon.

Town sketched in with dabs of color.

Figures

10

Portraying figures in their correct proportions is certainly not one of the easiest tasks in painting so, if you are to succeed, it is essential to have a basic grasp of human anatomy and some experience of drawing. The be all and end all of good figure drawing is keeping to the correct proportions, because if any part ends up too big or too small, it quickly destroys the good effect. This means you will have to practice long and hard in order to achieve the precision needed for this genre.

PROPORTION AND RULES

The proportions must be correct. This is easily said, but how can success be achieved? People have been pondering the question of correct proportions for centuries. Leonardo da Vinci's drawing of "Vitruvian Man," showing a man with arms and legs outstretched in various positions framed in a circle and a square, is well known. Incidentally, Vitruvius was a Roman architect who developed a set of compulsory rules or instructions for designing columns, on which the proportions of the other parts of the building were based.

In fine art, and therefore in painting, the rules constitute a method for relating the proportions of one part of the human body to another, based on a unit of measurement. This unit is the human head.

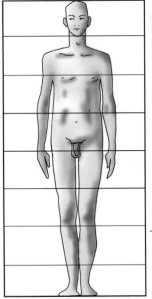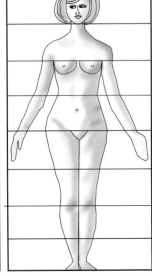

The rules for the human body *of a man and a woman. It is divided into eight zones, each section corresponding to the size of the head measured from the crown to the chin.*

Tip

Before and while practicing, you should keep looking at photos or successful paintings of people in different positions in order to gain an understanding of the proportions of individual parts of the body.

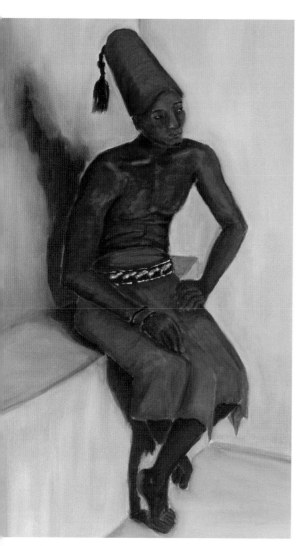

The proportions vary with changes in the position of the joints, depending on the angle of particular parts of the body to the viewer.

FROM TOP TO TOE

Unfortunately, in figure studies it all too often happens that the head ends up much too large in relation to the rest of the body. This is reason enough to make it the unit of measurement for keeping the proportions correct. The procedure is as follows: The human body is divided from top to bottom into eight equal sections. The height of each section corresponds to the length of the head from the crown to the chin. This means that the following seven regions of the body are to be painted in the same proportion as the head:

1. from the chin to the nipples
2. from the nipples to the waist
3. from the waist to the pubic bone
4. from the pubic bone to the thigh
5. from the thigh to the bend of the knee/top of the shin
6. from the bend of the knee/top of the shin to the calf
7. from the calf to the sole of the foot.

Obviously people vary and individual differences may occur. In addition, the average ratio of upper body to lower body for women is 1:1, whereas for men the upper body is relatively shorter in relation to the lower body. Nevertheless, these rules provide a useful guideline, which you will benefit from following.

Incidentally, the proportions for children should not be determined by this method. Small children have a ratio of 5.5:1 (at 1 unit, the head is distinctly bigger than the rest of the body). For a child aged about 10, the correct ratio is 6.5:1.

SHORTER WHEN SEATED

As soon as a person is no longer standing upright, for instance when they go to sit down, the proportions of individual parts of the body as represented will change. This is due first and foremost to a change of perspective, which in turn depends on the position of the viewer. Some parts of the body appear longer, others shorter than before, and a bent back no longer appears the same length as it does when standing straight.

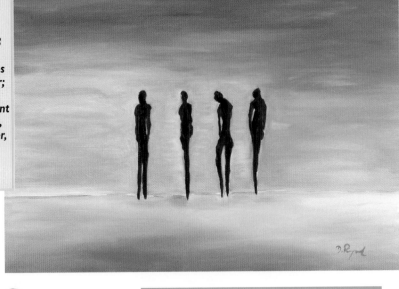

Step by step
Four friends

Observing the princi-ple of starting with something easy and pro-gressing to the more difficult, as an introduc-tion to the genre of figure-painting we have chosen a subject that is really easy to paint. The starting point was a photo of four men walking toward the horizon on a bright, sunny day. Only their slender silhouettes can be made out in the shimmering heat. Though it is not a matter of portraying figures in detail, the proportions must nevertheless be correct.

Materials
Stretched canvas 20 x 28 inches (50 x 70 cm); graphite stick; flat brushes nos. 6 and 18; jar of water; cotton cloth or paper towels; palette; colors: burnt sienna, raw umber, black, titanium white, light ocher, cobalt blue, and ultramarine

Burnt sienna

Raw umber

Black

Titanium white Cobalt blue

Light ocher Ultramarine

1 In the preliminary drawing with graphite stick, which you don't spray with fixative, first set the line of the horizon. Draw only very simplified figures.

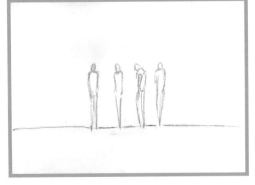

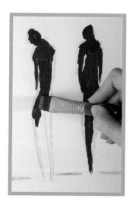

2 Using the paint opaque from the start, paint the people with mixtures of burnt sienna, raw umber, and black, giving the bodies different tonal values.

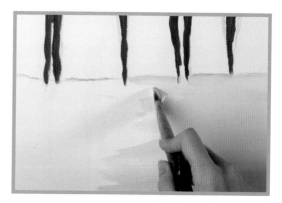

3 Paint the ground with mixtures of titanium white, light ocher, and raw umber. Paint over the graphite line of the horizon.

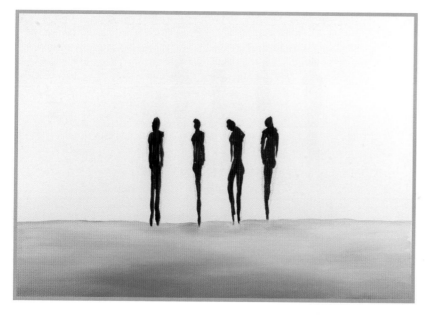

4 How attractive the ground looks will be determined by the variety of shades you create by blending the various color mixtures on the canvas.

5 For the sky, mix cobalt blue and ultramarine with just a touch of black. Lighten with increasing amounts of titanium white as you get closer to the horizon. Break the blue with a little raw umber close to the horizon.

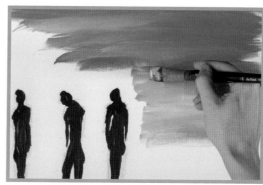

6 Paint the outlines and bodies of the figures in the same colors as in step 2, but with a little more black.

7 A lovely picture has been created using simple means—and you have familiarized yourself with the genre of figure painting.

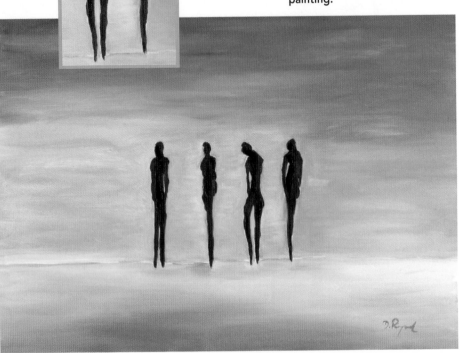

SUMMARY

Sky becoming lighter toward the horizon.

Figures in shades of brown and black.

Paint the ground in different shades.

Brown shades in the sky near the line of the horizon.

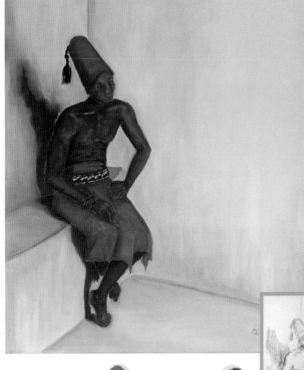

After the four friends pausing on the way to the horizon, this man from Africa is the subject for our next figure painting. This is a more challenging task, because this person is not standing but sitting on a ledge in a room. As a result, some of the proportions of the body will be different in the painting. However, the lines here are still clear and the proportions recognizable. Only the torso and the lower legs need to be adjusted for perspective.

Materials

Stretched canvas 24 x 28 inches (60 x 70 cm); pencil; graphite stick; fixative; flat brushes nos. 8 and 20; jar of water; cotton cloth or paper towels; palette; colors: light ocher, burnt sienna, vermilion, black, Prussian blue, titanium white, and ultramarine

Light ocher

Burnt sienna

Vermilion

Black

Prussian blue

Titanium white

Ultramarine

1 In the preliminary sketch, first draw the figure in pencil and the shadow in graphite stick and spray with fixative, and only then draw the room. Pay attention to the shapes and volumes of the human body.

155

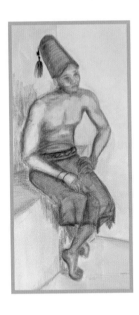

2 Using burnt sienna thinned with water, block in the skin tones. Use burnt sienna mixed with vermilion for the clothing, and light ocher and black for the belt.

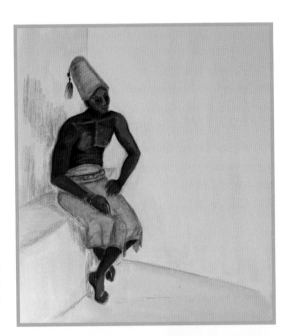

3 Use light ocher thinned with water for the first application of color for the room. Add the details of light and shade to the body surfaces using burnt sienna, light ocher, Prussian blue, black, and titanium white.

4 Finish the clothing in vermilion, darkened with black in places, and the belt with light ocher, black, and titanium white.

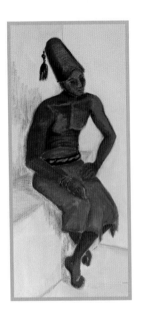

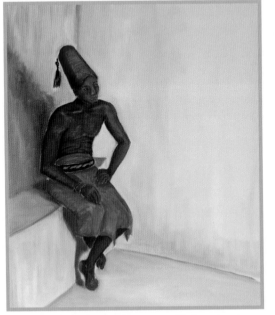

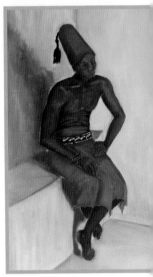

5 Paint the shadows in a mixture of light ocher, burnt sienna, and a little ultramarine. For the floor and walls, use various shades made from light ocher, burnt sienna, and titanium white.

6 Put in the deepest shadows on the body and emphasize the light spots. Do the same for the clothing and jewelry.

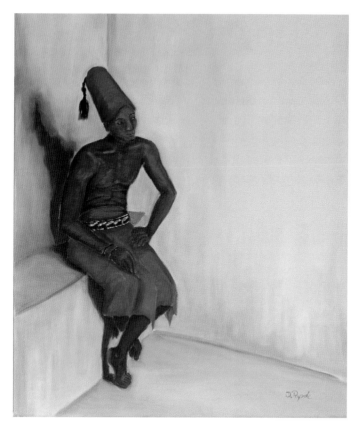

7 The background and the shadows have been worked over one more time.

SUMMARY

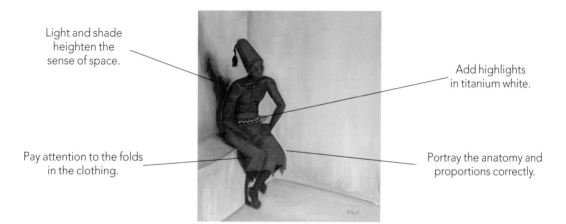

Light and shade heighten the sense of space.

Add highlights in titanium white.

Pay attention to the folds in the clothing.

Portray the anatomy and proportions correctly.

Market scene

Depicting people in their own surroundings is a subdivision of figure painting. It is known as genre painting, which means the painting of scenes of everyday life that come from the artist's own times and sur-roundings. This picture is based on a sketch (page 36) that was made in a weekly market in Turkey. In our description, we will be concentrating primarily on how the figures are developed.

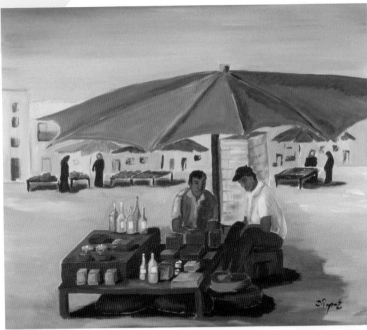

Materials
Stretched canvas 20 x 24 inches (50 x 60 cm); pencil; fixative; flat brushes nos. 2, 6, 18, and 32; jar of water; cotton cloth or paper towels; palette; colors: light ocher, ultramarine, burnt sienna, raw umber, chrome yellow, vermilion, chromium oxide green fiery, black, titanium white, and cobalt blue

- Light ocher
- Ultramarine
- Burnt sienna
- Raw umber
- Chrome yellow
- Vermilion
- Chromium oxide green fiery
- Black
- Titanium white
- Cobalt blue

1 Do the preliminary pencil drawing corresponding to the sketch. Make the foreground very detailed, the middle and background sketchy. Cover with a wash of light ocher thinned with a lot of water.

158

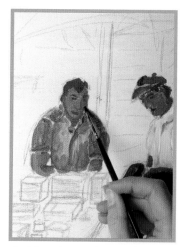

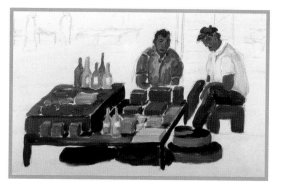

2 After the wash, use the paint opaque straight away. The skin tones of the foreground figures are mixed from burnt sienna, raw umber, and a little ultramarine, lightened with titanium white.

3 On the market stall in the foreground, the bottles were painted in light ocher, ultramarine, and titanium white, and the cans in burnt sienna, raw umber, and vermilion.

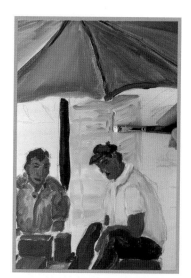

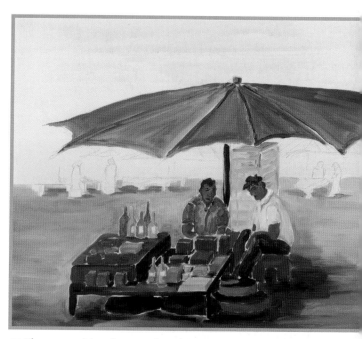

4 Paint the sun umbrella with mixtures of chromium oxide green fiery, chrome yellow, and ultramarine. For the cold box use cobalt blue and titanium white.

5 The ground has been painted in raw umber, titanium white, and black, using horizontal brush strokes.

6 Paint the figures, stalls, and umbrellas in the background with burnt sienna, cobalt blue, vermilion, chromium oxide green fiery, chrome yellow, and black.

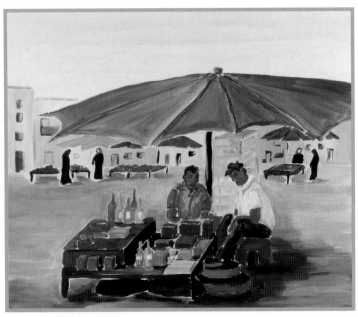

7 Using mixtures of burnt sienna, black, and lots of titanium white, paint the houses. Merely indicate the windows and doors in black, using a fine brush.

8 Using a fairly fine brush, paint the details of the figures. This includes the shades of the clothing, here finished in titanium white, black, and ultramarine.

9 Detail the facial expressions—no easy task— and darken the shadowy side of the figures with raw umber and a little ultramarine.

10 Add light and shade to the traders' wares, which will make the painting more three-dimensional.

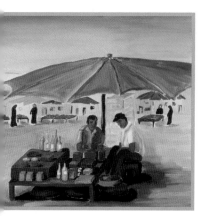

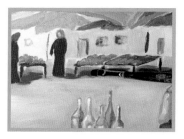

12 Now paint the background in more precise and careful detail. For example, you could darken the shadows on the ground a little with raw umber, black, and titanium white.

11 Paint the sky in ultramarine, cobalt blue and titanium white. Darken the shadows on the ground with raw umber, black, and titanium white—dark in the foreground and getting lighter toward the background.

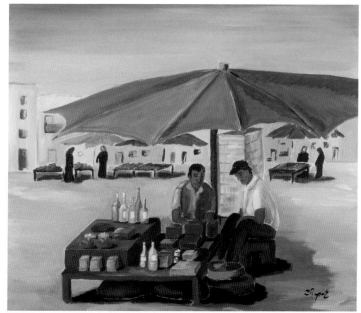

13 The last details in the foreground, middle ground, and background have been brought out. This traditionally includes adding highlights and emphasizing the darkest areas.

SUMMARY

Umbrella in foreground finely detailed.

Hint at the windows and doors of the houses.

Bring out the light and shade on the market stall.

Figures carefully painted in detail.

Animals

11

Animals are our best friends—not everyone loves them all, but each to their own taste. And we enjoy painting the things that please and fascinate us. Painting animals is similar to painting people. Only accurate knowledge of the anatomy of the species in question, plus plenty of experience in drawing animals will produce top quality results. So pick up your pencil and start by drawing living creatures in your sketchbook.

DOG, CAT, MOUSE

What makes animals more difficult to paint than humans is the fact that there are so many different species. Two, four, six, eight or more legs, with or without wings—and with a huge variety of body shapes.

You probably have one or more favorites that you would most like to devote yourself to. Once again, accuracy is required when it's a matter of getting the proportions right. You should know the measurements and the play of light and shade as well as the structure of the skin, fur, plumage etc.

Dogs and cats are the most popular pets—and definitely the favorite subjects when it comes to painting animals.

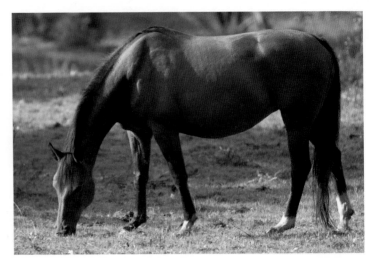

Horses are elegant, powerful, and hardworking —and especially popular with young girls.

Step by step
Cat

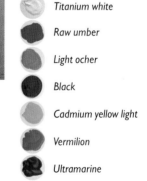

Details are important in our first animal painting. The cat's face in particular requires meticulous work with fine brushes, and the preliminary drawing should, of course, provide an adequate basis. Especial care should be taken with the eyes. The size of the head and upper body must be in the correct proportion to one another. The drawing and structure of the fur show you the appropriate direction for the brush strokes.

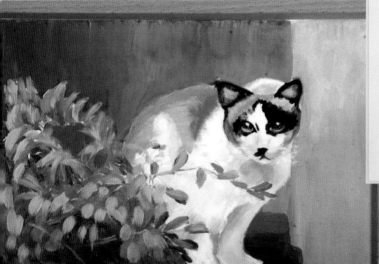

Materials

Beechwood block 8 x 12 inches (20 x 30 cm); masking tape; white wall paint; pencil; flat brushes nos. 2, 6, and 20; jar of water; cotton cloth or paper towels; palette; colors: titanium white, raw umber, light ocher, black, cadmium yellow light, vermilion, and ultramarine

Titanium white

Raw umber

Light ocher

Black

Cadmium yellow light

Vermilion

Ultramarine

1 Tape over the parts of the block that are not to be painted. Then prime the wood as described on page 23. Make a detailed preliminary drawing in pencil.

163

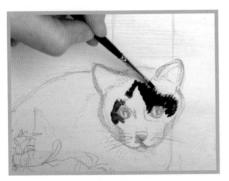 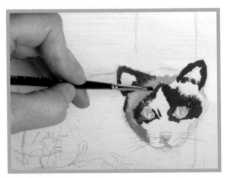

2 Apply the colors opaque. Paint the darkest parts of the cat's head with a mixture of raw umber and black.

3 For the paler parts, add traces of light ocher and vermilion and lighten with titanium white. Paint the very lightest parts in titanium white with pale blue patches in between, mixed from titanium white and a little ultramarine.

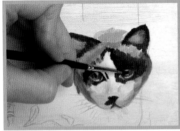 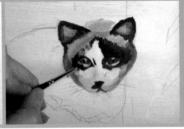 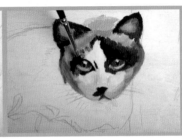

4 After putting in the nose in a pink mixed from titanium white, a little vermilion, and light ocher, paint round the edges of the eyes with a mixture of raw umber and black. Paint the irises with a mixture of ultramarine and black. At the bottom, paint a pale blue curve with a mixture of titanium white and a little ultramarine. Use black for the pupils, and titanium white for the lightest reflections in the eyes.

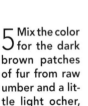 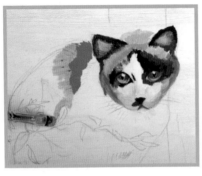

5 Mix the color for the dark brown patches of fur from raw umber and a little light ocher, vermilion, and titanium white. For the lighter brown fur add more titanium white.

6 Paint the pale fur with titanium white and the pale blue from step 3.

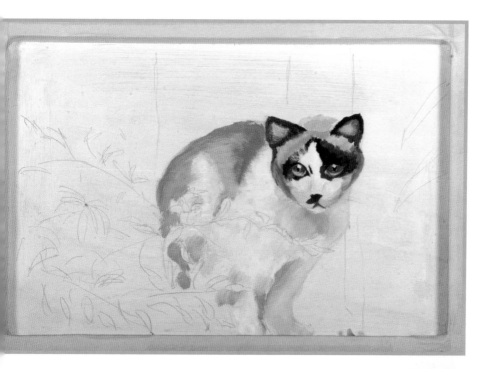

7 The painting of the cat itself has been completed.

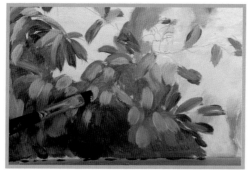

8 Paint the plants on the left in various shades of green mixed from ultramarine, cadmium yellow light, and titanium white, occasionally adding a little vermilion.

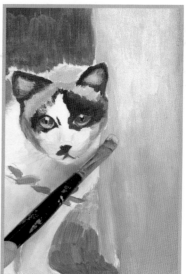

9 Use titanium white mixed with ultramarine, raw umber, and a little cadmium yellow light for the light background on the right-hand side of the picture.

Advice

Do not fail to prime the wood. If it is not primed, the paints will sink in too far and go dull, whereas if the wood is primed, they will shine out brilliantly.

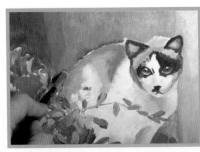 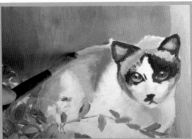

10 Paint the dark background above the cat with a mixture of raw umber and ultramarine, slightly lightened with titanium white. Finish the edge of the cat's fur by picking up a little of the raw umber and titanium white mixture on a dry brush and applying it carefully.

11 With a dry brush, pick up a very small amount of titanium white and paint a few short, smooth strokes over the background for the cat's whiskers.

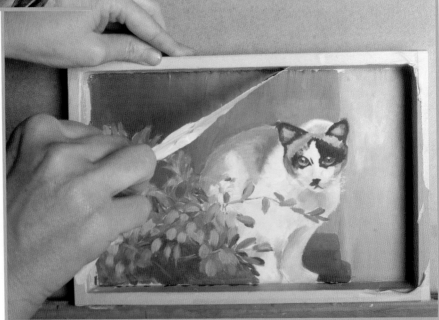

12 All the paint has been applied. Now pull off the masking tape.

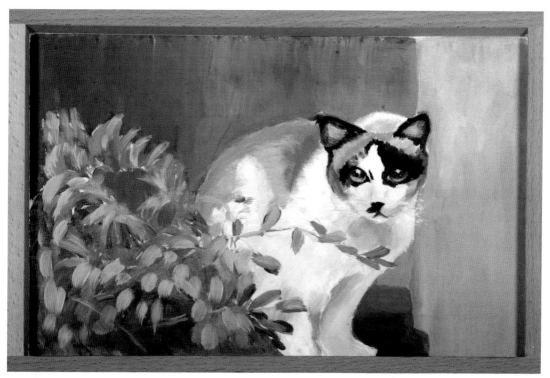

13 When the picture is dry, you can apply a coat of varnish.

SUMMARY

Paint the fur following its structure.

Use pale blue in the fur to make the cat more three-dimensional.

Eyes in various shades of ultramarine.

Pupils in black, reflections in the eyes in titanium white.

Three elephants

Of all Africa's wild animals, elephants are the most impressive giants among the so-called "big five." If they happen to appear against the background of a dramatic landscape, the beauty of the scene is almost perfect. Of course in our latitudes it is extremely unlikely that a herd of elephants will cross your path, but photos from books and newspapers or a visit to the zoo are perfectly good when it comes to finding a model.

Materials

Acrylic block 20 x 25 inches (50 x 64 cm); pencil; flat brushes nos. 10 and 18; jar of water; cotton cloth or paper towels; palette; colors: raw umber, ultramarine, vermilion, titanium white, light ocher, cadmium yellow light, crimson, and black

Raw umber

Ultramarine

Vermilion

Titanium white

Light ocher Crimson

Cadmium yellow light Black

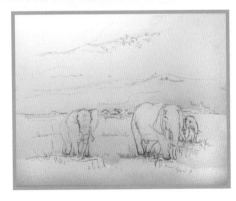

1 In the preliminary pencil drawing, fix the horizontal line between the plain and the mountain. Draw the outlines of the elephants, indicating the shadows and volume.

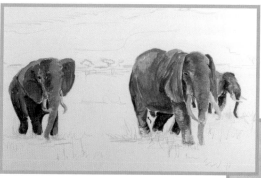

2 Block in the elephants in a gray mixed from raw umber, ultramarine, and a little vermilion. Lighten the gray with titanium white in various places.

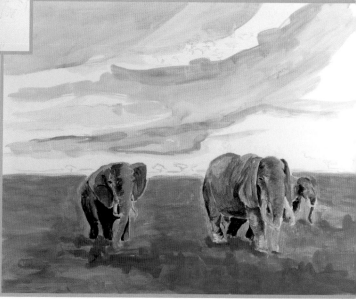

3 Using mixtures of light ocher, ultramarine, and titanium white, block in the ground and parts of the mountain. You should already be paying attention to light and shade.

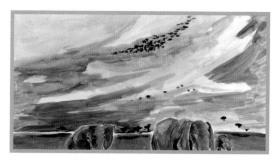

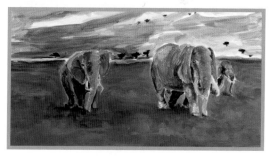

4 Block in the mountain, trees, and some of the shadow areas with a mixture of raw umber, ultramarine, light ocher, and a little vermilion.

5 Finish the ground in the same colors as for step 3, but add cadmium yellow light to the mixtures.

Tip

When applying the second coat, you don't have to paint completely over all areas. A picture also gets life from surfaces that were painted earlier shining through.

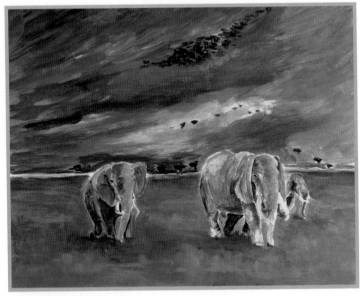

6 Now finish the mountain in the background with the same colors as in step 4. Let your brush strokes follow the slopes. Add crimson accents to the ground.

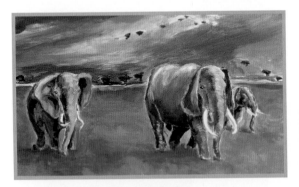

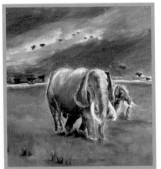

7 Now paint the elephants with the same colors as in step 2, but with greater contrasts and thick paint consistency. Add reflections in the animals' eyes with titanium white.

8 Finish the detail of the ground and the mountain, using the same colors as in steps 3 and 4. Emphasize individual tufts of grass and trees.

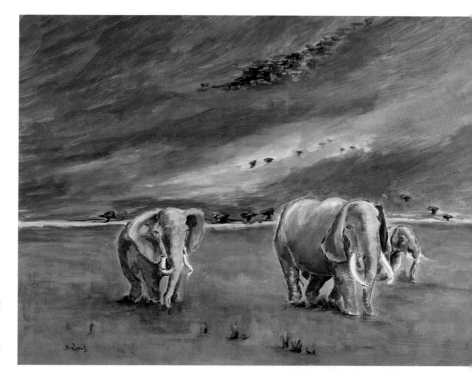

9 Put in the last accents in the darkest areas in black. Emphasize the light spots with titanium white.

SUMMARY

Set the horizon between the plain and the mountain.

Follow the slope of the mountain with your brush strokes.

Paint the elephants in various shades of gray.

Emphasize the grasses in many places.

12 Stretched canvases

Stretched canvases are the most popular of all the supports we have described in this book. You can buy prestretched canvases in various shapes and sizes, paint on them straight away, and hang your finished work on the wall without going to very much trouble. Even without a frame, the painting looks valuable and attractive. The painting surface, usually made of cotton or linen, is already primed and needs no additional treatment, so you can start enjoying the pleasures of painting immediately.

BEFORE AND AFTER BUYING

When purchasing prestretched canvases, check that the painting surface is undamaged and the stretcher isn't warped. The primed fabric should have no dents and the angles at the corners must match. We recommend stretchers where the canvas is fastened at the back. Check the package to see that all the wedges supplied—usually eight—have been included.

After purchase and before painting on the canvas, put the wedges in place as shown on this page, with the points in the grooves provided, and hammer them in a little way.

Hammer the wedges a little way into the grooves.

If there are any dents in the canvas, rub gently with a wet household sponge.

> ### Advice
> *If you failed to spot a dent in the primed canvas when you bought it, this can easily be remedied by sprinkling the back of the spot with a little water and rubbing gently with a household sponge. The fabric will contract again as it dries, and the dent will disappear.*

HANGING STRETCHED CANVASES

"That picture's not hanging straight!" is a frequently heard comment that can easily be prevented. With the right technique and equipment you will have no trouble showing your work in a professional manner. We recommend using wire and screw eyes for hanging, because it is stable and simple—all you need is a hook on the wall.

1 Fix the screw eyes in the upper third of the stretcher but, even in the case of large-format paintings, no more than 8 inches (20 cm) from the top edge. Measure to be sure the two hanging points are at the same height and screw the eyes into the wood.

2 Pull the picture wire through the eye, make a loop, and wind the short end round the long end several times.

3 To hang heavier pictures, secure the wire additionally with a crimp sleeve.

COMPOSITIONS USING STRETCHED CANVASES

Not only are stretched canvases practical and attractive to paint on, they can also be used in combination as elements in a composition. You can assemble a mosaic of different sizes and formats, distributing your painting across all the canvases, and then hang them that way on the wall. This double-page spread shows a composition made up of four canvases.

ORANGE, YELLOW, RED

First the surfaces and sides of all the canvases were painted with an orange mixed from a lot of primary yellow, cadmium yellow light, and a little vermilion. This was repeated after the first application had dried.

After positioning the canvases on the floor in the arrangement in which they would later hang, the parts were painted with energetic sweeps of the brush, first with cadmium yellow light, then with vermilion, and finally with crimson. The most important thing was to paint over all four canvases at once with big, almost uninterrupted, sweeping movements. Dry patches at the edges were painted in orange again and smeared while wet with the yellow and red shades.

After the first coat of orange, *paint over all canvases in great sweeps of cadmium yellow light.*

Next come great sweeps *of vermilion and*

Materials

Four stretched canvases: 40 x 8 inches (100 x 20 cm), 9 x 12 inches (24 x 30 cm), and two 7 x 9 inches (18 x 24 cm); flat brushes nos. 32 and 20; jar of water; cotton cloth or paper towels; palette; colors: primary yellow, cadmium yellow light, vermilion, and crimson

Primary yellow

Cadmium yellow light

Vermilion

Crimson

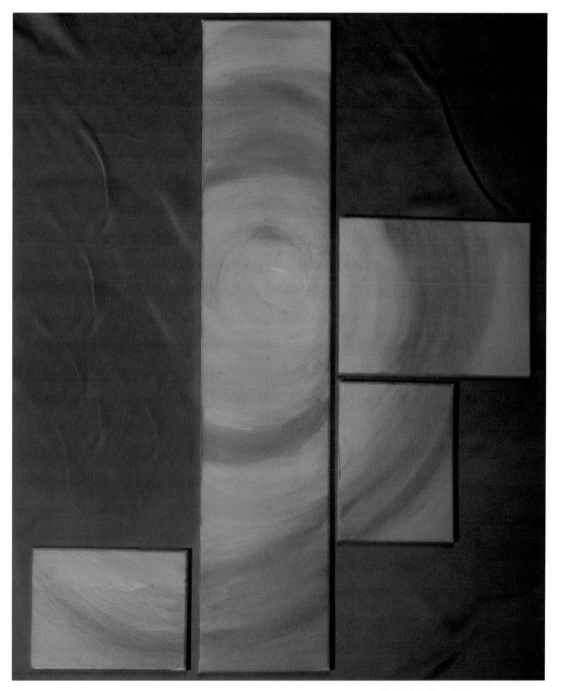

The finished work, *shown on a blue ground.*

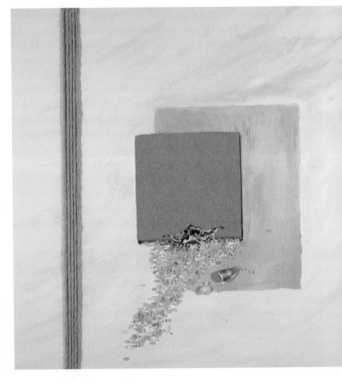

Step by step
Cluster of shells

In addition to triangles, rectangles, squares, and hexagons, stretched canvases also come in special shapes that are ideal for attractive creations. For you, we have chosen a square canvas with a gap in the middle. In addition to paint, we also used filler, acrylic gel, and various objects that we introduced into the picture. The result is known as an "assemblage," i.e. the combining of various random objects into a three-dimensional work of art.

Materials

Stretched canvas: 24 x 24 inches (60 x 60 cm), with a square gap; pencil; palette knife; flat brushes nos. 12 and 16; jar of water; cotton cloth or paper towels; coarse filler; fine filler; palette; colors: titanium white, Vandyke brown, light ocher, ultramarine, Prussian blue, and chromium oxide green fiery; cord; wood glue; thick acrylic gel; small pebbles; shells

Titanium white

Vandyke brown

Light ocher

Ultramarine

Prussian blue

Chromium oxide green fiery

1 After marking a square round the edge of the gap in pencil, fill this area with coarse filler.

2 Spread fine filler over the remainder of the surface with flowing hand movements. Allow both types of filler to dry.

3 Paint the inner square with a mixture of Vandyke brown and light ocher, lightened with a lot of titanium white.

4 Paint the outer area and the outside edges with a mixture of ultramarine, Prussian blue, and chromium oxide green fiery, also lightened with a lot of titanium white.

5 Wind a thick cord several times round the left-hand side of the frame. Fasten the ends at the back with wood glue.

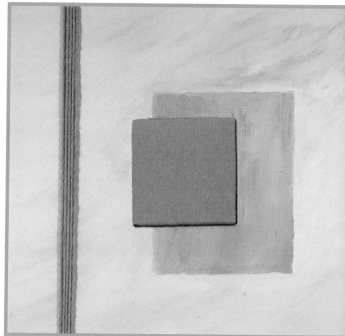

6 Now, using a palette knife, apply very thick acrylic gel that will be transparent when dry. Work from top to bottom, tapering off toward the cord.

7 Cover the freshly applied acrylic gel with tiny stones, pushing them gently into the gel with your hand.

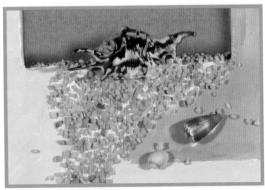

8 Single stones around the edges, also attached with acrylic gel, complete the design.

9 Now it's time for the shells. Distribute them where they look best and attach them with acrylic gel as for the stones.

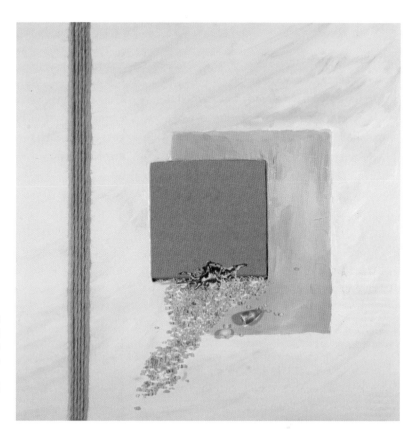

10 The "shell cluster" is finished—an abstract picture with a maritime look. The colors and materials are in perfect harmony, conveying the desired atmosphere.

SUMMARY

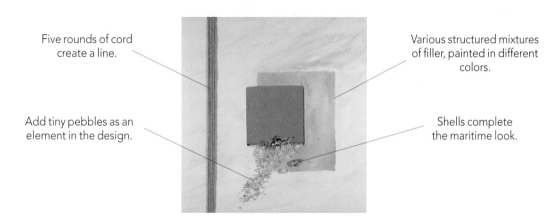

Five rounds of cord create a line.

Various structured mixtures of filler, painted in different colors.

Add tiny pebbles as an element in the design.

Shells complete the maritime look.

13 Experiments

In the picture "Cluster of Shells" on the preceding pages we have already abandoned the world of representational painting on a two-dimensional ground. In addition to the painted image, objects were added to the work and arranged as part of the composition, opening the way to a true third dimension. The materials used here basically set no limits to trial and experimentation. Finding suitable materials gets easier each time, as you become more involved in it.

FINDS

In the early 20th century, artists began to work two-dimensional objects such as newspaper cuttings, pages from books, sheets of music etc. into their paintings. This form of artistic expression is known as collage. When three-dimensional objects are added or used exclusively as elements in the picture, it is known as an "assemblage."

Adding all kinds of finds—to suit every different taste—is still popular and produces attractive results. This page shows you a few typical finds we collected by the wayside, but you can also buy similar things or use things that have accumulated in your own home.

Leaf, bark, horse chestnuts, *and golden fabric.*

Shells are among *the most popular things to find and collect.*

Wall object

The finale to our brief excursion into experimental painting with acrylics is a second assemblage. The ground consists of two differently shaped wooden frames, which are combined to form a single object. In it we have placed things we have found in the countryside. Once again the effort expended—apart from the arrangement—is small, but the resulting effect is even greater. With the right lighting, you can enhance the spatial effect after the object has been hung.

Materials

Square beechwood painting block 16 x 16 inches (40 x 40 cm); triangular beechwood block with 12 inch (30 cm) sides; white wall paint; flat brush no. 20; jar of water; cotton cloth or paper towels; coarse filler; fine filler; palette; colors: crimson and dark madder; stones; tree bark; wood glue

Crimson

Dark madder

1 Prime the wood blocks with white paint (page 23). Arrange the individual elements of your object and assemble it all on a horizontal surface. Consider the best way to distribute sizes and quantities, and mark the positions in pencil.

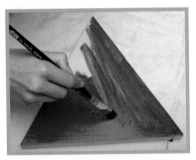

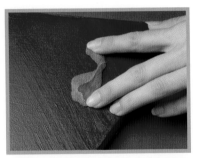

2 Disassemble the objects again and paint the square block in crimson and the triangle in dark madder. Repeat this coat if necessary. The marking will still be visible to start with.

3 When the paint has dried, first stick the triangle to the square where previously arranged and marked with wood glue. Then glue on the pieces of bark.

4 When the glue has dried, put the frame of the object upright and glue on the stones.

5 The object is finished and ready to be presented.

Author: Francisco Asensio Cerver

Watercolors
for Beginners

Illustrations: Vincenç Badalona Ballestar
Photographs: Enric Berenguer

Materials

THE MEDIUM

Watercolor painting, just as its name indicates, is based on water. The watercolor medium mainly comprises gum arabic and color pigments. Watercolor paints are sold in solid or liquid form. Solid color must be wetted in order to soften it so that it can be loaded on the brush; the liquid paints, which are creamy in consistency, also require water for painting with, but they dilute much more easily.

The watercolorist does not require much in the way of materials to paint, but in as delicate a medium as watercolor the few items you do need are of fundamental importance. This section is concerned with the basic materials used in watercolor painting. Their use will be explained in detail throughout the pages of this book. It is indispensable to become acquainted with the quality of the materials and accessories without which many effects and techniques cannot be achieved.

THE BEGINNER'S PAINTING KIT

To get started in watercolor does not require a lot of materials. A little paintbox, a brush, and paper are enough. These first items should be selected with great care. You will find an abundance of materials to choose from in your local fine arts store: a fact that can create confusion.

▼ *Watercolor paints can be purchased in tubes or in pans.*

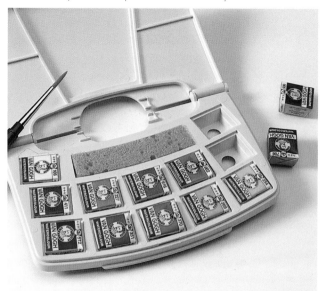

You only need a brush, a glass of water, a piece of paper, and, of course, a paintbox to get started in watercolor painting.

▲

WATERCOLOR PAINTS

Watercolor paints come in a wide variety of sizes and qualities. The cheapest types are so-called school paints. If you really want to learn how to paint with watercolors, these paints should be automatically excluded, since they will not produce good results. The most recommendable for the beginner are medium-quality paints, regardless of whether you buy tubes or pans. These paints are manufactured by well-known brands and allow all manner of painting styles.

▼
Tubes of watercolor paints.
This option is recommended once beginners have acquired experience and know how to use the colors of their paintboxes. Tubes of paint are sold in a variety of sizes, depending on the manufacturer.

Paintboxes with moist colors in pans. ◄
This choice of watercolor is a question of taste. Dry colors require more work to paint with than moist paints. Moist colors are more convenient because they are ready to paint with.

▶ *Paintbox containing tubes of watercolor paint. Paintboxes normally contain a complete range of colors, although they may be minimal. The lid of the box can be used as a palette. This paintbox has a medium range, highly recommended for the beginner.*

PAPER

Whereas other pictorial media can be painted on all manner of supports, watercolor can only be applied on paper. Nonetheless, watercolor cannot be painted on any type of paper. This medium requires a paper support with special characteristics. The right weight of paper, and thus its density, is fundamental. Another essential factor to bear in mind is the degree of absorption of the paper which depends on how it has been sized. The grain of the paper determines its smoothness; fine-grain paper is smooth, while coarse-grain paper has a rougher surface. The most commonly used paper in watercolor is medium-grain paper, which weighs about 250 grams per square meter.

Among the most widely used watercolor pads are the type which come glued on all four sides so there is no danger of it wrinkling when it is painted on. The sheets must be separated with a knife.

▼ *Watercolor drawing pads.* *This is one of the most convenient types of paper. As a general rule, the cover of the pad indicates its characteristics. We recommend you use semi-rough paper for painting in watercolor (the heavier type). There is a wide variety of formats and sizes of pads on the market; the smaller type are ideal for traveling with and painting sketches; the larger sizes are used for full-size watercolor paintings.*

▼ *Brand-name paper.* *Manufacturers who specialize in drawing and watercolor paper normally produce various qualities and thicknesses. These sheets usually have a watermark or a stamp in relief on each sheet. This type of paper is sold in units, although these manufacturers also produce pads or blocks of paper.*

◄ *Handmade paper.* *Handmade paper is normally of the highest quality, and therefore it is usually reserved for very special work.*

WATERCOLOR BRUSHES

If such importance is placed on the color and paper, this must also be the case with the brush. Watercolorists are the most demanding artists when it comes to the quality of the brushes they use. Watercolor requires special brushes. The main requirements of a good watercolor brush are its capacity of absorption and retention of water; flexibility to respond to the slightest pressure; and spring, meaning a brush that resumes its initial shape and a perfect tip regardless of how hard it has been applied to the paper.

SUITABLE BRUSHES

The painter does not need many brushes to paint in watercolor. This is because a single brush can be used in a variety of ways.

▲ This selection of brushes is appropriate for watercolor painting: A number 40 paintbrush (1), a number 9 paintbrush (2), a number 17 flat brush (3), a number 14 round brush, a number 5 round brush (4).

PARTS OF THE BRUSH

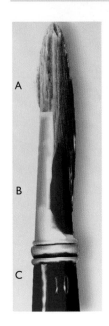

Since watercolorists demand quality brushes, they should be aware of the different parts of this implement.

▶ **A. The Hair.** *It may be synthetic, hog bristle, or mongoose hair, the latter being the highest quality. The hairs must form a perfect tip. The hair is attached to the handle and is held securely together by the ferrule.*

B. The Ferrule. *This is the metal band that keeps the hairs firmly attached to the brush. It should be chrome plated and made in a single piece. The shape of the ferrule is what determines the shape of the brush.*

C. The Handle. *Since the handle is made of wood, it is indispensable that it be of high quality. The reason for this is that brushes are often submerged in water and are thus exposed to the consequences of its action. The handle should be varnished, painted, or lacquered. High-quality brushes are given anti-dampness treatment in order to protect the wood from peeling or rotting.*

THE SHAPE AND SIZE OF THE HAIR

The shape of the hair is usually either round or flat. Round brushes allow fine strokes, even when the hair is thick; flat brushes allow thick or fine lines, depending on how the brush is applied to the paper.

◀ *Round sable hair brush (1), high quality synthetic hair flat brush (2), round mongoose brush (3), and Chinese wolf hair brush (4).*

CARING FOR AND CONSERVING BRUSHES

Watercolor brushes are extremely delicate. There are several rules that the artist should bear in mind in order to use, care for and preserve these precious implements. Above all, you must always regard the brush as a priceless precision instrument; a well-cared for brush will not only last many years, with time it will adapt to the hand of its user. Always remember that it is easy to damage an expensive brush.

▶ *Round brushes are sold with a transparent tube to maintain their shape. It's a good idea to keep the tube for later use. The brush should always be dry before you place the tube over the hair. If you don't follow this rule, you could destroy a very expensive brush.*

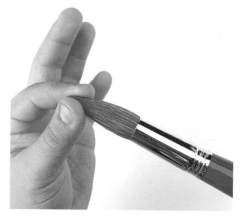

▼ *New watercolor brushes are sold with the hair glued together in order to maintain the form and keep the hair rigid. The hardness is removed by wetting the brushes in clean water just before you begin painting. Never try to force the tip with your fingers while it is still glued together; doing so could irreversibly deform the brush.*

A PIECE OF ADVICE

If your brushes are going to be left unused for a considerable period of time, the best thing to do is to store them wrapped up with camphor balls. This will keep insects at bay and thus preserve your brushes from attack.

Brushes can be carried very easily by rolling them up in a type of mat. This highly useful item allows you to gather up and store your brushes very quickly and conveniently.

▲

◀ *Brushes are easy to clean under the tap, but when you want to give them a thorough clean, just put a little soap in the palm of your hand. Having washed them, rinse and drain out the excess water.*

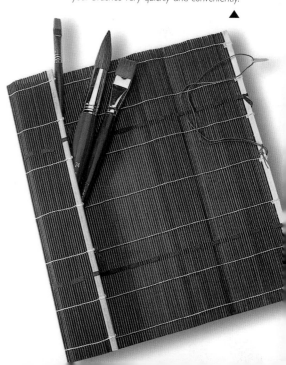

TESTING YOUR BRUSHES

O nce you have the necessary materials for painting with watercolors, you should try them out on a sheet of paper so as to see and practice the different results that can be obtained with them.

Place a color on the palette and use all your brushes in order to see the type of stroke that can be obtained with each one of them. First wet the brush in clean water and rinse it. Now load some color on the brush by turning it around on the palette to impregnate it with enough color.

MATERIALS REQUIRED FOR THIS EXERCISE

To carry out this simple exercise you will need everything that has been mentioned up to this point: several sheets of watercolor paper of various brands and qualities, round brushes (thick and thin), a flat brush, and wide paintbrushes; a paintbox with a lid that doubles as a palette, and a glass of water. The test should be done on fine-grain paper, medium-grain paper, and coarse-grain paper.

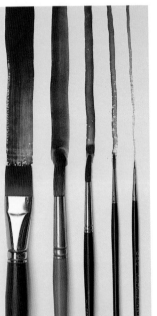

▶ This exercise is carried out with each one of the brushes. Make sure you load each brush with as much paint as it can absorb. First paint a line with the widest paintbrush; then apply strokes with the other brushes from the widest to the thinnest. Of course, it goes without saying that the finest brushes absorb less paint than the wider ones.

HOW TO LOAD COLOR

P lace a little paint on the palette. This should not pose a problem, although there is a slight difference between paint in a pan and liquid paint from a tube. Once the paint is on the palette, load the brush. This is carried out in the same way, regardless of the type of watercolor paint you are using.

◀

If the watercolor paints are from a tube, apply a little more pressure on the surface in one of the corners or near the edge of the compartment of the palette in order to be able to work comfortably with the brushes. In this case, a porcelain palette with compartments is necessary.

▶ The paintbrush is tested by covering an entire surface in paint. This type of brush absorbs a large quantity of paint, so care must be taken not to allow it to become saturated with color.

◀

If the watercolor paint comes in a pan, it must be picked up with a clean wet brush. Make sure the brush is merely wet and water does not drip from the brush. The brush is passed over the paint until it softens and soaks into the hair of the brush. Once you have done this and the paint is in a compartment, you are ready to paint.

FINE-GRAIN PAPER

This type of paper is not especially suited to the watercolor medium, nonetheless it can be used for works that require a specific degree of detail. The virtual lack of texture of fine-grain paper prevents the brush from depositing paint on the paper. Very thin paper should also be avoided, since it wrinkles easily.

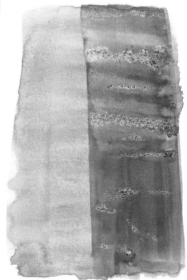

▲ This is what happens when watercolors are applied to low-quality paper and paper that has very little grain. The color does not spread well and the paper wrinkles.

MEDIUM-GRAIN PAPER

This is the most commonly used paper for painting with watercolors. It has enough texture to allow all manner of work, from the most delicate to the freest and most expressionist. As a rule, most watercolor pads are sold in this type of paper.

▶ This type of test is very easy to do. Take two pieces of different paper and paint a similar stroke over each one. In this case, use very thin fine-grain paper and a coarser one. Now paint almost identical lines on each paper. The paint on the fine-grain paper collects in pools and the paper wrinkles; the paint on the medium-grain paper spreads evenly over the surface without the slightest alteration.

This exercise demonstrates the degree of absorption of each paper. Paint similar strokes on the three papers. Note how each paper responds in a different way to the applied paint. ◀

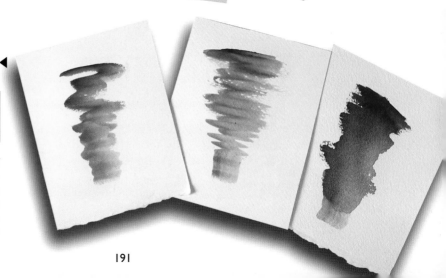

COARSE-GRAIN PAPER

This type of paper has a lot of texture and is only used in special paintings. Coarse-grain paper is only made in large sizes sold in a specific weight. Many manufacturers produce this type of paper by hand or partially by hand.

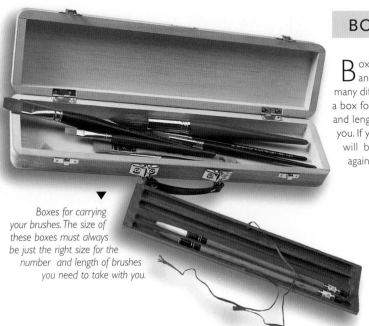

BOXES FOR BRUSHES

B oxes for brushes are handy both for carrying and for preserving your brushes. There are many different sizes of boxes. When you purchase a box for your brushes, bear in mind the number and length of brushes you will want to take with you. If you put too few brushes in a big box, they will become damaged every time they roll against the wooden walls.

Boxes for carrying your brushes. The size of these boxes must always be just the right size for the number and length of brushes you need to take with you.

RECIPIENTS FOR THE BRUSHES

T here should be many household items you can use, including those that contained food, such as a yogurt pot or a jam jar.

Keep a variety of empty containers handy for watercolor painting.

PLASTIC BRUSHHOLDER

This type of jar is ideal for holding the brushes or water. A white plate makes a handy palette.

T his is a relatively new invention. Because it can be sealed hermetically and carried with the brushes in water without touching the bottom, this holder is especially useful for painting outdoors. It can also be used in the studio thanks to the grips which keep the brushes securely fastened so that the tips do not touch the bottom and the wooden handles do not get wet.

▶ *This plastic holder can be hermetically sealed so that the brushes are suspended by the handle and do not touch the bottom.*

STUDIO AND OUTDOORS

Watercolor is an ideal medium for painting outdoors or in the studio. We recommend you paint in the open air as much as you can; painting outdoors is much more fun. As you may imagine, painting outside the studio requires other materials in addition to those used in the studio.

PALETTEBOXES AND PALETTES

The main advantages of the palettebox is that its lid doubles as a palette and that the colors can be used without the need to clean the recipient after the session. Regardless of the type of color you paint with, palettes are far more convenient for use in the studio rather than outdoors.

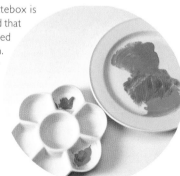

▶ A palette box containing tubes of paint. This type of box is for keeping your paints in when painting in successive sessions. The tubes are kept apart.

These palettes are normally made of porcelain in order to make them easier to clean. They are useful as long as they don't have to be carried around. A white plate is a good option, as well as this type of palette with mixing wells.

PORCELAIN PANS

Although these large pans are generally only used in a studio, they can be painted with in the open air. They tend to be high quality colors; the shape of the pan is specifically designed to support the brush.

OUTDOOR BOXES

Miniature boxes are a delight to many an artist. Despite their smallness, the quality of the colors can be exceptional. These tiny boxes, with the colors included, tend to be the best choice for painting all manner of work.

This truly marvelous palettebox contains all the necessary materials for painting with watercolor. There is even a water container and a small tray for wetting the brush. Once you have finished painting, the compartments fold up into a box that fits into the palm of your hand.
▲

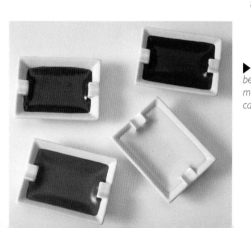

▶ Porcelain pans. These are best for studio use. Their size makes them inconvenient for carrying and handling with ease.

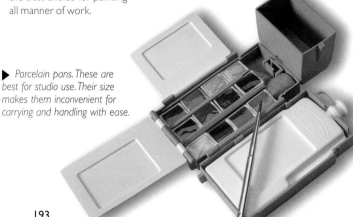

SUPPORTING THE PAPER

The paper has to be attached to a rigid support. This provides a firm surface over which smooth lines can be painted. When paper is wetted with color, it tends to wrinkle. Therefore it is essential to fasten the paper down at all four corners in order to prevent any creasing.

The paper should be attached to a rigid surface. The best support is a piece of board or wood. The paper must be fastened down at all four corners before the artist begins painting; this way, the paper won´t crease or warp when the paint is applied on top. The following is a list of accessories that are used for the purpose of attaching the paper. Adhesive tape (1) and (2), three-pointed thumb-tacks (3), thumb-tacks with a large head (4), or clips (5). The latter are good for attaching the paper to a folder, so long as the paper is as big as the folder itself.

▲

FOLDERS

There is a wide variety of folders to choose from, all of which are as practical as they are aesthetic. The simplest folders are made of rigid cardboard and have a corner piece made of fabric that makes them more flexible at the opening. Others have a zipper and contain plastic separators, which allow the work to be seen and protected at the same time. This type is not very appropriate for outdoor work, since they are too pliable and as a result it is difficult to place a piece of paper on them.

▼ *Various folders for different uses. The zipper type allows the artist to keep a limited number of paintings inside. The small type is useful for storing small paintings and can be used as a support, although it deteriorates easily. The simple cardboard folder is a good one to have because the paper can be easily attached to the surface with thumb-tacks.*

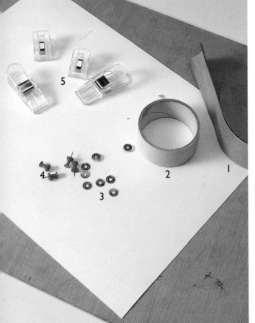

STRETCHING THE PAPER

This is a relatively simple process to carry out. When done successfully, the result is a sheet of paper that will not wrinkle when you are working with abundant water.

▶ *1. Place the paper on a wooden support and wet it with a sponge.*

◀

2. Once the paper is soaked, apply the waterproof adhesive tape round the edges. Once the paper has dried, it is stretched as if it were the skin of a drum. Once you have finished painting, cut round it with a knife.

OUTDOOR EASELS AND TABLETOP EASELS

The easel is one of the artist's most important tools. This accessory allows the paper to be supported at a certain height and inclined according to the artist's taste. There are many shapes and sizes of easels. Here you can see some of the most practical.

Since watercolor requires water, when the artist has to apply color over the entire surface of the paper, it is essential that the paint is spread evenly. The fact that painters work on a practically vertical surface allows them to cover the surface by using gravity.

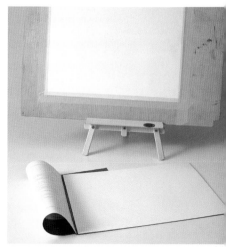

The easel keeps the paper in a vertical position, which is far more convenient and stable than painting over a flat horizontal surface such as a drawing pad.

TABLETOP EASEL

It is small, but very useful for painting in the studio. The table easel is slightly bigger than a notepad and can be used with various formats, large ones included.

▶ *A folding easel (1) and a tabletop easel (2). These can be used in the studio, but the metal one (1) is highly convenient as an outdoor easel.*

1

2

OUTDOOR BOX-EASEL

When the painter is used to working in the open air, there is nothing better than a box-easel. Although somewhat more expensive than the tabletop easel or outdoor easel, this implement is extremely versatile for the artist.

The box-easel, as its name suggests, is a box in which your paints and brushes can be kept. This easel has three folding legs, which can be adjusted to the desired height by unscrewing the wing nuts. To summarize, the outdoor box-easel provides the artist with a convenient portable studio.

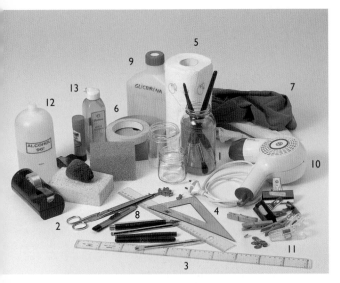

THE IMPORTANCE OF A STUDIO

The artist must have a corner which is exclusively dedicated to the painting. It can be a small room, a corner, an alcove, or a niche in a back room. Light is a very important factor. A good window is ideal but, as this will not always be available, one will have to make do with adequate artificial lighting.

SUPPORT MATERIALS

Until now, we have shown you what the basic tools required for watercolor are. But once you have had some experience in this medium and want to take it one step further, other accessories are necessary. Most of the accessories used by the watercolorist in the studio are easy to find: many of them are everyday household items.

▶

Pots and jars for holding water, brushes, and pencils (1).
Scissors and a utility knife for cutting paper, sponges (2).
Long and short rulers for measuring (3).
Set-squares for cutting paper at a right angle (4).
Roll of water-absorbent paper towels (5).
Adhesive tape and special adhesive tape for water (6).
Rags for cleaning and mopping up (7).
Pencils, pens; any kind of drawing material can
be used in watercolor painting (8).
Gum arabic for sticking paper (9).
Blow-dryer for speeding up the drying process (10).
Thumbtacks and clips for attaching the paper
to the board (11).
Alcohol, which can be used to speed up the drying
time of a watercolor painting (12).
Glycerine, which slows down the drying time of watercolor (13).

▶ *It is important that the painter adapts a corner of the home so that he or she can work at any moment, without setting up all the equipment every time that he or she wants to paint. The space does not have to be too big but it must be comfortable. The diverse tools always have to be at hand and neatly stored.*

USING A BLOW-DRYER

The watercolor painter often superimposes colors. As you will learn later on in this book, the artist does not usually want the underlying color to mix with the superimposed one; the area where the painter wants to apply a new color over another must be dry in order to prevent the two from blending together.

▼ *It's best to work with an old blow-dryer, and not necessarily the one you use at home. Since abundant water is used in this medium, take care not to leave the dryer in any wet areas. Always unplug it after every use.*

1

Wash

COLOR AND WATER

A small amount of paint is placed on the watercolor palette. Watercolor paint from the tube is denser and more concentrated than solid colors, which are wetted and softened by running the brush back and forth across the pan. Once the color is on the palette, water is added with the brush. The more water you add, the more transparent the tone then appears.

▶ *You will find that paints from the tube are easier to place on the palette; pastel-form paint, on the other hand, must first be wetted until it is soft enough to be loaded onto the brush, and then be transferred onto the palette. Here we are using a porcelain palette, although the painter can also make do with the lid of the paintbox.*

The first technique a beginner needs to know in order to get started in watercolor is the wash technique. The principle of watercolor painting is simple: all one needs to do is wet the brush with color and water and spread it over the paper. Before painting with all colors, we recommend you practice the basics of the wash technique with a single color. Once you understand the possibilities that this technique can offer, it will be much easier to try out more complex procedures. For the present, we will concern ourselves with one color, although in the examples reproduced in this section, we can carry out our tests with different colors, without mixing any of them together.

GRADATIONS ON WET BACKGROUNDS

Moistening the paper before you apply color is the best way to execute gradations, but it is difficult to handle the color using this technique.

◀ *Paint is applied where the gradation begins. Since the paper is wet, the color will spread much more easily. The more you extend the paint, the more transparent the color becomes.*

APPLYING THE COLOR

Once the color is on the palette, a little is placed in a compartment. Then a little water is added with the brush in order to lighten the color.

First apply the color with a moist brush. Next the brush is washed in water and rinsed and the color is spread a little. A tone is made more transparent by adding water to it. By repeating this procedure, adding more water each time, you can obtain a gradation of the tone. ▲

◀ *With a clean brush, you wet the area where you want to paint the gradation; in this way, the color seeps into the wet area, since wet paper allows the paint to spread on its own.*

GRADATION TONES

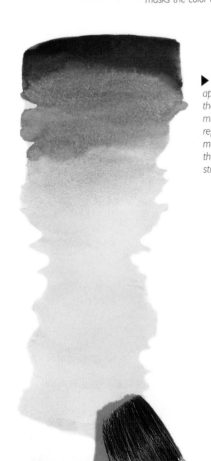

T he wash technique is apparently simple: it mainly consists of loading some paint on a wet brush and applying it to the paper, "stretching" it out by adding ever larger amounts of water to obtain a gradation of the tone from dark to light. As the gradation becomes lighter, the tone becomes so light that it can barely be distinguished from the white of the paper.

▶ As we have just seen, the color on the palette can be extremely dark (more so if tube paint is used). The density of the color allows you to paint an opaque stroke that completely masks the color of the paper.

◀ In the same way we painted the previous gradation, we recommend you try your hand at this technique by first wetting the paper. The gradation on the left was painted on dry paper, the one on the right was applied over previously wetted paper. Note how different the results are. In future exercises we will show you how to use both techniques in a single painting.

▶ If you pass a clean wet brush over the previous application and stretch the color in zigzag form, the color lightens as the water from the brush mixes with it. If you clean and rinse the brush and repeat the procedure, the tone gradually becomes more transparent until it practically merges with the white of the paper. Later on we will demonstrate more complete and interesting possibilities.

◀ This landscape was painted with only one color. The different tones were obtained by adding more or less water to the original color in order to lighten it, as well as applying pure color in the darkest zones of the painting.

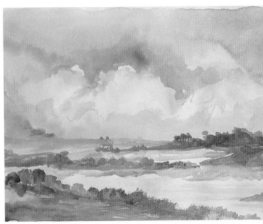

198

THE WHITE OF THE PAPER

The greater the amount of water added to the paint, the lighter and more luminous the resulting color is. The less water added to the paint, the more opaque it will be. Thus, it is easy to see that the color white does not exist in watercolor. It is represented by the color of the paper.

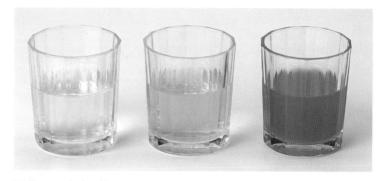

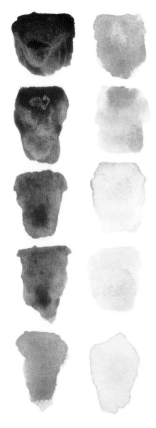

▼ *If you gradually add paint to a glass of clean water, it will become more noticeable, while at the same time reducing the water's degree of transparency. Exactly the same process happens with watercolor; the maximum degree of transparency reveals the white of the paper, while the most opaque color becomes less transparent, thus less luminous.*

Look at the beautiful snow-covered landscape in this example. This type of work requires great skill in the technique, but it is a good example to see the utility of transparency in watercolor and how diverse tones can be obtained from washes of different colors. The highlights and bright parts of the picture are always represented by the white of the paper. This is another reason why watercolors are not painted on colored paper.

▲

▼ *Add water to this darker tone; gradually add more water with the brush to lighten the tone. Note how the lightest tone is the most transparent. The color white is the color of the paper itself.*

This short exercise is for practising drawing with a brush and gradating the color. It is not essential for your final result to resemble the one reproduced here. The main purpose of the exercise is to carry out the procedure and try to achieve a result akin to the example. All you need to concentrate on here is how to handle the brush in the same way you would a drawing instrument. In addition, just as we demonstrated in an earlier exercise, you will also attempt to gradate the model using a single color in order to study tones.

▶ **1.** *First outline the shape of the pear; the line must be continuous and constant. Once the outline is closed, some paint is applied to the interior with a slightly more diluted application of the same color.*

▶ **2.** *Continue painting the surface of the pear, but not all of it. The fragment that corresponds to the highlight is left unpainted. Before the color has time to dry, wet the brush and load it with a darker tone and paint the curve. Since the rest of the paper is still wet, the new tone quickly blends.*

DRAWING AND WASH

Despite the fact that wash is executed with watercolor, it is really a drawing technique. No matter whether you are experienced at drawing or not, you will see how closely wash is linked to drawing. The brush is used to apply lines in the same way one forms lines with a pencil.

Moreover, the gradation technique is similar to stumping or shading, progressing from dark to light using a single color. In both cases the artist can achieve a great number of tones.

In this example you can see how the wash technique allows the type of line akin to a drawing. Exercises of this nature are recommended in order to gain experience with brush and paint.

▲

▼ **3.** *The brush is rinsed and the tone is spread out with delicate strokes. In the darker zones, we add a touch of denser color (barely diluted with water). This is a practical application of a gradation from a drawing in wash.*

Step by step

Landscape with wash

Wash allows the artist to paint different tones of the same color, according to the amount of water that is added to the paint on the palette. If you have understood the previous exercises, the one included on this page should not pose any problems for you. Before you begin to paint, it is advisable to go back and review the theory explained up until now.

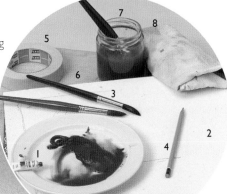

MATERIALS

Watercolors and palette (1), medium-grain watercolor paper (2), watercolor brushes (3), pencil, (4), adhesive tape (5), board for attaching the paper to (6), jar or similar container filled with water (7), and a rag (8).

1. *We are going to apply the basic notions that we have demonstrated at the beginning of this topic. We will go about this in successive steps in order to make it easy for you to paint this beautiful landscape. First we make a simple drawing in pencil; it does not have to be exact but it should be roughly correct. In the lower part of the paper, draw a straight line, on top of which you sketch the little house and the trees. Above these elements, draw a line to mark out the mountains and, slightly above that, draw the tallest mountains.*

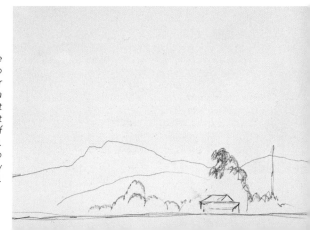

201

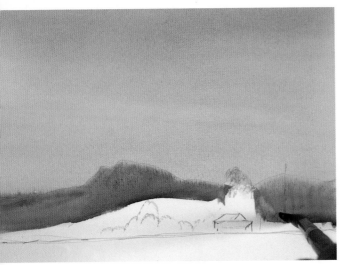

2. *As you have seen at the beginning of this topic, you must gradate a broad area of the background. The entire surface of the paper is first wetted with a clean brush. Before it dries completely, load the brush with some sienna and draw a line on the top part of the paper. The dampness of the paper causes the color to spread out. The brush is then cleaned and run over the color to spread it; the procedure is repeated until the first gradation is achieved. Now dip the brush in a slightly darker tone and paint the mountains in the furthermost background.*

> The white areas of the painting must be left unpainted. If you want to reserve a white area, it should be wetted with clean water.

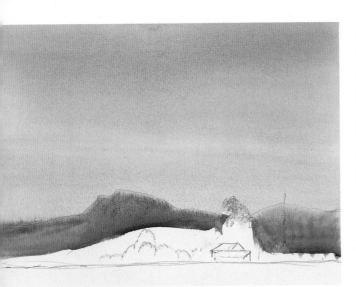

3. *Pay attention to the steps carried out until now: first paint the sky as a gradation and then the mountains in the background. They were painted while the area of the sky was still wet. The tone has spread out from the outline in the sky.*

> Take care when you are measuring amounts of water with the brush not to load so much that it drips off the brush.

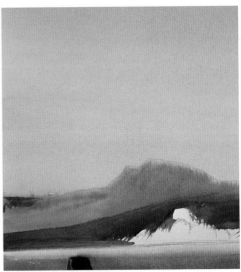

4. *Load a little paint from the palette. This time your brush should only be damp, rather than wet, in order to paint a medium-dark tone. Now apply another stroke on the mountain; it is located on a closer plane than the former. This time, the background is much drier so the new tone does not blend with the previous one. Take care not to allow the paint to penetrate the areas reserved for the trees and the house. A long straight line is applied across the foreground.*

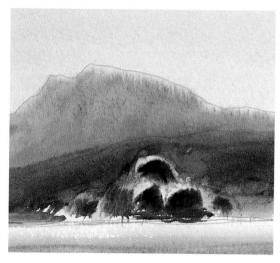

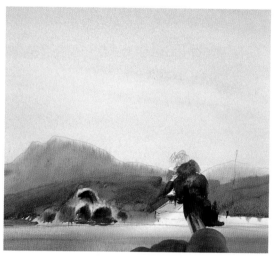

5. *The work has been simple up to this point: it was no more difficult than choosing the color; the tone is lightened by adding more water or darkened by adding more paint. The drawing is the artist's guide to each area of the picture, something that you will continue to do as you progress with this painting.*
Now load a dark tone, almost without water, and paint the trees with the tip of the brush. Don't fill in all the reserved area; the upper part is left unpainted.

6. *With the same dark tone used in the last step to paint the trees in the center, the right-hand zone is painted; these dark areas are different to the previous ones. Here two dark tones have been combined. Outline the house with the same dark tone, leaving it unpainted.*

> The drawing is the foundation of a water-color painting. It is used as a guide as to where to apply the various tones or colors. Therefore, it is essential that the artist draw the lines correctly before starting to paint.

7. *With the same dark tone utilized for painting the trees, heighten the contrast of the mountain on the right-hand side of the picture. Finish off the remaining trees on the right. Wait a few minutes for the paper to dry completely. Once it is dry, paint the little house with a very light tone, leaving the triangular form unpainted. Once again you must wait for the layer of paint to dry before going on to paint the darker tone of the shadows without their mixing or merging with the contours of the previous tone. The preliminary drawing allows you to paint with precision, since the lines indicate the limits of each area.*

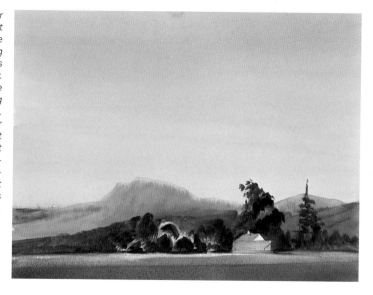

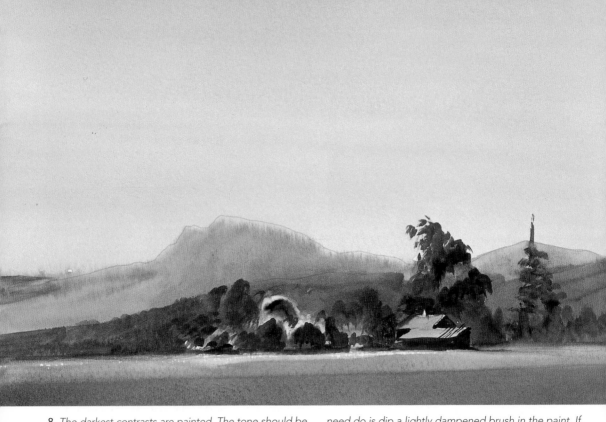

8. *The darkest contrasts are painted. The tone should be the closest you can get to applying the color without water. If you are painting with tube watercolor paint, there is no problem, since the paint is so creamy that all you* *need do is dip a lightly dampened brush in the paint. If, on the other hand, you are working with pans of tablet- form colors, you will have to be more persistent adding a little water, until you acquire the desired thickness.*

SUMMARY

The background was painted with a gradation. First the corresponding part of the paper is wetted. Before it has time to dry, a brush loaded with a dark tone is applied lengthwise across the paper. The brush is cleaned and then passed over the area in order to "spread" the tone.

If you paint when the **tone below** is not completely dry, the edges will blend together.

Very dark tones barely contain water. The brush must be dampened so that its hairs can absorb the paint and are able to glide across the surface of the paper.

A darker tone is painted with barely any water added to the color.

The whites are the color of the paper.

2 Color theory with watercolor

WASH WITH THREE COLORS

The three basic colors, also known as primary colors, are yellow, magenta, and cyan. By mixing these three colors in different amounts you can obtain all the other colors. You can paint with the three primary colors without ever having to mix colors together. The pure colors are treated as if they were independent washes of three different colors. Nonetheless, this is not entirely true, since wash can only be made with one color or with a mix of two. This question will be examined later.

There are an infinite number of colors, but all of them are comprised of the three basic colors, the primary colors: yellow, magenta, and cyan. By mixing two primary colors together we obtain secondary colors. All painters should understand how these colors behave when mixed together in differing amounts. Such knowledge allows the artist to obtain a good palette and ensures that the hues applied to the painting appear planned, rather than improvised.

▶ 1. *Place the three primary colors on the palette. Separate them in order to avoid mixing them together. First practice a simple exercise similar to the one we did in the last topic. You are going to gradate each one of the three colors in order to see the kind of tones each color can produce. Begin with the most luminous color, yellow. Dampen the brush, and load the color onto the hairs of the brush.*

2. *Gradate the yellow, the most luminous color of the three, since it is brighter and thus reflects the light. Gradate the other two colors, magenta and cyan, without allowing any of the three stripes to blend together. These three colors allow you to obtain a wide range of tones.*
▲

3. *The last part of this exercise involves painting a simple flower without allowing any one of the three colors to come into contact with one another. It is slightly difficult, since wet tones mix and change into other colors. So what are these colors produced by the mixes?*
▲

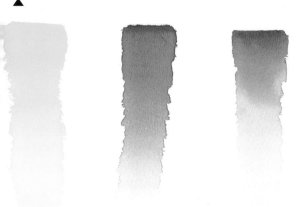

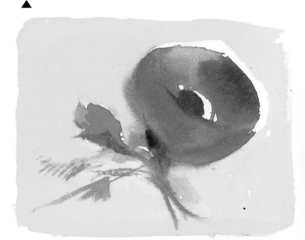

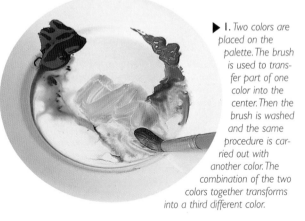

▶ 1. *Two colors are placed on the palette. The brush is used to transfer part of one color into the center. Then the brush is washed and the same procedure is carried out with another color. The combination of the two colors together transforms into a third different color.*

TWO COLORS IN THE PALETTE

By mixing two colors together you obtain a third color, but the pureness of the color depends on how much of each of the two colors are used. With a wash containing two colors the resulting color may be different to the two used to produce it. Equally, by gradating the color change, you can create intermediate tones that gradually take on the definitive color of the mix.

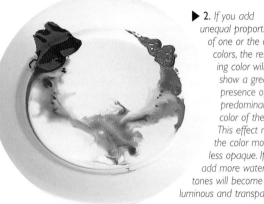

▶ 2. *If you add unequal proportions of one or the other colors, the resulting color will show a greater presence of the predominant color of the mix. This effect makes the color more or less opaque. If you add more water, the tones will become more luminous and transparent.*

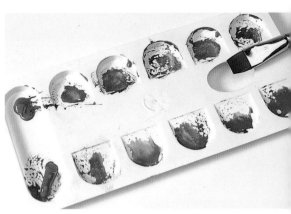

▼ *From the mixes obtained on the palette, you can organize an enormous palette from two colors, which, in reality, is far more complete since it comprises all the possible intermediate tones between the two colors and the intensity of each color according to its transparency on the paper.*

3. *Here you have tested the colors on paper. The tones are never completely definitive on the palette; on the contrary, they look much better on the paper, since they can be seen as they really are, once they have dried.* ▲

This in an interesting exercise to understand the transition from one color to another. Gradually add small amounts of the secondary color to the main color. The effect can be observed in each gradation. ▲

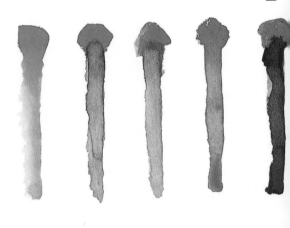

SECONDARY COLORS

U p to this point you have studied how to paint with one color, with two primary colors, and with a combination of two colors. When you mix two primary colors together, you obtain a secondary color. At first you may find the mixing of colors to be rather difficult, but with a little practice you will quickly master it. Try the exercises reproduced on this page and the theory will be better understood in practice.

1. The artist always requires two primary colors to obtain a secondary color. In this exercise, use the same colors that were employed in the previous exercise. This time mix the colors together in the center of the palette. A secondary color can only be obtained by mixing two primary colors together, so choose a combination of yellow and cyan which produces the secondary color, green.

3. By mixing the primary colors in different proportions you get secondary colors. Thus with only three colors you can obtain all the colors of nature. If you compare this flower with the one done in this topic (see page 205) you can see that the color combinations have produced a wealth of colors.

▲

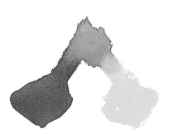

▼ *2. You can practice obtaining secondary colors on the palette, but it is better to carry out the tests on paper. Reproduced here are three possibilities. The first is a mix of yellow and magenta which produces the secondary color, orange. The second mix of yellow and cyan gives way to green, another secondary color. Lastly, the combination of magenta and cyan produces violet, another secondary color.*

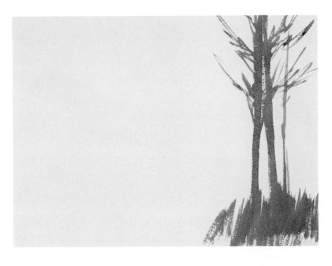

▶ 1. *First paint with one primary color, cyan blue, to begin this entertaining exercise. There is no need to wet the paper. Load the brush with color and apply several long vertical strokes. Then, at the bottom, paint short energetic strokes in zigzag fashion. Lastly, with a touch of paint – there is only a little paint left on the brush – paint the thin branches.*

FROM MONOCHROME TO CHROMATIC RICHNESS

Beginners should regularly experiment with their colors, both on the palette and on paper. The more mixes you try out, the more colors you will obtain. With your three primary colors you can produce a wide range of colors. This exercise will help you to consolidate what you have learned up to this point. First you learned to paint with one color; then you combined two to obtain a third color; finally you learned how the three primary colors can be mixed to obtain all the colors of the rainbow.

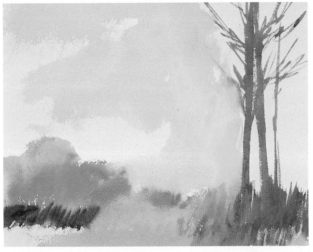

▶ 2. *Straight away, so as not to give the cyan paint time to dry, load some yellow and paint the background. The contact between the two primary colors produces a secondary color in the area of the grass and the areas where the color dampens the blue branches. A broad patch of magenta is painted on the left-hand side. Paint yellow around this color, applying more quantity in some areas and less in others. The result of the combination of magenta and yellow is a variety of orange tones, another secondary color.*

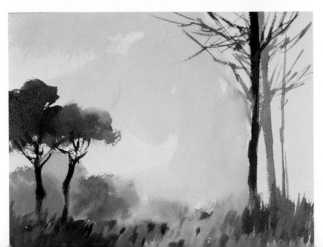

▶ 3. *Place some cyan paint over the magenta on the palette. The result of this mix is another secondary color, violet. With the different tones of violet, paint the small trees on the left and darken the trunk on the right.*

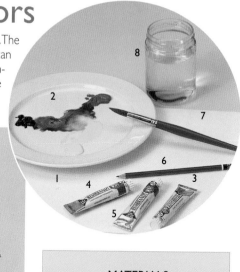

Step by step
Flowers with three colors

The best subject for a beginner to study color is a small bunch of flowers. The primary colors are yellow, cyan, and magenta. With these colors you can obtain all the colors of nature. The bunch of flowers we have chosen contains a great variety of colors and tones, but we are going to place three basic colors on our palette. Nonetheless, with a little concentration, we will obtain all the necessary colors for this still life.

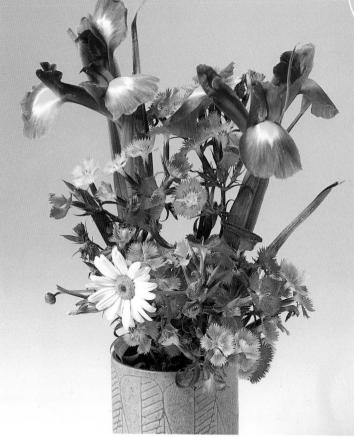

MATERIALS

Watercolor paper (1), white plate (2), watercolors: yellow (3), magenta (4), and cyan (5), pencil (6), watercolor brush (7), water container (8).

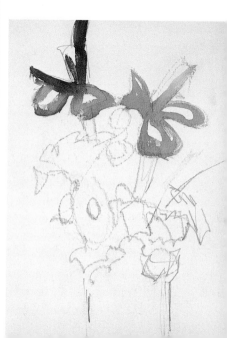

1. Draw the model as accurately as possible. Since watercolor is transparent, the drawing will provide you with a guide to the different areas of color. The drawing should not include shaded areas or too many details: it must be simple and concise, although each of the areas you are going to paint in must be indicated. Once you have finished drawing the subject, mix some cyan and magenta on the palette. The result is violet which is used to paint the uppermost flowers. Use two intensities, one with abundant paint and little water, and the other one more transparent.

209

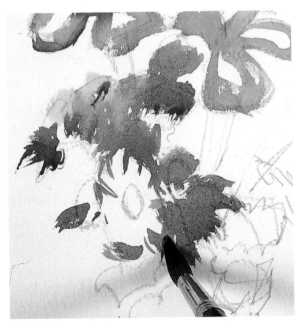

2. *Begin to paint the red flowers with pure magenta. The brightest and pinkest are painted with watered-down magenta. The darkest flowers are also painted with this color, but with less diluted paint. Since there is no white in watercolor, the color white is the color of the paper itself. Trace with your brush the shape of the daisy.*

> Once the color has been mixed, it can be made more transparent on the palette by adding water with a brush.

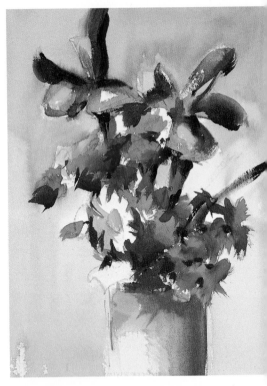

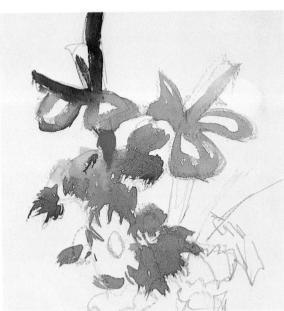

3. *A mix of yellow and cyan produces a yellowish green. To make the tone more yellow, add a smaller amount of cyan. In order to control the proportions, always add dark colors to a mix in small doses to the light one of your combination. This way you can decide how intense you want the tone to be.*

4. *The combination of yellow and blue produces green. If you add a touch of magenta to this color, you obtain an orangy tone. The tone is first watered down and then used to paint the background. Remember to allow the previously applied color to dry first, otherwise the two colors will mix together. When painting the background, do not enter the areas where light or very luminous colors are to be applied, neither should you touch areas reserved as highlights.*

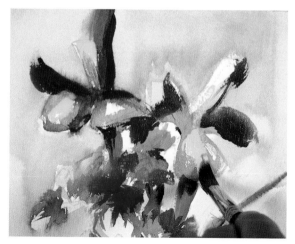

5. *In the same way as the violet was applied, now work with another tone, this time much darker. The best way to obtain such dense tones is to load the paint onto the brush straight from the tube. Here you are painting with a violet tone tending toward magenta. Use this tone to paint the uppermost flowers. Now, with a pure, not too diluted yellow, paint the flowers' lighter areas.*

The mixture of two primary colors produces a secondary color. Therefore, yellow mixed with cyan gives the color green. Yellow mixed with magenta gives orange. Magenta mixed with cyan makes violet.

6. *This is the palette that has been used up until now. Observe how the colors have been mixed. In the zone on the left you can see the green that has been used for the stems. On the right, on top of a blue tone, a yellow tone appears, in this case to make the green darker. In the center of the palette the much more liquid colors are placed. You can also see the colored edge of the plate. This is due to the number of times that the painting brush has been squeezed out.*

7. *The stems and the leaves are painted with two tones of green, one very luminous tone in which yellow predominates, the other very dark and dense, obtained with more cyan and a touch of magenta. From this, mixed with yellow, the various orange tones of the flowers in the lower area are obtained. First the orangy colors are painted; then before they dry, superimpose several magenta strokes that softly blend over the orange. Once again, with the violet mix obtained with magenta and cyan, paint the petals of the uppermost flowers. Now with almost pure magenta, barely watering it down, paint the darkest petals of the reddish flowers.*

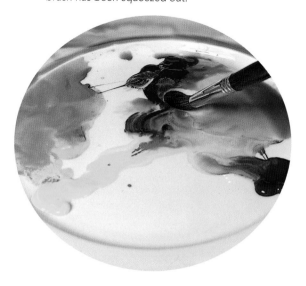

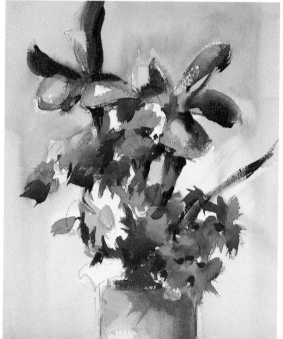

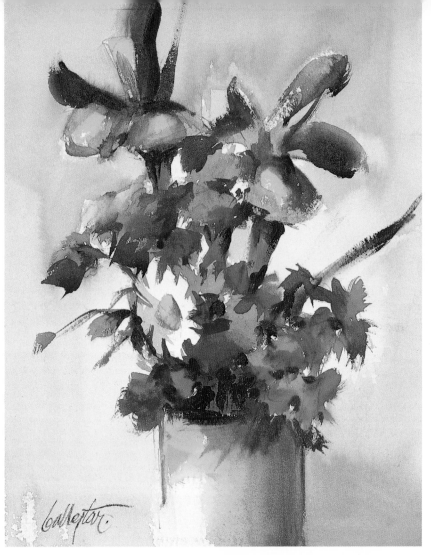

8. *Finish the lower parts of the flowers with magenta. It is necessary to paint another even darker tone over this one. Therefore on the palette mix a touch of cyan with the magenta. In order to paint the jar, mix magenta and yellow, to obtain an orangy color.*

Over this add a touch of cyan; the mix becomes a more orangy color.

Using this color, paint a gradation from right to left, leaving the brightness unpainted.

You can now consider this floral subject, painted with only three basic colors, finished.

SUMMARY

The yellow is completely pure here. In order to avoid dulling it, it should only be applied once the underlying colors have dried.

Green obtained with a mix of cyan and yellow.

Orange obtained with a combination of magenta and yellow.

Luminous violet. First the violet was painted with cyan and magenta, after first watering it down on the palette.

Dark violet with a magenta tendency. It was obtained with violet and a greater amount of magenta. In order to avoid transparency, it has been mixed with very little water.

Color ranges

THE COOL RANGE

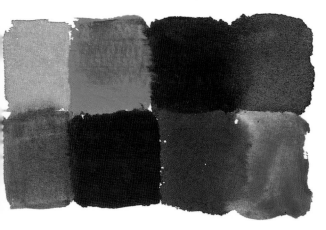

Depending on the chromatic "temperature," colors can be classified into ranges. A range is a group of colors that share certain characteristics and form a harmony. When you look at a monochromatic gradation, what you see is the tonal harmony of this color. If you put together two similar colors that contain some of the aforementioned color, we can be said to be building a chromatic range or harmony. To summarize, a color range is comprised of colors that are classified according to coolness, warmth, or neutrality. The first are cool colors, the second, warm, while the last are called dirty or broken colors.

▼ The cool range of colors encompasses everything that begins as a mix of yellow and cyan, from which an entire range of yellows, greens, and blues can be obtained. You can also add magenta to this mix in combinations that turn blues into violets. There is also the possibility of painting transparencies with this color range. It is essential to try some simple tests in order to understand the nature of the colors.

You can mix together colors from different color ranges. For instance, a warm color range can include green in order to obtain yellowish greens or warmer greens by means of mixes.

1. The area of this landscape corresponding to the sky is painted with blue and green. The clouds are left unpainted. The intermediate zone is painted with a very dark bluish violet.

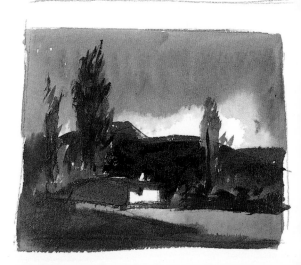

2. Paint the lower area with a watered-down green. Over this add various tones of cobalt blue; thus the foreground is significantly darker than the previous color. With the same blue, paint the trees and the wall of the house in shadow. In this way, all the luminosity of the paper is reflected. As you can see, in this example you have worked only with the cool range of colors. This is called the cool harmonic range.

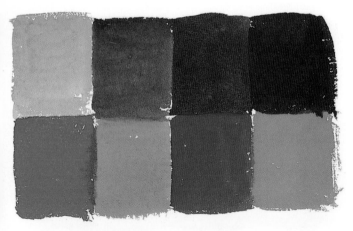

THE WARM RANGE

The warm range of colors comprises red, magenta, yellow and the mixes obtained from them. Therefore, you can include red in the range of cool colors in order to obtain violet. Likewise, you can also add a cool color such as blue to obtain a specific warm tone or to obtain a green of a warm tendency.

▶ *This is a good example of the warm range. The colors do not have to be pure, but they must always share a common harmonious factor. Even when green is used, the color does not appear excessively cool. Yellow is added and a touch of orange to tone down the contrast with the rest of the range. Colors from other ranges can be included with a warm range of colors, as long as they do not appear too dominant.*

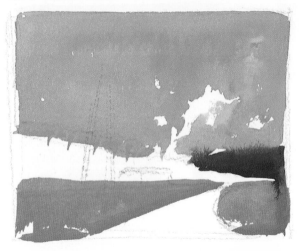

▶ **1.** *A combination of red and yellow produces a very luminous orange which is used to paint the landscape´s entire sky. On the right-hand side paint a sienna-umber tone. Earth colors form part of the warm range, although certain earth tones, such as green oxide, approach the cool range of colors. In the lower area apply green; but to continue with the warm range of colors, orange has been added. This results in a warm tone akin to ochre.*

Complementary colors are those of the chromatic circle that face or oppose one another. Complementary colors create enormous visual impact; examples of complementary colors are yellow and deep blue, magenta and green, cyan and red. These colors are used in all color ranges in order to achieve effects of contrast to reduce the monotony.

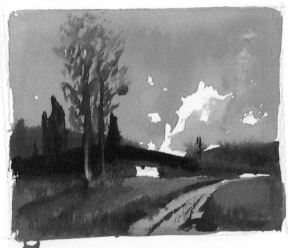

▶ **2.** *The background is painted with sienna mixed with red. Over this, paint an almost black tone that separates the focal planes, but the tree trunks are left unpainted. The path is painted ochre. Over the greenish tone, now apply a somewhat darker green, but without allowing it to appear entirely cool. In certain areas sienna is painted with the green to make it appear warmer. Lastly, the trunks are painted with dark colors of the palette. The treetops are painted with short, supple strokes of orangy green.*

BROKEN COLORS

A *broken color* is an undefined and "greyish" color. A broken color is nothing more than a "dirtied" color. Colors dirty when two secondary colors are mixed together or a secondary color is mixed with a primary color. This chromatic range is somewhat ambiguous and can include both the cool and warm ranges of colors.

1. *A simple exercise to practice painting with broken colors: With a violet "broken" with green you obtain brown. We make a pale wash and paint the sky. Add some sienna to red and use it to paint the strip in the middle, leaving the areas destined for other colors unpainted. You then produce a broken green stained with ochre; it is diluted on the palette and painted over the foreground.*

▲

▼

Broken colors are obtained by mixing two secondary colors together. For instance, the combination of magenta and yellow produces orange. If a little green is added, you get a broken earth tone. Dark blue can also be broken by adding a touch of brown to the mix. Earth colors are ideal for obtaining broken ranges with watercolors.

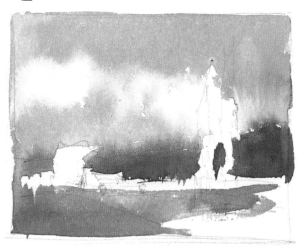

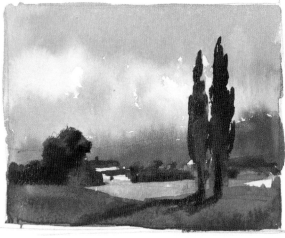

◄ *The top row of colors are those that create the color patches below. You can carry out this kind of test on the palette and on paper.*

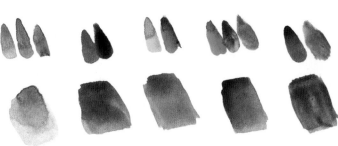

▼ 2. *Give the paint time to dry before painting over it, without blending the two layers together. On the palette, the same green used before is now mixed with a touch of blue and a little slightly darker green. If the result is too clean, add ochre in order to break the tone.*

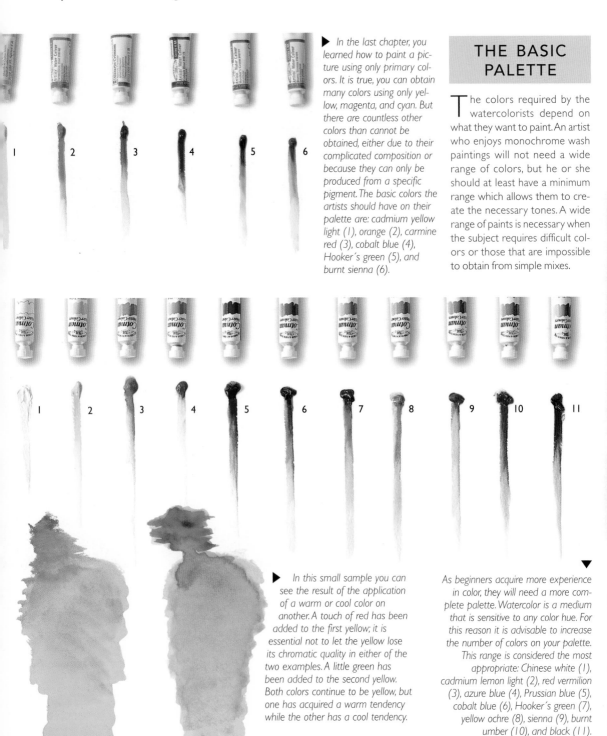

▶ In the last chapter, you learned how to paint a picture using only primary colors. It is true, you can obtain many colors using only yellow, magenta, and cyan. But there are countless other colors than cannot be obtained, either due to their complicated composition or because they can only be produced from a specific pigment. The basic colors the artists should have on their palette are: cadmium yellow light (1), orange (2), carmine red (3), cobalt blue (4), Hooker's green (5), and burnt sienna (6).

THE BASIC PALETTE

The colors required by the watercolorists depend on what they want to paint. An artist who enjoys monochrome wash paintings will not need a wide range of colors, but he or she should at least have a minimum range which allows them to create the necessary tones. A wide range of paints is necessary when the subject requires difficult colors or those that are impossible to obtain from simple mixes.

▶ In this small sample you can see the result of the application of a warm or cool color on another. A touch of red has been added to the first yellow; it is essential not to let the yellow lose its chromatic quality in either of the two examples. A little green has been added to the second yellow. Both colors continue to be yellow, but one has acquired a warm tendency while the other has a cool tendency.

As beginners acquire more experience in color, they will need a more complete palette. Watercolor is a medium that is sensitive to any color hue. For this reason it is advisable to increase the number of colors on your palette. This range is considered the most appropriate: Chinese white (1), cadmium lemon light (2), red vermilion (3), azure blue (4), Prussian blue (5), cobalt blue (6), Hooker's green (7), yellow ochre (8), sienna (9), burnt umber (10), and black (11).

Landscape in warm range

The ranges of colors do not necessarily have to conform to those of the subject. When artists choose a certain color range, they use it to interpret the subject with the chosen color. In this exercise you are going to paint a simple landscape with a range of warm colors. Don´t rule out the possibility of using cool colors, but if they are included, they must never be predominant.

MATERIALS

Watercolor paper (1), paints (2), watercolor brush (3), pencil (4), water container (5), adhesive tape (6), rag (7), a support (8).

1. *As you gain more experience in watercolor, you will see how important the preliminary drawing is and how, without it, the watercolor paints would lack any support and guide. This subject is sketched with a pencil, although you can also use charcoal for the task. The drawing must be precise enough while not including unnecessary details.*

2. *First paint the entire area of the sky with a gradation, a technique explained in the topic on wash. Wet the paper, making sure not to touch the tree; and then apply the brush loaded with an orangy ochre tone in the top part. With long sweeping strokes applied from side to side, extend the color over the wet zone. Once the background has dried, paint the mountains on the horizon with sienna. Once this area has dried, the entire length of the tree is painted with cadmium yellow.*

Colors from other ranges can be included within a specific range. This serves as a complement and contrasts with the colors applied.

3. *A touch of green is added to the yellow on the palette, and is mixed until a slightly darker tone is obtained. Cadmium yellow is an intense color, which belongs to the warm range of colors; by adding a dash of green, the tone can be altered enough to paint several uncontrasted shadows. With a very luminous green, paint the vegetation at the edge of the road. Although this is not the definitive color, it serves as a base over which other warm colors can be applied.*

4. *With a barely damp brush loaded with a touch of very transparent sienna, apply abrupt strokes in the darker part of the tree. Continue with this work until part of the yellow base is removed. Now with magenta, sienna, and a touch of blue, you obtain a very warm, violet tone which is used to paint the intermediate area. Since the underlying color is dry, the tones do not blend together. Now the green is almost entirely covered with this new warm, dark color.*

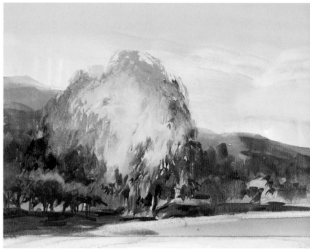

5. *A very transparent wash of sienna is applied and the white of the paper is tinted in all the lower part. This color nullifies any completely white brightness and will be the base for the other darker colors. With the violet which has just been used for the background, start to paint the shaded zone above the road. The color is the same as that used previously, but as the painted area is very bright, it does not seem so opaque. On the right-hand margin, orange is painted. This warm tone will be used as the background for the later darker colors.*

Drying of the watercolor can be speeded up with the help of a hand-held hair dryer. Do not place the tube so close that the drops of color run.

6. *With sienna mixed with umber, the darker contrasts are painted in and the umber tones in the landscape are increased. When the dark zones are painted, the highlights stand out more, due to the effect of the contrasts. The brushstrokes of the shadows lying underneath have to be wide and uniform. The brush drags the color horizontally. It must take a little bit of color with it every time it passes over this zone so that a gradation is not formed.*

7. *With a very bright orange somewhat tinted with umber, the painting of the top of the tree is continued. The new brushstrokes drag away part of the former sienna color and both are mixed on top of the paper. The trunks of the trees on the left are painted with sienna mixed with a little umber. The background should be completely dry so that the colors do not merge into one another. Observe how the color orange stays in the background. On the lower part of the road an ochre tone mixed with orange is painted. The most luminous strip is left unpainted.*

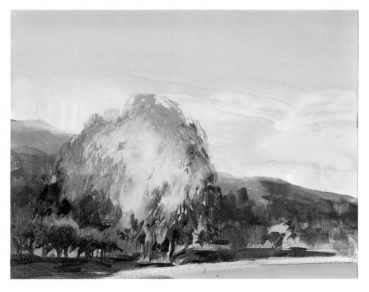

8. *It is necessary to wait for the painting to dry completely before applying the final touches. Once the background color is dry the right-hand side of the mountains are painted red, and on the left in a very* dark marine blue. In the foreground the contrasts of the color of the road are made stronger with a sienna wash. With very dark violet brushstrokes a few lines are added to the base of the shadow of the trees.

SUMMARY

Very **pure cadmium yellow** in the background as the base color to paint the tree.

Superimposition of **red** on the already dry background.

The color green with warm nuances. This color will be the base for later darker colors.

The sky has been painted with a very warm tonality in order to illuminate the whole landscape.

Blue has been used as a complementary color so as to compensate for the excess of warm colors.

A very luminous sienna wash is the brightest part of the road.

Wet on wet

THE IMPORTANCE OF PAPER AND WATER

The basis of watercolor painting is water. Water allows the paint to flow easily over the paper. In this topic you will focus upon precisely this characteristic, developing many of the artistic possibilities that this effect offers. Until now, when painting in watercolor, we have strenuously maintained that a brushstroke must be allowed to dry before applying another color or tone. In this topic, you will study the possibilities offered by applying or removing paint while the background is still wet.

▼ The paper is highly important when working in watercolor, whether the painting is on a wet or on a dry background. Watercolor paint is transparent and so insubstantial that the papers texture remains visible. To paint on a wet background a proper paper is needed that will not buckle or wrinkle easily. Here, a test of three types of paper is made, similar in quality but differing in degrees of grain. As you can see, the brushstrokes and the degree of wetness have responded in distinctive ways.

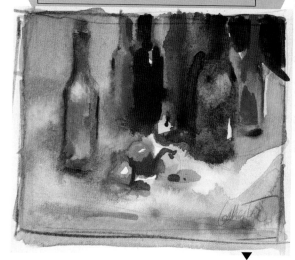

Watercolor on a wet background allows all manner of techniques. Colors blend together and extend. With practice, these effects can be controlled. In this exercise, some of these characteristics are observed. ▼

▶ For this exercise, any brush can be used. The brush is dipped in watercolor paint just as before. Remove excess paint on another piece of paper or a rag. Delicate brushstrokes are made to observe the tracks of the brush. Later, with this same technique, using hardly any color, paint a tree, starting with the foliage. When all of the paint is used, load some more, again removing the excess and drawing in the trunk. With the brush practically dry, sketch in the earth. Here the brushstroke dominates, since the background is now almost completely dry.

STRETCHING THE PAPER

Before beginning to paint with different watercolor techniques, it is helpful to learn how to stretch paper over a board. This will avoid the formation of pockets of colors, as well as assure that the wet paper does not buckle. Many artists use painter's tape or even thumb-tacks. The surest method of stretching paper is demonstrated here. The system is quite simple and practical, as you will shortly see.

2. *Paper warps easily when wet, since its fibers swell. Pockets of color are formed precisely in this way. Paper deforms in an irregular manner, which produces internal tensions and contractions that usually translate into buckling and wrinkling. To avoid the formation of awkward pockets, wet the entire paper surface with plenty of water, using the sponge to smooth the water over the paper.* ▲

▼ *1. To stretch paper, the only things needed are painter's tape, a drawing board, a sponge, water, and, of course, the paper. Any paper can be stretched in this way, but a certain thickness is recommended so that it doesn't rip during the process.*

Many artists attach the paper with thumb-tacks.

▼ *3. Wait for the paper to soak up the water. This will not take long; no more than one or two minutes. While the paper is still well, stick the four strips of painter's tape on each side of the paper so that it is fastened to the board. Wait until the paper is thoroughly dry before beginning to paint. It is not important if pockets form in the paper while it is wet. They will most certainly disappear when the paper dries, and its surface will be smooth and taut.*

▼ *4. Once the painting is complete, you must wait for it to dry again. Then, a ruler and utility knife can be used to cut it away from the drawing board. To remove the painter's tape from the board, you only have to wet it again.*

REMOVING COLOR FROM A WET SURFACE

Many effects are possible with watercolors. On a wet background, many changes and all types of techniques can be applied. In this exercise, you are going to develop a painting where the paint itself is not the main focus of the work, but instead the clear tones that can be made by absorbing colors with the brush. This exercise is very important for understanding the potential of gradations and as a base for opening up whites, which will be examined in Topic 7.

1. *The entire background is painted in a dark tone. It doesn't necessarily have to be a gradation. The brushstrokes are vertical, covering the whole background with a uniform tone. This exercise will be carried out on a wet, but not thoroughly soaked base. If it is too wet, you will have to wait a while until it dries a little. With a dry brush, we begin to remove some of the color. When the brush passes across the wet paper surface, the hairs absorb the paint.*

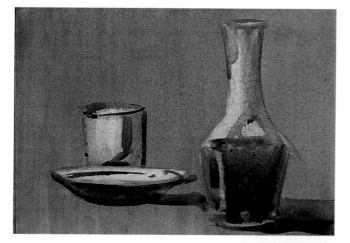

The quality of the paper has an important role in doing this example. A low-quality paper would be dyed by the color and would never allow the complete absorption of the color.

3. *In order to capture the brightest reflections, or, to put it another way, to obtain the whitest of whites possible, several passes with a clean and wrung-out brush must be made. For the final touches, the dark tones may be highlighted, but in this case the background must first be completely dry.*

▼ 2. *The pressure of the brush regulates the amount of color that is lifted off the paper. This is another way of creating gradations in tone over which another color can later be applied, or, as in this example, developing distinct planes. Each plane is an area of the painting. By drawing the brush over the paper, a sketch can be precisely drawn. The darker areas are established by accumulating some of the absorbed color at the edges of the brush.*

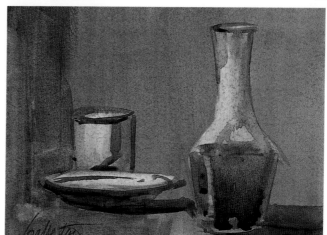

▶ 1. *A wet shading can run and expand in various ways. Watercolor paint is extremely sensitive to any alterations in the wetness of the surface. In order to paint this area, it isn't necessary to wet the paper beforehand, but it is important that it be painted in a continuous manner to avoid possible breaks between the brushstrokes.*

REDUCING THE WET COLOR

The colors that the watercolor painter must have will depend on the use to which he or she puts them. A person who enjoys painting monochromes will not need an extensive range of colors, just the minimum to allow the necessary tones to be displayed. An extensive range is necessary when the painting demands unusual colors or colors that are impossible to create with simple mixtures.

▶ 2. *Since the background is still wet, a clean and dry brush may be moved across the paper to remove some of the color. The paper must be quite wet, but not to the extent that the paint itself runs. The procedure to remove paint is as follows: first, with a dry brush, remove all of the color that one stroke can soak up. Then, wash the brush in clean water, squeeze it out, and repeat the process. The more often a brush is passed across an area of the paper, the more the wet background becomes like the white of the paper.*

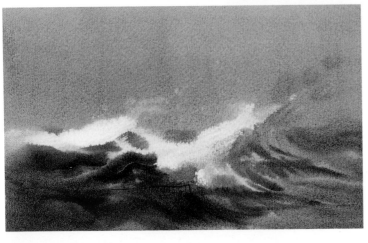

▶ 3. *Once the necessary whites have been opened up, contrasts can be added to define the forms. This exercise is very simple but can provide various options for the work we have seen in previous sessions.*

Landscapes. Opening up whites

In these first topics we have frequently emphasized doing landscapes, since the basic watercolor techniques practiced on this subject do not require as much precision, unlike still lifes or figure motifs. A landscape allows for a certain margin of error and subjectivity that, for other themes, would be too glaringly evident. This could, as a result, discourage the student-artist. In the following step by step process we are going to revise some of the ideas that you have studied before: the gradation and the opening up of whites.

MATERIALS

*Watercolor paper (1),
watercolors (2) and
palette (3), watercolor
brushes (4), pencil (5),
water jar (6), masking
tape (7), rag (8),
and support (9).*

1. *With a pencil, the principal areas of the landscape are drawn in, without sketching anything more than is strictly necessary. It must serve as the template for all the work to be performed in watercolor. The drawing must be plain, without shading or any other ornamentation; only the bare minimum so that you have a guide as to where the color is to be applied.*

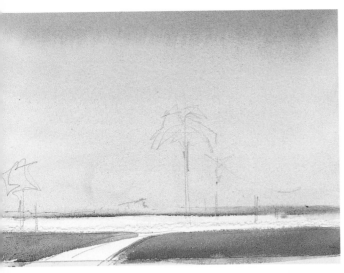

2. In previous topics, you learned how to make color gradations. In this exercise, you will make another gradation to define the zone that corresponds to the area of the sky. Let´s recap the procedure: first, we wet the area where you want the gradation. Before it dries, paint a wide horizontal band of blue along the top border of the paper. Since the background is still wet, the color tends to expand, and the brush helps this expansion along until the color is fused with the white of the paper. In the lower band of the sky, the process is repeated, only this time with a very light ochre color. Before this dries completely, a band of burnt sienna is added for the horizon line. When the lower area is dry, the objects on the ground can be painted without affecting the background.

> The paper must have the right weight and must be specifically for watercolor. Otherwise, the color will make a soggy patch on the paper surface and it will not be possible to paint.

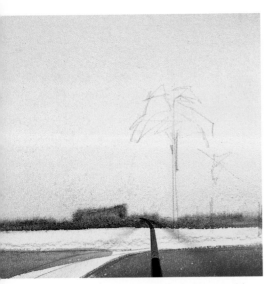

3. The umber color is mixed with some blue to paint the band of the horizon, and a simple profile of the buildings in the background is sketched. Since the paper is still wet, this building will lightly blend with the recently painted horizon.

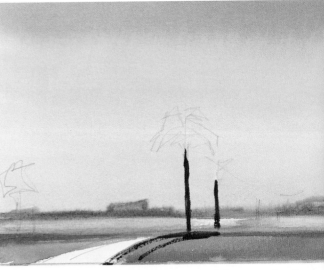

4. Colors that are painted in watercolor must follow an order; the lighter tones and colors are always painted first, and over these are painted the darker and more opaque colors. Watercolors can dry quickly if a hair dryer is at hand while they are applied. In this way a new color can be painted rapidly over a previously applied layer without blending or mixing the two. For the band of color that corresponds to the sea, a bright blue is applied. The areas of reflection are established by soaking up color from the paper with a dry brush, just as we did before. After this new background dries, a dark brown is painted to create the tree trunks.

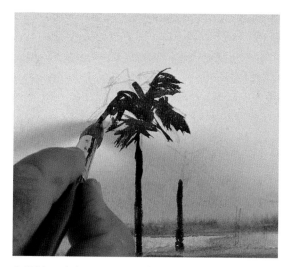

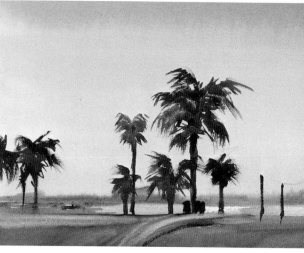

5. *With a dark green, paint the leaves of the palm trees. Just a touch of paint is used, and work only with the tip of the brush, so that the lines can be precisely traced. It is fundamental that the drying time be respected when pure colors are painted, to ensure that they don't mix with the colors on the paper. In this example, the difference between the work performed on a wet surface (the sky) and that done over the now dry background can be perceived.*

6. *All of the treetops are now painted in the same way, including those to the left, which are painted before the tree trunks. This is done to take advantage of the color mixture. It doesn't matter if the trunks are painted later, since the sketch is still visible and the pencil lines provide us with a guide. In the area to the left, a small correction has been made over the still fresh background. The dark color has been absorbed by the brush and then repainted in an earth tone. The rest of the ground has been completed in similar tones. Now the dark bands of the railing and bench are added.*

> Watercolor paint can be removed from the paper with a clean brush. Wherever the brush touches the background, the wet paint is absorbed.

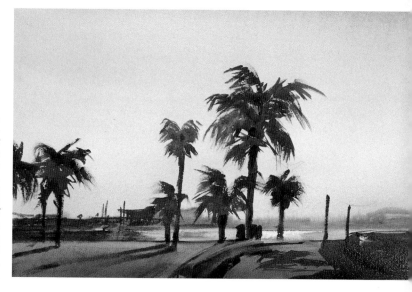

7. *Before painting the palm-tree trunks, paint the greenish tones of the sea. A dark blue is applied for a contrast with the area of the water in shadow. The long shadows of the palms are painted with a dark burnt sienna. The same color is applied to the right of the painting, slightly mixed with blue to establish the clarity of this new form. Run a dry brush across the form to remove some of the color, just as you did before, but without opening up the paper's white. Finally, paint the red of the railing.*

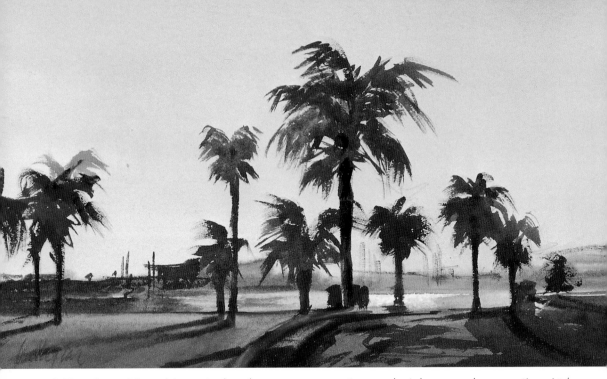

8. *The only remaining task is to paint the palm trees with dark green mixed with burnt umber. Some palms are left bright while others are darkened. As you finish this simple exercise, you can see how you put into* *practice some basic lessons, such as correcting mistakes, working on a wet background and painting on a dry background; three techniques that we will develop in greater detail later on.*

SUMMARY

A gradation made on a wet surface. It is important to work with the support upright.

A lighter tone created by dragging the brush across the paper while the color was wet.

A correction with help from a clean and slightly damp brush. The mistakenly applied color was removed.

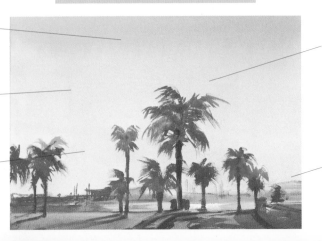

Superimposing of one color over another when the background was completely dry. In this way the treetops of the palms were not blended into the background.

The tone was lightened in the shadow to the right without actually removing so much paint so as to see the white of the paper.

5

Watercolor on dry

THE GRAIN OF THE PAPER
AND THE BRUSHSTROKE

Just as with the previous technique, the brushstrokes and the grain of the paper are of great importance. To practice this technique it is necessary to have a good knowledge of the absorption qualities of the different papers, in order to select the type of paper best suited.

Here we will continue to treat one of the principal techniques of watercolor painting. Up until now, you have seen how watercolor paint blends with other paints already on the paper if they are still wet, and how to avoid this effect, you must wait until the previous layer is dry. Painting on dry has many more options than those already discussed, and in this topic you will study some of them.

▶ To carry out this exercise correctly, it is helpful to make up a set of different types of paper. It isn't necessary to use large pieces of paper; a small piece big enough for a single brushstroke is all that is required. The purpose of this exercise is to discover the appropriate paper for watercolor. There are many different types of paper on the market, but not all are equally recommended. The pieces of paper are placed in rows. You have already written on the back of each piece its trademark, weight and grain. The pieces of paper are joined together with painter's tape.

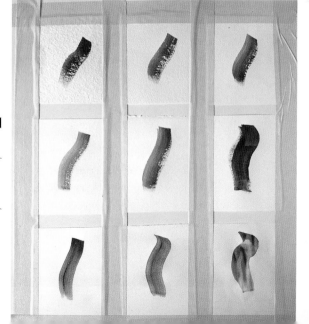

◀ A wash of any color is made, preferably an intense, bright color to contrast with the paper's whiteness. The most difficult aspect of this test is to capture the same amount of paint on the brush for each stroke. You should try to make each brushstroke identical to the one before. After they are dry you will be able to see which type of paper best accepts the color (not all paper has the same degree of whiteness). You will also be able to ascertain which papers are not appropriate for watercolor painting (some allow paint to flood the paper and other papers inordinately wrinkle and buckle). The brushstroke is executed on a dry surface; in this way the degree of absorption can be noted.

BASIC TECHNIQUES. SUPERIMPOSITION OF COLORS

One technique available to the watercolor painter is the ability to superimpose one color or tone over another. In watercolor painting, when two equal tones overlap, the overlapping area is darker. This can have many positive applications, such as changing a color or producing an illuminating effect.

Whenever two colors are superimposed, the intersection gives rise to a third color.

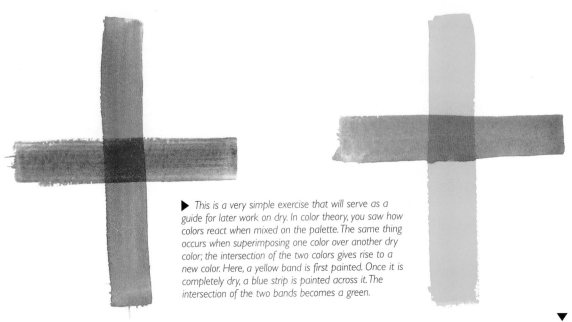

▶ This is a very simple exercise that will serve as a guide for later work on dry. In color theory, you saw how colors react when mixed on the palette. The same thing occurs when superimposing one color over another dry color; the intersection of the two colors gives rise to a new color. Here, a yellow band is first painted. Once it is completely dry, a blue strip is painted across it. The intersection of the two bands becomes a green.

▼

The following example is the same as the previous one, although we have varied the colors. The vertical strip is a magenta. Once dried, a horizontal band of blue is painted. The resulting intersection is the color purple.

▶ This example is very simple; it can be carried out on any sketch or, in this case, over a painting made especially for this demonstration. We have painted a landscape with a large sky and allowed it to dry completely. Meanwhile, we have prepared a transparent wash of the color ochre. With this tone half of the landscape is painted. You shouldn't make repeated passes over the background: you don't want the background to dissolve and mix with the wash! The achieved effect is quite interesting; you have added a curious illumination to the atmosphere which affects all of the lighter tones.

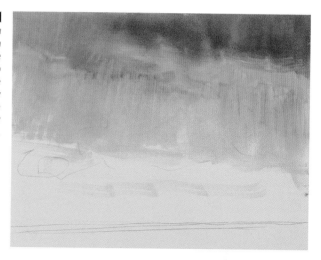

1. To perform this exercise with Chinese white, choose a cream-colored paper. It isn't usual to use colored paper in watercolor painting, although there are times when it can be quite useful for painting certain subjects. First, you want to test the way in which the color of the paper will affect the transparency of the watercolor. Apply a transparent gray wash over the paper and let it dry. Another wash of the same color, but much darker, is added over this. Note how the color of the paper affects the lighter tone much more.

RESERVES AND CHINESE WHITE

Watercolor paint is very transparent, so much so that any underlying color will alter its tone. The use of Chinese white is one way to decrease the transparency of watercolor paint. Chinese white is a very dense watercolor that, when mixed with other watercolors, serves to make them more opaque and pastel-like. A reserve is a section of a painting left open and unpainted, so that a dark color is isolated from a lighter color; it will be left white if the paper is white. The use of Chinese white bears no relationship to a reserve. Chinese white allows light tones to be painted even if the paper itself is colored.

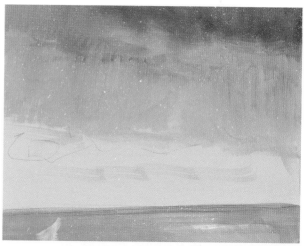

2. Observe the difference that the darker gray tone acquires when it is mixed with Chinese white. Some brushstrokes of Chinese white are painted to test its opacity on the colored paper. In the lower area of the paper a triangular form is painted. Here you can see that the paint is not completely opaque since the color beneath can still be discerned. Several dabs of Chinese white are applied with the brush. In the darker area the white points are more evident.

3. Some dark blue is placed on the palette alongside some Chinese white. First, with pure dark blue paint some trees, as can be seen in this image. The brightest, or most illuminated areas of the treetops are painted with the same color, although more watered down. To paint the bottom area the blue is mixed with some of the Chinese white until the mixture acquires the desired tone. With this somewhat lighter color the ground is painted. To finish, dab some Chinese white over the painting again.

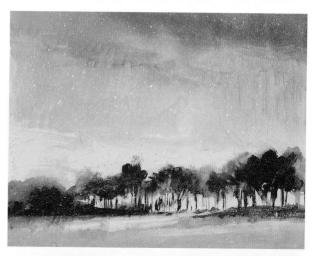

▶ **1.** *The upper area of the painting is painted with an orange tone down to the foot of the mountains. The rest is left white. When this is dry, a violet tone is used to paint the mountains. If any part of the background area is not dry, the two colors will run. A medium sized brush is moistened with this violet tone mixed with sienna, squeezing out the excess color, and horizontal strokes are painted over the white foreground.*

DETAILS WITH A DRY BRUSH AND TEXTURES

V arious effects can be achieved with a dry brush. A dry brushstroke on a dry background brings out the grain of the paper and can create an interplay with previously applied coats of paint. A dry brush can be used to paint over a white surface or one previously tinted with a wash.

▶ **2.** *A very dark green is used to begin filling in the lower part of the painting. When applying this color, there is no need to make the brushstrokes regular. When the color in the brush is used up, pass the brush over the upper part of the painting to bring out the relief of the paper before reloading the brush with more paint. Once the mountains are dry a new layer of the same color is superimposed. The addition of the second coat makes the mountains darker.*

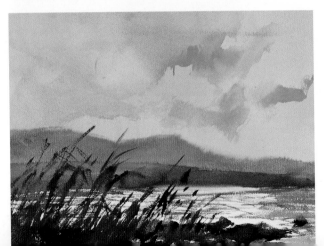

▶ **3.** *On the right, a dark gray is painted with strokes that leave small areas unpainted suggesting reflections. When the background is completely dry, a trace of greenish ochre is painted below the mountains. The brushstroke is continued until the paint runs out. Finally, when all the paint is dry, the tall grass in the foreground is added. Soft, flowing brushstrokes are made at an inclined angle to trace the stalks. The brush should not be too loaded with paint to allow broken brushstrokes.*

Step by step

Landscape with tree

The technique of using a dry brush is one of the most interesting ones that can be performed with watercolor. Naturally, it isn't something to be used at all times, since some areas of a painting will inevitably demand techniques involving blending colors or creating gradations. The exercise that follows is a landscape with a large tree in the foreground. This subject is sufficiently rich in shades and textures to allow it to perfectly demonstrate the technique of using a dry brush.

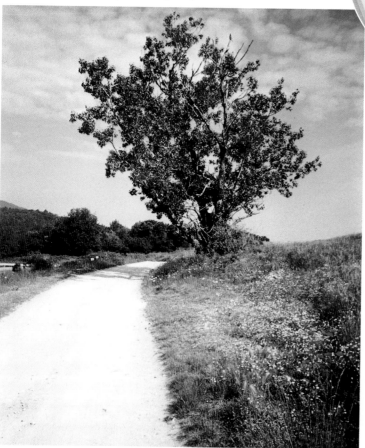

MATERIALS

Watercolor paper (1), watercolors (2), a palette or a plate (3), watercolor brushes (4), pencil (5), water jar (6), masking tape, (7) rag (8), and a support (9).

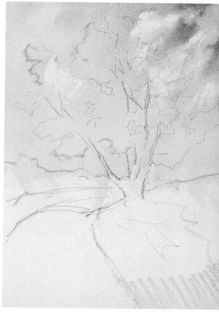

1. The main outlines of the landscape are sketched in with varying degrees of precision. The area corresponding to the road is minimally but clearly outlined. Care is needed to draw the curve that differentiates the road from the earth and its vegetation. The tree trunk is precisely sketched and its most relevant branches are clearly shown. The area that corresponds to the higher branches is barely sketched at all to allow a free hand with the dry brush. Begin by painting the background sky with smudged blue, graduating toward white to suggest clouds.

STEP BY STEP: Landscape with tree

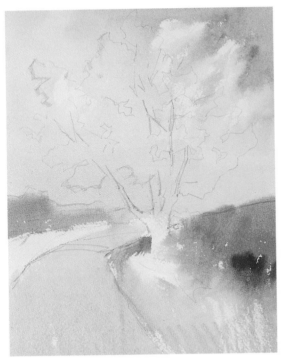

2. *A very light, ochre-colored wash is applied over a completely dry background in the area of the road. The colors are painted in areas separated by blank sections in order to prevent the colors from mixing. In this way, the lighter colors don't run into other, darker tones. Along the borders of the road, separated by a central patch for the dry areas, the green foliage of the vegetation is painted. On the right of the painting a touch of sienna is also added, which mixes with the green.*

> The white area directly below the tree must be respected throughout the development of the painting. It will later be treated with a dry brush to create a bright reflection.

3. *The entire background is slightly darkened with a light green, including the trees in the distance on the left and the area of foliage on the right. Using a very dry brush and a yellowish green mixed with ochre, paint the area on the right of the road. The brushstrokes are long and follow the curve of the road. In the nearest foreground of vegetation, over a completely dry base, an olive tone is added. The brushstrokes here are slanted. They are not as long or as broken as those executed in the previous exercise.*

4. *At this stage, the tones of the background are strengthened. Some areas have dried completely, others are still half wet, but none of them should be so completely wet that the color and brushstrokes are uncontrollable. In the distant trees to the left the area is finished by applying dark greens among the lighter greens. To the right, a dark green has been added, delineating the tree trunk; here the background is completely dry. In the road, a long brushstroke following its curve is made, darkening its tone with a luminous wash of ochre and orange tones. Attention must be paid to the brushstrokes that define the treetop: they are short, dense and always painted on a dry background.*

5. *Advantage is taken of the paper's texture in the area of the vegetation by using a very dry brush lightly loaded with green paint. Small brushstrokes of bright red on top of the green earth color are added to paint the poppies, some of which are allowed to run and mix with the background. With a watery mix of sienna and violet, paint the shadow of the tree on the ground. In order to properly create this shadow the background must be completely dry.*

> The background must be thoroughly dry and the brushstrokes must not deposit too much paint in order to allow the texture of the paper to be seen.

6. *Run a clean wet brush across the green area on the right to blend and soften the excessively dry brushstrokes, in order to develop this area in greater detail later. To blend the colors, the red used for the poppies is mixed with green, which creates a brown color appropriate for the earth tones of wild vegetation. A clean and moist brush is repeatedly passed across the background greenery to the right until the tone lightens. The treetop continues to be worked on with the same brushstrokes used before. So that the tones do not run together, this area must be left to dry before adding new layers.*

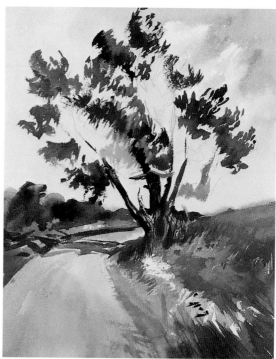

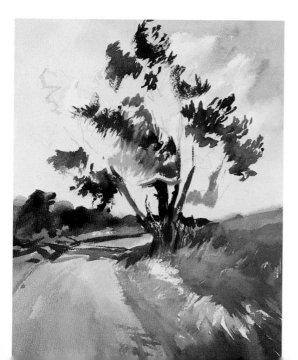

7. *Continue to work on the tree's foliage until it acquires the desired form. The green tones run from dark to light green, and include tones that are very dense and almost blue. A rusty green is painted over the completely dry green of the terrain. Under the tree, using short brushstrokes that define the ground to the left, a shadow is added that contrasts with the edge of the road. In the area to the right a tone is used that allows the underlying tones to show through.*

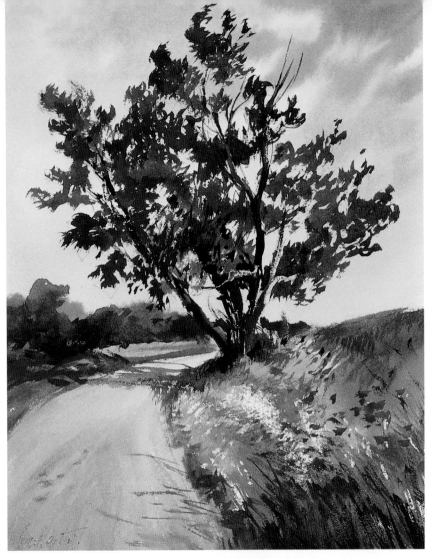

8. *The work that remains is to develop the contrasts of the countryside. The treetop is finished with a succession of short and dark brushstrokes that are superimposed on the underlying tones. The finest branches are drawn in, as is the grass in the foreground. Small hints of color are added to the road with a very light and transparent sienna color. And so this beautiful landscape, where we were able to develop the dry brush technique, is finished.*

SUMMARY

The foliage is painted on a completely dry background. Wait for the color to dry each time you intend to add another color.

This white zone is maintained as a reserve from the beginning of the painting. It is the brightest and most reflective area of the ground.

The texture of the paper is put into relief by an almost dry brush, which allows the underlying colors to show through.

The background of the sky is painted on dry, but the blending of the tones is created with a gradation of color that finishes off as the white of the paper.

The red, superimposed on the green in this area, is mixed, giving rise to an appropriate brownish earth tone.

The grass in the foreground is painted in the last stage. The brush must carry just the right amount of paint to establish the desired texture.

The combination of wet and dry techniques

THE WET BACKGROUND

The wet background allows effects of ambience, vague shadows, merging areas, gradations, and the merging and blending of colors to be realised. The extent to which an added color will spread depends upon the degree of wetness of the background. Controlling this enables the painter to work with great precision in the area where the color is being applied. The wetness is controlled with absorbent paper, with a sponge, a dry brush or by the natural evaporation of the water.

It is difficult to use just the technique of painting on a wet background or just the technique of painting on a dry background in any given painting. Usually, both are used simultaneously to achieve the desired effects of each, capturing the fusion of tones on the one hand and the precision of a dry brushstroke on the other. The only problem posed, is that these two techniques demand completely different drying times between applications. If the base is wet, the newly applied paint will spread and merge. If the base is solid, the brushstrokes will appear definite and precise.

▶ 1. The base is completely wetted with a sponge or brush after attaching the paper with some painter's tape to avoid swelling and wrinkling. With the paper upright and quite wet, paint a horizontal brushstroke along the upper border. (We have done all of this before, but it is important to insist on learning how to control a wash in order to understand the basic watercolor techniques). Assisted by the paper's wetness and by the brush, the color gradates toward white.

2. It is necessary to wait for the paper to dry a little. If we paint while the paper is still soaking wet the same thing will happen as in the initial gradation; the color will expand out completely. While the background is still wet, but not soaked, a darker blue is added. We can see that with a dryer base, the form of the brushstroke can be controlled much better, although the paint still swells and blends into the background around the borders of the stain.

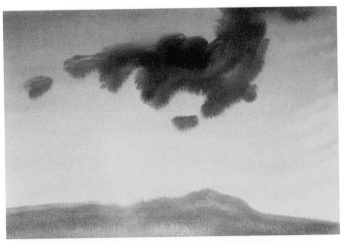

▶ **1.** *In the same way as for the first coat, now almost dry, a new one is added, this time along the bottom edge. There is no reason for this to be identical to the first; this is nothing more than an exercise on drying times for various layers of paint. Up till now you have painted three different areas on the paper, each one with a specific drying time. Controlling the flow of the paint on the paper improves as the paper dries.*

DRYING TIME FOR EACH COAT

To observe the drying times for each coat of paint, continue the same exercise. In this way you will have a reference point close at hand involving the two methods that form part of this exercise. The work on wet is performed while the paint is drying, until the point comes where the work is executed on dry.

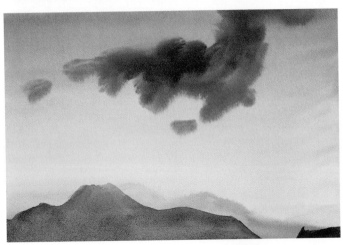

▶ **2.** *The stain in the background can be varied while it is wet, even to the point of making it a gradation. Once the background mountains are dry, paint the second ridge of mountains with more definition, using a darker tone. Note that its borders are perfectly delineated and they don't blend into the mountains in the background. It is important to remember that you can't paint light tones over dark tones with watercolor paints. It must always be the other way around.*

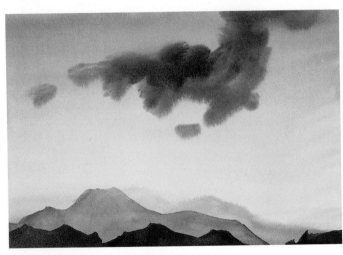

▶ **3.** *Finally, to finish the study of different drying times, paint yet another overlapping ridge of mountains in the foreground. As you can see, with practice the exact definition of their form can be created but only if the background is completely dry.*

1. *The paper's color is white, which is the lightest possible tone. The whiteness can be modified by painting a uniform application, as here, where we have painted a very light ochre tone. Even though the paper has been painted completely, the transparency of the watercolor still allows the brightness of the white background to been seen through the paint, which is to say the ochre color is not opaque.*

LETTING THE BACKGROUND SHOW THROUGH

The color of the paper is the lightest tone of a watercolor painting. If it is white, the reflections will be white. If, on the other hand, the light tones are of another color, the reflections will be this chosen color. In this practical exercise you will be able to see how the background color acts and offsets the work as a whole. The brightest tones have to remain visible through the darker and denser tones.

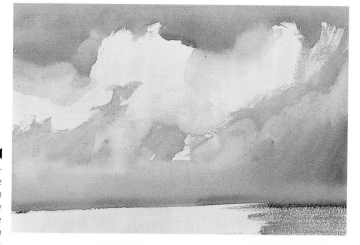

2. *The background color is left to dry almost completely. Begin to paint in the dark parts of the clouds with some sienna and outline their form. In some areas the color blends with parts of the background that had not yet totally dried. In the lower area we have made use of the dry brush technique to paint in the reflections on the water. The brush hardly retains any paint, and as it is passed over the surface, the grain of the paper's texture becomes evident. This is called letting the background show through.*

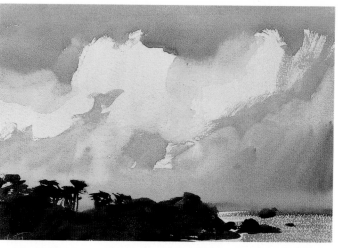

3. *We now have to let the background dry completely, since we don't want the tones to mix. With a very dark, burnt umber, paint this perfectly defined area of back lighting. Since the background is completely dry, the tones do not run and blend. At the same time, within this shading, some of the color is absorbed, lightening up the tone without losing the color's freshness.*

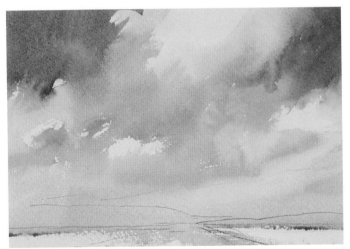

▶ I. *The background is begun with a watery cobalt blue. The form of the clouds are outlined, leaving them perfectly etched out in the sky, as now the background is completely dry. In the area below we have used a tone that is much more transparent and bright. Just before the blue background dries completely, a transparent wash of black and yellow is prepared. Using this tone, create the dark areas of the clouds. In the areas where the two tones are in contact, they blend. In contrast, the white of the paper is dry, and is isolated so that no color seeps in.*

COMBINATION OF TECHNIQUES

Once you control different drying times, it is possible to combine both techniques. With practice, this combination will yield astonishing results that are much more simple to create than would appear on first impression. The effect of a blend on wet can be applied next to the effect of a painting on dry to demonstrate the depth of a landscape, textures on objects, volume, etc.

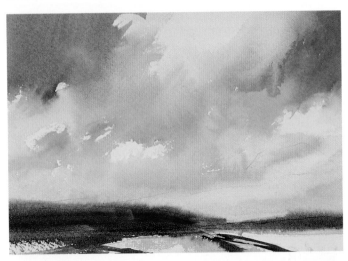

▶ 2. *We paint the area of the horizon with a very dark blue while the background is still wet. This will blend with part of the bluish color of the sky. The area below the horizon is painted with dark gray. These brushstrokes are supple and precise. They do not run or blend since the background is now totally dry.*

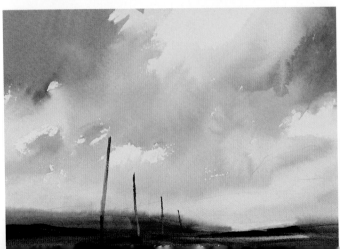

▶ 3. *We wait for the entire painting to dry. Now we can paint in detail the areas of contrast. The dry brushstrokes allow the background to be partially visible; the white color of the paper remains visible through the textured tones left by the brushstrokes, or left as reserves.*

Step by step
Figs and apples

The exercise that will now be presented is a straightforward still life comprised of two simple elements: apples and figs. Fruit is much easier to paint than symmetrical elements like a plate or a bottle, for no margin of error is allowed with these. In contrast, fruit permits a certain amount of licence when deciding their shape: it does not have to be completely homogenous. In this exercise the two principal techniques of watercolor are going to be put into practice: the necessary techniques to be able to develop any subject. Of course, in this example the difficulties have been moderated so that the enthusiast can easily take in the techniques of painting on dry or on wet.

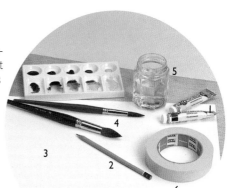

MATERIALS

*Tube colors (1),
pencil (2), medium
grain paper (3),
watercolor brushes (4),
water jar (5),
tape (6),
and support (7).*

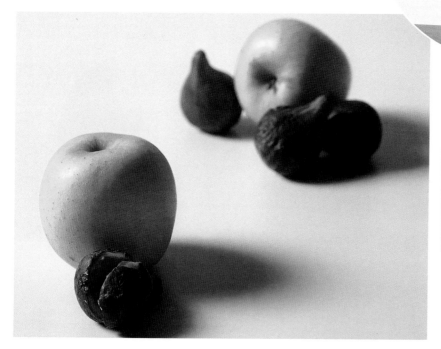

1. *The drawing of this still life is very simple: it is based on a shape as elementary as a circle. The most complicated part of the still life is the composition of the elements on the paper. The drawing is done in a very basic way: only the outlines of the fruit are laid down. Very fine lines mark the shadows on the table.*

STEP BY STEP: Figs and apples

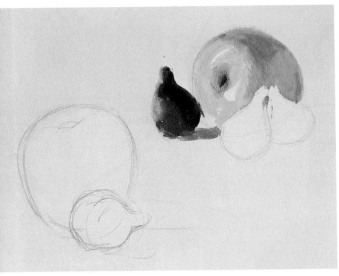

2. *Start painting the apple in the background. All its surface is painted in bright yellow, leaving the highlights unpainted. The color is darkened a little on the palette with some green and the shading is painted. This color melts into the last one because the latter is still wet. The darkest part of the shadow is painted in a subtle tone of sienna. The brush is cleaned and then dragged over the right side, removing some of the fresh color. The shadow of the fig is painted with very dark carmine, which is gradated in the illuminated area.*

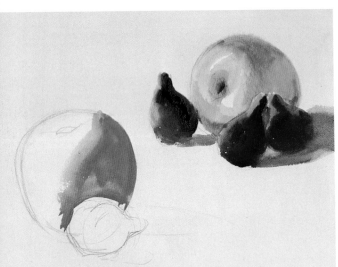

4. *The shadow area of the apple in the foreground is started in a greenish yellow. The brushstrokes outline the shape of the fig but the color does not penetrate into the latter because the background is completely dry.*

3. *The figs on the right are painted in violet tones, bluer than on the left. First, the lightest tone is painted and on top of this the dark parts of the shadows. As the background is still wet from the last colors put down, these mix directly on the wet paper. The violet is watered until it is very transparent and the result is used for the shadow cast by the fruits at the back. Wait until the paint of the figs has sufficiently dried or, in spite or this new coat of paint, their shapes will dissolve into the newly applied paint.*

When it is laborious to open up a clear space on top of a dry color a few drops of bleach can be added to the water. The white which is then opened up will be perfect.

5. The luminous zone of the apple is painted with a very clean golden yellow, although the highlight is left white in this area. In the upper part of the shadow a dark area is painted with burnt umber and it is melted into the rest of the color insisting with the brush. When painting this shadow area, you must be very careful not to touch the yellow zone: this must be kept clean. With a very dark pure carmine paint the opening of the mature fig. Using the dirty water for brush cleaning, put down a very transparent layer on all the background. Do this only when all the previous colors are completely dry.

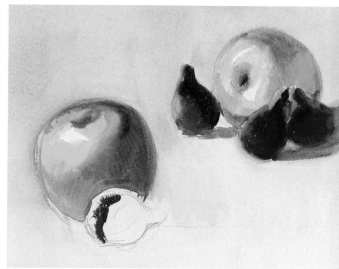

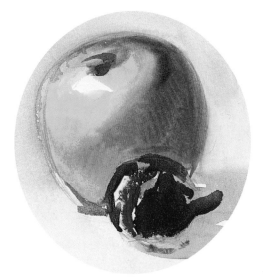

6. Once all the background is dry, the fig in the foreground is painted with a very luminous ultramarine. The highlight zones are left white. With this same color the shadow of the fruit in the foreground on the table is also painted. On top of the luminous color of the fig, once it is almost completely dry, shade in a darker stripe, even though this leaves a lighter stretch on both sides of the cut.

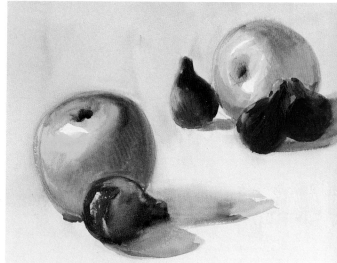

7. Repeatedly pass a clean and wet brush over the upper part of the fig to open up a clear area. Before this area dries out, paint in an orange color that will quickly merge into the violet of the previous layer. The darker tones are obtained with a violet made by mixing dark carmine and cobalt blue. A little ultramarine can also be added. While the color is still moist, take some of it off with repeated brushstrokes. If the color has dried completely, it is still possible to open up the paper's white but you need to persist a lot more with the brush.

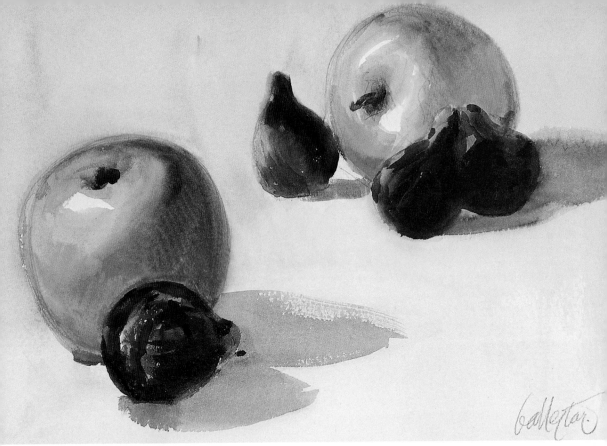

8. *Once the excess humidity is dry, paint in the most intense contrasts on the just painted fig. Using the almost dry brush, repaint the shadow on the table trying to ensure that the brush leaves its track. It is only possible to achieve this texture when the back-ground is completely dry. With this the exercise is finished: you have practiced the two principal techniques of the watercolor. It is not difficult to do, provided that the drying time of each zone that is being painted is always respected.*

SUMMARY

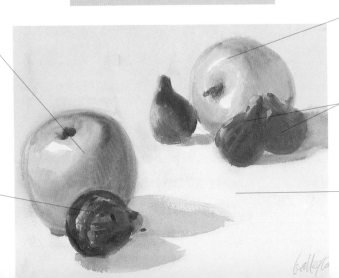

When painting the apple in the foreground the dark color blends into the most luminous one. This is because the second zone has been painted while the first was still wet.

In the fig on the left the dark parts are painted once the first base color has dried.

The first color painted is the one of the apple in the background. All the other colors used on it are done while the yellow background is still moist.

The figs next to the apple in the background are not painted until the latter is completely dry.

In the background an almost transparent layer is painted. The colors do not mix because you have waited for everything to be dry before painting it.

Opening up whites

WHITES TO BE OPENED UP

In watercolour painting, opening means to restore to the paper the light that the color has taken away. There are different techniques to open up the white in watercolors. All of them have the same aim: take away color from the paper. Color can be removed in a number of different ways to achieve a variety of effects. On this page some very quick and simple exercises are shown. They will teach you how to resolve different problems that can occur when opening up whites in more complicated exercises.

On more than one occasion a beginner will hear someone saying that a watercolor cannot be corrected. This is not entirely true; in fact, the technical richness of this medium is such that one of the most interesting techniques that it has is precisely the opening up of white spaces. The clear or white spaces opened up in watercolors can be used for several reasons: to simply correct an area which has turned out badly, right through to the elaboration of all types of technical effects or textures.

▶ 1. A square area is painted in any color. This exercise is done while the color is still wet. A dry sponge is used in the same way as cotton wool and is pressed against the middle of the colored area. When the sponge is removed you can see how it has absorbed a part of the fresh color and has left the impression of its texture on the paper.

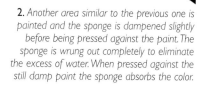

2. Another area similar to the previous one is painted and the sponge is dampened slightly before being pressed against the paint. The sponge is wrung out completely to eliminate the excess of water. When pressed against the still damp paint the sponge absorbs the color.

▶ 3. A third similar area is painted and once again the sponge is dampened and the excess water is squeezed out. The damp sponge is passed over the still wet surface, pressing and dragging at the same time. The result is more whiteness than that obtained by simply pressing.

4. The final test is done with a brush. A square area is painted and while it is still wet the brush is passed over it repeatedly. After every stroke, it is washed and blotted. The result is an opening up of white much more controlled than those obtained with the sponge.

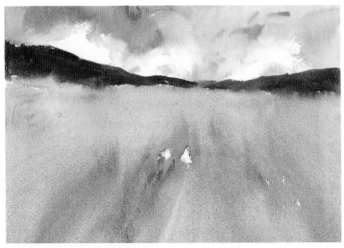

▶ I. *The upper part is painted with a very gestural, expressive, brushstroke in a blue wash mixed with a little burnt umber to create the dark tones of the sky; some parts are left unpainted and remain completely white. Once the sky is completely dry, the mountains in the background are painted with burnt umber mixed with blue. Once the mountains are dry, an overall wash of all the ground area is carried out: it is painted ochre. On top of this, while it is still wet, brushstrokes of sienna are added. The brushstrokes are long and indicate the perspective of the earth.*

CLEANING UP A WET AREA

While dealing with previous subjects different ways of opening up whites have been carried out as, for example, in doing skies, but this option is much richer in possibilities. The white of the paper is much more responsive while the color is damp: it gives up more color. When a white space is opened up in a damp color, it is unlikely that the white of the paper returns to its original splendour, unless the paper is top quality. The whiteness of the space depends on the quality of the paper. A first-class paper allows white spaces to be opened up in all the scale of tones, even going as far as the perfect white.

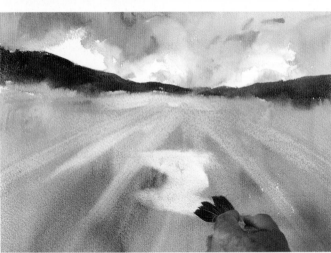

▶ 2. *While the earth is still wet, different whites can be opened up with the aid of a clean and dry brush. First of all, the brush is run across the center of the horizon and long lines are opened up that indicate the perspective of the landscape. As the paper is still wet and as the brush is not used insistently, the whites opened up are not as pure as that of the paper. A much bigger white space is opened up exactly in the middle of the terrain. This area is made much whiter than the other spaces. To achieve a cleaner white the brush has to be passed over numerous times, washing it out and blotting it for each stroke.*

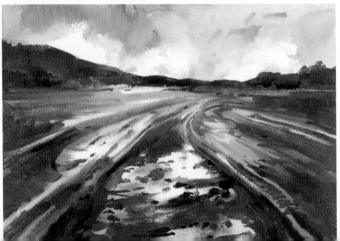

▶ 3. *It is not necessary to obtain such a fine finish; this is simply a practical exercise to show the opening up of former white spaces. Once the earth wash has dried out almost completely, the darker tones can be painted: they allow the whites and other tones to be more clearly made out.*

▶ **1.** Paint the trunk of the tree with a very dark burnt umber. The density of the colors in tubes permits darker tones to be obtained than with colors in tablets. As can be seen, almost all of the brightness of the paper has been blocked out. This shape is not difficult to do, especially as it needs not be identical to that in the picture. To continue practicing, it is necessary to let the color dry completely; this can be speeded up by using a blow-dryer.

2. Once the paint is completely dry, take a round, quite thick brush, wet it and drain it to get rid of the excess water, and start doing vertical brushstrokes over the dry color. After several brushstrokes the dry paint begins to soften up and impregnates the brush. When the brush starts to fill up, it is washed and rinsed before repeating the opening up of white spaces. The more you insist with the brush over a certain area, the whiter the result will be.

CLEANING UP A DRY AREA

On more than one occasion the watercolorist will observe that in an area which the artist considered to be finished, it becomes necessary to open up a white or clear space which has a tone similar to that of the paper. In the same way that it is possible to soften the dry color in palette, it is possible to do the same on the paper. The two techniques that are explained on this page, and the next, will be fundamental in order to master the numerous technical effects explained throughout the rest of the lessons.

▶ **3.** Some lines are left very white, others are hardly suggested. Thus the aim is to become sensitive to the touch of the wet brush on the dry paint. In later chapters this technique will be used again to elaborate very varied textures.

Topic 7: Opening up whites

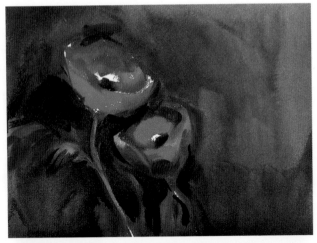

▶ 1. *This exercise can seem extensive, but it never fails to follow it in practice. You can learn how to open up clear or white spaces in a particular way. Doing this type of exercise will in the future permit the student to correct compositions which contain mistakes, or even to add new elements in complicated or very dark areas. First, the flowers have been painted red; the elaboration is very simple. Then the stems, and, finally, a very dark blue background have all been added. Before doing this, the painting must dry completely.*

REDOING ELEMENTS

It is possible that after painting a picture, once it is completely dry, one finds that it is necessary to paint an additional element. If the background or the elements of the picture are very bright there is no great problem because it is always possible to paint a dark color on a lighter one. However, if it is the other way round and the background is dark, it is necessary to clean the area and to lighten it before painting in the brighter color.

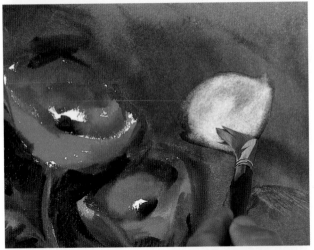

▶ 2. *In the same way that on the last page vertical lines were opened up to draw the whites out of the bark of the tree, here a wet flat brush is used to soften and clean the shape of a new flower. This time it is crucial to be insistent with the clean and dry brush, as now you are aiming at as bright a white as possible. It is in this kind of work that the quality of the paper takes on an important role: a good quality paper permits a neat piece of work, while it is possible that one of low quality cannot be cleaned adequately.*

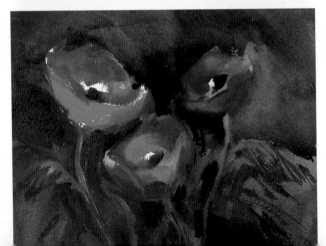

▶ 3. *When the background around the flower has been completely cleaned, it can be painted with the necessary colors. The colors can be bright in relation with the white that has been obtained from the paper.*

Step by step
A white vase

White is one of the most important colors in watercolor technique. Although it is usually present in every watercolor, this color does not exist physically as a paint. White in watercolor is the paper. The watercolorist, when painting eliminates with the color part of the brightness of the paper. In this exercise we are going to practice with the white color of the background, marking it off with very dark colors. Moreover, we will study various aspects throughout the lesson, such as how to reopen clear tones by absorbing the color.

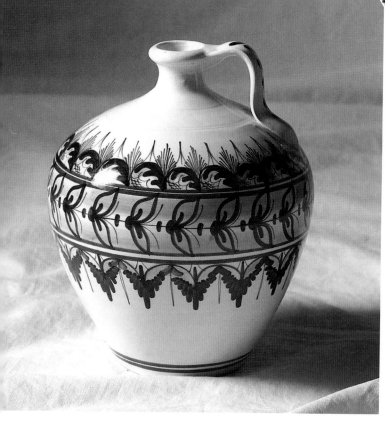

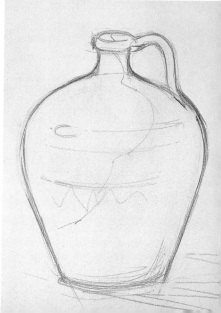

1. Before starting to paint, it is important to establish clearly which areas will be occupied by the highlights. The sketch of the vase will visibly separate its outline from the background. In this exercise it is important that the dark areas are markedly distinguished in the drawing, for it is the dark tones that will contrast with the lighter tones and colors.

249

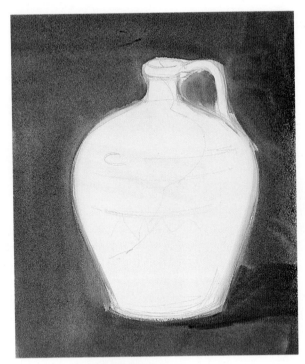

2. The background is painted with dark sienna, burnt umber, and blue wash. The shape of the vase is perfectly delineated by the dark color. Now it seems as if the area of the vase is painted white. When the background is painted, take care with the profile of the drawing so as not to penetrate the area reserved for clear colors.

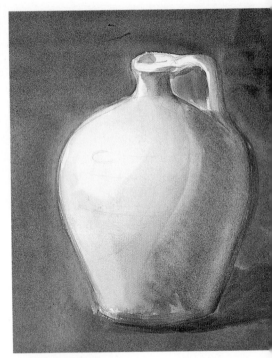

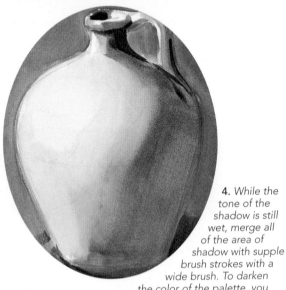

4. While the tone of the shadow is still wet, merge all of the area of shadow with supple brush strokes with a wide brush. To darken the color of the palette, you need only add a little more color. To get the grey tones of the vase a mixture of blue and burnt umber can be used. A good merge between the color and the white can be achieved with a brush dampened in water: this takes prominence away from the contours of the shadow.

3. Once the background is dry, the interior of the vase is painted with a very clear wash, almost transparent. This tone is applied from the right with very inclined brushstrokes. Once again the area of light on the left of the vase is left in negative. Before this tone is dry, in the same way that the highlights were opened in the first part of this chapter, a luminous area is opened up on the right with a wet and clean brush. It is not necessary to insist too much with the brush if you do not want to open a perfect highlight.

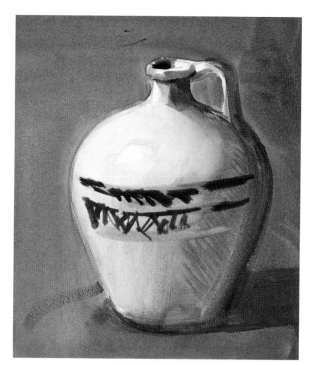

5. *With a gray layer somewhat thicker than the previous one, rapidly stroke the shadow area with the brush, just as you did before. On the right side a thick, long brushstroke is made with a wet brush, but without hardly removing any paint. In this way the right edge of the vase is restored. When the background wash is completely dry, the frieze is drawn in a very clear blue, and on top of this a new blue tone, but this time much darker.*

While the color is still wet, it can easily be manipulated with a clean, dry brush.

6. *With the brush only moderately loaded, the frieze of the vase is now finished off. The background is now repainted with a mixture of sienna and a little, but much darker blue. The outline of the shape of the vase is painted with care. Notice in the picture that, by the background being painted in a darker tone, the shape of the vase on the left has been changed.*

7. *Notice how a small error in the center of the vase has been corrected: this highlight has been opened up with the clean, wet brush, making small, repetitive strokes across the area in such a way that the surrounding blue merges. Now is the time to start correcting the left side of the vase. First, try to retouch it by modifying it with the dark exterior tone, but this will fall short of the result sought after. This curve will have to be redone by opening up the tone from the interior of the shape.*

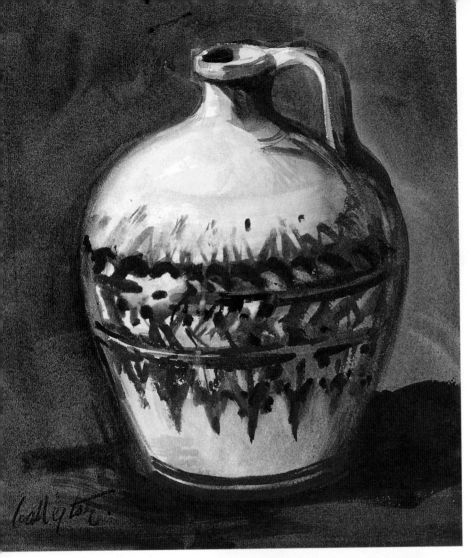

8. *Start giving a new shape to the left side of the vase with a clean, wet brush. These strokes have to be very gentle. Continue until the shape takes on the desired curve. Once the correction of the shape has been realized by dragging the color, allow the area to dry and finish off the decoration of the ceramic. When the vase's decoration has finished drying, make some dark brush strokes in the shadow area. Lastly, lay down an almost transparent yellow layer. Despite this latest addition of color, the most luminous highlights have already been reserved.*

SUMMARY

White area reserved from the beginning. The brightness of the inside of the vase has remained intact since the start of the picture.

Highlight opened up by dragging strokes of a clean, wet brush.

The right-hand zone of the shadow has been painted by the brush, but not so much as to open up a highlight.

On the left of the shadow the shape of the vase has been redone by repeatedly dragging the brush across the dark background tone.

8

Highlights and reserves

THE MANUAL RESERVE

The manual reserve is made by hand, impeding color or dampness from penetrating into an area destined for a white or clear color. When doing a manual reserve, it is necessary to be especially careful not to penetrate the reserved area. To achieve this, one of the best ways to make this type of reserve is through a correct initial drawing. The line of the pencil lead must not be crossed either by the color or by the brush.

In the last topic we studied how to open up highlights by removing color from the paper, which can be done for a number of reasons. This topic is also going to deal with white, but in a different way. One question is the treatment of white when it is an opening up of an area with a color tone already on the paper, and another, very different, when it is a white area in negative, reserved, from the beginning. The reserve can be done manually, by leaving out color in a certain area, or by using masking fluid. This is a product which is applied with a brush and temporarily makes the area it covers impermeable.

► **2.** On the light tones, darker ones can be painted. Providing that the initial tone has dried completely, you can do new reserves that show a different unpainted tonality. The most luminous highlights must remain intact unless the tone requires a little retouching.

▼ **1.** Before laying any color down, it is necessary to do a detailed drawing that shows the principal shapes and highlights that must be reserved in negative as perfect whites. One recurrent error of many beginners is to start to paint before having finished the preliminary sketch. The drawing must always provide fundamental technical support for the watercolor. After doing the drawing you can start to paint, first with the lightest tones that isolate the bright areas: these highlights must not be touched by color.

3. After several layers, different brightness can be highlighted, all of them based on more or less recent reserves. The most luminous areas correspond to reserves left during the first layer. As darker layers have been put down, clearer reserves have been made on top of previous layers.

253

THE MECHANICAL RESERVE

Despite such a spectacular name, this mechanical reserve is the mere laying down of a blocker that prevents a certain part of the paper from being painted. A mechanical reserve can be made in different ways, the most practical for the watercolorist is to use masking fluid. This material is a liquid paste that is applied with a brush. Once it is dry it makes the area covered impermeable. When the watercolor is completely dry the mask is taken off by simply rubbing gently with the finger, and a clear white space becomes visible.

▶ **2.** *Before applying the masking fluid, the previous wash has to be completely dry. The masking fluid is applied with a brush. In this case a yellow variety is being used but it also comes in gray. The masking fluid has a non-white color to distinguish it from the paper underneath. The brush does not have to be dipped completely in the pot, only the hairs. As soon as the application is finished, the brush must be washed with running water to avoid the hairs becoming brittle.*

▼ **1.** *This exercise is very simple. You will practice the use of the masking fluid. Some very sketchy trunks are painted in sienna. It is not necessary to go into details, only the general lines that situate the principal shape and a few branches.*

▶ **3.** *The masking fluid dries very quickly. You can paint on it in any color or tonality knowing that the masking fluid will pre-vent the watercolor from pene-trating. First allow the colors of the picture to dry and then take off the masking fluid. It will have become an elastic film which is easy to take off by simply rubbing it off with one of your fingers. When the masking fluid has been removed the protected area is revealed white.*

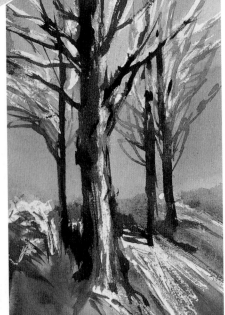

4. *Here you can see the effects achieved with masking fluid.*

WASHES AND RESERVES.
WHITE TEMPERA

The reserves can be made in many different ways, but they always aim at isolating a part of the paper which will be used for a highlight, a luminous area. Sometimes the color of the paper is not exactly white, which makes it harder to use this color for the maximum luminosity in the wash unless a medium is introduced into the painting that is not a watercolor technique: white tempera. Different to the Chinese white used in previous chapters, the white tempera is completely opaque and allows perfect whites to be achieved in part of the picture. White tempera is used, above all, to obtain reliefs on colored paper. In this simple exercise a comparison is made between work done on colored paper and work done on white paper.

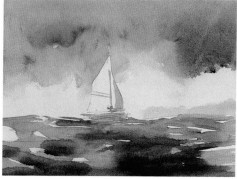

▼ 1. To do this exercise it is necessary to have both white and colored watercolor paper. Both papers are held to the board with tape. The paper on the left is a cream color while that on the right is completely white. Obviously, on colored paper it is not possible to paint whites since in watercolor whites are achieved by reserving. By using white tempera, a similar effect can be obtained on both papers.

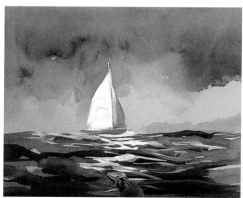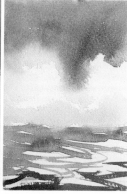

▶ 2. To compensate for the lack of whites on the colored paper, white tempera is used. This means that the picture becomes more dynamic and incorporates light effects. Nevertheless, some areas are left in negative so that the background color comes through the darker areas of the blue.

3. Compare the treatments that have been carried out on each of the two papers. You can see that white tempera can be used to greater effect on colored paper. This technique is not very normal in watercolor painting but it is always convenient to know it.

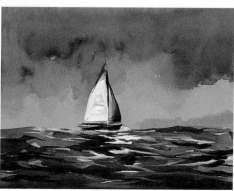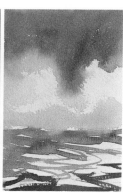

SUPERIMPOSING LAYERS AND PROGRESSIVE RESERVES

When a layer is superimposed on another already dry layer, the result produced is the sum of the two tones or colors used. This has been seen throughout various topics.

This same effect can be used to make reserved areas. In this topic we have studied the use of masking fluid to obtain perfect whites. If masking fluid is applied to a surface already painted and dried so that certain areas are protected, or reserved, when the masking fluid is peeled off, the new tone or color will include a reserve of the initial color. At the same time the zones that are reserved for whites can be painted in light tones that hardly effect the colors around them.

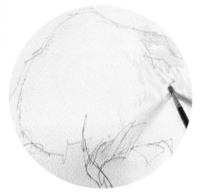
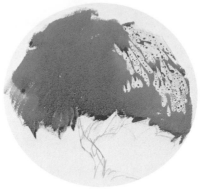
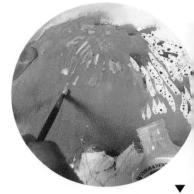

▼ 1. The first reserve is going to be carried out with masking fluid. To begin the process a drawing is made to sketch the shape of the reserve. With a medium brush dipped in the masking fluid the areas that are to remain white in the first phase of the layers are protected.

▼ 2. Once the masking fluid is dry, a uniform color can be painted. As before, the color does not penetrate in the area protected with the masking fluid. The mask is much more secure than the manual reserve, although it does require a much slower and laborious process. Masking fluid is especially suitable for small details and areas that are difficult to protect by hand.

3. On the dry color, before peeling back the masking fluid, a few more reserve strokes are made. This time the color that is reserved is the green tone that was employed initially.

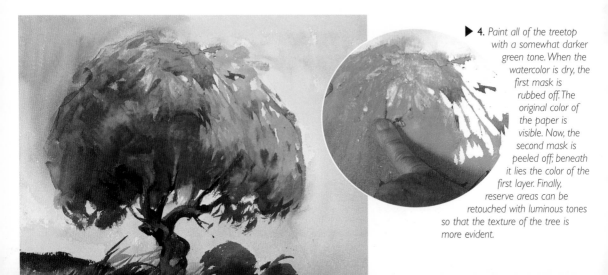

▶ 4. Paint all of the treetop with a somewhat darker green tone. When the watercolor is dry, the first mask is rubbed off. The original color of the paper is visible. Now, the second mask is peeled off; beneath it lies the color of the first layer. Finally, reserve areas can be retouched with luminous tones so that the texture of the tree is more evident.

Step by step
A mountain landscape

In this chapter you will look at different ways of reserving spaces. We have chosen a snowy landscape to do an exercise with a large reserve. Here the space reserved will be the snow-covered mountain. In this part of the picture, successive reserves are going to be applied. In all of them the white of the paper is the most important consideration.

To do this landscape it is not necessary to use masking fluid because it is vast and has no small details or fine lines that need to be protected.

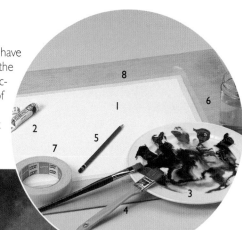

MATERIALS

Watercolor paper (1), watercolors (2), palette (3), watercolor brushes (4), pencil (5), jar of water (6), tape (7), and support (8).

1. One of the reasons why a landscape is recommended to someone who wants to learn to paint watercolors is because it requires less precision in the drawing than still lifes or figures. It is easier to draw lines that represent a mountain than, for example the oval that describes a plate in perspective. This drawing is very simple, although it is necessary to sketch in the areas that will contain the darkest tones of the mountains. In this way the white reserve can be executed with great precision.

STEP BY STEP: A mountain landscape

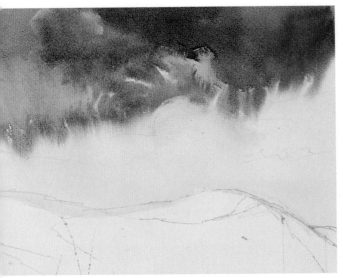

2. *In order to reserve all the white areas of the mountains from the wash that is going to be applied to the paper, the sky is first dampened with a clean brush. The mountain area is left untouched. The moistness of the water will act as a reserve of the white of the paper because the color will spread only over the previously dampened areas. Start applying different intensities of color from the top: cobalt blue and a dash of ochre to get green tones.*

Manually reserved areas keep intact the white highlights.

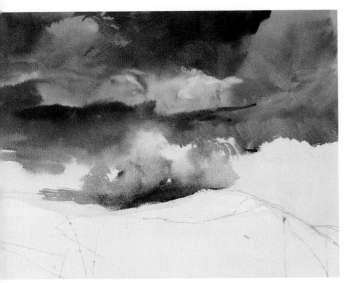

3. *On top of the previous color, once dry, a very pure ultramarine blue is painted. The initial color becomes the first reserve area as the blue now isolates spaces that a moment ago were occupied by the first grayish tonality. In the lower one, the blue outlines and reserves what will be the clouds that crown the mountain. To maintain the reserve of the mountains, the sky that outlines them is once again wetted with a brush and clean water. Now, the clouds on the horizon are painted without there being any danger that they penetrate into the white zone.*

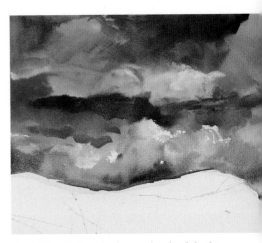

4. *Finish painting the lower clouds while the mountains are still wet. Here use cobalt blue with some burnt umber to give a leaden hue to the clouds. All this area is not painted in a uniform manner, instead different intensities of wash are applied to get darker and lighter tones. The most luminous areas of the clouds have to be reserved while the darker ones are being painted. The importance of the ultramarine blue reserved while doing the clouds can now be appreciated. This is also the case with the white mountain reserved by the clouds on the horizon.*

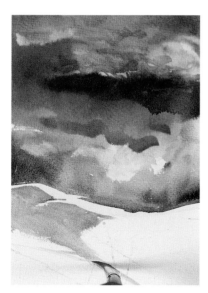

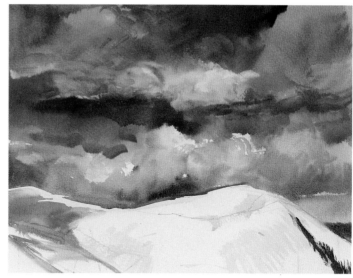

5. *Start the painting of the shading of the mountain in an ultramarine blue mixed with little cerulean blue. This color is painted with precision using very watered-down paint and respecting the previously sketched-in area. The blue color must not touch the clouds, instead leave a fine white line between them. This white strip is also considered part of the reserved area.*

6. *Once the shadow area on the left of the mountain has been painted, add other tones in a mix of cobalt blue and little ochre. An almost transparent wash is used to paint the most luminous shadow tones of the mountain. The background must be dry in order to keep as a reserve the brightest white. On the right, the painting of the trees is started using a mixture of dark green, blue, and a little sienna. Use short and vertical, rather dark, brushstrokes on the upper area to maintain some space so that the white of the background shows through.*

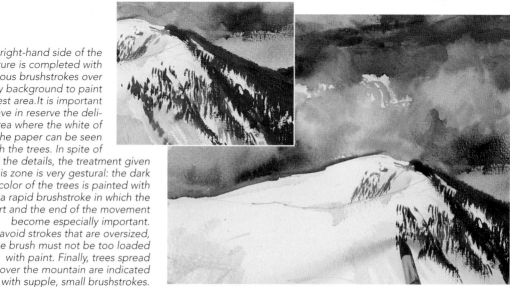

7. *The right-hand side of the picture is completed with numerous brushstrokes over the dry background to paint this forest area. It is important to leave in reserve the delicate area where the white of the paper can be seen through the trees. In spite of all the details, the treatment given to this zone is very gestural: the dark color of the trees is painted with a rapid brushstroke in which the start and the end of the movement become especially important. To avoid strokes that are oversized, the brush must not be too loaded with paint. Finally, trees spread over the mountain are indicated with supple, small brushstrokes.*

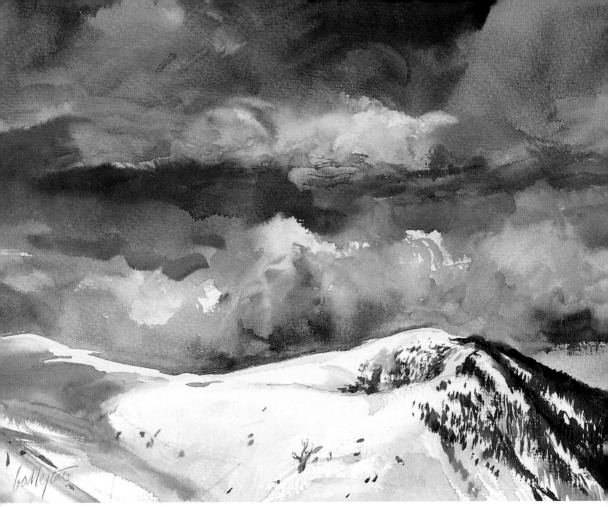

8. *The final touches are given to the dark area of the forest with a mixture in which burnt umber and dark green predominate. The space on the left is completed with an ultramarine blue wash. All these are the final details of a picture in which the white reserve has played the leading role.*

SUMMARY

The ultramarine blue of the sky in turn reserves the first wash of grayish colors.

The grays of the mountains were drawn from the beginning of the picture. In this way the white reserve can be done much more precisely.

The zone of grays on the left receives a final touch of very luminous color.

The purest white is that of the paper.

The forest area allows the color of the paper to come through as it has been worked when dry.

The small details of the trees spread out over the mountain are painted when the picture is almost finished.

Special techniques

SPECIAL MATERIALS

There are many techniques that normally can be used to alter the surface of a watercolor. One of the most usual tools in the studio of a watercolorist is the blow-dryer. This can speed up the water evapo-ration from the paper. Another tool that can modify the surface of the paper is sandpaper.

The watercolor is very sensitive to any alteration that is produced on its surface. This quality is an advantage when the techniques that provoke such changes are known. When using watercolors, accidents often happen, like a scratch on the paper, scraping with the brush, or many other incidents. This topic will deal with these effects as a part of the normal possibilities for the watercolor technique.

▶ *1. The dark color is painted in the usual way. In this exercise we are going to do some textures with sandpaper on a painting of rocks. The colors used for the rocks can be very dark.*

▲ *2. Some techniques are done when the color is completely dry. To accelerate the drying of the color and to be able to work on the the dark mass, the paper is dried with an electric dryer. If the paper is too wet it is wiser not to get very close with the dryer so that the color does not run or the drying is irregular on the surface.*

3. Rub the surface of the rocks with a medium-grain sandpaper. This action causes the upper layer of the paper to be taken off and the dry color with it. It is not necessary to press too hard. Some areas can be left untouched: just rub where you want to texture the surface.

▲

4. You can then repaint on the retextured surface with very transparent washes or with dark colors without completely covering up the resurfaced area. ▼

▶ 1. *The effects that can be achieved with watercolor can be realized on a completely dry surface, or on fresh paint. When the paint is wet it is possible to achieve more varied results, for it is not just a question of getting rid of the paint. Depending on the type of paper, the painting can be scored with grooves that do not completely take off the superficial layer. Here the experiment will be done with fresh paint.*

SCRATCHING THE PAPER WITH THE TIP OF THE BRUSH

At the opposite end to the hairs, that is to say the tip of the handle, there is another very practical tool which offers many possibilities. Different tasks can be done with the sharp point of the brush, especially when the watercolor is moist. Some brushes have a sharp tip, and others have a blunt one. Some watercolor brushs even have a beveled tip, specially designed to scrape the paint.

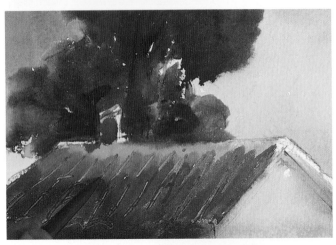

▶ 2. *While the painted surface is still moist, start with the tip of the brush. You can see the effect in the photo. Do not press too hard: the smallest indentation is enough to mark the paper. Stroking like this will not achieve pure whites. In the indentation made on the paper, more color is accumulated than on the rest of the surface, unless you insist several times with the brush. In this case pass the brush over each stroke. By so doing, instead of building up more color, part of it is taken away, and this makes the result a clearer and finer tone.*

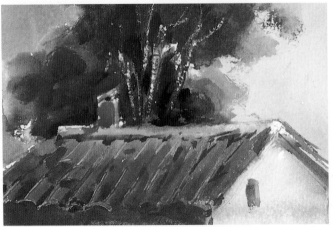

▶ 3. *When the tip of the brush is pressed hard over the still moist background it is possible to open up whites like those among the trees. To make these type of marks not all brushes will do. Some of them have a tip that is too blunt. If it is necessary to make indentations that remove some of the paper a sharp toothpick can be used.*

A KNIFE AND TURPENTINE

A knife or a cutter can scrape the paper with great precision. As these tools are so sharp, they must not be used on wet paper as as it could scrape to the point of tearing. The cutter is a more practical tool than the knife for it can be handled with the precision of a pencil. Moreover, another technique that produces interesting effects on the watercolor is the use of turpentine; the mixing on the paper of a brush loaded with turpentine with another loaded with water produces an unusual texture that is worth experimenting with.

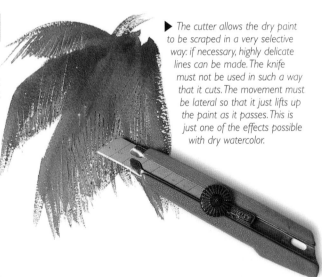

▶ *The cutter allows the dry paint to be scraped in a very selective way: if necessary, highly delicate lines can be made. The knife must not be used in such a way that it cuts. The movement must be lateral so that it just lifts up the paint as it passes. This is just one of the effects possible with dry watercolor.*

1. This little exercise demonstrates the combination of the technique of watercolor with turpentine and the opening of whites with the cutter. As with all the exercises in this book, it is a good idea for the learner to put it into practice: it is the only way to understand how the technique works. All work in watercolor is initiated with a drawing. Once the main motif is finished, the paintwork can be be started. A brush is dipped into turpentine and some areas of the background are covered. On top of this you paint with a dark color. The turpentine gives the watercolor a very textured appearance.

▲

2. Once the background has been painted, the figure is outlined perfectly. A dark green color is used to paint the leaves of the plant. In some areas quite a lot of turpentine is applied and in others none at all. In the areas with turpentine the color penetrates with more intensity.

▲

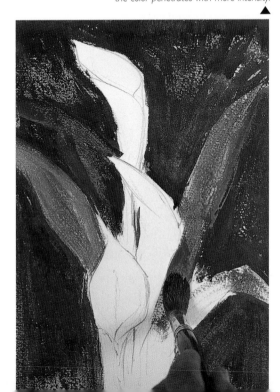

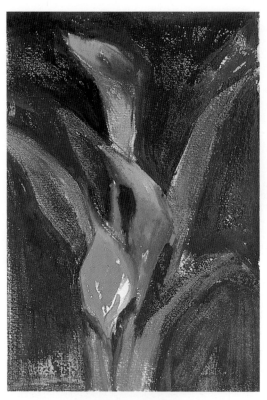

▶ 1. *In spite of using these special techniques the watercolorist must always keep in mind the principal techniques: that is to say if you do not want tones or colors to mix you have to wait for the previous layer to dry. Once the green leaves have dried, the red central flowers can be painted. In this area turpentine is not used. However, it is used on the upper flower in which ochre, sienna, and red are present.*

COMBINING TECHNIQUES

The special techniques do not have to be used constantly in watercolors. In general, it is better to use these effects as very defining notes in any work. All the techniques of watercolor must be combined intelligently so that the painting is not cluttered up with special effects.

3. *Finally, once the necessary scrapes have been done, repaint with darker tones to outline the forms or to include layers through which the background of the paper can be made out.* ▲

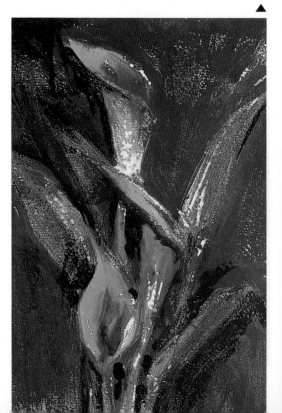

▼ 2. *When all the painting is completely dry, the cutter is used to open up new textures and to lift up the white of the paper. The long strokes produce white lines, while, if little scrapes are made close together, very textured white areas are achieved, as can be observed in the upper flower.*

Step by step
A boat on the sea

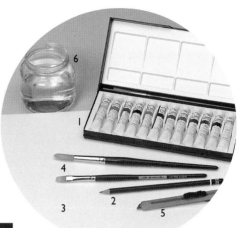

In the following exercise a theme that combines the principal techniques of watercolor is going to be dealt with: the color wash and the brushstroke superimposed on dry. In the exercise not too many texture effects are going to be done, only those that are vital, like scraping with the cutter or with the end of the brush. Here the subject is a marina with a boat. It is not difficult to do if you pay close attention to the steps detailed below.

1. *A subject like this does not need great drawing skills, but it is necessary to know at least how to sketch the form of a boat with the essential lines. After these first lines you can start to paint the first color.*

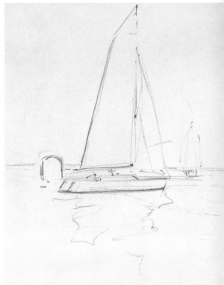

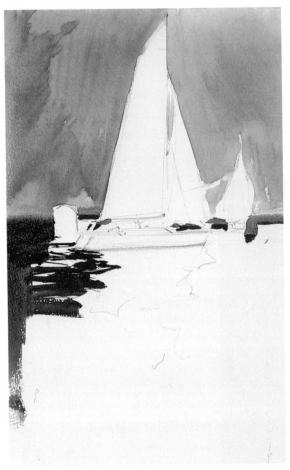 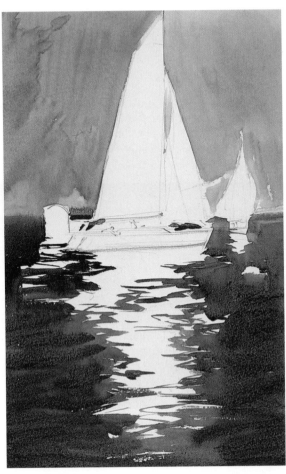

2. A first wash is made over the background with transparent blue, outlining the form of the boat with the brush. It is useful to remember that in watercolor the white is always the white of the paper, so whenever this color is needed, a zone has to be reserved. The color of the sea is begun with dark blue. In the same way that the white of the sail has been reserved so too are the highlights in the sea.

3. In this step the complete outlining of the shape of the boat is finished in the principal tones of blue. Pay attention to how the whites in the water are reserved. The brush is used to draw the dark zones of the reflections with horizontal brushstrokes. In some areas within the reserve these brushstrokes have a very mannered look.

The most luminous areas must always remain white. This means that later grey tones can be added as nuances of the white colors.

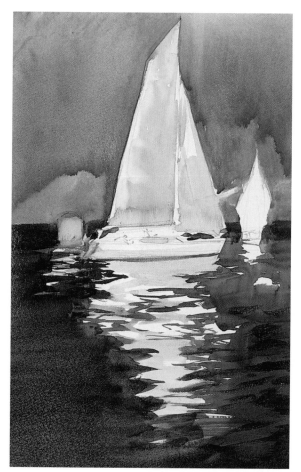

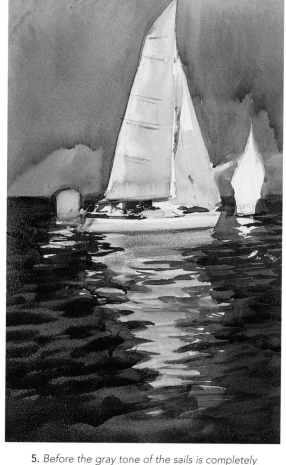

4. The background is made darker by recovering it with a new blue wash; this allows a break to be made with respect to the first layer of color which is already dry. The work on the sea is developed with the same very dark blue with which the area was initiated. As new layers are superimposed on top of former ones a darker tone is achieved which represents the waves of the sea. Wait until all the color is dry and then paint the sail and the hull of the boat in gray, and the white reflection in the water. The buoy is painted yellow, and a red waterline is added to the boat.

5. Before the gray tone of the sails is completely dry, the back of the brush is used to trace the lines of their structure. The color quickly falls into these little "furrows" and they become saturated. With the same gray color used on the boat the darkest zones of the hull and of the sea reflections are modeled. Now that the sea color is completely dry the shadows can be painted in with irregular horizontal brushstrokes.

6. The cutter is used to begin the outlining of the brightness in the sea. It is not necessary to scrape too much: passing over a few times to lift little scrapes will be enough so that the brightness shows up perfectly.

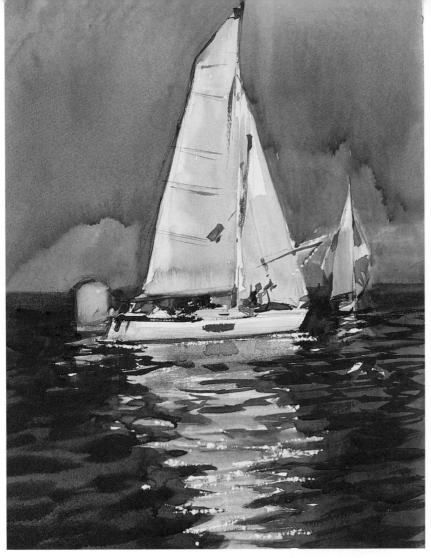

7. *Using the knife finishes off this work in which different techniques, related to the moistness of the color on the paper and the work on the texture, done with the knife or with the almost dry brush, have been combined. It has been demonstrated that the light effects produced by the scrapes on the paper are striking. To maintain interest it is necessary not to overdo the use of this technique.*

It is important to work on heavy grained paper. These effects cannot be done on thin paper.

SUMMARY

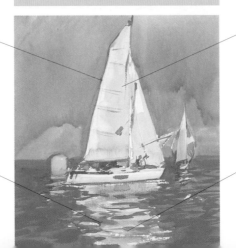

The first layers have the role of completely outlining the form of the boat against the backdrop.

To do the sails the back of the brush is used.

The brightness of the sea is obtained with the trails left by the brushstrokes on the white of the paper.

The textured zone has been opened with a knife, making soft lines.

10 Value and modeling

LIGHT AREAS, HIGHLIGHTS

To place the highlights on any object it is important to know the direction from which the principal light comes. Light falls on an object and runs over the shape; depending on its intensity it will provoke shadows or highlights of varying luminosity.

The valuation consists in the correct gradation of the tones to achieve a scaled effect of grays on the surface. A valuation is nothing more than classification of the possible tones that can be obtained from a color. In previous chapters the different techniques of the watercolor have been studied. If in a scale of tones the differences between one tone and another are made finer until a point is reached when it is impossible to appreciate the difference, an effect of modeling is achieved. Starting from the basis of this explanation the volume of an object can be painted according to the light that falls on it. In the exercises that we are going to do in this chapter ideas that we have learnt before will be applied. It is fundamental to pay a lot of attention to the images and to the explanation.

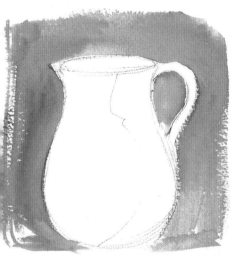

▶ **1.** As already stated, the drawing is the basis of all watercolor work. It is crucial not to forget this before starting any work with the paint. This preliminary drawing should always be as clean and neat as possible: the lines must only indicate the fundamental shapes of what is going to be painted. The jug is drawn and the shape of the shadow is also defined. So that the effect of the light can be observed more closely, the background is painted with ochre.

3. The brush is dampened with clean water, it is drained and then it is run along the edge of the still fresh brush-stroke. The wet brushstroke with the color has to follow the shape of the jug. It is dipped in water, drained, and run along the edge of the gradated area again. In this way you obtain a gradated area which fits the shape perfectly.

▲

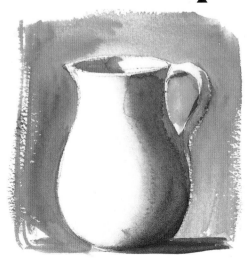

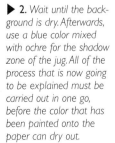

▶ **2.** Wait until the background is dry. Afterwards, use a blue color mixed with ochre for the shadow zone of the jug. All of the process that is now going to be explained must be carried out in one go, before the color that has been painted onto the paper can dry out.

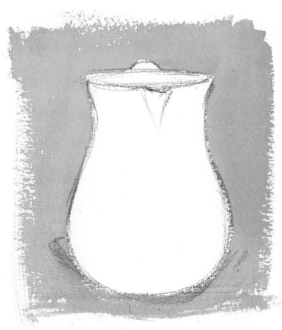

▶ **1.** *Just as in the last exercise, a ceramic jug is taken as the reference. Here the light is frontal and therefore the most luminous point is in front of the viewer. The shape is drawn carefully and any unnecessary lines are rubbed out. The area that surrounds the shape is painted in a yellowish orange so as to emphasize the shape.*

ALWAYS DARK ON LIGHT

The process of watercolor painting has a premise that must always be respected: the lighter colors must always be reserved, the dark colors outline the highlights, and light areas cannot be painted over dark tones. That the color white is only contained in the color of the paper and that it is the darker colors which isolate it and make it stand out are important factors to bear in mind. The subject of the color white in watercolors has been dealt with previously. In this simple exercise a valuation is going to be realized using the color sienna. The color white will play a role through the gradation of the tones.

3. *Quickly, without allowing the color to dry, the brush is dipped in clean water and drained off. Several brushstrokes are made following the shape of the jug. The color is gradated and valued toward the centre of the figure. The dark color remains on the edges of the shape. When the color is almost dry, make several brushstrokes on the right-hand side of the shadow: the color comes out a little and provokes an effect of volume. This technique will be constantly used in all the spherical shapes painted with watercolors.* ▲

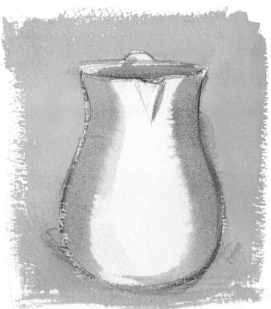

▼ **2.** *This time, to do a variation on what we did in the last chapter the white background of the jug is dampened before applying the darker color. The brush is dipped in sienna and both sides are painted in the same way. The color tends to spread out over the damp zone. On the spout of the jug the shadow is painted with very fine brushstrokes.*

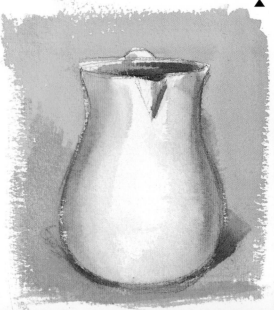

MERGING COLORS AND TONES

To get the volume right it is necessary to control the merging of the tones. The level of moistness of the color will be a deciding factor in controlling the merging of the colors properly. It is necessary to wait for a prudent period of time so that the modeling of one color onto another can be achieved by gently caressing with the brush. In this exercise the subject is an apple, but the technique is valid for any other object or color.

1. To do these exercises of valuation and modeling, subjects that are straightforward to do have been chosen. In general, it is always easier to paint an object that does not require perfect symmetry like an apple. After having drawn the fruit, paint all the surface of it with a very luminous yellowish green. As you paint, the most luminous area is left in reserve. As said before, the painting must be done from light tones to dark, that is to say, first a very transparent color and then the center of the fruit is painted, but in a darker tone.

> To open up highlights any brush can be used, but it is always better if it has many hairs that allow a good tip to be obtained. Sable hairs are the best.

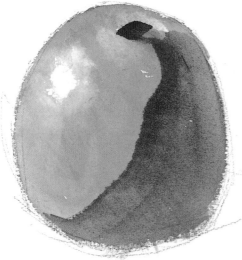

▼ *2. When the first color laid down has dried, all the shadow zone is painted in a dark green. The color does not have to be applied wet because the valuation must not be done by merging with the previous tone, but by gradation of the last color. In the picture, you can appreciate the direction that has been given to the brushstrokes. First, the brushstrokes define the contour of the shadow. These brushstrokes are then stretched to the right with a soft inclination and in a straight line. Lastly, on the right side the clean and drained brush is passed over again, following the shape of the apple.*

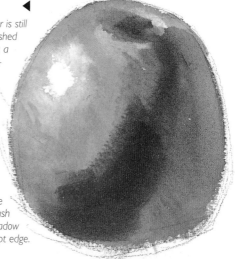

3. While the color is still fresh the paint is brushed to the right of the apple in a soft gradation of the background. If necessary, you can paint a little more of dark green in the central area, but not in the part where the tone is graduated because otherwise you would not be able to do valuation work with the color. To finish the modeling, before the color dries completely, stroke the clean and semi-wet brush along the profile of the shadow so as to soften the abrupt edge.

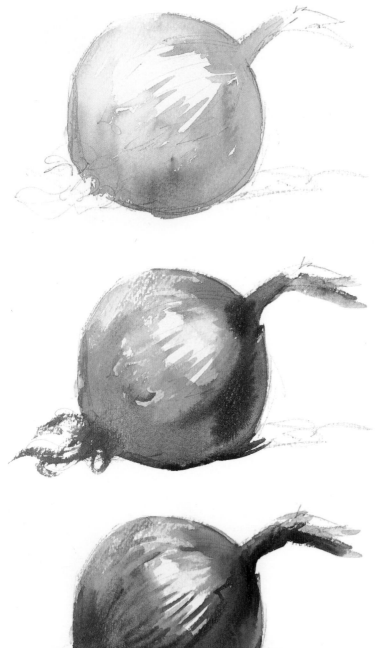

▶ **1.** *After drawing the shape of this onion, the color is applied onto the completely dry background so that the principal highlight can be placed at the same time. The brightness is created with long drawn out, supple strokes. The valuation has to be done while the color is still wet. On top of the first very luminous wash, a few small brushstrokes of carmine are made in the lower part. The color quickly merges into the contours but adds a certain volume.*

VOLUME AND FINISH

On the previous page we studied how it is possible to achieve the volume effect thanks to modeling the valuation. Sometimes, the object depicted requires a better finish than that obtained by values and tones. To obtain this finish it is necessary to combine the techniques studied up till now. First of all, work is done on the values and white reserves and later the texture is added to the dry background.

▶ **2.** *The application of color is begun on the right side of the onion, keeping the brightness intact. The background is still wet and the violet sienna color that is painted now must not be too watery so that it can maintain its density. The brushstrokes merge on their own in the curves, while spreading to the limit of the wet background.*

▶ **3.** *Until now work has been done on the wet background; the work of valuation not being very different from that done in the rest of the chapter. To paint on the texture it is necessary to let the background dry. The painting of the texture of the skin is begun with a violet color obtained from sienna, a little carmine, and blue. Long and supple brush strokes are made in the highlights. An area of shadows is also made, merging the colors. Finally, as has been done in previous examples, with a clean, wet brush the highlight on the contour in the shadow zone is opened.*

Step by step
Still life of fruits

The color, the brightness, the highlight, or the texture can all be varied but essentially the process of valuation and modeling of the shapes is always the same. Getting striking results is a question of study, and above all of a lot of practice. Now we are going to put into practice the notions that have been learned in this lesson. It will be necessary to pay attention to the drying times of each area. Sometimes the work will be done on the wet background, and at other times it will be realized when it is dry. A model with a variety of colors and textures has been sought out so that different solutions to tone valuation questions can be worked on.

MATERIALS
Watercolor paper (1), watercolors and palette (2), watercolor brushes (3), jar of water (4), and support (5).

1. *The work is begun with a very plain sketch of the shapes that you want to represent. As can be seen, it is not very complicated but this drawing has to be done neatly and with precision. Do not start painting until it is complete.*

273

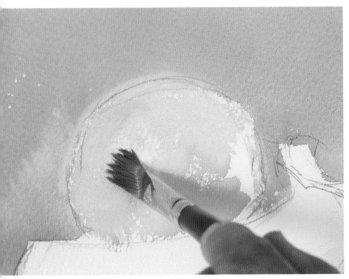

2. *As was done in the first exercises on this subject, isolate the principal elements of the picture by completely painting the background. In this way the shape is outlined and the white of the paper is perfectly marked out. A broken tone of green, sienna, and ochre is used to paint the background. To increase the luminosity of the white, the tone that surrounds the shape of the fruits is darker than the rest. Once the background is dry you can start to paint the orange. Pay attention to the highlight: the color tone is densest in the shadow area.*

To correctly model the tones and colors, the work must be done before these are completely dry.

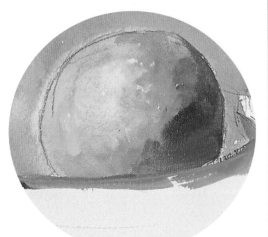

3. *The valuation of the orange is done with progressive tones of the same color, always conserving the same highlight as a reference for the volume. To do the valuation around the shadow, luminous green, orange, and some sienna are mixed in the palette. A curvature that follows its shape is painted on orange. Where the highlight meets the shadow, brushstrokes tinted with red are made. Once the orange is dry, the painting of the banana is initiated with long brushstrokes in luminous green; follow its shape.*

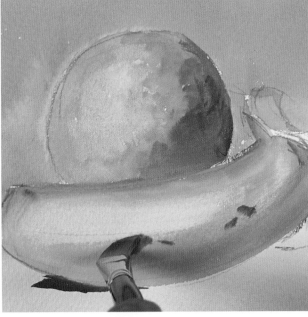

4. *Be very careful of the valuation of the tones of the banana. Before the green of the first brushstrokes are completely dry, the banana skin is begun with golden yellow. The direction of the brushstrokes has to follow the shape of the banana and pull the green until it is softly merged into its contour. In the lower part the valuation is realized with some sienna and orange. Lastly, in the most luminous part of the banana the clean, wet brush is passed over until some of the color is drawn out.*

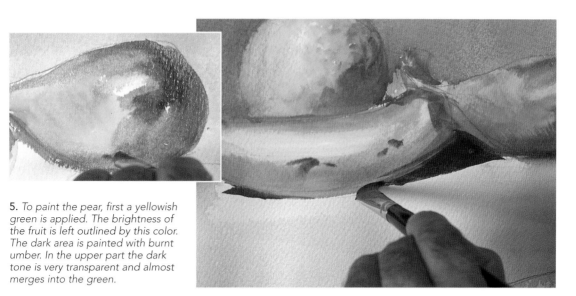

5. *To paint the pear, first a yellowish green is applied. The brightness of the fruit is left outlined by this color. The dark area is painted with burnt umber. In the upper part the dark tone is very transparent and almost merges into the green.*

The color of the paper gives luminosity to the paint. The dark tones do not allow reflections from the paper. These tones must only be used in the darkest area.

6. *A little of dark green is mixed with some water, not too much, to darken the pear. The brushstroke must follow its shape, pulling and merging with the shadow color. In the lower part of the pear, to increase the modeling effect, the clean, wet brush opens up the typical brightness. Once the pear is dry a final transparent layer of green shadow is is painted in the highlight area. On the tablecloth, the shadow is painted in very dark burnt umber.*

7. *So far we have done the complete modeling of the three pieces of fruit but the contrasts are not accentuated enough. If the contrasts of the shadows are increased, the highlights will stand out more and the volume will be more accentuated. The finish of the orange is begun with a very dense cadmium orange and small brush strokes to make the texture more noticeable. The upper part of the shadow is painted with a mixture of violet and carmine which as it descends turns into burnt umber.*

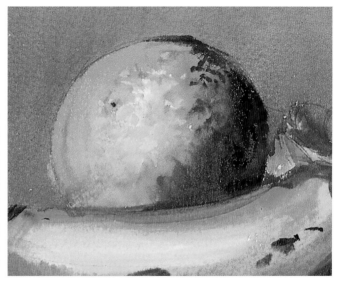

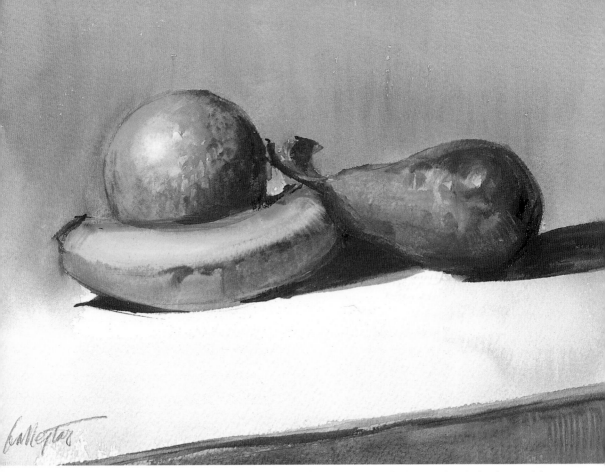

8. *The painting of the orange is rounded off by merging the dark colors that have just been painted into the background with successive brushstrokes. On the pear the shadow is painted with burnt umber and soft brush strokes are made on the limits of the green until the tones are integrated. On the right of the pear shadow, on the dry background, long, wet brushstrokes open up a soft area of light. Lastly, to darken the banana, the lower part is slightly dampened so that the shadow color expands gently. Thus this watercolor with valuation is finished: the shadows and the white of the paper have played the leading roles.*

SUMMARY

The background is painted first so as to emphasize the shape and light of the fruits.

The brightness of the orange is left reserved from the beginning.

The green color of the banana is softly merged into the yellow tone.

The highlight above the banana is opened with a clean, wet brush.

The contrasts on the orange increase the volume effect.

The green of the pear is done in two phases: the first to approximate the tone, the second with a darker green, dragging and forming the tone of the shadow.

On the banana the darkest plane is painted once the lower one has dried. Firstly, the zone is wetted so that the shadow color merges in.

11

Still Life

PREPARING THE MODEL

In this topic we are going to develop important concepts related to the technique and practice of the still life. To do a faithful still life it is first necessary for the set up to be correct for it forms part of the composition itself.

Still life is traditionally the pictorial genre that generates the most interest. It can be practiced from the moment you start with watercolors. It is important that the enthusiast covers all of the topics so that the creative capabilities which most suit the artist can be developed. Doing landscapes can involve concepts that leave aside questions related to the still life. For example, the proportions or precision in the form of a landscape are not always paramount. Conversely, in a still life these questions are indispensable.

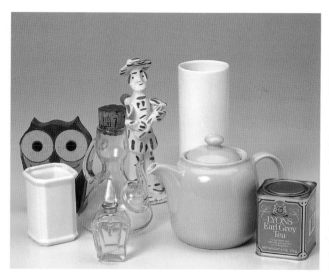

▶ *The still life is one of the subject which keeps the majority of painters the busiest. To elaborate a still life, the model has to be prepared with care and the possible composition techniques have to be thought out.*

The phase before painting a still life can be as simple or as complicated as the artist wishes. It is always wise to invest a certain amount of time in the preparation, especially if you do not want the still life to be run-of-the-mill, but attractive for the unity of its forms and colors.

▲

The tools to arrange the flowers are diverse. Scissors, water atomizer, wire, and synthetic cork to fix the bunch. The pot to hold the flowers is also important for the picture depends to a great extent on the objects that make up the composition. The model must be laid out so that it offers the image sought after before painting. If a flower is too droopy a piece of wire can be thread into the stem so that it is held upright as desired.

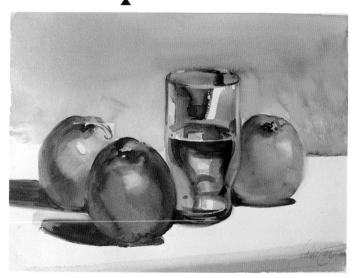

▶ Piling up or placing the objects too close togther prevents a correct composition. A lack of space compresses the objects and makes the whole set-up heavy on the eyes. The space around the collection of objects also forms part of the painting. Grouping the objects too close spoils the harmony of the composition.

THE STILL LIFE MODEL

When preparing the still life, some key points have to be borne in mind, like, for example, the composition of the model that will be used as a reference. The grouping of the elements of the still life is a fundamental question that has to be considered whenever two or more objects are in use. Here we will explain a few practical concepts about the location of the different elements as well as the relationships that are established according to the distances between them.

▶ When the objects are spread out too much the whole composition breaks down completely. The distance between the objects of the still life marks a visual rhythm and helps to establish the basic lines of the composition. Therefore, avoid dispersing the objects that make up a still life too much.

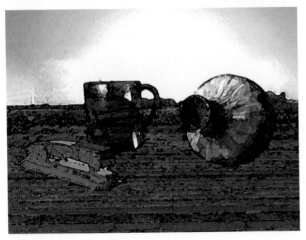

▶ Grouping the objects correctly before painting is not difficult but it requires attention and a sense of composition. When the objects are placed for the still life you have to stand back to coolly observe the whole. The corrections that are made to the model must always be made from where you are going to paint. To obtain an adequate layout for a still life, a harmonious and balanced composition is called for, without excessive bunching nor too much dispersion.

TYPES OF STILL LIFE

It is possible to find inspiration for a still life anywhere, it is just a question of looking around you to realize that the majority of objects that surround us can be part of a composition. Up until now we have seen numerous still lifes with classic elements, such as apples, bottles, and flowers, but you do not have to draw the line here. Even the most everyday objects can be used as a model worthy of being painted.

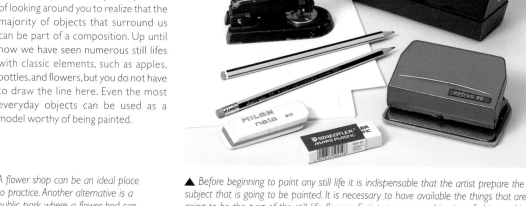

▲ Before beginning to paint any still life it is indispensable that the artist prepare the subject that is going to be painted. It is necessary to have available the things that are going to be the part of the still life: flowers, fruit, pots, or a combination of objects which offer an adequate composition for the picture. With the necessary material spread out on a table you can begin to set up the still life according to make a balanced composition. This collection of desk items is an example.

A flower shop can be an ideal place to practice. Another alternative is a public park where a flower bed can be the subject. Photographs are also a good source, enabling you to work at home or in the studio.
▲

PLACING AND SHADING

As we have explained, before starting to paint it is necessary to bear in mind a series of matters related to the model, among others the placing of the different elements of the still life. Once they are adequately laid out you can start to work on the model. This little try-out aims to initiate the enthusiast a step further in the still life. By painting these flowers we are trying to convey the idea that even the smallest detail needs preparation. We are going to practice with the following example: set up this floral still life, studying the elements that compose it. It can be painted as shown below.

▶ *Drawing is necessary for the completion of every still life. It starts out from a simple structure, just the general forms that become more detailed and gain body as the lines find their exact place on the paper. It is much more straightforward to do a picture with a good structure, with the objects fitted, rather than just starting out freehand with nothing to guide the painting. From a scheme already conceived, it is easy to finish the forms and the color. The whites of the flowers are perfectly outlined by the darker tones.*

▶ *Painting any watercolor has to go from the general idea to the details, from light to dark. General toning brings the smaller forms closer as it outlines them without going into details. When the whole idea has been completely sketched in, the forms are corrected and the smallest forms are defined with fuller shading. The drying of the different layers must be respected if you want to avoid the colors mixing.*

▶ *The colors have to be applied progressively, always from light to dark. The most luminous tones are enclosed by the darker tones and in this way the forms can be made firmer. Finally, the small details and the layers that give nuances to the white are painted in.*

ILLUMINATION

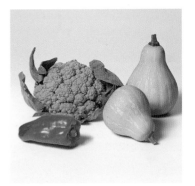

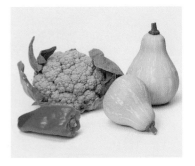

▲

Illumination is one of the important factors of a still life. Observe how the same still life in the two pictures above completely changes with the light. Both versions are correct but they are radically different.

Step by step
Still Life

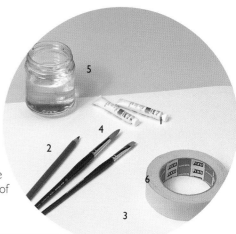

The still life that has been chosen for this model has a great variety of warm colors. Also, it can be seen that some elements like the pumpkin or the fruits have decidedly cold zones. These will help to compensate the overall excess of warm colors. Great care has been taken to prepare the model: a harmony has been sought between the different elements, trying not to put them either too close or too far apart. Composition is one of the principal factors in the realization of a still life. It starts with the preparation of the model.

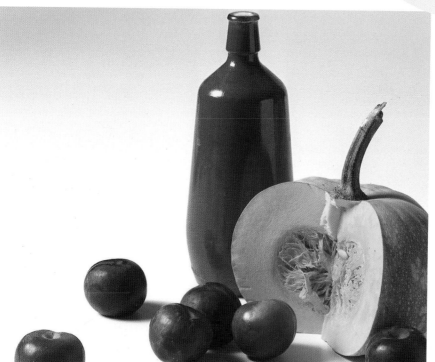

MATERIALS

Tube colors (1), pencil (2), medium grain paper (3), watercolor brushes (4), jar of water (5), and tape (6).

1. *Start doing a rough sketch without rubbing out the double lines and trying to respect the correct proportion between the elements. The shadows are also put in, placing each one carefully to avoid any error in the painting which is started with an ample yellow wash. The background is not painted completely: the areas that will contain very luminous highlights are left in white. The color is not painted with the same intensity in all the areas: lower down the tone is intensified and the rest is much more luminous. The inside of the pumpkin is painted in a quite pure orange tone. On the left side the tone is darkened with a dash of blue.*

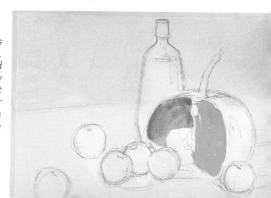

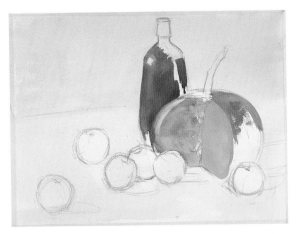

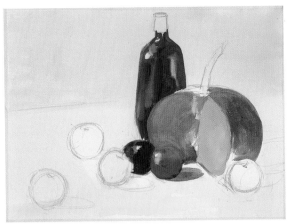

2. Now you are painting with the warm part of the chromatic range, although blues and greens are used to cool it down and to darken the shadows. This is how the dark areas on the outside of the pumpkin are approached. The bottle is started in a dark red lightly mixed with sienna. The space reserved for the highlights in the crystal is left blank. This first color of the bottle is going to be the base of other darker colors.

3. The dark parts of the bottle are painted after adding burnt umber to the red of the palette. The previous layer is showing through this new darker color as a highlight. Also, a new reserve is left so that the red of the background can be seen. Where the pumpkin is cut it is painted with long strokes loaded with red tones. The part in the center is painted with a very intense red and the dark part is tinged with burnt umber. The outside is painted in a clear green, the brushstrokes merging with the orange colors. The plums are a carmine red, except for one which is a dark violet blue.

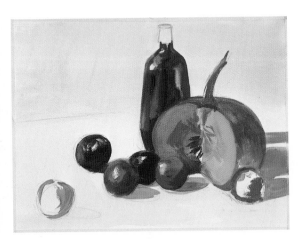

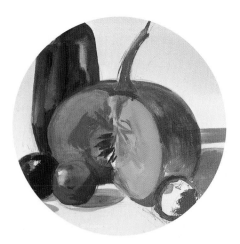

4. The remaining plums are depicted in a variety of warm tones, in red, carmine, and yellow. The shadows are painted with a little burnt umber added to the mix, leaving the brightest points unpainted. The darker fruit is colored with cobalt blue and dark carmine added into the mix.

5. Use supple strokes to paint the center of the pumpkin in reds and browns. The shadows of each one of the elements of the still life vary in tonality according to the color of the object that projects them: purplish for the plums and slightly gray for the pumpkin.

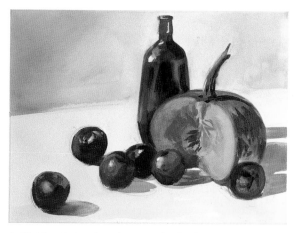

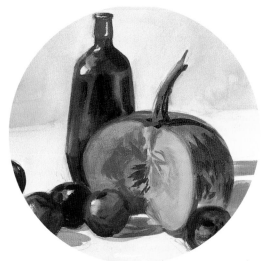

6. Finish painting the plums, perfectly placing the colors to show the highlights and shadows. Various blue nuances, or purplish tinges, when in contact with the warm colors, round off the tones of the fruit. The projected shadows are also painted: they vary in tone according to the colors that surround them. The nearest shadow to the pumpkin is darker than the others. The highlight of the bottle strongly contrasts with the very dark purplish mix, although the most luminous parts of the glass are not too bright.

7. The outside of the pumpkin is painted in a green mix with a dash of carmine, creating an olive tone that contrasts with the bright green and the low orange area.

8. Note carefully the delicate variations in this step with respect to the last. The definition of the volume of the two plums on the left is concluded. Although the contrasts of the shadows of the plums are cold, the purplish tone produced from the carmine mix gives it a warm nuance.

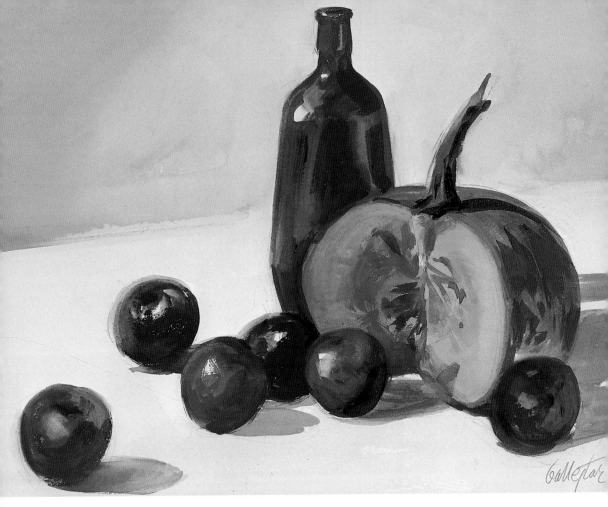

9. To finalize, warm tones that contrast with the different textures are used for the interior of the pumpkin. The chromatic ranges that have been used harmonize with the colors of the composition. This exercise has practiced the composition of warm colors but without excluding greens or blues.

SUMMARY

The initial sketch must organize and carefully compose the objects of the still life.

The dark areas of the plums come from the superimposition of blues and carmines.

The highlights are left clear from the outset.

The planes of the pumpkin are in two tones, one darker than the other.

The shadows that are thrown form part of the composition of this still life. Each shadow has distinct nuances from the others.

12

Figure

DRAWING AS THE BASE FOR PROPORTION

As we have seen, all the elements of nature can be synthesized from others which are simpler. To illustrate this we are going to look at the construction of a hand. This is one of the most complicated parts of the body to paint: however, as you will be able to see, with a good drawing the proportions and the fundamental anatomical forms can be perfectly shown.

The figure is one of the greatest challenges that a watercolorist can take on, not only because of the subject itself, but also for what can be done with the watercolor techniques. With other pictorial themes a watercolor can have some limitations. However, with figure exactly the opposite occurs. This subject requires a lot of rigor, starting of course with the initial drawing. Although this book is about watercolor, it is important to bear in mind that the outline of the drawing is the base of the color. Therefore, when doing the drawing it is necessary to constantly keep in mind the painting process.

▶ The initial sketch has the task of laying out the most elementary and simple outlines before filling them in with color. These outlines have to be expressed in very straightforward lines and at the same time they have to fit. To draw this hand observe the interior spaces, the inclination of each one of the lines and the distance between them. The advantage of starting with such a simple sketch is that the corrections to the outlines are also very easy.

Having done the initial sketch, and having accepted it as valid, the drawing is concluded in an approximate way, but without leaving any line that could induce error in the painting. Before starting to paint, the drawing, although simple, has to be perfectly finished. In this case the hand is finished in a very elementary but effective way: it is enough to fill in the dark area that surrounds it and then the medium tone that reveals the form of the knuckles. Finally, the fingers are not painted completely: they are just hinted at by their shadows.

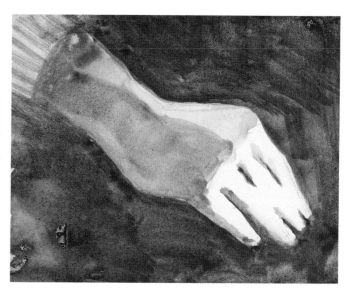

THE PLAN OF THE FIGURE

The figure must be planned in detail, like the hand, but apart from the possibility that these geometric shapes offer, it can be constructed from a well-studied internal structure. In general, the figure moves on several axes which, according to how they move, change the pose of the figure; these axes are shown by the lines of the shoulders, the spinal column, and the hips

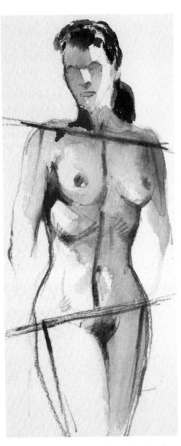

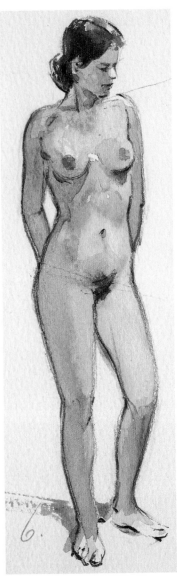

▼ 1. The upper line will be used to show the position of the shoulders. In the central zone the spinal column is represented with a vertical line. The line of the hips, just like the shoulders, will be inclined so that the legs are in a natural pose. Starting from the hip line, the proportions of the legs are sketched with straight lines and the joints are defined.

▼ 2. Building on the previous sketch the drawing of the figure is constructed. As you can appreciate, a lot of practice is needed to constuct the figure, but the system of fitting it together using axes allows a well-proportioned development and the security that the drawing is reliable.

▼ To practice the basic scheme of the figure try to find the internal lines of this already finished figure. In the first place, set the axes of the shoulders and of the hip, then the spinal column, and finally, do the sketch of the arms and legs.

THE VOLUME OF THE FIGURE

When you have learned to construct the figure correctly, the next step is to give shape to the drawing. This is done with color and the various light effects that are carried out on the paper. Just like the other themes that can be painted with watercolor, a certain amount of light is projected on to every figure. This means that some areas can be represented with light and others with shadows. The light areas always have to be those reserved by the darker tones. It is precisely this effect that produces the volume. The parts of the figure most exposed to the light will have to be outlined by the shadow, which will always adapt to the anatomy. Here are two exercises.

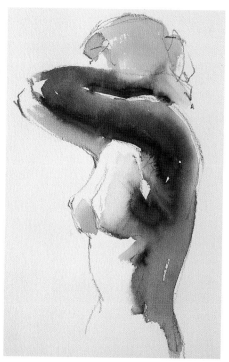

1. Once the figure is defined and the drawing is refined, the painting of the volume is started by placing the shadows and the light areas. When starting out with the volume procede with caution for it must be suggested by the points of maximum luminosity. In this example the most luminous parts are perfectly marked out by the darker zones. Likewise, in these shadows medium tones are also painted in. It is sufficient to absorb part of the color with a clean, dry brush while it is still moist on the paper. Or otherwise wash the area with a clean, wet brush if the color has dried completely.

2. The volume is finished off with medium tones that pull some of the darker tones towards the lighter ones, and then they are blended by repeatedly passing the brush over the most luminous parts. To put the final touches to the contrast of the body of the figure, all that has to be done is to paint a dark background. In this way the shadow tones are perceived as having more volume due to the contrast, while the clearer tones gain luminosity.

▼ *First, the drawing must be constructed as correctly as possible. Starting from the dark areas the densest shadow tones are established. These, in turn, are the backdrop to the highlights. Lastly, the background is darkened and the shadows are merged with the most illuminated areas.*

TECHNIQUES OF SYNTHESIS

The synthesis should be the principal recourse of the water-colorist. Synthesis means the process by which the representation of the objects is reduced to the most basic elements. In general, when painting without experience there is a tendency to fall into the trap of cluttering with excessive details. As experience is acquired, unnecessary factors are eliminated. Here we are going to study the synthesis process in the figure and how economizing on techniques can give much more expression to the overall effect of the picture. To paint well you have to know what is important and what is superfluous.

▶ *Paint this figure following these steps: first sketch the general lines within a triangular form, omitting any detail. Draw the lines that reveal the shoulders and the spinal column. Finish off the drawing of the body with only essential elements. As you can observe, the fingers are not drawn and the legs are hardly outlined. However, the figure is completely defined. With a very quick shading, the forms that make the highlights stand out are finished off.*

▶ *1. The dark parts of this figure define perfectly the principal points of light and allow the form to be modeled. On one hand they integrate the shadow into the illuminated area, and on the other they open up small highlights in the volume of the breasts. To achieve the maximum contrast all the side that is in contact with the illuminated zone is darkened.*

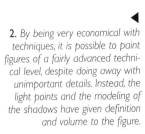

2. By being very economical with techniques, it is possible to paint figures of a fairly advanced technical level, despite doing away with unimportant details. Instead, the light points and the modeling of the shadows have given definition and volume to the figure.

288

Step by step
Female back

In this exercise the aim is not to do an excessively complicated painting. If one studies the approach to the principal volumes, starting with their shadows, it will turn out to be very easy.

On top of the picture which will be used as a model, a graph has been superimposed so that it is easier to sketch the principal planes. The lines "a" and "b" correspond repectively to the lines of the shoulders and hips. Starting from these two lines a trapezoid is done on one side, and on the other a triangle and a square.

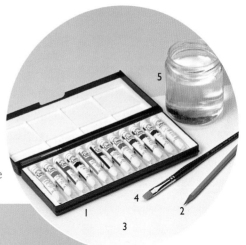

MATERIALS
Tube colors (1), pencil (2), watercolor paper (3), watercolor brush (4), water jar (5).

1. *Starting from the simple geometric shapes drawn on the model, outline the figure. The back fits into a trapezoid, the pelvic zone from the waist to the hip fits into a square, and the legs and feet into a triangle. From these forms it is easy to define the basic anatomy of the model. The drawing must be perfectly finished before starting to paint. Once it is done, start painting the dark areas with burnt umber.*

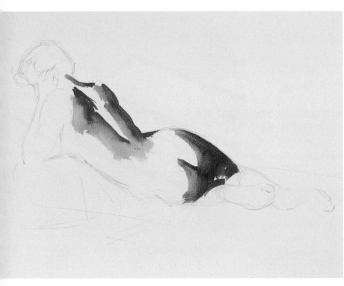

2. *With wet, clean brushstrokes color is dragged from the back in a soft gradation, reserving the strip of the spinal column. The process is continued with the shadow of the legs which defines the round shape of the buttocks and frames the shadow of the hip.*

Sometimes it is difficult to imagine the result of a color on another, above all when it is a question of several layers. This is why it is always recommended to have available papers of the same quality as the one being used in the definite work so that you can do color blending tests and check the final result.

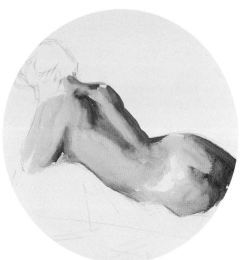

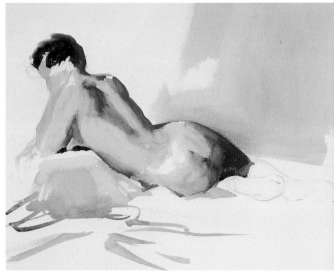

3. *The color of the flesh is obtained with an orange transparent layer. When the paper is wet, the sienna tone that is added to the side of the body blends in easily and suggests the volume. A very faint purple tone is added in the armpit zone. The form of the buttocks is modeled with almost dry color: the burnt umber is blended by successive brushstrokes. A very transparent greenish yellow layer is added which mixes with the previous coats of color.*

4. *The contrast of the armpit is increased and the hair is painted with a burnt umber and cobalt blue tone. The color of the skin is obtained from the illumination of the space that surrounds the figure. A transparent wash of burnt umber and blue is prepared with which to paint the background of the picture in a somewhat irregular way. The bluish hue is intensified around the hip.*

5. *When superimposing tones or planes, synthesis or summary should be the main objective of the water-colorist. A lot can be expressed by well-placed shadows and by omitting unnecessary details. Therefore, to paint the hand the fingers are not drawn. This part is resolved with the dark shadows that surround the illuminated area. The back of the hand is contrasted with a slightly bluish burnt umber. The fingers are defined by the hair and by the shadow of the face.*

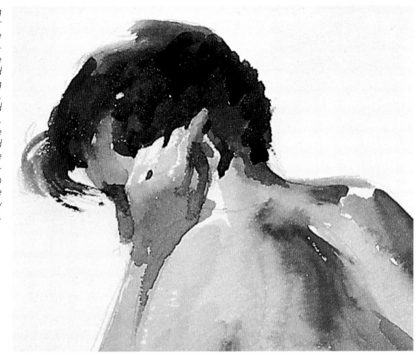

A general layer can be painted at the end of the session with the dirty water in the jar. This technique is widely used because this water has a highly transparent broken tone. If this layer is painted, the colors underneath must be completely dry, and you must not insist too much so as not to soften them again.

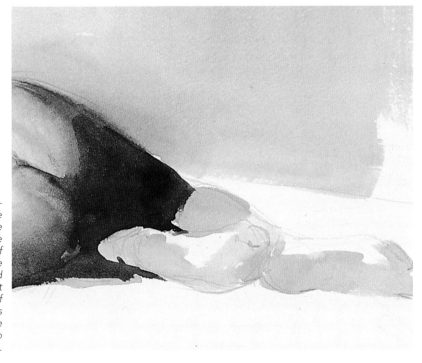

6. *To paint the feet the contrast of the shadow of the legs is intensified and the most luminous areas are defined: the right calf muscle and the soles of the feet. The latter are painted with a very clear burnt umber wash and a dash of blue. The brightest parts are left white. This is the best way to give relief to the highlights of the skin.*

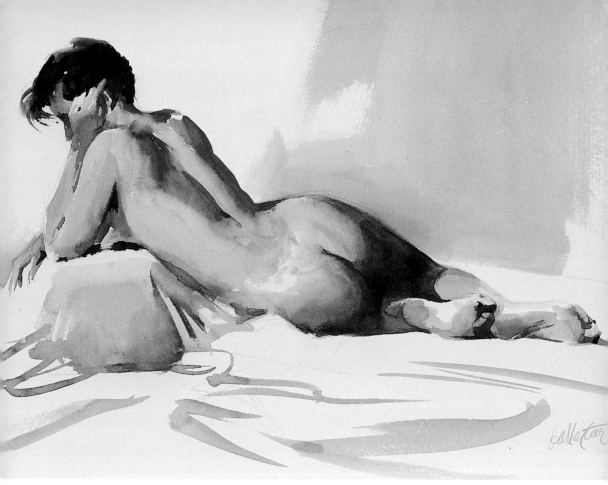

7. *The contrasts of the soles of the feet are intensified with small brushstrokes that outline the highlights of the toes. The tone painted before must be completely dry so that the colors do not mix. The brush is wetted and drained off prior to gently brushing the shadow of the legs so that they have depth. Finally, the inside of the leg is contrasted and the buttock is defined. Pay attention to the modeling of the buttocks: the brushstroke must be curved and must blend the colors without destroying the shadow as it softly superimposes the tones.*

SUMMARY

The fingers are not drawn in. They are defined only by the hair and by the shadow of the face.

The color of the back is dragged with the wet brush in a gradation, leaving the strip that defines the spinal column.

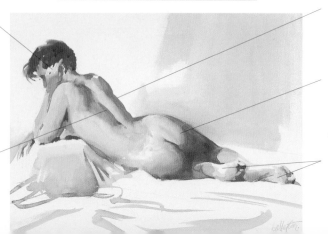

The figure is outlined by drawing simple geometric shapes into which the model fits.

On the buttocks the brushstrokes must be curved and blend into the colors without destroying the shadows.

The soles of the feet are painted with a very clear wash of burnt umber and blue; the most luminous parts are left white.

Quick sketches

SKETCH OF THE LANDSCAPE

O ne of the sketches that is held in high esteem by the enthusiasts is the painting of landscapes, because of the freedom and endless possibilities of adapting the subject to their own tastes and aptitudes.

The quick sketch is one of the best exercises that the watercolorist can develop. Continuously practicing it, one learns rapidly and intuitively the techniques of watercolor. Doing a sketch requires a great effort by the painter because speed and an ability to synthesize come into play. The details are left aside so as to give priority to the shadows and to the light areas. A sketch can be done in any place. All that is necessary is paper, a brush, and some watercolor paints.

▶ 1. *Clouds change their shape very quickly, this obliges the artist to work fast. By practicing the strokes proposed here, you will acquire skill in rapidly solving problems of color mixes and of the opening up of whites.*

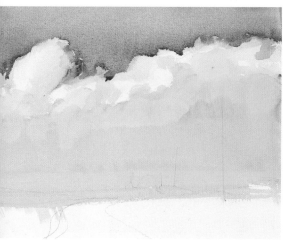

▼ 2. *A line is drawn that defines the limit of the clouds against the sky. A second line situates the horizon. Starting from this sketch, the form of the dirt road is indicated. Wet the brush with clean water and outline the shape of the clouds, without moving into the sky area. Finally the blue of the sky is painted. As the clouds are some-what wet, part of the color merges at the edges. This way the exremely sharp definition of the line is broken.*

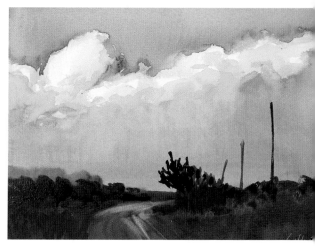

▼ 3. *A cold gray is obtained with a cobalt blue and sienna wash: this is for the contrast of the clouds. The shadows of the horizon are painted. The path is painted with carmine mixed with violet and sienna. With a clean, wet brush a clear space is opened up in the upper part of the path and in the mud in the foreground. The sketch is concluded with contrasts of dark green for the bushes on the left.*

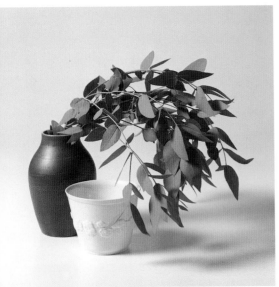

STILL LIFE SKETCHES

Most everyday objects allow the artist to do sketches immediately. Doing an exercise starting from elements in the home or garden enables the watercolorist to practice models and perfect geometric forms, like pots, vases, flower beds, and other simpler, but not less attractive, shapes, such as flowers, leaves, and other still life elements.

▶ **1.** *Any object in the house can be used to do a quick sketch, but there are advantages in choosing selectively. Here a sketch of a still life is proposed. Despite the elements appearing simple, it is much more difficult to draw and paint a geometrically perfectly defined object than a landscape or clouds. In this study special attention must be paid to the highlights and the contrasts among the objects.*

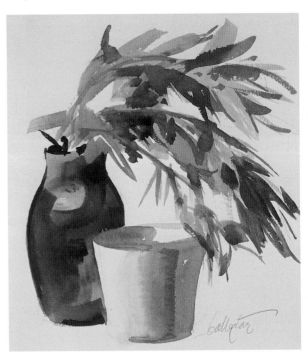

▼ **2.** *The sketch is made with a few strokes: precision is not necessary. The pencil need only indicate the principal lines. First the vase is painted with a transparent wash of burnt umber slightly tinted with blue. The flat brush is used to shade all the vase, while the flower pot is outlined and profiled. On this clear tone repaint a darker tone, leaving the highlight unpainted. With a greenish, grayish tone the shadow of the flower pot is painted.*

▼ **3.** *The flower pot is finished with the green used before. This stroke on top of the previous tone produces a dark cut. With the clean, wet brush merge the left side of this shadow in a vertical zigzag. Using the same color with which the vase was painted, the form of its left-hand side is now profiled. The leaves are painted with a wide variety of superimposed tones. The darkest are put in once the lightest have dried.*

FIGURE SKETCHES

A figure sketch is more dramatic than a still life one. It brings into play a higher number of more complicated recourses both for shadows and color. The figure not only demands much attention when drawing the outlines, so as to respect the proportions, but also when the skin tones are painted and the same with the clothing. Pay close attention to the simplicity with which the shadows that synthesize the lights are resolved.

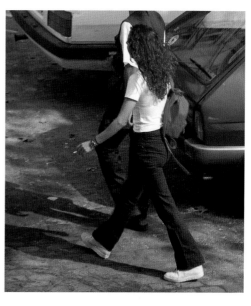

◀

1. The street is the best place to do movement sketches. Here a girl walking has been chosen. Special care has to be taken with the movement and position of the legs and of the arms. It is advisable to do the sketch looking at the real thing, but you can always resort to a photo.

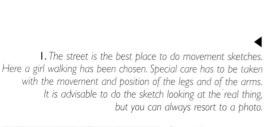

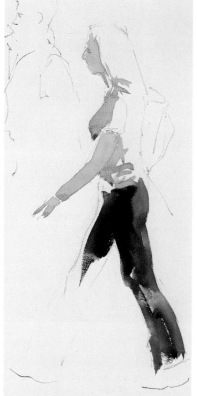

▶ *2. After observing for some moments the person who is going to be the subject of the sketch, do a quick pencil outline of the principal lines. When the model is moving, the initial sketch is more important because it is certain that when the painting is started she will have disappeared from view. If you study this just started sketch, you will see that the main points of interest are the form of the head, the curve of the back, the knees and the base of the feet.*

◀

3. The trousers are finished with the dark blue tone used to paint the dark area. The hair is painted with the original burnt umber, darker on top and mixed with an orange tone at the back. The rucksack is painted in two stages: first with a very transparent red, and afterwards with the same tone somewhat more opaque in the shadow zone. Finally, the small details that define the eyes, the mouth and the gray zone of the shirt are put in.

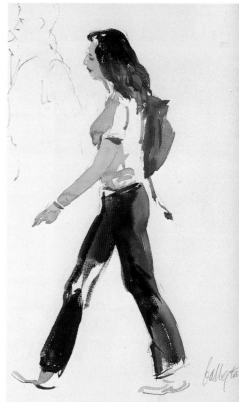

NATURE SKETCHES

As has been observed at the beginning of the chapter, sketches of nature are always freer than more demanding themes like still lifes or figures.

It is important when doing these sketches to reinterpret nature and to improve it as much as possible, varying the too perfect vertical, or horizontal, elements, such as the plane of a bridge or the verticality of trees. Do not hesitate to adapt the sketch to your interests, for at times the model is not always the subject of artistic expression.

▶ **1.** *If you contemplate a woodland area, like the one shown in the illustration, it could seem that it is a complicated subject because of the quantity of details that appear everywhere. One has to learn to see and to appreciate the impact of the image in just one look. Here, you can see a very symmetrical composition with a bridge dividing it across the middle.*

▶ **2.** *Here only the lines that demarcate the arch of the bridge and the river bed, almost hidden by the grass, are drawn. With a great proportion of yellow mixed non-uniformly with green and ochre all the surface of the picture is covered, but for the part below the arch. With a very luminous green the upper shadows are painted: it does not matter if it mixes with the background color. The trees in the upper part are painted with a fairly transparent dark green. The trunks on the right are outlined with a small touch of burnt umber on the dark green. The bridge is suggested with a burnt sienna wash. The area under the arch is painted with quite opaque, dark green.*

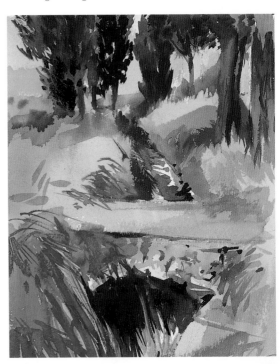

3. *Once the preliminary sketch is finished, paint the contrasts that make the terrain and the vegetation recognizable. The trees in the background are painted with small, supple brushstrokes that allow the light tones to be seen. Finally, paint the undergrowth with supple, gestural strokes in bile green, dark green, and bright green.*

Step by step
Figure sketch

This exercise is very interesting for any watercolor enthusiast, and there-fore not just a sample exercise. It goes further and aims at showing what a fast sketch is: fresh and spontaneous; something a beginning watercolorist should always practice.

The painter must respond rapidly to any movement, however complicated it may be. The only way to master each subject skillfully is through practice. To do a quick sketch we have opted for a dressed figure. As can be noticed, the pose involves no difficulty, but pay attention to the initial structure and the immediate solution of the light areas.

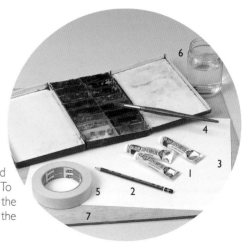

MATERIALS

Tube colors (1), pencil (2), medium grain paper (3), watercolor brush (4), tape (5), water jar (6), and support (7).

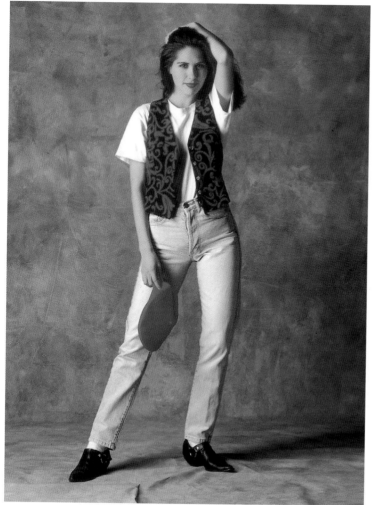

1. *If a lot of attention must always be paid to the subject, this is even more so with the figure. Before starting to draw you must try and comprehend the internal structure of the figure, and how the proportions of every part of the anatomy relate to the volume of the clothes on the body.*

STEP BY STEP: Figure sketch

2. Throughout this topic, different sketching processes were studied and the synthesis of complex forms using the least number of possible elements in their development were shown. If the examples of the topic have been followed, you will have observed how the forms that require the most details are resolved by taking advantage of the highlights. The face is painted with the same color throughout, although the left side is done with a light wash, this will be the most complicated area. Leave unpainted the highlights in the hair. The latter is to be painted with a mixture of red and blue, complemented with burnt sienna. The skin is painted with a very vivid yellowish orange and the highlights are left open. The raised arm is painted in an intenser skin color. Once the color is dry, the shadow areas of the face are painted with sienna.

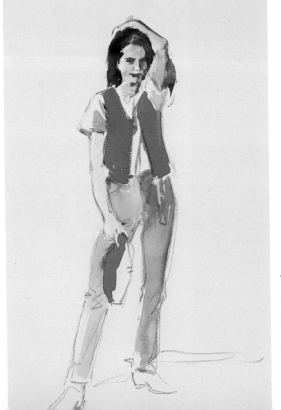

3. The figure is sketched with rapid strokes. Observe the proportion between the different elements of the body and how the principal lines relate to each other. Not one detail is drawn, and the lines that mark off the volumes are corrected as you go along. Once the drawing is completed it can be painted. In this case it is done in a chromatic order that allows continuous work in different parts of the body. The relaxed arm is painted with a very transparent wash.

4. It is the highlights that permit the volumes of the face to be suggested, and the change of tones denotes the different situations of the planes. With a vivid red the lips are drawn. The waistcoat is rapidly painted and the highlighted area of the beret. With purplish blue you paint the rear leg, taking color away from the thigh to suggest volume. The leg in front is painted in the same color as the other, but in a much more transparent tone.

5. *In this detail you can see the evolution of the study of the face and the upper part of the torso. The work is very quick and excessive details are absent. The pattern of the shirt is resolved with a few dark strokess that leave the same background color as part of the graphic effect.*

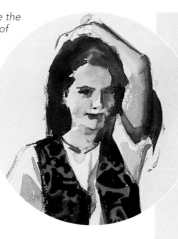

Care must be taken working with the folds and highlights of the clothes. These indicate the joints of the shoulders and the knees.

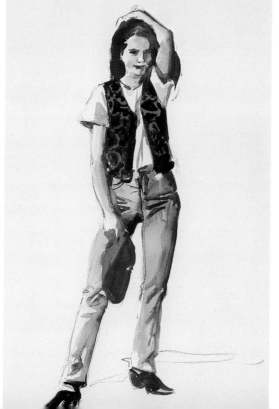

6. *Once the principal shading of the figure planes have been decided upon, start painting the contrast of the shapes and volume, working from the shadowed areas. In the study there is no modeling of the colors, only valuation of the different tones on top of the dry background. Each original tone receives a color of its own range, superimposed, to suggest the volume. The arm holding the beret is rounded off with some brush strokes of sienna, giving it shading. On the darkest leg the shadow is painted and the folds of the trousers are added with blue strokes.*

7. *In the way that the folds of the trousers have been painted on the left leg, now the same is done on the right. The original blue color is the base of the darker tone that is applied now. On the left leg the tone tends toward violet. The right leg is painted with a much purer, but highly luminous, blue. The shoes, with the highlights left open, are painted black.*

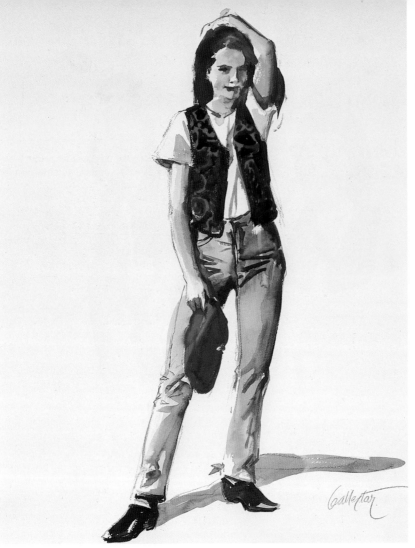

8. *Take off part of the orange color next to the thumb and paint in a new very transparent layer of the same color on the arm. All that remains to be done is the shadow cast on the floor. Thus the sketch of a dressed figure is concluded. The importance of waiting for the paint to dry has been seen, even in quick sketches when superimposing tones without them mixing, and how the synthesis of color reinforces the original drawing, starting from reserving the most luminous highlights.*

SUMMARY

The features of the face are very sketchy, but perfectly define every area.

The T-shirt stays white in the brightest parts.

The color of the waistcoat is done in two stages: first the base and then the dark shadows.

On the face the tones are put in around the highlights that are reserved.

The initial scheme is made in pencil, quickly and concisely.

The trousers are done in various stages. The folds are painted at the end.

14

Techniques for landscapes

WATERCOLOR ON DRY AND WET BACKGROUNDS

Trees can have many shapes, but they are easily represented with a simple combination of shadowing. A watercolor must always be painted from light to dark. After outlining the area where the trees must go, a light green wash is applied, and then the contrasts are put in.

When the surface is wet the paint spreads. On a dry surface, on the contrary, the brushstroke can be controlled. The two techniques facilitate the realization of all kinds of landscapes, although what is important is to use the correct technique in the right time and place. If the two techniques are used together with a certain ability this can pay dividends for the landscape painted, or trees, reflexions or atmosphere in the background of the picture.

▼ To do the wash, dip the brush in water and load it well before touching a little color with the tip on the palette. Then pull it across the surface, exercising some pressure so that the water is released. Move the color in the water to dissolve it and make a homogenous mix.

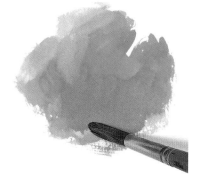

▼ Drain the brush; there must not be too much water. Use the wash to color the area destined to be the top of the tree. The brushstroke has to be uniform and cover all the area.

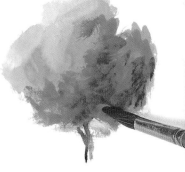

▼ When the lightest color of the tree is almost dry the middle part is shadowed with a tone somewhat darker than the original. This is done with supple brushstrokes. The middle tones allow the highlights to be isolated. Finally, with very dark brushstrokes, the shadows are painted over the dry background.

▶ If you want to paint a far-off group of trees the process is similar to the one explained at the beginning: the shades of the first tone have to be together. The medium tones isolate the light points. Finally, darker strokes over the dry background paint in the shadow areas.

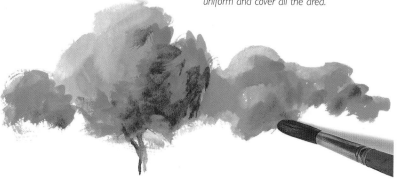

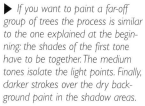

TREES IN THE DISTANCE

In general, the backgrounds of landscapes, like the sky or the water, are painted on wet paper. On this surface, tone gradations and merging of colors can be done which show well the luminosity and atmosphere of the landscape. Once the background tone has dried, different effects are realized to paint trees and reflexions.

▶ **1.** *Before doing anything, the paper must be fixed with tape to the support board. When the paper is wetted it can easily buckle. Fastened by its four corners it will remain tense and tight. The paper is dampened with a sponge, in this way you avoid soaked areas appearing on the surface. On the wet paper, starting from the top, a blue wash is applied. The brush spreads the color from above in strokes that cover all the paper. The further down you go, the less color is spread.*

3. *On a dry background it is possible to do clean and precise strokes. The brush is dipped in the watercolor, which can be watery or denser, before adding new tones or painting trees. One simple way to solve the problem of the foreground is as shown in the picture below: in front of the background some branches are painted in with few strokes and the leaves are depicted with supple strokes.* ▲

▶ **2.** *As many gradations as necessary can be done. The background can be used as a base for any other color. Be careful not to darken the background too much as the transparency and luminosity of the paper would be lost. Wherever a highlight or a lighter color is going to be placed, this area must be left unpainted. On top of the previous background, once dry, a dark gradation is painted. Turn the wood support around so that horizontal brushstrokes can be painted more easily. When you paint on a vertical support the watercolor tends to run down. To avoid dripping, use the brush to pick up excess water and to spread it.*

WHITE IN THE SKY

As has been studied from the beginning of this book, watercolor is very transparent, to such an extent that the white of the paper comes through the color of the paint. Clouds in the sky stand out for their whiteness. They can be shown in various ways, but what is important is to leave the cloud area white.

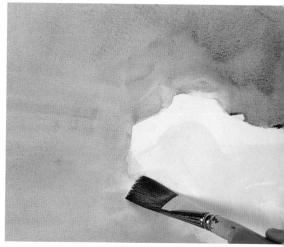

▼ **2.** *The base of the background color, once dry, allows the sky to be painted, for the blue is darker than the first wash. Thick cloud areas will be left untouched. The blue of the sky can be done homogenously.*

▼ **1.** *When different intensities of white are desired, it is sufficient to apply at the very beginning an almost transparent wash and to leave the most luminous areas unpainted. If you want to harmonize the white so that there are no breaks in the application, the background must be wetted with a sponge or with an almost dry wide brush. Where you do not wet the paper the color of it will remain intact. The aim is to make the color very transparent, just to the point that it slightly alters the color white.*

Wet zones are soaked up better with brushes that retain a lot of water, that have a dense tuft and natural hair. To spread color in defined areas, or to do fine white lines, a sable hair brush can be used. Its tip is pointed and makes easier the opening up of small details, while the hairs permit more water to be absorbed.

3. *Leaving aside the reserves that are not painted, while the color is still wet, part of it is absorbed with a clean, dry brush. The more times the brush is dragged over the surface, the more water is removed. After every stroke it must be washed and dried with a cloth. Once the white areas have been opened up on the paper, a new blue wash is used to outline the shape of the clouds. On this background new clouds can be started. These new clouds will always be more spongy than those outlined with the brush.*

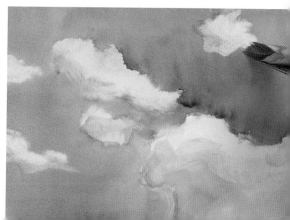

REFLECTIONS ON THE WATER

To get a good result, it is necessary to bear in mind that the reflections painted in watercolors depend fundamentally on two things: the background of the composition and the dark color that is used for the reflection.

Earlier we have seen how a gradation can be created. It is important that the background of the reflection is a gradation done previously. The shimmers have to be done on a completely dry background so that the paint does not run.

1. *Throughout this chapter we have studied the majority of the techniques necessary to paint a river landscape: gradation in the background, trees and vegetation in the distance and the sky. The zone of the water always has to be painted somewhat darker than the sky. The brushstrokes have to be long and continuous so as not to make breaks in the superimposition.*

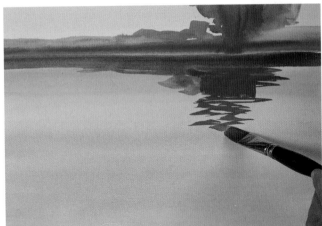

▶ 2. *Once the trees and shore have been painted, in the area where the water is painted, make some horizontal brushstrokes with the color used for the trees. In the area near to the shore, the mass of color is much darker and denser. With the color of the trees, the shimmer zone is darkened a little. As the reflection is reduced it is painted in zigzag and with very thin brushstrokes.*

▶ 3. *To finish the reflections, once the background is totally dry, their contrasts are indicated in a darker tone than at the beginning. The darkest brushstrokes have a space between each one so that the background color can show through.*

When the paper is touched with the fingers or rubbed with an eraser it is possible that it becomes greasy. The wash does not hold to an oily surface. To get round this problem the paper is sprinkled with talcum powder. When it is taken off you can paint with the certainty that the color will flow correctly.

Step by step
A landscape with reflections on the water

To become a skilled landscapist takes years of practice. However, starting from a few basic notions it is possible to paint acceptable landscapes. In this topic we have studied some of the most common elements of landscapes, the majority of which, like creating skies and trees in the distance, can be applied in general landscapes. Painting reflections is, naturally, part of river scenes and sea views. In this step-by-step exercise, a landscape that can seem to be complicated at first sight has been chosen. Really, it is not so difficult. All the techniques used are explained in detail in the chapter.

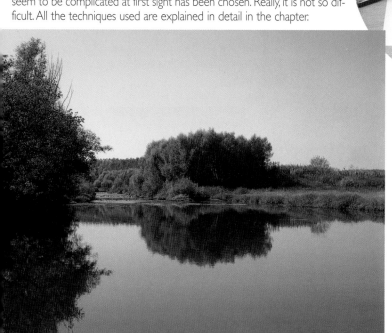

MATERIALS

Tube watercolors (1), palette box (2), medium-grained watercolor paper (3), watercolor brushes (4), flat brush (5), pencil (6), cloth (7), tape (8), board to hold the paper (9), and jar of water (10).

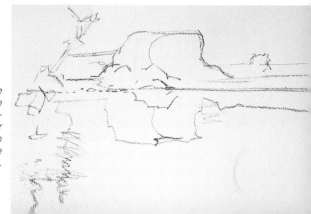

1. *The principal shapes are drawn with very precise strokes. First the line is drawn that separates the water and the vegetation. Above this line the principal volume of the trees is sketched. In the water zone the same drawing is made, but upside down as if it were seen in a mirror. On the left-hand side the basic outline of the vegetation is sketched in.*

2. *As was seen in the theoretical part, the background is created with gradations and merging colors with long, horizontal brushstrokes. First of all, the paper is dampened. In the lower sky a very light yellow tone is painted. Before it dries, a blue gradation is painted in the upper part. In the intermediate part a somewhat darker blue tone is applied. The lower part is realized with a mixture of ochre, sienna, and green.*

When working with techniques that combine wet and dry paint a blow-dryer can be used to quickly dry the paper. Do not get too close with the dryer because droplets can form in the wash.

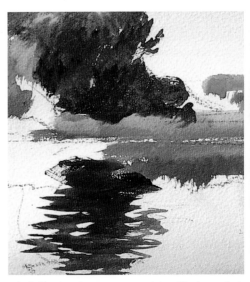

3. *When the background is totally dry, you can rest assured that painting on top will not mean that the colors merge with each other. As was seen at the outset of the topic, the trees are painted in several phases. First, a clear wash is applied in a uniform manner and then the background of the trees is painted. After, in a medium tone some areas are shaded with vertical brushstrokes. The river bank is painted with dry pasture, using a mixture of ochre and luminous green, in long brushstrokes. Above the line of the river bank an extended orange stroke is drawn.*

4. *Following the process explained in the technical section, the reflection in the water will now be painted. The wash that was done at the beginning presents a soft gradation into the white of the paper, which coincides with the lightest part of the bank. Starting from the shore, long brushstrokes are applied with very dark green. In the upper part of the reflections these brushstrokes almost touch. The further down the paper you go, the finer and more spaced out the strokes become.*

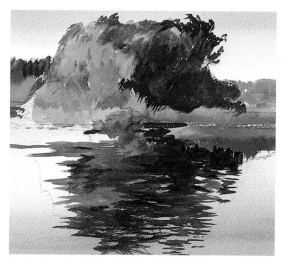

5. On the right-hand side of the reflection the tones are painted darker, the lighter greens are on the left. In this area mix in a more luminous bile green. Use long, fine, horizontal brushstrokes repeatedly on the dark part of the reflection, and sweep several times across the darkest color of it. In this way the two tones are mixed together, although the first has dried. Once the light part of the reflection has been painted, the lines of the lower part are laid down in a somewhat darker tone. Notice that the part of the reflection which is illuminated coincides with the illuminated part of the trees.

6. On top of the green foilage of the trees, paint in new brushstrokes that help to make its shape clearer. Blue is introduced into the first row of trees on the left, while the trees in the background are painted with vertical brushstrokes of dark green. Continue with the zone of the reflection. Just as there are two different planes for the trees, the same is the case for the reflection. The principal part of the reflection is finished in the same luminous tone as the trees. Once dry, the reflection of the background trees is painted in quite dark green and with horizontal brushstrokes. Do as was explained in the technical part: on top of the blue sky paint supple strokes that form the branches.

The reflection on the water must be similar in size to the trees that make it; for they are at the water's edge. If they were further away the reflection would be smaller.

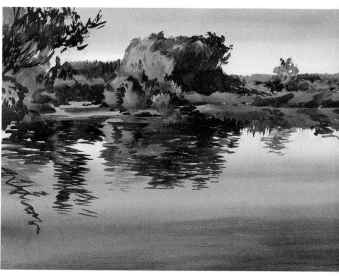

7. In the forest area on the left, paint in shading vertically in an orange yellow, somewhat sullied by green. On the right-hand side paint the luminous green tree, and around it paint some dark shading to give depth to the background. Also, in the river bank area paint a dark-toned strip that separates the greenery and the water.
The reflection of the bush is painted with a few strokes of the same color.

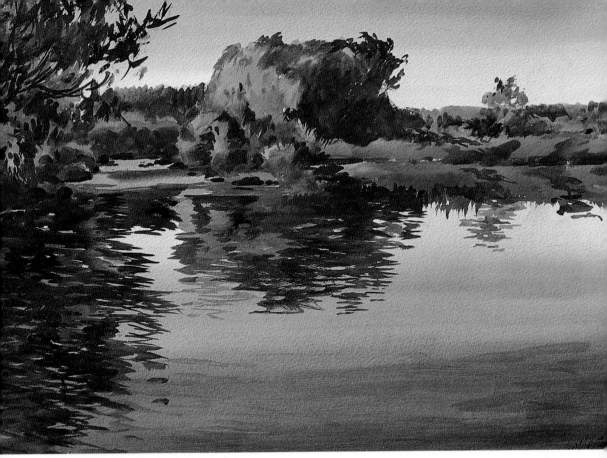

8. *The reflection area on the left is finished off with numerous sweeping strokes. Blue and green are used in such a way that they do not blot out the luminous tones of yellow that are the base. As you move away from the reflection of the upper part, space the brushstrokes out* more. *Apply brushstrokes to the greenery in this area until the background is almost totally covered. Finally, in the near foreground finish the water with several very long brushstrokes in blue that merge into the brownish gray background.*

SUMMARY

The medium tones of the trees have been intermixed with dark touches so that the volume can be perceived.

On the dry background lines and small shadows have been painted for **the branches and leaves.**

The reflections have been painted with fine horizontal brushstrokes. As you near the end of the reflection, the strokes become more widely spaced.

A quite dark, dense green has been used to paint **the trees** over a luminous tone.

The background has been done using very clear gradations in water on wet paper. Use a flat brush with long, horizontal brushstrokes.

When the color is dry several tones can be used that will mix well with this one. You have to be insistent with the brush; dampened in a dark tone. The clean, wet brush used over time can open up **luminous highlights.**

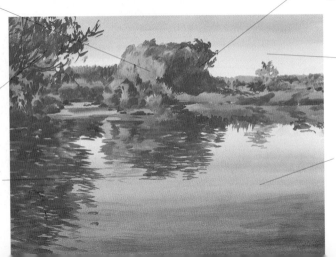

15

Mountain landscape

STRUCTURE OF THE LANDSCAPE

The first step is to plan the basic structure of the landscape. To start off, a good sketch must always be made. Only when the drawing has been done can color used. In this example, the color that is going to be used in the sky is bluish gray. To get this color in the palette, mix a dark purple with a dash of black. Starting from this mix you can obtain all the gradations possible.

The mountain landscape is without doubt one of the most interesting subjects that can be done in watercolor. It stands apart from other subjects, like the figure and still life, for it does not require a great deal of rigor in its proportions, and this permits more liberty in the treatment of the technique. However, it still can not be said that it is easy. With a little practice works can be done similar to that shown here. Above all, the enthusiast must learn to alternate the techniques on dry and onto wet.

▶ 1. *The upper part of the picture is painted with a dense color in an ample wash that leaves some areas clearer and more luminous. The terrain is painted with a variety of very bright green and yellow tones to show the contrast with the sky.*

2. *The lower areas are painted with brighter tones than the higher ones. With the wet brush stretch this tone until the sky is completely covered. In the intermediate area much darker tones are painted, without letting them blend into the background. Finally, the darkest colors are painted with tones that come close to black. Dark tones are also painted in the lower part and the furthest plane is left strongly illuminated and contrasting with the background of the sky.*

THE FIRST SHADINGS

Before starting to paint, it is necessary to do the drawing of the landscape. The clouds do not always have to be drawn; sometimes they are painted directly, above all, when the forms are abstract or they are done starting from gradations. In the mountain landscape the terrain requires more attention than the clouds, as the forms are very complicated, and spaces have to be reserved for light tones or luminous whites. The first shadings, as is usual in any watercolor work, must always reserve the clearest, and most luminous, zones.

▶ **1.** *The first color that is painted is very luminous, an almost transparent wash. The aim of this shading is to break the white of the paper so that the clouds stand out from the clearest parts of the mountain landscape, where the snow will show pure whites. This wash will be the base of the dark color that will paint the upper area: a lead gray that will cross the picture and blend into the background wash.*

▼ **2.** *The most luminous zones are gradually surrounded, little by little, by the darkest. When the background is dry, a very luminous gray wash is painted below the upper dark area. The color is watered down in the palette until it is transparent and a little blue is added before painting the clear grays of the clouds. Before it dries, paint the blues of the sky.*

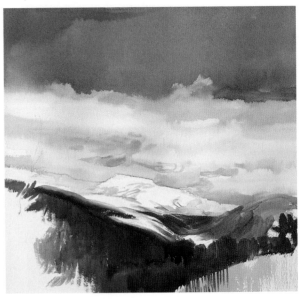

▼ **3.** *After the first shadings in the sky, paint the brightest mountains in the background on the right and leave reserved the lightest areas. Here, the white of the snow will stand out against the blue of the sky. In the far mountains, the contrast on the snow is painted with small, almost transparent green stains. The foreground is shaded with very dark brown.*

DARK TONES AND CONTRASTS

When the most transparent colors and tones have been painted the first contrasts outline the most luminous zones. It is now that the dark tones and densest contrasts have to be applied. In this way the most luminous reserves take on the brightness and presence necessary from the start.

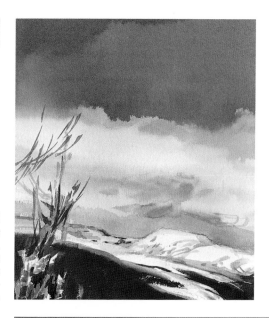

4. Having set out the initial tones and the most luminous zones, intensify the contrasts to do the same for the white reserve in the tree on the left. These dark shadings should be painted with care, in such a way that the white of the paper appears to be painted. With very fine brushstrokes the shape of both sides of the branches is outlined. Afterwards, the background is painted with small strokes in very dark tones.

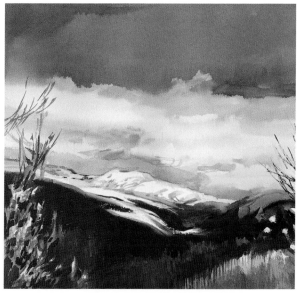

▼ *5. The tree on the right is done in the same way as the one on the left, but with a much lighter gray. On the mountains in the background, certain areas are darkened with a blue tone. The blue of the background is now seen as snow in shadow. The blues of the lower part of the sky are redone. Give a profile to the form of the mountains, which are now strongly illuminated by the contrasts.*

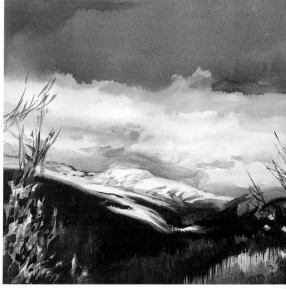

▼ *6. With different tones of an earth color, the dark areas of the foreground are painted and the white branches of the tree on the right are defined. This can be the final touch to this beautiful mountain landscape in which the key role has been give to white as a counterweight to the dark contrasts of the earth and the clouds.*

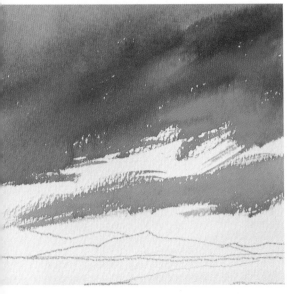

DEPTH AND COLOR

When painting outdoors, it is best to choose those hours when nature reveals itself in all its splendor. With a little luck, one can be present during those marvelous moments when the sky takes on an almost unreal hue. These moments have to be used to the full. In this exercise one of these skies charged with light and color will be painted.

▶ 1. *To begin, the form of the landscape has to be drawn to establish the horizon line that separates the sky from the earth. The mountains are also sketched as in this picture they are the most distant elements. The irregularities in the terrain help to mark the differences between the planes, for the proportions vary according to the distance. Starting from the top, the sky is painted in a violet wash, transparent in the highest zone and somewhat denser in the lower part. Before it dries, it is painted with an orange color. Violet and orange blend giving each other power. Wherever you want to do a well-defined brushstroke, the background must be dry.*

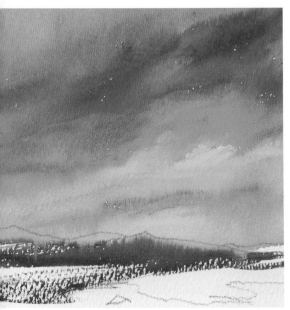

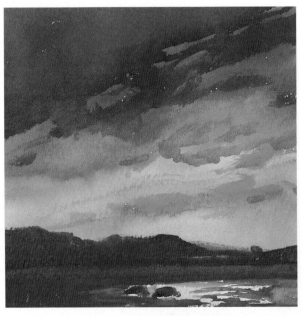

▼ 2. *On top of the orange, the zone that remained white is painted with yellow ochre. Where there is contact between the two colors a mix is produced due to their moistness, although they do not completely blend because the first color was already nearly dry. However, in the central area, which was the last to be painted, it blends completely with the ochre. Beneath this color-loaded sky, the painting of the landscape is begun in a very dark violet color.*

▼ 3. *While the sky colors are drying, different touches are made to model the clouds. The violet is contrasted until it is rather dark. This color gives an edge to the clouds and to some clear parts on the upper right side. With cadmium red some traces of light are painted in the sky. The earth is finished off with very dark colors, thus strongly contrasting with the sky. Some areas are left completely open to represent the brightness on the surface of the water.*

Step by step
Mountain landscape

The watercolor is completely transparent, its colors must be superimposed on top of one another according to their opacity, in such a way that the most luminous zones are reserved by the darkest. The opening of whites allows the luminousity to be restored to a previously darkened zone. This technique, added to the reserve, facilitates all types of textures on the terrain. The mountain landscape means that multiple techniques which make evident the transparency and different textures are necessary, both on dry and wet backgrounds in order to blend the tones. This is not a very complicated exercise. However, it demands that the enthusiast pays a great deal of attention to the definition in each area of the image.

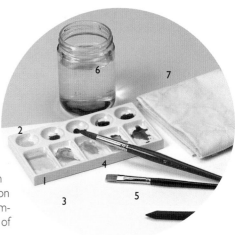

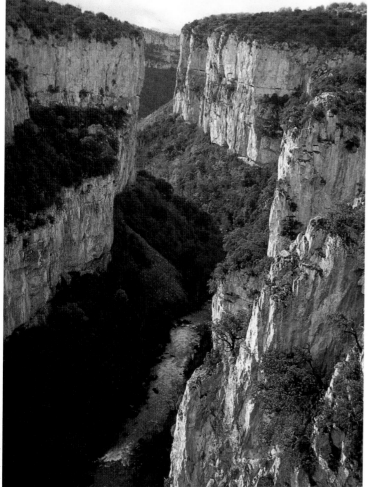

MATERIALS
Watercolors (1), palette (2), medium grain 250g paper (3), watercolor brushes (4), charcoal (5), water jar (6), cloth (7).

1. *The first lines must be very concise, without any type of decoration or shadow. To draw with a stroke that can be corrected without problems charcoal is normally used. It is much more easily erased than pencil. Any mistake can be wiped out, hardly leaving any trace.*

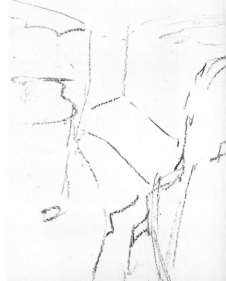

STEP BY STEP: Mountain landscape

2. *The painting is started on wet paper. To do this, it is necessary, first, to wet the surface of the paper with a brush loaded with clean water, and to spread the dampness over all the surface. When you are working on wet, it is very important that the paper is placed in a vertical position so that the color slides downwards into the moist areas. Before the background is dry, paint the walls of the cliff ochre and the vegetation of the upper area green.*

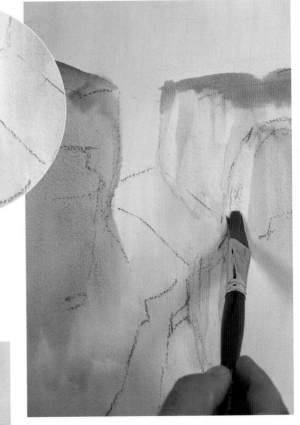

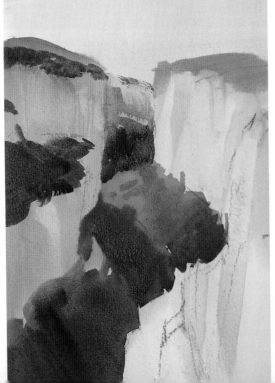

3. *With the clean, slightly wet brush on top of the still fresh background, make the first openings of white. The brush is passed in vertical strokes over the walls of the cliff until the first clear zones are obtained. Every time the opening of a clear space is done, the brush must be cleaned and drained before restarting. If the underlying color is too wet, the recently opened area will be stained by color. This is why a lot of attention has to be paid to the drying time of each color.*

4. *Once the most luminous whites have been opened, the surface of the paper has to be completely dry before putting on new layers, so as to avoid the mixing of colors. When the background is dry, dark colors can be painted in the upper cliff area. First, blue tones are put in, and then on top of these the brush is passed to open up clear spaces. Pay attention to the colors of the palette: two green tones are used, one clearer and more luminous for the background of the ravine, and another darker one for the shadows.*

5. *The river is painted in very transparent cobalt blue. However, be careful: the reserve must be left for the highlights.*

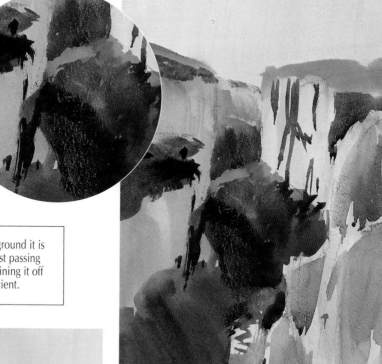

On top of the wet background it is easy to open whites. Just passing the clean brush and draining it off repeatedly is sufficient.

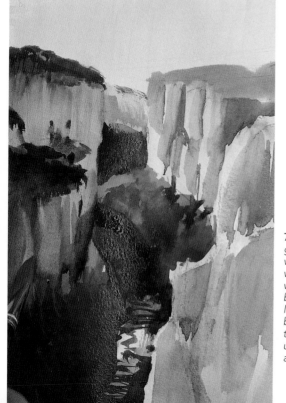

6. *The colors used to paint any mountain landscape can be varied as you wish. Depending on the distance and the texture, the colors that are painted in the mountain can include any tone or mix. Here, for example, violet is mixed with cobalt blue to paint the rocky background wall on the right. This tone is then watered down and the dark rocky portions of the nearest cliff are painted.*

7. *In the river, beneath a dense thick blue layer, glimpses can be seen of the former tones next to the white of the paper. The greenery on the left contrasts with the dense, dark greens. The painting of the left wall is started with a green mixed with ochre. The background is now completely dry so a transparent layer, sufficiently tinted to change the color tone, can be painted. Before this new layer is completely dry, the brush is drained and new clear spaces are opened up with the brush. Persist until very luminous lines are achieved.*

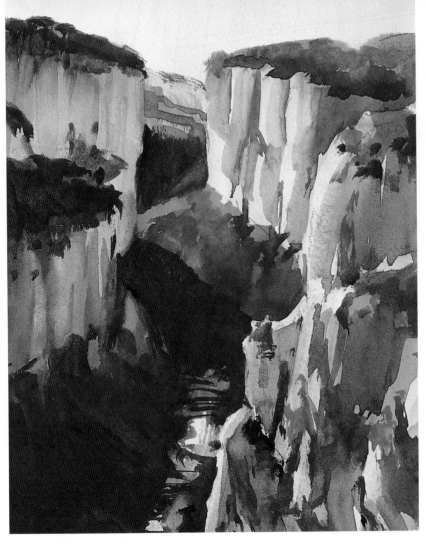

8. *Once the last clear spaces have been opened up on the paper, the densest contrasts are painted on the rock walls. In some areas ochre is used. Before continuing, allow it to dry to avoid the color running. Then paint a dark blue, very controlled wash without insisting on top of the lower layer, thus avoiding softening or spoiling the color. All that remains is to open up new, very luminous whites with a clean, wet brush in some portions of the rock face.*

SUMMARY

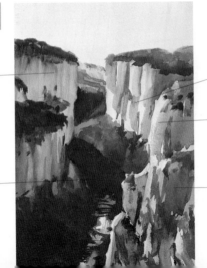

In the upper area of the ravine, the greenery is painted, allowing it to merge a little with the color of the walls.

To paint the dark zone that define the rocks the background has to be completely dry.

The background of the ravine is painted on wet.

On top of the rock faces, clear spaces are opened up with a clean, slightly wet brush.

The last white openings on the right side of the rocks help to increase the strength of the tone contrast.

Texture of the skin

THE COLOR OF THE SKIN

The color composition of the skin is obtained with different colors, tones, and reflections. While the skin is young, it reflects the light uniformly and with precise highlights. In contrast, the texture of mature skin no longer reflects light uniformly but intensifies the texture and the shadows cast by the wrinkles over the features of the face.

The painting of the skin is an advanced value related study. Carnation, the color of the skin, is one of the most complicated challenges in watercolor. The examples that are dealt with on these pages are accomplished works. In this topic we will offer the fundamental techniques to solve one of the most common problems related to the figure and portrait: the skin and its texture.

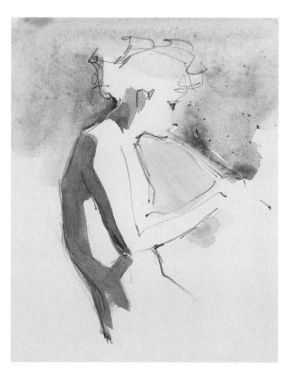

▶ 1. In this illustration, the shadow is only a small tonal difference with respect to the light zones. In contrast, in the light areas sufficient highlights have to be opened up so that the carnation reflects the light. The texture of the skin is begun by painting the carnation but reserving the most luminous area. The tone applied to reserve the brightest areas of the figure is a highly transparent carmine, Naples yellow, and a little ocher, although it does not exactly have to be so. What is important is that the carnation has warm and very transparent tones.

◀

2. The very clear tones can be painted by brushing the colors over the dry background, cutting out the highlights. In some areas, a blue layer can be painted to suggest a finer and more transparent skin, or the highlight absorbed with the clean brush. If the paint is dry, repeatedly passing the brush will enable whites or clear spaces to be opened up, perfectly outlined. Here, the texture of the skin has been done by blending two tones of different colors. The shadow is painted by blending the tones in the areas where it touches the tone below. This blending must be minimal and very controlled.

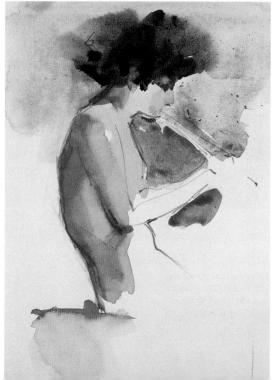

TEXTURE OF THE SKIN

Besides being able to represent the texture of young skin, it is important to master modeling if one wants to give a correct texture to the skin tones of any figure. In this process we will study in detail each one of the steps that must be followed. This exercise shows one of the many possibilities that can be be developed in watercolor.

> Paper is very important in watercolor technique if the work is being constantly corrected.

▶ 1. *The first layer will be the base for all the texture of the carnation skin tones. This base color will allow all the later applications to act like a filter, modifying the original colors according to the opacity with which they are painted.*

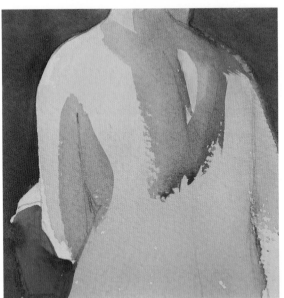

▼ 2. *The background is darkened and the principal shadows are painted. The colors used are the following: sienna on the back and burnt umber on the arm. This step and the next must be realized before the color dries on the paper so that the tones blend. It is important to control the moistness of the paper to avoid unnecessary wetness.*

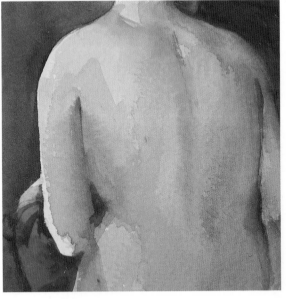

▼ 3. *Shading is spread with the wet brush, somewhat insistently, to blend it into the background. The areas reserved on the skin are the shiniest areas. This is an important question to bear in mind in all carnation work. The highlights must be reserved from the start so that they do not have to be opened up later. Finally, the shadows are softened by sweeping the wet brush over them. The sharpest contrasts are defined with a soft profile. In this way the figures are outlined and the texture of the skin acquires the brightness and volume necessary.*

FEATURES OF THE FACE

B esides being able to represent the texture of young skin, it is important to master modeling if one wants to give a correct texture to the carnation of any figure. We will study in detail each one of the steps that must be followed. This exercise shows one of the many possibilities that can be developed in watercolor.

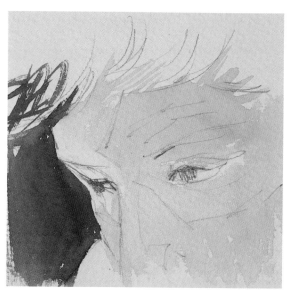

1. The drawing must be as perfect as possible, correcting any possible errors. Each part of the face is drawn with the maximum precision, bearing in mind the proportion between the features. In this work the planes are very defined. The background is painted in a dark tone to put the face into context. First, an almost transparent layer of sienna is painted over all the face.

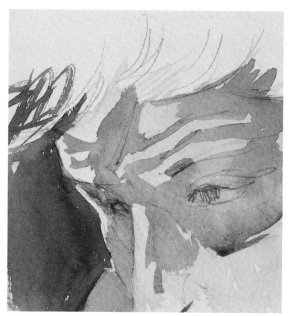

▼ *2. It is necessary to respect the drying times between the layers, both when you want to blend two tones, or when you want to superimpose them. The forehead is painted in orange mixed with a little sienna. The wrinkled area is left blank: to do it, the background has to be dry. As the color descends down the face carmine is added. The reserves of the wrinkles on the forehead are made, painting around them in an orange tone.*

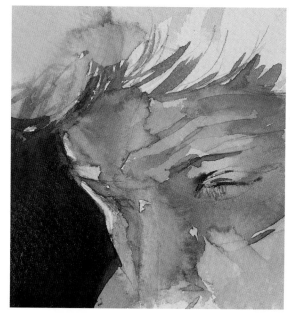

▼ *3. The wrinkles of the forehead and the nasal septum, reserved beforehand, are given a yellowish layer. When the colors underneath are dry, they are retouched with a wet brush to merge the tone of the furrows and to define the forms of the shadows. When the brush is passed over the zone to be blended, the fusion of the tone on the background is controlled. Adding new tones could take part of the background away (on the nose septum). New tones are superimposed on the background to intensify the contrast (on the forehead wrinkles).*

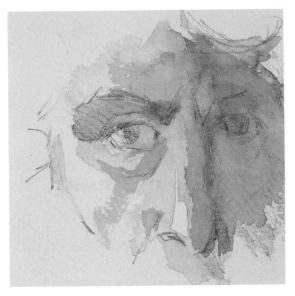

HIGHLIGHTS AND SHADOWS

The highlights on the skin depend on its tension and the amount of light that falls on it. Some areas tend to shine more than others, above all if the skin is smooth or slightly greasy like on the nose or forehead. The highlights of the skin have to be reserved from the start so that the dark areas can be put in once the first layers are dry. With the first color intervention, the light and shadow tones can be established in a luminous way.

▶ 1. *At the beginning the luminous areas of the face are reserved. The background wash is resolved with two different tones to separate the light planes. When the drawing is complete, the light area is painted with a very luminous yellow ocher tone. The maximum highlight area remains reserved. The most intense point of light is on the nose. A dark layer is painted in the shadow zone. In this way, the highlight appears even brighter, making the reserved zone appear much more luminous.*

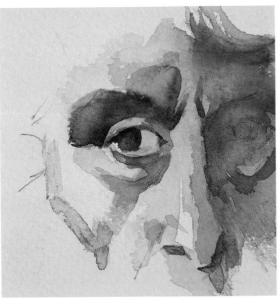

▼ 2. *Increasing the shadows of one area of the face produces a contrast with the adjacent lighter areas. To balance the luminosity of the skin, a strong contrast is painted with sienna in the upper part of the eyebrow. This gives depth to the eye. Watering this color slightly, the shadow of the nose is gently darkened. Its highlights now appear more luminous. On the forehead, a brushstroke of very transparent red gives a more realistic look to the skin texture.*

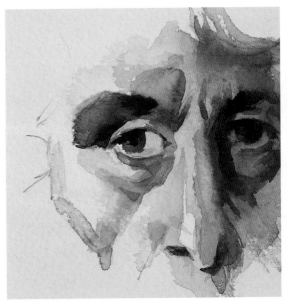

▼ 3. *The final contrasts define completely the texture of the skin. These contrasts are obtained with a very pure sienna which is used to profile the darkest zones of the face. As can be seen, the highlights of the skin have not been touched since the start, despite the numerous layers that border on them.*

Step by step
Portrait of an old man

The texture of the skin, its carnations, and the reflections of light on the face are learnt with continuous practice, in which the possibility of copying famous artists should not be ruled out. If, moreover, as in this case, a model is available, and a record of the steps which the artist followed, it is guaranteed that you will learn. The model chosen is an elderly person, portrayed against the light. His face, his features, the skin texture, and the way the light falls on the model make this a perfect example for this exercise.

MATERIALS
Watercolors (1), stucco watercolor paper (2), pencil (3), watercolor brushes (4), and water jar (5).

1. *The first step requires that the watercolorist makes a great effort to do the drawing well. If it is too difficult to do, he or she can resort to tracing. In this exercise a simple outline is not enough: it is advisable to take the drawing further so that when color comes in, it is integrated into a perfectly defined structure. The features must be sharply defined and the light areas and the most prominent wrinkles schematized with neat lines, without either grays or fuzziness.*

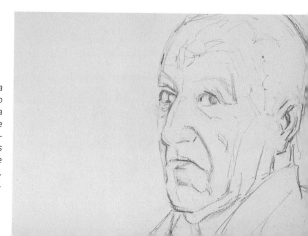

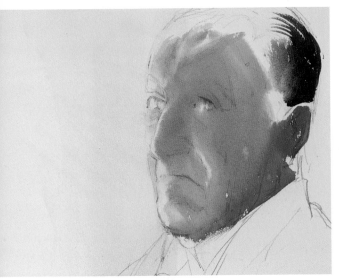

2. *Starting from the perfectly constructed drawing of the head, the skin base is painted. The base color is elaborated in the palette with orange, ochre, and sienna. You have to paint over the dry background sufficiently rapidly so that the tones do not separate when drying. All the face is painted without creating sharp tone changes. The principal highlights are left reserved. The hair is painted with lines of Payne's gray.*

When a portrait is realized, it is necessary that the first rough drawing is sufficiently complete and contains all the elements that precisely define the features of the face, thus allowing easier future development. It is vital that the finished portrait has a good likeness to the model.

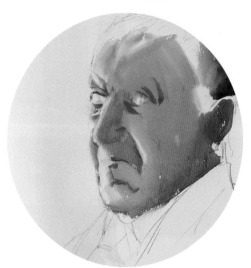

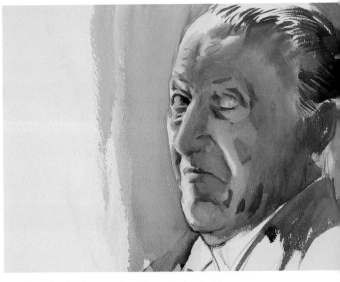

3. *Before the base color is completely dry, the first contrasts are painted with burnt sienna. This intensification of the shadow is only done in the darkest areas of the face. The skin base is fundamental to proceed with the successive colors. With the color used to darken the nose, the wrinkle of the eyebrows, the chin and the upper lip are precisely painted. Due to the effect of the simultaneous contrasts, when putting in the dark spots, the highlights gain intensity.*

4. *Allow the background to dry completely. Now you can paint on it without the colors mixing. The right side of the face is darkened with a very luminous gray wash. This phase is extremely delicate: start on the forehead, reserving the highlights. At the same time that the gray area is painted, the lit up part is profiled, outlining the upper part of the eyebrow and cheekbone. The wrinkles of the forehead are depicted with soft, quick brushstrokes of the same color. The wrinkles of the chin and of the face are painted once the gray background is dry. Hence the colors will not mix.*

5. The background must be dry before starting the work on the texture of the skin. As we are using heavy paper, it is possible to do mergings and washes on top of previous layers without the quality suffering. The dark shadows of the skin are intensified with burnt sienna, and the profile of the shadow is reinforced around the eyebrow zone, in the eye, and on the cheekbone. The shadows that suggest the wrinkles are gone over again until they expand and blend. The shadow of the cheekbone is done in a triangular shape that merges around the mouth.

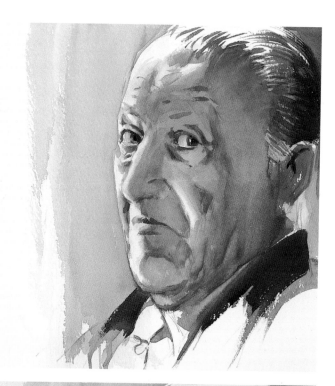

6. Mix wash of burnt sienna and umber and use the resulting color to contrast the principal wrinkles of the face, leaving in reserve the brightest parts. The orange color that was used at the start shows through all over the face in the transparencies of the different colors. This base color is covered in some zones by the wash, in others it remains intact. The principal highlights have been reserved since the beginning of the portrait. All the right side of the face and the shadow of the lips are darkened. In this way the volume of the face is accentuated. The wrinkles of the forhead are depicted with fine brush strokes.

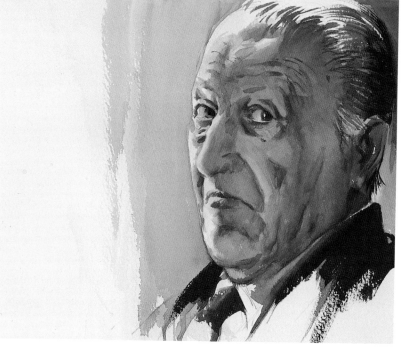

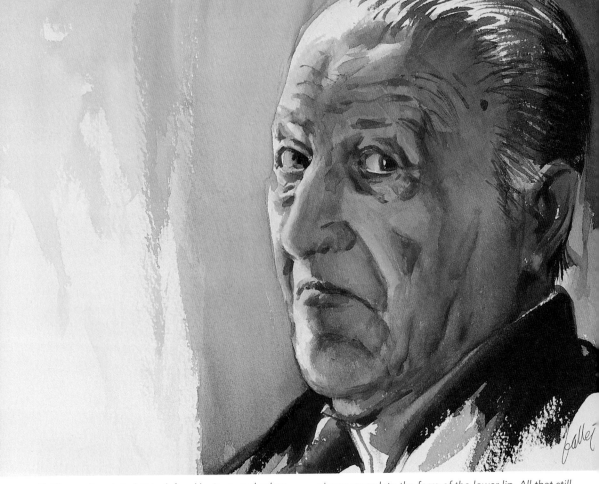

7. The ear is painted: it is defined by its own shadow. The wrinkles of the forehead are darkened, thus increasing their volume. The background color remains as the luminous part of the wrinkles. The right eyebrow is darkened with rapid and spontaneous brushstrokes. Very watery carmine and a little sienna complete the form of the lower lip. All that still has to be done is a very transparent layer over the background, and then this painstaking piece on the texture of the skin is finished. Although it has been a complex work, many concepts have come into play. They will be useful later.

SUMMARY

The dark part of the shadow is transparent and outlines the face. On top of the right paper, the tones can be fused over the completely dry background.

The drawing is perfectly defined before the color is approached. The skin does not have a unique color, it depends on the many colors that surround it.

The first color application is an orange wash that is the base of later colors.

The color of the clothes in a portrait does not have to be true to the reality. They can be toned according to the needs of the image and to make the face stand out.

Animals

BASIC STRUCTURE AND THE DRAWING

The first thing that the painter must resolve before painting any animal is the study of its anatomy. A simple sketch with a pencil or charcoal will suffice, but you cannot jump this preparatory stage. By studying each of the parts of the animal you can develop the shadows and other volumes before starting painting with watercolors.

Painting animals with watercolor is a complex subject although, once the necessary practice is acquired, this barrier becomes a motivation for any artist who wants to improve. The watercolorist must always practice drawing, whatever the subject that is being developed. For the motifs that require an anatomical study the drawing is more a necessity than a support, as it can be for a landscape. Proportions, measurements, shadows, and highlights must be studied before painting. Painting animals will, doubtlessly, be one of the subjects that most rapidly attracts the attention of the enthusiast. Therefore, pay close attention to the following pages.

▶ The structure of any animal can be synthesized in the preparatory work with straightforward geometric shapes. These shapes can be done for any model. For example, in this sketch of a horse the lines of its form have been drawn. Once this is done, the sketch is divided to show where the legs start. This dividing up will help substantially with the proportioning of the animal, for these very elemental lines aid the understanding of any shape, however complicated it may be.

◀ Try to copy these drawings starting from the sketched outlines. Next, do the internal structure, and finally unify the lines to place the contrasts. A good way to comprehend this is the tracing of the sketch with tracing paper. Then transfer it to the drawing paper and work until the form of the animal is completed. It is helpful to do this exercise both with these sketches and with any photo of animals.

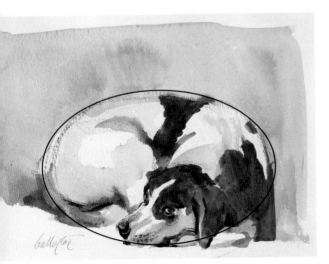

COLORING THE DRAWING

When the drawing is completely defined, you can start to add color. The best way to learn is with practice. Here we will show already finished works that can be used as a reference to be borne in mind for later works. The techniques that have been used for these examples are the same as those used for landscapes and still lifes in previous subjects, only the way the stroke is applied changes.

▼ This dog, in spite of its complexity, has a very simple structure. If you look closely, you will see that its shape is fitted inside an almost perfect oval. The legs are hidden, which makes its initial drawing even more straightforward. Once the drawing is taken care of, the first layer of color must be very faint. The brightest grays, which outline the pure whites of the paper, are painted. The head of the dog is defined with dark sienna and burnt umber tones, once the initial layer has dried.

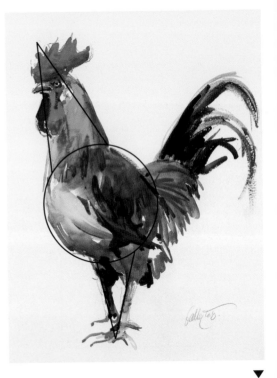

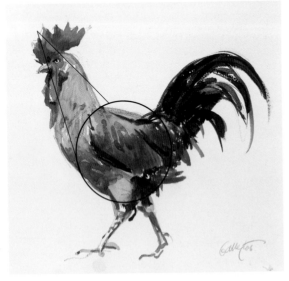

▼
Observe in the superimposed scheme how easy it is to structure the anatomy of this bird. It is only a circle for the body and a triangle for the neck and head. Once the drawing is complete, the painting process is started with a very luminous ocher and umber wash for the lightest tones of the breast. The first washes do not give texture to the feathers. These are painted with very supple strokes. Pay attention to the whites that remain reserved.

▼ As you can see, the pose of this cock is different from the other. However, the method used does not change at all. In this illustration it can be seen how the red brushstrokes of the wing are superimposed on the initial orange wash.

TEXTURE OF THE SKIN

O nce you have learned to outline the form of different animals, it is recommended to practice an exercise that will be useful in the future. It consists of painting the head of a dog. In this exercise, the texture of the fur or of the skin is one of the most important elements, once you have understood the basic structure of the animal. Here it is important to bear in mind the way reserves are continually made.

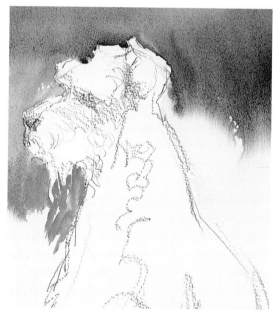

1. Do not start painting until the drawing is perfectly defined. Watercolor is based on transparency and the corrections have to be minimal. First the background is wetted with a brush dipped in clean water. When wetting the background of the paper, the shape of the head is outlined so that the color does not penetrate inside it. The wetness of the paper ensures that the color expands.

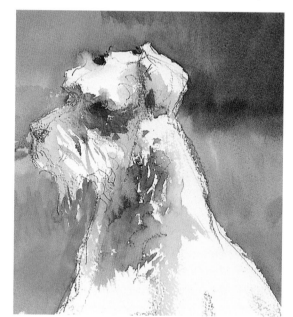

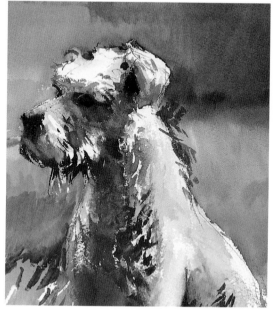

▼ *2. While the background is still wet, the first applications of color can be made: they merge into the colors already on the paper. As the background dries, more precise tones and brush-strokes can be laid down. The painting of the eye is started with sienna and very clear gray for the fur. The dry tones allow whites to be reserved.*

▼ *3. The most luminous highlights on the fur are left unpainted so that the white of the paper is always seen. Next to these completely white parts, on the dry background, the ear and the forehead of the dog are painted with an orange wash, the color drained out of an almost dry brushstroke.*

AREAS OF COLOR, LIGHT, AND SHADOW

Painting animals sometimes calls upon all the technical skill of the artist because of the complexity of the process, although the success of a great work often lies in simplicity. The synthesis of the forms, the combination of every single feature will result in a vigorous study, full of realism. Here a simple exercise is proposed with a parakeet. Pay attention to the reserves, to the color, and to the light areas.

▶ 1. *In the first place, close attention must be paid to the initial sketch of the anatomy of the bird. The drawing is straightforward and based on two correctly placed curves. If you look closely at the illustration, you can see that the body is ovoid, and the head is an almost perfect circle. Once the initial sketch is done, finish off the lines that define the anatomy of the bird.*

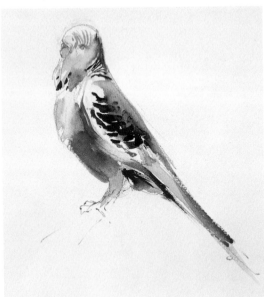

▼ 2. *The pure whites must be reserved from the start. The principal color is blue. It is used in a transparent tone which permits each one of the light or shadow zones to be placed. This is where the initial drawing becomes essential: it would be impossible to establish the white reserves without it. The dark shadow tones are painted on top of the most luminous colors. The brushstrokes on the head and wing are done on the dry background.*

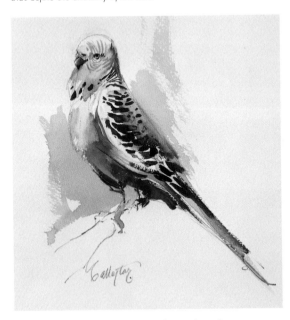

▼ 3. *Only when all the shadows on the parakeets have been done can the contrasts that finish the painting be applied. Here the shadows are defined by intensifying the tones used. Observe the blue under the tail. Lastly, the final details allow different parts of the bird to be contrasted. In this exercise, the background is darkened to better bring out the brightness of the white areas of the bird.*

Step by step
A pair of parakeets

The simplest animals to draw and paint are birds. This is due to their rounded and tapering shape, and absence of a complicated structure. To paint birds it is not necessary to go too far: you may find a good model at home, or in any pet shop, photos in books or magazines, or in the zoo. The models used in this exercise have been photographed in an animal shop. The aid of a photo is one of the most widely used, especially when you must paint fidgety animals.

MATERIALS

Tube colors (1), pencil (2), watercolor paper (3), watercolor brushes (4), water jar (5), and a rag (6).

1. *As has been studied throughout all the topic, before starting to paint, it is necessary to do a drawing as perfect as possible: perfect in the synthesis of lines and forms. The brushstrokes must guide the color exactly so that the different areas cannot be confused. Start by drawing the parakeet on the left. Each bird is placed, starting from an almost oval form. The back is corrected with a straight line and the head, beak, and eyes are put in.*

329

STEP BY STEP: A pair of parakeets

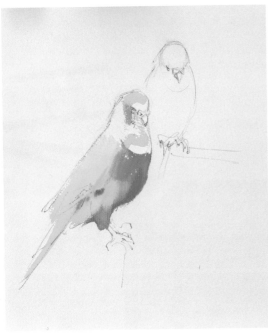

2. *Once the first parakeet has been drawn, the second is done. The other also has an oval form, with an almost circular head. Such a simple shape allows rapid and pleasant work, for the corrections needed are minimal. Once the drawing is done, the painting of the bird on the left is started: first, with a golden yellow reserving the brightest zone of the breast. In this highlight, cutting across the line of the breast, a very luminous green is painted, merging the tone at the same time that the form of the body is modeled. The darkest part of the parakeet is painted with a dash of umber. As the background is still damp, the colors blend easily.*

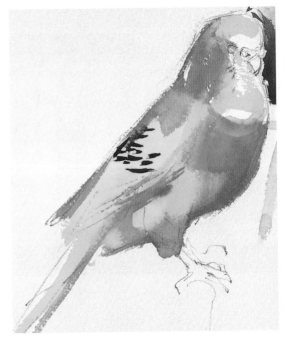

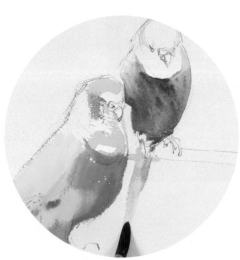

3. *While the color of the first parakeet is drying, start to paint the one on the right. The wet parts of the paper must not be touched, otherwise the colors will mix. For this bird, a cobalt blue mixed with ultramarine in a very luminous wash is used. When the tail is painted, in one stroke, it is made even more transparent.*

4. *Alternate the painting of the two parakeets so that the drying times do not interrupt the work on the watercolor. If only one bird were being painted it would be necessary to stop every time you wished to do a brushstroke on top of a dry background. With the same tone as was used to paint the last part of the body, the rear of the head is painted and the shadows on the wing. Using black and with small brushstrokes, add the strokes which characterize the plumage.*

5. *Before starting to paint the feathers of the parakeet on the left, to avoid the dark colors of the just painted tones blending, it is necessary to let them dry. Meanwhile, pay special attention to the parakeet on the right. On the head, a very transparent gray layer is painted which outlines the upper highlight, which is now seen as a white circle. While this zone is still damp, some small shadows are added to the base of the neck. This color is put on with the tip of the brush and blends into the limits of the just painted wash.*

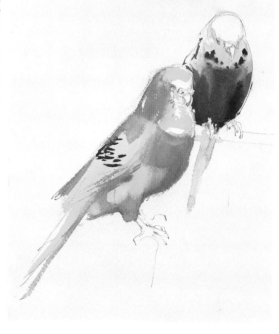

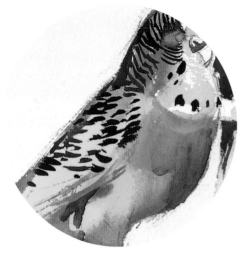

6. *All the strokes on the back of the bird are done. As can be seen, the lines are curved and help to suggest its volume.*

If you were only painting one animal you would have to stop every time you wanted to do a brushstroke on top of the dry background.

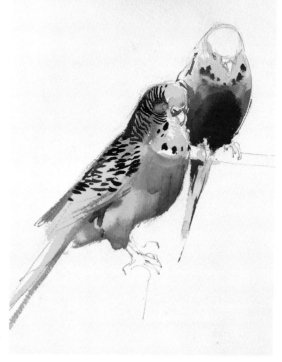

7. *Use the color blue to rework the parakeet on the right. Repaint all the right hand side of the chest. This shadow is oval shaped and gives more volume to the bird.*

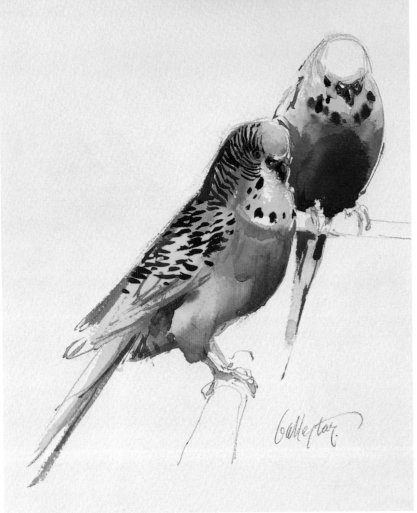

8. *This is an exercise that can be done very quickly. On the one hand because of the simplicity of the shape of the two parakeets, and, on the other, because of the possibility of alternating the painting of the two birds, giving each one sufficient drying times. All that remains to be done is to paint the contrasts on the beaks, without touching the highlights, and carefully paint the eyes of each bird.*

SUMMARY

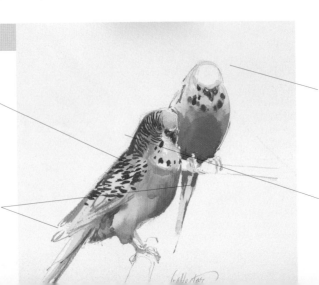

The initial paint on the bird on the left is yellow. Before it dries it is painted green.

The tails of the parakeets are done with one brushstroke. Afterwards the necessary contrasts are added.

The head of the bird on the right is reserved with a very transparent layer, on top of which the dots of the neck are painted.

On the back of the parakeet on the left multiple brushstrokes of black are used to complete the texture of its characteristic plumage.

The way they painted:

William Turner

(London 1775-London 1851)

Saint Mark's Square

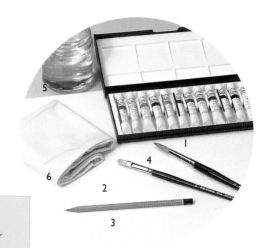

This English painter was famous for his landscapes and sea views. He started painting watercolors and then later he switched to oils. A journey to Italy marked the beginning of a period characterized by luminosity and highly intense and vivid colors. Later, he began to make light itself the center of the paintings, as can be appreciated in his very dreamlike views of Venice. His work, which was very romantic, is one of the precedents of Impressionism.

MATERIALS

Tube colors (1), pencil (2), watercolor paper (3), watercolor brushes (4), water jar (5), and a rag (6).

In recreating this work, the aim of which is not to do an exact copy, we are going to study some of the techniques that Turner used constantly, and which have been explained throughout the previous chapters. The techniques that Turner employed are not complicated. However, they are executed with precision and great care in each of the different parts of the painting. Painting on wet gives a characteristic style to the fusion of colors and forms: it is the degree of moistness of the paint on the paper which conditions the blending of the tones. Turner had perfected working with different drying times; this is what is going to be attempted in this exercise. Before starting, look at the subject carefully. Let's see if you can guess the areas that he painted first and how he did them.

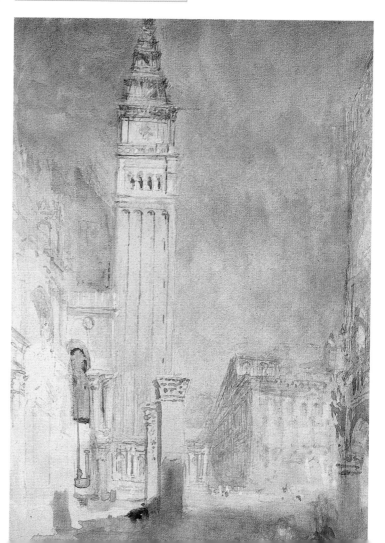

STEP BY STEP: *Saint Mark's Square* by William Turner

1. *It is important, before doing anything else, to start with a good drawing for the work that is going to be done later will be conditioned by this. It is not necessary that the drawing be exactly like the model, but the different elements must be approximately in proportion. In the drawing any possible change in the inclination of the line must be observable. Here, for example, compare the perspective of the upper part of the building on the right of the model. Doesn't the building that has just been painted seem less inclined? These are the type of corrections that must be done.*

2. *If you look closely at the original work you can appreciate the total lack of whites. Instead, the lightest tones are yellow, the product of the initial layer. A very watery yellowish mix is obtained with ocher. It is used to paint all the buildings area. However, the sky is left unpainted. How do we know that for the base of the sky Turner did not paint a yellow layer? We know because the blue would have turned greenish and this is not the case.*

> You have to be very careful
> with the chromatic effects
> that are produced by the
> superimpositions of color.

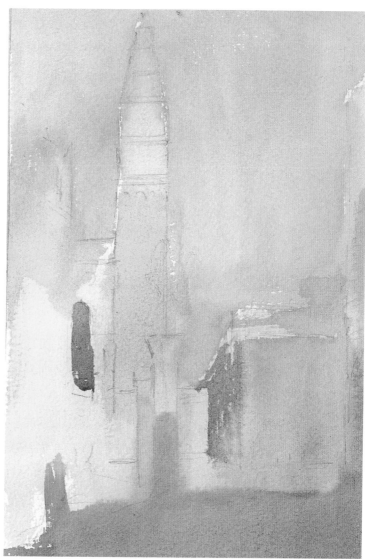

3. Paint the area on the right with an orange wash. This color will blend with the just painted part of the sky; it does not matter for it can be corrected later. It is certain that this also happened to Turner, if we judge by the earth tone that the sky takes on in certain areas. It can be perceived in the model that the sky was not painted in one go. Rather, it has several layers of color that allow the brushstrokes to show through. A very clear wash of a little umber mixed with dark blue is used to repaint the sky, letting the brushstrokes be very evident. On the left, it can be seen how Turner made a correction. Here, one is made, too, by absorbing the excess of tone with a clean, dry cloth.

4. Some parts of the buildings, above all, on the left and the building in the background, appear merged into or gradated with the blue of the sky. This happened because when Turner was painting the sky these zones were not completely dry and the first color mixed with the new one. In the same way, the color of the buildings is allowed to penetrate into the first layer on the white of the paper. When color is superimposed on top of an already dry one, the tone darkens. In this way dark tones can be achieved that modify the first tones of the upper part of the buildings. Wait until the background is almost dry and repaint it with blue mixed with a little sienna. The dark parts of the buildings are painted in burnt umber.

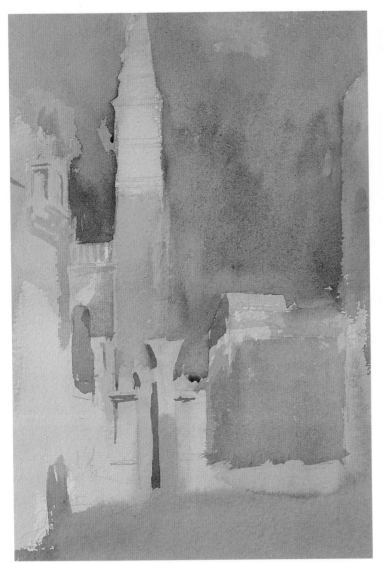

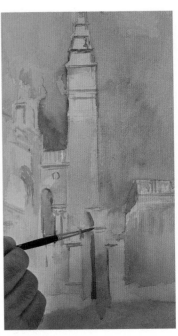

6. *As you can see in the illustration, you have to continue drawing throughout the exercise. A brush is used to paint the lines that define the relief of the buildings, after having painted in the first colors. Paint the decorations on the buildings in the same way. The strokes have to be precise, without either blending or forming flows. Draw the lines with a sufficiently transparent sienna so that although the first color is not totally covered, the drawing of the well-constructed strokes can be seen.*

5. *It is necessary to wait until the background and the later additions of color are completely dry before proceeding. Then, a blue wash with a little sienna is prepared and applied over the background with vertical brushstrokes. This new layer of color is what finishes off the outline of the buildings. Afterwards, with a burnt sienna lightly tinted with blue, but only as a very transparent layer, the shadows of the buildings in the background are painted. The base color changes appreciably the dark tone of this layer.*

The colors that are superimposed produce an overall effect when the lower layers are dry.

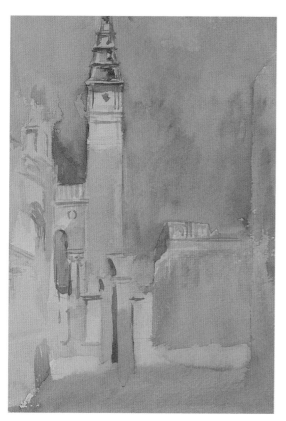

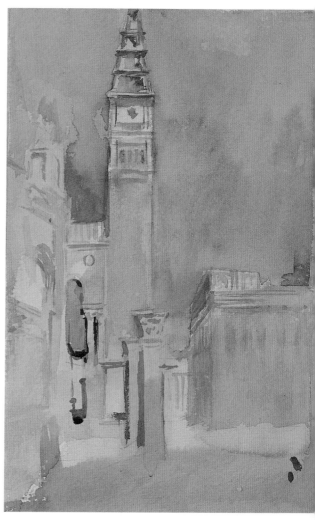

7. The drawing done on top of the first color washes gives a sharp definition, and the cornices, the nuances of the walls, and the entrance arch on the left are perfectly traced. It is important that the strokes do not stand out too much. The color must be sufficiently watered down in the palette. Pay attention to the drying process of every tone. When a brushstroke dries completely, its tone intensity diminishes.

The colors superimposed on top of wet colors merge into each other.

8. The details become clearer as the lines are defined. First, the principal lines of the cornice on the tower are drawn, and on top of these the ornamental details are filled in. Finish off the area on the right of the picture with an orange tone, making a mesh of brushstrokes that blend to a great extent. Go over the drawing of the window on the left and the contrasts of the colonnade with a darker tone than the ones used till now. Some carmine tones are painted on the lower right side. Before they are completely dry you must move on to the next stage.

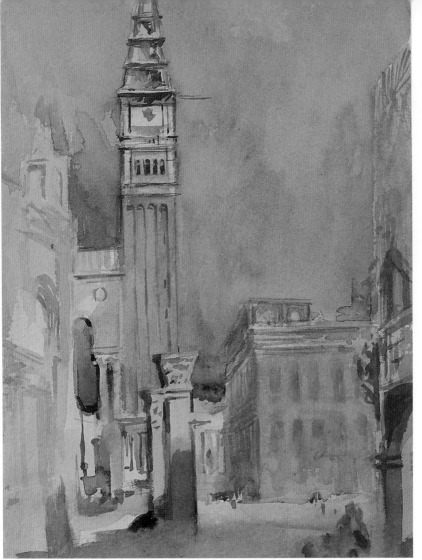

9. *Burnt umber is painted around the carmine tones and blends into them. Draw on the tower the vertical strokes that define it and finish off contrasting the entrance of the building on the right. Finally, all that remains to be done is apply a small touch of color to the lower part of the shadow and add nuances where the contrast can be intensified. The similarity with the original is very close, although rather than do an exact copy, what has been attempted is to experiment with the principal techniques that Turner put into practice. The differences in brushstrokes between the original and the finished work can be explained by the degree of absorption of the paper and the drying times of the wet layers. Moreover, there are more similarities than differences. Of course, the style, the brushwork, and the expression are unique to each artist.*

SUMMARY

The sketch is done beforehand in pencil, setting out the forms of all the buildings.

A first, almost transparent, yellow wash covers all the urban landscape and will be a support for the other, darker, colors.

The background color shows through in the upper part of the tower.

The sky is painted with successive layers of blue, every application becoming darker.

The windows of the building in the background are suggested on top of the almost wet background.

La belle Hélène

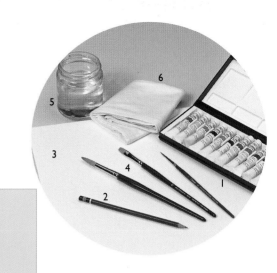

Two accidents that he suffered in his adolescence left this artist scarred and injured for life. He led a bohemian life in Paris, where he fell under the influence of Bonnat and Degás. He hung out in cafés, theaters, music halls, and brothels, where what he saw and the people he met became an important source of ideas. His works, excellently drawn, are characterized by the spontaneity of the brushstrokes and the expression and freedom of movement.

MATERIALS

Tube colors (1), pencil (2), watercolor paper (3), watercolor brushes (4), water jar (5), and a rag (6).

This watercolor proves that simplicity can be a solid base for a painting. In this exercise the aim is to practice one of the most difficult decisions to make. However, it is also simple: how to know when a painting is finished. Often a not too experienced enthusiast, when practicing, becomes desperate when they see that the work which was progressing well has become so saturated that it is almost completely spoiled. The secret of success in painting, in great part, lies in knowing when to stop: only painting what is necessary.

Besides practicing the synthesis of the forms and applying colors, we will also study how the most transparent layers work on the white of the paper and the superimposition of brushstrokes with the background.

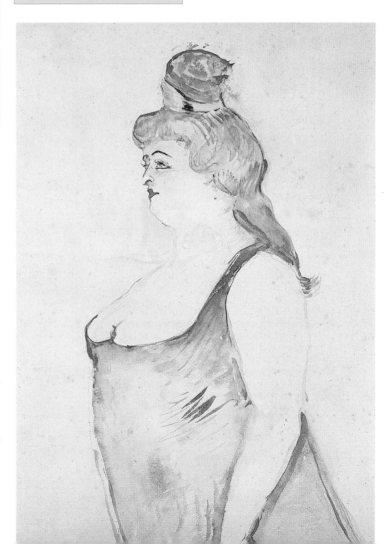

2. *Once the drawing is completed, a very transparent layer of color is applied homogenously over all the picture. This color is yellowish, a mixture of ochre and yellow. Despite being highly transparent, this first layer changes the luminosity of the paper. The colors that will be applied afterwards will be affected by this base tone. This layer must be dried before continuing, for any addition on the wet background will make the tones blend. This is not the objective.*

1. *Although you could start right away with watercolor, as has been done on other occasions, in this case, in which the transparency of the colors is intense, it is wiser not to do so for some zones must be reserved next to others slightly darker. It is important that the drawing is well defined before starting to paint and also that the brushstrokes are extremely clean. This is because, owing to the transparency of the work, any badly placed pencil line can be perceived.*

> In all watercolor work, the initial drawing is a vital guide so that later developments find a good structure into which to fit.

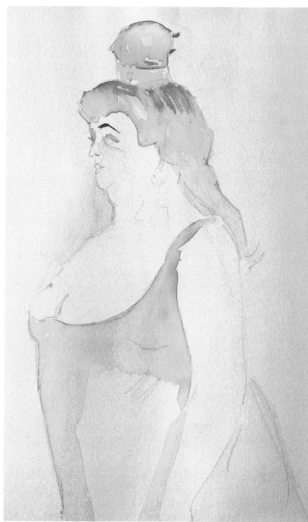

3. Once the background color has dried, the first base color is painted, which here corresponds to the first layer of the hair. The woman is blond. This hair color uses a luminous yellow as the base, although it is much less transparent than the background. Observe the difference between the painting of a general coat (in the background) and the other more specific layer that is put down now. Not all the hair is painted with the same intensity; the color is applied with different transparencies and qualities, allowing in some zones that the background of the paper shows through completely.

4. Paint the upper area of the fringe in cadmium red and add a few brushstrokes of burnt umber to the back of the head. In this zone the background has already dried, and therefore some yellow reserved areas show through. The picture is allowed to dry and another wash is applied around the figure to make the color of the skin stand out from the background. The features of the face are painted with transparent sienna. This work must be carefully done so that the colors do not mix with each other. The dress is painted with a very transparent red wash and the most luminous zone is left unpainted. The following steps must be done quickly so that there is no break in the blending of this area with the background.

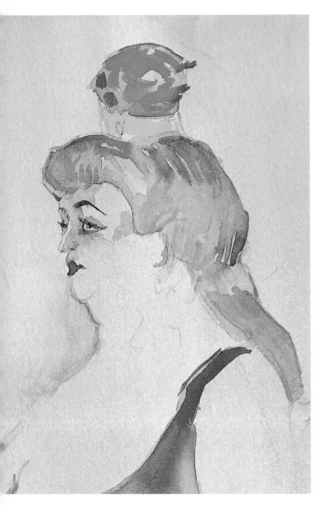

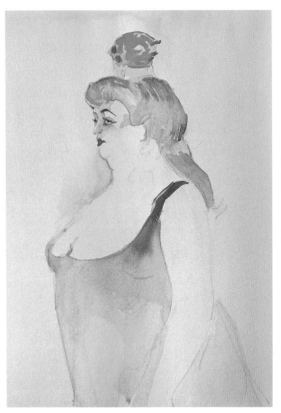

6. With a slightly wet brush, go over the dress until the bright area starts to blend into the background. As the dress has been dampened, it is possible to introduce a redder and denser tone to the shoulder strap. Start to apply red to the upper part. It will blend due to the moistness of the paper.

5. The face and the hair are the areas which involve the most complex work, above all, the white reserves on the face. It is important that the sienna tones and the eyebrow, painted before, are completely dry, otherwise the colors will mix. The shadows of the face are painted with a transparent sienna and the brightest parts are left blank. The eyelashes are painted once this shadow is dry. The hair is enhanced by adding sienna and orange.

Using high quality paper is very important because with ordinary paper merging colors is practically impossible once the color has dried.

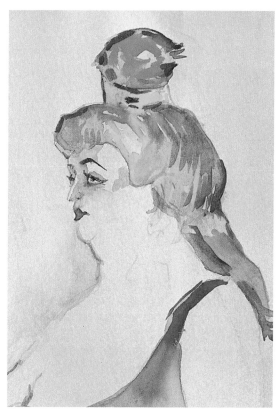

7. *Focus your attention on the dress while it is still drying. This is especially delicate as the effect that you want to achieve is one of successive layers that are superimposed with free brushstrokes, without the colors blending together, so as to get adequate volume. However, in spite of the work on the hair and the delicacy with which it must be treated, this area is not very difficult, provided that the drying times of the previous layers are respected.*

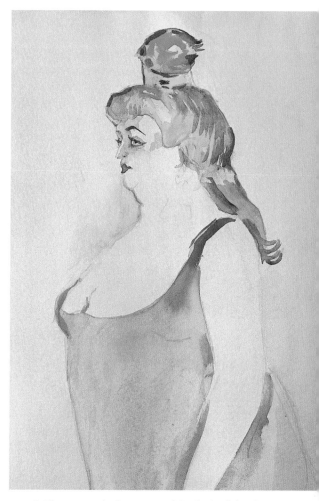

8. *The arm and a large part of the flesh of the chest and the face have been reserved since the beginning of the exercise. This color is the first coat on the paper. With red mixed with a little carmine the outline of the dress is reinforced in the area of the breasts. In the part surrounding the form of the arm, paint with a cadmium red wash, without penetrating into the arm, which will now be perfectly outlined. Once again a transparent sienna wash with which to paint the background is prepared. Leave the right side a little darker so that it contrasts with the back of the figure.*

When putting down layers on the background, it is always prudent to start with the lightest tones and afterwards, if necessary, to intensify them progressively with successive layers of color.

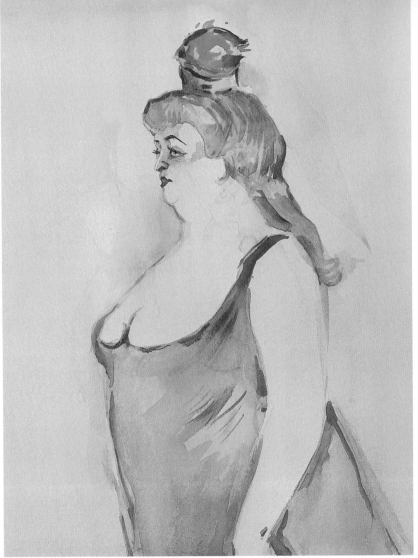

9. When the background is completely dry the strokes that give texture to the cloth of the dress are painted. This last step requires special mastery of the paint and of the brush as the wet paint must be combined with very defining stokes. The colors that are used on this part of the dress are carmine and cadmium red, always very transparent, respecting the parts that contain the highlights. The creases of the cloth are painted with firm strokes. Now the painting is finished. The similarity with the original is close. It must be emphasised that the object of the exercise is, above all, to interpret the technique of the great painter.

SUMMARY

The initial drawing must be as clean and as precise as possible as all the color additions that will be done later will be very transparent.

The background is painted with a very transparent yellow tone so as to soften the white of the paper.

The base color of the hair is yellow. On this the darker colors are applied, although in different reserved zones the yellow comes through.

The dress is painted in successive layers of red and carmine, leaving luminous zones as reserves in the lower layers.

The way they painted:

Marià Fortuny
(Reus unknown-Roma 1874)

An Andalusian house

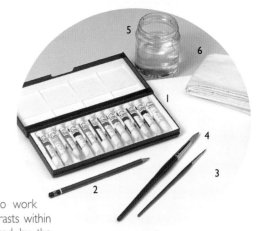

Among his more convention-al pictures and etchings there are figures that remind one of Goya while the very original chromatic effects stand out. His color palette is very luminous and so explosive that he has been associated with Impres-sionism, although within the art world he has been considered to be academic and pretentious.

This exercise allows you to work with whites and shadow contrasts within the zones or spaces structured by the walls of the building. In general, rural or vil-lage houses with a fresh and clean aspect are selected. This is what Marià Fortuny did to paint this magnificent watercolor.

In this exercise the complexity does not lie in the techniques used but in when to use them and in observing the drying times of each intervention.

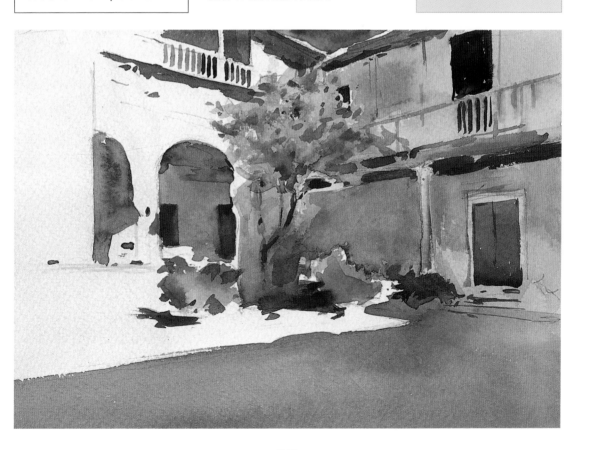

STEP BY STEP: *An Andalusian House* by Marià Fortuny

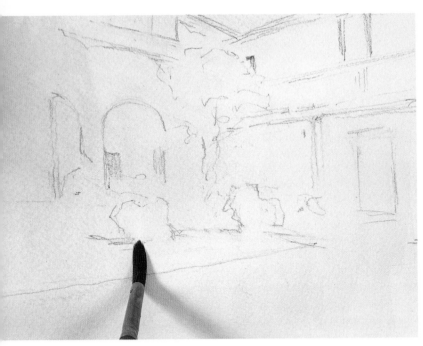

1. If the subject appears very simple it is because Fortuny started from a perfectly defined drawing. Only in this way is it possible to apply each color in its exact place. The drawing has to be clean. Define with the minimum stroke expression the planes and the objects therein, like the tree, the plants, or the openings of the doors, arches, or windows. Once all the patio has been drawn, paint an almost transparent ocher in the most illuminated area, so as to soften the excessive whiteness of the paper.

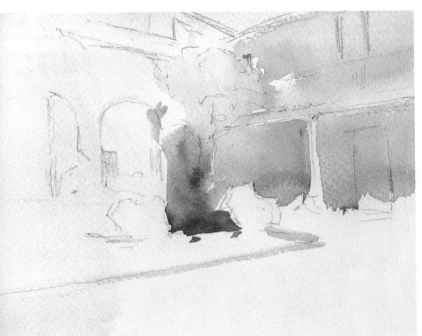

2. Start painting the upper part of the shadow. In this area there will be the greatest number of color tones, always very transparent and carefully situated so as to outline and define the most luminous zones, like the column in the corner on the right, or the tone differences between the background and the upper part of the wall in the shadow. The tree is situated with a transparent green tone. Below it, the darkest part of the patio is painted with burnt umber.

3. *Paint part of the patio with burnt umber and a little blue to cool the tone. This color establishes the principal light areas in the picture. It has to be painted in one go so that there are no borders to the color. Each one of the areas that has been painted respects the drying times of the adjacent areas. Here, however, part of the dark tone is brushed towards the wall on the right, permitting the color to play a role in the texture of the wall.*

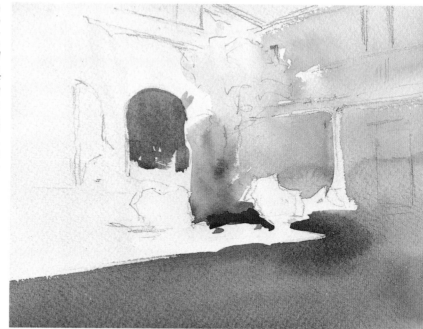

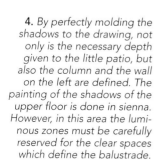

4. *By perfectly molding the shadows to the drawing, not only is the necessary depth given to the little patio, but also the column and the wall on the left are defined. The painting of the shadows of the upper floor is done in sienna. However, in this area the luminous zones must be carefully reserved for the clear spaces which define the balustrade.*

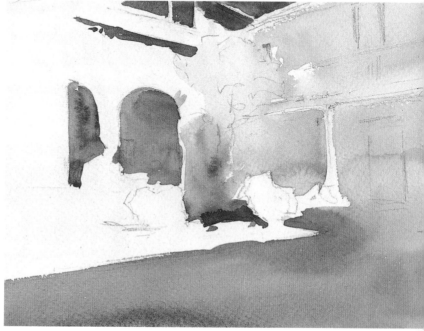

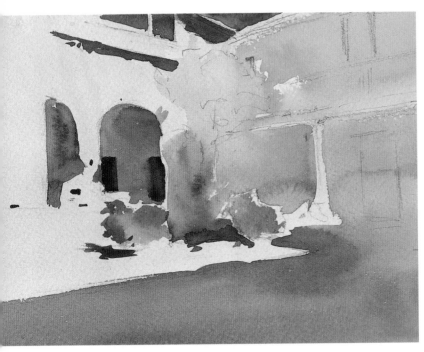

5. *Paint the darkest zones of the interior of the house. Within the shadow zone, on the left, the darkest entrances to the rooms are painted. In the patio, the plants are painted in luminous green. Every clump of green is painted with different intensities of the color.*

Each part of the picture is painted when the adjacent zones have dried completely. This is fundamental so that the tones of each of the zones do not mix.

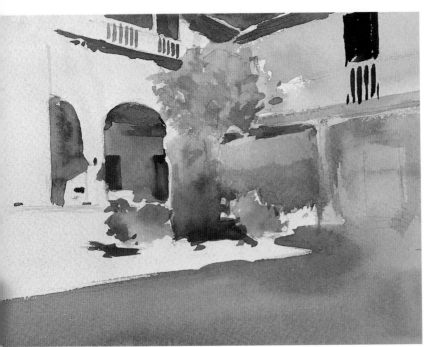

6. *Transparent sienna is used to paint the dark parts of the upper floor and the roof. In the interior of the passage, the dark areas are intensified with layers of sienna. The tree is painted with different tones of green, always of the dry background. The bars of the balustrade are defined by the shadow that is painted behind them, through which the passage is suggested. On the right, the door is painted in brownish gray. The bars of the balustrade are also defined.*

7. *Before the balustrade of the upper floor is completely dry, some of the brownish gray is taken off with a quick clean-up with the wet brush. Then the bars are barely suggested by the strokes of sienna that are mixed and blended on top of this wet background. The shadow on the upper floor above the corridor is painted with very dense burnt umber. A transparent wash of this same color darkens this area, leaving the column unpainted.*

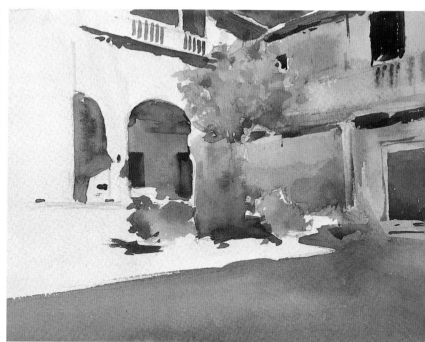

8. *The main part of the floor on the upper storey is painted with sienna which blends into the base color. The tree trunk is depicted in burnt umber, with a thin and curved brush-stroke, cutting across the brightest areas. Continue to paint the soft contrasts that shape the top of the tree with different additions of green.*

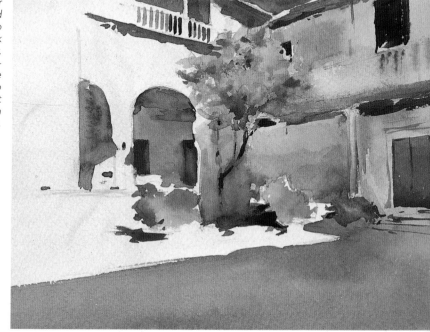

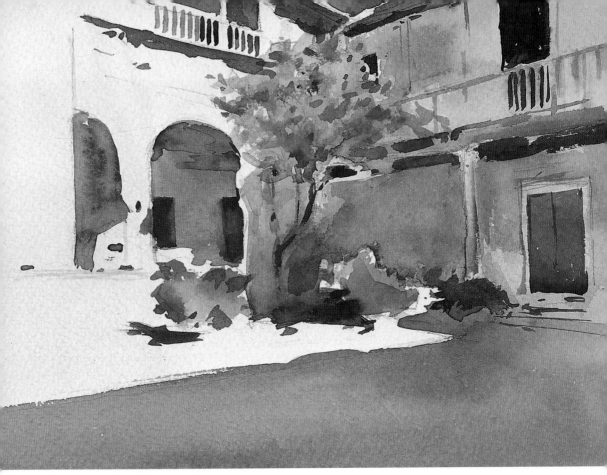

9. *The upper floor balustrade is painted with a very luminous green mixed with sienna. The brushstrokes are not continuous, they stand out in the areas that would otherwise be luminous. The same tone is used to paint the lines of the embellishments. Once again the dark behind the bars of the balustrade and of the door in the background are repainted. This finishes off the work.*

SUMMARY

The railings are defined by the darkness of the shadow behind them.

The backlight means that the light zones are clearly defined in two areas; one completely white and the other where the shadows give form to the planes and darknesses.

The top of the tree is painted in several tones of green, always on the dry background, so that the brushstroke can be controlled with precision.

The tree trunk is painted with burnt umber. The brushstroke is fine and breaks up in the most illuminated zones.

The way they painted:

Emil Nolde
(Nolde 1867-Seebüll 1956)

Flowers

Nolde is the pseudonym of the German painter Emil Hansen. His style recalls that of Van Gogh and Ensor, painters for whom he felt a great admiration. Many of his paintings, full of religious scenes that in their day caused much scandal because of their sensuality, abound in striking colors and expressionist forms.

Flowers are one of the themes that gives most play in a watercolors. A simple green shadow is converted almost by art into a fresh, colorful flower. This allows the development of very gestural pieces, full of vigor and color, as in the present example. This exercise aims at doing rapid, enjoyable work that gives a very effective result.

Once again, it is not a question of copying the model, but rather of trying to understand the technique that the artist used.

MATERIALS

Tube colors (1), pencil (2), watercolor paper (3), watercolor brushes (4), water jar (5), rag (6), and sponge (7).

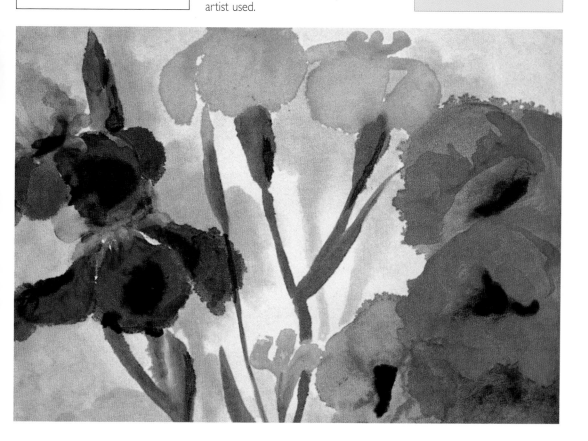

1. *It is certain that Nolde did not start painting from a pencil sketch, but this is what we opt for here as it will be easier to follow. What must be sought after in the drawing is the proportion between the forms that will become flowers. Although we are not trying to obtain an exact copy of the model, just an interpretation of the artist's painting style, try to be as exact as possible. A subject painted by another artist is as valid as any photo or natural model.*

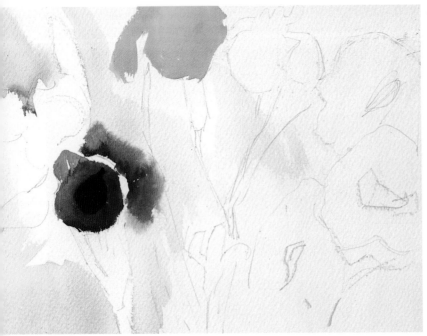

2. First, a very transparent violet wash is put down over the background, leaving reserved spaces for the white of the paper or to separate shades that must not be blended. Bearing this in mind, the painting of the violet flower is started. The central part of the flower coincides with an area that is untouched by any wash, thus allowing painting with precision. Just to the right, the blended petal seen in the illustration is painted. The color mixes immediately on top of the wet background. Start painting the yellow flowers in the upper section.

3. In the center of the flowers a very luminous, almost transparent red tone can be seen. On this color, darker coats can be perceived, as well as much more precise brushstrokes. The red flower in the upper section has the most tones of red. To paint it, it is first necessary to give it a transparent wash and allow it to dry before applying the second layer. The lower flower is painted with a much more opaque red tone. The flowers on the bottom right are painted in shades of violet. In doing this, a part of the color of the red flower is blended in.

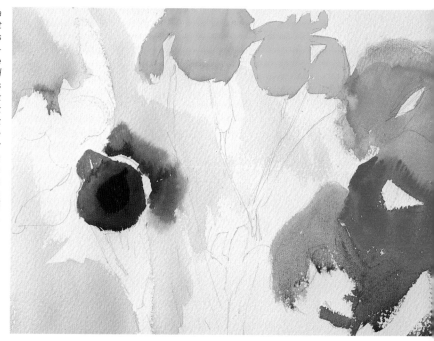

4. With a somewhat dirty violet tone, this area is completed, allowing the different tones to blend together. Black is used to paint the center part of the poppies on the right, and red tones are superimposed on the already dry first layers. Paint the upper part of the first flower, slightly pressing down with the point of the brush. The same yellow color that was used for the flowers is also used to sketch in the stems. Before these dry, go over them with green brushstrokes and let the color mix in for most of the stroke.

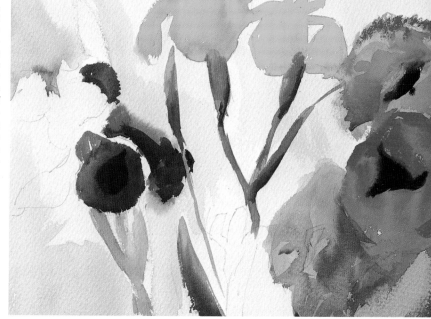

353

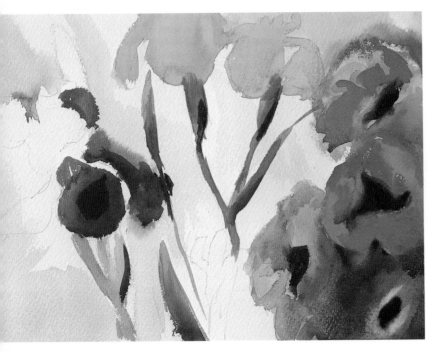

5. *The principal painting of the picture is complete. Now the first contrasts that separate the flowers can be painted. The background of the flowers must not be completely dry if you want to achieve an effect similar to Nolde's. To create the dark shadows use a very dense cobalt blue. As for the flowers lower down, just below the poppies, some of the red color is blended in to get a violet tone. Black is used to paint the darkest part of the flowers.*

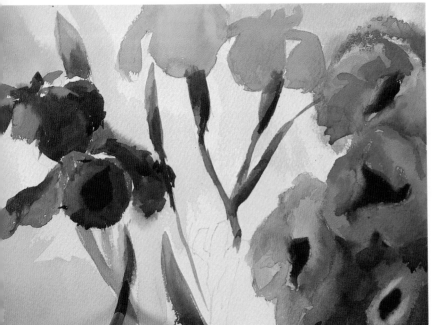

6. *Next to the lilac-colored shadows on the left of the picture, the petals are painted in a strong orange color. But first, make a splash of very dense golden yellow so that the color that is painted on afterwards has a firm base on which to mix. Then, superimpose cadmium red brushstrokes. When they mix, they become a luminous orange. Before the orange tone is dry on the paper, paint the violet again, allowing the color to mix with the lower tones that are still wet.*

7. *Allow everything to dry before applying layers that darken the background so that these will not alter the colors by blending. When the background is dry, paint it with a violet tone, somewhat stained by sienna to make the tone much warmer. This shade is painted on the layer that was painted in the beginning. It does not encroach on the most luminous colors.*

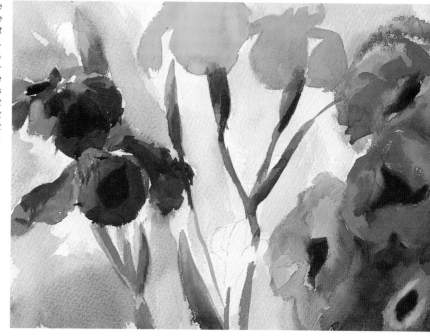

Yellow is one of the colors that permit the most luminous staining.

8. *Continue working on the flowers on the left, giving the petals form with somewhat darker tones, but without contrasting too much with the previous colors. The only remaining flower, which is still outlined in pencil, is painted with the same yellow as was used to paint the flowers in the upper section. As can be seen the final retouches do not have to be too obvious.*

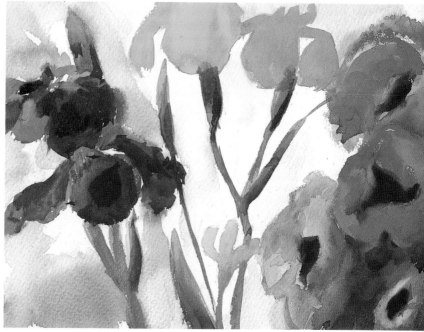

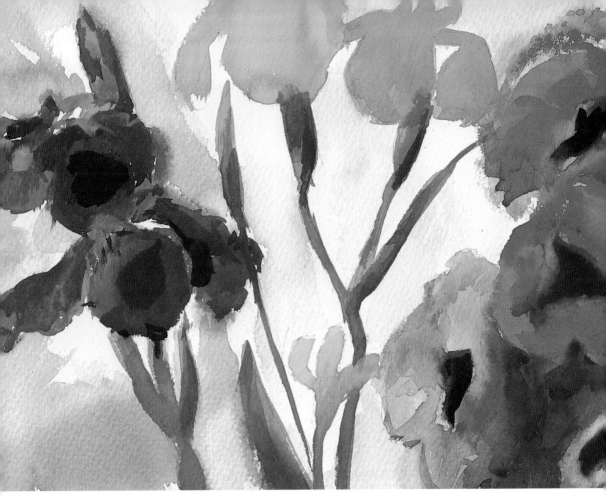

9. *All that remains is to darken the orange petal on the left a little. This contrast is obtained by violet paint that is complemented by the original orange. On top of the violet flower, a new layer of the same color is applied, and it is allowed to blend in with the green stem. These final retouches finish off this interesting gestural work. Once the piece is finished it is important to reflect on the steps that have been taken and how the work of the artist has been interpreted.*

SUMMARY

The first application of color is the violet layer on top of which the violet flowers on the left are painted.

Next to the lilac color on the left, the petals are painted in a strong orange.

The poppies are painted in several phases; first, with a very light wash and then afterwards in denser tones.

The painting of the stems is started in yellow. Before the zone dries, the brushstrokes are gone over with green.

Author: Francisco Asensio Cerver

Oil Painting
for Beginners

Illustrations: Vincenç Badalona Ballestar
Photographs: Enric Berenguer

Materials

OIL PAINTS: NEW POSSIBILITIES

If there is one thing that distinguishes oil from all other painting media, it is the intense luminosity and high quality of its colors. Furthermore, oil paints retain their original color despite the effects of sunlight and time, and their texture remains creamy after it has dried.

Oil is a pictorial medium that offers a wide range of possibilities. This is probably why oil painting has become what it is today. The origins of the oil medium date back to the beginning of the Renaissance. Since then, it has become the most widely-used medium and established itself as the king of all paint media. Even though the essence of the medium has remained virtually unchanged over the last six hundred years, innovations in the fine arts industry have provided artists with a large number of products and implements that make this art form easier and more accessible.

▼ Oil paints have an oily, pasty consistency that makes them easy to apply and extend with a brush. However, the intensity of their color depends largely on the quality of the paints you are using. High-quality paints are recommended to insure proper drying.

Oil paints are mainly made of linseed oil (which is the medium) and pigment colors. Once combined, these ingredients have a creamy texture that allows color mixtures like the ones shown here to be obtained with ease.

▲

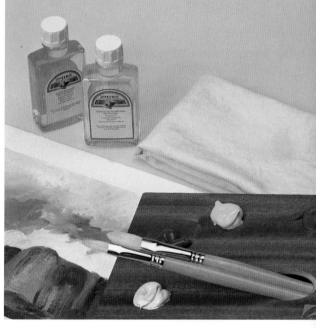

▼ The basic materials needed to begin painting (you do not need many) are some tubes of oil paint of the following colors: white, medium yellow, red, green, and black; two hog's hair brushes, a palette for mixing your colors on, linseed oil, turpentine, canvas-covered cardboard and rags. All these items can be purchased in art supply stores.

THE COMPOSITION OF OIL AND THE PALETTE

Oil paints are made of pigment and oil, which is why only turpentine can be used to dilute the colors. Unlike other pictorial media, oil colors do not dry by means of evaporation, since there is no water in their composition; instead, they harden through the oxidization of the oil. The most signifi-

cant characteristics of oil paint are its slow drying process and the way in which it can be superimposed in opaque or transparent layers. There is an extensive range of techniques for painting in oil, many of which will be explained later in this volume.

◄

Oil paints permit highly luminous transparent colors obtained by linseed oil, turpentine, and Dutch varnish, or even an oil medium or one of the many products sold for this purpose. In order to obtain transparent layers, normally coiled glazes, you will need a container in which the color can be diluted.

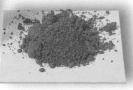

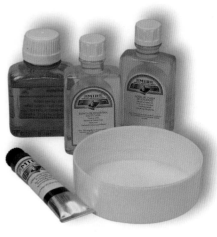

▼ *Oil paint is made up of linseed oil, pigment and may contain a little turpentine. With these three components it is possible to paint any subject. The following pages in this chapter explain in detail how oil paint is made. The brushes used to apply oil paint must be cleaned with turpentine, and then rinsed with running water.*

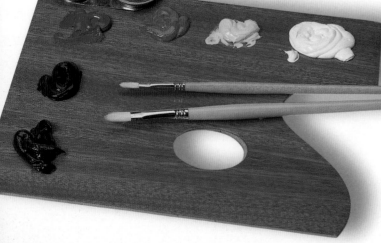

SOUND ADVICE

Dippers are indispensable accessories for painting in oils. These metal recipients are used to hold linseed oil and turpentine.

▶ *The colors are placed on the palette according to shade, as shown in this example. They should be placed around the edge of the palette, leaving enough space between each one to avoid smearing. The paints on this palette have been arranged in a correct order.*

MAKING OIL PAINT

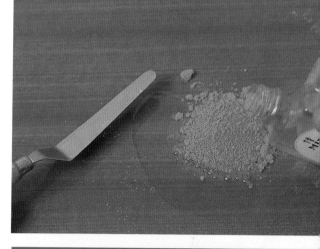

One important technical aspect of this medium is knowing how to make oil paints, a process that requires more effort than skill. This page explains the basic procedure for making your own paint. Even though all colors of oil paints can be purchased ready made, it is useful to know how to make them yourself. Once you have mastered the basics of making paint you will be able to try out some of the techniques explained later on.

1. *Only a few basic materials are required to make oil paints. All you need is linseed oil - the refined type if possible – good quality pigment, a steel palette knife and a clean and varnished brush. Place a small amount of pigment in the center of your palette; then pour a tiny amount of oil next to it.*

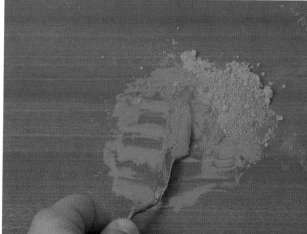

If the paint is too shiny and thin, you have used too much oil. If such a mixture is applied to a canvas, it will crease and bubble. If the paint appears dull or cracked you have used too little oil.

2. *Drag part of the pigment with the edge of the palette knife over to the oil and mix the two together. The two components must be combined gradually until the pigment has been completely blended.*

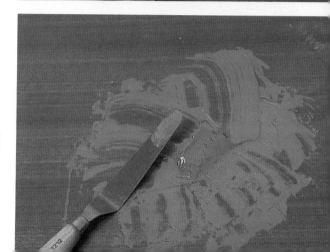

3. *If the mixture appears too thin, add more pigment and continue mixing. Once you have acquired the appropriate consistency, repeat the process until the paint has an oily, elastic texture with no lumps or particles of pigment. You may then add several drops of Dutch varnish.*

PAINTBOXES

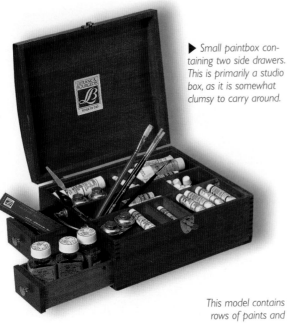

▶ Small paintbox containing two side drawers. This is primarily a studio box, as it is somewhat clumsy to carry around.

il paints are mostly sold in tubes, which can be bought separately. This is the best option if you have a paintbox to carry them in. There are paintboxes containing sets of colors of various qualities. These are indispensable because they allow you to keep your colors arranged in the right order, and store various painting accessories in them.

◀ This model contains two rows of paints and two palettes that separate the compartments and fit perfectly into the slots.

▶ This paintbox has guide strips inserted along the sides of the lid for transporting canvas-covered cardboard. Placed in this position, a recently painted picture can be transported without any damage to its surfaces.

Box-easel set: an inexpensive option recommended only for those who paint very rarely.
▲

ADDITIVES FOR OIL PAINTING

Oil paints can be applied in a wide variety of ways: they can be applied in transparent layers, glazes, and opaque layers, blending them with underlying colors applied earlier in the process, or they can be applied with additives that give them a grainy texture. With the exception of linseed oil and turpentine, the following products are not indispensable, but they are important for obtaining certain effects that will be discussed later.

Ground marble and hematite. These two additives can be used to create textures. They should be added to the paint while it is still on the palette so that its tiny particles are completely coated. Applied to canvas, these additives can create spectacular visual effects.

▲

▼ Linseed oil and turpentine. Two components that are never absent from the artist's paint-box. In addition to being painting materials, they are also used as paint thinners. Given that they form the foundation of paint, they should be of a high quality.

Acrylic textured gels. These products are very easy to apply to the canvas before painting. They dry quickly and can be used to create a wide variety of textured surfaces.

▲

Varnish is applied when the painting is completely dry; this liquid unifies shiny and matt areas and protects the surface.

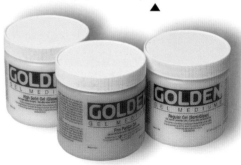

BRUSHES AND PALETTE KNIVES

Brushes are indispensable tools for painting in oils. Virtually an extension of our hands, brushes are used to apply paint to the canvas, to obtain color mixtures, and to execute all manner of brushstrokes. Unlike brushes, the palette knife is used to apply the paint in the form of dense impastos; painters also use this implement to drag paint across the canvas. These two tools help the artist execute highly individual and effective brushstrokes.

▶ There is a wide range of oil paint brushes to choose from. Here is a selection of the various types of brushes available on the market: fan brush (1), flat brush (2), round-tipped brushes (3-4), and filbert brush (5).

▼ Selection of palette knives. There are many types and shapes of palette knives, some that are long and flexible, others with shorter and more rigid blade. It is important to take care of your palette knives in order to prevent them from rusting. The best way to do this is by thoroughly cleaning and drying them after each use. If you are not planning to use your palette knives for some time, apply some oil or grease over the blades and wrap them up in old newspaper.

▶ This brush, whose tip is made of rubber, falls somewhere between the palette knife and the brush.

▼ Wide brushes are straight and flat. These are considered the most useful of all paintbrushes. Despite their somewhat rough appearance, they can be employed in a variety of ways. The brushstroke made with a wide brush facilitates color blending and roughing out, the technique of filling in the canvas.

CANVAS AND UNIVERSAL SIZES

The type and the size of a surface to paint on are just a few of the many questions posed by the painter. There is a wide variety of surfaces to choose from, some of which come ready to paint on, others that require a certain amount of preparation, and those that can be purchased completely "raw." All the materials needed to paint on canvas can be found in your local arts supply store.

▶ Canvas is the most commonly-used support for oil painting. The two examples of canvas shown here are completely unprimed. Canvas can be bought by the meter in rolls or mounted on a stretcher. A primed canvas is ready for immediate use. If it is not primed, you will have to prime it so that the fiber surface is protected from direct contact with the oil paint. ◀

Both the canvas and the cardboard available on the market can be bought in three main formats: landscape, seascape, and figure. As the names of these formats indicate, they are basically designed for these three motifs, although this does not imply that they cannot be used for other subjects.

Canvas-covered cardboard is a cheaper and very suitable support for painting in oils. It is made of rigid cardboard about 5 mm thick, and comes covered with a primed layer of quality canvas. Therefore it is ideal for painting most of the exercises included in this book. However, this type of support is not sold according to the universal size measurements; it can be purchased only in small formats.

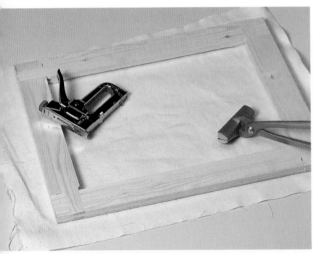

MOUNTING A CANVAS

A good art supply store offers a variety of products for painters to prepare their own materials. It is, of course, very handy to buy canvases already mounted on stretchers, but the amateur painter should learn how to mount an unprimed canvas. Starting with an unprimed canvas allows artists to add their own personal touches, such as choosing the type of canvas and the most suitable stretcher for it.

▶ *There are many types of canvases to choose from; the most popular ones among oil painters are made of linen, cotton, or a combination of cotton and polyester. The linen canvas is a high quality support; highly recommendable, although also expensive. Supports made of cotton bring good results, although they are not as stable as the linen ones. However, many artists paint on cotton canvases without encountering problems. The intermediate option is to use a canvas made of linen and cotton. In order to stretch a canvas, you will need material large enough to overlap the stretcher by five centimeters on either side, a pistol-type stapler for fabric and a pair of pliers for pulling the canvas taut.*

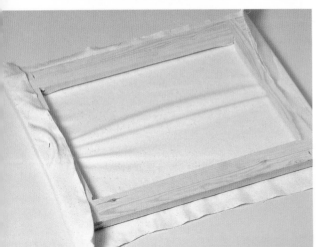

▶ *1. Lay the canvas on a flat surface. After centering the stretcher on the canvas, punch the first staple into the center of the crossbeam. Then stretch and fold the canvas over the opposite crossbeam. This procedure should be done with your hands to ensure that the first staple is not pulled out. Without allowing the canvas to loosen, punch in a second staple. A ripple will form across the surface. This is a result of the tautness.*

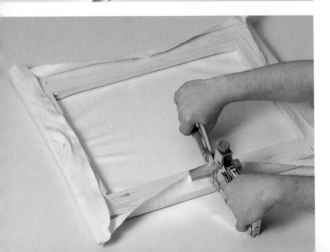

▶ *2. Once again, stretch the canvas to one of the two free sides. Once you have stretched and fastened the canvas to three sides of the stretcher, use a pair of pliers for the final side. Be sure to distribute the tension evenly since excessive force could pull some of the staples out. Staple the fourth side without releasing your grip on the pliers. The canvas should now be attached to the stretcher at midpoint of all four sides.*

STRETCHING A CANVAS

This process is very important, regardless of whether the canvas you are stretching is primed or not. By distributing the tension evenly among all four sides, the ripples will disappear from the surface. It is essential to ensure that the corners are folded over correctly; this will complete the tightening of the canvas.

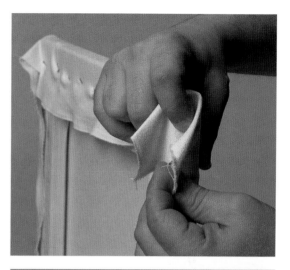

From the center of any of the four sides, at about ten centimeters from the central staple, stretch the canvas a little and fasten another staple. Do the same on the opposite side, ensuring that the canvas remains as taut as possible to prevent rippling. Stretch the canvas again on one of the adjacent sides, to compensate for the transversal crease, and staple. Do the same on the opposite side. The canvas should now be almost completely fastened. All that remains is the corners. Pay close attention to this phase, since this is the most critical moment of the tightening procedure. Take the corner of the canvas and fold it inward toward the corner of the stretcher. Tuck the corner of the canvas in forming a 45° angle with respect to the stretcher.

Not all canvases are easy to stretch. Primed canvas is far more difficult to stretch than the unprimed variety and can even tear on one side. If, at the end of the process, there is still a wrinkle or two, it can be smoothed by dampening the back of the canvas.

Without letting go of the folded corner, fasten it to the stretcher with a staple. Then fold the surplus piece inward and staple it as well. Now follow exactly the same procedure for the three remaining corners, always working on the side opposite to the one you have just finished. This allows you to correct the tension on the surface of the canvas.

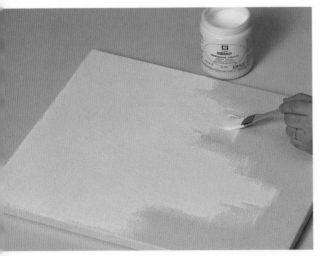

PRIMING THE CANVAS

If the canvas you have stretched is already primed, it is ready to paint on. If it is not, you will have to apply a primer to prevent the oil paint from coming into direct contact with the surface of the canvas. You can make your own primer using animal based glues, but this task is somewhat complicated and messy. The best option is to buy an acrylic plaster primer, which guarantees highly satisfactory results. In addition to canvas, this product can be used to prime wood, cardboard, or paper, which, if unprimed, cannot be used for oil paints. To sum it up, a correctly primed surface is indispensable for painting a good oil picture.

▶ **1.** *To prime any type of surface, you will need a pot of primer and a good wide brush. Apply the primer lengthwise in thick strokes in one direction to ensure that the liquid penetrates the canvas and seals the pores. Continue until the entire surface of the canvas is covered.*

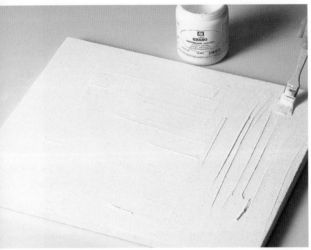

▶ **2.** *Once the lengthwise surface of the canvas has been covered, repeat the procedure going from side to side. Greater care must be taken along the edges as the brush may not reach certain areas. Once the canvas is completely covered, it is ready to be painted on.*

▶ **3.** *The canvas must now be left to dry. It may take several hours, although leaving it in direct sunlight or near a source of heat may accelerate the process. Once the canvas is dry, you may find certain irregularities in its texture. This can be remedied easily by rubbing a piece of sandpaper wrapped around a block of wood over the surface. This procedure must be done very lightly.*

OTHER TYPES OF OIL PRODUCTS

Despite the fact that oil is a very traditional medium, new possibilities and applications have been added to conventional oil paints. All good art supply stores stock a variety of products for use in oil painting. These modern implements can be used alongside the more traditional painting techniques.

▼ Oil paint con also be applied in the form of sticks without losing any of its unique characteristics. This set allows the artist to work with oil paint without the use of brushes as if it were a completely different medium. The range of colors is luminous and stable. They can be used to touch up a picture painted with traditional oil paints or for creating special effects. Oil sticks can be used to draw, paint, or apply thick impastos.

◀ Oil pastels are bound with oil and gum Arabic, which makes them completely compatible with this painting medium.

▶ The painter Edward Munch spent much of his time investigating the oil medium. He attempted to obtain a formula that would convert the greasy paint into a resin, making oil paint soluble in water. The great painter was on the verge of achieving this goal, but he lacked the necessary means and his endeavor ended in failure. Nonetheless, over the last few years, several oil paint manufacturers have achieved Munch's dream. The result is a paint with the characteristics of oil, which dissolves in water and dries rapidly. This type of oil paint allows the artist to rough out the canvas knowing that the preliminary layers will dry very quickly.

369

PALETTES, PAINTBOXES, AND EASELS

If painters do not like the type of cases and paintboxes available on the market, they might prefer to make their own painting equipment. Likewise, they may prefer to make their own palette. Another tool necessary for panting is the easel, of which there is a wide variety to choose from.

▼ Cases for transporting an artist's paints and equipment. You will find easels ranging from the smallest and most simple boxes without compartments to the most sophisticated double-box type. They contain metal trays to hold paints and other accessories, and are much better than the box sets with plastic compartments.

▼

It is very likely that you will need a bigger palette than the one included in the case, or, on the other hand, an even smaller one. Palettes come in many shapes and sizes. The one important thing to remember is that its surface must always be covered with two coats of protective varnish. The color of the palette is not important, although some artists opt for one that is either very dark or very light. This range of palettes shows some of the most commonly-used shapes and sizes.

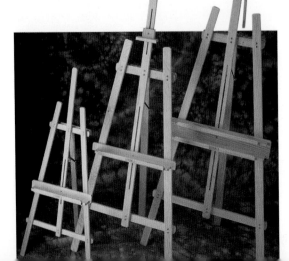

▶ It is extremely difficult to paint comfortably without a firm support to rest the canvas on. You can improvise but if your support is not good enough, all the time and energy invested in the picture will be for nothing. Therefore, the sturdiness and firmness provided by the easel makes it an indispensable item for all amateur painters.

1

Mixing color

TESTING COLORS

The palette should not be filled with excess paint. You should place on it only the colors you are going to use, and in the necessary quantities. With only three colors it is possible to obtain all the colors of the rainbow, and by extension all the colors existing in nature. Once you have enough experience in color mixing, you will easily be able to obtain any color.

In this first chapter, we are going to outline the fundamentals of the medium. It is not difficult to start painting in oils, but the beginner does need some basic knowledge on how to mix colors. Before any artist begins to paint, he must arrange the colors correctly on the palette. Before going on to more complicated matters, it is essential to fully understand the rudimentary aspects of this art form. Here we will demonstrate how easy it is to blend oil colors.

▶ *To begin, you will need the three primary colors: blue, carmine, and yellow. It is important to place these colors far enough apart so that they can be mixed conveniently. Remember that the better the quality of the paints, the better the results obtained. The palette you use must also be of good quality and have a varnished surface so that the paint does not penetrate the pores of the wood.*

▶ *1. In order to learn about the possibilities of the oil medium, you should begin painting simple motifs such as a flower. Dip your brush in the yellow and paint several strokes in the shape of a fan. This is easy, isn't it? If you combine blue and yellow you get green. Now apply a new stroke of this color to paint the stem; if there is little paint on the brush, the marks of the hog's hair brushes will be left on the paper.*

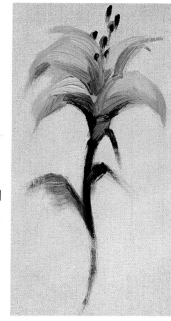

2. Paint several strokes of carmine over the yellow. By dragging this color over the other we get orange. Paint a few strokes of yellow, with slightly more color, on top of the green stem in order to lighten it. The opacity of oil paint allows light colors to be applied over dark ones.

MORE COLORS ON THE PALETTE

Having tried our hand at the first exercise, we will now attempt to work with more colors, since many tones are difficult to obtain with only the three basic colors. When inexperienced amateurs take up oil painting, they often arrange their colors randomly. This is a mistake; the order in which artists arrange their colors will make the task of mixing and applying either easier or more difficult.

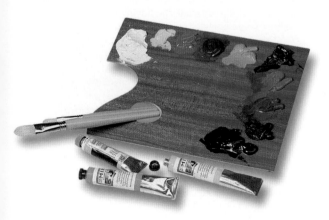

▼ This is a classic arrangement of colors on the palette; white should always be first and in abundance; the other colors in ascending tonal and chromatic order, yellow, red, and carmine; then the earth colors, such as ocher and burnt umber; last green, dark blue, and black.

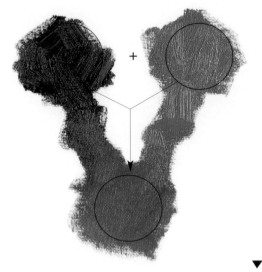

▼

A common error made by beginners is the way they make luminous color. White is used to gray tones and to obtain highlights. Try the following simple exercise: lighten carmine by adding red and then darken it with white. In the first case, the result is a lighter but intense tone; in the second, a pinkish pastel tone.

▲

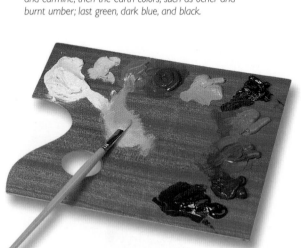

▼ The best procedure for obtaining correct color combinations is to drag a tiny amount of the first color to the center of the palette. Then drag the second color over it and mix the two until you obtain a homogenous color. Then you can add other colors to this mix to achieve the desired tones.

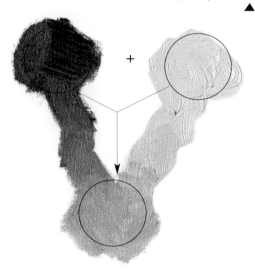

OBTAINING COLORS

The primary colors are yellow, blue and carmine red. By mixing these colors together we obtain the so-called secondary colors, that is: by mixing yellow and carmine red together you obtain red; yellow mixed with blue produces green tones; blue combined with carmine red produces a range of violet tones.

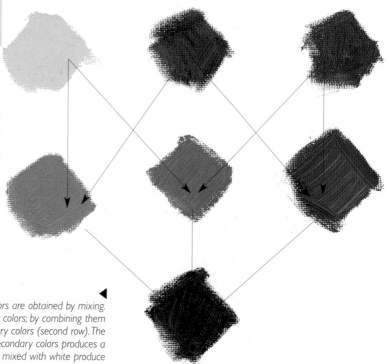

These examples show how colors are obtained by mixing. The top row shows the primary colors; by combining them we obtain the secondary colors (second row). The combination of two or more secondary colors produces a tertiary color. Tertiary colors mixed with white produce broken colors, also known as neutral colors.

There is no precise color for painting an orange or a tree. Unintentionally, we tend to relate a color to a specific object. For instance, when we think of an orange, the first color that comes to mind is orange, but this is not altogether true. The color of any object is made up of many other colors; furthermore, the light that envelops an object makes a color tend toward one tone. The orange's skin may very well be orange, but only under certain conditions. For instance, placed next to a blue object its shaded area will no longer be orange but will take on bluish and even violet tones.

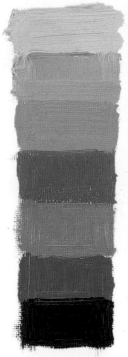

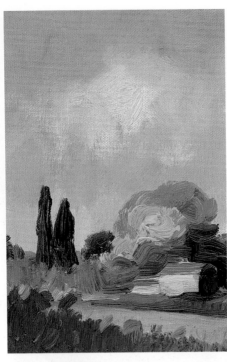

HARMONIC RANGES

Colors can be organized according to their range and tone. They are divided into three basic ranges: cool, warm, and neutral. The colors belonging to the warm, range are those that appear to give off heat, in other words, red, pink, carmine, orange, and their mixtures. Other colors considered warm are earth colors, such as brown or ocher. The cool range of colors includes green, blue, and violet. The colors corresponding to the neutral range comprise gray or "dirty" tones that are the result of mixtures made on the palette.

▶ *Warm range colors are formed with carmine red and yellow, but by combining them with earth tones, an extremely wide range of tones can be produced. Therefore, the warm range of colors extends to yellow, orange, red carmine, and the so-called earth colors: ocher, sienna, and burnt umber. Cool colors like green have been combined with red to make them warm.*

Neutral colors, also known as broken colors, comprise dirty undefined colors. When a „dirty" color is added to clean or pure colors, the result is a dirty blend but, when this range is used exclusively with neutral colors, a pictorial range of stunning beauty is achieved. A neutral color is obtained by mixing two secondary colors together and then adding white.

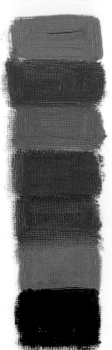

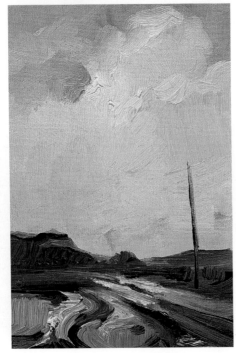

▶ *The basic colors comprising the cool range are greenish-yellow and blue; but if we combine them together, we can obtain a very wide chromatic scale. By combining different amounts of red, a range of violet tones is produced. Therefore, the cool range of colors comprises tones of green, greenish yellow, and violet.*

Landscape with basic colors

With only three colors and white, we can obtain most of the colors existing in nature. To demonstrate this, we have chosen this cliff top as our model. It is important to pay close attention to each step and not become discouraged. In the initial roughing out, the brushstrokes may appear akward; but this is normal. If you carefully follow the instructions explained in each step, this exercise will be easy. Pay special attention to the color mixes produced on the palette.

MATERIALS

Palette, oil paints: white, blue, carmine, and yellow (2), hog's hair brush, (3) canvas-covered cardboard (4), and dippers: one filled with turpentine and the other with linseed oil.

1. *First, dip the brush in turpentine and wring out excess liquid to prevent dripping. Then, using a little blue, begin to draw the brush over the canvas-covered cardboard. Paint the outline of the cliffs first. If you make a mistake, the oil medium allows you to make as many corrections as necessary. Paint the hollows in the clouds last.*

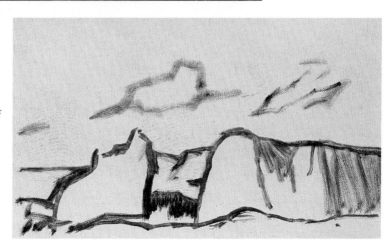

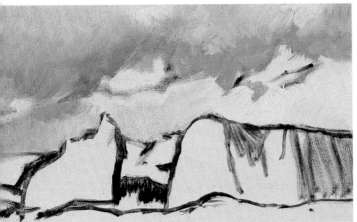

2. *Blend a little blue and white together on the palette. The mix should contain more white than blue. A touch of blue is enough to give the white a cerulean tone. Always start in the uppermost part of the sky, where the white of the clouds is clearer. As the shapes of the clouds are defined, add a touch of carmine to the mix; the tone obtained is akin to violet. Paint the darkest areas of the clouds with this tone.*

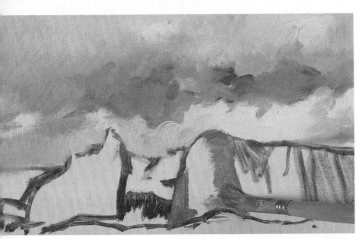

3. *By combining blue with white, we obtain a cerulean tone that is much darker and more luminous than the color of the clouds. This new mix does not include carmine. Use this blend to paint the blue of the sky. Then, with an almost pure white, paint the tops of the lowest clouds. For the cliffs, start with a mixture of carmine and yellow to obtain an orange tone, and then add a hint of blue to "break" the mix.*

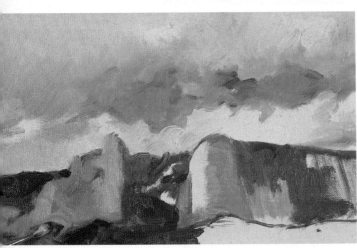

4. *Paint the right-hand side of the cliff with various colors obtained from mixes made on the palette: blue mixed with yellow produces green; blue mixed with carmine produces a violet color with a tendency toward one or the other color, depending on the proportions used. By blending a touch of yellow and carmine you can obtain red, but if the amount of yellow is increased, it turns orange. A touch of violet added to the green produces the broken color on the right-hand side of the cliff. To apply lighter tones to the left-hand side, we first created a yellowish green tone, to which we added orange. Finally, white was added to lighten the tone slightly.*

5. *In the previous step, we mixed broken colors together. The contrasts of the craggy cliff face should be painted with darker broken tones than the ones previously applied to each area. The brightest area of the cliff is painted with a pinkish tone obtained with carmine and white to which a touch of yellow has been added.*

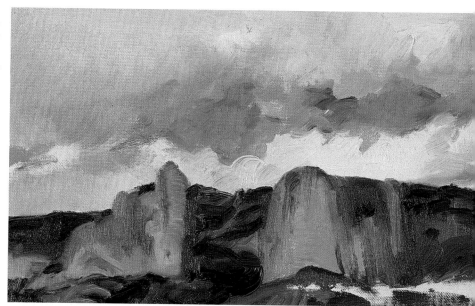

As the canvas advances, the layers are applied more densely without adding any turpentine to the mix.

6. *The range of greens of the lower area is slightly broken. The first green has been obtained from green and yellow and blue, the result of a homogenous mix made on the palette; with carmine and some white the color has been turned into an earth color. The tone varies in some areas, and is even mixed with blue. The houses situated below the cliff are painted with several small patches of white, dragging some of the underlying color with it so as to obtain slightly dirtier colors.*

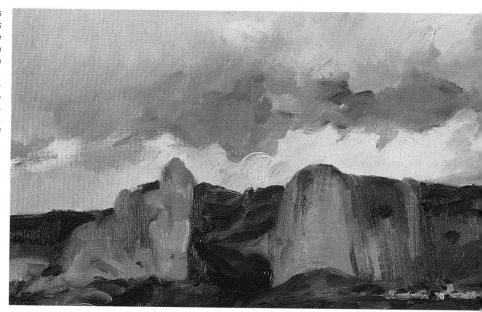

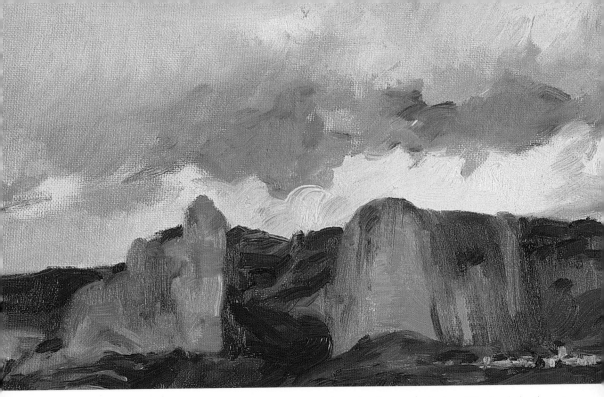

7. *All that remains now is to increase slightly the contrasts of the cliff with the darker tones. These same dark tones are used around the little houses, so as to make them stand out even further. This simple landscape shows you how easy it is to paint a picture based on mixes obtained from primary colors.*

SUMMARY

The whitest aspect of the clouds is comprised mainly of a large proportion of white and a small touch of blue.

The lightest tones on the right were grayed with white.

The greenish tones in the lower part were painted with blue, yellow and a touch of carmine.

The orange tone of the cliff was painted with carmine, yellow, and a dash of blue.

The preliminary outline was painted in blue.

The village was painted with tiny touches of white.

2

The brushstroke

BRUSHES AND THEIR IMPRESSION

The impression or mark that paint leaves on a surface depends on the instrument used to apply it. In this chapter we will first deal with the effects of different kinds of brushstrokes and then move on to their practical use. As we have seen in the first section of this book, there are many kinds of brushes, each with its own characteristics and uses.

Oil paint is sticky to the touch, but it is also soft enough to be able to mold it with a brush. The paint saturates the brush and permits the tip to interact with the canvas in a variety of ways. A brushstroke can create lines, smudges, and a number of effects that, when viewed together, allow for numerous types of textures.

▶ 1. After dipping the brush in oil paint, we place the tip on the canvas and spread the color over it. The length of the line depends on how much paint the tip can hold. For this reason, there are different kinds of brushes for different types of effects. This picture shows a line painted with a small, flat brush. Flat brushes leave a line with an even, regular edge.

2. In order to produce a smooth gradation between two colors, the two original colors must be kept perfectly clean and free of any other color before their edges make contact. This permits us to add several tones on top of these colors.

▶ 3. The two colors are blended by passing the brush several times over the two freshly painted colors. Use long strokes that merge a part of one color with the other. After several horizontal strokes without adding more paint, the two colors will blend together in soft, progressive gradation.

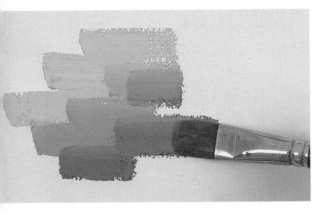

THE USE OF BRUSHES

Some areas of a painting may require brushstrokes that allow the colors to blend, whereas others need brushstrokes that are superimposed on one another, leaving small, clearly distinguished lines. These different types of lines can be painted easily if the correct type of brush is used. Some brushes allow you to rough out the surface with patches of color, and others with small dabs. Still other kinds of brushes are ideal for creating large, uniform surfaces. As we will see in this section, there are brushes for every type of line, and after all, lines are the main technique in painting.

▼ 1. *This is a simple exercise that consists of practicing brushstrokes and changing from one color to another by adding a second color to the first on the palette. Paint a yellow line with a flat brush. Then add a bit of red to the yellow paint on the palette and mix them. With the resulting orange paint, apply another stroke on top of the first. Avoid using repeated strokes, which would start to pick up the color underneath. In this exercise, the brushstrokes should end straight. The procedure creates on accumulation of small strokes with decreasing amounts of yellow until they finally are completely red.*

The brushstroke can vary according to the thickness of the paint, the drag of the brush, and the condition of the underlying layers of paint. By taking these various factors into account, we can blend the different colors or apply them one on top of the other.

3. *Brushstrokes can produce an infinite variety of appearances depending on how the brush is applied over the colors. The line can be soft and barely show the grooves from the bristles, or the brush can be used to daub on blotches of color, as in this illustration. Here the strokes are small and pasty, and they are superimposed on top of one another.* ▲

▼ **2.** *These brushstrokes, painted with a filbert brush, end differently than the previous ones. This technique uses cool tones. First, paint strokes with blue paint that has been lightened by adding white on the palette. Paint dark blue over this without mixing the colors. From this point on, add new tones without mixing them with the previous ones. Compare the results of this exercise and the previous one.*

STROKES AND PATCHES

Each brush has its own characteristics, which are expressed when it is applied to the canvas or on top of other colors. In this exercise we will use different techniques for blending colors, as well as different types of strokes, to create different parts of a painting. This simple exercise will highlight the uses of each type of brush in terms of its impression and how it is used to blend.

1. The largest areas should be painted first. Before painting them, consider what the next color will be, so that the two tones can be blended or superimposed. When painting the larger area, keep in mind where the next color will begin.

▲

▼

2. Just as we blended the patches in the first part of the chapter to form a gradation, this exercise calls for a blend at the boundary between the two areas. To do this, use a medium-sized brush instead of a large one. This will allow a discrete blended area where one color mixes with the other.

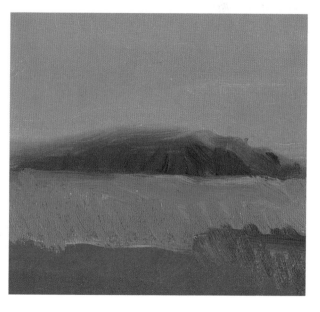

◄

3. The foreground also has two colors, but there is no gradation between them. Not all parts of a painting require the same treatment: some require gradations, while others require the colors to be superimposed.

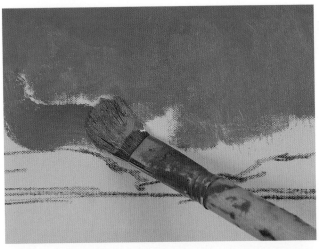

▶ **1.** *Since the preliminary sketch reveals that the sky occupies a large part of the landscape in this composition, it should be painted with a large brush. With just a few brushstrokes we can cover this area of the canvas, including the contour of the sky above the mountains. Use long, uniform brushstrokes, and avoid leaving lumps of paint on the canvas.*

APPLYING IMPASTOS AND BLENDING

A brushstroke can produce many different effects, depending on how it is applied across the surface and the amount of paint used. If we use thick brushstrokes on a freshly painted surface, the stroke will move some of the underlying color along the new line. If, on the other hand, the brushstrokes are precise and do not drag on the wet paint, there will only be a minimum of blending between the two tones.

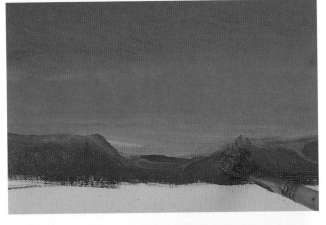

▶ **2.** *Any medium-sized brush is suited to this part of the painting. A flat brush or a filbert brush will work equally well. First, dip the clean brush into a bit of white paint and use long horizontal strokes on the blue background. Paint the mountains in the background with burnt sienna. Blend part of the blue paint from the sky into your stroke when painting the top edge of the mountains: this will add texture to the painting.*

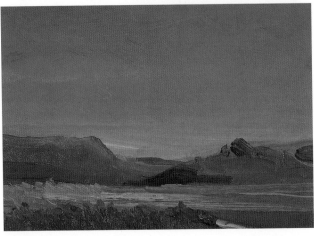

▶ **3.** *Use a small brush to paint the distant parts of the landscape. Combine green, yellow, and brown, and paint with long brushstrokes. By superimposing and dragging the brushstrokes, the tones and colors will blend. Paint the foreground in bright green, applying the paint with a medium-sized brush and using long strokes. This area shouldn't be covered with a thick coat of paint, but rather covered with color as quickly as possible. Add texture to the grass by using short, vertical brushstrokes.*

Step by step
Fruit

Here is a simple exercise in terms of both drawing and composition. The shapes in this still life are all extremely simple and based on circles. The exercise allows you to practice with several types of brushstrokes and color. In contrast with the previous exercise, we will deal with the shapes and take a close look at the brushstrokes involved in a step-by-step analysis. In order to simplify this exercise, we will use a very limited palette of colors.

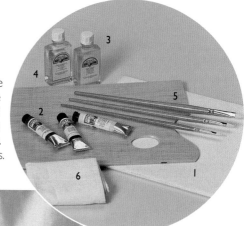

MATERIALS

Canvas-covered cardboard (1), oil paints (2), linseed oil (3), turpentine (4), paintbrushes (5), and a rag (6).

1. Since the preliminary sketch of this still life is extremely simple, it can be drawn directly with oil paint instead of pencil. A more complex composition would require a preliminary sketch of the main contours using any type of drawing medium. Sketch the outlines with heavily diluted paint. Add the three pieces of fruit using quick, approximate strokes. There is no need to erase any mistakes: the lines can simply be covered over again.

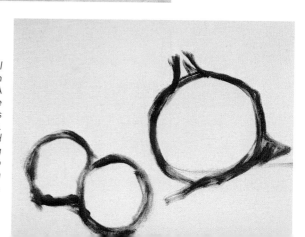

STEP BY STEP: Fruit

2. *Once the fruit has been sketched, we can start with the first colors. The first step is to color in the background. A neutral color is a mixture of the dirty colors on the palette. If the palette is still clean, it can be made by mixing green, umber, and white. Paint the area corresponding to the shadow of the pomegranate and upper part of the plum. The most illuminated part of the pomegranate should be shaded with violet carmine, leaving the area of the reflection white.*

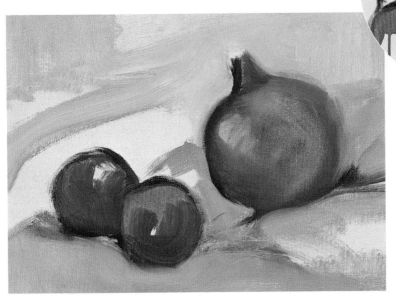

3. *The plums are painted with the same violet carmine that we used for the pomegranate. The gray area of the right plum separates the two pieces of fruit. Run the brush over the pomegranate several times so that the colors blend. This will also give the fruit its spherical shape. Start painting the tablecloth with more white and violet carmine, green, and blue, without letting the colors mix completely on the palette.*

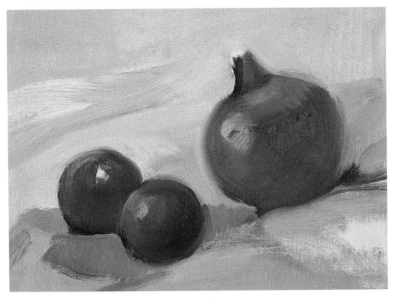

4. *Use curved strokes to bring out the spherical shape of the pomegranate. When the brush passes over the gray area the color will lighten slightly, as it removes some of the underlying colors. Now is the time to start separating the illuminated areas with touches of dark violet mixed with cobalt blue. Use this same color mixed with a bit of ultramarine blue to paint the foreground. These brushstrokes will also pick up some of the underlying color.*

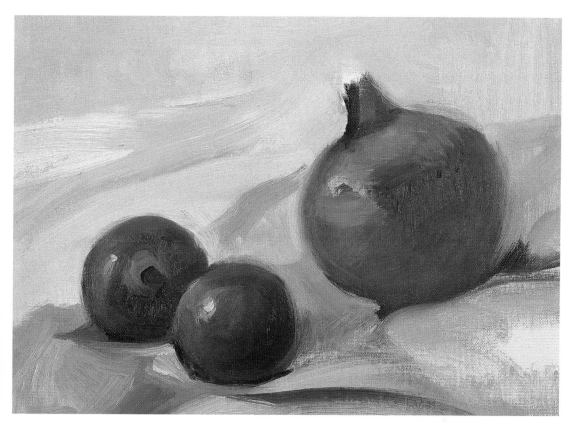

5. *Resolute brushstrokes of carmine should be applied to the plum on the left. The colors on the right side of the painting tend to be cooler and bluish, whereas on the right they are much warmer. The highlight should be the main reference for positioning the darker tones. The bluish tones on the brighter side should be slightly lightened with white. Paint the more illuminated parts of the pomegranate with violet carmine lightened with white. Bluish lines mark the folds on the tablecloth.*

6. *In this detail we can see the lighter tones, which define the shaded area. The brighter colors on the pomegranate range from white, at the brightest reflection, to a complete gradation of carmine. There are a few touches of blue near the main highlight.*

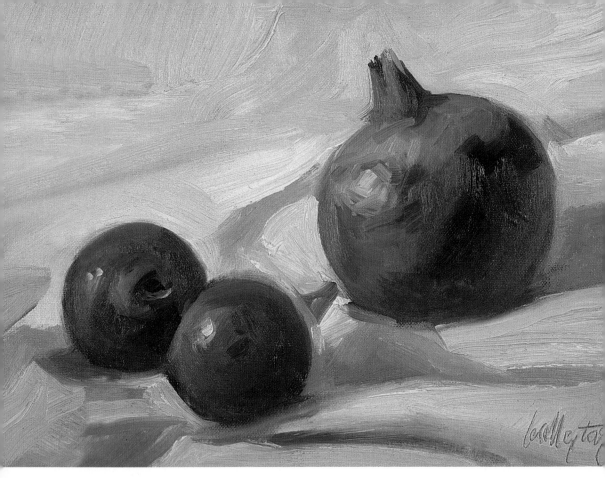

7. On the pomegranate, the highlights can be enriched with tones of orange that contrast with the red and pure carmine. In order to do this without changing the color to pink, we use Naples yellow instead of white. The dark parts of the plums completely define their spherical shape. This puts the finishing touch on this exercise, which involves a great variety of both direct and blending brushwork.

SUMMARY

The preliminary sketch was painted directly with a paintbrush and oils. The brushstrokes should be free and very diluted.

A very diluted grayish color was used to paint the plum on the left and the pomegranate. Some tones blend in this area.

The areas of reflection on the plums and the pomegranate were left unpainted so that they could serve as a reference point. The reflections are later painted with bright dabs of color.

The dark area of the plum was painted with dark violet and cobalt blue. Repeated brushstrokes were used to make the tones blend with each other.

Blocking in
and planes of objects

BLOCKING IN AND COMPOSITION: OILPAINTS AND CHARCOAL

The blocking-in technique consists of simplifying the complex forms of a model. The first step is to look carefully at the shape of a model and try to find the simplest lines that could define it. In these exercises we will see how different motifs can be developed by blocking in their essential lines, and how objects can be understood through simpler elements.

A painting should be understood as a succession of objects located on different planes, even though only a couple of them need to be shown. When composing a painting, it is essential to observe the location of each element from the beginning. Representing a model in a painting can be a very complicated task if you start painting directly without previously blocking in the objects. The blocking-in technique allows the artist to synthesize the shapes of reality, transforming them into simple objects that can be easily drawn.

▼ 1. This sketch shows the logical location of the objects in the painting. The still life will evolve from these simple drawings. Each block will contain a fully developed element in the final painting.

3. Once the main forms have been blocked in, you can start applying colors. This application is gradual and must conform to the way in which it was blocked in from the start. The nearer planes should be given more detail than the most distant ones.

▲

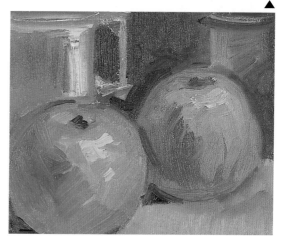

▶ 2. The still life will be based on the previous sketch. Start by painting the foreground, using a reddish color. The drawing technique should be fast and direct. Use a brush with turpentine to paint the first element: a circular shape that will eventually be a piece of fruit. The turpentine will help the color to spread quickly over the cardboard-covered canvas. Use an orange tone to draw another sphere in the next plane, slightly higher than the first. In the background, sketch in the containers in brown, using very basic lines.

▶ 1. *The first thing to do is to establish the shapes that make up the simple elements, such as a rectangle and two spheres. The foreground is always what determines the rest of the composition. The rest of the objects should be arranged in reference to this. Once the still life has been sketched, paint in the foreground. Different tones should be used for the other planes so that there is a contrast between the closer and farther objects.*

BLOCKING IN SHAPES AS GEOMETRICAL FIGURES

When painting with oils, an artist generally starts with the general and works towards the specific. In other words, the first strokes constitute a rough sketch of the basic shape, which will later be filled in with detail. The first colors applied are also gen-eral: the details are left for later. Blocking in and applying patches of color are two closely linked concepts in the evolution of a painting.

▶ 2. *Thanks to the preliminary blocking in and the first applications of color, the object painted with oils can be outlined or suggested with loose strokes that mix with the background colors. Planes surrounding the foreground should be painted in clearly differentiated tones. The main subject should stand out against the background.*

The thickness of oils allows brushstrokes to create blends with only the color applied to the canvas. Having passed the brush several times over an area, it is possible to break the form of the background and make the planes of the shapes look as if they were out of focus.

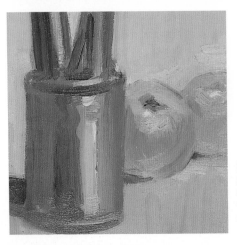

▶ 3. *This exercise illustrates the importance of blocking in the first stage of the painting process. A sketch can sometimes be so essential that it would be impossible to develop the painting without one. Once you have applied color to the perfectly defined shapes, blur the profiles of the pieces of fruit in the background. This will increase the difference between the two planes.*

TAKING ADVANTAGE OF BLOCKING IN

Blocking in is one of the most important aspects of painting. In fact, a correct blocking-in procedure is the first step in any kind of painting, no matter what technique is being used. This quick exercise deals with how to apply brushstrokes in the foreground after the main sketch. This will show how to take advantage of the sketch and develop it into a complete picture.

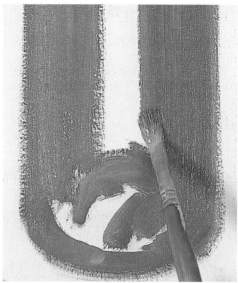

◄

1. After the main shape has been blocked in, fill in the interior with the colors that will make up the color base. This will establish a clear difference between the areas of light and shadow. In this simple sketch, the areas of light remain unpainted.

2. On top of the first patches of color, apply short, horizontal brushstrokes to the front part of the object, which is also the brightest. It is essential to respect the shape of the sketch in spite of any modifications that may be made to the interior of the objects, since this is a detail of what might be a more complex still life. The preliminary sketch allows us to define each of the shapes and planes of the object.

▲

3. The sides of the object should be pointed with a long, vertical brushstroke. If the contours and reflections of the object had not been previously sketched, it would have been impossible to develop the object freehand.

▲

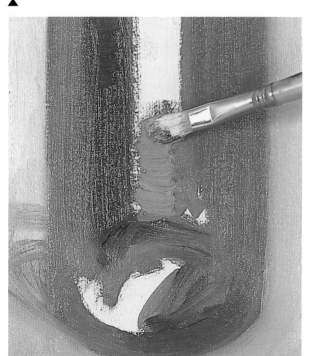

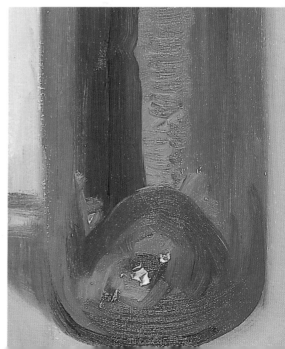

A SKETCH FOR EVERY METHOD OF WORK

The position of various objects in the painting allows the artist to assess the different possibilities in terms of the composition of the elements that make up the whole. How detailed the sketch needs to be depends on the precision each element requires.

▼

1. The first sketch of this simple landscape allows us to put each element in its place and establish the various highlights.

2. With oils, a light sketch is enough to sum up the shapes. The shapes in the background can be suggested with vague patches, whereas the contours of the objects in the foreground should be given more detail. The shapes in the background should also be smaller than those in the foreground. Shapes should be suggested with fresh, direct brushstrokes.

▲

▼ *1. The most important highlights are treated with direct dabs of color or pure white. This characteristic will determine how the model is sketched. After sketching out the main shapes with free strokes, darken the background to isolate the main highlights, which in this case are focused on the objects.*

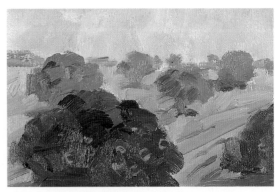

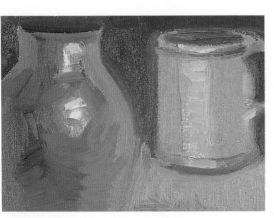

▶ *2. The dark background painted in the first step of the sketch has isolated the main elements, perfectly defining their shape. The highlights are painted with free brushwork that does not mix with the underlying colors. Now the color and reflections can be established in the foreground. Sharp contrasts are created by alternating dark and light tones. This juxtaposition highlights both the light and dark tones.*

Step by step
Bottles with tablecloth

The sketch of the model is the first step toward the painting. Even the simplest subject should be prepared using this process, which consists of correctly positioning the main structural lines of the objects or shapes to be painted. Once the forms have been sketched, the closer planes will receive a more clearly defined treatment than the more distant ones. Each plane should be dealt with differently, in terms of both brushstrokes and color.

MATERIALS

Oil paints (1), charcoal (2), linseed oil and turpentine (3), paintbrushes for oils (4), canvas-covered cardboard, (5), a palette (6), and a rag for cleaning (7).

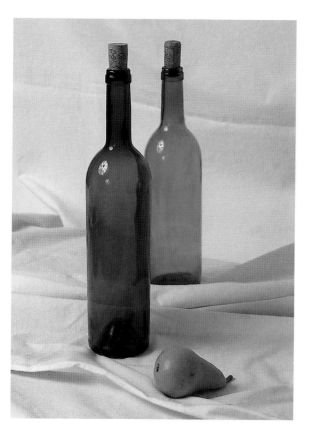

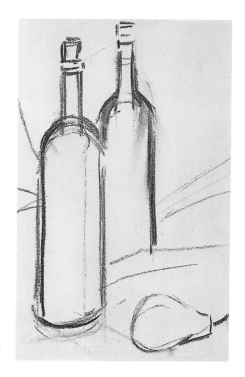

1. *The first sketch distributes and positions the various elements in the painting. The main elements of this painting are the brown bottle and the pear. The green bottle is located in a more distant plane. The sketch should be concise, with only the essential lines. The shapes should be sufficiently defined with the strokes, since symmetrical objects like the bottle are always more difficult to draw.*

STEP BY STEP: Bottles with tablecloth

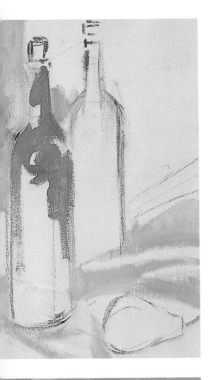

1. *Start painting the back-ground area with blue mixed with a lot of white. The cloth in the foreground should be painted with a very dry brush, only suggesting the areas of shadow. Fill in the bottle in the foreground with a mixture of sienna and English red. This mixture should not be carried out on the palette, but rather on the painting itself, by drag-ging the latter over the former. When painting the bottle, leave the areas corresponding to the highlights blank. These areas will be painted later.*

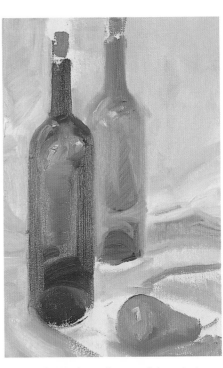

2. *Fill in the background with a bright mixture of cobalt blue, white, and Naples yellow. The neck of the bottle in the foreground should be painted with long, tightly-grouped brushstrokes. Use natural sienna for the central area of the bottle. Paint over the sienna with burnt umber, as well as English red mixed on the palette with some sienna. Then paint the pear in the foreground with bright yellow, Naples yel-low, and green, using a purer green for the lower area. The bottle in the background should be less clearly defined than the objects in the foreground.*

3. Work on all areas of the painting at the same time. Paint the center of the bottle using downward horizontal strokes which mix with the umber color from the previous step. The lower part of the bottle should be painted with curved brushstrokes that blend togeth-er with the previous colors. The bottle in the background should be painted in a similar way, but limit the tones to greens that have been mixed with a great deal of white and Naples yellow.

When defining the planes, choose the colors according to the place-ment of each object in the still life. If the foreground is painted in dull colors, it would be illogical to use bright colors for the background.

4. *This step illustrates the different ways that the objects have been dealt with up to now. In the first bottle, the color is contrasted: the neck is painted in dark brown, with long, vertical brushstrokes, whereas the center has short, horizontal brushstrokes, which make up a different plane. New planes are created in the body of the bottle: the center has short, red, horizontal brushstrokes, and the curved area has orange strokes that follow the shape. The reflection is painted in yellow.*

To make a distant plane merge with the background, run the brush over the contour several times until the outline becomes fuzzy.

5. *The foreground is full of contrast and much richer in color than the middle ground, which almost blends in with the background.*

393

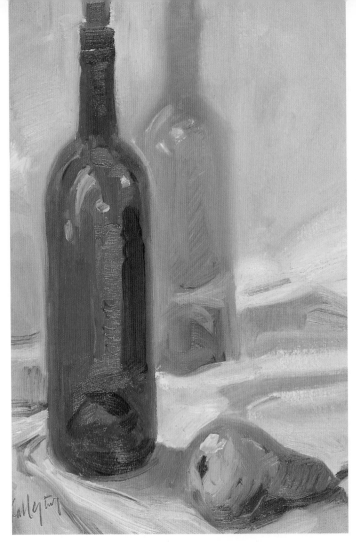

6. *Painting the tablecloth is simple, although the foreground requires more attention than the background. The preliminary sketch should have established the main lines, which will provide a clear path for the brushstrokes to follow. The light tones are much brighter and more pure in the foreground than in the background. Run the brush very lightly over the contours of the bottle in the background to give it an almost blurred appearance. This concludes this exercise in sketching and painting planes with oils.*

SUMMARY

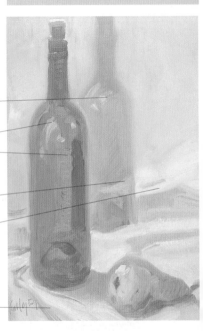

The shadows and colors in the foreground are strong and contrasted, whereas those in the background are soft and tend to blend in with one another.

The highlights on the **main bottle** were painted with strong, bright colors.

Following the preliminary sketch, the contours of the bottle in the background are blurred, without a clearly defined shape.

In the background
the colors tend to blend.

The tablecloth is more clearly defined in the foreground. The lines are more precise in this part of the painting.

Beginning a painting with diluted paint

THE ORDER OF COLOR: FAT OVER LEAN

This section deals with a process which is essential when painting with oils. After the preliminary sketch come the initial applications of color. Although it might seem complicated at first, it will quickly become second nature. These should provide a base that is stable enough for the other colors to dry on naturally, and consist of very diluted colors in discrete tones.

> One of the basic principles dealt with from the beginning of this book is that oil paints can be diluted with turpentine. This section will deal with a preliminary process using oil paint that has been heavily diluted with turpentine.

1. *After drawing the preliminary outline, divide up the areas of light and shadow. This is done with a brush dipped in turpentine and then in paint diluted on the palette. Use this color to paint the entire dark side of the subject. Don't worry if the brush strays into the light areas: corrections can be made by running a brush dipped in clean turpentine over the error while it is still wet. This is a simple and effective way to remove unwanted paint.*

▲

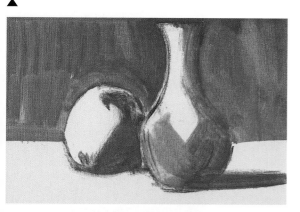

3. *Once all the areas of light and shadow have been situated on the canvas, continue roughing out with the brush soaked in turpentine. In order to open up a white, all you have to do is run the brush over the area in question to remove the previously applied color and thus obtain the white color of the underlying canvas.*

▼

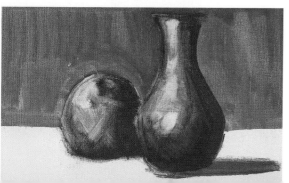

▶ 2. *Colors diluted in turpentine allow forms to be defined according to dark and light areas, which are virtually drawn by the deepest tones. The first applications made with very diluted paint, a technique also known as roughing out, define the main areas of light and shadow. These gray strokes are all that is needed to obtain the framework.*

DILUTING THE COLOR ON THE PALETTE

Following the previous exercise, in which we painted a still life using heavily diluted tones, we will now deal with the next step in the application of color. In the first steps of an oil painting, the oils should be diluted in order to provide a base for subsequent layers of paint. This procedure also allows us to make any necessary corrections without wasting paint. The process of filling in the picture with color is part of the first application of diluted paint. Now we can dilute the colors on the palette to obtain sharper lines. If this procedure is carried out correctly, the painting will dry properly.

▶ 1. *Once the main elements of the model, the light and shaded areas, have been sketched using diluted paint, the next step is to apply slightly darker colors. This process should be repeated at each stage of the oil painting, and should be done progressively: first, fill in the lighter tones and then the darker ones, using fairly dry strokes with heavily diluted color.*

3. *The darkest contrast should be left for last. In this exercise, the darkest colors should be applied directly, without being diluted with turpentine. The brushwork is denser, and the colors should be mixed on the palette to maintain the purity of the colors.* ▲

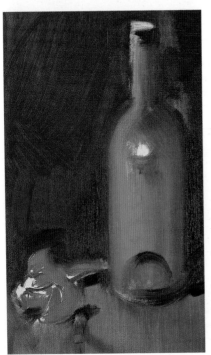

▶ 2. *When applying a brush-stroke of dark color on top of a lighter tone, the stroke will pick up the underlying color, especially if it contains turpentine. With several repeated brushstrokes, the new color will blend in with the underlying tones. Apply darker brushstrokes, slightly diluted with turpentine on the palette, on top of the previously painted green color. Paint the flower with very bright pink, diluted with turpentine before applying the brush to the canvas. Use a very dark color for the shadow of the flower.*

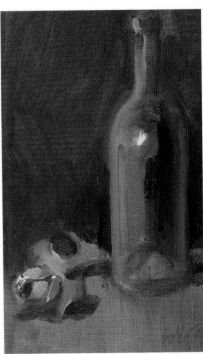

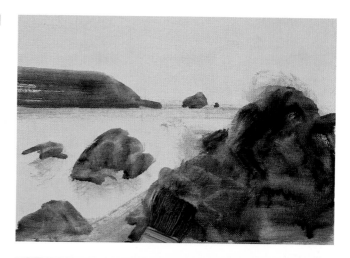

1. The strokes of the wide brush are broad and sweeping, making it ideal for filling in large surfaces. Surprisingly enough, the wide brush permits a great variety of techniques, since its outline can be fairly precise. Dragging the wide brush also quickly blends the diluted tones of the painting.

APPLYING PATCHES OF COLOR AND USING THE WIDE BRUSH

The wide brush is one of the most practical tools for any painting procedure. Despite its clumsy appearance, it facilitates the roughing out of the picture with diluted oils by providing a quick method especially suited to the first stages of painting. This simple exercise consists of practice with the wide brush, working on techniques that can be applied to any subject, especially during the preliminary stages of roughing out the picture with color.

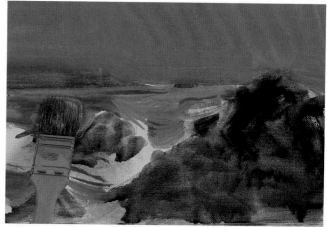

2. Once the main areas of the picture have been colored in with heavily diluted paint, we can start on more detailed brushwork, such as defining the outlines which are now more clearly visible. The wide brush permits a wide variety of brushstrokes, although it is obviously not wellsuited to detail work.

Old wide brushes should never be thrown away, since they can produce brushstrokes that are impossible to perform with new brushes.

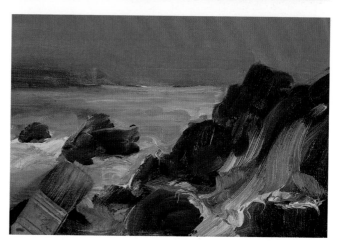

3. After roughing out the painting color, the shapes can be defined using darker tones, employing different part of the brush to create a variety of strokes.

397

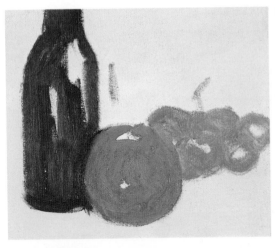

▶ 1. *Using paint which has been slightly diluted on the palette, sketch out the bottle and the grapes and fill them in with color. Two easily distinguishable tones of green are used in this preliminary sketch, which includes no details of the shapes, although the highlights should be left blank. A brightly colored orange serves as a point of contrast.*

PAINTING THE CANVAS WITH PATCHES OF DILUTED COLORS

When painting a picture, the colors should always be applied progressively, using the fat-over-lean principle, even when the tones are highly contrasted. The sketch and the roughing out of the subject should be painted quickly and freely, painting both the shapes and the colors at the same time. This is the greatest advantage of oil painting over other media: it allows us to build up the painting progressively, using patches of diluted color.

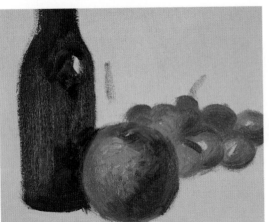

▶ 2. *The tones can be corrected during the preliminary stage of filling in with color. Since both the colors and shapes have been painted in unison, the colors can be corrected as you work. At first, the bottle was a dark green color. However, repeated applications of increasingly thick paint changed the tone progressively to a blue tone. A reddish brushstroke should be applied to the bottle. Use a combination of blue and orange, mixed on the palette, to give the orange its shape. The grapes in the background should be painted in a much brighter tone than the other colors.*

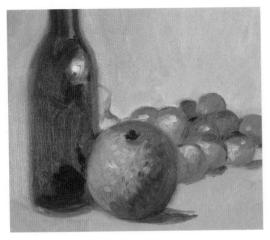

▶ 3. *The colors and shapes should be corrected progressively. Apply increasingly precise brushstrokes on top of the preliminary patches of color to gradually create the shape. The last stages of the painting process should be completely free of turpentine. With undiluted oil paint the brushwork can render a wide range of blends and dabs of color.*

Step by step
Still life sketch

Oils are one of the most noble kinds of paint. When dry, they maintain their bright color and freshly-painted appearance for years. This is only true, however, if the painting has been properly created using the techniques described in this section. The first step should always be to fill in the painting with patches of diluted color, and each successive application of paint should be less diluted than the previous one.

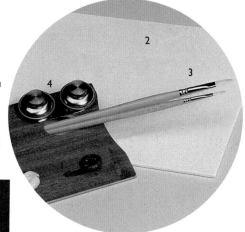

MATERIALS

Oil paints and palette (1), canvas-covered cardboard (2), brushes (3), turpentine and linseed oil (4).

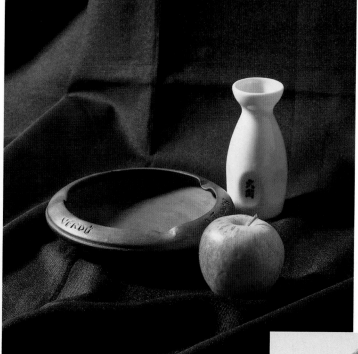

1. *The first layers of oil paint should always be more diluted than the later ones. Dip the brush in turpentine and dilute the paint on the palette. After removing the excess paint from the brush to keep it from dripping on the canvas, start to sketch out the shapes of each of the objects in the painting. Since this subject is fairly simple, it is not necessary to sketch the objects with charcoal first. As you can see, the dark background defines the shape of the vase.*

STEP BY STEP: Still life sketch

2. The entire background is painted in a dark, still very diluted color, which is essential during the preliminary stages of roughing in the painting. In this way it can be easily corrected by dipping the brush in pure turpentine and passing it over the area that needs to be retouched. This is especially useful for opening up the main highlights on the painting. Accent the darker parts of the painting with a slightly thicker shade of violet. The white vase, on the other hand, should be filled in with an almost transparent tone. Next, apply the first thick and dense brushstrokes to the apple.

3. Now move on to the ashtray. Paint the interior with darker, less diluted colors so that the edge looks brighter by contrast. Colors mixed with a great deal of white and diluted with less turpentine can be used to paint the outside of the ashtray. Drag in part of the underlying colors when highlighting the curve.

4. The strokes should now contain increasingly smaller amounts of turpentine. In fact, once the painting has been entirely filled in, the paint can be applied pure, without any turpentine. The previous brushwork on the apple was already done without turpentine, so none should be used for further work on this object. If necessary, use linseed oil to make the paint more fluid. Apply reddish brushstrokes to the apple, mixing them with the yellowish colors directly on the canvas. The small white vase should be painted with bright, free strokes. Then add a highlight to the mouth of the vase to suggest its shiny surface.

5. *Complete the painting by applying a very bright shade of white to the vase. Since the surrounding background is dark, the contrast makes the vase appear even more brilliant and luminous. Model the apple with repeated brushstrokes until its spherical shape is clearly represented. The successive strokes make the colors blend and turn orange in some places.*

Never use regular paint thinner to dilute oil paint. The only acceptable product for this purpose is turpentine. When buying turpentine in a drugstore or hardware store, make sure that the label guarantees that it is pure turpentine, and not some other kind of solution or mixture.

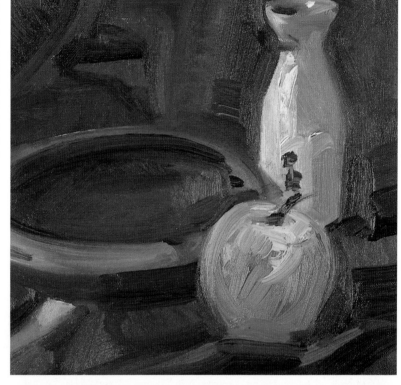

6. *One of the advantages of oil painting is that you can constantly retouch the objects that are being painted. Nevertheless, make sure the layers are not too thick, since the resulting pasty mass will be difficult to work with. The oval of the ashtray can be corrected with repeated brushstrokes that put the finishing touches on its shape and volume. Similarly, paint the darker areas with successively superimposed strokes, each one thicker than the last, but not so thick as to create lumps.*

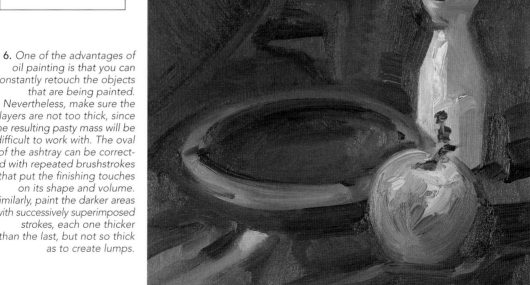

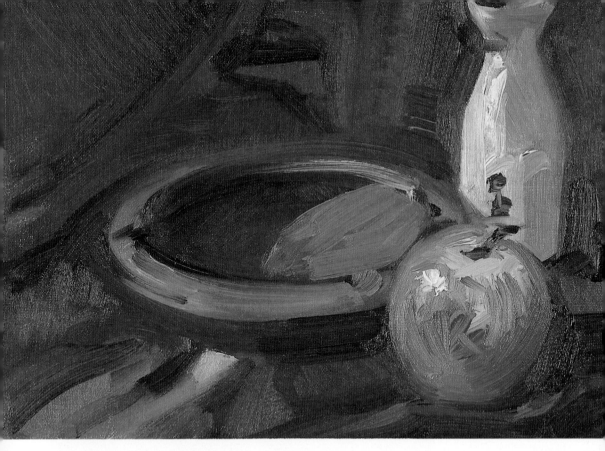

7. *Since the tones on the inside of the ashtray have too much contrast, they need to be corrected with a lighter shade of gray. This should be applied only to the high-* *lighted section of the ashtray. The contour of this object should be completed with long soft brushstrokes that drag in some of the underlying colors.*

SUMMARY

The preliminary sketch was painted with highly diluted paint and very little variety of color. The color at this stage is, in fact, treated as if this were a drawing.

The highlight on the ashtray was done using free brushstrokes that drag in part of the underlying colors.

Pure white paint was used for the brighter

The apple was painted much more directly than the other elements. The mixture of the colors it is filled in with should be applied directly on the canvas.

The layers of color should be gradual. When roughing out the painting with color, remember the principle of fat over lean.

The palette knife

APPLYING IMPASTOS

This topic provides several exercises to practice working with a palette knife. Even though the palette knife is nothing more than a steel blade attached to a handle, this tool can perform various tasks, such as laying on paint, modeling, or applying impastos.

> The palette knife is a tool used almost exclusively in the oil medium. Its variety of uses makes it an invaluable tool for the artist, and, though not as widespread as the brush, it can produce results that are just as interesting.

▶ *The palette knife can be used to execute large impastos. The amount of paint needed must first be prepared before it is loaded onto the knife. Since oil paint does not shrink after drying, the form in which the impasto is applied to the canvas will remain intact after the paint has hardened.*

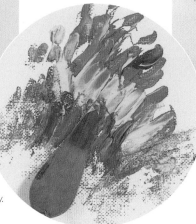

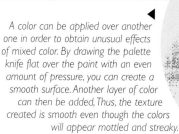

◀ *A color can be applied over another one in order to obtain unusual effects of mixed color. By drawing the palette knife flat over the paint with an even amount of pressure, you can create a smooth surface. Another layer of color can then be added, Thus, the texture created is smooth even though the colors will appear mottled and streaky.*

▼ *Textures like the ones reproduced here can be achieved with small quantities of paint. The most important aspect of working with the palette knife is the way in which the color is applied. Oil paint is very soft; even more so when it is manipulated with a metal instrument like the palette knife. The small amounts of paint can be applied consecutively, with soft touches that do not squash the color over the surface of the picture.*

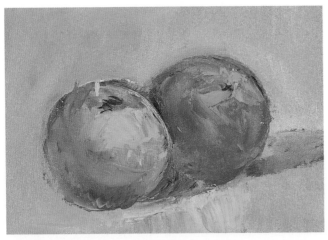

▶ I. *As a beginning painter, you may experience the following more than once: at a certain stage in the development of your painting you are no longer pleased with the results. You cannot remove the paint with a brush cleanly anymore because it will cause the color to expand and dirty the areas that you do not wish to alter.*

RECTIFYING

With oil paints, a color texture that is too complicated to correct with a brush is common. The palette knife comes in very handy for this purpose. The corner of the blade can be used to remove unwanted paint, provided it has not had time to dry. The following exercise demonstrates just one of the various ways in which this tool can be used to correct an error.

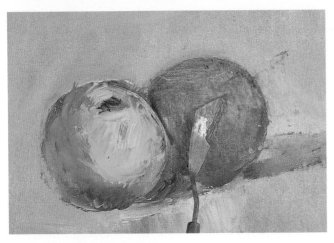

▶ 2. *The palette knife is a perfect tool for removing paint cleanly from any surface. Just scrape away the unwanted color using the corner of the palette knife as often as necessary until there is no paint left in the zone. Once the layer of paint or the impasto has been removed, the surface is free to repaint without the danger of the previous color mixing with the new one.*

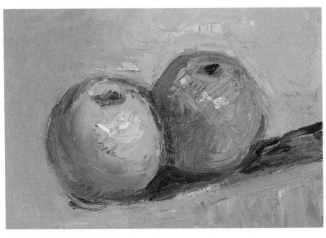

▶ 3. *The use of the palette knife enables you to open up the necessary space in the right area, without affecting adjacent areas that are considered correct. It is easy to repaint the form over the clean area in oils. As you can see, the new applications of color have successfully corrected the area in question.*

THE USE OF THE PALETTE KNIFE

The palette knife is easy to use and highly versatile: it can be employed in as many ways as the brush, although the impression it leaves on the support is completely different. This simple exercise will highlight the basic uses of this tool. The way paint is applied and dragged across the surface of the canvas is important as well as the amount of preassure applied to the palette knife.

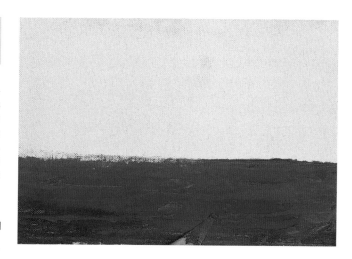

◀

1. This example demonstrates a simple method to obtain special effects using the palette knife. After scooping up a regular amount of paint apply it to the canvas with the palette knife in long sweeping strokes. It is not necessary to create thick impastos with the palette knife; the normal procedure is to apply the tool softly over a freshly painted surface.

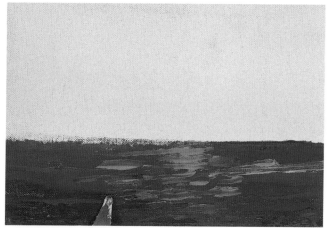

◀

2. The reflections on the water are painted by applying small touches of white with the palette knife. In this case, only the corner of the palette knife is used so as to leave just the right amount of paint on the surface. Compare this application of color with the one demonstrated in the last step; the texture of oil paint can be modeled very easily with the palette knife, often by dragging some of the underlying colors.

It is important to clean the palette knife thoroughly after each painting session. The best way to clean it, having removed any leftovers of paint, is by using a rag soaked in turpentine.

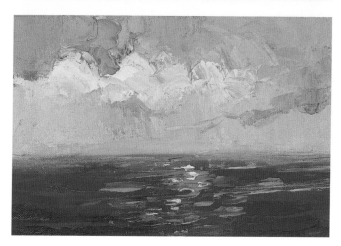

◀

3. By holding the palette knife flat over the surface of the canvas, you can produce big impastos in the sky. As you can see, the application of one color over another always causes some blending. This allows you to obtain a variety of effects, very different from those produced with a brush.

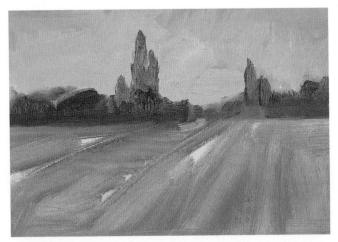

THE TEXTURE OF OIL PAINT WITH THE PALETTE KNIFE

The palette knife is not only limited to a knife technique. It can be combined perfectly well with the brushstroke. In fact, the palette knife is used exclusively to lend a specific texture to the painting's finish. In this exercise you will learn how both techniques are combined, that is, by starting with the brush and then continuing on with the palette knife.

▶ 1. *The first step is to obtain the basic outline of the subject with a brush. As previously demonstrated, the first applications ore diluted with more turpentine than subsequent ones. The brush is much easier to control than the palette knife, and thus allows the painter to obtain a more detailed base in less time. If you do plan on using the palette knife in your work, it is best not to apply thick impastos with the brush, since this is precisely what the palette knife should be used for.*

▶ 2. *Having roughed out the canvas with the brush, begin applying impastos using the palette knife. The techniques demonstrated up to this point can be used, but care must be taken when dragging the color, because if the initial applications are too diluted, it may be difficult to lay the point correctly with the palette knife.*

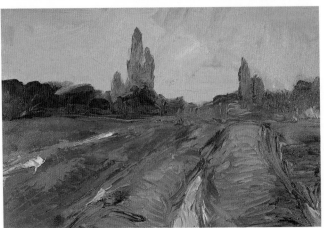

▶ 3. *The finishing touches on the painting, as well as the textures produced in this case on the field, were done exclusively with the palette knife. This exercise demonstrates the wide range of techniques possible using this tool.*

Step by step
Landscape

Landscapes are the best motifs for practicing with the palette knife. They provide a space to work freely with impastos and dragging techniques. Unlike other genres, landscapes can be adapted according to the tastes of the artist. For instance, the color of the model and even the proportions of some of its elements can be changed without detracting from the final result.

MATERIALS

Oil paints (I), palette (2), canvas-covered cardboard (3), linseed oil (4), turpentine (5), rag (6), brushes (7), and palette knife (8).

1. Before you begin painting with the palette knife, you must first rough out the most important elements using a brush thinned with a little turpentine. It is important that the brush be merely damp rather than wet, so that the color does not run over the surface of the canvas. The first impression left on the canvas should indicate clearly the main areas of the landscape. Its structure is very simple: above the line marking the end of the field, several dark patches are applied to indicate the area below the trees.

STEP BY STEP: Landscape

2. *Continue to use the brush, applying the colors with a little turpentine, but be sure to squeeze out excess paint with a rag before touching the tip on the canvas. The tones used in this stage include a wide variety of greens. After filling in the background, begin work with the palette knife. Load some cobalt blue onto the tip of your knife and apply it below the trees to represent shadows.*

3. *After adding the dark tones that define the first contrasts in the trees, paint the lightest areas with tiny impastos. These new applications will blend with the underlying colors. Enrich the greens on the palette with tones of yellow and ocher. The dabs of luminous green painted in the foliage on the right are pure color applications. The palette knife can also be used to paint the sky, using the same color as before, this time thinned with turpentine.*

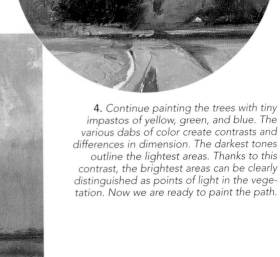

4. *Continue painting the trees with tiny impastos of yellow, green, and blue. The various dabs of color create contrasts and differences in dimension. The darkest tones outline the lightest areas. Thanks to this contrast, the brightest areas can be clearly distinguished as points of light in the vegetation. Now we are ready to paint the path.*

5. *Paint the entire area with the palette knife; it should be applied much flatter in the field and path than to the texture of the trees. Using the same colors, shade the areas of foliage before defining the trunk.*

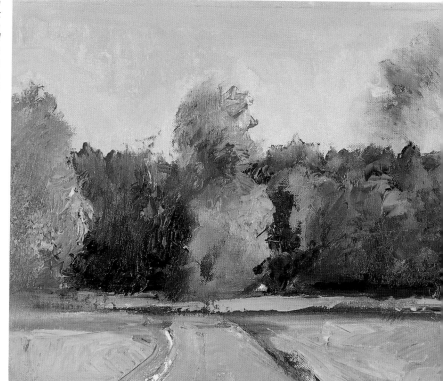

The most precise applications done with the palette knife are those that correct and form the details of the painting. For this reason, they are added toward the end of the session.

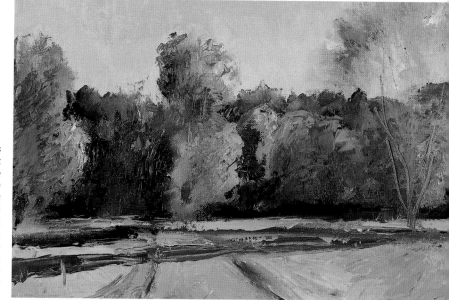

6. *Contrast the darkest areas of the trees with a very dark blue. Then use the tip of the palette knife to sketch the shadows on the field. The drag of the palette knife makes the blue mix slightly with the underlying tones. Once again, use the tip of the palette knife to scratch the surface of the still wet paint in order to draw the main branches of the tree on the right.*

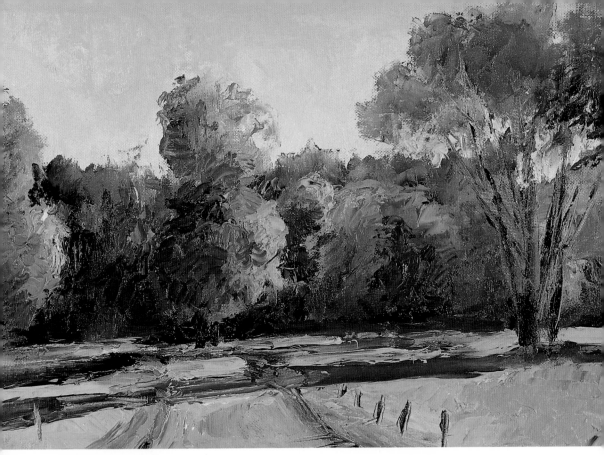

7. *Apply the final contrasting colors to the trees. These dark areas bring out the most luminous tones. Paint the posts of the fence leading down the path* with the tip of the palette knife. All that remains is to paint the definitive contrasts with the tip of the palette knife using dark blue.

SUMMARY

The preliminary outline was sketched with a brush dipped in dark blue thinned with turpentine.

The first applications of the palette knife define **the dark areas between the trees.**

The texture of the trees was created with tiny dabs of pure color.

The tree on the right was drawn by sketching with the tip of the palette knife directly on the canvas.

The path was painted with very flat and sweeping applications of the palette knife.

6

Applying the color base

COLORING THE BACKGROUND AND SUPERIMPOSING PLANES

Applying a color base is a simple way to obtain a background against which you can develop painting. It is always advisable to color the canvas with undefined brushstrokes prior to painting. It is essential, however, that these first layers, as well as the brush-work, be correctly applied. In this exercise we suggest a simple experiment: create a floral background and superimpose a flower in the foreground.

After the preliminary wash with highly diluted color, continue to define the forms and spaces. The opacity and texture of oil paint make this process a form of painting in itself, though still far removed from the perfection of the final product. There are as many ways to apply this color base as there are subjects; in this topic, we shall look at several of them.

1. *To suggest a plane of depth in a painting, an object in the foreground can be highlighted in perfect detail. This background of blue and crimson flowers toned down with white was created with free brushwork without detailing the form of the flowers; in this way, a background which appears slightly out of focus is obtained.*
▲

2. *Against this background, paint a flower with bright, pure colors that are not toned down with white. The brushwork suggests movement, as it has spread out some of the colors in the background. The preliminary application of the background provides a perfect chromatic base over which to paint the new lines that define the form of the petals.*
▲

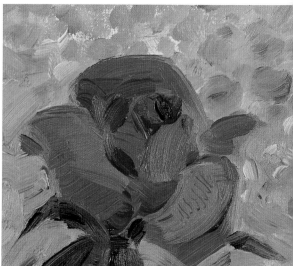

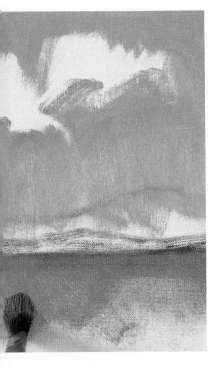

▶ 1. *After drawing in the forms, begin to cover the canvas with paint. These preliminary bands of color are intended to cover the different areas of the painting as quickly as possible. It does not matter if this process covers up the original drawing, as this can be restored later. In any case, this preparation of the background should be done with fairly thin paint, so that the underlying drawing remains visible.*

DILUTED AREAS

Earlier we learned that oil paint should always be applied fat over lean; this allows artists to apply the first layers of paint very quickly. The preliminary coloring of the painting, lacking in detail, should cover the canvas as quickly as possible, establishing the main areas and overall color scheme. In such cases as this, the colors should be applied in large patches to unify the different areas of the painting.

3. So far, no details have been added to this preparatory stage. Details should not be included until the background color has been fully established. First apply another layer of color to the mountains, including more detail in the foreground. The shaded areas between the flowers should then be superimposed on the evenly shaded field. Once this background is finished, the group of flowers can be painted, using short brushstrokes.

▲

> The layers of color become more and more defined as the painting develops. The forms are constantly redrawn as the colors are applied to each of them.

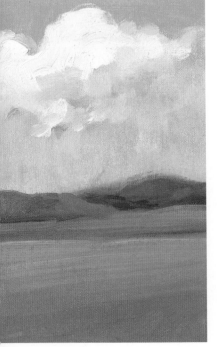

▶ 2. *Every area of the painting, however small it is, should be painted in a particular way, working from the general to the particular. First paint the clouds, superimposing the color over the background with precise brushstrokes. The mountains should be painted with a certain amount of detail, though this is not yet the definitive layer, but instead will act as a base to which you can later add more detail. As you might expect, the colors become more and more defined, using an increasingly smaller amount of turpentine.*

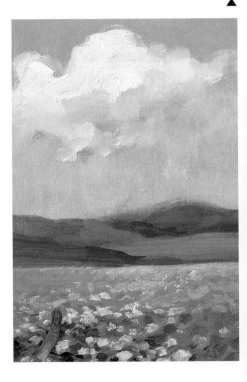

BUILDING UP FORMS

Once artists know how colors interact, they can then apply them directly to the painting, so that these patches of color create the structure of the forms. This technique is applicable, above all, when the motif calls for a certain abstraction of form, such as a bunch of flowers, for example, in which the different patches of superimposed colors themselves create the form of the subject.

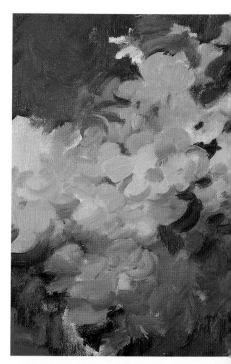

I. *The first applications of color should be performed quickly, without paying too much attention to detail. The main aim at this stage is to cover the background with colors to provide a base upon which subsequent layers of color can be added. This process should be carried out gradually. In this exercise, the dimension of the subject is suggested by the more luminous tones.*

2. *All the work carried out during the preliminary stages of the painting is aimed at creating the tones and different colors over which successive layers of paint can be added later. During this process, the main colors merge together to produce new ones. These color mixes, created directly on the canvas, produce tonal variations within the same chromatic range - the cool range in this particular case.*

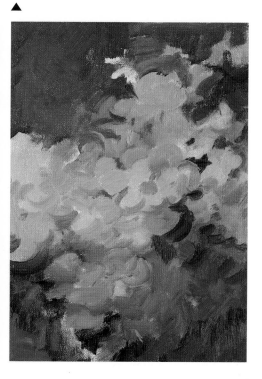

3. *The contrasts painted over the luminous tones create the outline of the forms and intensify the details. These colors should be added gradually and should become more precise as the painting develops. They are then covered by new, denser brushstrokes. The same process should be used in any similar work. Detail should always be left to the final stage.*

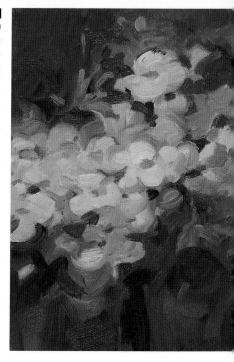

Topic 6: Applying the color base

SUGGESTING FORMS WITH COLOR

A simple patch of color allows us to create forms which are not defined by the use of lines. A single brushstroke is often all it takes to suggest an object or simply to enrich the canvas. This exercises shows that it is not necessary to paint objects or forms using excess detail; it is the context that provides the information necessary to understand the detail, without actually defining the forms or objects.

▼ 1. *In this exercise, the background has been covered with the colors that will form the base for subsequent work. During this preliminary stage, different shades of green should be used; this difference in tone helps to situate the two different planes present in the painting.*

2. *The color base sets the course for subsequent tones and colors. For example, the texture is suggested by the tones of the chosen range; this allows us to suggest forms in the bushes which would otherwise not stand out. It is not until all the colors are seen as a whole that the objects take on a recognizable form.*

▲

3. *The colors used as the base of the painting are primarily two tones of green. When red touches are added, they create a sharp chromatic contrast with the dark green. This red is too dark to be painted over the lighter green areas. To suggest the forms, the red used in these areas is much brighter. The contrasts in each of these areas should be balanced.*

Step by step
Landscape with garden

The application of the preliminary color base should always be the first step. Sometimes, the base will be very general, other times it will conform to a perfectly defined structure. In this exercise, you can practice using different shades of color until the painting is considered finished. This model uses very simple forms, beginning with its symmetrical and elliptical composition. The real difficulty in a painting is often painting forms that require a high level of precision. The color sketch of the large green areas surrounding the pond provides an excellent base on which to work.

MATERIALS

Oil paints (1), canvas-covered cardboard (2), linseed oil and turpentine (3), brushes (4), palette (5), charcoal (6), and rag (7).

1. *Start to block in the subject with a quick charcoal sketch. Then go over the lines with a brush dipped in black oil paint and a little turpentine to situate the forms within the frame. The pond is spherical in shape, though as a result of the perspective, it appears elliptical. Draw in the main shaded areas surrounding the columns, as well as the trees in the background. In this sketch, and in the following stages, all detail should be omitted. This stage can be completed very quickly, allowing us to situate the forms in accordance with the main contrasts in the painting.*

2. *A large area of luminous green suggests the elements surrounding the pond. This process adds no texture or detail, as the only intention here is to cover each of the main areas of the painting. Painting quickly and freely, outline the forms of the trees to the right and shade the background with ocher.*

3. *The trees in the background should be painted in the same tone mixed with white. Once the background has been covered, new tones can be added and superimposed over the previous layers. During this process it is inevitable that the brush picks up some of the underlying color. Add a more luminous tone over the ocher, mixing the new color with the previous ones. Many small brushstrokes can be applied around the pond to form the trees. These colors should be dark and opaque for the trees on the right, over which you may add several bright green notes.*

4. *Details should not be painted until the main forms of color have completely covered the background. After painting the treetops on the right, paint the shafts of light filtering through the foliage and between the tree trunks, superimposed over the large green area. Then continue to paint the vegetation on the left. After painting the grass with tiny brushstrokes, begin to outline the pilasters around the pond.*

5. As the background is gradually filled in, new brushstrokes are super-imposed to add texture or to correct errors. Although it may mix with some of the previous color, paint a vivid yellow over the bright-est tree on the right; small, dark brushstrokes should also be applied to the area on the left.

The paint and brushwork should have just the right thickness. Too much paint would spoil the finish in certain areas.

6. The lines of color that form the pilasters should be retouched to give them the desired form; care should be taken not to color the inside of the pond, as its ocher tone should remain pure. Over the pilaster in the background, a few red brushstrokes suggest the wild flowers. The base color of the background has to be completely finished before the details can be added.

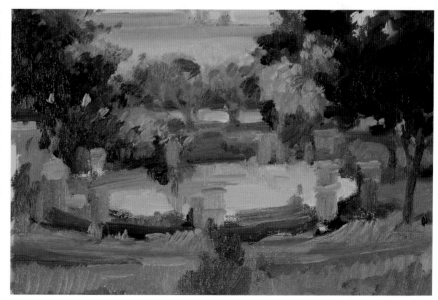

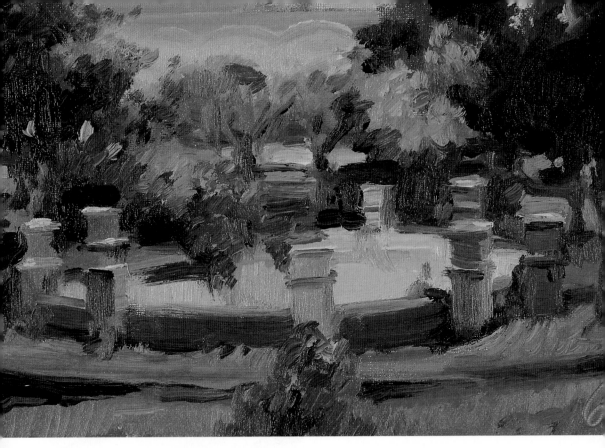

7. *Now paint in the definitive contrasts of the pond, first on the square columns, using blue and grayish colors for the shadows. No highlights should be added until all the details have been completed. The exterior of the pond should contrast sharply with the interior, which still* *possesses its original luminous tones. Make the final touches on the different contrasts on the ground and the vegetation in the foreground. Retouch the forms of the arches in the background and this will complete the exercise.*

SUMMARY

The colors should be perfectly distributed so as not to mix more of the underlying layer than is strictly necessary. The tree trunks were superimposed over the ground.

The red flowers were painted once the background was finished.

The first layers of paint should never be too pasty. Preliminary forms are painted with highly diluted paint, making no attempt to include any detail.

Several small contrasts could be added after the color in the background had prepared a sufficiently broad, stable base. Before painting the details of the trees, the trees themselves were painted using large, flat patches of color.

After the main colors have been applied to the background, it is possible to situate the forms in accordance with the contrasts they produce. The ground surrounding the pond is painted as one large swath of green.

7 Development of the painting

ROUGHING OUT WITH DILUTED COLORS

The roughing-out stage is one of the most critical parts of any oil painting. This constitutes the moment when the painting comes to life. A correct roughing out helps to break the "silence" of a blank canvas, and serves as a guide to develop the work.

Having learned the different approaches, artists can develop their paintings from many perspectives. Regardless of the technique they choose, they must always follow a number of rules that are applicable to any work process. The development of an oil painting must comply with these norms; otherwise the result will almost certainly be a disaster once the paint has dried.

▼ 1. This exercise will allow you to follow the development of a typical painting in oils. In this case, we will forgo the usual preliminary sketch of the subject that all paintings require. The aim of this topic is to understand the complete painting process. The first applications of color must be thinned with turpentine. At this stage, you should only be concerned with the basic forms in order to obtain an approximation of the background over which other layers of color can be applied to gradually bring out the details.

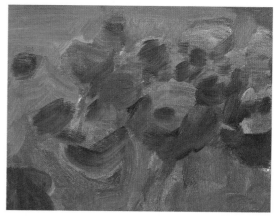

▼ 2. The background made with paint thinned in turpentine provides a perfect base on which to proceed. The next application of color should not be too pure, this is a rule that must always be respected. The amount of turpentine that is added to the paint should not be excessive, each subsequent application of paint should contain less turpentine, so that the paint becomes thicker as the picture develops.

3. New mixes of colors and tones can be added with paint that is still not too thick. The background is fundamental for building up the main forms, especially in subsequent brushstrokes destined to bring out the forms more precisely. This is the stage in which the most important lines are painted to approximate the flowers that will eventually emerge on the canvas.

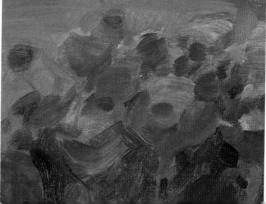

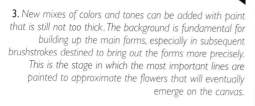

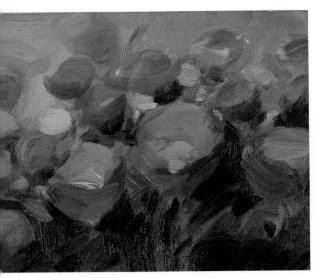

SUPERIMPOSING LAYERS AND CORRECTIONS

The thickest applications of paint are applied over the background. This is a gradual process that consists of applying paint thinned with less and less turpentine, without applying excessively thick layers. If the background is too wet due to the effect of turpentine, the thicker layers may run. The paint must first be prepared on the palette. One important piece of advice to bear in mind: a tiny amount of turpentine can thin a large quantity of oil paint; therefore, consider carefully how much you really need.

▼ I. *We can now begin to apply new layers of slightly thicker paint over the thinned color base. If a more fluid application is required, some more turpentine must be added, although it will have to be compensated for by also adding a little linseed oil. If you want to speed up the paint's drying time, several drops of Dutch varnish should also be added to the paint. This makes the paint "lean" thus conserving its liquid appearance.*

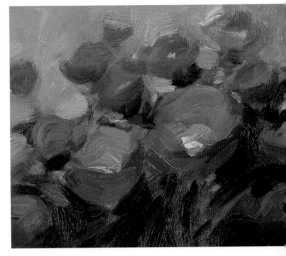

2. *Over previous applications of much thicker paint, begin to add almost undiluted direct strokes that will define the flowers by means of contrast.*

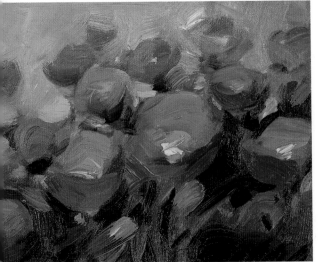

▶ **3.** *Paint the final strokes with the characteristic freshness of pure oil paint thick impastos with intense colors. The highlights, as well as the contrasts, should be painted definitively with very direct strokes; this technique can be varied according to the type of finish you want to achieve.*

1. *The first stage of a painting involves roughing out the canvas. In this stage, the colors must be applied with abundant turpentine and the white canvas should remain visible between the strokes and patches. No attempt should be made to add details or define forms. In addition to the initial colors, the planes of each strip of land are established.*

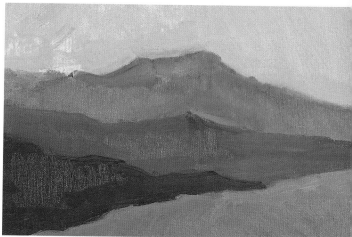

THE DENSITY OF PAINT

In the next exercise we are going to summarize the last exercise clearly and concisely, although in this case the subject is a landscape. The layers of color applied during the first steps were thin enough to reveal the developmental process. In order to speed up the drying time of the most diluted layers, several drops of Dutch varnish can be added to the mix of paint and turpentine.

> A painting that requires a highly detailed finish must be executed with sufficient layers of paint, always working from the most general to the most specific.

2. *Roughing out provides a base for "leaner" layers, that is, paint containing less turpentine than was used in the first applications.*

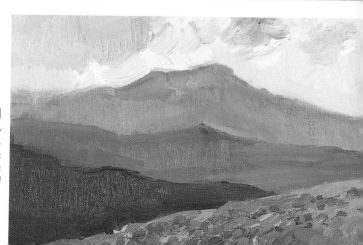

3. *The most decisive layers are left for last. Only after a correct roughing out can loose brush-strokes be applied to work on the details. As you can see in this landscape, the final details are strokes that could not have been elaborated during the first stages of the work.*

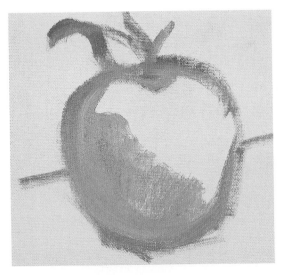

COLOR APPLICATIONS AND BLENDS

The process of oil painting can produce fresh and sponta-neous results, or even results in which tones are blended together. In the exercises we have done so far, the finish obtained was very direct; this exercise examines a different fin-ish, even though the technique involves similar processes. All the examples demonstrated in this topic may undergo slight variations, but they always commence with a similar elabora-tion, and their procedure is identical.

▶ **1.** *Paint the outline with one of the colors that you will use later in the painting. The blocking in of the form is one of the fundamental aspects of the still life, portrait, and human figure genres. Since the sketch is painted with only one color, it will be easy to blend it with the other tones.*

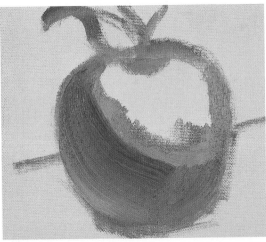

▶ **2.** *The color base must first establish an outline before the first color can be applied that will be blended with others. This color should be applied very directly over the thinned background. The di-rection of the stroke is crucial, as it establishes the shape to be blended. The most luminous areas are still the light areas of the preliminary background.*

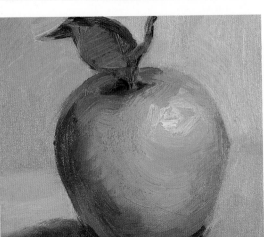

▶ **3.** *The colors should now be applied in the form of impastos, although the brushstroke should continue to blend the various tones. We can thus enjoy pure colors and direct applications as well as colors that have been completely blended into one another.*

Step by step
Figure in backlighting

In this exercise we will paint a male figure standing against a window in backlighting conditions. Due to the distinct contrasts between the areas of light and shadow, the tones of the model are reduced to a chiaroscuro. Since there is no great variety of colors and tones, this picture should be relatively simple, although great care must be taken with the separation line among the shadows. This is a perfect model for following a simple step-by-step exercise of a picture painted in oils.

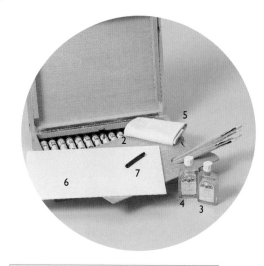

MATERIALS

Oil paints (l), palette (2), linseed oil (3), turpentine (4), rag, (5) canvas-covered cardboard (6), and charcoal (7).

1. *The preliminary drawing is very important. Like many subjects that are done in oil, the drawing is a simple suggestion that will be built up as the painting advances. Although in subjects like this one, where there is a clear separation of areas, it is necessary to include much more of what is to be painted. First, sketch the general lines; then, having worked out the shape of the figure, draw in the shadows.*

STEP BY STEP: Figure in backlighting

2. *Begin the picture with colors previously thinned with turpentine on the palette, ensuring that they are not too diluted. As in the earlier step, where we included the shadows, here we have used a very dark tone comprising umber, sienna, and a touch of cobalt blue. The areas in shadow should be painted as single blocks of color. Highlight the pants with cerulean blue mixed with electric blue and grayed with white.*

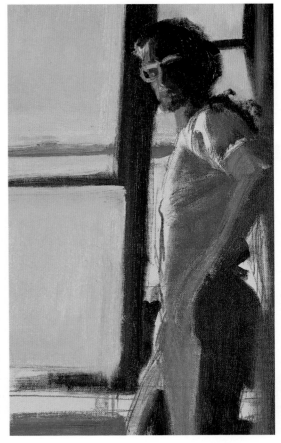

Don't use too much paint during the first stages of the work. The white color of the canvas must be left unpainted in the areas where the highlights will be placed.

3. *The colors for the highlights on the skin should be prepared on the palette: rough out the face with a mix of orange ochre and a hint of red. Apply the same color to the arm, toned slightly with a touch of blue. The shadow over the T-shirt is blue with a clear violet tendency. You will notice that in this area, the diluted brush is quite dry.*

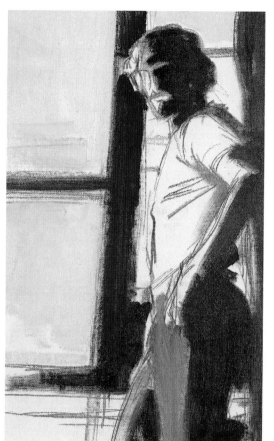

4. *Retouch the lighter area of the face until it merges with the shadow on the forehead. The nose, on the other hand, requires a direct stroke to create a sharp contrast with the shadow cast over the body, therefore start to superimpose thicker colors over the previous ones. Create the highlights on the T-shirt with direct touches of white, although this should only suggest the creases produced by the fabric that later on will be given more detail.*

6. *Paint the shirt with direct brushwork in white toned with blue. Contrast the illuminated area of the arm with the shadow. There is no need to gradate the tones, this sharp contrast between the planes is enough to suggest a very sketchy volume. Define the planes of the windowsill by outlining it with dark tones. Apply tones of blue and ocher to the window frame, in order to heighten the shadows.*

5. *Here we can see how the face has been painted under conditions of backlighting: several dabs of color create the main highlights. Next to the nose, a subtle tone of umber creates a contrast with the illuminated side of the profile. The highlight in the shoulder has been painted with intense strokes of white that superimpose the previous applications.*

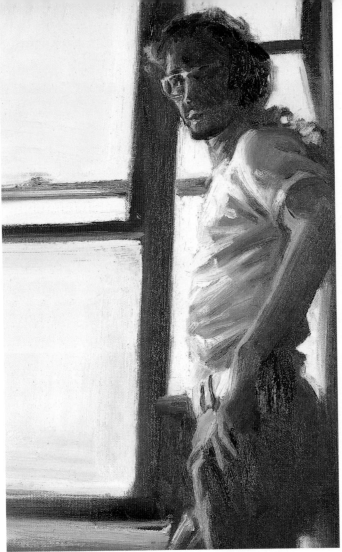

7. Paint the creases of the T-shirt with touches of direct white, which bring part of the underlying tones to the surface. The face, which is almost in shadow, should be painted with luminous and dense touches. Go over the arm with delicate sweeping strokes, which merge with the tone of the light. All that remains is to finish the pants with a highly luminous blue and to suggest the hand, painting only the fingers that are visible.

> Never overdo the color white, especially in works where the areas of light are extreme. The lightest color mixes should be made with luminous colors like Naples yellow or cerulean blue.

SUMMARY

The preliminary sketch was executed with a very direct drawing, on which corrections and the study of light and shadow can be carried out.

The first application of color consolidates the study of highlights and shadows. The first shadows are very flat, lacking detail, and were applied thinned with turpentine.

The blue tone of the T-shirt provides a base for strokes of gray and white that suggest the creases.

The hand was completed last with two strokes to represent the fingers.

Obtaining tones and direct methods

BLENDING COLORS ON THE CANVAS

The main method for blending colors is to mix them with the brush directly on the canvas. In this way, the tones are mixed until they are indistinguishable. This provides a base for later brushwork. This first exercise uses a blending technique which is almost inevitable in any form of oil painting.

In the previous topic, we studied the general process followed in all types of oil painting which can, however, lead to varying results depending on the techniques employed. Some artists prefer a highly blended, detailed finish while others prefer a more spontaneous effect with a marked impressionist finish. Blending is the preliminary stage to modeling, one of the most academic techniques.

1. *Draw the preliminary sketch in charcoal. Then go over this drawing with very thin paint, making sure it does not run. To keep this from happening and to produce a broken line, squeeze out the brush as much as possible before beginning. This type of line merges the tone of the paint with the background drawing.*
▲

2. *Apply the first patches of color over the drawing of the model. The preliminary colors, as with all oil techniques, should be lean. In the study of how to obtain the right tones, the direction of each line is important. The lines in the background should flow and the brush-strokes should be slanted. Use blue, toned down with white. The stems should be painted in an almost white tone, and the brightest petals with shinier, thicker brushstrokes than before.*
▲

3. *After painting the main forms, use a fine brush to increase the contrast in the darkest and lightest areas of the painting. These contrasts serve to create the definitive outline of the flowers. The different planes within the painting can be separated by the use of different tones for each area.*
▲

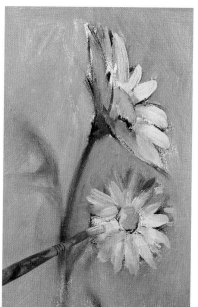

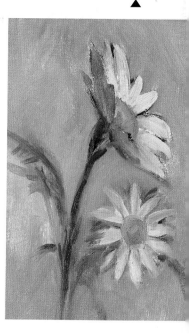

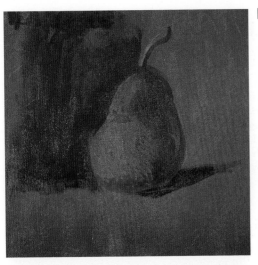

▶ 1. *This dark color can be used for the drawing as well as to differentiate the tones. The preliminary drawing should be perfectly finished, with all the shadows well defined. Once you have obtained a base of uniform color, let it to dry to prevent further applications of color from smudging the preliminary work.*

PRINCIPLES OF VALUE PAINTING

Value painting is the method in which shadows are created using different tones of the same color. In this exercise we are going to study some of the basic rules for interpreting tones. In the previous exercise we saw how lines can be completely blended on the canvas, but what happens when a line gradually merges into the background or over another color?

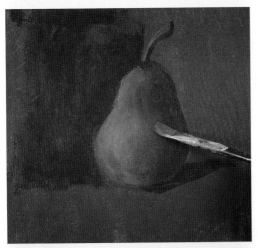

▶ 2. *To prepare transparent colors for this type of work, mix oil paint, a little linseed oil, and Dutch varnish; this mixture produces an almost transparent color to paint the brightest tones with. To integrate the background color into this process, leave the dark areas unpainted. For this type of work in which the tones need to be completely blended together, it is important to use high-quality brushes.*

> In value painting, do not use black to darken the tones since this color easily dirties any adjacent colors and causes the paint to crack as the layers of paint dry out at different speeds.

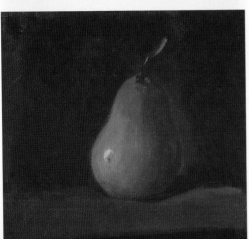

▶ 3. *In this preliminary stage, areas of light and shadow are established. The shadows are of the same color as the background, and are thus less likely to merge with subsequent highlights. To adjust the tones of the lighter areas, use an even more transparent color.*

428

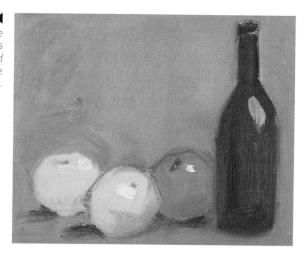

The use of complementary colors can create intense contrasts. In this exercise, the green bottle contrasts sharply with the red apple next to it. The yellow is applied to offset the difference between the colors. This technique is used to complement the value painting procedure.

THE IMPRESSIONIST TECHNIQUE

Impressionism represented a break with the entire academic tradition; this vision of painting interprets objects in terms of brightness of the color, meaning that no value work or modeling of shadows takes place. Colors are applied directly, complementing or contrasting with each other. This still life will help us to understand this technique.

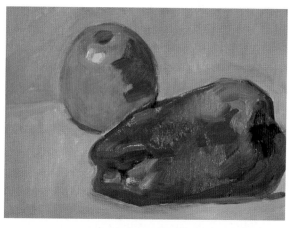

When colors are used in the impressionist fashion, the highlights of the objects must affect all the elements contained in the picture. Thus, add a yellow highlight to the bottle, as a reflection of the apples on the left. Painting the background with a mixture of the colors used helps to unify the range of colors present in the painting.

The opacity of oil paint can affect transparent color in two ways: a light transparent color becomes opaque when successive layers are applied, but if the background is dark, it becomes more luminous.

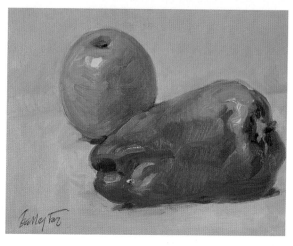

In Impressionism, colors affect each other and make the luminosity of the elements in the painting interdependent. The reflections between objects should be painted using complementary colors. These striking colors do not have to mix; their reflection in the other elements in the painting is enough.

429

Topic 8: Obtaining tones and direct methods

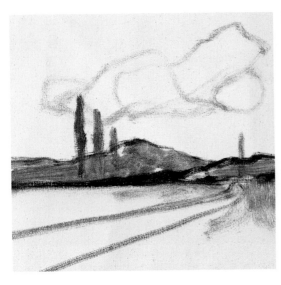

▶ 1. *In this exercise, there is no need for charcoal or pencil; simply use a brush dipped in thin paint to draw the basic design directly on the canvas. Then squeeze out any excess turpentine from the brush and start to draw. In this preliminary stage, lines can be corrected and redrawn as often as necessary. If you need to erase any part of the drawing during this stage, simply rub the area with a cloth dampened in turpentine.*

WORKING DIRECTLY ON THE CANVAS

One of the best methods for making quick sketches is one that allows artists to capture the model directly on the canvas, without having to deal with other aspects that could hinder the process, such as careful drawing, excessive use of different tones, highly modeled forms, etc. Direct work, also called *alla prima*, is the favorite technique of many artists who prefer spontaneous drawing and painting. This exercise provides a clear example of how this method is applied.

2. *You may now begin to paint over the sketch with thicker colors since the goal is to capture the scene as quickly as possible. When paint thinned with turpentine dries, it loses its shine and the color tends to fade. Dutch varnish can be mixed with the paint on the palette to prevent this from happening. Also, you need not use the best quality oils for roughing out the canvas, as they will be painted over later. It is therefore better to start with medium-quality paint followed by higher-quality paints.*
▲

3. *As you progress, use less diluted paint until you are working with pure colors. Also, remember to never add a drier layer of paint over the one on the canvas; this would violate the rule of fat over lean.*
▲

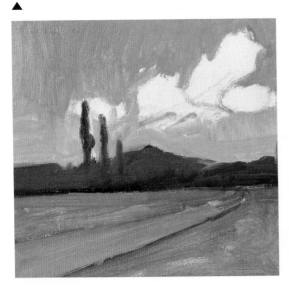

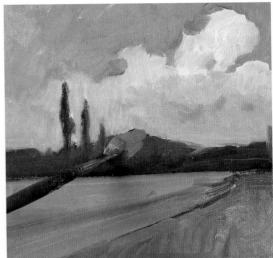

Landscape and river

The model for this exercise is a landscape with a river. We have deliberately chosen a very simple model so that the reader can practice the *alla prima* techniques studied earlier. The process starts as should all paintings in oil from the general to the particular. The way the different brushstrokes influence tone will create the large, light colored area of the river in this beautiful landscape.

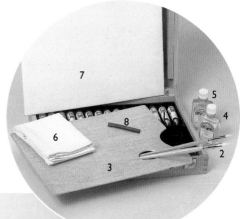

MATERIALS

Oil paints (1), brushes (2), palette (3), turpentine (4), linseed oil (5), rag (6), canvas-covered cardboard (7), and charcoal (8).

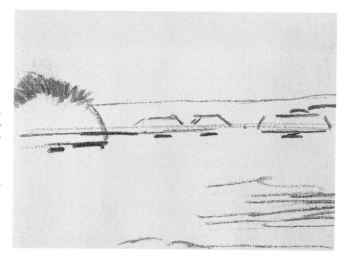

1. *Painting directly is one possible technique when working in oils and could be applied here, given the simplicity of the model. We shall, however, start with a quick charcoal sketch to shape the model. Holding the charcoal flat, you will be able to draw a completely straight line. For the mountains in the background, draw slightly broken lines using the tip of the charcoal stick. After drawing the basic layout, sketch in the bridge and cluster of trees on the left.*

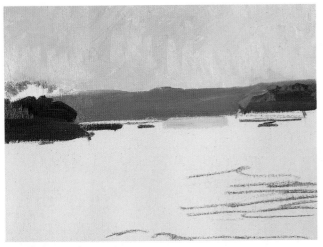

2. *The layout of this exercise is so simple that the roughing out can be done very quickly. Only the main contrasts in the landscape should be included at first. Use paint that is very thin but not too runny. The first patch of color will depict the mountains. Using darker, thicker paint, shade in the vegetation and the darker areas on the left. This entire layer of paint should be applied over the thin blue of the background. Paint the sky almost white, with a few drops of linseed oil to liquify it.*

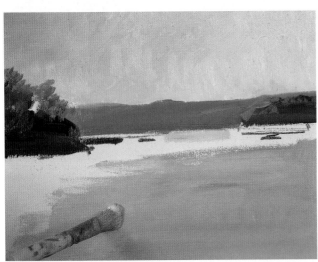

3. *Next apply ultramarine blue and cobalt blue directly to the vegetation. This layer will mix with some of the underlying color. Then start to paint the water in a dark gray blue. Since this area of the painting will undergo major modifications, this first layer should be very thin. Mix different tones of green and white, using sweeping, horizontal brushstrokes.*

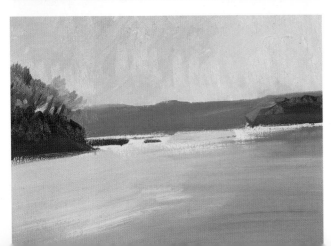

4. *Then move on to the trees along the riverbank, using more precise, detailed strokes than before. Apply this brushwork over the color mix obtained earlier. The color applied to the water should now be much thicker than before, and mixed with some white. Repeat this process on the upper part of the painting, using horizontal strokes and working downward. Then cover this bluish area with darker, thicker colors and definite brushstrokes that blend with the background.*

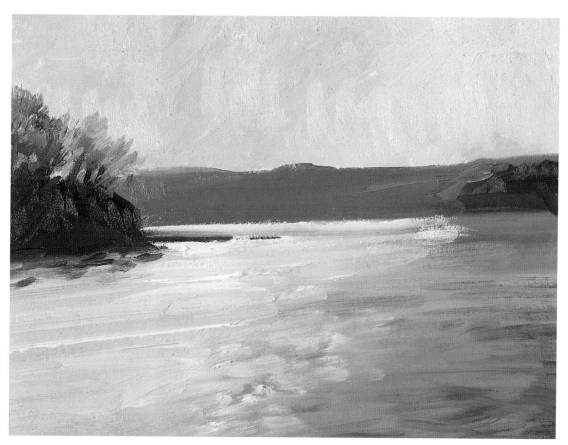

5. *Once you have applied the color base, do not add more turpentine to the color mixes. Paint the darkest patch of water directly in dark blue. Observe the brushstrokes: they are not identical, but a mixture of short and long strokes, some of which blend into the underlying tones. If the paint is too thick, you may add a little linseed oil but just enough to liquify it.*

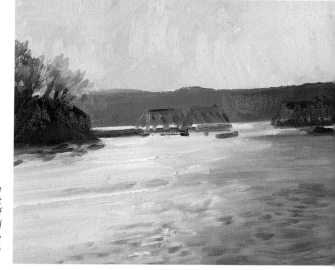

6. *The brushstrokes on the surface of the water mix dark and light tonalities of different intensity. Those next to the lightest patch of water should be short and delicately overlaid onto the luminous background tone. Paint the lines representing the bridge with a brush dipped in a grayish blue and a little white.*

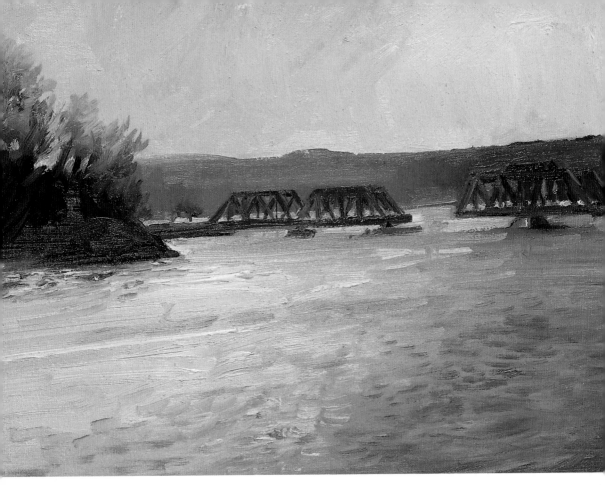

7. *Use shorter, more detailed brushstrokes on the surface of the water. Do not use too much paint, just enough to alter the tone of the underlying color. Redraw the bridge on the right with completely straight lines. More detailed brushwork should be used for the trees, with short* *brushstrokes that blend into the background, yet do not disappear entirely. Retouch the bridge last with several dark, straight brushstrokes, painted over the underlying colors. Finally, use a slightly broken white on the brightest patch of water for a few, well-placed highlights.*

SUMMARY

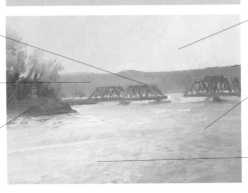

The preliminary scheme was drawn in charcoal; the entire landscape is based on the horizon line.

The mountains in the background were painted with a thin blue. This layer forms the base for the darker tones later.

The group of trees on the left was painted in blue with very little turpentine. The brushstrokes are short and clear.

The sky is a luminous, almost white color.

The water requires several layers of paint; the first are very thin and form the base for denser, more contrasting brushwork at a later stage.

The brushstrokes that represent the reflections in the water are highly specific and well defined.

Palette knife and brush

PALETTE KNIFE AND BRUSH: PAINTING WITH IMPASTO

The palette knife can perform a wide range of techniques; it has a sharp edge which can be used to separate and spread out paint. The texture of oil paint and the brush which modifies every line and smudge offer the painter an almost endless variety of creative possibilities. After reviewing the previous section in which this technique was used, we here present a new exercise in which the potential of brushwork is combined with that of the palette knife.

> The palette knife is much more useful than you might imagine. In a previous topic, we demonstrated some of the possibilities of this simple instrument. In this section devoted to the palette knife, we shall study several other techniques which cannot be performed with any other painting tool. Working with a palette knife is very different than any kind of brushwork. The combinations of the two that we are going to explain here will take you one step further in learning the techniques that combine palette knife and brush.

1. *Use a brush in the first stage of this exercise since it is more suitable for painting lines. The application of a color base at this stage is very important as it situates the main colors. It is also important not to dilute the paint too much, unless you intend to let it dry first. Pasty brushwork allows you to represent the volume of the main forms very quickly.*
▲

3. *To mix two colors, draw the palette knife over the some area several times. Using a dark color and the edge of the knife, paint the tree trunks. Repeat this until the line acquires the right consistency. Use various palette knife techniques on the sky: some delicate, so as not to pick up the underlying color, and others more forceful to obtain the opposite effect.*
▲

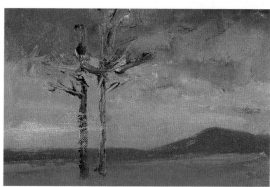

▶ 2. *Once you have roughed out the canvas, scoop a little paint onto the edge of the knife; then apply it to the canvas and spread it out, pressing down slightly on the knife. At first, it is not necessary to apply a large amount of paint; the impasto can be created as the painting progresses. Using crimson mixed with a little white, draw the knife over the underlying colors. This will cause them to mix together slightly.*

435

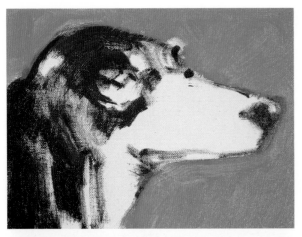

▶ 1. *Block in the subject with a brush and a dark color. At this stage, you may make as many corrections as desired, since the work with the palette knife will completely conceal these underlying layers. After blocking in the subject and the main, dark areas, paint the entire background with a brush, retouching the outline of the animal with a quick stroke.*

FIRST IMPASTOS

In the first exercise on this subject we created various impastos using both palette knife and brush. Palette knives are ideal for this purpose, and in this particular case we shall study one of most striking uses: their creating a variety of textures in the same area of the painting. To put this technique into practice we shall paint the head of a dog. Pay special attention to the superimposition of impastos after completing the preliminary brushwork.

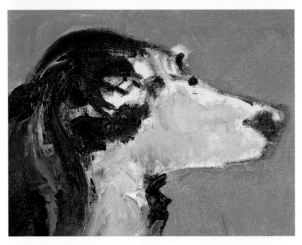

▶ 2. *Paint the color base of the dog's head by applying an impasto with the palette knife; the lighter areas should be painted in grayish white mixed with other tonalities. Apply just the right pressure with the knife so that the surface remains smooth. Using an almost black color mixed with cobalt blue, add in the main dark areas of the fur. The marks made by the knife should be longer here than those used for the animal's face.*

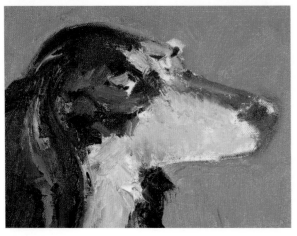

▶ 3. *The definitive form of the head should now be superimposed over the most luminous areas. Do not add any details yet to the forms and features of the animal; the most important thing at this stage is to preserve the tone of the colors to prevent their merging together.*

TECHNIQUES WITH THE PALETTE KNIFE

Despite its crude appearance, the palette knife is capable of performing highly detailed work. These details depend on the amount of paint applied and how the knife is placed on the canvas. However, this technique, like all others, requires regular practice before it can be mastered. If you look closely at the final stage of the last exercise, you will see a wide variety of impastos and lines, some of which would be very difficult to obtain with only a brush.

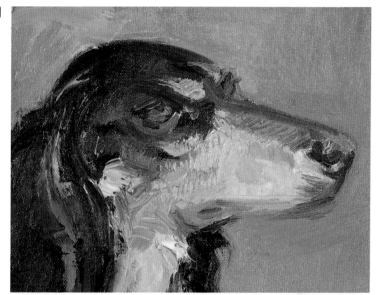

4. Depending on how it is applied to the canvas, a palette knife can be used to create many different types of lines, planes and patches of color. Be careful not to apply too much paint as this makes it impossible to obtain precise details. Apply several impastos, all in the same direction, to shape each of the areas of the dog's head. At the same time, add new bluish tonalities as you build up the planes. Notice the difference between the texture of the upper part of the muzzle and the rest of the face; the impastos on the upper part are slanted while on the rest of the face they are vertical.

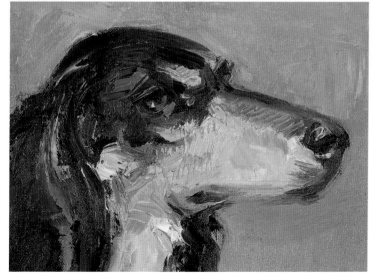

5. Apply a dark color with the tip of the palette knife to redraw the forms of the animal. Do not add the definitive details until the end of the process, which is also the time to remove any excess paint, if necessary.

PALETTE KNIFE TEXTURES

As we have seen in the two exercises devoted to this technique, the use of the palette knife is a wonderful source of creativity for the artist. In this exercise, we are going to paint a waterfall, in which the knife is used to create the effect of cascading water.

▶ 1. *After rapidly sketching the structure of the subject, position the main areas of the painting using a brush. Then use the palette knife to apply homogenous impastos to the sky. Using gray tinged with the other colors on the palette, start to paint the rocks. The color mix used here is not uniform, so that the palette knife can create a mottled effect.*

▶ 2. *Paint the rocks in green and ocher. The texture of this area should be flat and will provide the base over which to add further impastos. Drawing the edge of the knife gently over the painting paint the cascade, just enough to obtain a broken color. Over this broken background, apply white.*

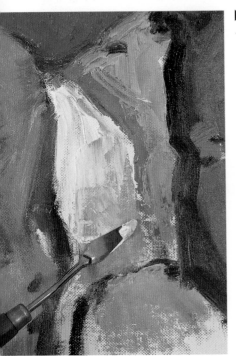

3. *Paint the cascade by applying the knife over the brushwork. The movement of the palette knife should be drawn out following the forms created by the flowing water. This color tinges the underlying layer of paint. Apply a large amount of white to the upper part of the cascade. Suggest the structure of the rocks by holding the blade flat on the canvas and then lifting it off to create a textured effect.* ▲

Step by step
The riverbank

Although it is possible to paint any subject using a palette knife, this tool is best suited to subjects which do not require a great deal of precision. In this exercise, we shall apply the techniques we have learned so far to capture this beautiful river scene. In order to demonstrate all the different lines and marks a palette knife can make, we have chosen a model with highlights and sharp contrasts. Painting with a palette knife is much faster than working with a brush, as more paint can be applied each time.

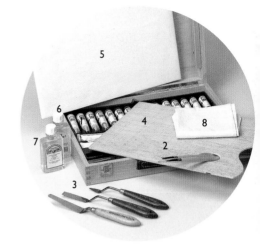

MATERIALS

Oil paints (I), brushes (2), palette knives (3), palette (4), canvas-covered cardboard (5), linseed oil (6), turpentine (7), and rag (8).

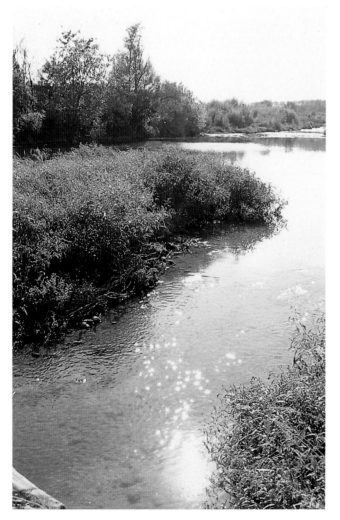

1. *Paint the preliminary sketch of the land-scape with a brush, without attempting to capture the precise outlines. The brush should contain some turpentine, but at the same time be almost dry, so that the impastos applied with the palette knife will adhere to the dry base. If the background is too damp, subsequent layers of paint will run.*

2. *Apply the first colors with a brush; this is done to mix the colors, a process which is more difficult to do with a knife. Another reason for using a brush at this stage is to obtain a thin color base which will gradually be thickened as the painting progresses. Your brushwork should be direct and spontaneous, attempting only to situate the main areas of color, without including any details.*

> If the paint is too thick in a particular area, it is best to remove it using the edge of the palette knife and start again.

4. *Then use the palette knife to add details to the vegetation which completely covers up the color base. The tones should alternate and overlap, mixing the colors without creating too sharp a contrast.*

3. *Only after you have fully developed the color base using the brush should you start to use the palette knife. First, apply touches of green and yellow to the vegetation on the right. To obtain the right texture, lay the blade flat on the canvas and lift it several times. During this process, it is inevitable that some of the underlying color will be pulled up, mixing the colors directly on the canvas.*

5. *Use a small palette knife to paint all the vegetation in the background in dark green, without creating as much texture in the foreground. Paint the area nearest the water by gently spreading out a mixture of blue and green that blends into the background. Apply white to the sky, sliding the palette knife gently and flatly across the canvas. Even pressure should be applied to mix this color with the underlying layer of paint.*

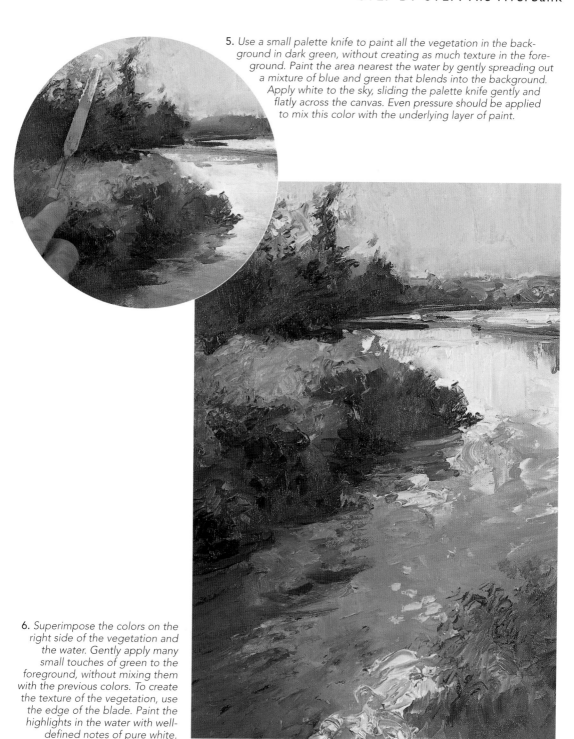

6. *Superimpose the colors on the right side of the vegetation and the water. Gently apply many small touches of green to the foreground, without mixing them with the previous colors. To create the texture of the vegetation, use the edge of the blade. Paint the highlights in the water with well-defined notes of pure white.*

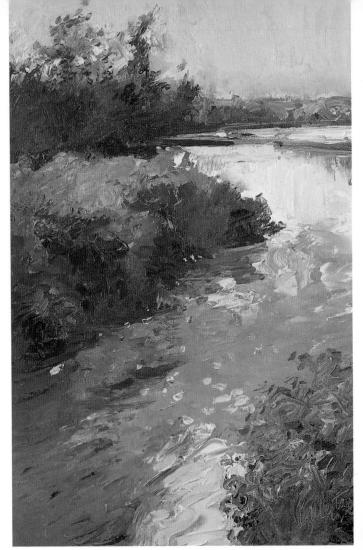

7. *Paint the texture of the vegetation in the foreground with earthy colors. Use the tip of the knife in this area to lend shape to the vegetation. To complete this exercise, model the whites on the surface of the water with a flowing, zigzag movement.*

SUMMARY

Paint applied with a palette knife can be pressed over the surface, smoothed out, or laid on directly. The sky was painted with a white that mixed with the underlying color.

Before starting work with the palette knife, it is important to sketch out the main areas with a brush. **The color base** is applied directly with the brush and the darker masses are outlined.

A palette knife can be used to create striking textured colors. Each part of the knife can be used to apply the paint in different ways. The **yellow patches** mixed with some of the previous color, and were created by pressing and lifting the knife on and off the canvas.

The **water** is represented with white notes that are blended into a zigzag shape.

10 Combined techniques

OIL OVER ACRYLIC

Acrylic gel can be used to create textures. Thus, a given volume can be painted and, when it is dry, repainted without modifying the original texture. To practice this effect, we have chosen a landscape with trees to show how to prepare the support with high-density gel. When the gel is applied to the canvas, it is a milky colored paste; after drying out, it becomes transparent.

Oil paints can be manipulated by adding materials which alter their texture or by mixing them with other pictorial media such as acrylic. At the beginning of this book we mentioned the possibility of preparing a canvas with acrylic gesso. Anyone who has done this before will know that acrylics dry very quickly, making them a perfect base for painting in oils. Since they are also excellent priming agents, acrylics can be used to obtain a color base and lend texture to a canvas.

1. To obtain the dark color of the plywood, simply dilute a little black acrylic paint with a little water and apply it with a flat, wide brush. In just a few minutes the base will have dried out completely. Then apply the high-density gel and form into the shape of the treetops. This can be done with a brush and palette knife to obtain the desired texture. Paint the lower area with gel to which ground marble has been added to lend it texture.

2. The background has dried quickly and you can now start to work in oils. This technique allows textured painting to be obtained very quickly and easily as the support is prepared beforehand. Use cerulean blue mixed with white and cobalt blue for the sky. These colors should be mixed directly on the painting. The trees should already have sufficient texture, so little paint is required.

3. In the lower area of the landscape, add some bright brushstrokes on the land and highlight the textured treatment of the trees.

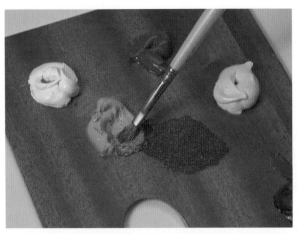

▶ 1. *Additives should be mixed with the oil on the palette. To obtain a good texture, mix a little additive with the oil using the palette knife or brush until the paint has absorbed it completely. Add the additive gradually, as required. You will be able to work with this mixture after a little practice.*

TEXTURED PAINTING

Inert matter does not react chemically if mixed with oil. The best way of becoming familiar with the world of textures is to begin with paints that have a medium amount of additive, such as ground marble or hematite in the right proportion. In this section we are going to do an exercise in texture, using a highly abstract motif.

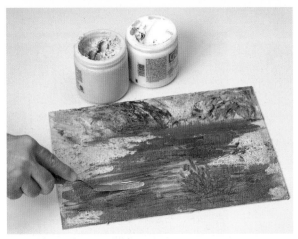

▶ 2. *As we saw at the beginning of this book, acrylic pastes and gels allow the artists to prepare a textured surface with the added advantage of drying very quickly. There are various types of gel that can create different textures on the support: some are especially suitable for impasto work, others already contain additives such as ground marble. In this exercise we are going to prime a wooden surface with textured gel.*

One of the greatest advantages of priming and preparing surfaces with acrylic gel is that the tools can be cleaned by simply rinsing them under the faucet.

▶ 3. *It is not necessary to use large amounts of acrylic gel; just enough so that it can be spread out with the palette knife. The shape you give it at this stage is the one it will retain when dry. First lay it on by drawing the knife around in a circular motion. Then spread it out over the painting and shape it. The texture should be even over the entire surface.*

I. *Using a sienna oil mixed with additive, paint a broad stripe in the center of the painting, using both the brush and the palette knife. The mark left by the knife on the surface creates dimension. Over and across this brown-colored stripe, paint another thick, textured stripe in a dark, black color. In the center of the composition, paint a red circle, textured with ground marble.*

FINISHING THE PAINTING WITH OILS

After applying the textured base, let it dry for a few minutes; a hair-dryer can be used to speed up the process, if necessary. The surface of the painting is now not only well primed but is also permanently textured. The exercise continues using oil paint mixed with hematite; if this is not available, ground marble or even rinsed sand will do.

2. *Once you have applied the texture to the painting, use the palette knife to spread out the color and scratch the surface with the tip of the brush, flattening part of the texture to create different planes. Make the horizontal stripe narrower and use the palette knife to produce a clear cut line. Any paint removed here can be applied to the lower part of the painting.*

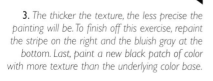

3. *The thicker the texture, the less precise the painting will be. To finish off this exercise, repaint the stripe on the right and the bluish gray at the bottom. Last, paint a new black patch of color with more texture than the underlying color base.*

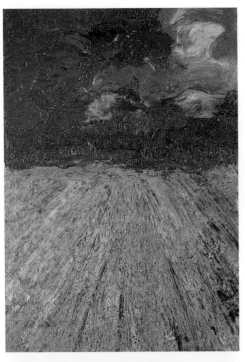

COLOR BASE AND DRYING

In the previous exercise, we created a series of textures based on a preliminary priming with acrylic gel. Another method for creating textured work is oil mixed with ground marble, sand, or any other mineral additive. In this way we can obtain textured paint that is very different than common oil paint.

▶ 1. *Mix the ocher-colored oil paint and the ground marble on the palette. The best method is to set a little paint aside, adding the powder until the desired texture is obtained. When it is thoroughly mixed, apply it to the painting with the palette knife. The furrows in the ground are obtained by scraping the surface with the knife.*

In textured work, results will not be obtained as quickly as with acrylics, since oils will dry more slowly. However, we do not recommend using cobalt siccative. A specific medium, Dutch varnish, or other mediums specially designed for this purpose should be used instead. The best way to ensure that the painting maintains its color and texture is to let it dry naturally.

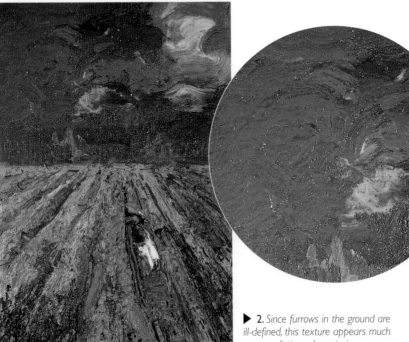

▶ 3. *To highlight the contrasts of the lighter area of land, paint the furrows black. The texture of the earth is enriched by the darker tones which become mixed with the colors already painted. You can enrich the texture of the ground by adding darker tones that will mix with the underlying colors.*

▶ 2. *Since furrows in the ground are ill-defined, this texture appears much more realistic and convincing.*

Figure using mixed techniques

Oil paint with additives can create a plastic effect which is completely different than the effect obtained using paint straight from the tube. Especially when a lot of additive is used, textured painting is not as well defined and delicate as ordinary painting: thus, artists should not seek the same degree of detail but concentrate more on achieving a harmonious balance of the elements in the painting.

MATERIALS

Oil paints (1), palette, (2), linseed oil (3), turpentine (4), brushes (5), palette knife (7), ground marble (8), and hematite or fine sand (9).

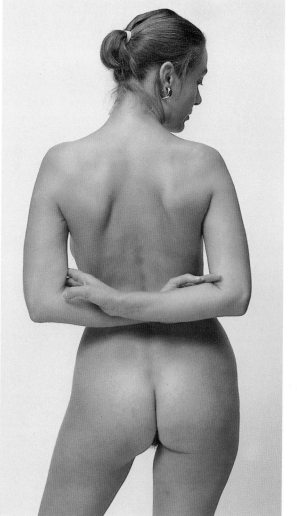

1. *Blocking in the figure is simple in this case, as it does not require a delicate finish. The drawing should act as a model for the successive layers of paint. Prime the painting first with a creamy tone; when this is dry, block in the figure using oils. The paint should be thinned so that this preliminary step can be done quickly and smoothly. Once you have completed the layout of the figure, shade in the background with paint containing a small amount of ground marble.*

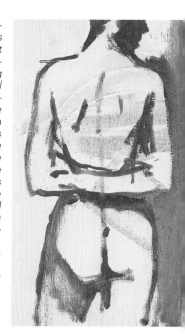

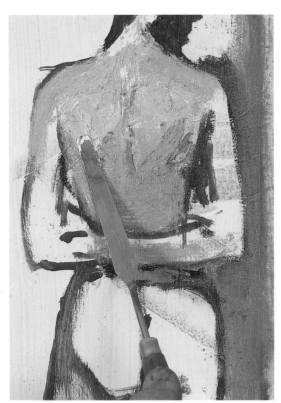

2. *Mix an orange colored paint with hematite. The texture of this mineral powder is finer than ground marble and creates a more delicate effect. Use a lighter color on the upper part of the back and then the darkish tone on the right; this situates the main areas of light and shadow. Use the same color with a little bit more white to paint the illuminated area on the back. This whole stage should be completed with the palette knife.*

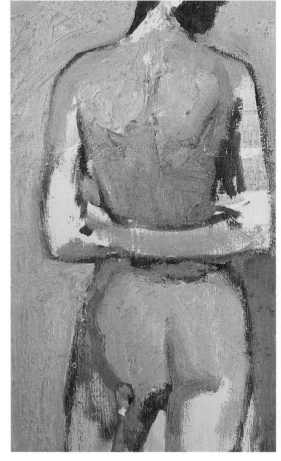

Don't use additives that may deteriorate in oil paint, such as paper, grains of rice, or bread. Other substances to avoid are chalk or plaster, as they absorb the oil.

3. *Once you have completed the upper part of the figure, move on to the lower part. The difference between these two parts as regards treatment and texture is obvious: the colors are much more luminous. First apply the lighter colors to outline the darker areas without mixing colors. Paint the background in a highly luminous blue, first mixed on the palette with ground marble.*

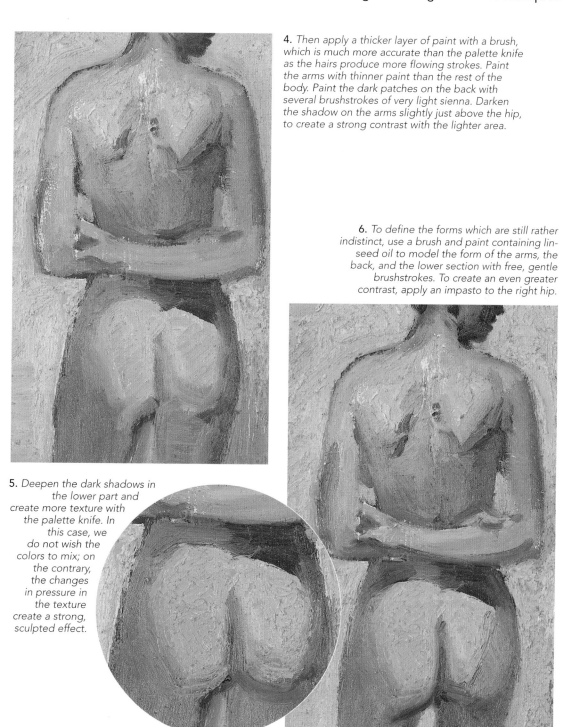

4. Then apply a thicker layer of paint with a brush, which is much more accurate than the palette knife as the hairs produce more flowing strokes. Paint the arms with thinner paint than the rest of the body. Paint the dark patches on the back with several brushstrokes of very light sienna. Darken the shadow on the arms slightly just above the hip, to create a strong contrast with the lighter area.

6. To define the forms which are still rather indistinct, use a brush and paint containing linseed oil to model the form of the arms, the back, and the lower section with free, gentle brushstrokes. To create an even greater contrast, apply an impasto to the right hip.

5. Deepen the dark shadows in the lower part and create more texture with the palette knife. In this case, we do not wish the colors to mix; on the contrary, the changes in pressure in the texture create a strong, sculpted effect.

449

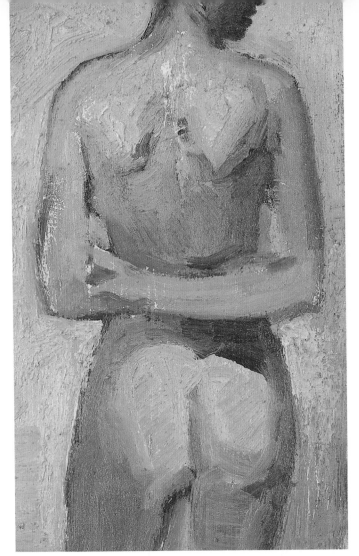

7. *Some further contrasts must still be added to the lower part, add touches of sienna under the arms and model the illuminated areas of the buttocks with a highly luminous tone. There should be a clear difference between the tones that make up the figure. After completing a session, clean all painting materials thoroughly.*

Any remains left on the brushes could ruin them completely. Take good care of them and the palette, which should be scraped with a painter's knife and then thoroughly cleaned with turpentine.

SUMMARY

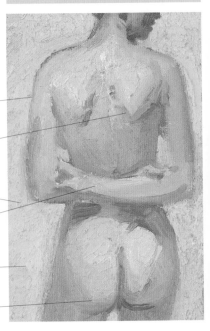

The drawing was sketched with very thin oil paint, but not so thin that it drips down the canvas.

After mixing the hematite and the oil paint on the canvas, we applied it to **the figure's back.**

The background, of a much rougher texture than the figure, was painted with added ground marble.

The arms were painted with very little additive, though a little ground marble or hematite can be added.

The highly textured background on the right was reinforced to create a stronger contrast with the figure.

The contrast of the figure was also strengthened with free brushwork.

From blocking in to roughing out

BLOCKING IN A HUMAN FIGURE

In previous chapters, we learned to block in structures and forms before beginning the painting process. This should always be done before beginning a figure, complicated though it may seem. In this exercise, the blocking in is different in that it has to be very superficial and unconcerned with superfluous details in order to project a better impression of the general structure. Details can be added later.

The study of a model is one of the most complex works for amateur painters, largely due to the fact that the shapes to be painted are not fully understood. We have already discussed different ways of blocking in a subject. In this section, we will go through two exercises showing the transition from the initial blocking in to the subsequent roughing out and final steps of the painting.

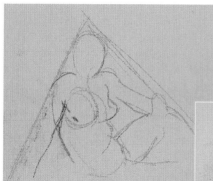

▶ 1. We have already seen how a complex form can be converted into a set of very simple shapes on the canvas. This process can be used for any subject, whether it is easy or difficult to represent. If the amateur proceeds directly to painting the subject, without stopping to block it in, the final result will most likely look nothing like the original. If you get in the habit of sketching in any form before painting, the results will be much more consistent.

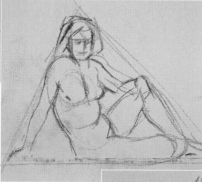

▶ 2. After blocking in the basic forms, add the definitive sketch to be used for the painting inside these lines. Blocking in is the first stage in which the final form of the subject is approximated. Allot as much time to this phase as necessary, although the lines drawn will not appear in the final work. When painting human figures, be especially aware of proportion.

The sketch should be concise and executed as quickly as possible.

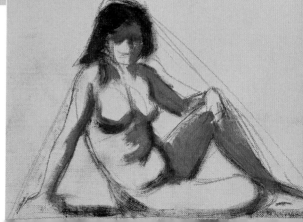

3. Upon completion of the blocked-in lines and subsequent sketching, the roughing out can be begun. The first paint should be very diluted with turpentine. In these first stages, details should be ignored. The first layers of color will be the basis for an entire series of thicker and direct applications later.

451

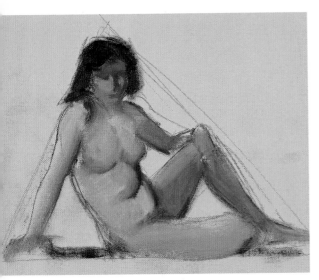

ROUGHING OUT AND CONSTRUCTION OF THE FIGURE

In order to rough out a blocked-in figure, use a brush that has been dipped first in turpentine and then in a dark color. It is not necessary to stop and correct possible errors. Simply retrace them with a new brushstroke.

▼ 1. The blocking-in process is finished and the roughing out has begun. The diluted base of color which is applied will serve as a support for later layers of color, as well as providing the initial tones. This first layer is like a rug for the next ones, and blends in and becomes one with the later tones. Denser brushstrokes help to define the contours of forms.

2. The addition of these first, darker tones helps define forms and frame the figure within the painting. Contrary to what most amateurs think, dark tones used in the roughing-out procedure should not incorporate black, as it mixes with the rest of the colors. Colors more suitable for this procedure are burnt umber, cobalt blue, sienna, and Van Eyck brown. Dark carmine also enriches dark tones. ▲

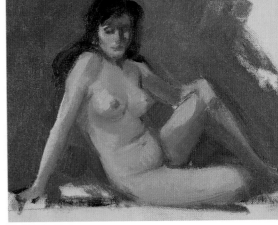

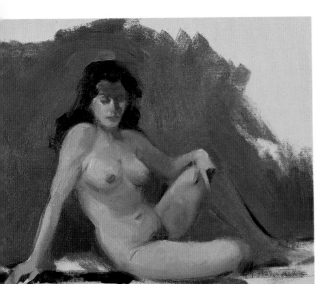

▶ 3. After darkening the background to make the figure stand out, add the final contrasts. These provide the definitive contours of the figure and unify the different parts.

BLOCKING IN AN URBAN LANDSCAPE

After demonstrating how the figure evolves in the blocking-in and roughing-out processes, we will now do a parallel exercise with a subject that may seem quite complex to many people. An urban landscape can be very simple if you understand its elements, or completely chaotic if you do not.

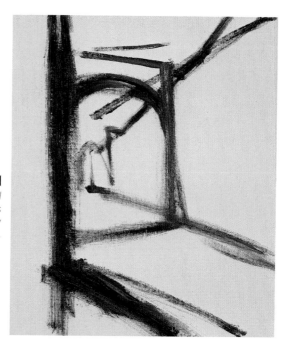

◀ I. *Straight, simple lines provide perspective for the wall and the archway. As you can see, the right wall is drawn in a perfectly triangular shape, and the archway projecting from it is sketched in as a rectangle.*

▶ 2. *With a brush dipped in turpentine, go over the lines of what are to be the wall, the arch and, more importantly, the dark areas defining their forms as well as the main shadows. This completes the initial sketch and the painting of the urban landscape can begin.*

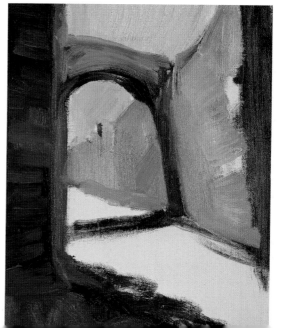

◀ 3. *Begin to rough out the painting with very flat tones of ocher, starting with the right wall and the archway. As in the previous exercise, this first tone will constitute the base for all later colors. The initial structuring of the painting will allow you to proceed quickly and precisely. In the following steps we will deal with one of the principle problems of on urban landscape: the structure of the painting.*

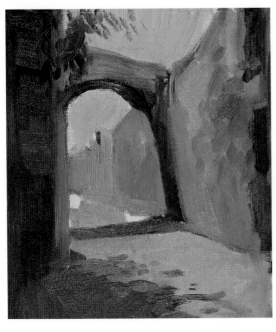

DEVELOPMENT OF THE ROUGHING-OUT PROCESS

Although somewhat diluted, the brushstrokes should be direct. Apply the colors very generally at first without many nuances. The surface of the painting should be covered quickly, as the blocking already provides the correct construction of the grounds.

▶ **4.** *If you want to add planes of different tones of a single color, you must use a palette. On the other hand, if you want to add a nuance or contrast to a small area within one plane, you can do this directly on the canvas. Paint the colors making up each area separately, but then add colors in small brushstrokes and mix directly on the canvas. In this roughing out, blue tones come out in the shadows on the left. Rough out the light-filled street area in a broken color made up of ocher, umber, and white, and do the right side in green tones.*

5. *The previous blocking-in process has provided a definitive structure for the painting. Now you can begin to add the nuances appropriate to each area. Contrasts are added in general, whereas shadows are more precisely done.*

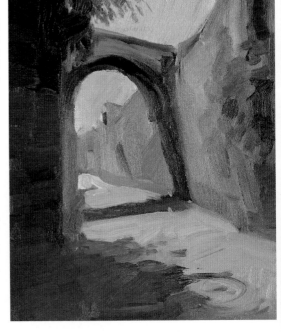

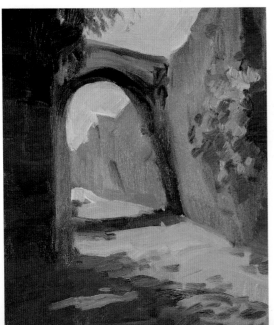

▶ **6.** *Complete the roughing-out process in this exercise with an assessment of the brightest highlights and starkest contrasts in each area.*

Step by step
Human figure

During the course of this exercise, it is important to remember the points we have established in this topic, i.e. blocking in based on simplified shapes and the progression of color based on an initial roughing out. Ultimately, specific contrasts and highlights will complete the definition of forms. Note that the technical process in the different sections is the same, and the variation lies in the calculations of proportions and, if necessary, the degree of finish.

MATERIALS

Oil paints (1), palette (2), linseed oil (3), turpentine (4), rag (5), canvas-covered cardboard (6), and brushes (7).

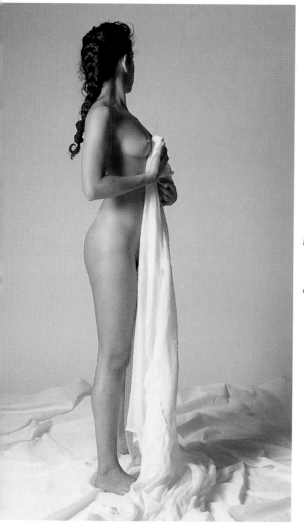

1. *In order to rough out the figure, you must first block it in. Here, the previously blocked-in figure has been represented graphically so that you can study it more closely. Based on these elementary forms, complete the outline in a dark-colored oil. For areas requiring a somewhat more definitive line, dip the tip of the brush in turpentine in order to achieve a continuous stroke. Do not attempt to obtain a perfectly constructed sketch.*

STEP BY STEP: Human figure

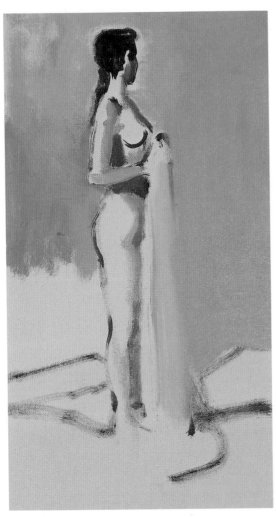

2. *Quickly go over the form of the figure with an orange-based color which highlights the contours. This should be done in a brushstroke that outlines the white area yet to be painted. As in previous examples, first paint the background in dark colors so that it makes the unpainted figure stand out.*

Flesh color does not exist as such. But it can be created from a mixture of the following colors: Naples yellow, carmine, sienna, white, and a touch of blue for shadows. Depending on the surrounding colors, orange can be added to highlight specific points.

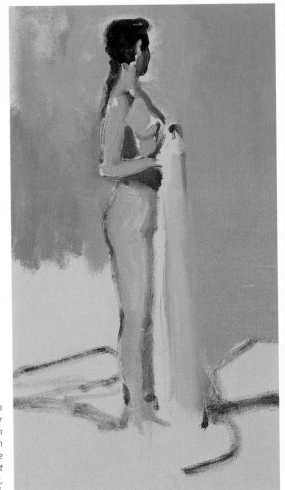

3. *Once you have painted the background, rough out the medium toned areas of the figure, for example the left contour of the leg. For the area in the middle of the leg you should use a much brighter color, toned with a bit of white. Along the arm and the breast, apply almost flat colors without attempting any type of modeling. For the moment, the brightest areas should be left unpainted.*

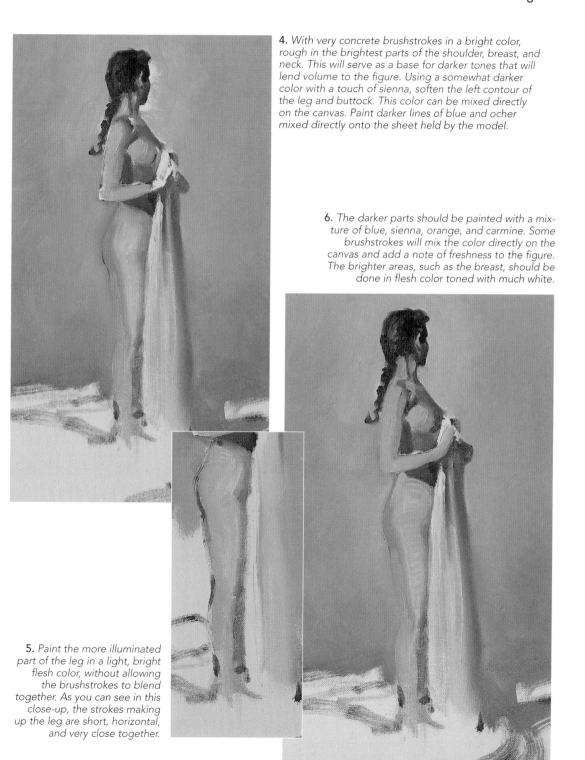

4. *With very concrete brushstrokes in a bright color, rough in the brightest parts of the shoulder, breast, and neck. This will serve as a base for darker tones that will lend volume to the figure. Using a somewhat darker color with a touch of sienna, soften the left contour of the leg and buttock. This color can be mixed directly on the canvas. Paint darker lines of blue and ocher mixed directly onto the sheet held by the model.*

6. *The darker parts should be painted with a mixture of blue, sienna, orange, and carmine. Some brushstrokes will mix the color directly on the canvas and add a note of freshness to the figure. The brighter areas, such as the breast, should be done in flesh color toned with much white.*

5. *Paint the more illuminated part of the leg in a light, bright flesh color, without allowing the brushstrokes to blend together. As you can see in this close-up, the strokes making up the leg are short, horizontal, and very close together.*

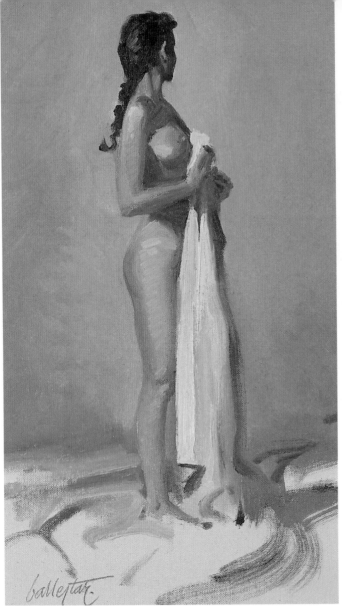

7. *To complete the figure, apply color in order to emphasize the depth of the darkest shadows, and add one or two very expressive highlights. So far we have left the entire lower edge of the painting unpainted. These white areas will integrate themselves perfectly into the painting. As a final touch, add a powerful stroke of white to the sheet held by the model.*

SUMMARY

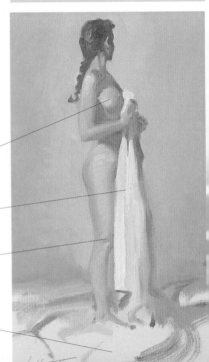

The highlights of the breast are painted

The white of the sheet

The knee was painted with a double brushstroke of carmine, toned with sienna, and white.

The lower area of the canvas was left unpainted.

458

Still life: glazes, highlights, and shadows

TONAL WORK

The still life is one of the most interesting subjects for learning the techniques of oil painting. The main interest lies in the study of highlights, shadows and the main representative methods. Some of the questions dealt with here can be applied to any of the other subjects in this work.

The process of obtaining the right tones has been dealt with in earlier topics, but we must return to it, because the process of painting itself is largely based on this principle. It is not only important to learn to represent the highlights in a still life, but also to observe the model closely. This apparently simple exercise demonstrates one of the first mistakes beginners make when faced with a real model.

3. The first brushstrokes are applied to the darkest shadow in this still life. When balancing the tones, artists do not usually use black as it reduces the shades of the adjacent colors. Instead of black, you can use burnt or dark umber. A more luminous note is added inside this dark area to underline the contrast. ▲

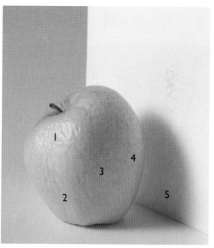

▶ *1. Before starting, study the model to see how the shadows define the different areas. Look closely at this apple and observe different light tones: a point of maximum brightness (1), an area of indirect light (2), a shaded area (3), reflected light (4), and the object's shadow (5).*

2. When creating the shadows, it is important to observe the model closely. Make a preliminary sketch in charcoal. After blocking in the form of the apple and the side of the box, draw in the darkest shadow. This is the shadow cast on the wall by the apple. ▶

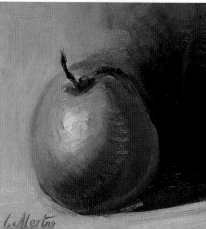

◀ *4. Gently blend the light and dark areas together. The brushwork should shape the shadows depending on the plane in which they lie. These tones will merge delicately.*

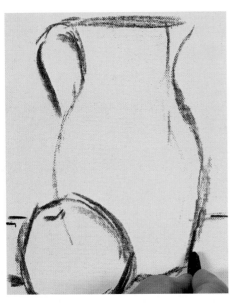

SHADOWS AND ATMOSPHERE

The range of possibilities offered by shadows allows the artist to create a very rich finish and lend the still life a certain atmosphere. This is done by representing the highlights of the motif in a very limited range of colors. Atmosphere is then created by representing the tones of light and shadow with a certain harmonic range of colors.

▶ 1. *Sketch the model using charcoal, which can be easily erased if you need to reposition the main elements. In this preliminary layout define the forms of each element well so as to avoid subsequent mistakes when creating the shadows.*

3. *The highlights are precise lines or spots. The shadows are larger, occupying most of the painting. When painting the areas of light, bear in mind that the point of maximum brightness should be applied last. The colors of the highlights should be mixed on the palette, though they will blend with the intermediate tones when applied to the painting. A perfect sense of atmosphere can be achieved by using colors of the same range.* ▲

2. *Use burnt umber to paint the background against which the main forms of the still life will stand out. Use this tone to sketch the shadows of the two objects as well. Fading brushstrokes are useful for creating intermediate tones.* ▲

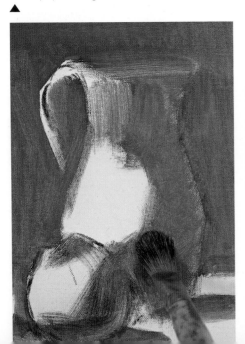

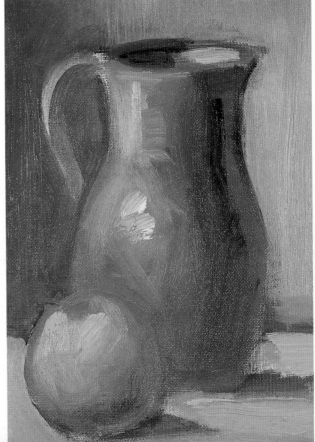

LIGHT AND SHADOW WITH GLAZES

A glaze is a layer of oil paint which is so transparent that colors beneath it will still remain visible. So far we have studied how to create shadows using tones that are darkened or gradated, but one of the greatest advantages of oil paint is its potential to be used as a transparent medium. This transparency can be used to create striking light effects.

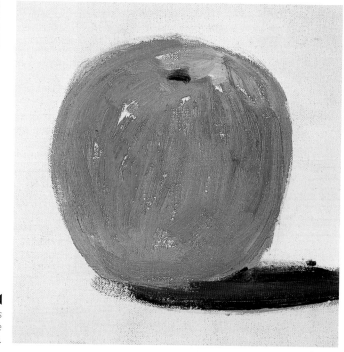

1. As in all oil painting techniques, the first colors should be thinned down slightly. Each successive layer should be fatter than the previous one.

One way to obtain a glaze is to mix linseed oil, a few drops of Dutch varnish, and a tiny amount of oil paint.

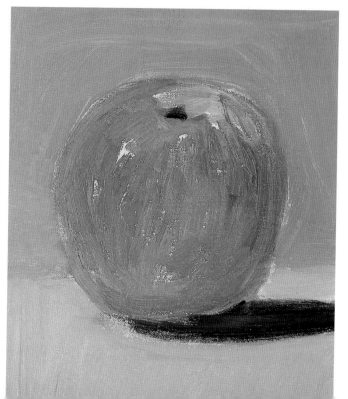

2. Glazes can be used in painting far different reasons: one is their transparency and luminosity, while dark glazes can be used to introduce modifications to the underlying color, without covering it up entirely. Always apply glazes after the first layers of paint making sure, however, that these underlying colors are completely dry, otherwise the two layers will mix instead of being superimposed. Using semi-opaque cobalt blue, fill in part of the background; use the same color to apply a glaze to the shadow of the apple. This glaze should be spread out evenly over the painting with the brush to create a uniform layer.

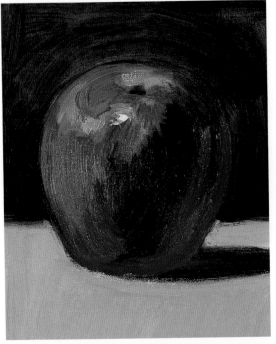

SITUATING GLAZED TONES IN THE PAINTING

Using glazes is a slow process, as the color base of the painting must be totally dry. Nevertheless, it is one of the most interesting complementary techniques for creating subtle shadows. The tones of a glaze do not only affect those of the painting; they can also create a transparent atmosphere, interpreting the light that bathes the still life.

▶ 1. *Use dark glaze to increase the contrast of the tones in shadow. If you apply another glaze over this one, their transparencies will reinforce one another. The resulting effect, however, is not one of greater luminosity, as this is obtained by using luminous colors. An additional glaze will add shades of the tones already present. A completely transparent color painted over a darker one will have no effect. Use a reddish glaze to retouch the shadowy areas on the right and obtain an intermediate tone.*

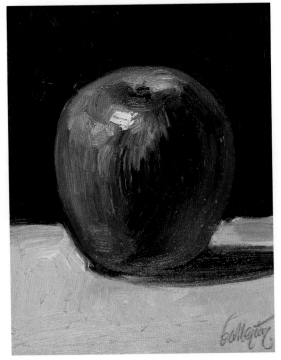

A good alternative for working with glazes is to paint the color base in acrylic since this dries quickly and is then ready for subsequent applications of oil.

▶ 2. *Create the volume by modeling the different tones created by the glazes. Add the highlights with direct touches of white and greenish yellow on the upper part of the apple. When these areas have dried, you can apply a new glaze to adjust the atmospheric illumination; this glaze should be a highly transparent blue. Reglaze the background to darken it and create a greater sensation of depth. Apply another glaze to adjust the shadow of the apple on the table.*

Step by step
Still life

As we have seen, shadows can be interpreted in different ways. Applying glazes is one alternative, although waiting at different stages throughout the process for the different layers to dry can be rather tedious. On the other hand, glazes are a means of extracting the full potential of oil paints to create shades of color and transparencies. To put this knowledge into practice, we now present an exercise consisting of a still life with glazes. We have chosen a model with an extremely simple composition.

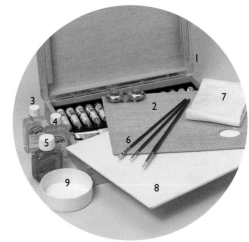

MATERIALS

Oil paints (I), palette (2), turpentine (3), linseed oil (4), Dutch varnish (5), brushes (6), rag (7), canvas-covered cardboard (8), and container for mixing the glazes (9).

1. *First, paint the dark area of the background to outline the more luminous forms in the still life. This dark color, a brown mixed with a little black, English red, and cobalt blue, should be slightly diluted with turpentine, but not so much as to make it runny. Leave the lighter areas of the tablecloth unpainted and paint the dark areas with light blue and glaze of highly transparent violet. Do this by first applying the almost transparent cerulean blue. When this has dried, superimpose the violet colored glaze. Paint the shadowy area of the pear green.*

463

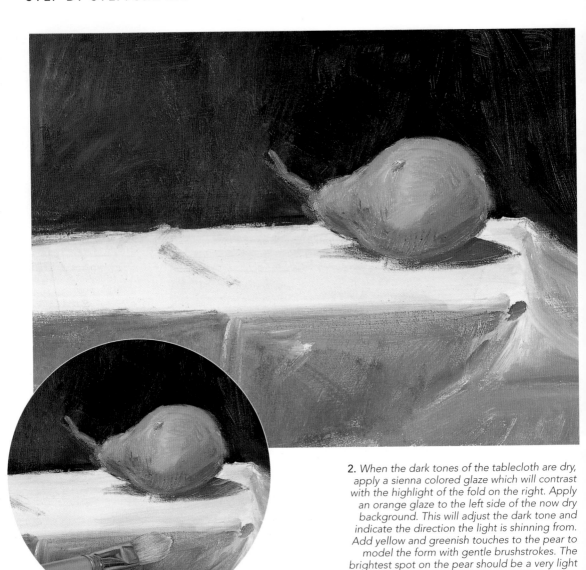

2. *When the dark tones of the tablecloth are dry, apply a sienna colored glaze which will contrast with the highlight of the fold on the right. Apply an orange glaze to the left side of the now dry background. This will adjust the dark tone and indicate the direction the light is shinning from. Add yellow and greenish touches to the pear to model the form with gentle brushstrokes. The brightest spot on the pear should be a very light yellow. To the right of the main fold, paint a more opaque color that covers the whole of this section. Some of the green of the pear is spread towards the lighted area. When blending colors in this way, very gentle brushwork is necessary. Most of the glaze work will be on the tablecloth. Use a bright blue glaze to modify all the colors already present in the tablecloth.*

3. *Modify the tone of the tablecloth using a luminous, transparent glaze. This effect can only be obtained if the underlying colors are completely dry. Oil paints dry very slowly so we do not recommend using large amounts of color. Paint a very bright ocher glaze over the white. This glaze will also alter the original tone of the darker colors.*

4. *Wait a whole day before resuming work. Paint the whole of the illuminated area of the table-cloth using sweeping, horizontal brushstrokes in white, yellow, and ocher. A further, reddish, glaze can then be applied to modify the almost black tones: this color suggests a warm light that creates the atmosphere.*

Because glaze work on shadows can be so time consuming, you may want to work on two paintings at the same time. This means less time is spent waiting and more time is spent acquiring a greater understanding of shadows.

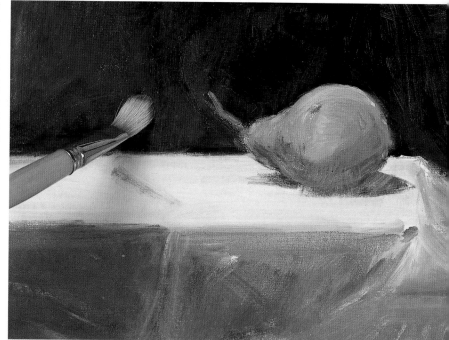

5. *When the previous stage is completely dry, paint over it again, without blending the colors already on the painting. Paint the dark shadows on the pear with a blue glaze on the right and a cadmium red glaze on the left. Then adjust the color of the tablecloth with glazes over the areas in shadow. Blend these glazes with opaque brushstrokes of a more luminous color. Paint the table top bright white on the right and white tinged with Naples yellow on the left.*

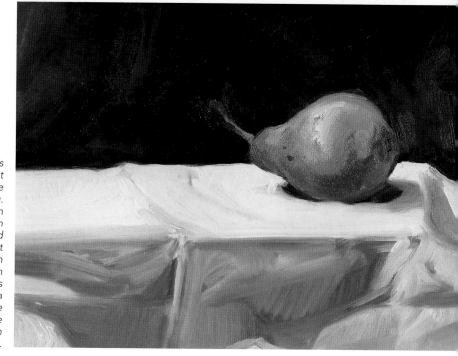

465

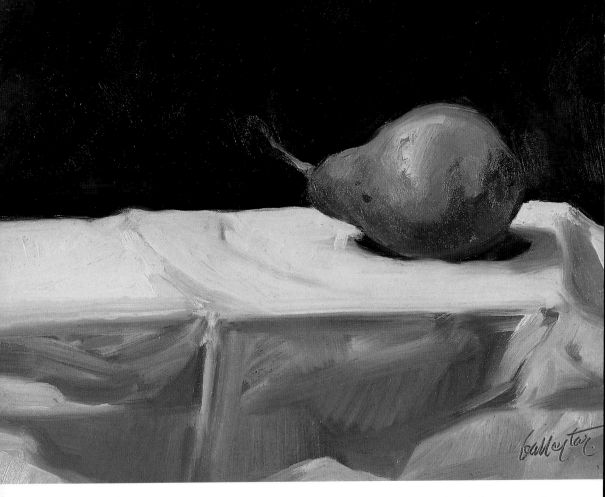

6. *Use luminous colors almost verging on white to paint the brightest highlights in the folds of the left side of the tablecloth. This is the final glaze in this exercise. As men-* tioned earlier, this type of work does not require great effort, but it does demand patience. Nevertheless, this may actually be an incentive for learning to paint in oils.

SUMMARY

The first colors are the darkest, outlining the form of the fruit and the table.

All colors should be perfectly dry before applying any glazes.

The first layers of color should be slightly diluted; thick layers of paint should never be used to shorten the drying time.

The glaze used to darken the shadow of the pear is blue and red; the modeling of the form should be done gently and gradually.

Different glazes were applied to the **tablecloth**. Their high transparency allows all the underlying tones to remain visible.

The brightest highlights were painted using opaque tones when the painting was almost finished.

13

Modeling with oils

MODELING A STILL LIFE

We recommend reviewing the concepts of tonal values, which will make this topic far easier to follow. We have chosen a still life in order to bring out the tonal values of a subject and then model its forms. It is important to study the lights, as well as the gesture of the brushstroke for painting shadows. This exercise is a fitting prelude for modeling a human figure, which will be demonstrated in the next exercise.

The modeling of any subject begins with the tonal values. This is discussed in several topics in this book, and certain basic concepts are provided, such as tonal evaluation, the study of light and shadow, and blending tones. This topic will put this theory into practice using motifs that are well suited to this technique, the still life and the figure.

▶ 1. *Many amateurs do not pay enough attention to the drawing of the model, and often end in failure before ever reaching the painting stage. The drawing is the foundation of the painting. With a good drawing, the application of shadows becomes almost intuitive. An incorrect drawing, on the other hand, will almost certainly lead to incorrectly placed shadows as well.*

▼ 2. *Using paint thinned with abundant turpentine, set out the subject. The advantages of starting with very diluted paint is that the shadows can be situated from the outset and errors are easy to correct. The best way to rectify an error is to run your finger or a rag over the painted area in order to open up a white or remove the undesired stroke.*

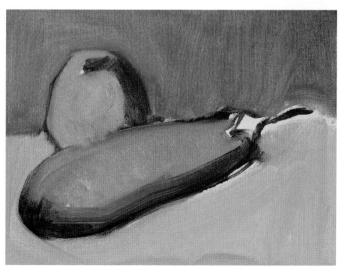

◀ 3. *First concentrate on the contrasts between light and shadows. Do not attempt to define anything. Apply the shadows gradually, looking for the form of the light. The first luminous tones will compete with the shadows and cause the emergence of simultaneous contrasts (a dark color placed directly next to a light one causes a mutual enhancement of the two), so you must constantly compensate for this effect by brightening or darkening tones.*

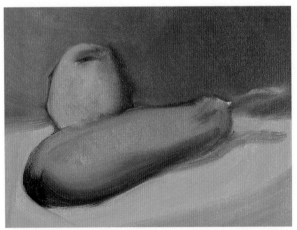

▶ 1. *Dark tones can be blended with light ones by running the brush over the two of them various times. Consider carefully which brush is most appropriate for each one of these blendings. While any type of brush can be used to rough out the canvas, blending techniques demand a particular type of brush, preferably the soft hair type. A wide brush made of synthetic hair can be used to blend tones together; several strokes painted with this brush are enough to blend two colors perfectly.*

THE USE OF THE BRUSH AND COLOR

The tones demonstrated earlier provide a guide to the light areas of the model. This will allow you to obtain the shadows by blending and modeling. At this early stage of the work, the movement of the brush is important, as shadows cannot be painted solely by gradating tones. The stroke must also be adapted to the object's plane.

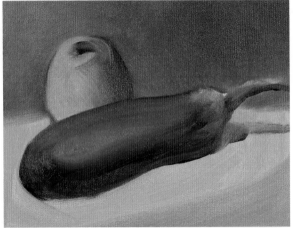

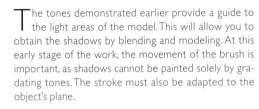

▶ 2. *When blending tones, it is necessary to study the plane in which the shadow is located. Because the objects in this still life have curved and spherical surfaces, the brushstroke must follow the form of each plane and distribute the dark tone around the area in light. The idea is to increase the presence of dark tones so that the contrast to the light tones becomes ever more evident.*

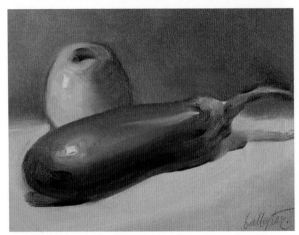

Modeling begins with the application of tonal values and ends with the blending of colors and tones to create the effects of light.

▶ 3. *Only after the modeling is complete can you add the highlights, which indicate the direction of the light and the quality and texture of the object.*

MODELING A HUMAN FIGURE

The reason we chose a simple still life as the subject of the previous exercise is to demonstrate that regardless of how complex a shape may appear, it can always be reduced to far more elementary forms. The shape of the apple painted in the last exercise can then later be compared to the round shape of a shoulder. Once you have studied how a still life can be modeled using a single color, you can apply the same concepts to model a human figure by means of tonal values. To simplify this question which may seen rather complicated, we have chosen a detail of the human body as the subject of the next exercise. This is an excellent model for studying the way in which light and shadows adapt themselves to different forms.

1. *Having sketched the shoulder with sienna, apply a dark background of the same color. In this way, the drawing fits better within the context of the painting. With a brush dipped in turpentine but still quite dry, add the first dark features of the anatomy. This procedure makes it easy to sketch the shadows and make subsequent elaborations.*

2. *Fill in the interior of the figure using ocher with a hint of orange. This subject will help you see how different curved planes can already be represented with brushstrokes according to the incidence of the light. For the moment the color will be very flat even though there is already a clear differentiation between the planes of light. Accentuate the difference in the light by applying a reddish tone between the chest and the collar bone. In order to highlight the contrast between the background and the figure, add some blue to the background.*

3. *The color base should now be complete. Over this color use tones that contain less turpentine, but are still somewhat transparent. Thus, add some linseed oil or Dutch varnish to the paint, just enough to superimpose a glaze over the background. This first glaze of almost pure white cannot be applied, however, until the background is completely dry.*

THE COLOR OF LIGHT

When modeling the shapes of a human figure, do not limit yourself to a fixed set of flesh tones. The color of a person's skin is dictated by the color of the light that envelops it. This is a crucial question to bear in mind when the shape of your figure is based on tones and colors reflected off the skin. Another point to remember is that highlights, colors, and shadows also depend exclusively on the light that creates them.

▶ 1. *When painting the color of the light that envelops the figure, begin with the shadow tones, reflected on the skin. Paint the darkest shadows, located between the chest and the arm, with a very dark combination of burnt umber and a touch of red. Allow certain areas to merge, while leaving others fresh with perfectly visible strokes. Blend the highlight on the neck until the brushworks disappear.*

2. *Model the figure by gradating light and dark tones. At this stage, intensify the contrasts in the neck and the arm with increasingly delicate brushstrokes that create volume, lending form to the musculature of the shoulder. Here you will notice similarities in the way the volume of the apple in the previous exercise and the shoulder have been obtained.*

Delicate brushwork is required to model the forms of a human figure. A wide brush with a synthetic hair tip is good enough for this purpose.

3. *To finish modeling, apply the final contrasts with increasingly dark glazes. Intensify the highlights on the skin by subtly blending them with a brush.*

▲

▲

Step by step
Female nude

Modeling in oils is one of the most traditional techniques of this medium. In addition to this, the application of glazes creates transparent layers that modify underlying colors. The subject of the last exercise in this topic is a female nude which will allow you to observe the use of gradations, blends, and glazes to model the motif. To make this exercise complete, we have illuminated the model with great care so as to obtain a good distribution of shadows.

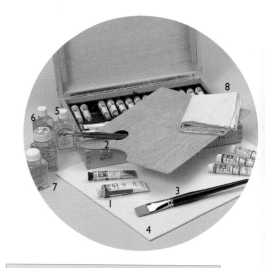

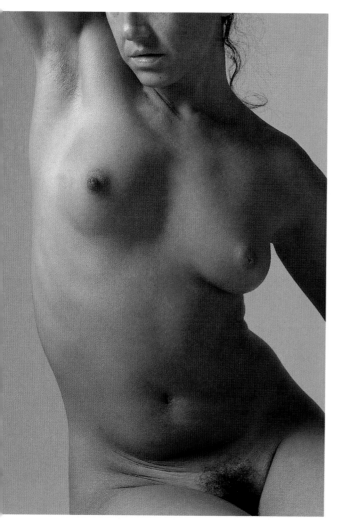

MATERIALS

Oil paints (I), brushes, (2), extra-soft brush for glazes (3), canvas-covered cardboard (4), turpentine (5), linseed oil (6), solvents for painting glazes (7), and a rag (8).

1. *Sketch the main forms with a fine brushstroke, and go over each part of the anatomy until you have obtained the right proportions. Paint in the most basic tones of the figure over the perfectly drawn form using two colors toned with white.*

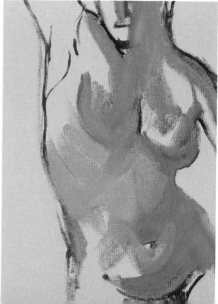

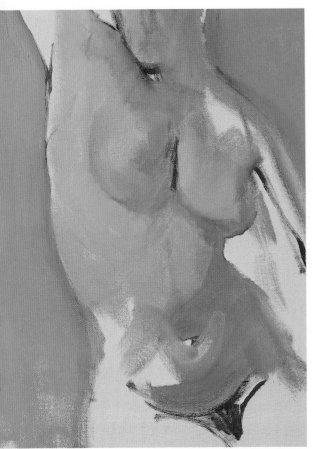

2. *Once you have developed the figure and defined the main areas of light with flesh colors, paint the background in order to outline the shape of the figure. In separating the form from the background, gradate the various areas of light by considering the illumination as a whole. The most luminous colors can now be applied. Without blending the tones, conform the brushwork to the direction of the plane being painted. The modeling and blending of the color should be done in the same direction as the brushstrokes.*

The first layers of oil paint must be very diluted so that the modeling process can be carried out on a lean surface, which allows blending. This process is very important so that the glazes can be added at the very end.

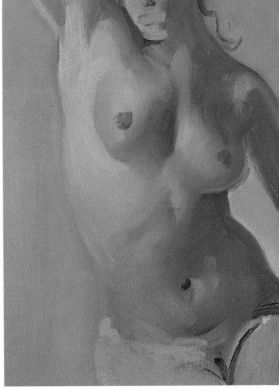

3. *Begin to paint the shadows of the figure and, at the same time, blend the dark tones with the much lighter underlying ones. The brushstrokes used in this blend should follow the direction of the form in its plane. Begin to paint the more luminous tones on the left in the same way that you painted the darker areas on the right of the figure. This procedure will allow you to model the breast and muscles of the raised arm. One important aspect concerning glazes: the stroke must be so delicate that it does not leave a mark on the surface of the canvas.*

4. *Once the painting has dried completely, paint the very transparent glazes with Dutch varnish and medium yellow. Paint the right side of the raised arm and model the top part of the breast with various tones mixed on the palette.*

Yellow light can help the artist to create colors from a specific color range on the palette. The choice of the color of light is very important for obtaining a well-modeled figure.

5. *The glazes will blend with the colors that are not glazed. It is essential to allow the first glaze to dry completely before starting the next one in the darkest area of the painting. Prepare a sienna glaze and paint the shadows on the right side of the hips below the breast and the arm. Paint the area around the stomach with a new glaze of orange, which will modify the light in this area.*

6. *Deepen the contrasts in the darkest parts of the shadow with a very dark color. Then, make this color transparent and finish the modeling by increasing the shadows of the right breast, the stomach, and the pubis. This completes this exercise in modeling and painting with tonal values.*

SUMMARY

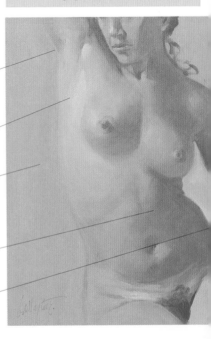

The preliminary drawing was sketched with a brush. It is important to use paint diluted with ample turpentine in case corrections need to be made.

The areas of light and shadow were established **with the first layers of color.**

The figure was outlined **with a dark color.**

The shadows were created with glazes of sienna and carmine and the use of mode line tonal values.

A dark tone lends form to the hips.

Flowers

DABS OF COLOR AND GLAZES

The direct application of pure colors can be combined with superimposed layers which modify those beneath. As we have already discussed in the corresponding chapter, glazes affect lighter colors much more than darker ones. Here we will demonstrate a simple exercise involving the application of glazes.

Flowers could be considered a separate category within the still life genre. Painting flowers requires special techniques which are not normally used in other types of still lifes, such as fruit or vase still lives. If you learn the techniques described in these pages, flowers can become one of the easiest subjects to paint, since in most cases they are not painted in an excessively realistic way, but rather with very loose, direct brushstrokes. In this topic, we will present several interesting examples.

1. The subject of this exercise is a white flower which is very easy to sketch. Few colors are needed and the flower can be painted with direct applications of paint which follow the contours perfectly. The flower ▲ should be painted in bright colors, even though these will isolate it from the background.

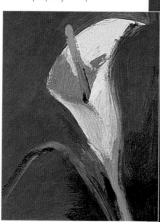

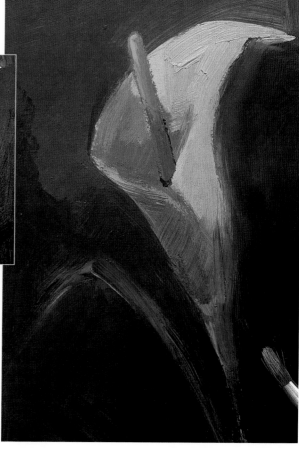

◀

2. You must wait until the paint dries completely before adding a glaze to create atmosphere. This glaze technique can be used in any flower painting although, as already stated, the paint underneath must be dry. Thus, several days may elapse before the final glaze can be applied. Apply a very bright ocher as a glaze on the right side of the flower. A highly transparent blue layer can be added to part of the flower, the darkest areas, and to part of the background. Glazes modify dark colors differently than light ones.

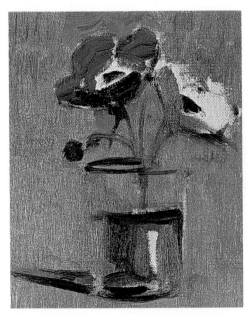

FROM ROUGHING OUT TO HIGHLIGHTING

In the previous exercise, we applied glazes over bright colors in order to change the luminosity of the flower. This is only one of many options artists have when painting the subject of flowers. Impasto is another technique often used for painting still lifes with flowers, which can be effected with direct applications of color. Flowers usually appear in vases or, as in this example, in a glass of water. Here it is very important to represent the highlights in a clean way, so that the colors nearby don't appear soiled.

▶ 1. *After blocking in the form, mix the colors you will be using on the palette and apply them to the painting. In this still life, use predominately short, vertical brushstrokes. Fill in the background with numerous brushstrokes in various tones of violet. Leave the most luminous colors, corresponding to highlights on the glass and the right flower, unpainted. The left flower should be roughed out with direct dabs of color.*

2. *In order to harmonize the dark colors with the bright ones, the highlights were left unpainted in the previous step. When you add white to the unpainted canvas, the color will not be dirtied by previous layers and will be all the more brilliant. Apply a strong highlight in white to the illuminated part of the glass.*

▲

3. *Strong contrasts and brilliant highlights add the finishing touches to the various forms of the flowers and the glass. All highlights will not have the same intensity. Apply the smallest ones, on the rim of the glass, with a direct brushstroke over the darker colors.*

▲

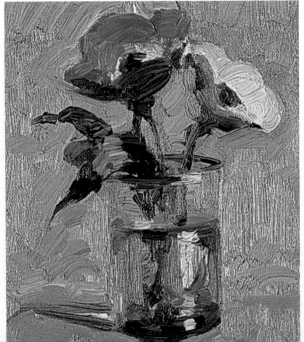

THE BACKGROUND IN A STILL LIFE WITH FLOWERS

Depending on how brushstrokes are applied within the composition, different planes can be created. Throughout this book, we have stressed the importance of the roughing-out process. Thanks to this process, the flower can be placed in a focal position, without ignoring the background, which plays a key role in the brightness of the whole.

In these examples we can appreciate how the brightness of the background is crucial in creating a contrast with the main element. Here, the change from one color background to another either heightens the contrast or even almost envelopes the flower completely.

1. *Points of light especially in areas of great contrast have a great influence on dark areas. They should thus be applied with care. The relationship of the central figure to the background is of great importance, especially in flower paintings, in which the different colors often present great contrasts among themselves. In the initial roughing out it is important to decide which colors will be applied to each plane. At this stage, any changes can be made easily.*

▲

2. *Dark areas do not require as much precision as brighter areas. Brighter areas also have more contrasts and details. The relationship between the tones of the flower and the background can be created by adding darker tones to the flower.*

▲

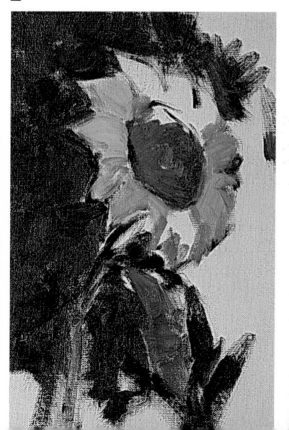

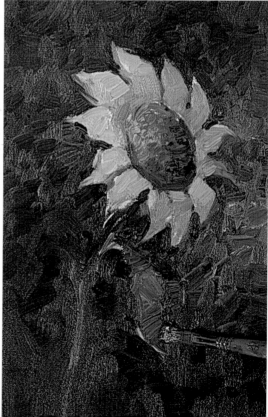

▶ 1. *Paint the drawing in acrylics after a previous pencil sketch. The strokes should be very similar to those done in oil paint. Acrylics can be thinned with water in order to obtain different brushstrokes and color effects.*

A VERY PRACTICAL TECHNIQUE

In the following exercise, we will create a flower using two different pictorial techniques. This is referred to as combined techniques. We will use acrylics and oil paints. First we will apply the acrylics, which are soluble in water and dry very quickly. To prevent the paint from drying while you paint, simply dip your brush in a jar of water. Once we have applied acrylics, we will then continue with oil paints to finish off the painting. The great advantage of this technique is the quickness with which you can work and the ease of cleaning the brushes.

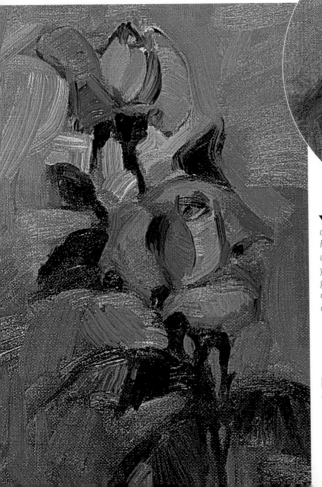

▼ 2. *Roughing out in acrylic paint provides a good base for oils, which can be applied once the acrylic layer has dried. First paint the background in a very diluted and transparent umber. This paint should dry in several minutes, after which you can paint the flowers in a very bright magenta. The green of the leaves should be added last. Once you have completed the acrylic roughing out clean the brushes thoroughly with water and soap to eliminate any traces of paint.*

▶ 3. *Once you have completed the entire background in acrylics, you can continue in oil paints just as if the previous layer had been done in oils as well, with the great advantage that it will have dried much more quickly. The final results will be no different from a painting done completely in oil paints.*

Step by step
Flowers with dabs of color

Often, amateurs find themselves in a dilemma, especially when they don't have a clear image of what they want to paint. This should not pose a problem, as the still life is one of the most exciting subjects that can be captured in oil painting. A simple bouquet of flowers can provide as much satisfaction as the most complex of models. This exercise should be extremely interesting and will allow you to experiment with subtle colors and textures which cannot be used in other oil painting exercises.

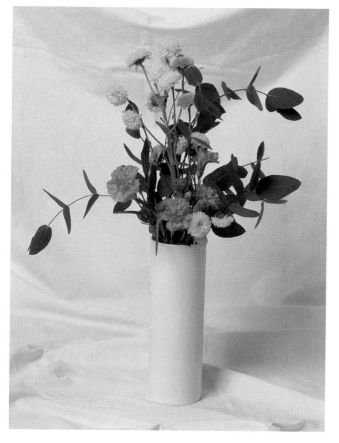

MATERIALS

Charcoal (1), oil paints (2), palette (3), linseed oil (4), turpentine (5), paintbrushes (6), canvas-covered cardboard (7), and a rag (8).

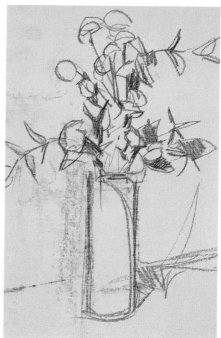

1. *The flower vase has not been placed in the exact center, but slightly displaced to the right, adding interest to the composition. With respect to the drawing of the flowers, notice the total absence of detail. Only the main forms should be drawn in as simple shapes. It is important to draw in the stems and leaves correctly, as they will serve as a framework for the flowers.*

STEP BY STEP: Flowers with dabs of color

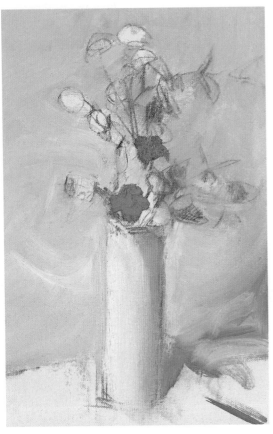

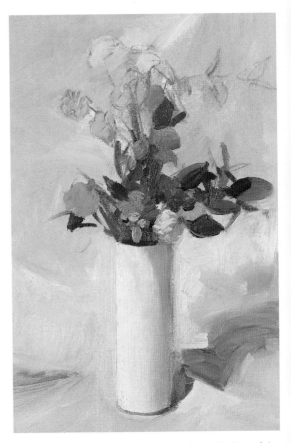

2. In a flower painting, it is important to first define the background on which the flowers, stems, and leaves are to be drawn. This is because it is much easier to paint a fine stem on a painted area than to paint a background around such a fine line. As in any other oil painting, the first layers should be more diluted. With this in mind, apply the background in a well-thinned cerulean tone. Mix some white brushstrokes directly on the canvas, with several touches of cobalt blue. Paint the carnations directly in reddish tones without too much definition. Rough out the shaded side in green, which will blend into the white of the illuminated side.

3. Emphasize the contrast of the shadow of the vase on the background with cobalt blue toned down with white. The base can be precisely outlined in this color as well. So far, the colors used to rough out the flowers, although executed in direct strokes, have been muted. This allows you to apply much brighter colors now. The previous colors now become the darker areas of the flowers. The brushstrokes on the petals should be added as small touches of light, implying the form of the petals without defining them.

Although you may want to use fresh, spontaneous brushstrokes, avoid doing this in works where you want total control of the forms. Excessively thick applications of paint will prevent details.

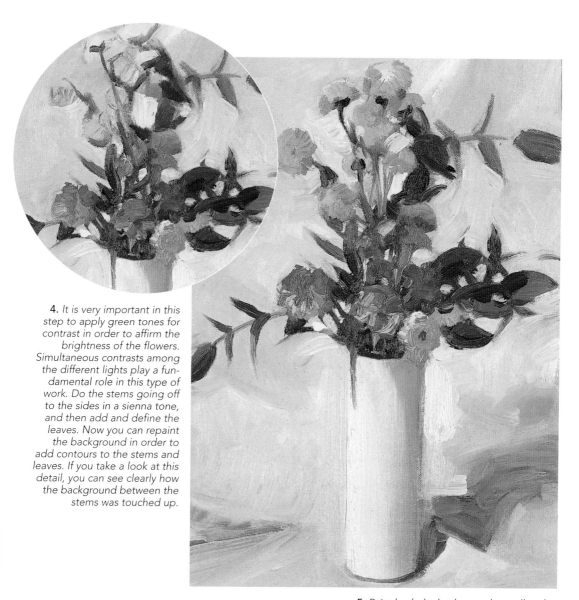

4. *It is very important in this step to apply green tones for contrast in order to affirm the brightness of the flowers. Simultaneous contrasts among the different lights play a fundamental role in this type of work. Do the stems going off to the sides in a sienna tone, and then add and define the leaves. Now you can repaint the background in order to add contours to the stems and leaves. If you take a look at this detail, you can see clearly how the background between the stems was touched up.*

5. *Paint both the background as well as the flowers in a very defined interchange of color. Then you can begin to paint the stems to finish off the bouquet. Paint these remaining details onto the blue background. As the brush moves along, it will mix some of the green with the background, which is an important factor in transmitting the brightness of the atmosphere. You can enhance the flowers with direct and luminous applications of color, keeping in mind, at this stage, the direction from which the light is coming.*

It may seem that the background is of little importance and does not deserve special attention, but this is not quite true. The emphasis, relief, and color of the central motif depends to a large extent on whether the background is done well.

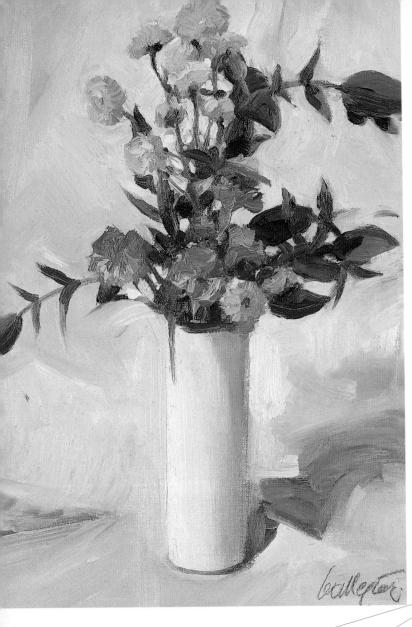

6. *The finish of this still life should be very fresh, thus be careful with your brush work so that the colors do not mix too much. The finishing touches will be the addition of the most powerful and direct highlights. In yellow flowers, cadmium yellow can be used for the strongest and most brilliant colors, and Naples yellow for the highlights. In carnations, the color used for highlights is white, which creates pink tones when it mixes with the carmine of the flower.*

SUMMARY

The background was roughed out first, since the stems and flowers must be painted in over it.

The flowers were roughed out without a very defined form. Yellow flowers should be done in a grayish tone at this stage.

The stems, added at the end, mix in with some of the background color.

The highlights in the flowers should be done at the end, with very direct and contrasting strokes.

15 Depth in the landscape

BUILDING UP A LANDSCAPE

Artists build up a landscape by creating the planes where the elements they want to include are situated. For instance, in this landscape, we could have chosen not to include the water situated between the trees and the spectator, but we have opted for the composition reproduced here in order to lend depth to the subject by means of this extra plane.

> The landscape is the best link there is between the painter and nature. Some of the questions included in this subject might appear complicated if they are not tackled with the right techniques. This topic will expound on some of these problems, such as depth and how to achieve each one of the planes by means of color, brushwork, and roughing out. You will find answers to any questions or doubts by following the exercises carefully.

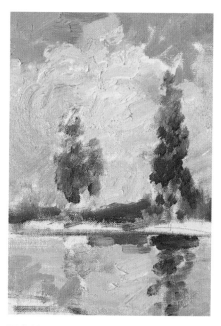
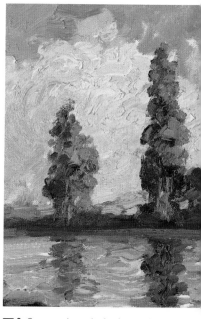

▼ I. The sketch is paramount since it allows you to study the composition and carry out any corrections that may be necessary. Even though it is done with a brush, the sketch for a painting is still considered a drawing. With a brush dipped in turpentine, that is damp but not wet, you can sketch with a texture that facilitates the execution of the basic forms.

▼ 2. Using the outline drawn with a brush and very little color, begin to paint with luminous tones. In this type of work, abundant paint is normally applied to the canvas, so it is necessary to define each area of color well beforehand. The brushstrokes must have a constructive character according to the plane being painted. The colors of the sky are definitive, although the dark color of the trees and that of the reflections on the water are not.

▼ 3. Once you have the brightest colors, apply the dark ones. In this exercise, the short brushwork and impastos should not drag up the underlying colors of the picture. Be careful to use just the right amount of pressure when applying the paint to the canvas. In this manner, paint the trees with many tiny brushstrokes, alternating the light colors in the brightest area with dark tones in the shadow.

PATCHES OF COLOR

The depth of a landscape can be interpreted by means of a series of patches that define each one of the forms and objects. The painting of a landscape using patches is a highly effective way of achieving the various planes required to create depth. The next exercise in this topic is designed to demonstrate how a landscape can be given depth by painting the trees with patches of color.

▼ 1. *Each stroke applied will directly define the plane of the object being painted. Build up the sky with tiny brushstrokes applied in no particular direction, so that an ambiguous texture is created in the background. For the trees, apply the brushstrokes in the direction of the plane; paint the brightest greens first. Paint a dark green tone in the area in shadow, this patch of color is not as constructive as that painted in the brightest area.*

A filbert brush is the best type of brush to use for this exercise. It produces brushstrokes without a pronounced cutoff which facilitates quick blending. The use of a medium-sized one will help you to avoid unnecessary details.

3. *As the painting process comes to a close, the brushstrokes should become more precise in an attempt to lend form to the plane. The foreground is always the most detailed plane, while the receding ones become gradually less defined.* ▲

▼ **2.** *Paint new direct tones in the treetops, without allowing the dark and the light tones to blend together. Each stroke should represent a plane that lends the crowns of the trees shape. Some strokes will superimpose others, permitting the different tones to alternate in the borders between light and shadow. Vary the brush treatment according to the distance of the tree from the spectator. Paint the ground with burnt umber, sienna, carmine, yellow, green, and white; the stroke in this area should be slanted and each application should drag some of the adjacent color with it.*

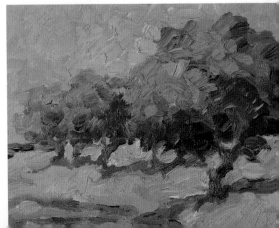

VARIOUS TEXTURES

In this painting, the texture of the brushstroke takes on a prominent role since, as you will see shortly, several simple patches of paint can represent a dense clump of flowers or the crowns of a group of trees seen from a distance. Textures in the foreground must be treated differently than those in the background.

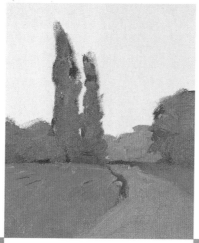

▶ *1. In the preliminary application of colors, the tones that separate planes according to distance provide the greatest contrast. In the first part of the painting, during the roughing out, avoid superfluous work. In the landscape genre, the roughing out of color provides a base on which subsequent brushwork and, toward the end, textures can be applied.*

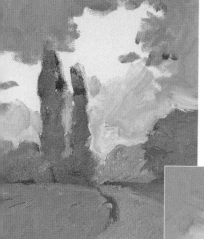

◀

3. The tiny hints of color differentiate the painting's planes and bring out the textures, volume, and brightness. Paint the clouds white and the sky that outlines them light blue. Paint the dark areas of the vegetation directly over the underlying colors.

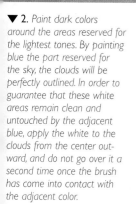

▼ *2. Paint dark colors around the areas reserved for the lightest tones. By painting blue the part reserved for the sky, the clouds will be perfectly outlined. In order to guarantee that these white areas remain clean and untouched by the adjacent blue, apply the white to the clouds from the center outward, and do not go over it a second time once the brush has come into contact with the adjacent color.*

▶ *4. With direct applications of yellow painted over the previously applied green, add the main areas of light. The final details should include tiny dabs of red to define the poppies. The texture in the foreground is more evident and contrasted, while the texture in the more distant planes is far more general in terms of area rather than detail.*

DEPTH AND COLOR

There are so many ways to paint a landscape that it is impossible to mention them all. Landscapes can be executed with all kinds of color patches and strokes, planes painted with direct applications of color, and a wide range of techniques used to convey the sensation of depth. Color can also be employed to heighten the effect of depth. If artists wish to paint a colorful landscape, the receding planes of the land and sky can be defined by color.

▶ 1. *In this landscape at dusk, paint the sky orange, going around the areas reserved for the clouds. Paint the dark areas with patches of violet. The two colors used from the start of the painting are complementary colors, therefore, by including violet, an interplay of contrasts is established, thus making the clouds appear much brighter.*

▶ 2. *Tone down the colors that are too bright according to the effect of distance. Harsh contrasts must be compensated for by adding several grayish tones. Paint the white of the clouds in this way (since clouds are never pure white). In order to avoid a too striking contrast, begin the areas of light in the brightest part and drag some of these tones in with your brush as you move on to the darker colors.*

▶ 3. *Paint the lower part of the landscape with two tones of green. In the foreground, the brushstrokes should be dark and vertical. In the background they should be a yellowish color and long and horizontal. The last application should consist of several small and quick strokes of dabs of red, which contrast with the green fields.*

Step by step
Landscape

The oil medium allows the artist to paint a landscape in numerous ways. The subject that we will demonstrate next requires the painter to develop each one of the different forms of depth contained in the model. If you scrutinize the picture carefully, you will see that there is a stream and a tree in the foreground on the right. The most distant planes possess much less detail and at the same time contain abundant vegetation. This landscape is not difficult to paint, although it is important to build each area correctly.

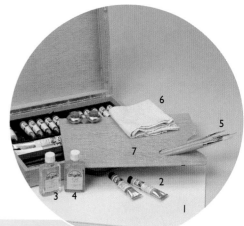

MATERIALS

Canvas-covered cardboard (1), oil paints (2), linseed oil (3), turpentine (4), brushes, (5), palette (6), and a rag (7).

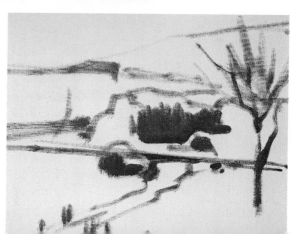

1. *Sketch the planes of the landscape directly using paint thinned with a high amount of turpentine and relatively dry brushstrokes. Represent the main forms of the trees in the background with thick applications of dark color. In earlier topics, the sketch was used to obtain as much of the model's forms as possible. In this exercise, only the main lines of each plane should be painted in.*

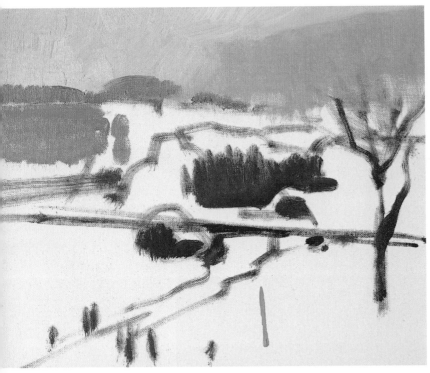

2. *Once the sketch is done, paint the sky with a color containing a greater proportion of white, cerulean blue, and a hint of carmine. To finish the first phase of this painting, apply long brushstrokes that are blended together. It is important to keep the different color treatment for each one of the landscape's planes in mind. The farthermost planes should be painted first with untextured brushwork, then the nearer planes with finer applications of thick paint. The effect of these strokes helps to construct each of the planes in depth. After roughing the sky, paint the violet tones (mixed with white) of the mountains and the first mass of green in the background.*

To paint each one of the planes correctly, the main dark areas must be defined. Corrections on a roughedout canvas can be made with a rag soaked in turpentine or, if there is too much paint, with the help of a palette knife.

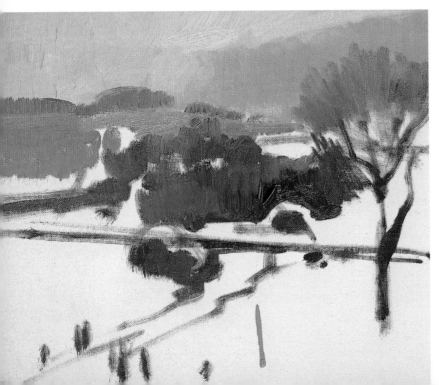

3. *Paint the tones of the nearest planes with a color containing much less white than the farthest ones, and apply it to the canvas in a pure state. This way, the contrast with respect to the planes in the background can be increased. The brushstrokes should be much smaller and thicker for the trees in the center of the landscape. In this area, use light, tiny brushstrokes that do not drag any of the underlying color with them.*

4. *In the middle ground, apply a white tone above the trees in order to outline them. Starting at the top, paint blue vertical dabs over the whitish green of the background, mixing them but without allowing the two colors to mix. In the surrounding area the strokes should be shorter and abrupt; paint a variety of green tones in the middle ground and on left-hand side of the stream.*

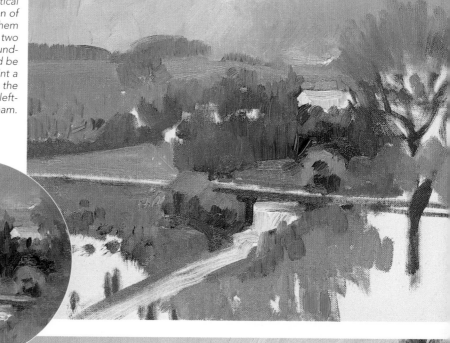

5. *Paint the trees in the middle ground with a great variety of short strokes in tones of violet, blue, and dark carmine.*

6. *Paint the darkest contrasts in the center of the wooded area. The most luminous brushstrokes in this area can be made with very clear tones of violet. Paint the darkest areas with dark green and blue. On the left bank of the stream, use closer together, more contrasted strokes than those on the right. Give the tree in the foreground greater detail. Starting at the crown, use short brushstrokes that drag part of the underlying color with them. Then, paint the trunk with a very dark brown.*

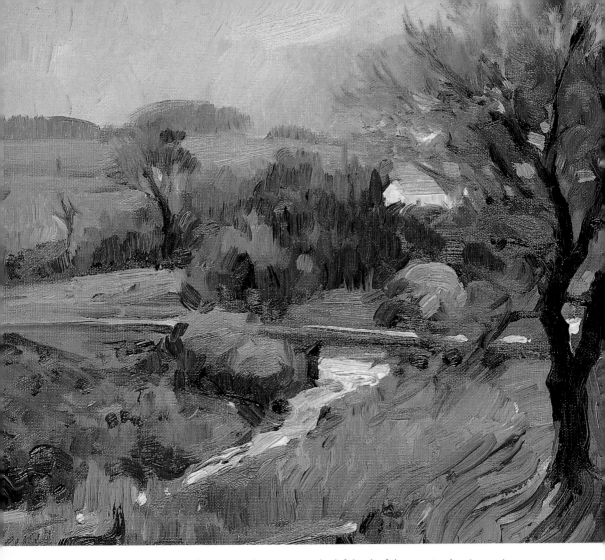

7. All that remains is to gradually increase the contrasts with tiny strokes that heighten the tone, while defining the forms of the landscape's nearest planes. Paint new dark tones on the left bank of the stream, thus increasing the contrast with the brightness of the water. Emphasize the contrasts on the right side in the area nearest to the foreground.

SUMMARY

Long brushstrokes were applied **to the sky.**

The colors of the background contain white to increase the sensation of depth.

The darkest colors in the center of the landscape were painted with tiny vertical strokes.

The treetop of the nearest tree was built up gradually, superimposing short, contrasted strokes over the tones blended with the background.

The brushwork in the foreground should become increasingly smaller and contrasted.

16

The sky

THE STRUCTURE OF CLOUDS

When painting in oils, it is essential to follow certain steps. This is true for any subject, even one as abstract as a cloud. One of the most important steps is the preliminary rough sketch of the shape, which should precede the painting of the subject as such.

The sky is one of the aspects of landscape painting that gives artists more opportunities for expression. Although a landscape may remain virtually unchanged for long periods of time, the sky is constantly changing, and these changes in the sky affect both the color of the landscape and its feeling or atmosphere. The effects produced by the sky have so many possible variations that every time we deal with a given landscape it can produce a different painting. Every cloud we paint will be different; its unique shape will never be repeated.

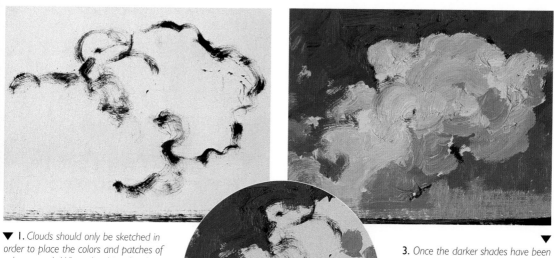

▼ 1. *Clouds should only be sketched in order to place the colors and patches of color correctly. When sketching the shape of a cloud, you must use a heavily diluted brush and very little color. The traces left by the brush will be more than enough to suggest the main shape of the cloud.*

2. *Mix cerulean blue with Prussian blue and white on the palette. Use this mixture to paint the sky around the clouds until their shape stands out against it. The clouds will be outlined by the surrounding sky; the white in the background is the unpainted canvas. Use grayish shades with a touch of blue to paint the clouds, leaving the luminous areas blank.*

3. *Once the darker shades have been filled in, we paint the main white areas. Naples yellow can be used instead of pure white to break up the excessive brightness. Dabs of white are added to the areas painted in blue, mixing the colors with the strokes of the brush.*

▶ 1. *The first layers of paint should be fairly diluted so that it flows across the canvas. This will also act as a foundation for later layers, which will require much thicker paint. First sketch the basic shape of the clouds directly with oil paint. The sketch does not need to be very precise, although it should contain the most important forms so that the colors can be accurately placed.*

THE USE OF WHITE

In this exercise we will study the effects produced by using a base color instead of the white of the canvas. This will help you to understand the treatment of white in the painting of clouds. This is a simple exercise, although it requires knowledge of different color ranges. Before starting, the canvas-covered cardboard should be primed with acrylic. This dries very quickly, so painting can begin almost at once.

▶ 2. *The shape of the clouds is framed by the blue of the sky, which undergoes a gradation towards the horizon. Use a very pure blue to paint the uppermost area of the sky, which will frame the shape of the clouds and blend into white in the lower sections. When using oil paints, colors can be painted one on top of each other, regardless of how bright they are. The lighter colors, such as white or Naples yellow, are easy to apply, so it is essential to clearly establish the limits of each area before starting to paint the highlights of the clouds.*

▶ 3. *Start painting the clouds in their darkest parts. Add the whites and the direct highlights last. It is important to avoid stark contrasts between light and dark areas. Blend them softly at some points, taking care not to create sharp angles. Leave the white for last, painting in the highlights that have been left blank. Finally, fill in the most luminous areas with applications of pure white paint. Pay special attention to the direction of the brushstrokes in each of the areas of the clouds.*

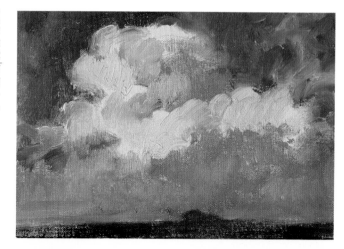

1. *First rough out the sky scene. Afterward paint in the blue tones that define the shape of the clouds by contrast. Your brushwork should be free without blending the different shades of blue. The inside of the clouds should also be painted freely, starting with the grays that enclose the highlights and ending with the whites of the brightest points.*

COLOR IN THE HORIZON

When painting clouds, different areas of the sky must be represented with different shades of color. Depending on the time of day, the weather, and the vantage point, the appearance of the sky can vary considerably. In order to practice this subtle effect, we have suggested painting the sky with a spontaneous finish. On top of the first sketch, we will continue the painting, blending the shades until the brushstrokes are completely eliminated. Note the treatment of the colors in the area of the horizon.

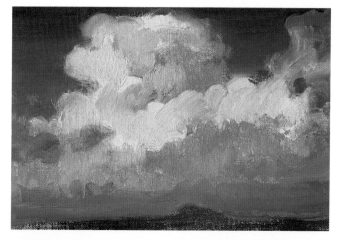

2. *Up to this point, the colors have been painted in a direct spontaneous style, and as a result the differences in color with respect to the horizon are clearly visible. The painting could be left as it is, but this exercise will go one step further, blending the colors until they create a completely different impression. Start by softening the blues with a filbert brush, continuing until the brushstrokes are completely blended.*

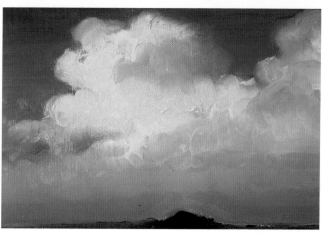

3. *While softening the blue shades of the sky, add new tones to enrich the colors of the painting. Apply tones of violet in the upper regions of the sky and reddish tones near the horizon. The brushstrokes should be fluid and very soft. Brush over the new colors repeatedly until they blend with the underlying colors, taking care not to leave visible brushstrokes on the painting. In this final step, add a few drops of linseed oil to the mix on the palette, as well as another few drops of Dutch varnish, to produce very fluid paint.*

▶ 1. *Impastos of color are extremely simple to paint. When we are not dealing with sharp, direct contrasts, a range of luminous tones can serve as a base. After painting the cloud with the appropriate half tones, surround it with a dense atmosphere of Naples yellow. This method produces an effect of great luminosity. As you can see, the sky does not always have to be painted blue.*

SKETCHES

Sketches permit a quick, spontaneous representation of clouds. An exercise like this one can serve as a basis for other paintings or simply as practice. Colors can be applied in a variety of ways with expressive brushwork or blending. Both of these methods are perfectly applicable to sketching. The atmosphere, combined with impastos, can produce interesting effects. This idea will be developed in the following exercise.

▶ 2. *Once the more luminous tones have been painted, use darker shades to give shape to the clouds. Burnt umber, brown, or any dark tone of blue should be used, rather than black. Paint the necessary gray areas inside the cloud and then add the brightest whites on top of this.*

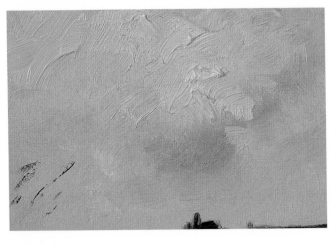

▶ 3. *Finally, blend some areas of the cloud with the yellowish sky, merging these areas into the atmosphere. This produces the effect of a dense, slightly misty atmosphere.*

Step by step
Sky with clouds

As a subject, the sky is simpler than a still life or a portrait and has the additional advantage of allowing artists a great deal of freedom of expression. Painting a sky is a pleasant exercise for an artist, since it offers gratifying results without overly complex procedures. In this exercise we will paint a cloudy sky. Although generally absent from the picture, a thin strip of land is included that ads as a reference point and brings out the immensity of the sky.

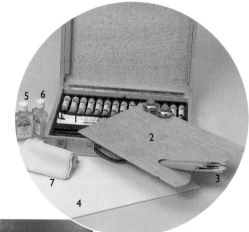

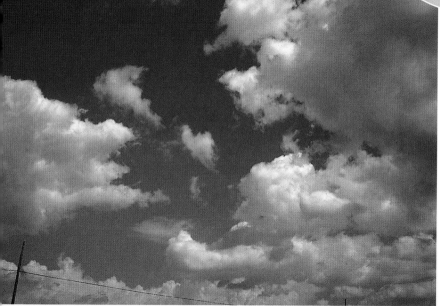

MATERIALS

Oil paints (I), a palette (2), paint-brushes (3), canvas-covered cardboard (4), linseed oil (5), turpentine (6), and a rag (7).

1. *First, sketch out the shape of the clouds. These first lines immediately establish the main forms of the clouds and their distribution in the sky. Use diluted cobalt blue so that the brush slides easily across the canvas. The clouds take up most of the surface of the painting, as the sky is very overcast. In fact, there is only a small amount of blue visible. The sketch should only outline the most important forms without going into any detail.*

STEP BY STEP: Sky with clouds

2. *Once the shape of the clouds has been sketched, fill in the small areas of blue in the sky, using Prussian blue mixed with cerulean blue. As you paint the lower areas of the sky, increase the proportion of cerulean blue, which gives a soft gradation creating the impression of a low sky seen in perspective. The previously sketched clouds should now be perfectly framed against the blue in the background.*

3. *Paint the strip of the horizon with brownish paint mixed with a touch of blue. Once the background has been painted, rough out the clouds that are framed against it. The clouds will be painted with leaden tones. These grayish tones can be obtained by mixing the original color with white. Paint the big cloud on the left with a mixture of Prussian blue and white, increasing the amount of blue in the white and not vice-versa. Use Naples yellow for the brightest part of the cloud. In the lower section of the painting, the areas near the horizon should be painted in very light shades of violet.*

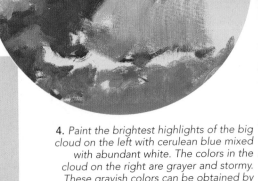

4. *Paint the brightest highlights of the big cloud on the left with cerulean blue mixed with abundant white. The colors in the cloud on the right are grayer and stormy. These grayish colors can be obtained by adding Van Eyck brown to the gray mixture.*

It is a good idea to keep a file of photographs organized by themes. You can use your own photographs or cut them out of magazines.

5. *The tones of gray in the lower area of the picture should become progressively darker. These tones, produced by mixing Van Eyck brown, Prussian blue, and white, should be painted on top of the lighter shades used in the first part of the exercise. Paint in blue areas between the clouds on the left, creating a contrast with the lower area of the cloud.*

When creating different tones of gray, it is always preferable to use brown or umber rather than black. When black is used to darken tones, the resulting ranges of color are poor and rather dirty. Moreover, if yellow is used in the mix, the gray derived from black becomes a dirty greenish color.

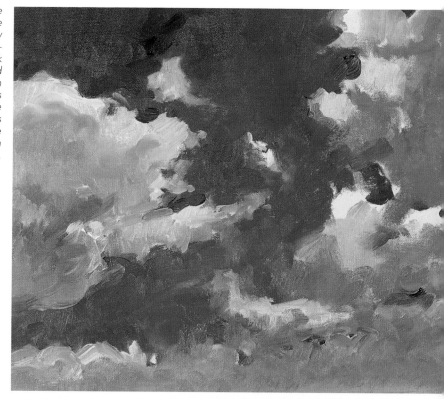

6. *Paint the lighter areas of the clouds with white mixed with the colors on the palette. Mix the white with quite a bit of color, especially in the lower areas near the horizon. In this area, apply short strokes that drag part of the underlying tones with them. Then sketch the profile of the trees on the horizon using dark, thick paint. The nearest trees should be larger and well contrasted, whereas the farthest ones should be smaller and merely suggested with tones that are a little darker than the sky.*

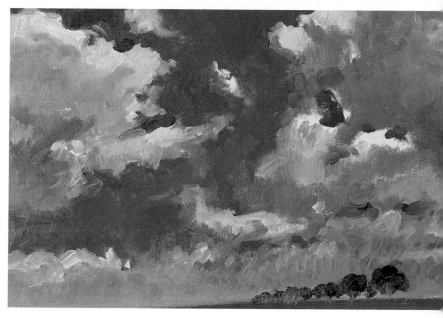

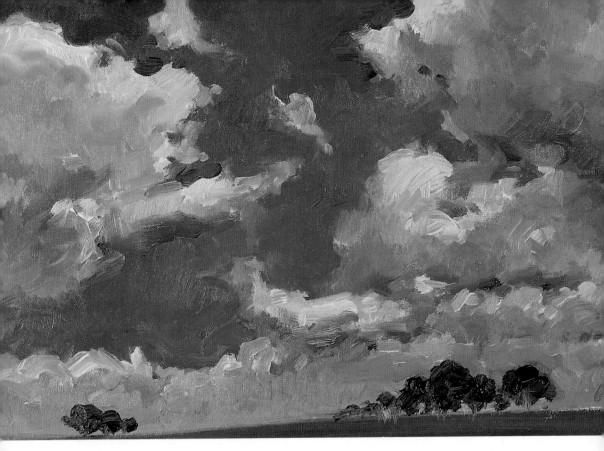

7. *Paint some trees on the left-hand side of the horizon to help define the lower area of the landscape. Paint the brightest highlights of the clouds last with nearly pure shades of white, filling in all of the parts that were left blank. At this stage, the brushwork should be much more precise. This can be seen in the cloud on the right, which requires most of the work.*

SUMMARY

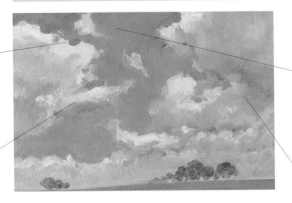

The sketch of the clouds was painted using slightly diluted blue paint. In terms of technique, the initial stage of this subject is no different from any other oil painting.

The lightest shades were painted last. The details should be painted with dabs of pure color.

The blue in the background outlines the shape of the clouds, even though the clouds take up most of the landscape. Tones of gray were used to darken the shaded areas of the clouds. It is important to avoid using black to obtain grays, since this produces excessively dirty tones.

The darkest shades of gray were obtained with Van Eyck brown. These gray tones model the clouds, giving them their final shape.

Trees and plants

SKETCHING A TREE

No matter how simple a tree may appear to be, it is never just a stick with a few branches attached to it. It has a sinuous shape, often with small variations that develop into knots or grains. Apart from this, the initial sketch of a tree should follow the same geometrical patterns as the other subjects we have dealt with in this book. Even a complicated tree can initially be regarded as a series of simple geometrical forms. The following exercise shows how a tree can be developed from simple lines and forms.

> The tree is an element of the landscape that requires a close study of nature. Painting a tree depends essentially on sketching its shape. In this section we will look at the structure of the trunk and branches and also deal with the painting of other kinds of plants. The focus will be mainly on the use of color and the appropriate brushwork for each area. The following exercises will provide a wide variety of methods and techniques that can be used in landscape painting.

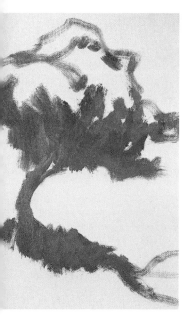

▼ 1. After the preliminary sketch, fill in the dark areas of the crown and the trunk, using dense brushstrokes of a dark color. Paint these areas as definitively as possible, paying special attention to the direction of the brushstrokes, which will give the tree its texture. In the first stages, it is important to avoid varying the tones so that the distinction between light and shadow is clear.

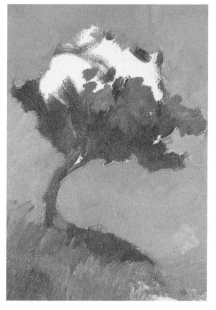

▼ 2. So far, the shaded areas that outline the highlights have been painted. Now fill in the background so that the whole shape of the tree is clearly outlined and the highlights are isolated. By filling in the rest of the painting and leaving the crown blank, the color of the background becomes evident. This color can be obtained by mixing blue, white, and red along with some of the other colors left on the palette.

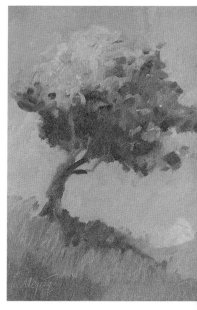

▼ 3. After positioning the highlights and filling in the shaded areas, paint the most luminous areas to bring out their full brightness. This area should have been left blank to prevent the lightest shades from being stained by other colors. It is essential to be especially careful with the texture created by the brushstrokes, which should be short and close together. As you can see, some of the yellow lines should be mixed directly on the canvas.

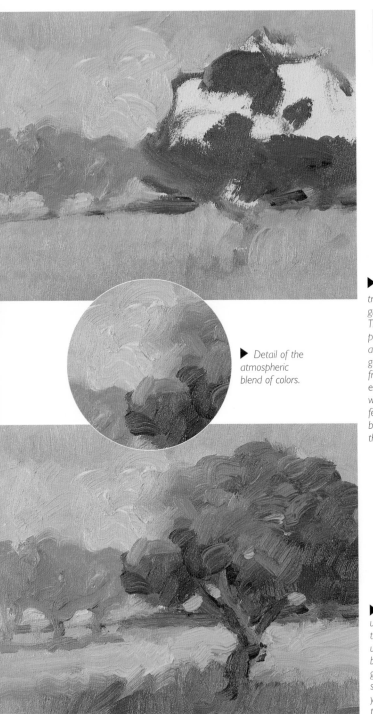

▶ Detail of the atmospheric blend of colors.

THE CROWN OF THE TREES AND THE ATMOSPHERE

The previous exercise involved painting one tree in isolation. The atmosphere allows us to position the trees in the landscape. As we will see, this is not an overly complicated process: it simply involves taking the background color into consideration as a contrast to the color of the tree.

▶ 1. This exercise involves positioning some of the trees in the background and others in the foreground closer to the vantage point of the observer. The trees in the background should be painted with patches of colors that blend in with the color of the atmosphere. In this case, use a very whitish shade of green with some Naples yellow added to keep it from becoming too much like a pastel. As in the first exercise, frame the preliminary sketch of the tree with the background. There should be a marked difference in contrast between the foreground and the background: the former has sharp contrasts, while the latter has almost none.

▶ 2. Paint the tree in the foreground without using white in the mixture, heightening the contrast through the use of dark tones of green, burnt umber, and blue. This will create a sharp difference between the trees in the background and the foreground. The terrain should be dealt with in the same way: the foreground should be full of reds, yellows, and earth colors without any white, while the background should be painted in pastel colors.

BRANCHES

The structure of branches can be very complex if the model is not carefully examined. The first step in any exercise dealing with branches must always be a detailed study of their structure. This structure starts with the foundations, which are the first boughs that branch out from the trunk. This topic includes two exercises which, with sufficient practice, will provide the techniques necessary for the confident and accurate painting of trees.

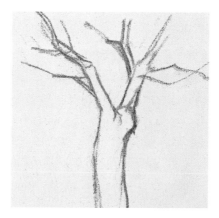

▼ **1.** *One of the most common media to sketch with is charcoal. In this case, two thick boughs branch off from the trunk. Separate lines extending from these represent the smaller branches.*

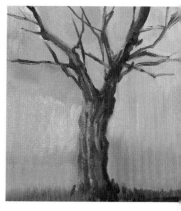

▼ **2.** *A charcoal sketch allows us to paint in colors confidently. Paint the dark areas of the trunk with lines that extend all the way to the smaller branches. Apply the background color on top of the preliminary sketch. Then sketch in the branches once again, this time with the paintbrush.*

1. *This second exercise starts with a sketch drawn diluted with oil paint and a fairly dry brush. After the main lines have been sketched, paint the inside with various intensities of color; some brushstrokes should be completely transparent, and others more opaque. Sketch the branches in with resolute strokes.*

▲

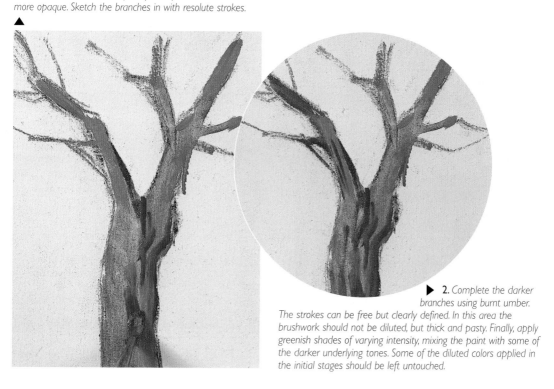

▶ **2.** *Complete the darker branches using burnt umber. The strokes can be free but clearly defined. In this area the brushwork should not be diluted, but thick and pasty. Finally, apply greenish shades of varying intensity, mixing the paint with some of the darker underlying tones. Some of the diluted colors applied in the initial stages should be left untouched.*

GROUPS OF TREES

Having painted the trunk of a tree, we will now move on to an exercise that practices painting a small grove of trees. The subject chosen for this exercise is part of a wood, which is not excessively dense and features a few trees in the foreground. After the exercise in the previous section, this subject should not prove too difficult.

▶ **1.** *As in the previous exercise, the first step is to sketch in the main shapes of the trunks and branches. First, sketch the general forms with charcoal, and then fill in the outlines with a very dark shade of violet painting over the charcoal, but taking care to follow the sketch closely and precisely. This technique is used to sketch in both the trees and the main features of the landscape.*

▶ **2.** *Fill in the entire background with a mixture of golden yellow and Naples yellow, creating the first contrasts in the painting. Paint the vegetation in the background with a very yellowish shade of green, enriching this base with bluish tones. Use the same colors to paint the foreground, adding touches of orange. Apply carmine to the shadow of the tree.*

▶ **3.** *The most illuminated areas of the terrain should be painted in bright orange. This shade will complement the violet tones. Apply dense, reddish brushstrokes to the trunks of the trees.*

Trees in the distance

An atmospheric effect is produced when particles of dust or humidity accumulate in the air under certain lighting conditions. Because of the distance, the density of the atmosphere whitens the colors in the background. This phenomenon provides interesting possibilities for oil painting. The atmospheric effect can be created by progressively adding white to the colors as they reach farther and farther into the distance.

MATERIALS

Oil paints (1), a palette (2), paintbrushes (3), canvas-covered cardboard (4), linseed oil (5), turpentine (6), and a rag (7).

1. *When seen from a distance, trees lack detail. However, it is still important to sketch the shape of the trees with distinct lines that contrast clearly with the rest of the painting.*

2. *The first applications of color should be in the most distant plane: the mountains in the background. Sketch this area with a mix containing a great deal of white with just a drop of cobalt blue and another of violet. Very little color is needed to give it the required tone. It is also essential to paint the lightest tones first. Use a luminous shade of white mixed with Naples yellow to fill in the area of the sky.*

3. *The horizon will require cool tones, with colors that become increasingly pastel-like as they recede into the distance. The colors should blend in with the background both on the horizon and in the grove of trees in the distance. The drag of the brush should create slightly marbled shades at the point where two colors meet. This narrow, blurred area will act as a link between the background and the outlines of the trees.*

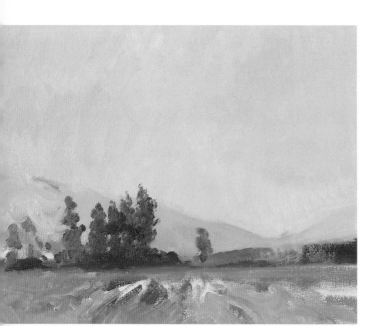

4. *After these steps, the landscape should be completely filled in with color. On top of these pastel shades, begin to paint a series of restrained contrasts that will profile the most important areas of the painting. Paint the trees with small, precise brushstrokes in green, adding white in some areas to suggest the atmosphere. Use a darker tone of green for the closer trees, contrasting them with those in the background.*

5. *The tone of violet in the background should act as a base for painting the trees on the horizon. Even though they are in the distance, these trees should be painted in dark green; this time mixed with white to represent the mist that intervenes between this plane and the closer ones. The brushwork in the lower area should be more detailed and precise, using concise, vertical strokes in dark shades.*

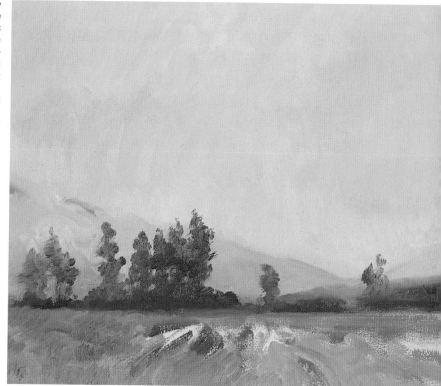

6. *Continue with small, dense brushstrokes in the area of the trees. This will make them stand out against the whiter shades in the background. This step marks the beginning of the work on the meadow. Use purer shades of green for this area that will contrast with the previous tones and suggest the atmosphere. The contrast should be gradual, with whiter shades for the area near the horizon.*

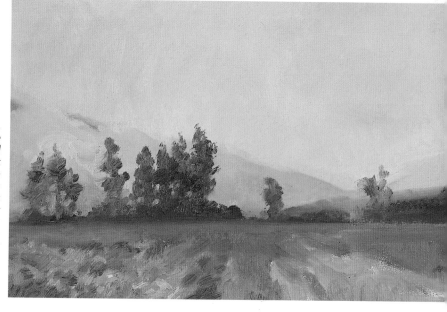

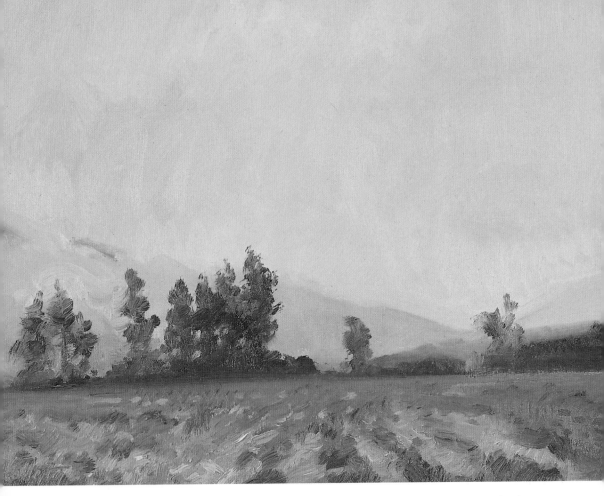

7. The grove of trees can be suggested in the background by using small dabs of color. These shades should be dark and blend with the pastel shades in the background. The depth of the atmospheric effect can be enhanced by adding various contrasts in the foreground. These pure, contrasted colors accentuate the depth of the background, which was painted in pastel shades. The trees should now be perfectly integrated into the background.

SUMMARY

The first colors were light and mixed with white to suggest the atmosphere.

The trees in the distance were painted as flat patches of color, with no individually defined shapes.

The contrasts that make the trees stand out were combined with different shades of green.

The terrain incorporates less white as it nears the vantage point of the observer.

The way they painted:
Claude Monet
(Paris 1840-Giverny 1926)

Water lilies

Monet was one of the most prolific artists of his time. The father of Impressionism, he developed the theories that allowed the movement to break with previous academic tradition. In fact, all of today's pictorial movements stem to some degree from Impressionism or the movements immediately following. Monet's work, like that of many other artists, is particularly useful for studying the different pictorial possibilities permitted by oil paints, since it does not involve complicated procedures.

In his works, Monet invested a great deal of time and interest in the study of light, one of the bastions of Impressionism. For the subject of this painting, Monet had a large basin built with the sole purpose of growing water lilies in it in order to paint them from nature. He created an entire large format series on this subject, which he placed in a circular room to give the spectator the sensation of being enveloped.

MATERIALS

Oil paints (1), palette (2), paintbrushes (3), canvascovered cardboard (4), turpentine (5), and linseed oil (6).

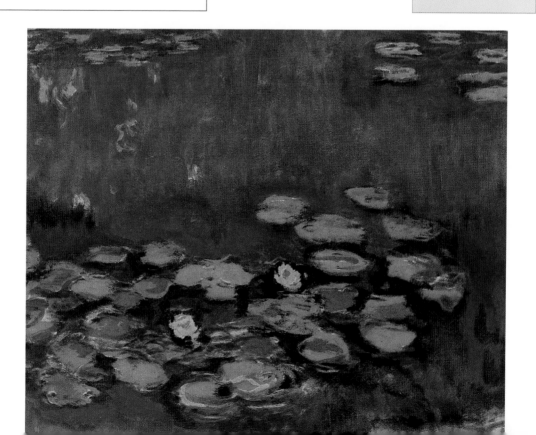

STEP BY STEP: *Water lilies* by Claude Monet

1. Monet's paintings are often very fresh and direct. In this work, we see an immediate impression of the subject, which makes a detailed drawing of the forms unnecessary. The work began with a very general and thinned roughing-out, with which the entire background of still water was done. The oil paint should be thinned with quite a lot of turpentine, but not enough to allow the colors to mix on the canvas. The original was quite large. Here we have reduced the format, but retained the principal techniques, such as the slight blending of the greens and blues in the background. This painting must be done on an upright canvas, so that the force of gravity carries the paint downwards.

2. The colors should be applied in nearly vertical brushstrokes, leaving the areas blank where the water lilies are to be. Strokes of very bright blue can be used to sketch in the shapes of the water lilies while providing dividing lines among them. Just as in any reproduction, it is important to note the main lines of the composition. If you observe the original attentively, you will notice that the water lilies are placed on the canvas in an S-shape.

3. *The initial roughing out should be very diluted. The white background should still show through the first layers of paint. Once you have selected the colors that will cover this background (all of which should be in very cool tones, including the yellows), you can begin to paint with much more concrete strokes that situate the most distant floating lily pads in the upper left-hand corner. In this area, the brushstrokes should not define distinct forms.*

It is important to see the original works in museums or galleries. When you come into direct contact with the work, you can see the different techniques used by the artist much more clearly.

4. *The shapes of the lily pads are defined by color areas that are reflected in the surface of the water. If you look closely at this detail, you will see that each individual brushstroke appears as a simple spot and its effect is meaningless. If, on the other hand, you observe the whole from a distance, you can see the points of light of the different areas of this landscape. This roughing out requires colors that are previously mixed on the palette. The color is not pure green, but approximates a bluish gray.*

509

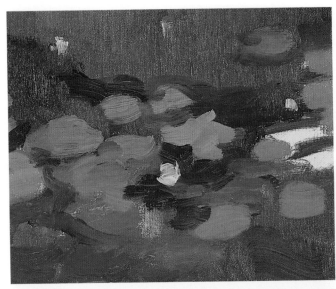

5. *Continue filling in the lily pads and their reflections on the left side of the painting. Mix cobalt blue with some ultramarine to contrast with the blue of the water. As you can see in this image, the water lilies appear much brighter due to the contrast, as the background becomes darker. With very short, precise brushstrokes, but without any definition, paint some flowers on the pond water.*

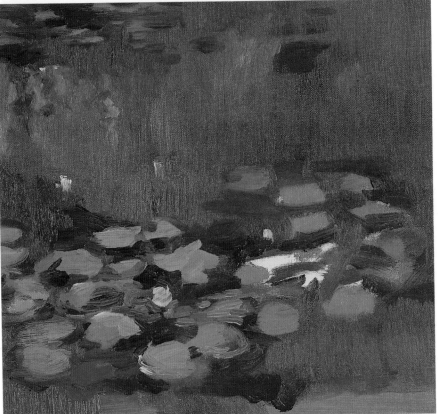

6. *Apply the colors making up the entire lower part of the painting with much more contrast. Your brushstrokes should continue to become thicker as you apply the paint directly, without blending the colors and tones in the layers beneath. Paint the blues around the leaves in the same manner. Also add some touches of yellow to the flower in the middle, using a very faded carmine to emphasize the contrast with the cold tones of the landscape.*

7. Add reflections to the upper area in soft, undulating brushstrokes that descend vertically. It is inevitable that some of the paint from previous layers will mix into these brushstrokes. After painting the central flower in the same way as the first yellow flower, develop the upper area. Here, with a few more patches of color, you can finish covering the entire surface of the water lily pads.

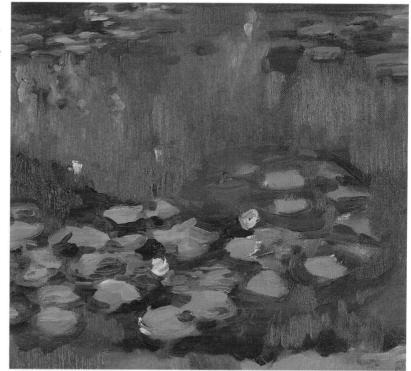

8. In the upper area, you can see how just a few very bright brushstrokes can perfectly define the floating lily pads. This time, the color contrasts well with the blues surrounding it. To heighten the contrast, add a dark blue. In the lower area of the painting, the contrast between the alternating light colors of the leaves and the darker background will complete the whole. Finish off the contours of the leaves in carmine and grayish green tones.

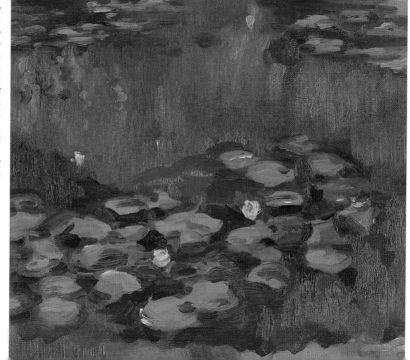

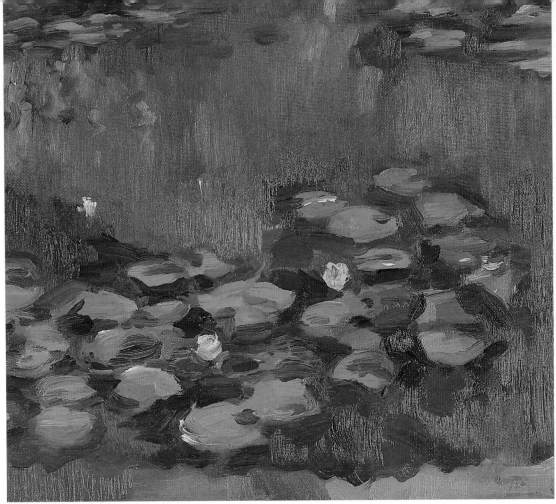

9. *Only the darkest and thickest contrasts have yet to be added to finish this painting. These final tones will help to emphasize some of the areas of medium luminosity. The dark greens applied in this final phase should not clearly define forms either, but will help to contrast the contours of the leaves against the surface*

SUMMARY

The first colors added were thinned with turpentine. Since the paint was very liquid, it ran down the canvas, allowing the background to come through.

Bright blue outlines the shapes of the leaves, as well as establishing their separation.

The leaves were painted in a somewhat grayish tone, making them stand out from the dark colors of the water.

The flowers were painted with direct strokes of yellow.

The way they painted:
Vincent van Gogh
(Groot Zundert 1853-Auvers 1890)

Pink peach tree in bloom

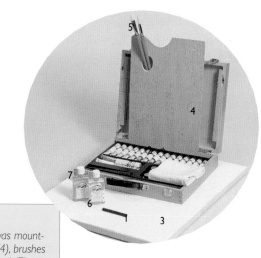

Van Gogh is one of the most controversial painters in history. This artist's work went unnoticed during his lifetime, and mental illness left him on the brink of madness. Despite this, many of today's artistic movements would not exist without Van Gogh. His invaluable contribution to art is the way he used color and the brushstroke, which provided the first step toward Expressionism.

MATERIALS

Charcoal (1), oil paints (2), canvas mounted on a stretcher (3), palette (4), brushes (5), turpentine (6), and linseed oil (7).

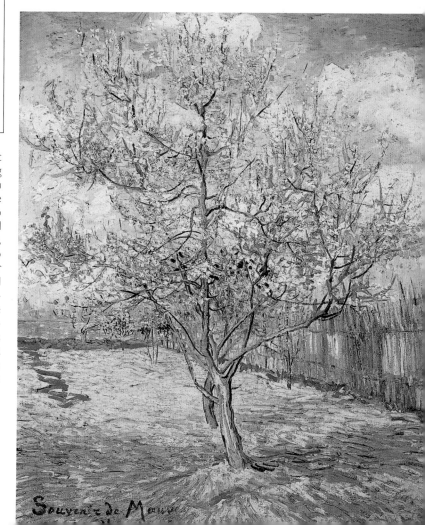

Van Gogh's paintings are energetic and full of feeling. Rather than being a virtuoso of the drawing, Van Gogh's real mastery lies in the impressive force he was able to convey through his use of color and brushwork. Likewise, his motifs, which were always very close to home, reflected his own particular view of reality. His twisted and expressive style is one of the characteristics that best define the artist's work. This is one of the landscapes that the master painted. As you can see in the model, he didn't search for a complex or grandiose motif. A simple garden containing a peach tree was enough.

Souvenir de Mauve

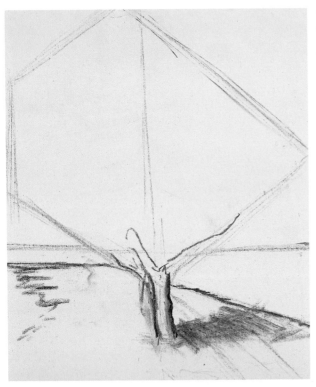

1. *Sometimes an apparently simple sketch requires even greater attention to detail. The composition of this painting can deceive the spectator, since the tree is slightly off center; its mass takes on a somewhat more precise form that could easily go unnoticed if its main lines are not studied with utmost care. A charcoal sketch will help you to understand these forms, as well as the general lines of the fence that encloses the garden.*

The brushstroke played a very crucial role in Van Gogh's painting. When attempting to reproduce this effect, it is important to study how the thick layer of color merges with the others on the canvas.

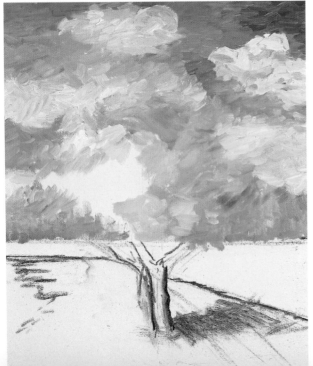

2. *The first step is to paint the sky. In this way, you can rough out the entire area against which the florid branches of the peach tree will be situated. Do not define all of the clouds in the same way. Slightly contrast the uppermost ones against the blue sky, but, as you move towards the lower clouds, add a hint of cerulean blue to your mixture. Pure white is not very useful in this case, as it can clash with the Naples yellow. Van Gogh always began his paintings with a simple structure which he enriched with successive layers of color.*

3. *Once you have roughed out the sky, paint in the ground and the fence. Just as Van Gogh did in the original, elaborate the ground with an interesting rhythm of tones and colors. The background color should be very bright, paint it with a base color of Naples yellow with a touch of yellow ocher and bright green. As you work towards the earth in the foreground, apply more leaden and slightly dark tones, always within the cool range. The colors used in the foreground should be earth tones. Paint this area with long directional strokes that lead toward the main tree. Paint the fence with vertical strokes, except the part in the background, where the brushwork tends to be somewhat more blended.*

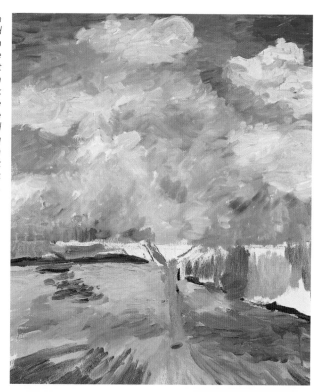

4. *Now that you have roughed out the background completely, it is time to define each one of the areas, studying the brushstroke and color that must be applied within each one of them. Bear in mind that on most occasions, the new brushstrokes will drag up part of the underlying ones. In order to compensate for the tones in the foreground, Van Gogh applied short strokes in a variety of very bright green tones in the middle ground. Apply blue to the shadows cast on the ground, and paint the parts in direct sunlight with ocher tones.*

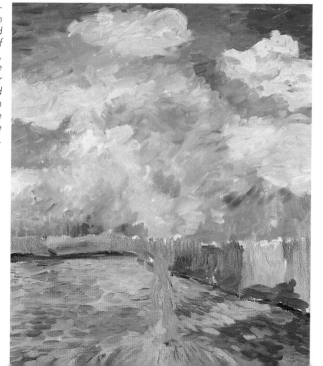

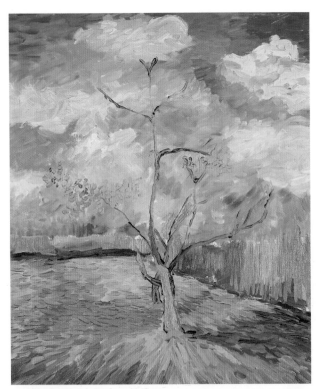

5. With a fine brush, trace over the outline of the main tree, applying various colors; on the one hand, black, and on the other hand a sienna tone that will blend in some parts with the background and with the black of the original drawing. Just as the great painter did himself, apply color to the main branch, from which the others are then extended. Continue to paint the ground with strokes that alternate colors and tones that correspond to the luminosity of each part.

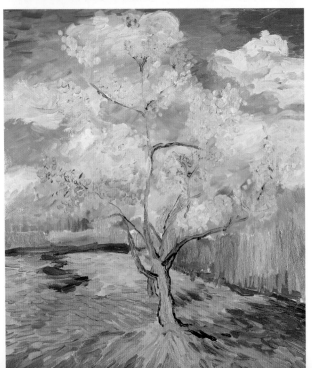

6. Once you have painted the most significant branches move on to the leaves. This stage is especially complex, as there is a risk of applying too much paint to the treetop. Therefore, it is important to paint this picture energetically but with sufficient restraint. The colors used in the pink branches should be a combination of carmine, orange, ocher, Naples yellow, and white. As you can see, several greenish tones were also included.

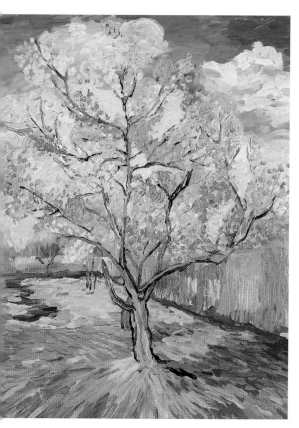

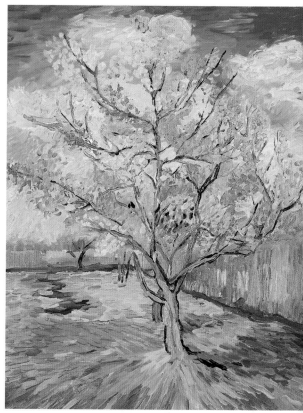

7. *It is essential to continue this detailed brushwork in each of the areas of the treetop. The brushstrokes must be short, but not so short as to be dots. Each one of these areas must be painted with a complete range of tones, applying different shades of color with each stroke. Paint the middle of the treetop with several orange tones, while red toned with Naples yellow should predominate on the right. As you gradually paint the crown of the tree, correct and add in the shape of certain branches, which should be represented as fine strokes interrupted by the pinkish foliage. Paint the trunk with bluish tones and a pumpkin color, without letting them superimpose the black lines that define it.*

8. *Continue with the tiny applications that give form to the crown of the peach tree. In certain areas apply small strokes of black, producing a stark contrast with the rest of the pastel-like tones that surround them. Draw the thinnest branches with your finest brush, without affecting the bright colors of the background.*

In works that contain color impastos, it is necessary to consider the mixture directly on the canvas, as well as on the palette. On occasion, a tone can be corrected by adding direct color.

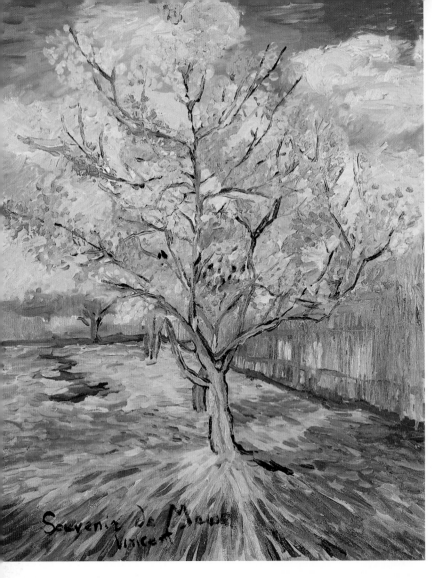

9. *The final and numerous brushstrokes applied to the treetop should gradually become purer in terms of color, you can even add pure tones of red and carmine that will produce a stark contrast with the whitish colors of what is now the background. The color work on the ground is meticulous, and should be painted with a much smaller brush than the one used so far. The work on the fence is also intense. The different degrees of light in each of its areas will help you to finish it.*

SUMMARY

The sky was painted with cerulean blue. The clouds were painted with a diverse range of very whitish tones.

The tone of the ground corresponds to the different qualities of light it reflects.

The outline of the main tree was drawn and outlined with a contour that perfectly defines it.

The leaves were painted with pastel-like tones, mixed to a greater degree with white and Naples yellow.

As the painting advanced, **the strokes and colors of the ground** were applied more precisely.

André Derain
(Chatou 1880-Garches 1954)

The Algerian

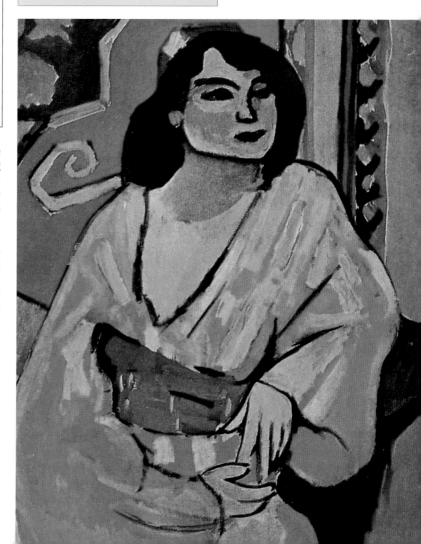

Derain, who inherited the theories that Gauguin unintentionally bequeathed, was one of the painters who lead the post-Impressionist movement known as the Fauves. Fauvism was characterized by the violent use of color, which required absolute knowledge of color theory. Despite the excessive academic zeal that emanates from Derain's work, it is impossible to negate the tremendous force of his paintings.

Fauve painting, as well as that of the Nabis, is characterized by, among other things, the use of complementary colors and the use of lines to define the forms of the objects being painted. The painting shown here is a good example of this pictorial style. It is a complex work that is also fun to paint. The process required is within the grasp of all amateur painters. Nonetheless, as you can see in the original, the result has an outstanding visual impact.

MATERIALS

Charcoal (1), oil paints (2), canvas mounted on a stretcher (3), palette (4), brushes (5), turpentine (6), linseed oil (7), and a rag (8).

STEP BY STEP: *The Algerian* by André Derain

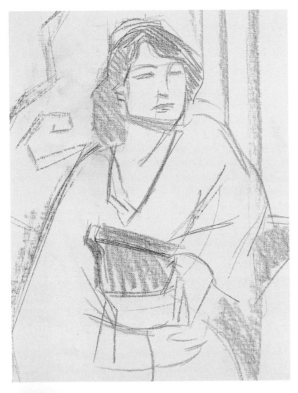

1. *If in other paintings, the sketch is fundamental, in this work it is indispensable, since the colors that will later be applied are completely flat and lack any type of modeling or tonal blending. The outline of the drawing must be exact in order to enable the artist to develop both the color of the line and the blocks of color that fill in each area. On the other hand, when drawing with charcoal, many of the most confusing lines can be erased cleanly with a rag. Derain drew a drawing similar to this one in order to closely study each one of the later painting stages.*

The preliminary drawing or sketch must be executed in a medium that can be easily rectified, such as charcoal or even oil paint itself. One technique that is common among painters is to sketch the model in acrylic, which can be corrected while it is still wet. Furthermore, acrylic dries quickly and is compatible with oil paint.

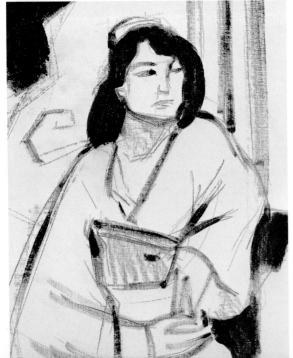

2. *Once you have sketched out the figure, the most important lines of the drawing must be checked. In this exercise, it is very important that the drawing be perfectly defined before paint is applied, because this outline will mediate between each area of the figure and the background. The lines must be painted relatively thick, because they will serve as a boundary that will separate the various areas of color.*

3. *After completing this preliminary drawing with thick lines perfectly marked out, you can begin painting the areas. Derain always started with the complementary colors. He painted the hollow on the right of the door with a very luminous violet; next to that a frame with a pinkish tone; the lower part is painted with an intermediate tone oscillating between the two. The background on the left of the figure should be painted with a reddish color, which later on will be made more intense. Just as in the original, the colors should be flat; that is to say, they should lack gradations or any type of tonal values. Apply a very light pink color to the face and use a dark violet tone for the shadow of the neck.*

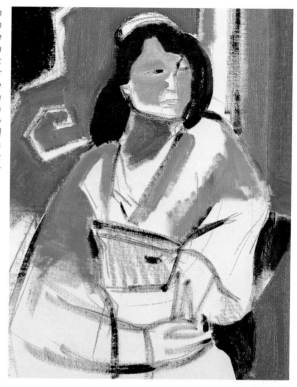

When working with pure colors, it is important to avoid mixing them as much as possible, especially with black. If a color has been dirtied excessively, don't continue; remove it with the palette knife and paint over the area again.

4. *Continue to work on the dress that began with green toned with a touch of white without attempting to express any volume, although other colors should be applied in the area of the sleeve, to increase the chromatic depth of the work. Paint the background definitively with entirely flat tones. The visual effect between cool and warm colors is marked by intense tonal complementary contrasts. Paint the face by area, applying new colors over the previously painted one. Each new area should form a different plane, even though there is no line of division.*

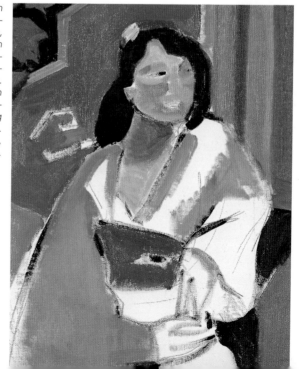

STEP BY STEP: *The Algerian* by André Derain

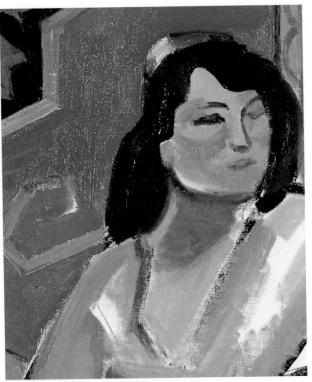

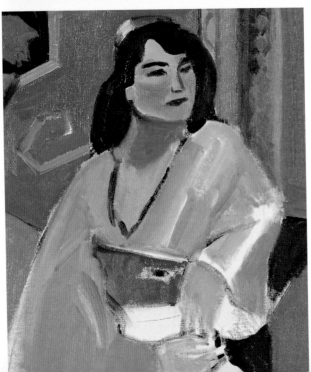

5. *Each area, even those that were left unpainted must be painted with a flat color which will in turn serve as a dividing line. Notice how on the left of the painting, in the background, the strokes of green create dividing lines. The volute that has been left unpainted should now be painted bright green. Paint a reddish stroke in the form of arches over the green door frame. Using a fine brush, begin to paint the face once again; this time the lines must be thin and precise.*

6. *Now the main features of the face have been outlined. With a fine brush dipped in black and violet, paint in the nose. Paint the lips with dark carmine. Use different colors for the dress, taking advantage of this to create new areas of flat color. On the left side apply sky blue tinged with white. In the unpainted areas on the right, apply a flesh tone. Paint the hands with a barely yellowish tone, which will provide a base for the next step.*

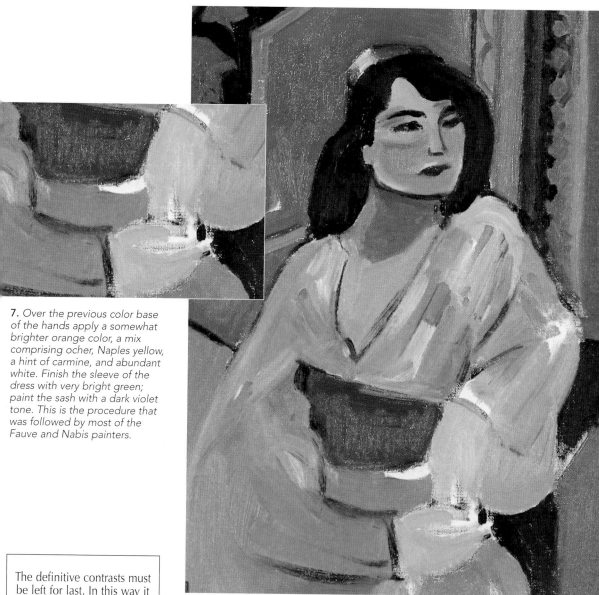

7. Over the previous color base of the hands apply a somewhat brighter orange color, a mix comprising ocher, Naples yellow, a hint of carmine, and abundant white. Finish the sleeve of the dress with very bright green; paint the sash with a dark violet tone. This is the procedure that was followed by most of the Fauve and Nabis painters.

The definitive contrasts must be left for last. In this way it is possible to add hues that enrich the overall color of the work, yet are not too conclusive. The outline of the forms must be precise and clearly indicate the different planes.

8. With a fine stroke, finish the woman's profile, which should now be perfectly defined and separated from the colors of the neck. Apply a brushstroke to the cheek to highlight and separate the areas of light around the eye. Paint the white of the eye with the same bright green used to darken the eyebrows and the eyelids. With burnt umber draw and outline the decoration on the frame on the right.

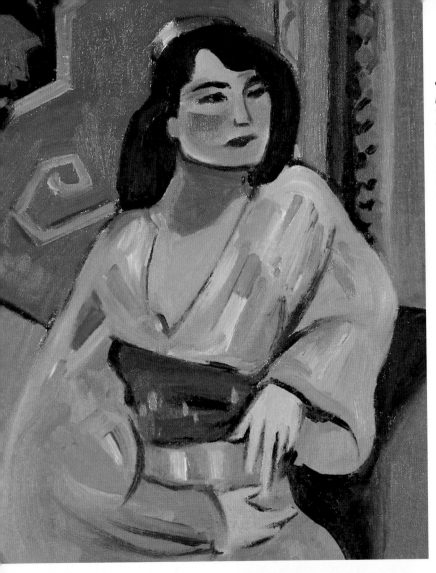

9. *Once the canvas is completely filled with the flat colors that have been used so far, all that remains is to fill in those areas that are still blank and go over the most important lines. With that, the interpretation of this painting by Derain is concluded.*

When painting the final strokes, artists must consider the colors of the picture; that is, if they want to reduce the brightness of certain areas, the outline of the last brushstrokes must allow the underlying colors to remain visible.

SUMMARY

The preliminary drawing was executed in charcoal, so that any incorrect lines can be rectified easily.

The intense red **in the background** produces a sharp contrast with the bright tones of green, as well as the violet tones. This is one of the characteristics of this style of painting.

Each one of the colors painted **on the face** is a plane: the sketched lines allow new features to be defined.

All the areas were outlined at the end with the same color they were painted with or with a black stroke.

The color treatment of the hands was achieved after the roughing out.

The way they painted:

Paul Cézanne

(Aix-en-Provence 1839-Aix-en-Provence 1906)

Still life

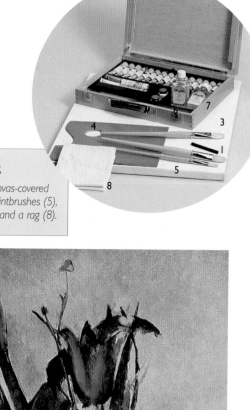

MATERIALS

Charcoal (1), oil paints (2), canvas-covered cardboard (3), palette (4), paintbrushes (5), turpentine (6), linseed oil (7), and a rag (8).

Cézanne was, along with Gauguin and Van Gogh, one of the principal precursors of the post-Impressionism movement. Admired by his contemporaries to the point of being called the genius, Cézanne is key to contemporary painting. His contributions to technique and theory gave way to the logic with which Picasso developed Cubism.

Cézanne's works strive towards the synthesis of planes, i.e. showing all the possible views of an object in one painting. In this still life, the theories of this ingenious painter were not yet fully developed, although we can already appreciate a few details that approximate such notions. Observe the plane of the table with respect to the rest of the objects in the still life, as well as the way in which the short brushstrokes construct forms through small planes.

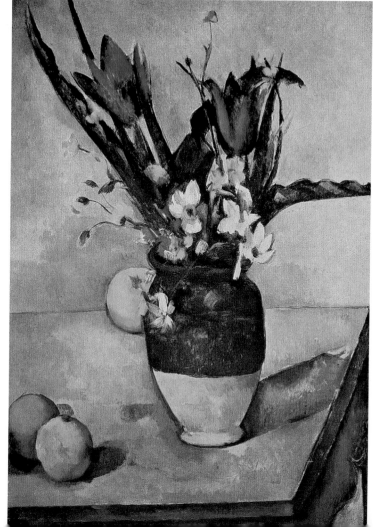

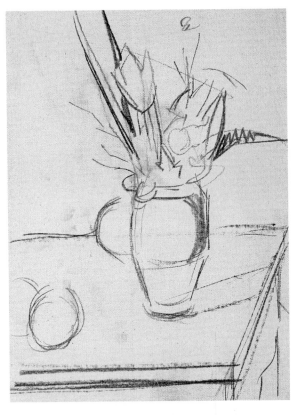

1. *Cézanne always placed a special emphasis on the study of composition in all of his paintings. Nonetheless, Cézanne's compositional technique was based on a progressive construction of forms. Cézanne probably didn't sketch the still life before painting it, but it will be easier to interpret his work if you block in its essential lines in charcoal. Make straight lines with the flat side of the charcoal, holding the stick lengthwise. In any case, do not aim for a finished sketch, but simply an idea of the principal planes through the lines that define them.*

If you want to preserve the initial blocking in as the basic structure of the painting, you can spray it with fixative. Although you paint over it or touch it up, the sketch will remain unchanged.

2. *Add the first color to the background, applying it very thinly, so that the lines of the blocking in beneath show through. The color should be applied irregularly, and not necessarily pure. Blue should be mixed with white and some touches of ocher. In this detail, you can see how the brushstroke penetrates into the sketched forms. Subsequently, more diluted layers will be able to cover these first transparent background layers perfectly.*

3. Finish the background in different intensities of blue and a great variety of brushstrokes in different directions forming different planes. The color should be mixed on the palette as well as on the canvas itself, allowing the paintbrush to drag up some of the paint from the underlying layers. As Cézanne did, paint the vase in a great variety of planes, without modeling shapes. In this example, you can see how the wide brushstrokes do not blend with one another, but overlap. To prevent the colors from blending completely, it is important to avoid going over each brushstroke excessively.

> The entire work should be roughed out as a whole, so that all of the areas will be finished at the same time and it will be easier to correct any mistakes.

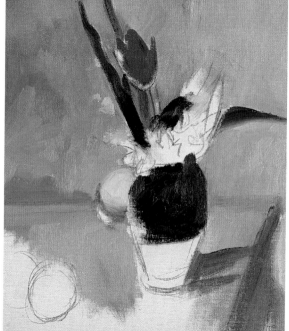

4. Rough out the painting until the form of the vase is completed. The direction of the brushstroke should provide the shape. The flower should be done in long, single brushstrokes with direct applications of color. As you can see, the color was applied flat, although the direction of the brushstroke lends texture and form to the petals. Paint the yellow flowers in direct strokes without defined contours. Paint the fruit in the background directly in yellow, and apply its shadow in a direct stroke of red. Fill in the table with tones of sienna, umber, and white. On the side in shadow, the color should be close to violet, very toned down with white to add a grayish tone.

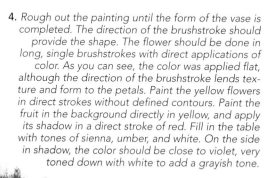

5. In this detail, you can see the technique Cézanne used to construct the different planes of the table with brushstrokes. Some strokes are slightly bluish, some blue mixed with white, others reddish and orange. The different brushstrokes combine to form criss-crossing planes which let the background colors show through. Quickly rough out the orange on the left with slightly grayish colors that have been mixed with white. The presence of white in the color mixtures produces impure colors.

6. Apply new tones over the previous ones of the table, including carmine and various blue hues. When mixed on the palette with white, slightly violet pink tones can be produced. The shadow cast on the table can be reproduced with a carmine toned down with some white and umber. Finish off the shape of the vase with some strokes of whitish paint along the base. Naples yellow, sienna, and white can be used to make the mix for this part. The upper part of the vase should include some small areas of ocher. Paint the right flower in very light tones, which will contrast with later additions of pure colors.

7. *Apply large areas of dark colors to the right side of the vase. Black, however, should not be used at all in this exercise. The dark tones are highlighted instead by the effects of simultaneous contrasts. Cézanne respected the theories of Impressionism, which rejected the use of black in the study of light. Given that very bright colors are used in the rest of the painting, you can simply use a darker tone in this area to intensify the extremes: the lighter areas will appear even more luminous and the darker tones will appear more dense. Use dark brushstrokes to finish shaping the leaves. In the lighter area of the vase, shadows can also be suggested with loose brushstrokes which do not blend into the background colors.*

One of Cézanne's theories was that all objects can be reduced to simple geometrical shapes. Each plane of an object can correspond to a color independent from the rest of the planes.

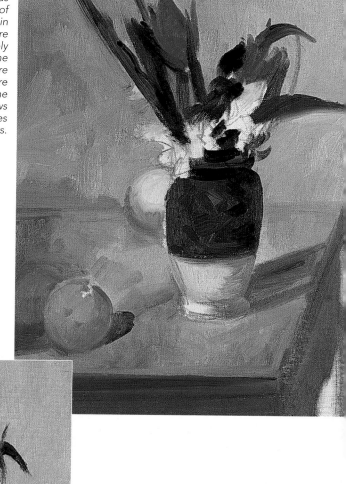

8. *The entire flower work should be done in pure colors and flat brushstrokes. The differences between each of the areas can be established through the application of completely different and very direct tones that are not blended together. Paint the smallest flowers in very direct, specific brushstrokes with no attempt at detailed contours.*

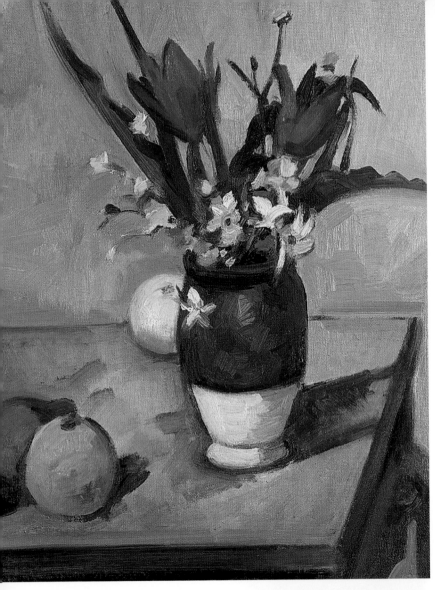

9. *To finish off the painting, the forms of each plane must be given more definition. Finish the contour of the vase by darkening the blue tones around it on the table. Lighten the fruit in the background with white to obtain tonalities closer to the original. Define the orange tones in the right by notably darkening the surrounding area with bluish tones. Give the different planes of the table the finishing touch by repeatedly darkening the dark areas.*

If necessary, allow the painting to dry overnight between each session to avoid undesired impastos. This allows for a much cleaner finish.

SUMMARY

The original sketch was based on simple geometrical elements which allow you to approximate the forms to those in the original and study the composition in depth.

The background was painted in blues toned down with abundant white. The brushstrokes are direct and the tones do not blend, but rather form independent planes.

The progression of colors in the flowers began with a flat tone applied in different areas.

The small flowers were painted in very direct touches of yellow and white.

In the vase, each change in tone was carried out directly, blending together without the colors.

Author: Francisco Asensio Cerver

Pastels
for Beginners

Illustrations: Vincenç Badalona Ballestar
Photographs: Enric Berenguer

Materials

A BRIEF HISTORY OF PASTELS

Pastel is a painting and drawing medium that goes back to the eighteenth century, although many earlier painters had already used similar methods for drawing. The widespread acceptance of this medium by painters meant that soon a great number of artists began to use it, and it caught on to such an extent that it competed with oil painting. Great artists who adopted it as their medium include Rosalba Carriera, Degas, Manet, Odilon Redon, Picasso and many others.

Pastel can be used in diverse ways. Depending on the artist's intention, it can be used with techniques totally related to drawing or alternatively using a pictorial method. In these first pages we are going to show a complete product range: some of which are absolutely necessary to put the technique into practice. Others are accessories which put the final touches to the application of the technique. Of course, it is not necessary for the beginner to buy all the materials that are listed. It is important to know of their existence and to be able to decide which ones must be used on specific occasions, and what tools and presentation are the most suitable as the work progresses.

The first point to bear in mind is that pastel is a pictorial medium which can be treated like any other normal drawing procedure. In fact, in the first exercises we are going to use a style similar to drawing to explore the possibilities that pastel offers to this technique. You can start to draw with one or two pastel sticks and a sketch pad, which can be acquired along with the paper in any art supplies shop.

▲

▼

The beginner will soon realize that pastel is a highly unstable medium. The procedure allows the stroke to be rubbed out or blurred on the paper with the fingers. The colors, too, can be dirtied just as easily: this means that it is necessary to use a cloth. Have one handy from the start so that you can wipe your fingers.

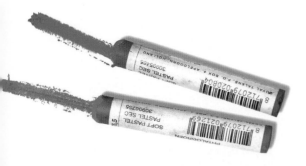

PASTEL

Pastels come in a stick form composed of color pigment, and plaster or white ground chalk, all stuck together with arabic gum, also called binder. When the mixture of the three products has been made, it is moulded and allowed to dry. This means that its composition is one of the most straightforward of all the pictorial media, but despite this, it has many different qualities that offer a host of effects.

▶ *When you are starting out with pastel technique, it is essential to use high quality material. Good pastels are brightly colored, shiny and break easily.*

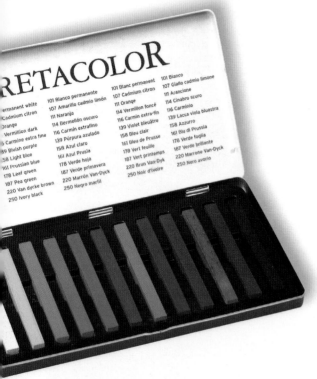

▶ *Different pastels have different qualities: oil pastels are denser and more waxy than normal pastels. They can be used for all the standard pastel applications. However, the stumping effect they give is not so uniform as they are manufactured with oil instead of gum, facilitating their mixture with oil paints. Several varied effects can be created when the stroke is diluted with turpentine.*

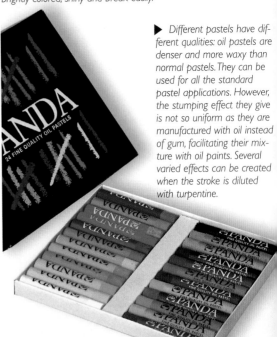

▼ *Colored chalks are in fact hard pastels, but they come in a more limited range. The advantage of hard pastels is that they produce a more defined line, which is good for outlines and small details. However, they restrict the stumping effects that you can achieve. Artists use soft pastels when they need versatility.*

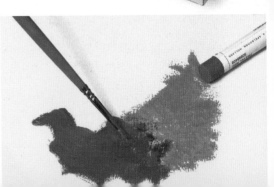

This is how pastels are mixed with linseed oil or oil paints. ◀

COLOR RANGES

As said before, pastels contain a neutral component that gives the bar a certain hardness. This element is white chalk which comes from Spain. Although it is a completely white element, it does not have the properties of a pigment. This means it does not paint, although, as will be seen throughout the chapters of this book, the luminous qualities of the pastel can be spoiled if you try to mix the colors on the paper.

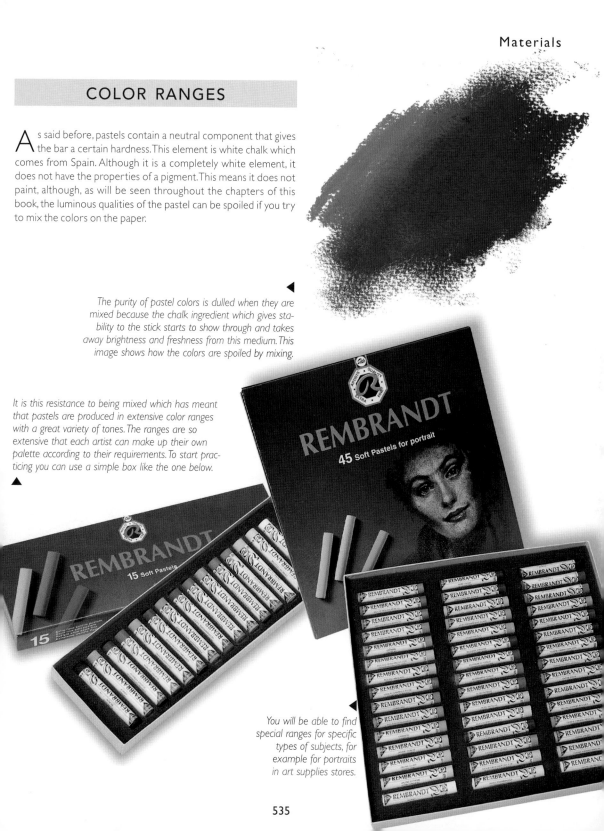

The purity of pastel colors is dulled when they are mixed because the chalk ingredient which gives stability to the stick starts to show through and takes away brightness and freshness from this medium. This image shows how the colors are spoiled by mixing.

It is this resistance to being mixed which has meant that pastels are produced in extensive color ranges with a great variety of tones. The ranges are so extensive that each artist can make up their own palette according to their requirements. To start practicing you can use a simple box like the one below.

You will be able to find special ranges for specific types of subjects, for example for portraits in art supplies stores.

535

OTHER RETAIL FORMATS

Pastels can come in many forms. Some artists opt for a personal selection of the colors, which explains why there is such a wide range in fine art shops. Other artists are perfectly happy with the retail ranges.

Not all of the pastel types are sold in wide ranges or with different packaging. Some high quality pastels are only available in a limited number of tints. It is worth remembering that you can also buy pastel pencils. Their characteristics are the same as sticks but they can be used like a normal pencil.

▼ **Thick pastels.** *This form is not the most common. The diameter of these pastels is larger than usual. They are normally made of high quality materials and in very small ranges. Their price is in line with their mass: that is to say expensive. These crayons are used by professionals who prefer large-scale formats and gestural pieces.*

Special colors. Today pastels are manufactured in all colors, even in flourescent, gold and silver. These pastels, unlike the other pictorial media, give freshness and great luminosity to the colors used.

▶ **Pastel pencils.** *These come in pencil cases, or loose, in ranges as wide as the normal pastel ranges. It is true that normal pastels are fragile but the pencils are even more so: any little knock can fracture the lead. That is why it is important that the pencils are made of good quality both in the lead and the surrounding wood. Cheap wood means that the lead will break easily when you sharpen the pencil.*

CLEANING

When a beginner starts to paint he or she will immediately realize that pastels break quite often. The sticks that they have just taken out of the perfectly ordered box soon become an endless collection of little stubs that quickly get dirty as they rub against each other. In the pastel technique, keeping your hands and the pastels clean is fundamental.

Pastels are very pure colors. Therefore, any contact with other pastels dirties them easily. Before starting work they must be cleaned so that they do not spoil the other colors on the paper. One way of cleaning them if there are only a few pastels is by carrying them inside a case with rice grains. The movement rubs the rice against the pastels and keeps them clean.

▶ *A box like this one is a handy way of storing pastels that have been bought loose. The case should have little compartments to enable you to separate the color ranges, and to prevent them from bouncing around and rubbing against each other.*

The corrugated sponge lining inside the box is one of the best forms of protection. This is why, even if the sticks have been broken and are loose, they will always be better off cushioned than beging loose in the box. It is one way of having the sticks on display with no risk of them dirtying each other.

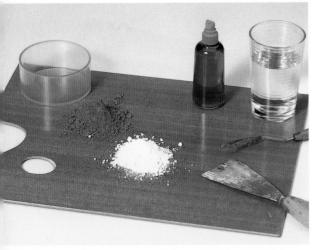

MAKING A PASTEL

▶ 1. *The following materials and ingredients are needed to make a pastel stick: a spatula to mix the paste, another spatula to stir the color in the container, a container in which the proportions can be mixed, the pigment for the color, precipitated chalk, gum arabic (also called tragacanth), and a smooth surface that may be made of marble or crystal, or a large painter's palette.*

This point is interesting because it helps us to understand what advantages we have when using a pastel stick. Whatever the painting method is, it is important that the painter at least knows how the paint is made; of course this does not mean making your paints, unless you wish. In general mixing paints is not difficult, but it is laborious. Unless one has some experience in doing it, the results often do not turn out according to plan.

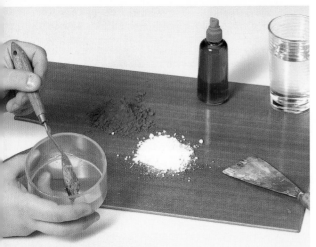

▶ 2. *In a container, make the medium that is going to be used to bind the pigment: it is composed of water and gum arabic. The right proportion is a few drops of gum arabic for every tablespoon of water. Not all the colors require the same proportions. You have to stir it sufficiently, so that the gum and the water form a homogeneous mix.*

If you have leftover stubs, which are too small to use, you can put them through the same process. They have to be pulverized in a mortar, but do not add dampened chalk. Mix the resulting powder with a tablespoon of water and add two drops of gum arabic.

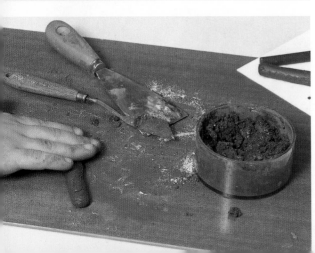

▶ 3. *Now mix the dampened chalk with the solution that you have just made. If the paste is somewhat dry, add a little water until it is softened. The color pigment is now kneaded in. If the chalk is too damp, the pastel stick will be brittle. Once the form of the stick has been moulded, place it on some paper and allow it to dry out for a few days. The stick will then be ready for use.*

SUPPORTS FOR PAINTING WITH PASTELS

In general, pastels are painted on paper. However, this is more a custom than a technical imposition as any material can be painted with this medium. Although the majority of exercises suggested in this book are designed for paper, it is worth considering other supports which can giving attractive results and offer the same reliability as traditional supports.

Painting on cardboard. Cardboard is cheap, if you have to pay for it at all, like when it is old packaging boxes. All beginners will have at sometime thrown away old wavy or eggcarton style cardboard with its very porous and absorbent surface which means that pastel adapts to it perfectly. Moreover, the thickness and color of some cardboards make them especially attractive for luminous pastel colors that stand out due to their purity.

▼ *Painting on top of wood and stiff cardboard.*
Wood is an ideal surface to paint on. The advantage of this type of support is its rigidity and its special texture. Stiff cardboard is another support well suited for pastel painting. It can be bought in fine arts shops, where it is also known as pastel-card. There is a great range of sizes available.

▼ *Primed canvases. Fine arts shops offer a great variety of canvases primed for painting. They are sold by the centimeter and come mounted on a stretcher. To paint with pastels, it is better to buy the cloth loose and to use it as if it were paper. To paint on top of fabric or paper, you need to have a board, drawing pins, and pegs or sticky tape.*

THE SUPPORT: PAPER

Pastel is an opaque and dry medium, the properties of which allow it to be painted on a wide range of supports, but without doubt, it is paper which brings out the best in it. Any type of paper can be used with pastel, although those specially designed for pastels enhance the beauty of the colors, offering the artist the surface needed for a particular style.

▼ **Colored papers.** *These are the most commonly used papers for pastels. The most renowned manufacturers have a wide variety of papers, in all colors and tones. To start with, buy some earth or tobacco colored papers before moving onto bolder, more daring ones. As will be shown later, the color of the paper plays a key role in the way the picture develops since it forms part of the color range used.*

▼
Watercolor paper. Watercolor paper, available in many different varieties, is also suitable for pastel painting because it is absorbent. Medium-to-heavy grained papers give the best results.

▼ **A pad of drawing paper.** *A useful material to do color tests and sketches.*

◄
Handmade paper. Its texture is irregular so any work done on it will incorporate its unique surface characteristics. In theory, they are not the most suitable papers for a beginner, although it is not a bad idea to try them out from time to time. In this picture you can see unusual and irregular paper shapes.

THE GRAIN OF THE PAPER

As painting in pastel is so direct, the characteristics of the support are fundamental to the way the painting develops, and, of course, to the end result. Paper is not only classified according to its color but also according to its texture, which is determined by the way the paper is treated when it is still in the form of soft paste in the manufacturing process. If paper is pressed on a very marked sieve, this will be noticeable in its texture.

Besides handmade paper it is also possible to buy coar grained paper, which are more economical than the former. However, the stroke effects will not be as marked, as we will see in the corresponding section, but rather highly expressive effects can be achieved.
▲

▼ *The grain of handmade paper comes into its own if it is utilized correctly. Pastel can be applied almost like a paste and an extensive range of effects in which the paper grain plays a role are possible.*

▼ *In general, commercially manufactured paper for art work has two different textures, one on each side. The smoothest texture allows the pastel stroke to mark the style. On this side of the paper it is possible to draw perfectly without the paper grain pattern standing out (above, on the left). If you turn the paper over you will observe that the texture changes significantly: the paper acquires a uniform roughness through which the grain of the paper can be seen (on the right). This surface is better for pastel painting because not only does the pastel stick respond to the paper but also the texture contributes to the stroke and shading effects.*

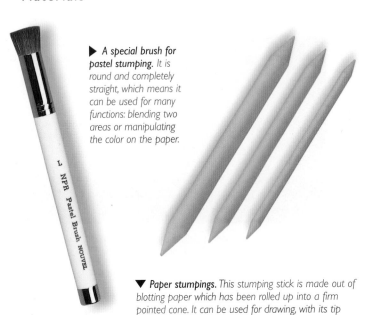

▶ *A special brush for pastel stumping. It is round and completely straight, which means it can be used for many functions: blending two areas or manipulating the color on the paper.*

DIFFUSING

Pastels are not sticky: they do not cling to the paper. Once they are applied they are completely fragile if anything rubs against them. This characteristic has the advantage that the colors can be blended on the paper, which means that it is possible start out with a stroke or shading and then go on to create a uniform surface on which the mark of the stick or the paper grain texture is not visible. There are many ways of blending colors, your fingers being the principal tools, although there are other methods of doing stumping or blending the color.

▼ *Paper stumpings. This stumping stick is made out of blotting paper which has been rolled up into a firm pointed cone. It can be used for drawing, with its tip impregnated with pastel powder, blending strokes and erasing pastel only loosely stuck to the paper.*

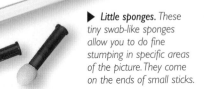

▶ *Little sponges. These tiny swab-like sponges allow you to do fine stumping in specific areas of the picture. They come on the ends of small sticks.*

▶ *Fan-shaped* ◀ *brushes make it easier to clean areas that have been stained by powder falling off the brush when the stroke was made. They, too, can stump or blend colors.*

◀ *When you need pastel powder to do a stumping on the paper, without using the stick, use sandpaper to rub the pastel. Specially prepared tools are available, too. Sandpaper is also used to sharpen edges or crayon tips.*

FIXATIVE

As pastel is a dry medium which gives very pure colors, it is very unstable when touched. Therefore, the painting process is very delicate. As a general rule, it is advisable not to use fixatives on pastel paintings, although there are spray fixatives that, when used correctly, allow the painting to be conserved, at least in the first stages of the picture, so that you can make corrections without fear of losing what you have done. One must remember that a fixative has serious disadvantages when it is applied to pastels. Therefore use it carefully.

There are a great variety of products that enable you to fix pastel. Only some of them are shown here. The principal painting brands offer high quality products. When you are buying these aerosols remember to avoid products harmful to the environment and the atmosphere. Normally the chemical specifications are written on the label.

Observe the differences between the end result with fixative and without. In the first case the freshness and spontaneity of the stroke can be appreciated. On the side where fixative has been applied the paint has become stodgy and impasted. This is a clear example of how fixative is not to be used.

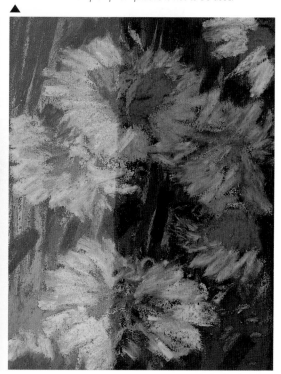

Fixative must never be applied to the finished painting because it would darken the colors, ruin the freshness of the pastel and make it stodgy. However, it can be applied at any moment during the painting process, provided that the stage in question has been finished. For example, the layout can be fixed when it has been perfectly defined. Once the fixative has been applied any alteration produced by the colors, or rubbing them out, will not effect the fixed layer. The spray fixative must be applied from about 30 c.m. away. A soft covering is sufficient to make the color stable on the paper.

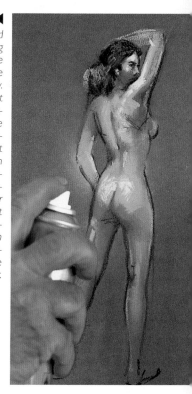

FRAMING AND STORING THE WORK

As we have seen in the previous sections, pastel is a fascinating painting medium, opening up as many possibilities as any other method. Although a pastel painting stands out for being especially fragile, it can last if it is framed and stored correctly. If due care is not taken, it is possible that the work will deteriorate quickly.

▼ When you finish a pastel painting it will be fresh, which means that any contact with the surface of the paper will leave marks. This is not to say that a pastel cannot stand the test of time. In fact, pastel is one of the longest lasting painting media provided that it is kept in the correct conditions. To store a pastel painting temporarily, place it in a file between two sheets of onionskin paper, or at least clean paper that will protect the surface of the painting. When stored, pastels should not be subjected to jerky movements which could cause the surface to be rubbed. If they are going to be packed away for a long period, put a little bag of drying agent so as to avoid mildew.

In these diagrams you can see how a pastel painting must be framed. The paper must never touch the crystal or glass surface. A special cardboard, called a passe-partout, is placed between the crystal and the pastel, enabling the picture to be framed perfectly. Art shops sell a great range of sizes and colors of passe-partout. They can be adapted to many formats. However, if you needed a special shape a picture frame shop will build one made-to-measure. The pastel must be mounted on a support to avoid it moving within the frame. A ph neutral adhesive is advisable so as not to harm the paper. Frame (1), crystal (2), passe-partout (3), air chamber (4), pastel (5), and plywood background (6).

▶ The simplest and cheapest option is to frame the work with special clips. However, even in this case there must be a passe-partout for the crystal or plastic must not touch the paper. Clips (1), crystal (2), passe-partout (3), air chamber (4), and plywood background (5).

1

Strokes and marks

OPENING STROKES

This first exercise deals with the first pastel strokes. As can be seen, all the edges and sides of the pastel can be used to draw lines as fine, or as thick as the stick itself, and from this base you can go on to explore pastel techniques.

Pastel is both a painting and a drawing medium that allows you to employ a wide range of effects. In this first topic we are going to delve into the elementary concepts of this marvellous technique. As will be discovered through the different topics of this book, pastel technique can be learned progressively. It is worthwhile for the beginner to work carefully through the exercises proposed and through the different points dealt with in every topic.

1. *It would be absurd to use a pencil or charcoal to do the layout of a piece that is going to be made in pastel. A pastel stick leaves a clean mark on the paper: you do not need to fall back on any other drawing media. As pastel paints with its entire surface, its strokes are similar to those of charcoal, although it is true that pastel is more stable, less prone to crumbling. This property is no set back, especially if the picture is going to be covered in color. The opaque quality of the pastel colors makes it possibleto use all types of strokes and corrections.*

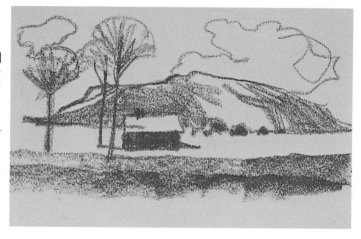

2. *In the other drawing media the amount of paint loaded on to the brush determines the color intensity, but this is impossible with pastels. Strokes can be done with the stick, crosswise or vertically, but the pastel cannot be spread as if it were a liquid method. Use strokes to build the surface of the painting. These can be closer together or far apart, and they can be wide or narrow like the tip of the stick. Whatever way they are done, even with the pastel stub, the picture is made up of strokes.*

Topic 1: Strokes and marks

FINE LINES AND TRUNCATED STROKES

Many different strokes can be made with pastel. So much so that the artist should start practicing with the different stroke possibilities before going on to develop different colors. Throughout the exercises presented you will be able to appreciate that strokes are often employed as simple lines, or as shadings which are cut short by a twist of the wrist. This exercise is about painting a flower. Pay a great deal of attention to the strokes in the different areas.

▲ 1. *Holding the pastel stick flat when you make the first strokes gives versatility. As can be seen, the strokes do not have to be straight. With a pastel stub stripped of the paper wraper, work with the pastel flat between the fingers. Its shape favors the width of the stroke: the petals are soon covered. If you gently turn the stub, without standing the pastel upright, the thick stroke becomes a fine line. You can now work lengthwise.*

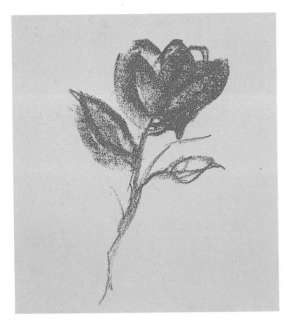

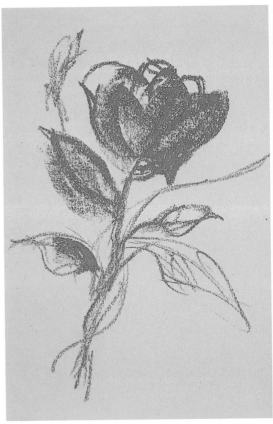

▼ 2. *When the pastel is held upright the quality of the stroke is very different. It becomes a fine line and responds to the delicate movements of the wrist and fingers. This can be seen in the flower stem exercise, where the leaf on the right has been drawn in a very loose, free way, without being too rigorous in the development.*

▼ 3. *Strokes made with the pastel held flat can vary both in intensity and in pressure. The granulation reflected in the stroke as it is dragged depends on the paper, the texture, and also on the pressure applied. Some areas seem to have a denser color because the pastel has been pressed harder onto the paper.*

DRAWING WITH THE PASTEL FLAT AND WITH THE TIP

Although many different ways of drawing are possible with the pastel stick, basically it comes down to a choice between holding it upright, thus giving a gestural line, or holding it flat and therefore rapidly covering wide areas of the paper. In this exercise we are going to experiment with the different possibilities.

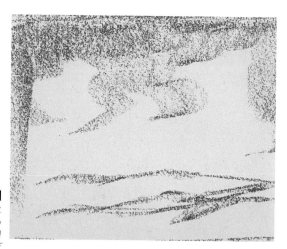

1. To do the sky in this picture use a pastel stub held flat between the fingers but do not press down very hard so that the whiteness of the paper is not completely blocked out. The blue area should be covered, while the outlines of the clouds are left unshaded. This is called reserving an area: it is the stain that outlines the white and gives it shape. The lower part is also painted with the pastel flat between the fingers, but now the stroke is lengthwise. Drawing like this enables the layout to be done quickly and ensure that it will turn out as planned.

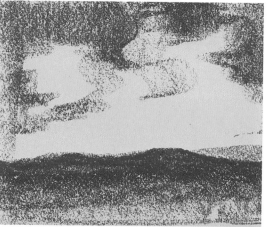

2. This phase of the drawing is carried out with a flat stick to give a crosswise stroke, the best way of going about the landscape. You can now work with a much firmer stroke. Where you are seeking a greater contrast, insist more intensely. In the areas that are going to have a softer tone use a flat stroke, pressing down very lightly on the paper.

Pay attention to the effect of superimposing the layers on top of one another, and to how the stroke can be more or less opaque.

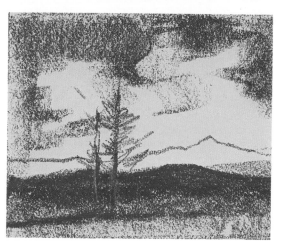

3. Once the layout of the landscape base has been completed, fresh touches that finish off the details can be added. It is only logical that the final strokes are much more descriptive than the beginning ones for they show the delicate profile of the mountain in the background, or the tree in the foreground.

Topic 1: Strokes and marks

In the previous exercises we have studied some of the principal applications of pastel. The exercise that we are going to do now includes all of them, and also deals with a new way of working with pastel, blending tones and colors. This is one of the most important effects used in pastel technique.

▶ **1.** *In this exercise we are going to paint a piece of fruit. Firstly, an orange shape is sketched with the pastel. Then the inside is colored with a golden yellow cadmium. On top of the yellow, paint in orange, dividing the fruit into two distinct parts. Without pressing more than is necessary so that the colors do not mix, gently rub over the right area until it is uniformly covered with the tone. When the fingers come to where the two colors meet, rub softly until they subtly merge together.*

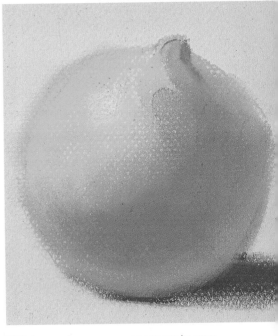

▼ **2.** *This stage is especially interesting for we can see how the blending of one color over another does not have to take in the entire surface. All that has to be done is to gently pass the finger over a light area without touching the upper part. This is an example of how the pastel retains its freshness.*

▼ **3.** *As many layers as are necessary can be superimposed provided that the colors are not mixed on top of each other. Take great care when you blend in the contours of the new tone. On one side the color is spread with a finger until it completely covers the contour of the fruit. Around the luminous area do a rough merging so that no fingerprint traces are left.*

Step by step
A still life

Pastel is an ideal medium for translating what may begin as a mere thumb-nail sketch, into a full-blown painting. In this exercise we are going to use pastel with quite simple techniques. It is not fundamental that the result be identical to what is shown in the images. This will be achieved later, with practice. It is important that every step is followed carefully, making it easier to achieve a satisfactory result.

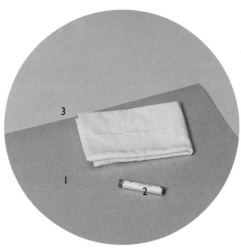

MATERIALS

Color paper (1), pastel stick (2), and a rag (3).

When you are painting in pastel, as it is a fresh medium, you must always be careful to avoid rubbing the hand against the paper.

1. *The entire surface of pastel can be used, both the edge and the point. Although the result is different for every application it is important to get the most out of each pastel application on the paper. Use the pastel flat to trace long, straight, highly precise lines: this is how the sides of the glass are drawn. If the stick is held upright, using the tip, the stroke can be more like handwriting. Start to carefully draw the apple by laying out a sphere.*

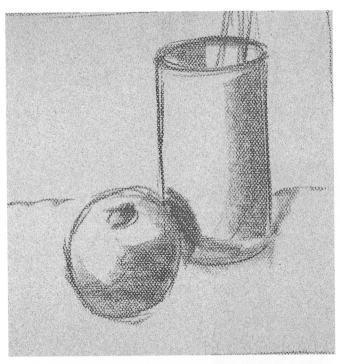

2. The beginner must get used to working with stubs because pastel is fragile and breaks easily. It is more straightforward and stable to work with a little bit of pastel than with the whole stick. Break the stick in two and then, holding it flat, you can start to do a side stroke. To avoid blocking up the grain of the paper, do not press too hard. The jar is drawn with one vertical line. The apple stroke is done with a twist in the wrist. Once again, the pastel is flat between the fingers.

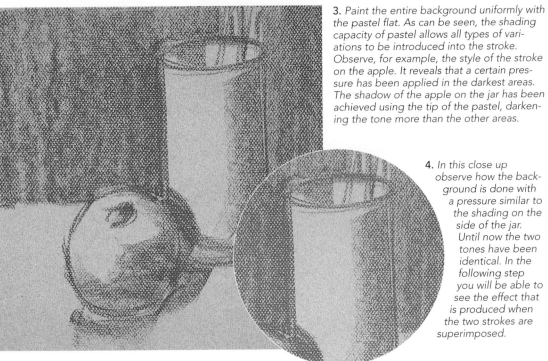

3. Paint the entire background uniformly with the pastel flat. As can be seen, the shading capacity of pastel allows all types of variations to be introduced into the stroke. Observe, for example, the style of the stroke on the apple. It reveals that a certain pressure has been applied in the darkest areas. The shadow of the apple on the jar has been achieved using the tip of the pastel, darkening the tone more than the other areas.

4. In this close up observe how the background is done with a pressure similar to the shading on the side of the jar. Until now the two tones have been identical. In the following step you will be able to see the effect that is produced when the two strokes are superimposed.

5. Passing the pastel twice over an already painted area enables the tone to be darkened. This time, to get the darkness of the glass right, use the tip of the stick. This has a strong darkening effect and at the same time enables you to closely control the forms as you draw.

If you do not exert too much pressure when painting, pastel can be removed with an eraser, or flicked off with a rag.

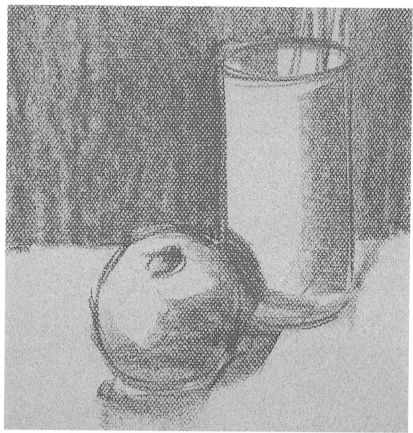

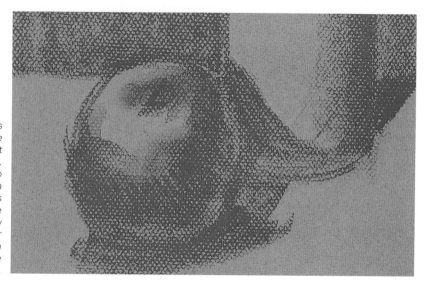

6. Once the first strokes have been laid down on the paper you can start to paint in the deepest contrasts. Paint the apple with the tip of the stick, which offers a direct and spontaneous style. The hardness of the stroke allows the shadow areas to be made darker and denser. As pastel is an unstable medium, it can be blended with the fingers.

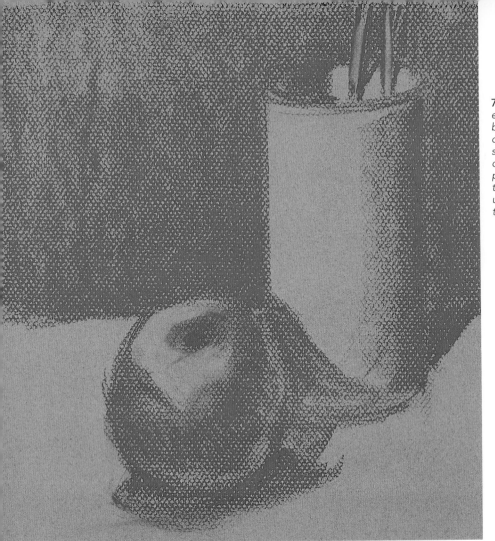

7. *To finish off this exercise, darken the background by going over it again with side strokes. Once these dark areas have been put in, they finish off the contrasting of the unpainted luminous tones.*

SUMMARY

The strokes that are drawn crosswise with the side of the stick allow areas to be covered with thick lines in an even texture.

When **the tip of the stick** is used, it enables you to draw in a gestural style. This is how the outline of the apple has been done.

The flat, lengthwise stroke helps you to do firm, straight lines.

Superimposing strokes on top of each other enables the paper pores to be covered.

Initial layout

DRAWING WITH PASTEL

When the pastel technique is explored for the first time what stands out is the possibility that this medium offers for working with the strokes on the paper. On one hand, you can draw perfectly, as if it were a pencil. Alternatively, the colors can be superimposed, both with the tip of the pastel or with it flat between the fingers.

In the pastel technique the way the stick is held and applied to the paper is very similar to any other drawing media, like charcoal or sanguine. Pastel is not a drawing medium, although it can be used as such. It is a method of painting. In the light of its properties, the approach to it must be fresh and spontaneous. Therefore, whatever happens, avoid mixing the colors to get other colors. Art supply shops will have the exact pastel tint you require.

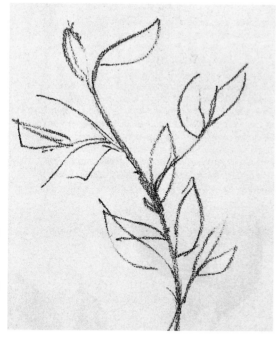

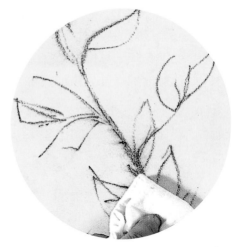

▼ The powdery texture of pastel allows the artist to draw, to shade, and to rub out like any other drawing media. All types of strokes can be erased with a simple flick of a cloth or the hand. This is why doing the layout for the drawing is not difficult: the technique permits on-going corrections to be made. The cloth should be made of cotton and clean so that it does not dirty the other colors.

▼ The pastel allows the layout to be made with a clean and direct stroke, the exact definition of which depends on the way it is used. As the pastel can paint with all its surfaces, the strokes achieved are similar to those of charcoal, both by painting with the pastel flat or by using the tip of the pastel. At the same time the opaqueness of the pastel colors allows any stroke or correction to be covered over.

Just passing the pastel over the paper surface is sufficient to do a line. If you pressed the pastel stick too hard against the paper either you would break the pastel or just clog the support up with too much color, which is totally unnecessary in the early stages.

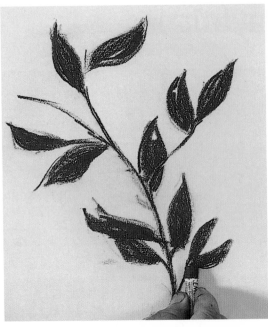

BUILDING UP THE PICTURE

In pastel painting, the work has to be done progressively. This in part is due to the opaqueness of the method, and, secondly, because it is possible to correct as you go along. This is clearly demonstrated in this exercise. On the previous page we looked at how to arrange the layout and how easy it was to correct it. Now, starting out from these barely insinuated lines, go over the forms with a firmer stroke. This is called restating.

▶ 1. *The painting of the picture is based on lines. These can be joined together or separated, and be as wide as the tip of the pastel or the pastel stub, whichever is being used. To quickly color each and every one of the leaves that have just been drawn, use a dark green. The lines are still visible during this process. This is one of the characteristics of pastel painting.*

▶ 2. *Pastel does not need drying time so it is not necessary to wait before painting a fresh color. This is a property that gives it great expressivity. Some other painting media do not permit certain layering of color unless the underpainting has dried. As can be seen in this sequence, it is possible to paint a lighter color on top of a darker color without it becoming transparent or mixing with the color underneath. On top of the dark color, paint the most luminous area of each leaf in a bright green.*

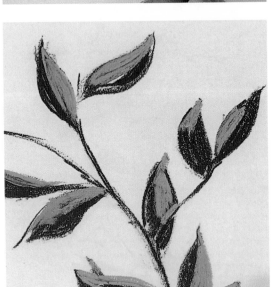

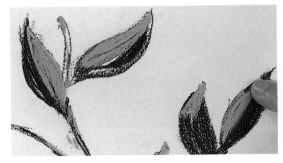

▼

3. Just running a finger along the dividing line between two colors is enough to blend the strokes together. Do not rub so much that the colors mix. Gently rub where they meet to blend their edges together.

COMPOSITION

We have studied how pastel painting is started with an initial layout, and how very simple elements like leaves are elaborated. These are some of the most elementary effects. The last exercise showed how the initial layout must be done carefully and precisely. If the elements are simple and do not require a marked structure to develop them, a drawing like the ones on the previous pages is enough. However, this exercise only aimed at practicing the stroke and constructing the forms. When the model is more complicated it is necessary to do a plan before going on to sketch the painting.

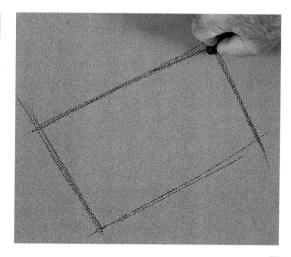

▼

1. *The layout is done on the drawing paper. Within this plan the most elementary forms are developed. The aim is to see the unity of the composition, as if it were just one object. This example is a simple still life of two lemons. Doing a layout will add realism to the picture: if you start with a general plan of a few lines it is much easier to place them in the picture. The internal forms have not been put in yet. First, we have to get the box shape, in which they will later be fitted.*

> It is advisable to do the layout of the forms with the pastel stick flat and using a lengthwise stroke.

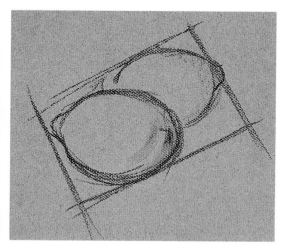

▼ 2. *Inside this very simple form, the basic shape of the lemons can be more fully sketched. When drawing them, their relative sizes and forms must be considered: the initial layout has to be respected. In this step and in the previous one, we have first done a straight line layout, then we divided it and went on to do more descriptive drawing.*

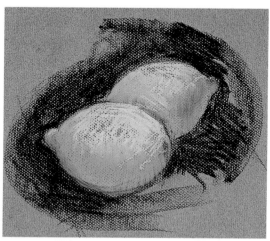

▼ 3. *By now the forms of the lemons are perfectly defined. At the start of this chapter we saw how pastel could be corrected easily. In this exercise it is not necessary to rub out the lines of the layout: you can paint directly on top since the new color will cover them completely. As can be seen, the layout is very important to ensure that the picture evolves smoothly.*

WORKING OUT THE COMPOSITION

When the forms of the model are even more complicated, you must be able to fall back on a more thorough layout. The most difficult forms to do are the symmetrical ones, and shapes that are nearly pure geometric figures. In fact, it is much more complex to do a simple white plate than to do a very exotic flower or a stormy sky. Whenever you have to do a geometric object, it is best to do a well-structured layout.

▶ **1.** *This could appear to be a very simple exercise as "all" that we are going to paint is a plain teapot and a flower. In fact, it is more complicated than it seems because the teapot has very precise forms in which every line of its structure has to be perfectly balanced with the overall image. In contrast, the flower does not have to be developed so accurately. First, do a layout of all the forms. The sketch of the teapot must have simple lines that make a square. The flower lying on the table can be sketched as a circle, and the stem as a simple line.*

▶ **2.** *Even though we do not yet have sufficient visual references to do all the teapot, the initial drawing of the flower is finished. Inside the square form that has just been outlined, a cross is drawn, centered in the middle of it: it will be the symmetrical axis of the definitive drawing. Using this axis, outline the spherical form of the teapot. The vertical axis is used to establish both the center of the lid and of the base. The horizontal axis is a reference point to position the spout.*

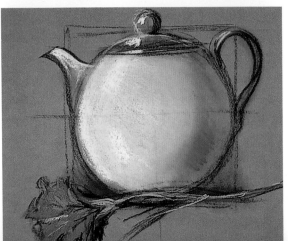

▶ **3.** *The drawing is now finished off. Without the initial layout structured into different parts it would have been difficult to develop the form of the teapot. However, to do the flower just a few strokes are necessary.*

Step by step
A still life

Pastel is not only one of the most complete painting methods that exists, it is also the medium which most resembles drawing. It is fundamental to learn to use all of the strokes and marks possible. In this exercise we are going to try out these possibilities with one color only, creating a monochrome, while studying still life composition. In future exercises we will include all the colors that this medium offers. Pay special attention to the simple forms for they help us to tackle the more complicate and elaborate forms.

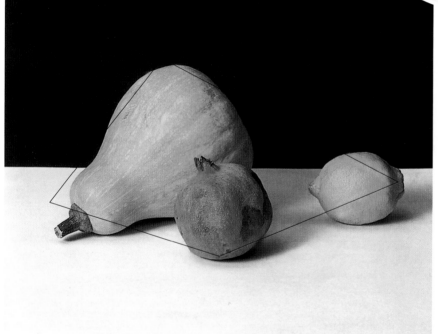

MATERIALS

Burnt umber pastel (1), white paper (2), and a rag (3).

1. *All drawings must be started with a carefully worked out layout. This will be the base on which all pastel pieces will be developed. However complicated a painting may appear, it is always based on simple, well-structured forms. Use the tip of the stick to do the layout.*

STEP BY STEP: A still life

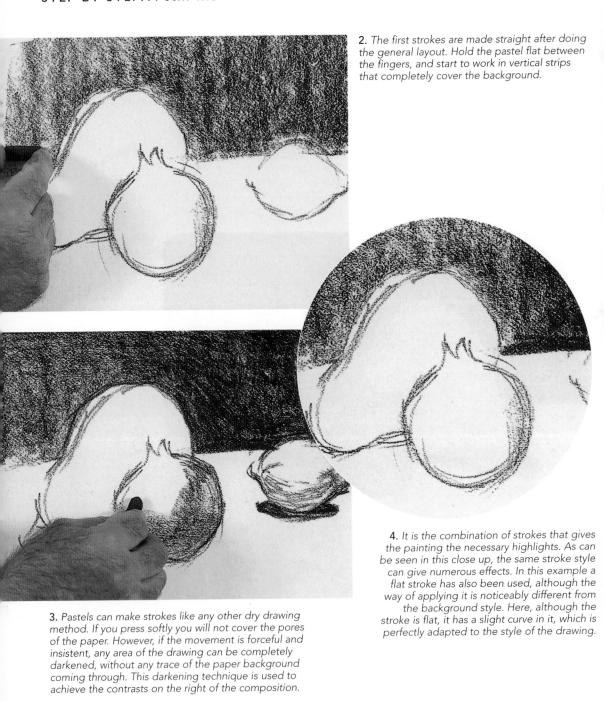

2. *The first strokes are made straight after doing the general layout. Hold the pastel flat between the fingers, and start to work in vertical strips that completely cover the background.*

4. *It is the combination of strokes that gives the painting the necessary highlights. As can be seen in this close up, the same stroke style can give numerous effects. In this example a flat stroke has also been used, although the way of applying it is noticeably different from the background style. Here, although the stroke is flat, it has a slight curve in it, which is perfectly adapted to the style of the drawing.*

3. *Pastels can make strokes like any other dry drawing method. If you press softly you will not cover the pores of the paper. However, if the movement is forceful and insistent, any area of the drawing can be completely darkened, without any trace of the paper background coming through. This darkening technique is used to achieve the contrasts on the right of the composition.*

5. As we have seen in different exercises, using the pastel flat can give a great variety of effects. Depending on the stroke, in some areas the pores of the paper will be completely covered by the pastel, and in other areas the stroke will be adapted to the design of the form. Use a flat stroke to shade the pumpkin. Go around the shape applying minimum pressure so as not to block up the pores of the paper. On top of this stroke do the furrows with the tip of the stick.

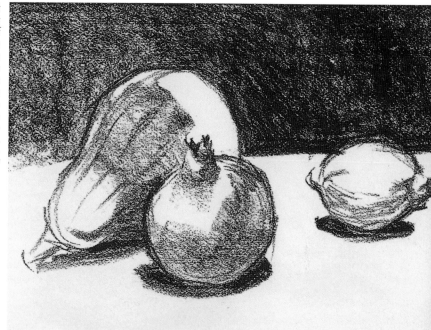

Soft pastels are especially suitable for pieces which need shading. Although, they crumble very easily, do not throw away the little stubs because they can be used to paint little descriptive details.

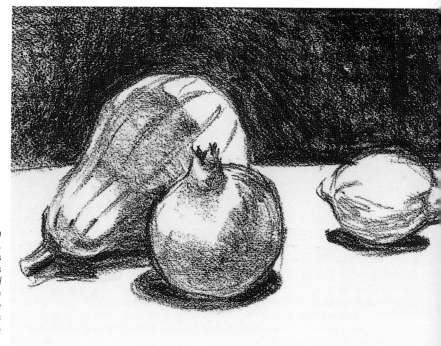

6. When you want to darken a previously shaded area, another pastel addition is made. The shade of darkness that is achieved will depend on the type of stroke used. In the background the still life forms are restated, but this time on the left where the stroke was much weaker.

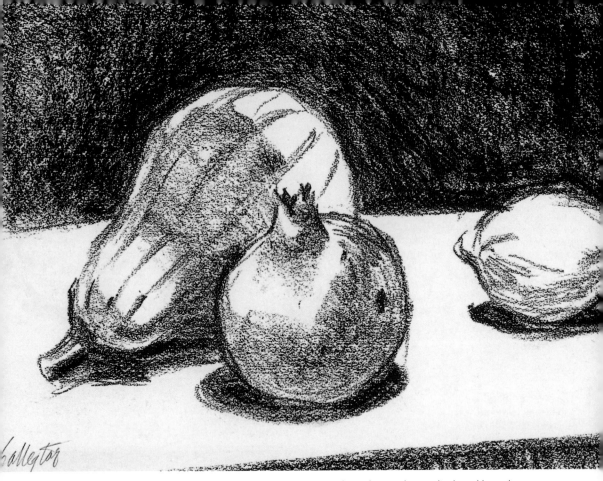

7. To complete the exercise, all that remains
to be done are some final strokes in the lower
part of the composition using the tip of the stick.
Throughout this exercise we have seen how different
stroke styles can be applied, and how the
layout is developed. This same technique can
be useful in any of the exercises that are
presented in the following topics.

SUMMARY

Pastel can paint with
its entire surface. The
stick is used flat to
color the background;
the strokes are vertical.

The stroke obtained
with the tip of the
stick helps to draw
lines and fine marks,
in the same way as if
one were drawing
with a pencil.

Superimposing strokes
on top of one another
produces dark areas. If
you press down hard
enough, the pores of
the paper will be
covered completely.

**If a low pressure
stroke is made,** the
paper grain shows
through. The areas in
which the texture is
noticeable were gone
over very gently.

Surfaces and mixed techniques

THE ROLE OF THE PAPER

It is the grain which gives paper its texture. In the following exercises we will practice on different grains of paper. The first exercise is very interesting because it enables us to learn about the stroke effects on different grains of paper.

Pastel can be painted on any surface and with many different methods. Good results are obtained by mastering the technique and understanding the surface on which you are working. In this chapter we are going to study different aspects of the technique, from drawing on different surfaces through to the realisation of one of the most interesting mixed techniques that can be tackled: pastel and oil together.

This tree has been painted on thick-grained paper. In this example the paper is especially designed for watercolor and has a very marked grain. When the pastel is passed over the textured surface, the shading reveals the roughness of the paper.

▼ Medium-grained paper is heavily used by enthusiasts of this technique. This exercise consists of doing a simple tree. On this type of grain any stroke is possible, from a fine line, through which the grain of the paper is seen, to a compact stroke that covers the background completely.

▶ Fine-grained paper allows you to do a completely homogeneous stroke, without any texture at all. Nevertheless, it is advisable not to use the first paper you come across. The best papers have a slight stucco texture and are a little abrasive when the pastel is applied. Compare the result of this exercise with the other two on this page to see the differences.

▶ 1. *As was seen in the last exercise, the paper always plays a key role especially as is the case here, when there is hardly any grain. The preliminary sketch is always fundamental, for setting out the principal color areas. When finegrained paper is used the texture of the painting, or drawing, will be minimal.*

FINE-GRAINED PAPER

Pastel is a technique that offers great spontaneous contrasts. As no drying time is necessary, the results of the contrasts can be checked immediately. Landscapes are especially suitable themes because the effects can be used to explore a wide range of possibilities, from direct strokes through to blending and tone modeling. The grain of the paper will be reflected in the texture. In this exercise, use fine-grained paper. Alternatively, the other side of the textured pastel paper could be employed.

▶ 2. *The sky is painted blue and the clouds white, blending the tones with the fingers before adding a new tone on top of the white of the clouds. This time the blending is low key, just enough to soften the impact of the stroke. In the foreground, a very dark and strong contrast, which clearly defines the different planes, is painted.*

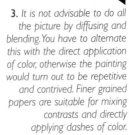

3. *It is not advisable to do all the picture by diffusing and blending. You have to alternate this with the direct application of color, otherwise the painting would turn out to be repetitive and contrived. Finer grained papers are suitable for mixing contrasts and directly applying dashes of color.*

PRACTICING ON DIFFERENT TYPES OF PAPER

A s pastel is a totally opaque method that can be worked on any type of surface, the paper does not have to be white. Paper manufacturers offer a wide range of colors. When practicing daily, the artist chooses the paper color that combines effectively with the pastel tints employed. Here is a simple exercise with three different colored papers which will reveal how pastel responds to different colored backgrounds.

◄

1. Place the three different colored papers side by side and join them with sticky tape: this is going to be the support. The landscape to be painted is dominated by dark colors. A clean stroke will outline the structure of the mountains and the foreground. Paint the sky blue. Each of the different paper colors responds in its own way to the pastel colors.

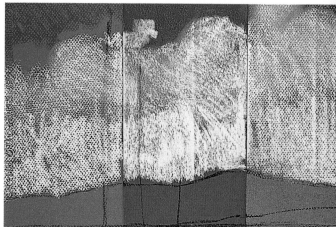

◄

2. Paint the clouds white, but do not press too hard with the stick so as not to cover the grain of the paper. Whether you paint with the stick flat, or with the tip, the background color will show through the stroke. Observe how each of the paper colors responds in a different way to the white lines. The yellow also gives similar results when it is used to paint the ground base.

> Always try to use top quality papers for painting. Cheap cardboard and other substitutes will fade as time goes by.

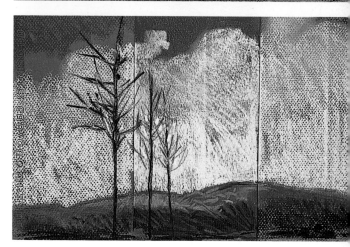

◄

3. The chromatic response of each of the different paper colors varies when the pastel is applied. In the same way that the color of the paper is visible through the strokes, a color layer can show through new pastel strokes put down on top.

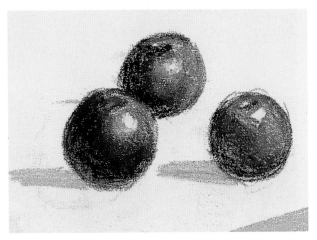

▼ 1. *Just like all other pastel techniques, when you paint on canvas the results depend on the way the different types of strokes are combined. However, as you will see, on canvas the pastel colors become much more compact since the primed canvas texture is far more abrasive than paper. Moreover, the pores of the latter also allow more color to be used.*

PASTEL ON CANVAS

Although pastel can be used on any surface, and it is best suited to paper, many artists use it on canvas. Any type of pastel is suitable for canvas, but oil pastel is the best. Not only does it stick well to the canvas, but it can also be applied with turpentine and brushes, and mixed with oil paints.

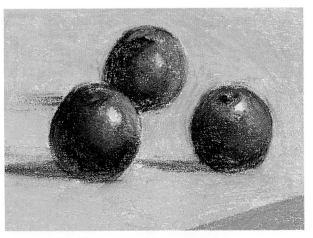

▼ 2. *When you paint with oil pastels the paint can become so compact that it creates areas of great density. However, the opaque properties of pastel remain unchanged. In this exercise you can appreciate how the color of the shadows on the table cloth changes.*

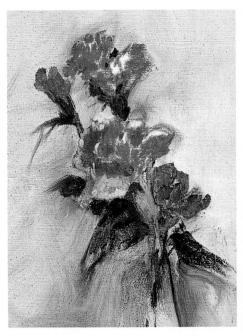

▼ *When you paint with oil pastel on canvas, very original effects can be achieved. Oil pastel can be blended on the canvas or on the paper with the aid of a brush dipped in turpentine. This makes the stroke more liquid. These blended areas of the pastel can be contrasted with the areas where the stroke of the pastel remains obvious. As can be seen, pastel opens up many possibilities, although traditionally this method has not been over used.*

Step by step
Flowers in pastel and oil

There are no hidden secrets to the method used in this exercise. The basic rules are very straightforward: paint in pastel and elaborate the rest of the picture with a brush dipped in oil paint and linseed oil. When the colors are mixed the pastel particles blend perfectly with the oil particles producing a new kind of oil-like paint. What is attractive about this technique is that it combines the effect of the pastel stroke with the blending together of the oil brush stroke.

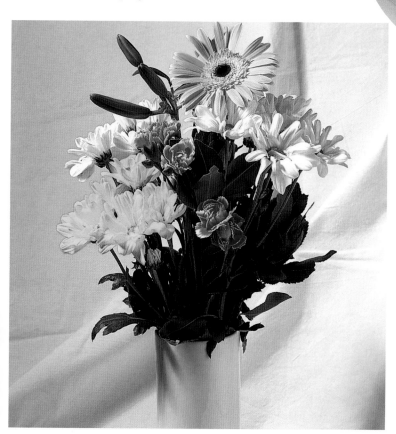

MATERIALS
Pastels (1), oils (2), palette (3), brushes (4), cardboard (5), turpentine (6), linseed oil (7), and a rag (8).

1. Start the painting with a rough sketch done in oil watered down with turpentine. The brush must be almost dry. Do not let the picture become smeared with oil or turpentine, otherwise you will not be able to do unblended pastel strokes. Once the drawing has been done, the first colors can applied. Firstly, paint the rose colored flower with free, direct strokes. Then add the gray spots on the daisies in the shadows. Do the rest of the colors in a very direct style, without going into the concrete details of the flower forms.

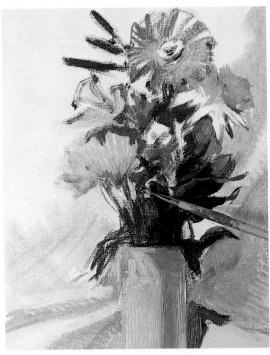

2. *Finish off the outlines of the flowers, the stems and the leaves. Dip the brush lightly in oil and then spread the color of the stems towards the side of the vase. Use the same style to insinuate the form of the vase with simplicity. Use a violet gray pastel to shade in the dark areas on the cloth in the background.*

3. *Wet the brush slightly in turpentine, load on the green paint and then pass it over the form of the stems. Use very fine brush lines initially to give form to the yellow flower. Up to this point, all the early work is done in pastel, except for some minor touches with oil. To give a good base to the oil, the surface has to be as free of grease as possible.*

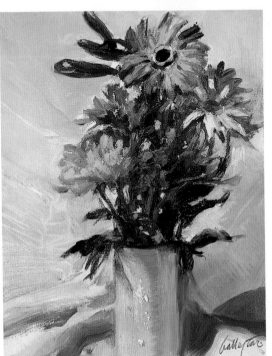

4. *Apply a violet pink tone pastel. This will be the base color for the work in oil. Paint the leaves on the right with olive green oil; the brush strokes are super-imposed on top of the pastel below, but without dragging the color. Do the dark parts of the lower stems with violet blue oil paint. The shadows of the leaves and the dark parts of the stems are done in a dark green. Paint white pastel onto the highlight area of the vase, and then mix it with a gray oil color.*

5. *Work on the yellow flower with dashes of pastel and oil. These very direct touches of pastel are applied without any subtlety in the wrist or hand. The brush strokes drag part of the orange color and mix it directly on the support. Paint some dark colored stains on the edge of the petals of the big flower in the middle. In the same way, some gray oil brush strokes are added to the grays of the daisies in the background. Darken the leaves in the upper part with a long oil brush stroke which drags part of the lower color along with it.*

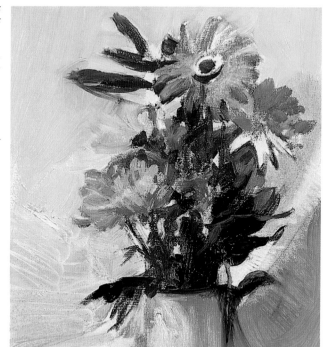

Painting with oil and pastel is not very complicated, but do not forget that not all the areas must be covered in oil. The pastel must show through the strokes that are overlaid on top.

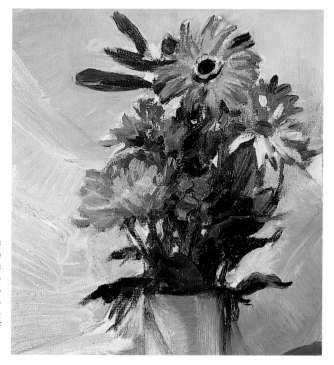

6. *This stage of the work revolves around blending and applying oil on top of the pastel base. Do the flower forms by alternating direct brush strokes with dragging strokes that blend some of the pastel painted beforehand. Dip the brush in oil and then go over the dark parts of the canvas in the background. If they still turn out to be too light, add violet gray pastel powder.*

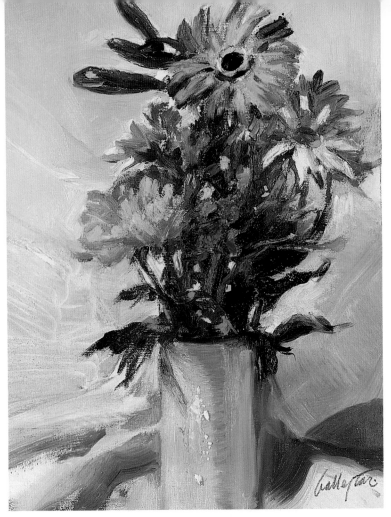

7. Once the principal oil shadings and blendings have been done, continue insisting with different pastels so as to produce impacting colors in some concrete areas of the flowers. Press hard with the pastel to leave part of the color very luminous. This picture which mixes oil and pastel techniques is now finished.

SUMMARY

The initial sketch is done with oil diluted with turpentine. The first layers of color in a mixed technique piece like this one always have to be less oily than the subsequent layers.

The canvas background is painted with the brush wetted in turpentine in order to blend the color.

Direct pastel strokes create highlights between the leaves and the stems.

Make the first marks of the picture in pastel and use them as a base to give nuances to the flowers. Pastel adapts perfectly to the canvas. Afterwards it can be blended with the oil paints.

Color ranges

COLOR RANGES

Pastel is a painting as well as a drawing medium. What does this mean? Simply that the way it is used allows the artist to achieve any of the effects found in painting, through the expression of the texture and color. The principal characteristics of pastel are the strong colors and the vitality of each stroke. To help to understand the way the colors work, it is worth noting that pastel colors are not obtained through mixing: you apply them straight out of the box where they are stored.

Whether or not the pastel technique is complicated depends on the way the artist uses it. Being familiar with the materials will allow the beginner to introduce new techniques, and materials, as the necessity to be more expressive grows. As a painting medium, pastel offers a great variety of possibilities, starting from the application of colors and ranges.

▶ *A color range is the harmony between a scale of colors. If you look at the pastel color palette, you can distinguish colors that can be grouped together according to temperature. One range, for example, could be the earth colors, which includes a great variety of tones.*

The pastel color ranges can be very wide, and therefore it is advisable to use specialized ranges for different themes: seaviews, landscapes, portraits, etc.

◀

Other color ranges are the so called harmony ranges, which are composed of colors of the same family. For example, the cool colors are all the blues, greens, greeny yellows and violets. At the other end, the warm color range is made up of reds, reddish yellows and oranges.

THE WARM RANGE

A s we saw on the previous page, the ranges are made up of groups of colors that are similar to each other in their tonal temperature. Each one of the ranges allows concrete themes to be developed, although it is possible to represent a model specific to any range. If you look at the sky at midday you can appreciate a great variety of cool tones, but they can also be represented by warm colors. In this exercise we are going to practice with different warm colors.

▶ 1. *The color of the paper will influence decisively the colors painted on top. It is important to start out from an initial layout. This can be done in any color. It does not matter if it is lighter or darker than the colors applied afterwards because the opaque characteristic of pastel allows the overlaying of any color. The initial lines will be blocked out by subsequent layers.*

▶ 2. *Start painting the first colors, shading the sky in the background. This step is done with the pastel stick flat between the fingers. The force with which the pastel is pressed will determine if the pores of the paper are closed up or not. All the colors you use in this exercise belong to the warm range. On top of the base color, in the lower part of the sky, apply a red tone which is then blended with the color below.*

▶ 3. *Use very luminous Naples yellow tones to paint the clouds. This process is not complicated, but it is worth doing with care because the luminous color has to be completely mixed on top of the background. Once the cloud masses have been shaded, gently spread them with the fingers and blend the color into the background. On top of this luminous color, paint with a much lighter one. This new addition will increase the clarity of the clouds. This time the light tones will not blend with the ones underneath.*

THE COOL RANGE

In the last exercise we saw how the warm color range can be used. In this exercise we will focus on some of the cool colors. The blues, greens and some yellows belong to this range. Just as in the last exercise, the objective here is to show how a particular range can be applied. We are going to paint the water surface, working on a very luminous blue color paper.

1. Draw the horizon, which is going to mark the beginning of the gradation, in the upper position of the paper: the focus of attention is the water. Start with a dark blue tone, always using horizontal strokes, and then gradate into a medium blue color. In the foreground, paint in emerald green. So far no color has been blended and in some areas the color of the paper comes through.

2. Gently blend the tones that have been applied. The boundaries between the colors disappear completely, and the stroke-like look fades away into a faint gradation that blends into the background. You do not have to press too hard with the fingers to make the tones blend. Just the slightest pressure is sufficient to achieve the desired effect. Moreover, we do not want to lose the paper's grain.

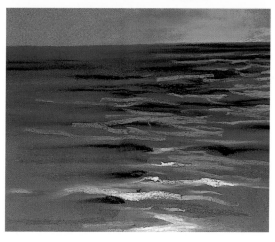

3. On top of the previous tones, paint lighter ones to represent the brightest parts of the waves. Add dark colors to contrast with the background and with the highlights. These last details determine the luminosity and texture of the surface. The highlights are very defined: they are brighter tones which form the chromatic base of the gradation.

COMPLEMENTARY COLORS

If a ray of light is passed through a prism, the white light breaks up into a color spectrum. This is how a rainbow is formed by the water droplets. The colors that form the rainbow are the basis for the rest of nature's colors. When painting in pastel, it is not necessary to do mixes because the ranges are already in the box. In this section we are going to study the effects achieved when the colors are used to their full potential.

▼ *When a ray of light is refracted, six basic colors, divided into primaries and secondaries, are formed. These are the building blocks for all the colors in nature. The primary colors are yellow, cyan and violet. The secondary colors are green, red and intense blue. The intermediate colors are orange, carmine, violet, ultramarine blue, emerald green and light green. These are the so called tertiary colors.*

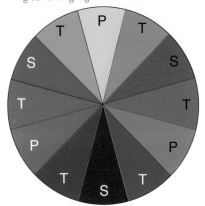

▶ *If these colors are placed in a circle they form the color wheel in which the complementary colors are facing each other.*

In this simple exercise we are going to use blue paper. We will paint a flower in its complementary color, red. You will be able to observe how this color stands out on the surface of the paper, while the narrow openings between the red strokes mean that the blue background comes through in a strong contrast.

▲

▶ *If red paper is chosen, you can work on it with complementary colors. This gives rise to a strong contrasting effect which makes the colors vibrate next to each other. Due to its purity, pastel is a medium that is especially suitable for this type of visual effect.*

Step by step
A landscape with cool tones

Landscape is one of the most interesting themes that can be developed in all the color ranges. We are going to do a landscape full of nuances and based on the cool color range. In this model you can appreciate the numerous dashes of color from the blue and white ranges. The development could seem a little complicated, but if you observe the images and follow the technical instructions closely, the final result will be positive.

MATERIALS

Tobacco color paper (1), pastels (2), and a rag (3).

1. *The initial layout is sketched in a very light color that stands out strongly against the background. Not all the trees are drawn at this stage as this would be almost impossible. Draw vertical lines to suggest their forms. Paint the lower part, where the ground will be, white and blue with vertical, energetic strokes so that two bands are clearly defined.*

STEP BY STEP: A landscape with cool tones

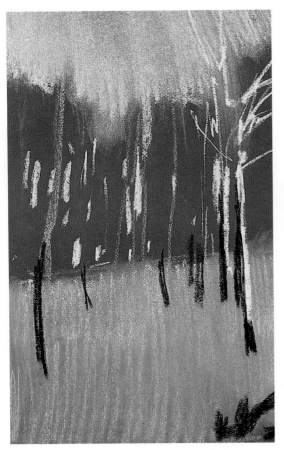

2. Paint the upper area in an off-white bone-colored tone, using vertical strokes. This will be the part of the sky visible above the bare tree tops. Both the upper and lower areas are blended with the fingertips. The stroke will temporarily become less visible. The first dark parts of some trees are done in black pastel, while the direct, bone-colored strokes form some of the bright areas in the background. The areas of maximum luminosity are painted with white strokes.

3. In the upper part, do some more shading with, the bone color, but this time in a much more direct way. Some of the branches of the trees are left unpainted, that is to say, reserved. Paint the background earth green and blend the colors slightly with the fingers. Also, the excessively luminous white of the trees is toned down.

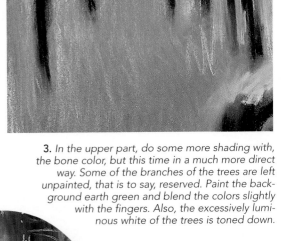

4. Luminous blue is used for the whole lower part. The color is blended immediately on the background. The tree trunks are reinforced in black and the shadows on the ground are drawn in. This touch perfectly reveals the way the light falls.

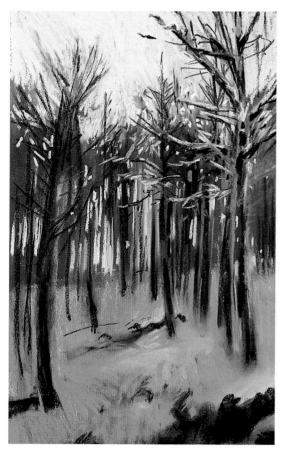

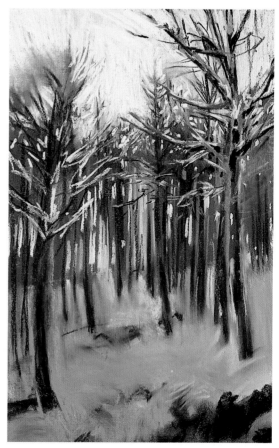

5. The profusion of bone-colored strokes in the sky allows the unpainted background to come through and interplay with the tree trunks painted in the foreground. To make the trunks seem more realistic it is necessary to paint some intense pastel black contrasts. This step is very important. The cool colors are used directly on the ground, and the strokes are superimposed on top of the already-blended background. If you look closely at the branch area, you will notice that they are superimposed in line strokes over the hazy base.

6. Some dashes of Naples yellow are made to vibrate between the branches. This luminous addition means that the blues vibrate more vigorously because of the effect of the complementary contrasts. The outlines of some of the branches in the foreground are restated in black pastel. Add a few touches of blue.

An effort must be made to use a variety of colors even though you are working with a particular color range. Colors from other ranges strengthen the luminosity of the principal range.

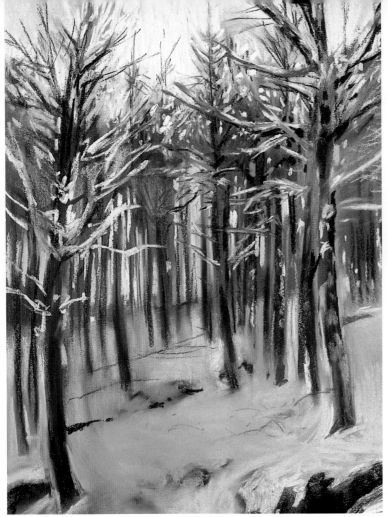

7. *Finishing off this exercise involves quite a lot of work. The details of the trees in the foreground are superimposed on top of those behind. This is exactly where the different contrasts reveal the forms. The highlights correspond to the snow on the branches; they are painted pure white. The contrast formed by the dry part of the tree is painted in black and gray. These tones increase the different effect of the luminosity of the snow. Finally, some blue touches add the final nuances to the most distant trees.*

SUMMARY

Do **the initial layout** in a very light color that stands out against the background.

The most luminous parts are the snow that hangs on the branches: paint them in pure white.

In the bottom part of the picture lies the ground: it is painted white and blue in vertical strokes that form two clearly defined bands. Afterwards, this plane is blended with the fingers.

A bone color is used to paint the vertical strokes in the sky outlining the tree tops.

The background is painted in earth green. The colors are gently blended with the fingers.

Go over the tree trunks in black and contrast the more dimly lit areas.

Layout and shading

STARTING THE LAYOUT

The layout of any picture is always started with the essential lines, which are indispensable for establishing the basic structure of the picture. For example, if you are going to paint a bunch of flowers, the first lines do not reveal the small details, instead they establish the context and the areas of light and shade. The first lines have to be the basis for later work which will build on the simple and synthetic forms done in the preliminary sketches.

To paint a picture well, it is necessary to begin it correctly. A good initial construction is a perfect base for what follows after, whatever the theme may be. In this chapter we are going to place special emphasis on the construction of the model. It is fundamental to learn the processes that are explained. If these become part of the routine of work, all the rest of the process will be easier and more successful.

▼ 1. *Starting out from an initial sketch like this one, which any beginner can easily do, you can draw the lines for the internal structure of the picture. These lines do not have to be definitive. Just as on the clean paper, the initial plan was sketched, now inside this plan the forms of the flowers are laid out. The first form is triangular and inside this shape more precise elements can be included.*

▼ 2. *When the structure of the picture has been defined, the finish will be much more precise. This work process will help the artist to attempt any model, no matter how complicated it may appear. With practice, the first steps of the layout can be omitted, although the image of every step must be born in mind.*

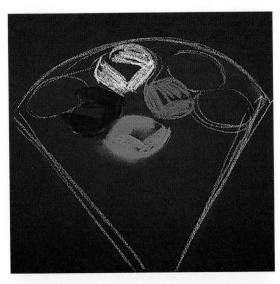

SHADING. WORKING ON THE COLOR

Once the layout has been completed on the paper, you can start the shading process in the picture. The first thing to do is remove all supplementary lines used to construct the still life. Depending on the method being used for the picture, these lines can be either erased or painted over with other colors.

▶ 1. Once this first stage has been completed, use a spray fixative. However, bear in mind that if you fix the layout, it cannot be changed later.

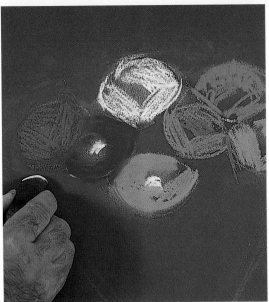

▼ 2. Pastel has the great quality of blending or of behaving almost like a line drawing. Both these effects must be well controlled from the beginning of the shading process. The areas that have been blended, can then receive new firm strokes. On top of these first marks new lines can be added that define the contrasts. Use an eraser to rub out strokes that overrun the flower contours.

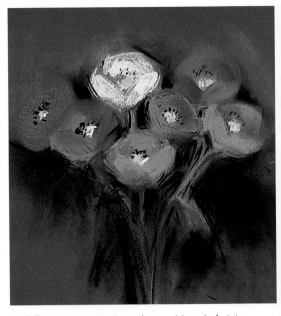

▼ 3. There is one exception to the no mixing rule. As it is very difficult for the artist to have all the colors on the market, a practical and common trick for the majority of pastelists is to use black to develop tone ranges. Observe the wide range of tones that can be achieved with black as a darkening agent, but, of course, when it blends, the colors below the stroke become less noticeable.

COLOR NUANCES.
THE ABSENCE OF MIXES

A s we have studied so far colors are not mixed in pastels. The artist's palette is what he has in the box. Mixing would just spoil the colors. Having applied the first colors, the artist will go on to need more and more colors to enrich the painting. Although some of the tones may vary slightly, they will give freshness to the picture.

1. In the pastel technique, more than in any other, the color nuance is of fundamental interest. This is a straightforward exercise in which the importance of different pastel tones can be appreciated. It will be seen that mixes are not necessary to achieve numerous nuances. First, paint with the color that will be the base. In this first layer a gradation of three different tones can be achieved.

2. Run the fingers gently over the top of the tones to blend the colors together. This is blending, not mixing. It simply allows the definition of a tone base on which direct strokes and nuances will be done. Take care to only soften the edges.

As it is not possible to have all the colors that are available in pastel, blending colors with black is a good option to establish tones and scales.

3. The color base allows new tones to be added. This time the tip of the pastel is used so that direct strokes can be superimposed on the underlying gradations. This is one of the most interesting pastel techniques that can be created. As you can see in this example, the different tones distinguish the different planes.

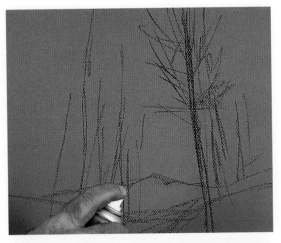

WAYS OF KEEPING
THE PICTURE CLEAN

Pastel is a medium that is always vulnerable to being rubbed off. Being able to modify a picture also has advantages. However, sometimes this is a drawback: the picture is constantly vulnerable to being smudged accidently. In the early stages of a picture this may not matter much. However, as the painting develops, a mishap can mean that many work hours are lost. To prevent this from happening, several easy measures can be taken.

▶ *One of the most common and surest measures is to fix the pastel at an early stage. A light spray will prevent the first layers from becoming unstuck if they are inadvertently scuffed with the hand or another pastel stick. However, this measure should only be taken in the first painting stages.*

▶ *When you paint with pastel it is quite easy to drag a hand over the picture and spoil the colors. However, preventing this is simple: just put a sheet of clean paper between the picture and your hand. Take simple precautions so that you do not drag this paper across the painting.*

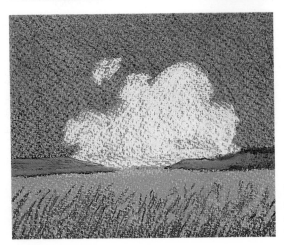

▶ *With the clean paper underneath the hand you can paint resting the hand against the picture without smudging the colored areas. Change the paper as often as is necessary to protect the brightest colors.*

Step by step
Flowers

In any painting technique layout is a fundamental issue. It is curious to think that just a few lines to set out the shape are sufficient as a base for the most elaborate work of art. Pastel, as an opaque painting medium, is suited to doing the picture progressively. Corrections to the layout can be done as you go along, just like color application. In this exercise we are going to do a flower arrangement starting out from the initial sketch.

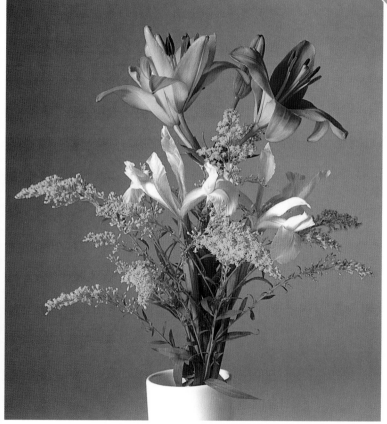

MATERIALS
Pastels (1), colored paper (2), and a rag (3).

1. *The layout must be structured. Just a few strokes are necessary to do these almost geometric elements. Starting from these forms you can go on to do a much more accurate construction.*

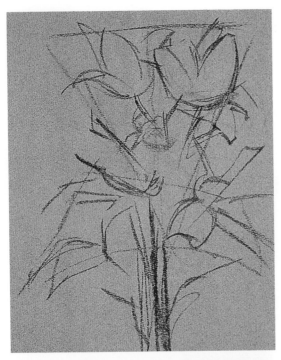

2. *Use the same pastel to further elaborate the layout. The forms are defined much more easily from the strokes of the first plan. It is not necessary to do an exact drawing because the opaque quality of the pastel allows it to be constantly retouched.*

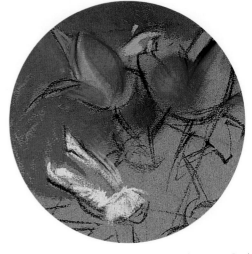

3. *Start painting the background in gray. Outline the forms of the upper flowers and cover over the initial layout lines. Start shading the upper flowers: the darkest petals with orange, and the lightest with a more luminous tone. Use white to give luminous tones to the flowers in the middle, but do not cover the paper completely.*

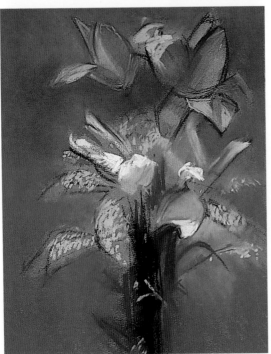

4. *The painting of the background is finished off with blue and gray. Start to blend the strokes with the fingertips. The shading of the flowers in the upper parts is continued with orange, leaving areas in which the paper color can be glimpsed through. Start to work on the texture of the small flowers by making direct strokes in yellow pastel. Two different yellows are used. Black is used on the stems of the flowers, and on top of this color, different green tone marks are made.*

5. Complete the blending of the gray background tones. All this area is unified by the fingertips, but without touching the flowers. Color touches are added to the yellows that were previously blended into the background. Yellow is now the base for further applications. The white flowers are also softly blended, but do not completely remove the glimpses of the colored paper.

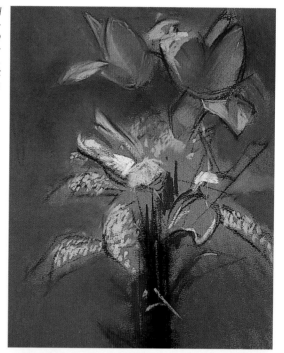

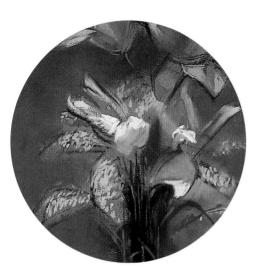

6. The first applications of color have now been completed. All new additions are going to define and describe details of the forms in some areas, like, for example, the flower stems. As can be seen, the opaqueness of the pastel allows luminous blue strokes to be painted over the black background.

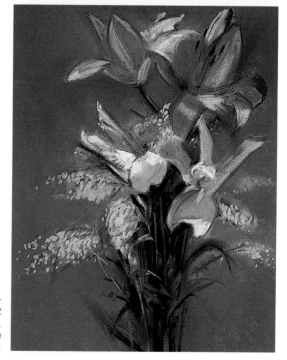

7. On top of the tones of the upper flowers, do new strokes combining different colors, but without doing any blending. The highlights are applied directly: you do not have to use your fingers.

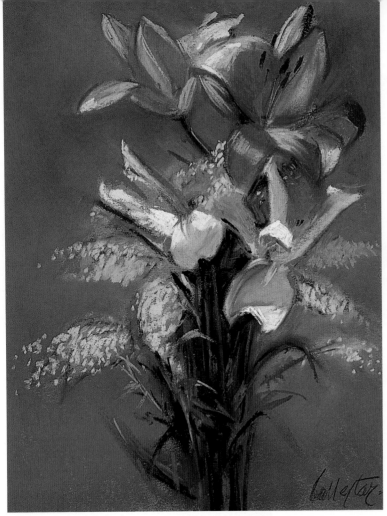

8. *The painting of the flower stems is finished off in a great variety of green tones and colors. The dark parts in this area are a perfect base to represent the depth of the shadows. Complete the outline of the white flowers with the dark tones and colors around them. Finally, numerous direct yellow strokes are added, which end up mixing with the earlier ones and the tones blend into the background.*

SUMMARY

The initial layout is completely geometric. In this way you can set out the whole composition without entering the details.

The shading of the upper flowers is very manneristic. Start with just two colors.

The white flowers are outlined by the tones that surround them.

On top of the initial black color of the stems, paint in luminous green.

6 Blurred edges and outlines

SEPARATING THE COLORS

Tricks do not really exist in painting; they are just correctly used effects. In this chapter we are going to do various examples that show the advantages of pastel: how and when to use them. Some areas are to contain blended tones. Other areas are to be linear, formed by unblended strokes and stains. In the following example both methods can be studied.

One of the most widely used effects in the pastel technique is blending tones by rubbing the fingertips across the surface of the paper. This topic presents a series of important issues that must be kept in mind when developing a picture. A beginner must learn how to use each effect to the right degree in each area. Due to a lack of experience, some artists construct the whole picture only blending, which means that the stroke marks and the freshness disappear completely. Others prefer to use strokes but go too far and convert the piece into a pastiche of marks.

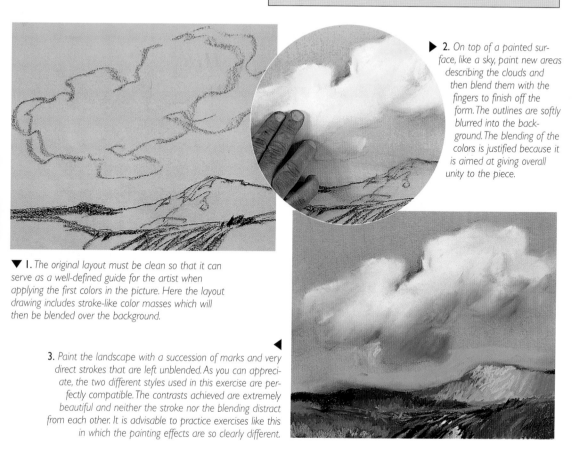

▶ **2.** On top of a painted surface, like a sky, paint new areas describing the clouds and then blend them with the fingers to finish off the form. The outlines are softly blurred into the background. The blending of the colors is justified because it is aimed at giving overall unity to the piece.

▼ **1.** The original layout must be clean so that it can serve as a well-defined guide for the artist when applying the first colors in the picture. Here the layout drawing includes stroke-like color masses which will then be blended over the background.

3. Paint the landscape with a succession of marks and very direct strokes that are left unblended. As you can appreciate, the two different styles used in this exercise are perfectly compatible. The contrasts achieved are extremely beautiful and neither the stroke nor the blending distract from each other. It is advisable to practice exercises like this in which the painting effects are so clearly different.

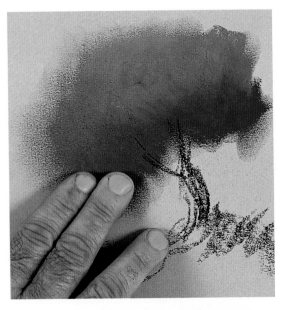

PROFILE OF THE AREAS

In the previous section we studied an exercise in which we practiced blurring and using different strokes in different areas of the picture. However, both work styles can be combined to bring out the best of the pastel properties. On this page we are going to show an example of how one style of painting can be combined with another.

▶ 1. *When you paint with pastel you can choose to leave the stroke on the paper as it comes off the stick, or you can spread it with the aid of the fingers. Spreading a mark with the fingers helps to model forms like the base of the tree top. Firstly, make a pastel mark, and then spread the color out with your fingers until it blends with the background. The blending is slightly blurred at the edges.*

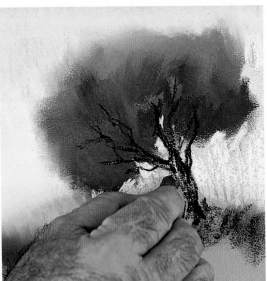

▼ 2. *On top of the smudged color, apply direct strokes. The background color on which they are laid enables the definitive forms of the trees to be outlined. The colors painted earlier provide a perfect base as they show through the peeks left between the color masses. One of the interesting effects in pastel painting are firm strokes which leave a mark and a mass of color on the paper.*

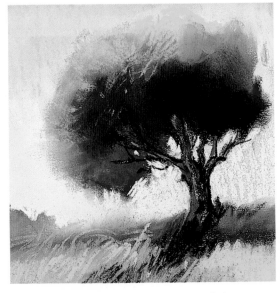

▼ 3. *After outlining the branches, do the same with the rest of the picture areas. Superimposing layers of color will be one of the most widely used effects from now on, as well as painting with softened edges and building up layers that are left much fresher and spontaneous.*

1. Before starting the landscape contrasts, it is important that each of the areas is specified in the drawing, otherwise the colors will end up getting mixed, which must never happen with pastel.

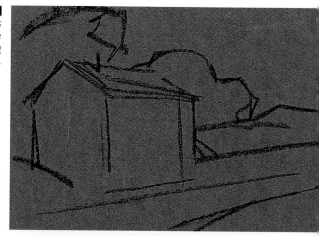

SIMULTANEOUS CONTRASTS

Behind this complicated title there is a technique that is common to all drawing and painting methods. It refers to the optical effect created between tones and colors in the picture. In reality, it refers to the laws of optics and the way the human eye functions. When a luminous tone is painted between dark tones or colors the former will be seen much more clearly because of the contrast effect with the darker tones. This also happens when a dark tone is placed between light tones. The dark part will appear much denser. In this exercise we are going to practice this interesting visual effect.

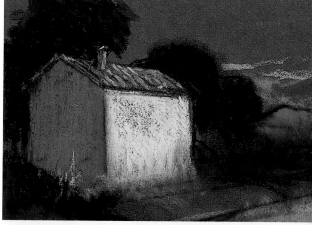

2. When the initial sketch has been set out, the marks must be added according to the way you intend to use the contrasts. In this example the highlight is going to be on the small house in the center left. Do the rest in darker and more contrasted tones and colors to increase the luminous tone of the building.

In the pastel technique, the tone of the paper is important when the other colors come into play. Dark tones painted over dark paper will seem darker than they actually are.

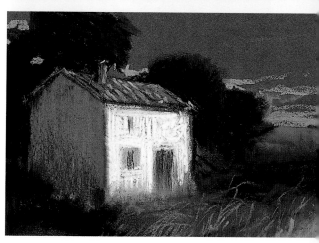

3. As can be seen, although the white of the house is the most luminous tone, it does not have to be painted completely pure. Other clear tones like Naples yellow can play a role. The contrast provoked by the darker tones that surround this tone allow it to be appreciated as a highlight.

587

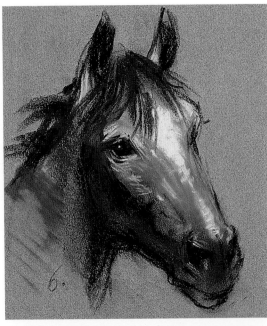

TESTS ON PAPER

The two methods that are being explored in this exercise will be tried out with a common subject but on different colored papers. The pastels used to do these horses' heads are the same. The aim is to show the extent to which the paper color can influence the result. In this exercise it is important to bear in mind the value of the tones since color values change with their background. Each of the paper colors responds in a different way to the stumping, although the same color pastels are used.

▶ *Draw this first head on gray colored paper. On this paper the colors stand out with great luminosity as gray is considered a neutral tone: it only influences the other tones through the simultaneous contrasts created by the lighter tones. The background color comes perfectly through the initial stumping. On top of this blurred color, draw with direct, strong strokes which will integrate well on this tone.*

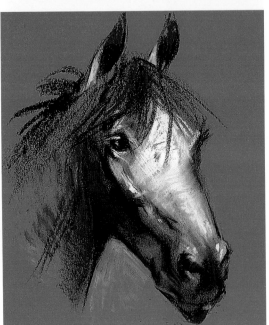

▼ *The exercise here is the same as the last one, although in this example the paper used is red. As you can appreciate, the contrasts between the dark parts and the clear areas show through with great naturalness.*

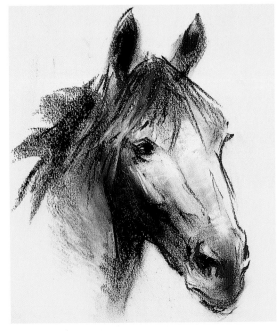

▼ *It is cream colored paper that allows the greatest naturalism in the tones and colors used, as it is not at all compromised by the contrasts created by the paper background tone.*

Step by step
A loaf of bread

As you will come to realize in this exercise, an ordinary loaf of bread can be a good model to practice several painting techniques presented in this topic. The model choice is always important, although it should not be a question that determines whether you start painting or not. This would be a great error because the most ordinary object can be represented in such a way that it takes on a new dimension and is worthy of being considered.

MATERIALS

Pastels (1), gray colored paper (2), and a rag (3).

1. *The layout is started with a luminous color that stands out markedly on the paper. Once the corrections to the drawing have been made, the first contrasts with black pastel are started. The stroke has a very noticeable drawing style. It goes along the lower line marking out the definitive form of the bread.*

STEP BY STEP: A loaf of bread

2. *Use the black pastel stick to strongly darken the background and to mark out completely the form of the bread. Use your fingertips to smudge the entire background. Inside the bread stick, paint golden yellow strokes and observe their characteristics. Each group of lines follows the form of the plane. On top of these recently drawn lines, the first contrasts are painted in red. They are softly blended with the fingers, but do not go all the way.*

4. *In this close up you can see how important it is that some painted areas remain fresh and intact. The contrast between completely blended strokes and others which remain untouched during the painting process is the key to painting in pastel.*

3. *Darken the upper part of the background totally, without shading the inside of the bread. This makes the contrast absolute. In the lower part, blend the dark color, and on top of it paint in blue. The shadow of the bread is painted in an umber color, but without totally filling the area. The finger work helps the distribution of the shadows over the tones in the lower part.*

5. *Contrast the entire background by completely blending the tones used. However, to get some luminous nuances, especially in the foreground, add some blue strokes. On top of the blended surface of the bread stick, you can start new strokes that allow glimpses of the color underneath to come through. This time the color employed is a very clear ochre orange which stands out against the hazy shadow tones because of its purity.*

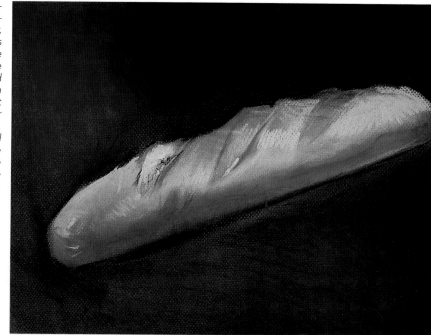

When you are doing the main contrasts, do not use extreme colors like black or white, at least not during the first stages. This will enable you to improve the color composition as you work with gradations of the same color.

6. *As has been discussed already, colors that blend with each other produce dirty tones due to the mixing. To solve the lack of luminosity, paint the blue in the midground once again. This time the area takes on a multitude of nuances. Then, apply direct yellow dashes onto the bread stick to restore the luminosity to these areas. Also, paint some emerald green touches to enrich the texture of the bread.*

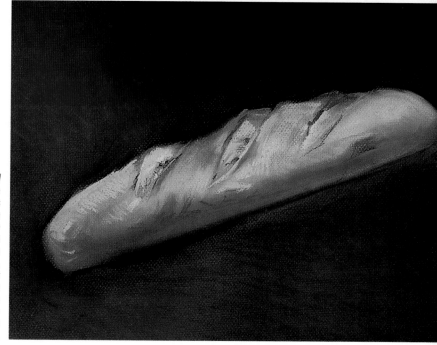

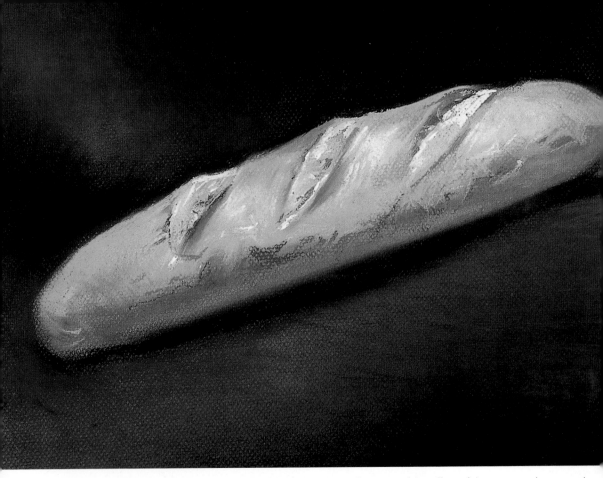

7. *Paint the table with cobalt blue in direct strokes that saturate the most luminous shadow area and increase the contrasts of the dark parts. The upper background, which was painted in violet carmine, will stand out much* *more because of the effect of the contrasts between the tones. To finish off, some luminous dashes are made on the hardest part of the crust. This will give the bread the floury look of having just been taken out of the oven.*

SUMMARY

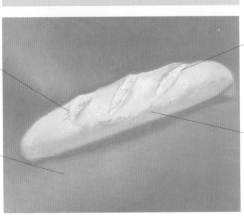

While some strokes are almost completely blended others remain intact during the painting process.

In the lower area, blend the dark color. On top of it, paint in blue.

Paint the most luminous impacts at the end and leave them unblended.

The colors that blend together produce dirty tones due to the mix. This effect enhances some areas.

Background and motif

A SIMPLE EXERCISE

The principal motif of a picture is not always sur-rounded by other forms. Often it is in front of a com-pletely plain or gradated background. However, the back-ground is considered to be incomplete when the princi-pal elements are badly placed in the picture. The problem can be solved by a simple correction, which can be rapid-ly done with pastel.

In all painting techniques beginners come up against an important problem when they have to decide on a crucial part of the picture: the difference between background and motif. It is not the same to represent an object directly on clean paper as it is to do it on a background, regardless of whether it is plain, has patterns or colors. Although a background may not have been painted, the color of the paper itself will take up this role, decisively influencing the principal elements of the picture. In this exercise we are going to try out different ways of resolving this interesting problem.

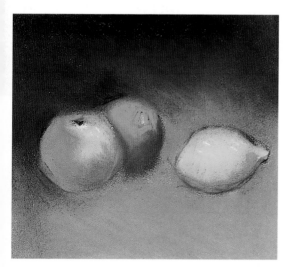

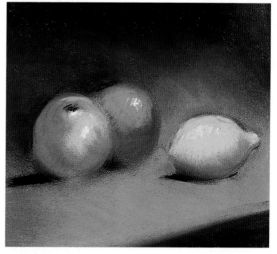

▼ 1. Observe how this still life has been resolved. The fruits that compose it have been laid out and developed against a neutral background. However, the relationship between these elements and the overall effect seems to have become lost in the disproportionate amount of space that surrounds the principal elements. It is not a poor application of pastel techniques that has ruined the picture, but the lack of harmony between the background and the motif.

▼ 2. It is not too difficult to correct the equilibrium between background and motif. A few additions, like the shadows and the diagonal in the foreground, give the picture dynamism and unity. It is these small issues that often go unnoticed by the beginner. However, if you practice exercises like this one, you will learn to see the equilibrium between background and motif very naturally. In the works of many great painters you can tell how they did correction exercises.

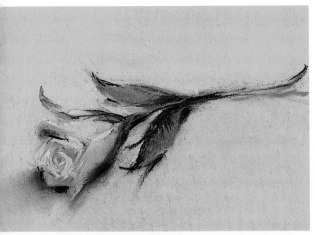

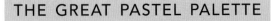

THE GREAT PASTEL PALETTE

There are many effects that allow the background and the figure to be compensated and in equilibrium. The immediacy and the vibrancy of fresh pastel color is one of them. Doing an immediate change to the background can rapidly give the whole picture a new atmosphere. The exercise on this page is an experiment to show the changes the form undergoes just by varying the color.

▶ 1. *The drawing of the flower is highly important because it does not depend on the color used to paint it. After having done a correct drawing of the flower, it is then painted in yellow tones. All the additions made to the background are going to exercise an influence on the contrasts in the picture. To start off, once the flower has been painted, the background is painted in yellow hues. The contrast between the background and the motif is minimal, although the color is in perfect harmony with the light.*

▶ 2. *On top of this example, add in ochre color tones so that the background makes the principal motif stand out more. As you can appreciate, it is important that the paper color, or in this case the background painted behind, shows through the new strokes. This will allow the whole picture to gain in unity and atmosphere.*

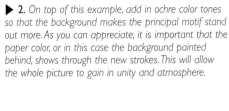

> When we refer to the background and the motif, do not interpret this strictly. It means the relationship between the principal elements of the picture and the elements around it.

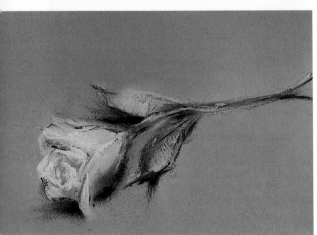

▶ 3. *Paint the entire background in dark sienna to create an intense contrast with the principal figure. Do not cover the paper completely. This will give the picture greater depth and make the flower more prominent against the two surfaces. If you go back over this exercise you will be able to appreciate how each of the additions made on the background have influenced the shadow tones of the flower.*

CREATING FOCAL POINTS AND BLENDING

In addition to the simple effects for working on the background and motif in pastel, there are a great many other techniques that give spectacular results, starting with creating focal points and tone blending. In this way it is possible to separate the background and motif by creating different visual focal points, leading the eye towards specific areas. This exercise will help you to understand how to master pastel techniques related to issue like the center of interest of the picture.

1. This is a simple composition with two principal elements against a background with highlights that outline the principal elements. The stroke is quite evident and has been done in a uniform way.

▼ *2. One way of increasing the focus of the principal elements relative to the background is by blending the background strokes. You must be especially wary not to smudge the form of the principal elements with your hand or fingers.*

▼ *3. Once the background has been blended, the composition can be enriched with new elements drawn and painted in luminous tones. When these fruits are painted, the background color becomes their base color. Later on the color values of the fruit will be effected by these tones.*

MAKING THE FORMS MORE DEFINED

In this exercise we can see how new, perfectly integrated additions can be made to the colors on top of a painted background. The focus of the new forms can be increased if the background behind them is altered. Observe how the background plays a key role in defining the different elements, depending on the plane that they occupy in the picture.

▶ **4.** *The elements which have just been painted in the background play an important role but they are not sufficiently contrasted against the background. This contrast can be achieved simply by darkening the background. The strokes are done in the same way as the first application, but with the difference that now the background serves as a tone which shows through the new contrasts. As all the background is darkened, the picture becomes more luminous, even the elements painted last of all.*

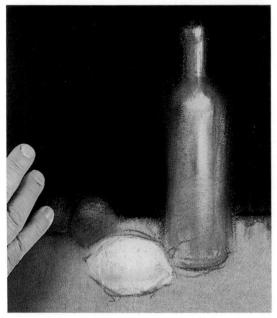

▼ **5.** *To separate the different planes in the still life all the elements in the deepest part of the background are integrated into the darkness by delicately blending the outlines of the new elements to tone down their forms. Remember that it is not a question of mixing the colors but rather of blending the edges of the fruit.*

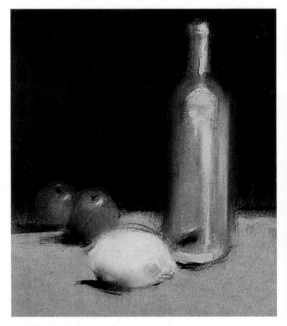

▼ **6.** *The highlights give the necessary luminosity to the picture. In the foreground the highlights can be achieved in a much more direct way, and in the midground they are far less defined.*

Step by step
Landscape planes

The subject that we will paint here is a mountain landscape with trees and different types of vegetation. Besides the subject itself, special emphasis will be placed on one of the most interesting points in painting: the relationship between the background and the motif. In this exercise it is essential to give the right value to each area, something which many beginners omit. The relationship between the motif, or principal element, and the background is manifested in an interplay of colors, tones and contrasts between the different areas. This is easy to create in pastel.

MATERIALS

Pastels (1), dark green colored paper (2), and a rag (3).

1. *The principal elements in the landscape are sketched and a layout is made in black pastel to establish a good contrast, whatever the base color may be. Even at this stage, with the painting in this undeveloped state, the priorities between the background and the motif should be established. Observe how the contrast on the main tree separates it perfectly from the other elements in the composition.*

STEP BY STEP: Landscape planes

2. *The principal planes have to be separated so that the situation of the each is clear. To do this you must first paint the most distant plane which includes the sky. Even this zone is related to the background: do not shade with just one plain color, instead paint tone variations to bring out the relationship and the contrasts between the elements in the foreground and the background of the sky.*

3. *Blend the entire background with your fingertips. Unify the color tones applied to the background to create an attractive mass of light and dark areas. Pay attention to how the plain color of the paper varies according to the tone around it. In the white sky areas, the green of the paper becomes dark due to the effect of the simultaneous contrasts. However, where the sky is blue, the contrast with respect to the green appears much more balanced.*

4. *In the first step we put highlights in the foreground with the aim of compensating the background tones, in this case the sky plane. Continue to paint the light area of the trees with sufficient pressure so that the tones are compact and completely cover the background color. It is noticeable that in this area the color of the paper plays a role as if it were just another tone in the range.*

5. *Continue painting the main light areas in the landscape. This means that the color of the paper can be included as a perfectly defined dark tone. To represent the medium tones in the landscape look for tone variations which can be blended in, and which can establish a new relationship between the background and the motif as they create a new plane which defines the foreground.*

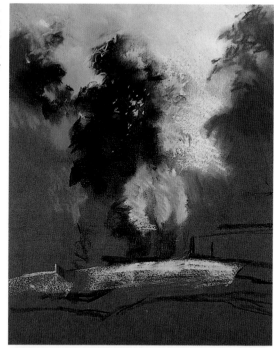

> The relationship between the motif, or principal element, and the background is transformed by playing off the colors, tones, and contrasts of one area with those of another.

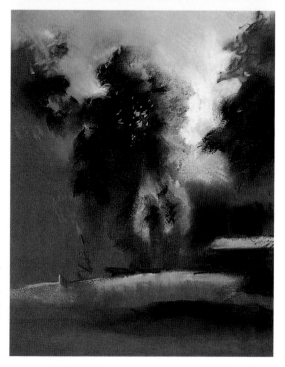

6. *When the darkest contrasts are applied, a considerable change is produced with respect to the previous steps. Putting black pastel down on the right allows the background color of the paper to be seen perfectly in some areas. Moreover, blending dark areas elsewhere aids the integration of the paper color with the pastels. In the foreground, mark the shadow area with a grayish blue. This tone will be the definitive base for the final step.*

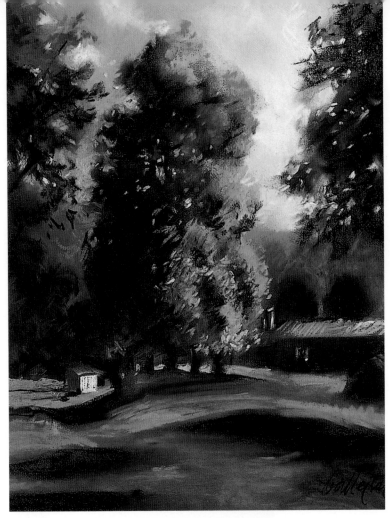

7. *Remember that in pastel technique mixes do not exist. All the colors applied come directly from pastel box. However, it is likely that some beginners do not have all the colors detailed in this exercise. Do not worry, it is always possible to use a similar color. Green is used to paint the luminous parts of the grass. Paint the shadows of the foreground in dark blues and grays. Finally, the bright touches in the main tree are applied with direct pastel dabs to make the trees and foilage blend into the sky background.*

SUMMARY

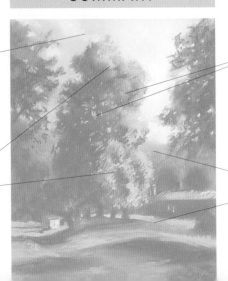

Painting the sky sets the landscape planes. The blue tones will have to be compensated with the tones that are applied in the rest of the picture.

Blend impacting light blue in with the background and the motif.

Balance the highlights in the trees with different bright spots in the sky.

The paper color shows through the marks and the strokes, blending in like the other colors from the palette.

Contrasts and colors

GRADATIONS

The possibility of doing gradations, the way one tone gradually turns into another, is one of the principal strong aspects of pastel. We have practiced various types of gradations. Here we are going to work on gradations and contrasts with colors. Gradations are useful because they offer a succession of tones, or of different colors blended together, to form a harmonious color composition.

Nothing works better than pastel in creating color blending effects. However, blending must not be confused with mixing, which must never be done. Blending, which forms part of the pastel technique, allows us to do more precise shapes. However, if we do not blend we can juxtapose colors that act as contrasting planes.

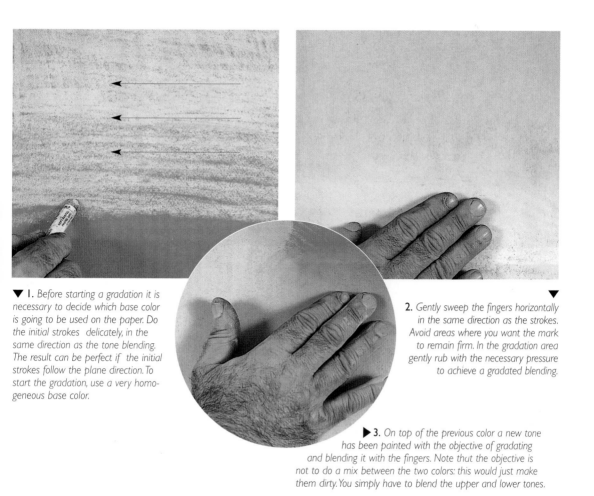

▼ 1. Before starting a gradation it is necessary to decide which base color is going to be used on the paper. Do the initial strokes delicately, in the same direction as the tone blending. The result can be perfect if the initial strokes follow the plane direction. To start the gradation, use a very homogeneous base color.

2. Gently sweep the fingers horizontally in the same direction as the strokes. Avoid areas where you want the mark to remain firm. In the gradation area gently rub with the necessary pressure to achieve a gradated blending.

▶ 3. On top of the previous color a new tone has been painted with the objective of gradating and blending it with the fingers. Note that the objective is not to do a mix between the two colors: this would just make them dirty. You simply have to blend the upper and lower tones.

TONES

T ones are the reflection of the fact that a color or a family of colors can gradate. With pastel, as with other drawing media, different tones can be achieved by studying value and the blending of one tone on top of another. However, pastel is different in one way from the other drawing media in that it can be completely pictorial: by combining tones and playing them off against each other it can produce mixing effects normally associated with strokes or shadings. In this exercise we are going to be working with tones, blending dark over light.

▶ 1. *Doing this tone exercise with fruit as the subject ties in well with many different drawing concepts. However, as soon as the paper color background forms part of the chromatics of the picture, the initial concept of the drawing varies as the guidelines of painting take over. Once the first shading is made, the parts of the background that show through, blend in with this luminous color.*

▶ 2. *On top of the first yellow tone, add in a dark color. Later this tone will be blended with the first color but this does not mean that the whole range of pastel colors will vary because you are not going to mix any colors; you are only going to blend warm tones together.*

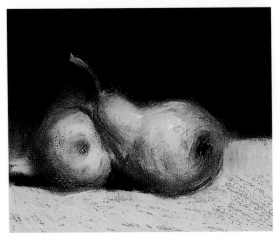

▶ 3. *Paint the entire background in such a way that a strong contrast is created between the foreground colors and those behind them. Paint the foreground of the table in an orange tone to finish off the color composition. Do the color blending with your fingers, rubbing one tone over another. To gradate the tones it is advisable to use a palette of colors of the same range.*

TONE AND COLOR CONTRASTS

Colors can be approached in two very different ways. As we have seen, blending two colors as if they were tones can easily become a modeling exercise. Nonetheless, you can also opt for a different work style: the contrasts do not have to be produced by directly blending the tones; you can produce them by directly contrasting colors. Working like this gives eye-catching results which are enhanced by the pastel technique. In this exercise the work will be twofold. The first stage is blending the tones, and the second phase is the direct color contrast.

To check on the optical effect of some contrasts it is wise to do a test beforehand on paper prepared for this type of work. When white paper is being worked on, the tests can be carried out on everyday paper.

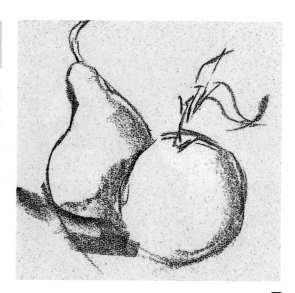

▼
I. *Whatever the pastel piece may be, the preliminary sketch is of vital importance to the construction of the composition. This layout style can be used in the following two exercises. Just a few lines are required to suggest the forms of the two pieces of fruit. At this stage all painting methods are the same.*

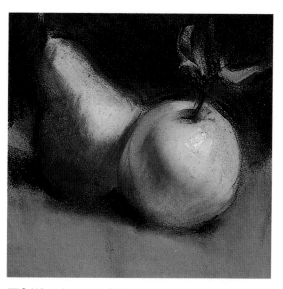

▼ 2. *In this amplified close up of the painting you can appreciate the blending of the tones and the way the darks gradate over the light areas until they are perfectly merged. Both the deeper shadows and the light half tones blend softly with the lower layers to give tonal contrasts.*

▼ 3. *When the piece is finished, you can observe how the shadows blend with the most luminous tones. The light tones do not make a striking color contrast, rather they are differentiated by the complemetary contrasts. Summing up: the light areas and the dark areas mutually strengthen each other.*

603

Topic 8: Contrasts and colors

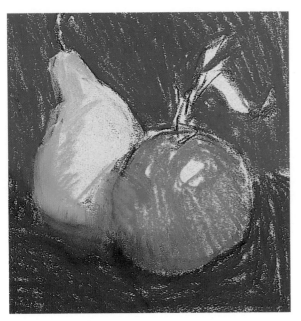

CHROMATIC CONTRASTS

In the first part of this exercise we studied how light areas and dark areas can be blended together following the same tone scale. This second exercise aims at working on the same topic as before, but with a completely different understanding of color. This time the contrast created is not tonal but chromatic. Pay special attention to the different planes and how the colors react to each other.

▼ 1. *This exercise starts with an identical layout as before. The opening lines allow you to start conceiving the work, regardless of how it will be continued later. Start the exercise by applying very defined colors that contrast strongly with each other. The first strokes are direct and spontaneous.*

2. *In this close up you can observe that although some areas blend together, others have a fresh and direct finish. The areas that merge are next to others which still have the original stroke pattern, through which the paper grain and color can be seen.* ▼

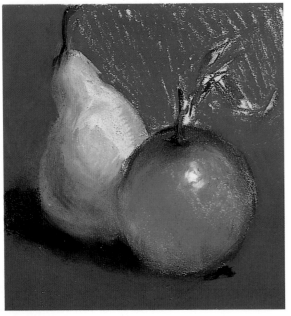

▶ 3. *Although it is important that the colors contrast strongly with each other, the tone mixes also play a role. For example, in the background the brightest blue is mixed with a less intense and much darker blue area. It is crucial that the different colors do not interfere with each other, or if they do, that it is as discrete as possible to avoid the danger of the different colors becoming mixed up. A blue can mix and blend with another blue, but it must never do so over an orange.*

Step by step
Seascape

The blending and contrast of tones is a constant aspect of all pastel techniques. Sometimes the color can be treated as if it were cloud-like and expanded over the paper without fixed limits. At other times the color will have perfectly marked forms and the stroke mark will be visible. To put the blending and stroke contrasting techniques into practice we are going to do a seascape. This is a straightforward exercise despite the intimidatingly magnificent result below.

1. *Painting in pastel can often seem like drawing. However, at this stage, since the painting develops in opaque color layers, this first layout does not have to be an accurate drawing. To start this exercise, put in a high horizontal line, leaving a vast expanse of sea which is more than sufficient to practice all types of blending and tone superposition exercises.*

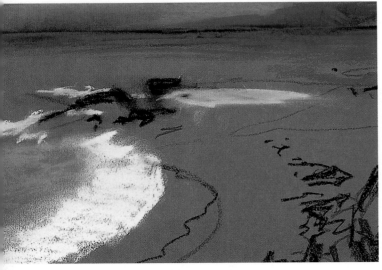

2. *The color range that is going to be used to elaborate this seascape belongs to the harmonious cool range, which consists of greens and blues. Using this restricted scale, and taking advantage of the color of the paper, the contrasts that are applied will not be chromatic but tonal. Firstly, paint in the narrow strip that corresponds to the sky. Work on the sea with a strong luminous blue that contrasts with the paper. Paint the foam where the waves break directly in white. Then immediately tone down the stroke with your fingers.*

3. *On top of the white foam of the sea put in some blue marks. These are perfect for blending with the fingers. Outline the frothy edge of the sea in a greenish tone, and next to this color paint in blue before finishing off the blending. On the right you can start the waves splashing against the cliffs in jabbing little white strokes.*

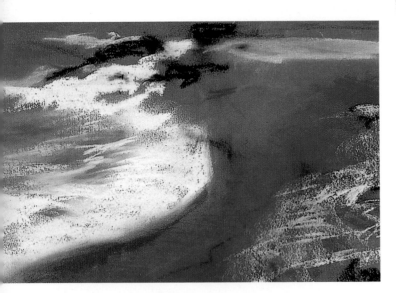

4. *A progressive blending of blue tones starts out from the horizon using ultramarine blue. However, do not let it cover the paper completely, allow its color to show through in some places. You can see that there is a clear difference between planes: they are separated by a horizontal whitish line and the rocks on the left. All the frothy parts are painted with direct white strokes and little dashes.*

Remember to reserve the brightest areas, where the highlights will go, because, together with the maximum contrasts, they will be painted last.

5. *In the lower area where the waves break against the reef do a color blending of the white against the background. Then immediately draw with the white pastel stick. This time the stroke is direct. On top of the rocks in the foreground, which were stumped in black, lay down blue strokes and then softly blend them with the darkness already on the paper. This will give shape to every rock. In the background, above the line of the horizon, the form outlines can be finished off. As you want to avoid the stroke marks being too direct, gently blend them with the fingers.*

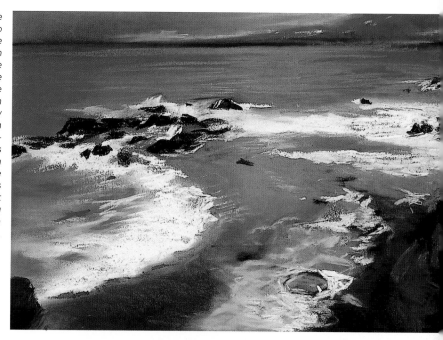

Blend the base color in the background to create an initial layer of colors without a definitive outline.

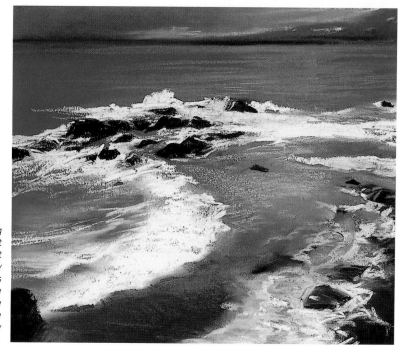

6. *Direct strokes and blending are very important to represent the sea foam. This step is not difficult, although it is necessary that the base white color is gently integrated over the blue background tones. Once the different tone blendings have been done you can add new white jabbing strokes.*

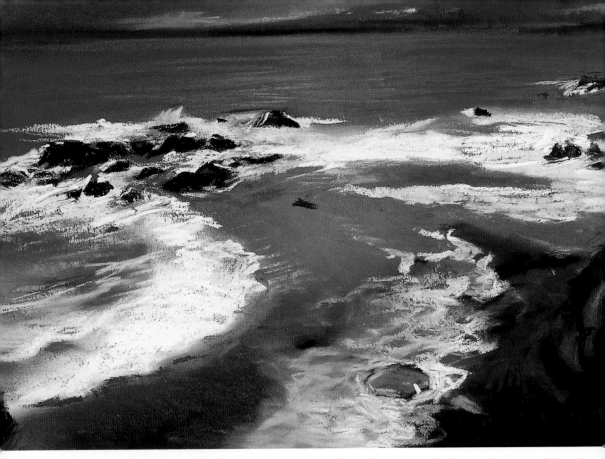

7. In the intermediate area between the foam do some new color blendings. However, make these more subtle. In the upper part of this area, the pastel stick is used flat and lightly, thereby enhancing the effect of the texture. Outline the dark parts of the rocks with the pastel point. All that remains to be done are some direct white touches above the horizontal sea spray line to create the impression of splashing.

SUMMARY

The middle distance marks the difference between the two planes in the picture. Below this line the work will be much more meticulous.

Once the wave tones have been blended you can do new direct additions that bring out the texture and contrasts.

Blend the first white color addition into the blue tone background.

Over the black rocks paint in blue.

Fixing pastel

FIXING THE FIRST LAYER

The first layer can be fixed provided that it will not have to be corrected later, or if the picture is going to be covered completely with color. Spray fixative is a good tool if it is used in moderation and at the right moment. In this first exercise we will show some of the effects that can be used before and after the first layer, which may only be the design drawing before the color is fixed.

On numerous occasions in this book we have mentioned that pastel is a fresh and spontaneous medium, however this characteristic could be lost if it is fixed. Using fixative can be very helpful when you are doing the first layers. It is worth pointing out that the finished painting should never be fixed. The methods explained in this chapter will help you to get the most out of pastel and the effects you can use.

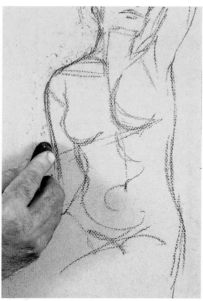

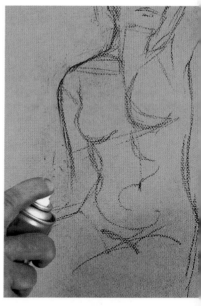

▼ 1. The sketch can be done in line or side strokes. It can easily be corrected by rubbing out or by drawing over the lines. Do not press too hard with the pastel stick so that corrections can be made later without leaving the stroke too marked on the paper.

▼ 2. The eraser can restore the definitive lines. Thus the sketch will become much more defined and can serve as a firm base on which to paint. The fundamental lines have to be kept clean of all extra strokes.

▼ 3. Once you consider your layout drawing to be complete, you can fix it. The fixative must be sufficiently far from the paper so that the spray forms an even film, without leaving drops. Once the drawing has been fixed you can only correct it by painting on top of the varnished drawing.

Topic 9: Fixing pastel

▶ **1.** *Fixative dries very quickly and allows you to continue using pastel almost immediately. If any area is damp, it is wise to wait for a few moments until it is completely dry. The wet areas shine a little until the moistness completely dries them up.*

SECOND LAYERS ON TOP OF A FIXED BACKGROUND

The fixing process guarantees that the initial strokes are preserved. However, it also allows you to establish certain shading and color effects as a base for the final finish. The new compositions that you make will not effect the lines fixed beforehand.

You can make new pastel strokes on top of the perfectly fixed drawing. The effects for this exercise have been chosen to demonstrate different composition and fixing techniques.

3. *Fixing the first layer means that it is possible to redo the painting as many times as you need to, adding either contrasts that outline the principal motif against the background or highlights that give volume to the forms. Use direct stains or strokes, letting the underlying color show through. Applying another layer of fixative would just clog up the stroke.*

▲

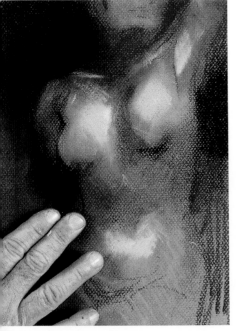

▶ **2.** *As can be seen, when the color just put down is spread with the fingers, the drawing that was fixed in the first part of the exercise remains stable and visible. Regardless of how much you rub it, neither the background nor the new colors will disturb it.*

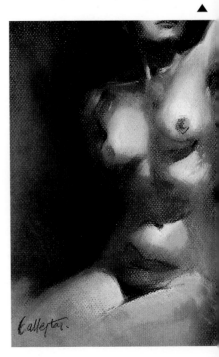

COMPOSITION AND CONSTRUCTING THE PAINTING

The unique properties of pastel open up a wide range of possibilities and effects. Bright, vibrant colors can be placed next to each other. You can then overlay them, correcting as you go along. Pastel fixing enables you to secure entire layers that will be the color base for later layers, no matter how many you may lay down.

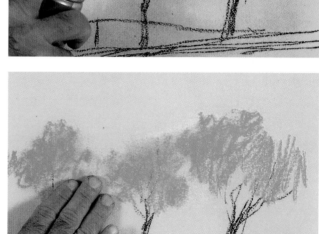

◀

1. As you could appreciate from the last exercise, the layout, can be fixed once it is totally finished. Fixing can be very useful for even a simple landscape sketch. As you will now see, the color effects created on this perfectly-defined linear drawing do not alter the original forms. It is not important if a few preliminary sketch lines remain, as is the case here, because later the colors applied will cover them up.

◀

2. Once the support sketch has been fixed the first color applications can be made. These strokes are then blurred with the hand but the layout beneath remains uneffected. The preliminary sketch references enable us to rectify and retouch the landscape forms. If you have to flick off some pastel, the lower levels will remain stable.

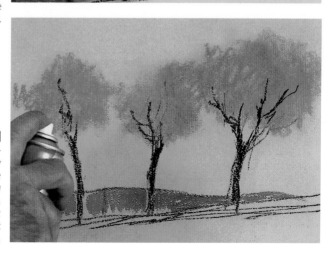

◀

3. As we are going to continue working on the picture, putting in more interesting color layers, spray on another very faint layer of fixative to ensure that you have a solid base on which to work a whole range of effects without altering lower layers. Above all, bear in mind that you must never fix pastel when the piece is finished, and that when it is used, fixative must be applied in very fine layers.

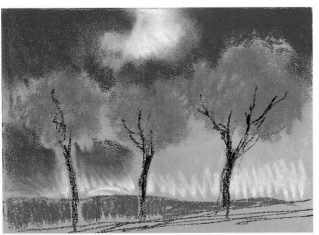

EFFECTS OVER A FIXED BACKGROUND

A color base is the best support that can be used with pastel: the new colors will be enhanced if the chromatic base increases the contrasts and the effectiveness of the blendings. In any case, as we have said before, fixative can only be used during the first additions because we want to preserve the freshness and spontaneity of the final strokes.

▶ 1. *The previous color base is perfect to continue the picture by adding new color or tones. Here, you can observe how the clouds are painted and blended on the background without the color mixing. From now onwards, any correction will have to be resolved by adding a new color layer above it. Just as the clouds were painted without altering the layer underneath, strokes and shading are added to the tree allowing the under layer to show through in some areas.*

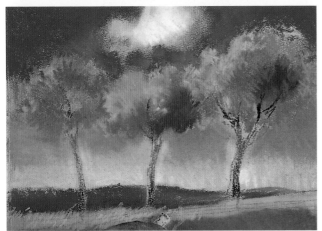

▶ 2. *For the ground, the details can be resolved with a direct style. The background color is a very apt base for new tones that are applied in pastel. In this area of the picture the different effects can be combined with direct strokes or color blending.*

> Painted layers of fixed colors make a good base for pastels to stick to, rather like a primed surface.

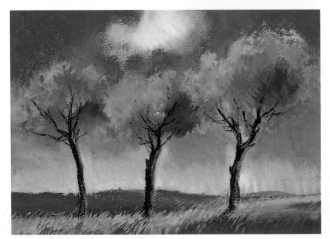

▶ 3. *A direct or fresh finish can be the ideal solution when using the effect of fixative at different stages. As can be seen, the lower layers show through the perfectly marked off and consructed new areas. The new blendings do not mix with the background colors thus giving the pastel an incomparable freshness.*

Step by step
Flowers

The pastel technique is the freshest and most spontaneous pictorial method, provided that you use it correctly. If you do not master the technique, or if you go beyond your limits, a picture that began with color and style could be spoiled simply by spraying fixative at the end of the piece. Timing is very important: never apply it at the end of the process. In this exercise we are going to paint some delicate flowers, with an emphasis on expressing the delicacy of color.

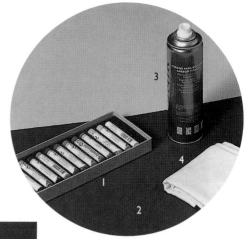

MATERIALS

Pastels (1), dark blue colored paper (2), spray fixative (3), and a rag (4).

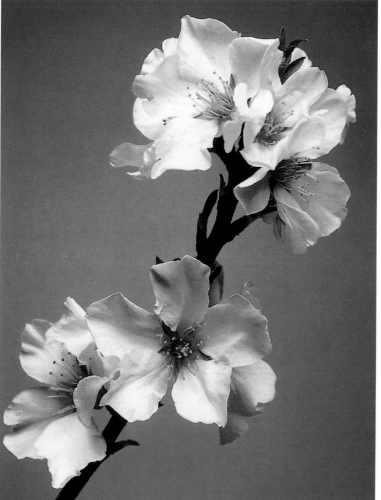

1. *As we have chosen dark colored paper, the best way to sketch the drawing is starting with a very luminous color, like white pastel. Sketch the principal lines with rapid strokes, only working on the planes. You can leave out the details for the time being.*

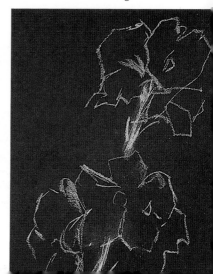

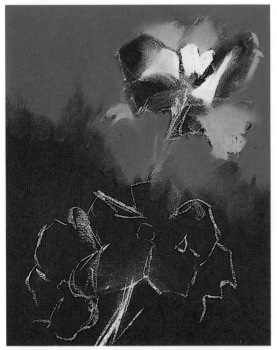

2. Start the painting of the upper flower in a gray tone, which will appear to be luminous, even on the dark background. This color is perfect for the areas of the flower which are in shadow, using hatching – a series of lines drawn closely together to give a shading effect. Use pure white for the brightest areas of the flowers: all the tones that are going to be developed are now in place. Outline the form of the flower by painting the background in marine blue, one of the most beautiful and luminous pastel colors. Use your fingers to blend the white over the blue background to give a much more whitish blue than before.

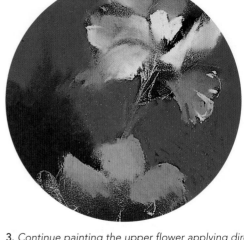

3. Continue painting the upper flower applying direct white color. Above this, paint gray to obtain the medium shadow tones. Without going so far as to completely block out the drawing form of the petals, blend the contrasts which appear overy brusque. This blending is extremely easy. The background paper color acts as a dark contrast between the petals.

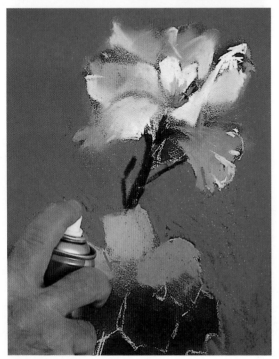

4. On the upper flower, start to paint some very direct white strokes to position the highlights. Bright orange and yellow strokes depict the center of the flower. Paint the stem with rapid strokes in dark green: do not go into details. Apply a layer of fixative to the entire piece. Hold the spray can far enough away so that the fixative does not clog up the paper surface or make the pastel sticky or stodgy. A light spray will suffice to protect the work against dirt or friction.

5. *The previous base has been fixed with the aim of protecting it as you continue working. For example, the new gray that has been painted on the petal of the upper left flower can be spread over the lower colors without dragging them in the process. Finish off the highlights of the petals that touch the background in this same way. The same approach is also valid for new orange touches that enrich the shadows.*

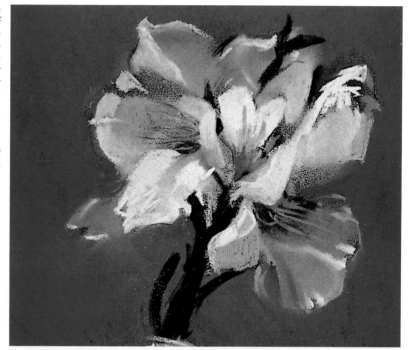

When you use a pastel fixative it is advisable to choose a well-known brand. Good quality manufacturers go to great lengths to ensure that their products do not interfere with the techniques or media used.

6. *While painting the upper area, you used the tones as the base for new color additions. You can do the same with the grays on the lower flower: when they have been fixed use them as a base for fresh tones. The blending of these colors will in no way effect the lower colors. Fixed colors do not mix.*

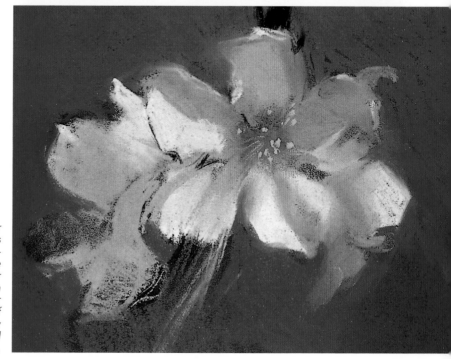

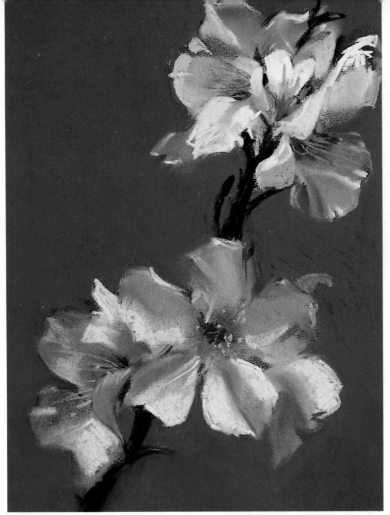

7. *Paint nuances of color that blend in with the edges of the colors underneath. This allows us to overlay new grays and very precise highlights. Lastly, all that remains to be done is paint direct red strokes and a few yellow dashes.*

SUMMARY

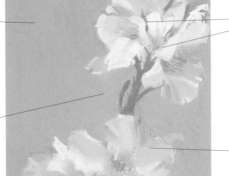

A dark paper color means that the composition layout will be luminous. Here it is done in white pastel.

A blue much brighter than the background allows us to outline the flower forms. Establish highlights by painting the lightest tones.

Very luminous white details emphasise the flower outlines as well as the highlights.

Paint the grays of the lower flower over the already fixed pastel layers.

Background effects

THE COLOR OF THE PAPER

When the color of the paper is going to create the base tone of the painting, it is important not to cover it completely with the strokes. The background has to be played off with the new colors applied, just like another color in the range. The result is an atmosphere in which the paper color determines the lighting of the model.

Pastel is a medium that allows the colors of the lower layers to be seen through the new superimposed colors, provided that the paper grain and pastel stroke are used properly. The background can have several different aspects: one unique painted or hatched color; a clean paper color; or several overlaid colors blended together.

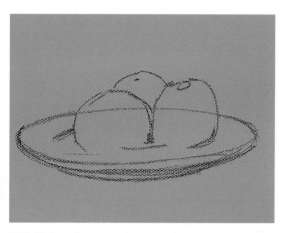

▼ 1. We have chosen quite luminous red paper to do this exercise because we want the color to condition the atmosphere. Draw an oval shape to represent the plate, and on top of it, three spheres to outline the apples.

▼ 2. Paint around the apples so that their forms are perfectly outlined and the colors are defined. Paint the plate in very light tones and leave the reflection areas in reserve. When you work on colored paper both the light and the dark colors give value to this background. If you paint in a luminous color, the color of the paper will take on the value of a medium tone.

3. To finish off the fruit, paint in a very direct style with a few carefully placed highlights indicating the way the light falls. Soften them with the fingertips.

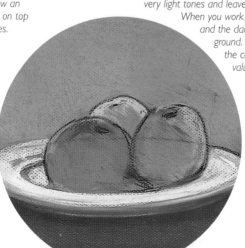

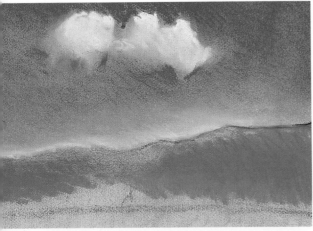

THE BACKGROUND

One option is to paint the background before working on the principal motif. Therefore, when you paint over it the base color will already be defined. This is a standard method in certain pastel paintings, especially when the background is complicated, such as a texture that could be altered by the main subject. Pay special attention to the steps in this exercise. Apply fixative to the background so that it is stable before you put on the different color layers.

▶ **1.** *In the background part of the paper, paint all the areas that form the atmosphere, including the hidden parts of the picture. What really interests us is to have a perfectly defined base, on top of which we can paint the focal point elements. We could compare this first part of the exercise to preparing a theater stage set. If you temporarily forget about the principal elements, you can work on the sky, the mountains and the background with ease.*

▶ **2.** *Once the first part of the exercise has been finished, you can fix all the work you have done so far. The fixative should be applied at a distance of about 20 cm., just a light layer that does not leave the paper sticky. Now the background is established and can be the base for the elements in the foreground.*

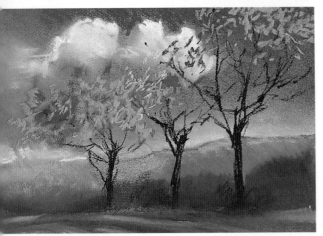

▶ **3.** *The layer that has just been fixed must be allowed to dry before starting to work on the landscape foreground elements. Any alterations that you may wish to make will not effect the layers that have been fixed. Paint in the foreground, the trees and the fences. The background can be seen clearly through the tree branches. The picture must not be fixed again.*

COLOR HARMONY
IN THE BACKGROUND

When the color of the paper in some way imposes itself as the base color it can be used to develop the color range of the picture. For example, in this exercise we will paint over a tobacco colored paper. All the colors used throughout its development belong to the same color range. Thus, it will be possible to establish beautiful color harmony.

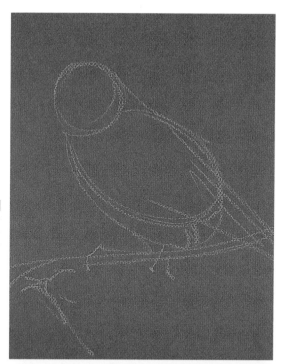

◀ *1. Tobacco colored paper is ideal for any theme. It is a great aid for obtaining a series of natural tones. Do the preliminary sketch in a very similar color to the paper so as not to provoke too strong a contrast. However, it must be sufficiently evident so that you can overlay the right colors.*

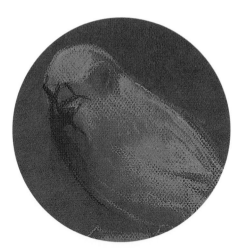

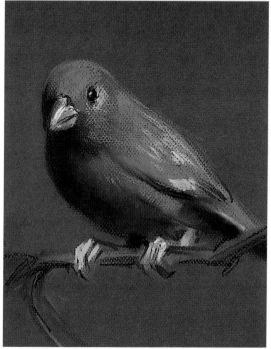

▼ *2. Using tobacco colored paper does not mean that the tones have to be variations of that same color. All types of colors from the warm range can be used, preferably the earth tones.*

◀ *3. The dark and light contrasts are added at the end. They mark out the forms and the dark areas outlining the bird against the background. As can be seen, the original paper tone shows through all the layers of color but there is no lack of harmony. The paper is the principal base of all the colors, uniting them together.*

SHADING AND STUMPING OVER THE BACKGROUND COLOR

In previous chapters the color of the paper has been considered as the chromatic base for the picture. This does not change throughout the pastel techniques: this medium is always much more luminous and effective when colored paper is used. The following exercise will not be difficult. It consists of combining marks, lines, stokes, and hatching with reserves of the color paper.

▶ 1. *Draw the preliminary sketch in a very light blue pastel so that the flowers are left in negative (reserved). The paper color will be decisive in the first marks you do on top of it, and in the final tones of the picture.*

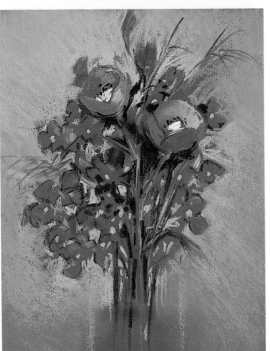

2. *Do the area around the flowers in very pale colors: press down hard enough to seal the paper grain in some areas. Add carmine and pink pastel to these flowers, but leave the blue ones untouched; they are going to use the paper color.*

▶ 3. *Do the highlights on the blue flowers with tiny dashes of a very light blue. In some areas this blue will blend perfectly into the background.*

Step by step
Landscape

When you take advantage of the background color, it becomes part of the range. This is what we are going to do now. Here we will do a landscape with a very limited range of colors. The final objective is to allow the base color to show through the pastels used and for it to work like the other tones. Paint on pastelcard so that the texture is very different to pastel.

MATERIALS
Pastels (1), gray card (2), and a rag (3).

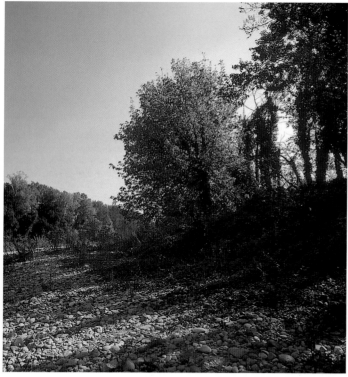

1. *Start with a layout of the landscape. These first lines must not be descriptive. They are only to position the masses. Draw with the different possibilities that pastel offers you: flat, crosswise and lengthwise. The tops of the trees are have been outlined with soft strokes, made with the stick working crosswise. In the lower part, do very dense, lengthwise hatching.*

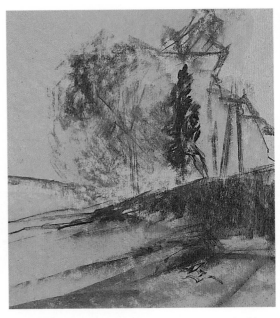

2. *Pastel is much more stable on card than on paper. The pores of this surface are quite closed, however, this first color layer could seal it completely. Use orange pastel to shade without covering the whole card surface: the stick is held flat between the fingers. The background color highlights the texture of the stroke.*

3. *When you paint the orange color over the blue it causes some dragging and a slightly green tone is created due to the mix. These are the only two pastels that are going to be used. Blue will create the contrasts that define the forms. The orange, apart from adding atmosphere, will compete with the blue and forge new tones due to the blending of the two colors.*

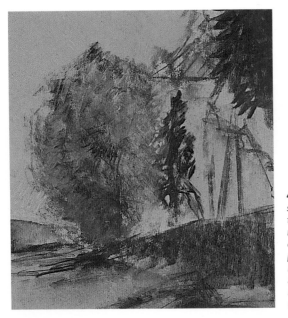

> Doing the layout with the stick held flat allows you to use a uniform and very straightforward drawing style.

4. *It is important to maintain the presence of the support tone despite the different color applications. The strongest contrasts, realized in blue, make these small glimpses of the support stand out for their luminosity. On the right of the picture, paint with the necessary pressure so that the blue is dense and opaque. For the tree in the middle add alternatively, in a jabbing style. The two colors are then mixed gently with the fingertips. However, do not completely do away with the stroke.*

5. *Continue to progress with the small mixes and color blendings for the bushes in the background. To give the right volume to the texture, paint some very direct blue contrasts. The trunks are painted with back light, which gives greater presence to the orange color in the sky. Observe how the tones blend and how the overlays create mixes. In some areas the blue strokes are dense, while in others they hardly touch the card, thus allowing the orange and the background to show through.*

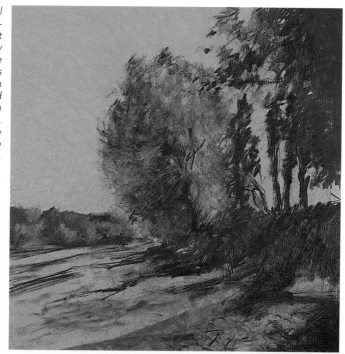

> As the pores of the card support are very closed, the stroke tends to slip.

6. *In this step the emphasis is on the colors applied with a direct heavy stroke, in blue as much as orange. Center your work on the foreground where the land lies. Firstly put in the blue contrasts. Over this blue, and also over the areas which were blended before, make direct orange marks. On top of the dark parts on the right, mark directly with little orange touches. This will tone down the excessive contrast created by the blue.*

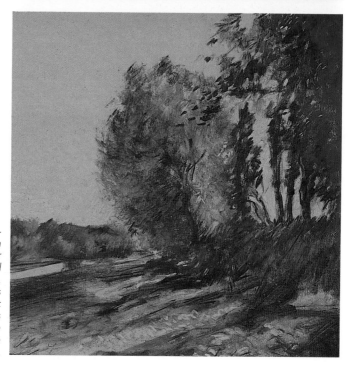

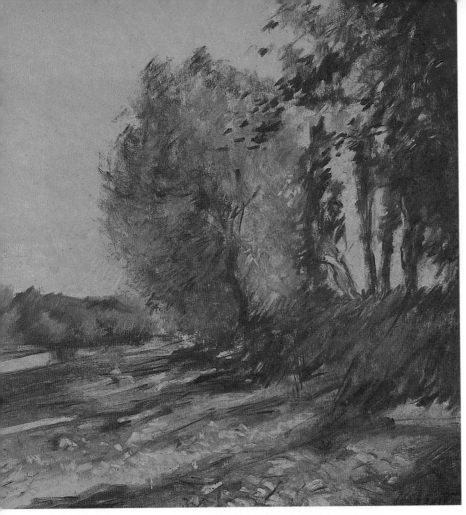

7. *To finish off this landscape exercise, blend the earth tones lightly and apply some direct heavy orange strokes. Finally, paint the large vegetation mass on the right in blue, which will enlarge it a little. This rounds off this landscape. Observe how the background color shows through the tones added and contributes towards the fresh and spontaneous finish.*

SUMMARY

All the support is painted with orange. Holding the stick flat between the fingers allows a light stroke through which the pastelcard color can be perceived.

When orange is painted over blue, a part of the lower color is dragged and so creates tone changes and mixes.

The contrasts are painted in blue, a color which is perfect for creating the backlight effect.

The orange applied with a direct jabbing stroke increases the luminosity of the ground: the tones contrast more intensely.

11

Animals

OUTLINE DRAWINGS AND SKETCHES

Pastel is an ideal medium for all types of sketches, especially for drawing animals. The two reasons for this are the similarities pastel has with drawing and the possibilities that the method offers for using all types of marks and strokes, so useful in creating form. In this topic we are going to sketch and paint animals with the effects offered by the pastel stick. The secret of good painting is not just in the stroke but in the way you use it.

Animals are one of the most attractive subjects to depict, whatever the drawing or painting medium or method. Top quality results can be achieved with pastel because stumped marks combined with stroke effects permit all types of skin or feather textures. In one of the previous chapters we already painted a bird, and in another a horse. We advise you to go back and check on the process before attempting the more complex examples. The exercises show how in this topic, animals, just like all elements from nature, can be rendered in very simple straightforward forms.

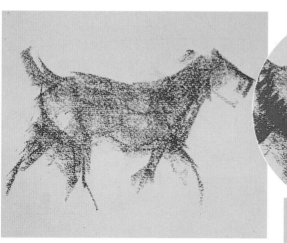

▶ **2.** *Outline the most characteristic areas and suggest the volumes through dark tones. Before working on the final texture of the skin or hair, the direction of the light source has to be decided. You can show this effect by increasing the darkness in the shadow areas and by using pale tones in the light areas.*

▼ **1.** *The stick held flat between the fingers allows a substantial variety of strokes. To paint certain types of animals it is best to start by doing preliminary sketches with the stick held flat. Rapid gestures can insinuate the shape of the animal. The first issue to be considered when drawing or painting animals is the stroke that structures the back and the proportions of the forms. This sketch has been entirely drawn holding the stick flat between the fingers.*

3. *The sketch can be finished off by tracing in some important lines. It is not necessary to completely draw the animal's outline as some areas are adequately suggested by the original strokes.* ◀

COLOR

There is nothing better than painting animals to put into practice a thorough colorist technique. In this exercise color will play the most important part. To start out, it is necessary to remember that colorism is a pictorial technique which depicts shadows with pure colors, not tones or gradations. In a technique like pastel, in which the colors are applied without mixing, colorism is one of the soundest options.

▶ 1. *In colorist painting, the color of the paper is important: you can start from a complementary color. Here, as a base, the paper color chosen is going to stand out intensely against the other colors. The first lines are for the preliminary sketch, and then you must tackle the synthesis of the forms, here oval, expressing, as far as is possible, the anatomy of the animal in pure geometric shapes. When doing the preliminary sketch you have to use a color close to that of the paper color so that corrections do not stand out too much.*

▶ 2. *Once the preliminary sketch has been finished, go over the principal lines and give form to the drawing, preparing it for the color additions. In this stage you can use the stick either flat or on its tip, depending on whether you want to do a shading or a stroke for the outline. Now you can add dashes of colors which will later be blended with highlights or color contrasts.*

> Practice with color. This is the only way of overcoming your uncertainty. Testing out colors on papers that you use for painting gives good results.

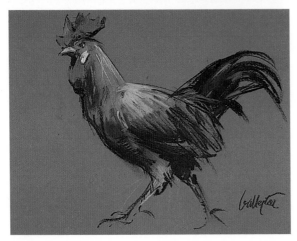

▶ 3. *On top of the defined base and the insinuated colors, add many more accentuated strokes and shading, using the under layers as base marks. Place the brightest colors opposite the darkest so that they mutually strengthen and complement each other. Instead of doing tone alterations of the same color or gradations, use a variety of luminous colors to depict the different planes and the feather texture. It is vital that the lower colors show through the new top strokes.*

LINES, HATCHING AND SHADING

Combining effects is the basis of painting animals. In previous sections we have seen two different aspects of depicting animals: sketches and working in color. As will be seen, the expression of a painting must not reside only in the language of lines and shading. The true interpretation of forms and textures is achieved through a balanced combination of painting styles.

1. In the initial layout we saw how a flat stroke can easily outline an animal. This will be the base on which we build. At this stage the characteristics of the stroke marks do not matter, but the quality of the form outlines do. Once you have made the stroke, blend it into the background but without blocking out the drawing. ◀

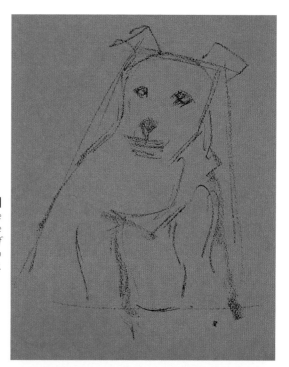

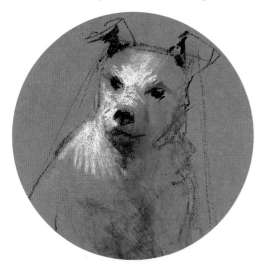

▼ *2. Shading can be a perfect base on which to paint animals. Suggesting shapes through shading and hatching often stimulates the imagination and helps to associate a stroke with the image sought after. Once a shading has been put down, you can go over it with a more direct stroke, but do not allow the form outline to become blurred.*

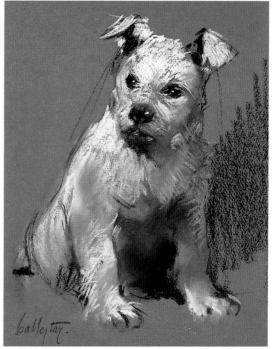

3. When you come to the end of this exercise try to achieve an equilibrium between strokes, hatching and shading. Some areas are left insinuated. Alternate completely defined strokes with contrasting stumped strokes that have blurred, diffused edges. ◀

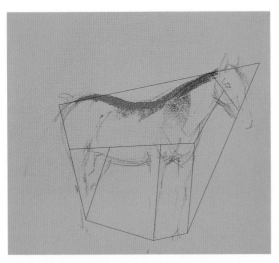

A COMPARATIVE STUDY OF TWO ANIMALS

The aim of this exercise is to learn how to construct the structures of different animals. Comparison is always a good tool for learning how to paint, if you have a discerning eye. When animals are compared, the first place to focus your attention is on the relationship between the head, the torso and the legs of each animal. The layouts reveal important differences in their proportions.

▼ *In this example which was developed in the same way as shown on the previous pages, you can appreciate how the horse's back has been constructed. A flat stroke has been used to make the long, curvy neck line, which naturally joins the back and hindquarters.*

Here you can see the two animals completely finished. Studying them reveals considerable differences, both in the legs and in the proportions of different parts of the body. It is important to notice the joints of the legs; each animal has a different build. ▲

The cow follows the same pattern as before. However, the cow's neck has a different shape to the horse's. The sizes and shapes of the heads are also distinct. Even at this stage the most evident differences between the two animals can be appreciated. ▲

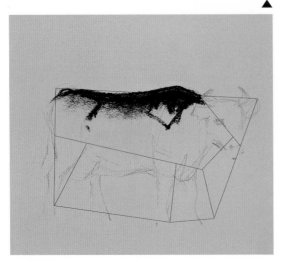

Step by step
A horse grazing

Painting animals is one of the most complicated themes that can be attempted, not only in pastel but in all media. However, pastel is very suitable for animal studies because its direct application means that it is similar to drawing in issues of technique. A very intuitive style is made possible. In this exercise, we propose painting this beautiful horse. Pay close attention to the process right from the beginning. Although it does involve greater complexity than the previous exercise, developing the picture will not be especially problematic if you do it systematically.

MATERIALS
Pastel (1), white paper (2), and a rag (3).

1. If the beginner is not sufficiently experienced, it is advisable to do as simple a layout as possible on the paper so that the structure is well set out and allows sure and accurate work. Do a preliminary sketch so that you have a guide. The horse fits into the square which, if it is divided up, allows you to plan the principal forms.

STEP BY STEP: A horse grazing

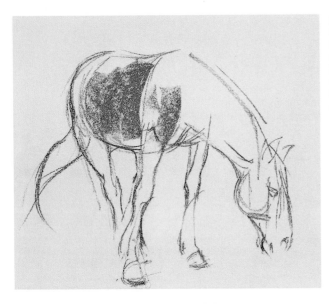

2. *Building on the preliminary sketch, go on to do a well-defined drawing. Use hatching to detail each of the horse's body parts, as well as its features. Holding the pastel flat between the fingers, start to paint its body. Rapidly depict its volume with curved strokes defining some areas of the anatomy, like the hindquarters or the front leg thigh.*

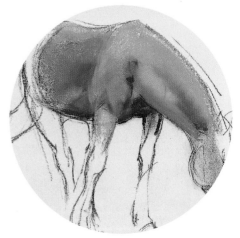

3. *It is important not to use just one color to do the shading of the horse. When you paint you already have to be thinking about which tones you are going to use next. Bear in mind that blendings between colors allow a very smooth transition between tones. If you start with a sanguine color tone this new application will be much more luminous and orangy. Paint the darkest black areas with gentle strokes on top of both tones. Use your fingertips to blend these tones, while at the same time seeking to model the forms.*

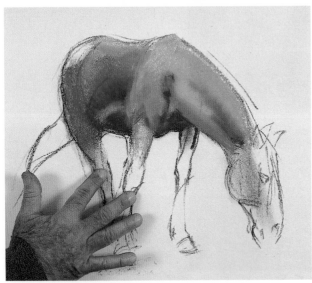

4. *If you observe how the animal is positioned you can appreciate differences in the highlights on the hindquarters. This area should be painted with a dark tone of the same range that has been used for whole the horse. Darken the lower part of the horse's belly, making the highlights more evident by using the effect of the simultaneous contrasts. To do the clearer tone of the horse's knee, drag some of the color towards this area with the aim of graying it a little.*

5. *Use black pastel to paint the densest contrasts; these are the ones that finish off the outline of the horse's forms. Paint the mane, the dark parts of the legs and the tail black. Contrast the modeling of the horse's belly with the fingertips smudged in black pastel. Afterwards, start painting the highlights using a pale gray color.*

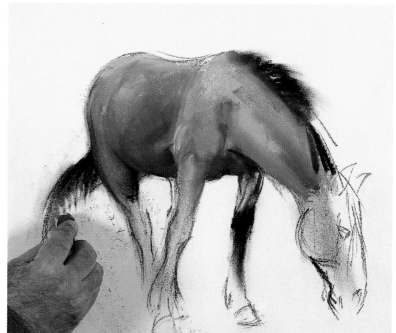

In any pastel work the first step you take must be focused on the forms and color areas. The contrasts and the details are left until the end.

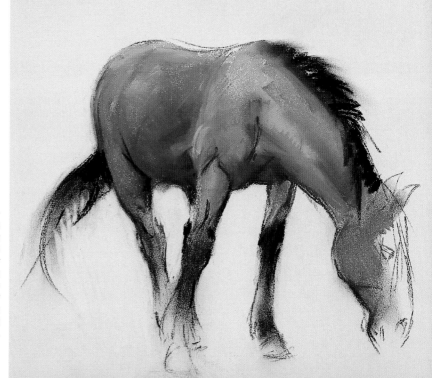

6. *You have to continue painting the areas that require a more gutsy contrast in black and blend the tones with the layers beneath. The exact color of the lower parts of the legs is achieved by blending the black to make it similar to the paper tone. Repaint some areas, like the hindquarters, with direct touches of an earth red color.*

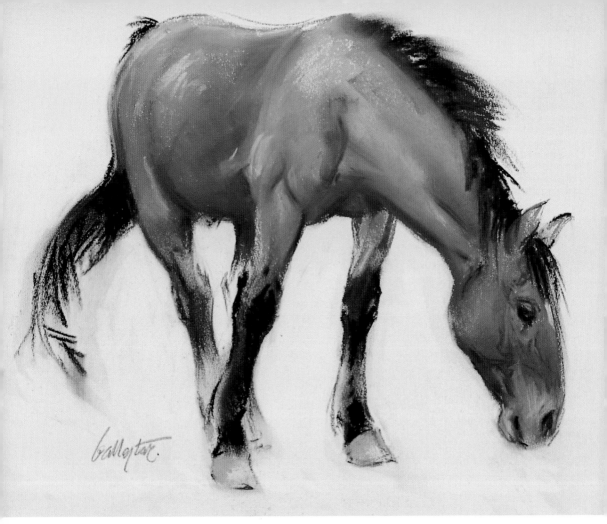

7. *You still have to complete the horse's head. Use the same technique of modeling, blending and contrasting the rest of the body. However, in this area you have to be especially careful when adding shadows. Paint the dark parts last and then* blend them softly with the fingers. Finally, *paint the mouth in a pale tone which you then blend on top of the previous tones. To highlight the details always avoid completely obliterating the characteristics of the stroke.*

SUMMARY

The layout must define the forms starting from simple geometric shapes.

Do the first color applications on the horse's belly. The stroke direction aids the form modeling.

Make the highlights on the legs by softly dragging a finger over the white of the paper.

Use black pastel to paint directly over the dark areas of the animal, such as the legs.

Skies

THE COLOR OF THE SKY

There is not just one color in the sky: any color under the rainbow can appear in the sky at sometime. The atmosphere, the time of day and the weather conditions are all influencing factors on the sky's color. On the following pages we will give some notes which will help you to develop a wide variety of skies.

The sky is one of the most important elements in the landscape, although, in fact, it is a subject capable of being painted on its own, or with other elements. Here, we are going to do skies at different times of day, and under varied meterological conditions. Painting skies is very creative, and offers the possibility of showing off the versatility of the pastel technique.

▼ 1. *You can paint a sky using various colors that form a gradation. To start, it is judicious to order these colors naturally, perhaps exaggerating the more realistic ones. However, often it is not really an exaggeration for nature can be wilder, or more spectacular, than the palette of any painter. In theory, the colors have to be conceived without blending or overlapping the tones.*

▼

2. With your fingers, blend in all the sky areas. The blending order is important because some areas must be blended but kept clean. In this example you have to start blending at the top. Gently blur the edge between the colors so that the change is subtle.

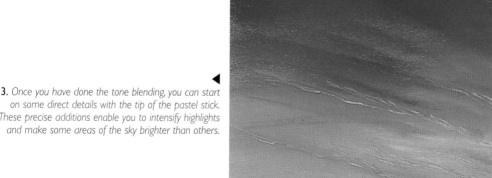

◀

3. Once you have done the tone blending, you can start on some direct details with the tip of the pastel stick. These precise additions enable you to intensify highlights and make some areas of the sky brighter than others.

▶ 1. To start a clear sky, first tackle the upper tone, which is nearly always the darkest and purest. This is due to the atmospheric layer which increases as the horizon is neared. Below this first color band there are others which form a tone gradation. It is essential that the color situated just under the horizon stands out for its luminosity. It is at this point that the atmosphere becomes thicker and tones down the brightness of the other colors in the sky.

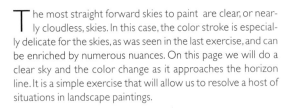

SHADING PALE SKIES. THE HORIZON LINE

The most straight forward skies to paint are clear, or nearly cloudless, skies. In this case, the color stroke is especially delicate for the skies, as was seen in the last exercise, and can be enriched by numerous nuances. On this page we will do a clear sky and the color change as it approaches the horizon line. It is a simple exercise that will allow us to resolve a host of situations in landscape paintings.

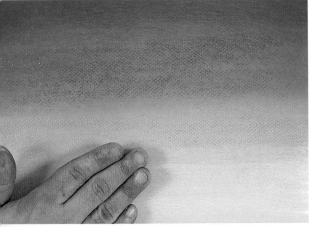

▶ 2. Just passing the fingers gently over the sky areas is sufficient to convert the sky into a homogeneous color mass integrated with the other colors in the picture. You must be particularly careful when going from one tone to another for clear or luminous colors can easily be contaminated by the dark ones in the upper part.

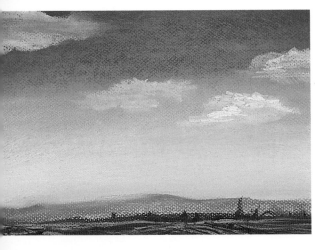

▶ 3. The final tone nuances add luminous dashes to the whole range of gradations. Starting from this color base, numerous modifications can be made such as can be seen in the bottom picture where some clouds have been superimposed. Another important question is the treatment given to the whites. Only apply pure white in the highly luminous areas.

CHANGING SKIES

We have already said that the sky changes throughout the day in a continuous process. In this exercise we are going to do three different skies of one landscape at different times of day. The first is at dawn when the horizon is tinged with red tones. The second will display the luminosity at midday with yellow nuances on the horizon. Lastly, you will paint an evening, almost night time, sky in which the deep blue tones are almost mauve.

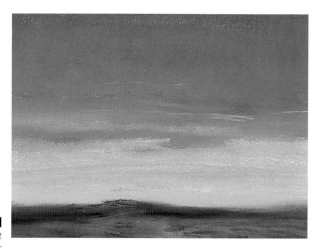

1. *The sky at dawn and in the first moments of the sunset can be almost identical. The sun on the horizon saturates the color of the atmosphere with pink tones and produces almost unreal colors in the lower areas. With pastel it is easy to obtain light and color, even after the original colors have been put in. Be especially careful when blending the tones so that they do not dirty each other.*

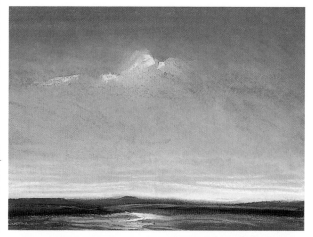

2. *It is at midday that the sky is full of light. The blues become rich and pure. On the horizon, depending on the day, tone changes can be observed. On very hot days, in some areas, dust particles hang in the air giving a reddish and yellowish hue.*

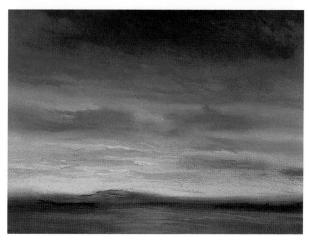

3. *Dusk always presents a display of very contrasted tones. The colors of the night, deep blues or violets, are contrasted with the remains of the day's colors. These final rays of sunlight are represented by luminous pastel strokes that tint the sky with pinks and oranges. Here, too, you must be careful when blending the tones because it is important to maintain the vitality of the luminous colors. Paint, blend and superimpose these tones saturated in light at the end.*

CLOUDS

Clouds come in many shapes, colors and textures. Despite the appearance of their capricious forms, the condensation does not happen randomly. This process divides the clouds into three groups: cumulus, cirrus and stratum. The altitude of the clouds, their density and the time of day mean that more or less sunlight passes through. Thus, some areas are illuminated while others remain dull. In this exercise we are going to paint some stormy clouds. Pay special attention to the tone blending and the maximum tone contrasts.

▶ 1. *The choice of paper is an important question if you want to take advantage of its color. In this example gray will help you to depict stormy clouds. In this exercise we are not going to allow any glimpses of the sky to show through. Therefore, what you have to work on is the clouds. The first step is to draw the forms of the storm clouds and then you can start to think about adding dark and light areas.*

▶ 2. *Paint the most luminous tones but leave the centers unshaded to take advantage of the paper color. These tones can be ivory white, pure white, or even Naples yellow. You can also start on the darker tones that correspond to the cloud shadow areas. As can be seen, the paper color is perfectly integrated into the clouds, although, as yet, the hues have not been blended.*

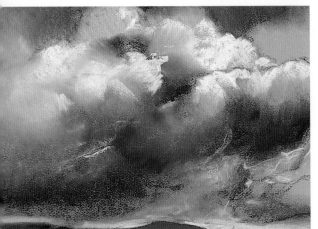

▶ 3. *Blend the dark tones and the light areas on the paper with the fingers, thus permitting the cloud forms to be modeled. Do the modeling with curvy movements which blend the tones into the paper color. Once all the blending has been carried out, paint and outline directly in some areas, while in others add precise highlights.*

Step by step
A sky with red clouds

Painting clouds can be one of the most rewarding and enriching works that you can do in pastel. You do not need to have a very elaborate preliminary drawing to start out. Besides requiring less preliminary work, another advantage is that skies can give spectacular results if you choose the right moment. This model is a fine example.

MATERIALS

Pastels (1), gray colored paper (2), and a rag (3).

1. *The preliminary sketch is not as important as it is for other pictorial themes. However, as will be demonstrated in this example, this sketch will be used as a guide to do the planes of the picture and to adequately situate the colors. Do the drawing with the tip of the stick. If you use a clean stroke you will be able to differentiate the land planes from the cloud forms. While the land is characterized by tight, dark drawing the clouds are much more curvy and suggestive.*

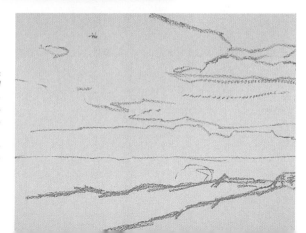

STEP BY STEP: A sky with red clouds

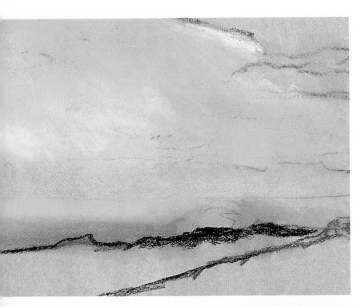

2. *Start with the most luminous sky tone, where the clouds still reflect the sun's rays. These first colors are of different yellow hues which gradually turn into orange tones near the horizon. After doing the initial strokes, pass the fingertips over the work to fade away the stroke a little.*

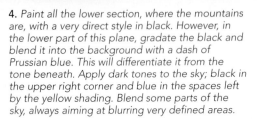

3. *On top of the orange band on the horizon, paint a very bright pink strip. Use pale violet on the lower part of the clouds, enriching the tone with a few blue dashes. Pay attention to the new lower band on the clouds. Draw a fine blue line on top of the pink band and then blend it with the fingers until you obtain a precisely located dirty tone.*

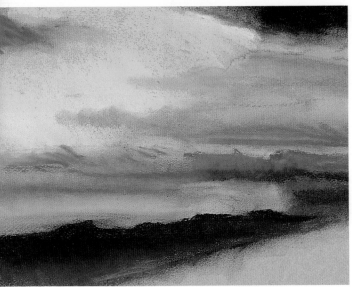

4. *Paint all the lower section, where the mountains are, with a very direct style in black. However, in the lower part of this plane, gradate the black and blend it into the background with a dash of Prussian blue. This will differentiate it from the tone beneath. Apply dark tones to the sky; black in the upper right corner and blue in the spaces left by the yellow shading. Blend some parts of the sky, always aiming at blurring very defined areas.*

5. *Paint the darkest parts of the sky gray. Make the contrasts with the most luminous tones stand out by placing them next to lighter areas; these are not in white, but rather very pale variations of Naples yellow. Paint the shining sun with the shading technique, in yellow, Naples yellow and orange. Do the foreground in a very deep black tone, as a good contrast for the gradation you did before.*

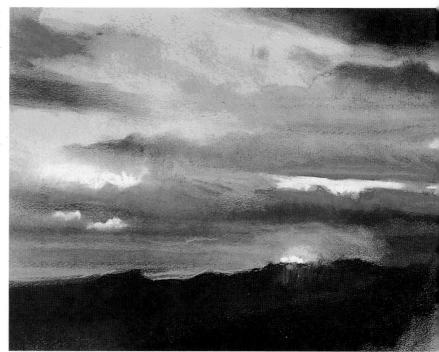

6. *Paint on top of the yellowish clouds with much more luminous tones that are superimposed over the dark parts of the picture. Where you have painted some areas blue, you must now darken them with black pastel. The bottom right corner of the land is painted with a blue hue which you should blend with the black. The base color is ideal for continuing to do different luminous details. Three distict styles can be used: very direct jabbing strokes, straight lines or little dashes to blend everything together, smudging, on top of the lower tones.*

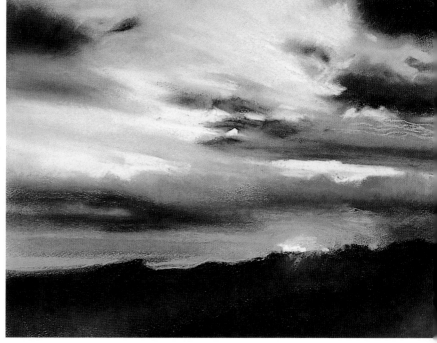

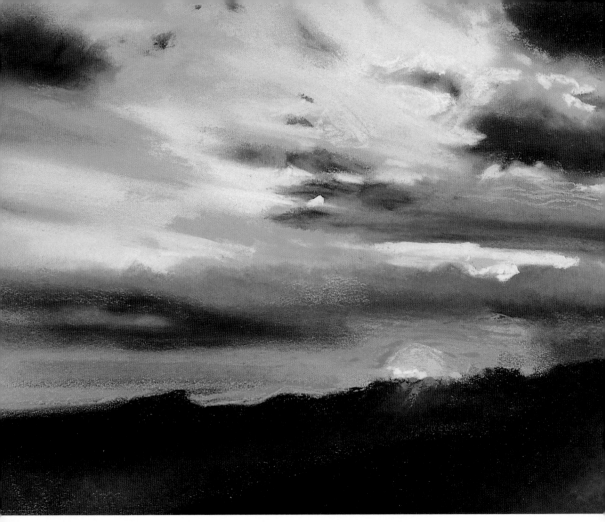

7. *A bone-colored tone gives the final, very direct, touches to the highlights in the sky. Further soften some areas on the left by incorporating a very luminous pinkish color. Finally, you have to paint the sun and the glow around it. You have now finished this impressive sunset sky.*

SUMMARY

Apply the brightest and boldest colors first before going on to superimpose the top darker tones and contrasts.

Paint the band near the horizon in orange and pink hues and then blend them into the first layer of color.

Paint the impacting light last of all. Do not blend all the areas. Instead leave them fresh and direct.

Paint the most striking dark parts black, a color which boldly contrasts with the most colorist sky areas.

13

Trees

THE STRUCTURE OF TREES

I t is important to be familiar with the internal structure of objects before starting to depict them on paper. As we have studied up until now, all forms and objects of nature can be represented by working from straightforward geometric shapes. A tree can also be seen in this way. The synthesis of its forms is much more obvious than other things in nature.

Trees are often elements that give the landscape a lot of its character. Sometimes they are an important part of the drawing and need to be highly elaborate and detailed. At other times, you can define them with simple green shadings that blends into the background. In this topic we are going to do some examples that will be a model for future exercises. The techniques we use will enable you to paint all types of tress in any landscape.

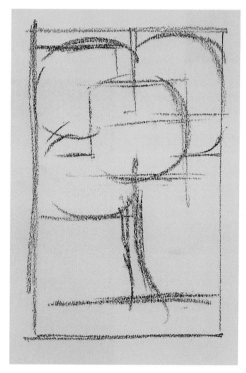

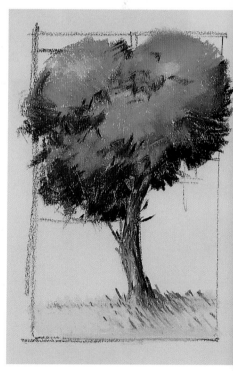

▼ We are going to use a triangular shape on numerous occasions to draw perennial trees like firs or cypresses. Before painting this tree you must sketch its form so that you can visualize it more easily. It is important to study the highlights of each one of the tree areas. The shadows help to correctly place the different green tones.

▼ A rather complicated shape can be fitted inside a simpler scheme, which, if you use it as a guideline, can help to understand the internal structure of the branches. As can be seen in this picture, the tree starts from a rectangular shape divided into different sections that allow you to describe the branches and trunk with almost straight lines.

▼ Once you have outlined the general shape of the tree, you can draw and paint the final version. First do the edges, then, the inside of the tree, add the strokes and colors it give texture.

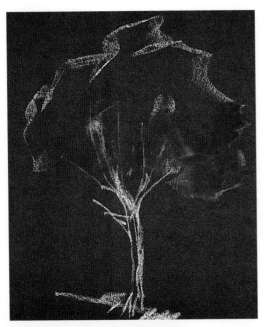

SHADING THE TREE

S hading always adds a sense of landscape, whatever media you are painting in. After the preliminary sketch the color shading helps to guide the whole process. In this exercise you can appreciate in detail how to use a correct shading technique so that the contrasts are supported by the light and dark tones. The direct style of the pastel stroke means that a broad variety of shading options which prepare for light or shadow areas, and the final texture and touches, are possible.

▶ **1.** *When you have finished the preliminary sketch, start the shading of the tree. The pastel stroke offers you the possibility of doing either flat lines, with curvy movements, or using the full width of the stick. This is why the first colors added always acquire a markedly drawing-like quality. The lines that start the shading of the tree are principally aimed at setting out the volumes. A tree, unless it has a perfectly pruned form, can come in a multitude of shapes, each one with its own light and shadows.*

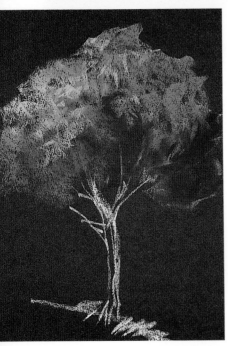

▶ **2.** *Once you have set out the first dark parts, you can paint the brightest areas. In this example, as the paper is colored, white stands out forcefully. Continue to shade the tree with your fingertips, making the stroke mark less visible and blurring the edges of some areas. In other areas the stroke is left visible. It is important to remember that you do not have to stump all the tree.*

3. *After the shading with your fingertips, you can start to finish off the tree by laying down new tones. Apply some tones directly and spontaneously without any stumping. Blend other hues but never go so far as to mix them with the colors or tones underneath.*

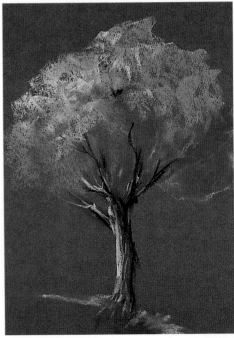

PAINTING A TREE

A s we have seen, the pastel technique offers an endless range of possibilities, from shading right through to different finishing touches. You can work on a tree in a great variety of methods, blending, shading and using direct strokes.

In this exercise we are going to do a double piece in pastel. We will start working in a fresh and direct style. Then we will study how to resolve the tree texture.

1. *Use green-colored paper. Many areas of it will blend perfectly with the pastel, especially the areas containing green tones. The first strokes to put down are completely drawing-like. Shading is not suitable here, nor is blurring the color. On top of the preliminary sketch, do strokes that gradually merge into other colors, but always maintain the fresh and spontaneous properties of the stroke. You must not make the pastel too pasty, neither must you blend it. Use a completely gestural style.*

▼ 2. *This early work uses only gestual drawing and the pastel stroke in an attempt to make the landscape real. In this way all the surface can be covered. When you paint the area around the tree in a luminous tone, you will see that the trunk becomes clearly outlined. In the upper part, blend the color of the paper with the tones of the tree top.*

▼ 3. *Hatch all the areas that are going to be the base of other layers. On top of these blended areas, paint darker colors that create contrasts. Re-blend some dark areas, and then, on top of them, add luminous colors. The work that remains to be done alternates direct strokes with the blending of different shades.*

BUSHES AND VEGETATION

A landscape is often covered by vegetation that is smaller than trees, like bushes, thickets and grass. They are portrayed in pastel by combining the two basic techniques of the medium.

Often the details are not drawn in, but they are insinuated by soft stumpings or tone gradations combined with direct tones. In these masses of vegetation, what is really important is the effect of the light areas and the dark parts.

▶ **1.** *When you start to paint a wide area of vegetation you are confronted with the reality that no bush stands out on its own. What is visible is a mass of green shades with some tone differences due to plane changes and deeper shadows in some areas. The way the whole picture is set out is important: it must be treated as one object. You must do the preliminary scheme linearly and you must give volume to the vegetation.*

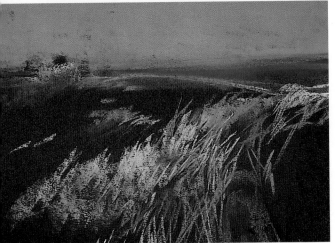

▶ **2.** *Use several green tones to mark the picture in different areas according to the degree of luminosity desired. However, do not go beyond certain well-defined limits. As can be seen, the stroke is sufficiently dense so as to leave an important quantity of pastel on the paper. Put the pastel down thickly so that you can blend it with your fingers, thus giving shape to the different plants and bushes. One important point is that the more the vegetation recedes into the distance, the more the trees and bushes tend to blend into one unique tone.*

> The color of the paper must always show through the strokes to convey the sense of space and light in the atmosphere.

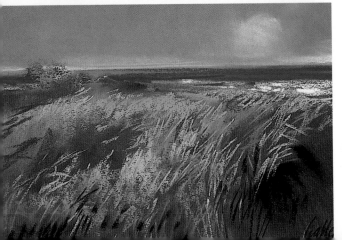

▶ **3.** *Once the tones have been merged, apply direct colors so that the painting is more contrasted and precise in the shadow areas. Paint free, loose strokes in the areas where light falls.*

Trees and vegetation

Portraying scenes in which the vegetation plays a key role is a recurring theme in landscape painting. When you start out, you may think that all vegetation is the same color, but with perseverance and much practice you will soon learn how to distinguish the wide range of nuances that compose a quiet corner like the one shown in the image. There is not one particular rule for painting vegetation. However, you should bear in mind the capacity of pastel to be blended and superimposed if you are interested in carefully laying down different tones in the trees and bushes. Pay special attention to the contrasts you create in the landscape near the lower part of the river bank, and the upper part of the trees.

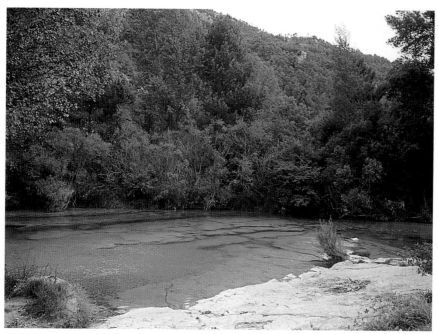

MATERIALS
Pastels (1), colored paper (2), and a rag (3).

1. *Here the drawing plays a key role, although it must be very simple. First the far bank is drawn in with a white edge. Over this line all the vegetation area is sketched in. In the tree and background mountain area limit yourself to just doing the outline. The near shore is also now outlined.*

STEP BY STEP: Trees and vegetation

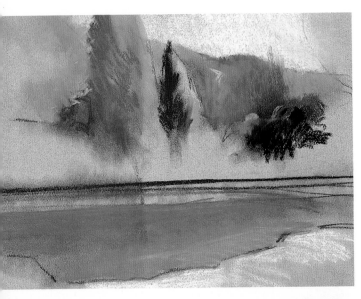

2. *With pastel, direct mixing cannot be done on the paper. Instead, paint each tone, whether it be clear or dark, in a pure color from the pastel box. Use a very luminous green in the lightest part of the trees, and a somewhat darker one for the shadow areas. Paint the densest parts with a black slightly mixed with the lower tones. Paint with white in the foreground so that the color of the paper contrasts and blends in like just another color. The sky is painted in white tinged with a little Naples yellow.*

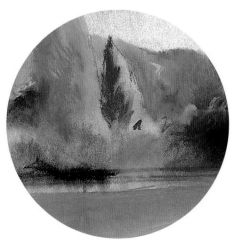

3. *Blend the colors where the edges meet, but do not mix them. Some colors, for example the violet tone above the bank and the cobalt blue on the right, act as base tones for other colors that will be painted later. The unique area in the picture where the colors mix is on the right. Here a dirtied color is necessary, so paint in a mixture of sienna, black and green. Mix lightly with the fingers so that the colors are completely blended.*

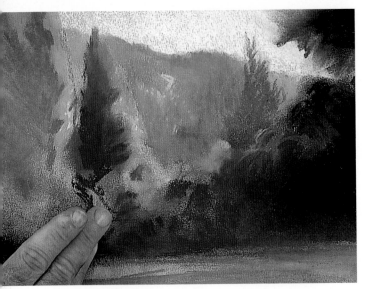

4. *Superimpose the colors in the luminous trees on the left. Allow the background tones to show through the darkest strokes. Blend some areas by rubbing with the fingers and contrast the recently painted dark brown tones above the bank.*

There is not a unique rule for painting vegetation although the following should be kept in mind: pastel has a high capacity to be blended and superimposed if you want to obtain different tones in the trees and bushes.

5. *On top of the completely shaded background, paint some very defined colored areas. This time do not blend the strokes. Instead, leave them fresh and let the layers underneath show through the gaps. Use dark green to shade above the bank. As can be seen in this image, the stroke must be zigzagged, very ordered and must follow the top of the thicket in this area.*

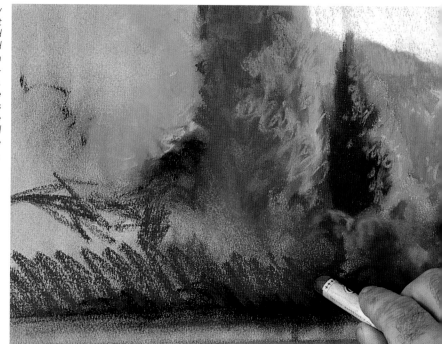

Pay special attention to the contrasts that are established in the landscape. In the final picture they give life and impact to the whole painting.

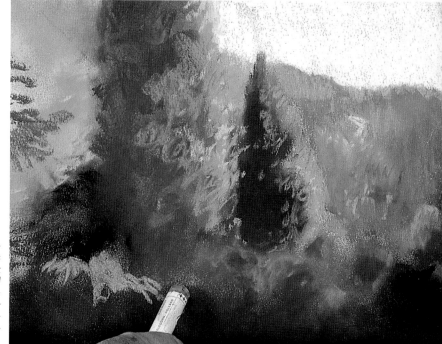

6. *Use your fingertips to completely blend the previous dark strokes. This somewhat dirties the unpainted band beneath the bank. Over this dark area, paint the upper section of the vegetation lit up by the sun with a very luminous green tone.*

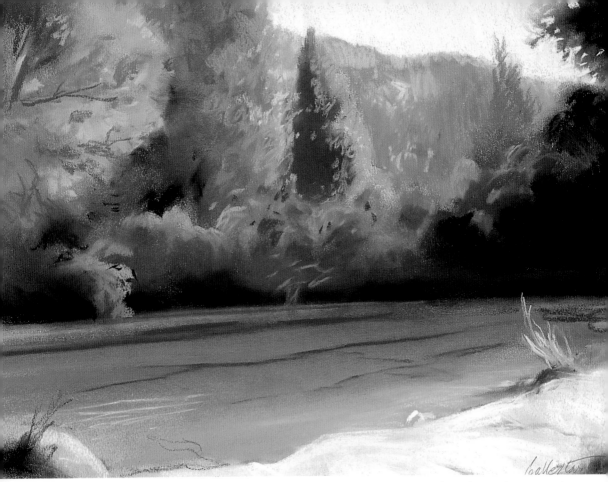

7. Taking care not to mix the upper colors, blend the light green part of the bank thicket over the dark background. With the same light color used to paint the most luminous area, lay down some new fresh strokes. Paint the left of the landscape in the same way as the bushes along the shore, but this time with much more luminous colors. First, do some shading that blends together. Finally, make some jabbing direct style strokes. After painting a few more contrasts in the foreground vegetation and in the water, you can consider this landscape finished.

SUMMARY

Before painting the trees lay down a base of blended tones.

The preliminary sketch is very straightforward. Only lay out the general forms of the trees and the banks.

In the foreground, paint in white. The background color of the paper is integrated into the overall effect.

Do the blending of the water area without mixing the colors.

The only color mixing that you do is on the right of the landscape, where it requires a deliberate dirtying of the colors.

Urban landscape and perspective

NOTES ON THE CONCEPT OF PERSPECTIVE

Urban landscape offers many possibilities because any town or city can be depicted from numerous viewpoints. To get the most out of these possibilities it is necessary to understand the principal concepts and rules of perspective. It will not be difficult to comprehend if you pay sufficient attention.

In cities and towns it is common to see artists using streets and squares as models, even in areas that at first sight do not seem to be especially attractive. Urban landscape can be considered as part of the natural landscape theme, although there are differences in the way it is treated and its technical requirements set it apart. One of the fundamental requirements to sketch and compose an urban landscape is the application of perspective, which we are now going to explore.

The horizontal line situates the horizon (1). On this line, mark a point called the vanishing point (2). All the lines parallel to each other that run from the viewer towards the horizon coincide in this vanishing point.

If the viewpoint coincides with the horizon line, the viewer is looking from normal eye level in the street. The lines drawn in blue represent viewpoints above normal eye level. At the point where the vertical line is cut by the vanishing line, draw the lines that mark the height of the frontal viewpoints. These lines, just like the horizon line, are completely horizontal.

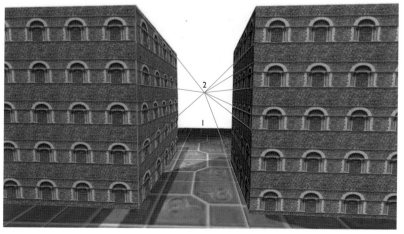

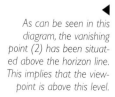

As can be seen in this diagram, the vanishing point (2) has been situated above the horizon line. This implies that the viewpoint is above this level.

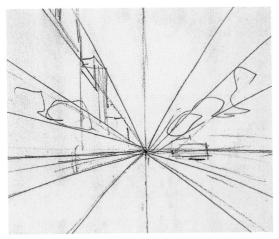

PERSPECTIVE AND LANDSCAPE

S tarting from the diagrams and explanations in the last section, we are going to do a perspective exercise in pastel. It will not be too complex, particulary if you follow the images and the steps in the text with attention. As can be seen, only one vanishing point is used and, therefore, all the lines of perspective follow in the same direction.

▶ 1. *Trace the horizon line. Mark the vanishing point in the center. All the vanishing lines run towards it. Draw several lines that go through the vanishing point. Two of these lines situated beneath the horizon line are to be the base of the earth planes and the vertical planes. Draw the buildings that border the line of perspective with several vertical strokes. Sketch in trees in the avenue between the two lines of perspective. They become smaller as they recede into the distance.*

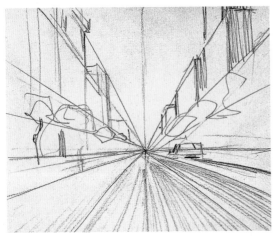

▶ 2. *The height of the vertical lines that correspond to the height of the buildings are determined by the vanishing lines. From the intersecting point of the vertical lines and the line of perspective, trace small horizontal lines parallel to the horizon. These lines finish off the form of the buildings. This process can be used to do all types of buildings and streets, always respecting the corresponding heights and depths.*

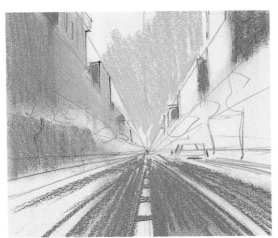

▶ 3. *Once the principal lines and constructions have been set out, you can start to distribute the principal color areas over the picture. Pastel allows a rapid and fresh work style, although it does not permit the colors to be mixed. You have to find a pastel stick with the right tone. Each plane is going to have a different tone. First, use gray to paint all the road area. Mark off the darkest area of the buildings on the right with a brownish gray. On the left, paint the buildings in an ochre color.*

COLOR AND DISTANCE

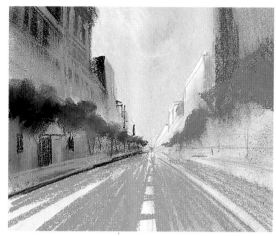

1. As we have studied, colors can be superimposed over light colors or dark ones, which helps the picture to be developed quickly. Paint the façades of the buildings on the left in orange, except the shadow areas which you can do in an almost black color. On the lightest side of the street, paint the tree tops in a very luminous green. On the darker side, use a darker green. As you paint the tones receding into the distance, you can fade out the details and the building contrasts, too.

> The colors are can be superimposed on top of both clear and dark colors, allowing the picture to progress rapidly.

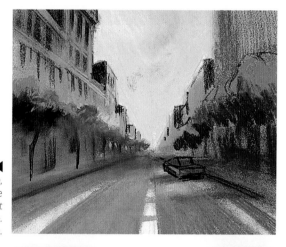

2. As the objects recede into the distance, nearing the horizon, they appear smaller and more blurred. The lines that run to the vanishing point indicate how much smaller the trees must become. The trees in this exercise can be painted using this guide. The further away the trees are, the less details you have to put in.

3. The features of the objects in the distance are also done in a very undetailed way. Observe how the traffic signals painted on the tarmac become smaller as they run towards the vanishing point. Lastly, apply the deepest contrasts to finish off the definition of the remaining objects in this urban landscape.

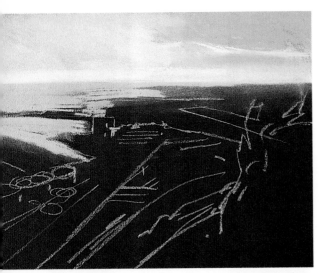

THE VIEWPOINT

The viewpoint allows a landscape to be depicted from different heights. A high viewpoint places the ground plane below the spectator in such a way that they observe the landscape looking down. This exercise presents an urban landscape viewed from the peak of a mountain overlooking the city. You must study the direction of the lines of perspective carefully as well as the effect produced when a plane in the foreground is situated between the viewer and the landscape.

▶ 1. *The preliminary sketch must take into account the viewpoint. In the first layout, the horizon line has been placed high up so that it coincides with the viewpoint. One is looking down from a high viewpoint on an extensive area of land and sea. One of the effects that can help to portray this type of perspective is placing a plane at the same height as the viewer. In this example, on the right a piece of ground at the same height as the viewer has been sketched in. You can use very clear tones to paint the sky, taking advantage of the paper color.*

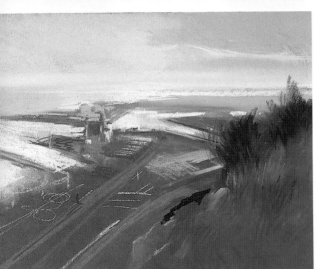

▼ 2. *The colors in the distance tend to tone down the contrasts and to merge together, especially when the atmosphere is dense. In this urban landscape, you can observe the color differences between the way the foreground has been resolved and the background planes. To intensify these differences, the background colors are whitish and outline the breakwaters in the port. Paint the land in the foreground with very contrasting colors.*

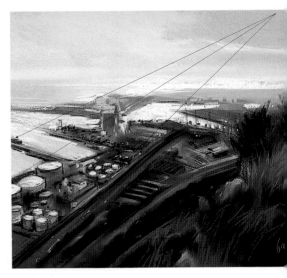

▼ 3. *Observe how this high viewpoint has been resolved. Placing perspective lines gives a sense of distance. The color of the paper also plays a fundamental role since with just a few luminous strokes and some defined dark contrasts, all this industrial port has been depicted.*

Step by step
Urban landscape

You can use any corner of the city as a model for painting. Even obviously sordid areas often make for highly interesting pictures. To get satisfactory results with an urban landscape, a good perspective drawing technique can be the key. In this exercise, among other points, we introduce straightforward effects which can be used to paint urban landscapes. To put them into practice there is nothing better than a busy city street. Long, straight thoroughfares are ideal to develop perspective and the vanishing point.

2

NECESSARY MATERIALS
Pastels (1) and paper (2).

A good technique for drawing perspective is essential for getting satisfactory results from an urban landscape. This is, without a doubt, the fundamental key to the development of a good painting.

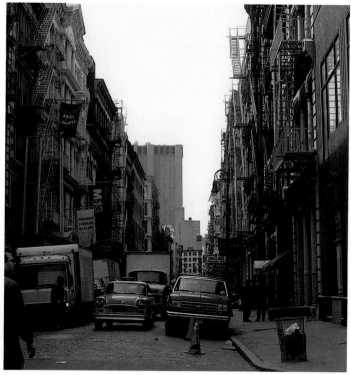

1. *In the diagram the lines of perspective have been set out. Mark off all the building planes, both the upper and lower parts, with lines that recede towards the vanishing point, situated on the horizon. To do this preliminary sketch, it is not necessary to put down strongly marked lines. However, if you are not very skilled in drawing you can do a series of perspective lines that will help you to layout the planes. Do this linear diagram by looking at the direction in which the sidewalk, the base of the buildings and the building tops point. The vanishing point is located where these lines intersect.*

STEP BY STEP: Urban landscape

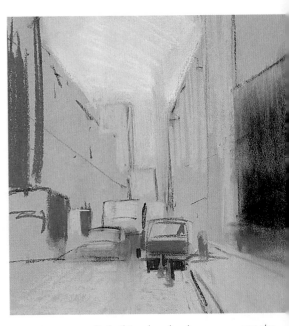

2. Once this part of the drawing is finished, paint the sky area; first use a very luminous yellow color that creates a strong contrast with background. On top of the base color do white shading and then run your fingers over it to blend the white and the yellow. The result is a dense color, typical of city fog or smog.

3. In this urban landscape we want the color of the paper to function like the other colors in the painter's box. In some places allow it to show through in such a way that the colors and tones create an interesting effect. Shade the darkest buildings with a dark pastel color and, immediately afterwards, blend this tone with the fingers so that the walls have a typically dirty city look.

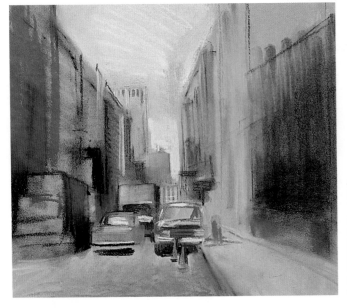

4. The most distant buildings are less contrasted than those in the foreground. Therefore, use a very luminous bluish gray tone on them. Outline the parts that must remain bright in a dark gray. These sections go well with the color of the paper. Make the highlights stand out with clear luminous gray strokes. Apply a deeper color on top of the dark gray of the sidewalk and then blend it with your fingers.

5. *Taking advantage of the color of the paper enables us to obtain an atmosphere with very realistic light. On top of the dark parts of the buildings on the left, paint a few pink dashes. Use very dark gray to outline the warehouse entrance on the right. It is then made to stand out with a luminous tone. Paint the cars with small dark strokes, not pressing too much. On top, apply little touches of shading to strengthen the highlights.*

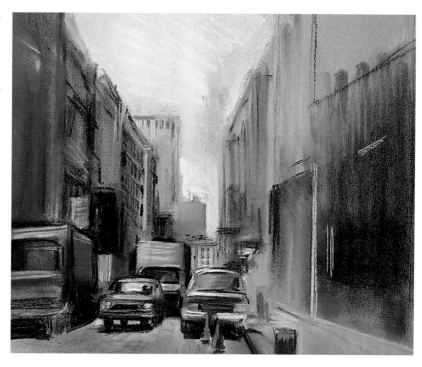

6. *Add a few yellow dashes to the buildings on the right so that the picture soaks up the openness of the sky. Use a very bright cream-colored pastel to paint the warehouse windows on the right. Perspective once again is highly important: observe how the window lines follow the same direction as the rest of the vanishing lines. Add new, almost white lines to suggest the shape of the windows.*

To merge the colors it is necessary to rub vigorously with the fingers. Do not be afraid of staining your hands.

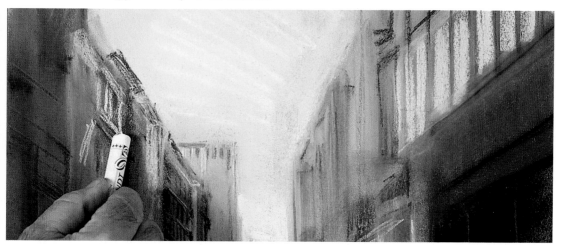

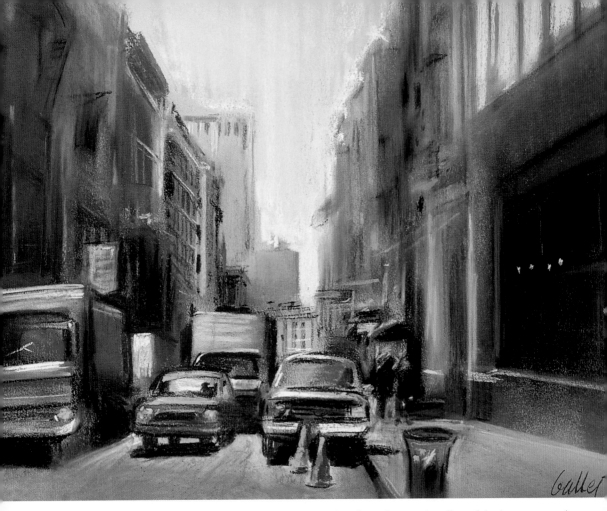

7. In the upper part of the left-hand side buildings blend the tones with your fingers to make the strokes painted last less prominent.

This also enhances the effect of the heavy atmosphere and the sensation of distance. These details finish off this pastel urban landscape.

SUMMARY

Firstly, paint the sky yellow. This immediately integrates the color of the paper color into the theme being painted.

To indicate the perspective of the planes, the lines of perspective must recede towards a point on the horizon. Two lines that start off parallel tend to intersect at **the vanishing point.**

The most distant plane is much less contrasted than the buildings in the foreground.

Use dark gray to stump the buildings on the right in the foreground. The color of the paper always shows through the stumped tones.

Still life

SETTING OUT THE ELEMENTS

Throughout this book we have looked at different questions related to still life. All of them were vital guide lines for doing any pastel painting well. In this chapter we are going to explore some concepts such as how to lay out the elements in a still life so that the picture composition is harmonious and balanced.

A still life is one of the most interesting themes that can be developed in pastel because of the techniques used and the many ways it can be elaborated offering far ranging possibilities. Moreover, it permits a thorough study of the forms and color, while the necessary techniques are not so difficult as for figure or portrait. Even beginners can produce good results with still life, whatever their level. This chapter deals with some general concepts related to still life in pastel.

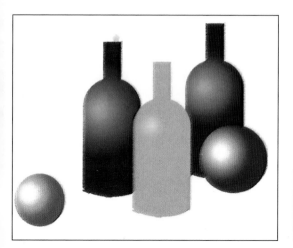

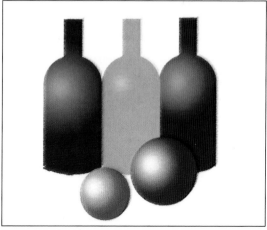

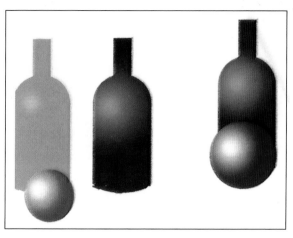

▼ It is important to arrange the elements of a still life well. In this image you can see that they have been correctly laid out. If one of the objects is moved, here the sphere has gone to the left, the group on the right is still well balanced.

▼ Here the same elements are presented but their distribution is not pleasing to the eye. The error is that they are excessively crowded. The line-up is too harsh.

▶ When you are seeking a certain balance between the forms you could fall into the trap of making the composition too dispersed. In this picture the objects have lost their unity: there is no equilibrium between them so the final composition does not hold.

INITIAL SHADING AND OVERLAYING STROKES

The painting of some objects in a still life can be achieved direct-ly on the paper. The technique allows corrections to be made immediately, either by flicking the stroke with a cloth or covering it up with another stroke.

Here we are going to do a flower, alternating the two principal pastel processes. Start the work with rapid strokes that outline the principal forms. It does not matter if one stroke overlaps another. Pastel allows you to change the drawing style from pure strokes to a more painting-like style, using the stick flat to do impacting colors.

▶ 1. *After you have drawn the flower, shade the interior. Alternate using the tip of the stick with the flat stroke which allows you to cover the surface much more quickly. As you progress with this area, start to reduce the harshness of the strokes. Gently rub them with the fingertips. You must work lightly so that the color surface is not completely blended.*

▶ 2. *The light and shadow planes in pastel are resolved very easily. It is merely a question of applying a lighter tone on top of the already painted tone. This will separate out the light planes of the object. The edges of the petals are drawn with small touches of a very luminous color on top of the pink of the flower. The clouder tones allow the separation of the planes inside the flower and at the same time you can work on modeling the forms.*

◀

3. *Do not mix to obtain differ-ent tones, neither light ones nor dark ones. Do the darkest shadows by painting over the lower color with a darker one.*

TONAL VALUE

In other chapters pastel has been used to bring the best out of values, tone gradations and blendings. You can do several effects without the need to blend the colors directly with your fingers. If you want to lessen the visibility of the stroke you can give little flicks or rubs with a brush. This technique for semi-blending the colors can be used together with tonal values.

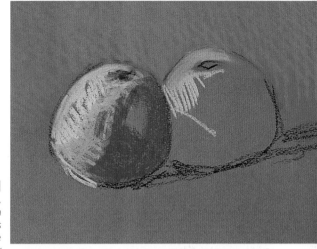

1. *Once the model, here a still life with two pieces of fruit, has been drawn, you can start to paint the background in green cross-hatched strokes. Outline the apples with this color. After painting the background, move on to shading the apples. The shadow colors are much denser and warmer than the highlight areas. The color of the paper sometimes shows through between the recently painted strokes.*

2. *Once all the colors have been put in, take the fan brush and start to gently blend the color. However, be careful not to push too hard because the brush removes the powder quite easily. When the brush is passed over the painted surface, the colors merge in a gentler way than with stumping or with the finger. The stroke does not blend completely.*

> Depending on the brush you use, you can produce different diffused effects. Some special brushes allow you to do very detailed work.

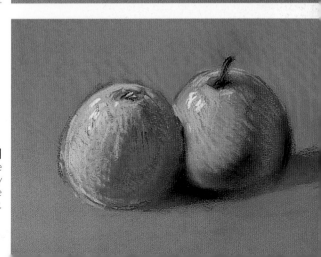

3. *In this exercise which is full of light and color, not only is the use of the brush important but the direct impact strokes also play a key role; they combine perfectly with the stumped areas to give the necessary final contrasts which define the forms of the fruit.*

HIGHLIGHTS AND REFLECTIONS

Highlights and reflections in a still life can be painted in several ways. It is always important to take into consideration that pastel can be painted with blending or with direct strokes of light. In this exercise you will be able to see how precise highlights are made on glass.

▶ **1.** *Right from the first moment pastel requires a well-constructed design drawing, especially when you do little painting work. You can do the drawing, which is always the base for any reflection or highlight, in light or dark colors, depending to a large degree on how much the line is to stand out on the paper. The stroke must be as clean as possible, although if you make a mistake you can erase it. Paint the most luminous highlight in white just below the center of the glass.*

▼ **2.** *The tenuous highlight in the center is resolved by gently blending the color. On top of this, inside the vase, paint the reflections in the water. The green color of the paper is reserved by the other tones, integrating it into the overall color effect. Alternate tone blending with direct pastel strokes.*

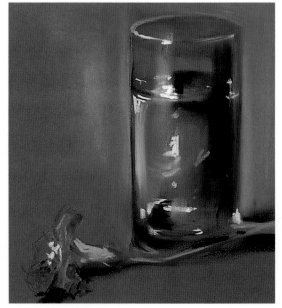

▼ **3.** *Working on the base of the defined contrasts, do the final forms with small highlights and precise dark areas in different areas of the picture. Paint the most heavily shadowed part of the glass in black. Next to it, make a small highlight which contrasts the glass shape against the background. Finally, paint the brightest parts, like the reflection on the edge of the glass or the highlights in the finger, with direct color strokes.*

A still life of fruit on a plate

The still life proposed here is not very complex. However, you must pay close attention to the initial layout as the colors of the objects greatly influence each other. You will also learn that it is easier to represent any fruit than to do the precise curve of the plate. Looking closely at the model, you can see the soft fruit shadows that create an effect with the adjacent colors. Despite these complications, it is not difficult work if you pay close attention to the steps outlined in this exercise.

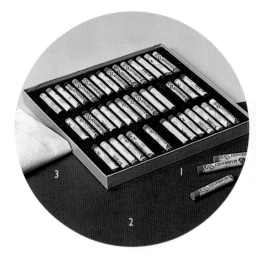

MATERIALS

*Pastels (1),
colored paper (2),
and a rag (3).*

You have to take great care of the model. Both the colors and the positioning of the fruits will have an important impact on the quality of the work.

1. *Before starting to paint it is important that you do as good a drawing as possible. Do the preliminary sketch in dark pastel. The most complicated form is the plate, so be prepared to dedicate time to it. You can correct it by laying down more strokes until you get its shape right.*

2. *Before starting on the color, fade the drawing a bit with a cloth so that the dark strokes do not contrast too much. Paint the darkest tones on the fruit: dark orange for the pomegranate and violet carmine for the shadow tones on the plums. Paint the light part of the plums with a violet pink. Do the most luminous colors on the pear and the apple with a yellowish stroke.*

4. *Remove any excess pastel on the table-cloth by gently flicking with the cloth. Paint the edge of the plate and the background in a very light cream color. However, do not allow the color produced to be too contrasted. Paint the pomegranate on the left with a very bright orange tone. All these touches will ensure that the contrast between the object colors and the background is finely compensated.*

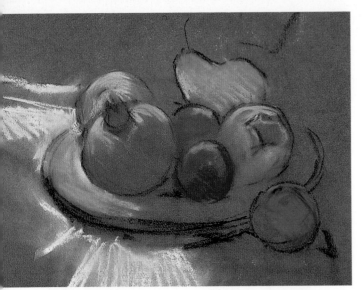

3. *Paint the plum on the table in a very brilliant pink, and the pomegranate pink, orange and green. The colors in this area are gently blended with the fingers. Paint the tablecloth a very luminous white which stands out against the background. Use firm strokes at the beginning. Draw a radial stroke outwards from the plate using the tip of the pastel stick.*

> The most precise forms are always the most complex ones, especially compared to pieces of fruit as the latter allow a margin of error.

5. *Do each dark part of the fruit in a different color. The colors of the pomegranates are reflected onto the other fruits around them, and vice versa. On top of the dark parts of the pomegranate, do pink tone shading, and on top of the plums shade with blue shades and a light orange tone.*

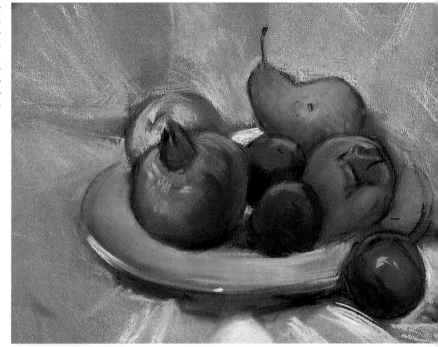

When you move on to do the dark areas and the areas in shadow it is important to remember that not all of them will have the same tone. Each shadow is affected by the color of the object reflected.

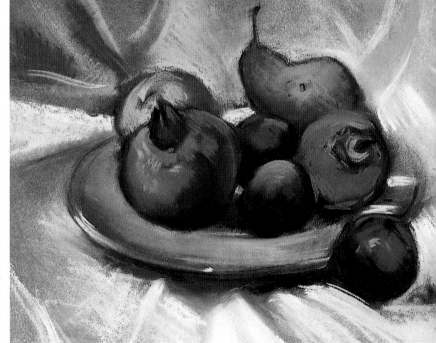

6. *Intensify the luminous effect of the pomegranate on the right with a very bright pink color. Paint some very direct white strokes on the plate. The color of the paper plays a role in this still life. Now the work is centered on resolving the tones of the tablecloth.*

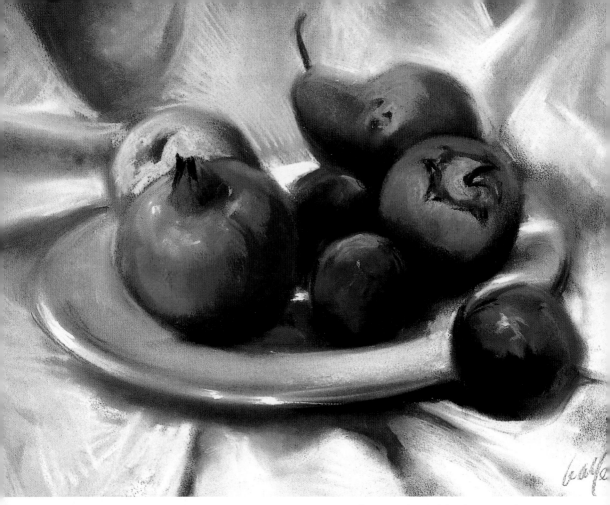

7. *Enhance the pale parts and the dark areas. Lightly blend the shadow of the plate on the tablecloth with the fingers before painting in a soft green tone. Paint a light gray on top of the plate* *and define the edges of the fruit by marking out the shadows. Leave some areas intact but gently blend others with the fingers to make the strokes less visible. Never go as far as to mix the colors.*

SUMMARY

Do the initial drawing by taking a lot of care and by correcting any possible errors on the plate. The precise forms are always the most awkward to achieve and are left to be done at a more advanced stage.

Sharply define the highlights on the plate. They integrate the color of the paper into the background.

Firstly, paint the dark parts on the fruit and then, immediately contrast them with luminous colors. The way you play with the simultaneous contrasts can enrich the picture.

Do the white of the tablecloth with radial strokes before blending the tone.

664

Figure studies

FIGURE SKETCHES WITH THE STICK FLAT

Very few materials are necessary to do quick sketches, and even fewer if you are working in pastel. This exercise tries to convey the essence of what a sketch is. Bear in mind that it need not be an elaborate work: just a few marks can be sufficient to capture the character of the figure. However, these marks must be placed accurately, even if this means correcting strokes already down on the paper. Pay special attention to the way the stick is used, and remember that it is the flat edge that gives the most adaptable stroke.

Sketching is one of the best ways of learning to draw a figure. Quick strokes and the spontaneous character of this way of drawing make for a very expressive motif. This is an aid when drawing highly complex figure forms. When pastel is treated as a painting medium, rather than as a drawing method, it is possible to create beautiful figure sketches without losing the properties of the stroke.

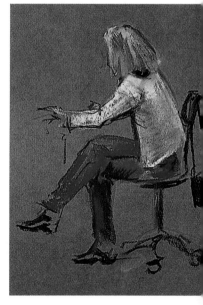

▼ 1. *After having done a quick layout, develop the figure working with a flat stroke, using the whole width of the stick. Use a light color in this first addition so that on top of it you can lay on darker tones in the following steps.*

▼ 2. *Once the figure form has been laid out, you can superimpose new colors, which give greater clarity. In this example a slightly darker tone than the previous one has been used to trace out the shadow areas. The first tones are left in reserve. This does not mean that you cannot add luminous tones. However, if you did then you would be going beyond a mere sketch and this is not our principal concern now.*

▼ 3. *The final contrasts finish off the definition of the figure's volumes.*

To understand and depict figures it is very useful to consult artistic anatomy books.

CALCULATING THE PROPORTIONS

When doing rapid figure sketches the basic proportions of the body must be observed, although these measurements can vary according to the build of the model. However, bear them in mind in any figure exercise.

Calculating the proportions between the different body parts of the figure will help you to do a better sketch. When you are doing rapid drawings it is very important to know the differences in the sizes of the parts of the body. Only if you get this right will the figure on the paper be more or less in proportion. A tiny or big head, or any other part of the body that is out of proportion, would turn the figure into a caricature.

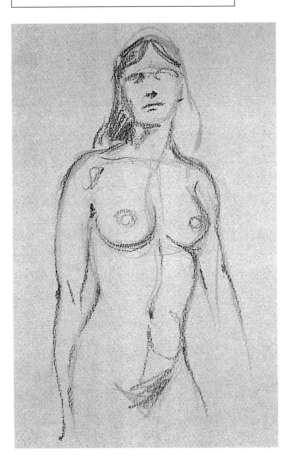

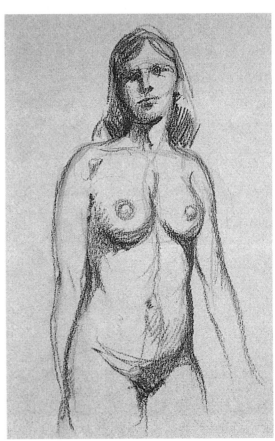

▼ 1. *Observe in this illustration the relationship between the head and the width of the shoulders. This measurement will determine the width of the whole body and is therefore highly important. On a normal body the shoulders tend to mark the maximum width of the torso, which narrows as it nears the waist.*

▼ 2. *Although the figure being drawn has a strong construction, what really counts is its internal structure. If this image is compared with the last one, the starting point for this exercise, you can see that the anatomy has changed considerably. Despite the pose being the same, it is the internal structure which determines the principal lines. The figure on the right is more corpulent but the internal structure is the same as before.*

LINES AND THE PRELIMINARY SKETCH

The best way to pick out the subtleties of the model is in the layout, which is a drawing technique all painting methods need. Up until now we have seen that a preliminary sketch helps when doing a still life and landscape elements, and this is also the case with sketches of figures in general.

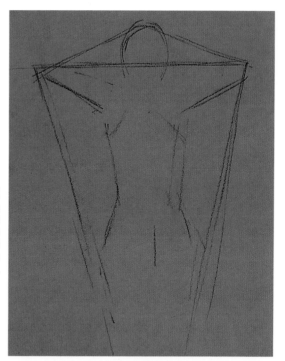

1. Drawing in grid-like boxes will enable us to schematize any pose, however complicated it may be. Doing the figure in this progressive way is very useful. It makes the outcome easier to control. The few lines seen in the image on the left are easy to elaborate and understand. Working directly on the figure is a much more complicated method.

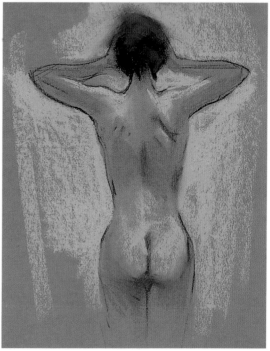

▼ *2. Once the forms of all the boxes have been set out, it is not difficult to position the different elements precisely. You must still use very simple strokes because you are not aiming at a detailed finish yet. What concerns us is giving a general understanding of the forms, which will allow us to close in on the details later.*

3. The lines that build the figure can be rubbed out easily or covered in new strokes. Position the light areas and the contrasts that will give definition to the figure. The color of the paper will be integrated into the overall effect.

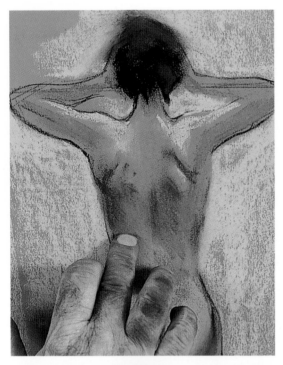

VOLUME IN SKETCHES

Just because we are doing a sketch does not mean that we can omit details like light and volume. Although a sketch is always done quickly and almost spontaneously, the properties of pastel make it possible to do blendings and modeling. Of course, one must not go too far otherwise the freshness and general pastel style would be lost.

▶ **4.** At the beginning of this topic we suggested that you should start the sketch with a flat stroke to give a solid-looking drawing and to define the forms clearly. If the paper is colored, as is the case here, it can be used to your advantage to integrate the forms. Then you go on to suggest the main volumes.

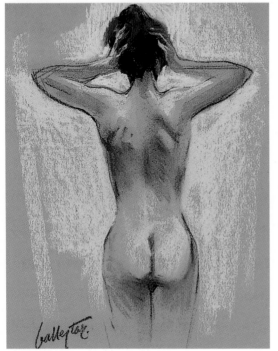

> Superimpose the main dark areas onto the sketch in such a way that the light areas are perfectly defined in the picture.

▶ **5.** The final step is to put in the principal highlights. This process shows that when you are seeking volume in a sketch, it is not necessary to use pure white. Clear tones can take its place: indeed they play a role in the transition from medium tones to brighter areas. If pure white is used, limit it to very defined areas. As nearly all the surface has been covered, the highlights will be integrated into the volume effect of the figure.

Step by step
A figure study

The value of the color of the objects is shown through gray strokes in the shadows and white areas in the light. To learn about white highlights we have chosen a female model. The effect produced by one unique color with touches of pastel gives a lot of volume. If this is added to the color of the paper being used, the impact is very realistic. To do the study on this page, we are going to use a restricted color range, which will enable us to observe the figure modeling without color getting in the way.

MATERIALS

Sanguine pastel (1), white pastel (2), pastel crayons (3), Havana tobacco colored paper (4), and an eraser (5).

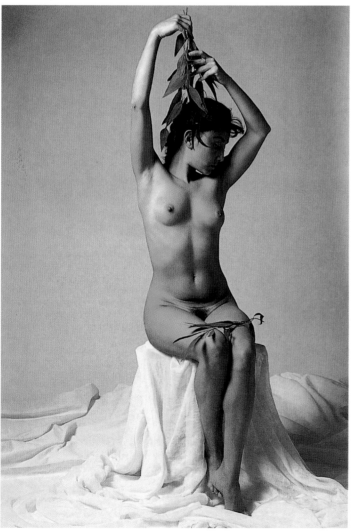

1. *To start the picture off, combine flat strokes with using the tip of the stick to outline the forms. Aim at making the drawing fine-lined, especially for the thighs and the form of the calves. You can put in the initial lines that begin to define the facial features and the hair. This will call for some precision, so use the tip of the stick, which will help you to be more accurate.*

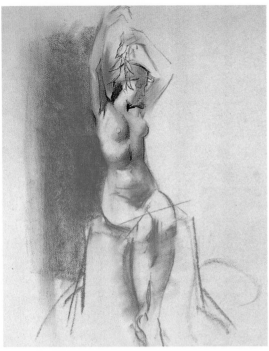

2. *Without rubbing too hard, use the fingertips to fade the most obvious strokes. Suggest the principal volumes with shading that allow the paper color to show through. You can outline the stumped areas more precisely by using the edge of the eraser. As the breasts, the back of the head and the raised arm are partly shadowed, trace gray strokes over them. The figure is then outlined by doing a general stumping over the background.*

3. *The contrast in the stumped background should be increased with soft strokes to produce a new mix which can then be blended with the fingertips. The contrasts that stand out the most are to be blended with sanguine. Model the abdomen area with a soft, dark stumping. Shade the background again and then diffuse it. Do the first highlights in white in the chest area and on the side. Increase the contrast on the abdomen and then diffuse with the fingers.*

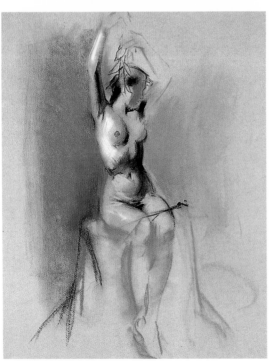

4. *Use the black pastel stick to increase the contrast of the darkest shadow areas, thus making the highlights seem much brighter. After doing each shadow shading, a new stumping with the fingers will blend the tone into the background and model the form of the figure. Open up new, direct highlight strokes with the eraser on the body side and the pubis. Use white to paint the principal highlights.*

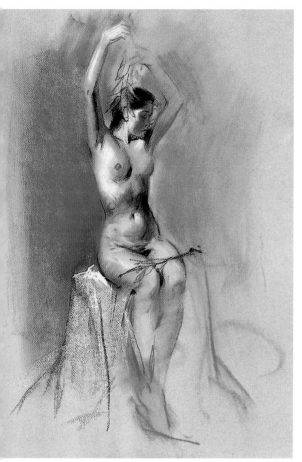

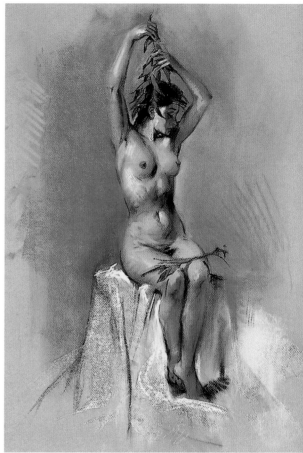

5. Mark the boldest highlights on the face. The dark part is painted in a sanguine tone. Use a black pastel crayon to outline the forehead, the nose and the mouth. Below the head, a very luminous white, which is blended to make it more similar to the paper color, is painted. Do a new sanguine stumping in the area on the left, including the raised arm. Shade the whole seat area with the white pastel stick held flat between the fingers. Intensify the contrasts on the arms and on the navel. Model the thigh with your finger, but without totally eliminating the original drawing form. Once again use the black pastel to outline the forms of the body, the ear and some dark areas.

6. Finish off the face with some more highlights and by increasing the dark tone intensity. Do the shiny parts on the left hand side with direct white touches, and then define them with the fingers. The facial features are marked with the sanguine pastel pencil. If you look closely, you will notice that the legs are slightly out of proportion. This need not be a problem as pastel can be corrected at any moment.

Colored paper is generally used in pastel pieces because the color can be integrated with the tones used during the painting process. It blends in and acts as if it were just another color.

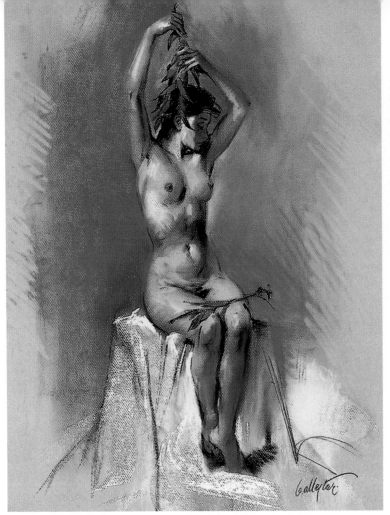

7. *The details of the figure can be done with dark and light touches softly blended into the background. Do the luminous areas of the medium tones on the legs with direct impact strokes in sanguine. Do the final contrasts in black and model the shadow areas by blending with the background. Use white pastel to do a few direct highlights on the knees and the heel. Finally, outline the hand area with the sanguine pastel stick.*

SUMMARY

This precise highlight around the navel has to be reinforced by contrasting with medium tones. The highlights not only indicate the way the light falls: they also give texture to the skin.

Use sanguine colored pastel to outline the hand area against the background.

Open up highlights with the eraser. This tool is highly useful in any pastel exercise. Besides enabling you to correct, it can also position shiny areas by taking advantage of the background paper color.

The knee highlight. This close up shows that just a simple mark is sufficient to produce a detailed effect.

Coloring the skin

THE PRINCIPAL LINES

When we studied sketches, we learned how to structure a figure. In this chapter we will move on to developing the form. Pay special attention to the joining of lines together, and how they are constucted from very elemental forms.

Figure is a complex theme. The basic principals related to layout and form proportion are complicated, but so too are the decisions that have to be taken when the process is more advanced, such as skin color or the need to model with light and shadows.

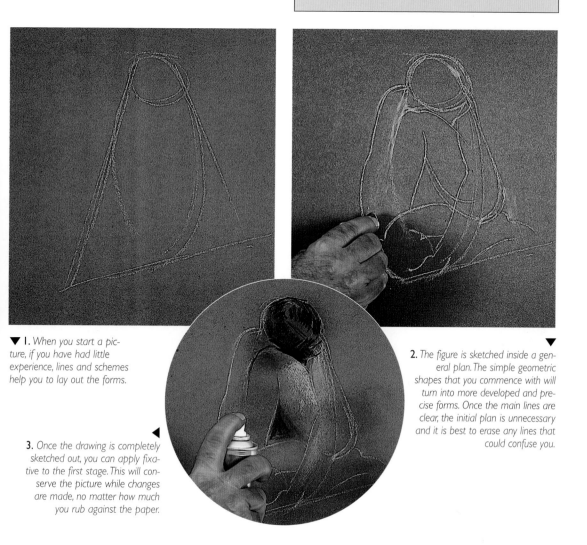

▼ 1. *When you start a picture, if you have had little experience, lines and schemes help you to lay out the forms.*

3. *Once the drawing is completely sketched out, you can apply fixative to the first stage. This will conserve the picture while changes are made, no matter how much you rub against the paper.* ◀

2. *The figure is sketched inside a general plan. The simple geometric shapes that you commence with will turn into more developed and precise forms. Once the main lines are clear, the initial plan is unnecessary and it is best to erase any lines that could confuse you.* ▼

Topic 17: Coloring the skin

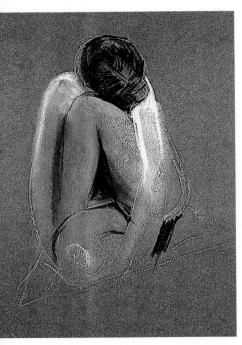

▶ I. *The first tones to be painted distinguish between the light and shadow areas. So it is important to get the colors right from the start. Do not apply excessively contrasted colors at this stage because, although pastel is completely opaque, you could create a base too dirty to blend on top of. Moreover, the pastel color range is sufficiently wide to permit the first tone separations to be subtle.*

DIFFERENT SKIN COLORS

The skin can appear to be various colors depending on the light falling on the model. We are going to color the figure we began in the last example. Observe how the lights and shadows are treated, how the highlights are intensified, and how nuances are created to tone down the directness. The color palette can be as wide as the artist wishes: it is a question of what the work requires.

3. *Flesh colors, are enriched by cool and warm nuances. Blue colors bring out the feeling of a smooth and fine skin. The final detail in this study of skin colors is to paint greater impact into the highlights. equal to the dark parts. Blend some areas with the colors below but work other areas with direct color impact strokes.*

▲

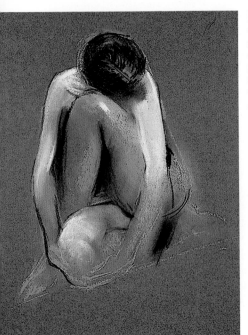

▶ **2.** *Once the first skin tones of the figure are done you can paint the darker shadow colors. In some areas the aim is to form a striking and direct contrast between light and shadow, while in others you have to blend the tones.*

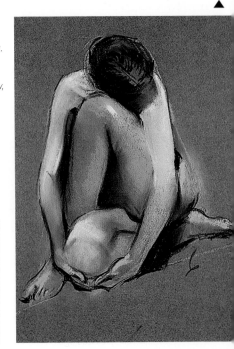

> The skin color depends to a large extent on the ray of light that falls on the model. The highlights are produced by this lighting.

FINE DETAILS AND SOME TIPS

In this chapter we are studying how techniques related to the figure, like highlights, can give a surprisingly realistic representation of the model on the colored paper. Highlights go a long way to bestowing the desired volume effect. The following exercise practices the concepts we have studied up until now.

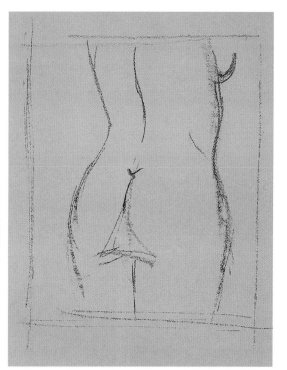

1. *To lay out the general form and the outline of the model, in this case the back of a female figure, some very simple sanguine pastel lines are traced. It is worthwhile to patiently build up any part of the body, always bearing in mind the essential form and the proportions between the internal lines.*

▼ 2. *Work over the dark areas with a simple and elementary stroke. This will establish the light and shadow areas. The dark background of the paper, which is finely integrated with the medium tones, outlines the body.*

3. *Intensify the contrasts in black pastel. After stumping, open up highlights with the eraser and apply direct impacts of white pastel to add light. This example shows that the highlights on the figure will not cause any problems. The color of the skin has been produced by using the color of the paper.*

Topic 17: Coloring the skin

WORK OPTIONS

In this exercise we are going to draw a figure using pastel in three different ways. The beginning is very simple, and then the figure is elaborated. The first step is with just one tone: we are only trying to construct the shadows. In later stages color will be superimposed on top of other layers.

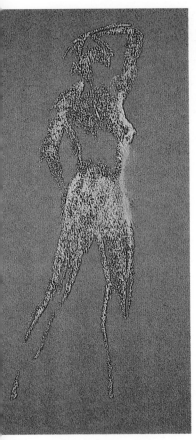

▼ 1. The figure is outlined with the pastel stick held flat. Sketching like this enables you to do a quick and well-constucted drawing. Use your fingertips to blend some areas over the paper. Where you want the highlight effect to show, use direct strokes to define the area.

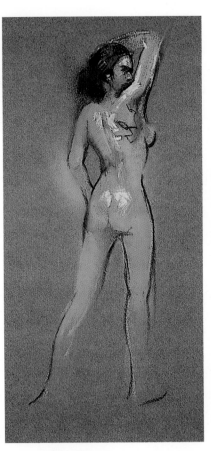

▼ 2. The previous figure is going to be the base on which to practice a great variety of changes, which could almost redefine the style. Apply fixative to conserve the early work. Use luminous, brilliant colors to paint the figure with very direct strokes that do not blend anywhere. Observe how areas of color are produced that remain intact when new strokes are passed over.

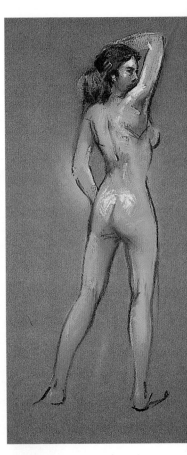

▼ 3. The piece could be finished with the last step, or alternatively you could give it a different look. Some areas are blended. Others remain untouched, still displaying the energetic stroke of the original flesh color.

Step by step
Figure

Figure studies are among the most inspiring and complicated themes that you can do in any painting media. Pastel enables you to get closer to the subject than any other method because using the pastel stick is similar to drawing. Now we are going to do a figure study with a nude model. It is fundamental that the beginner has solid references when drawing the forms. Figures can be done if you start from a good sketch.

MATERIALS

Pastels (1), clear colored tobacco paper (2), and a rag (3).

1. *In the preliminary sketch the forms are only outlined by very vague strokes. On top of this, start to use shading techniques. Of course, whenever the color of the paper is incorporated as another tone, it has an important influence on the rest of the colors. Therefore, paint around the figure in a light color to isolate it.*

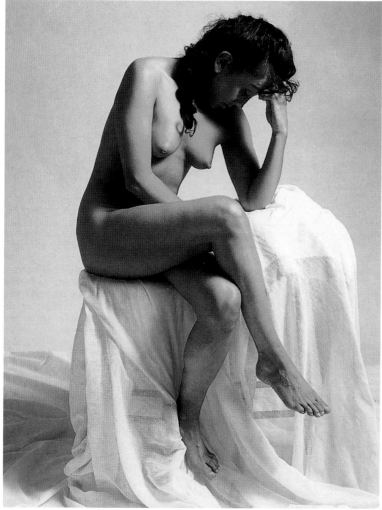

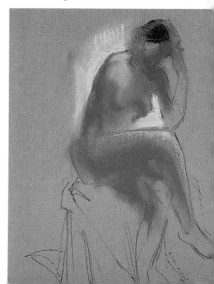

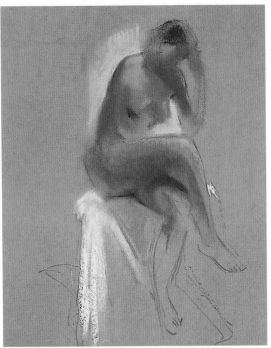

2. *The luminous tone around the figure allows the color of the paper to be integrated into the overall shading effect. Observe the medium tone that runs from the thigh to the knee closely: it is the color of the paper and is going to be preserved until the end of the work. The colors applied are not random, although we are not yet trying to define the forms. Instead the aim is to distribute the principal tones, both light and dark.*

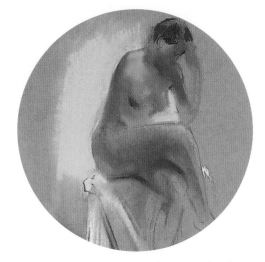

3. *Pay special attention to the way each color corresponds to the different light planes. Each different lighting intensity represents a different color. The maximum highlights are on the right shoulder and are painted in an orangy, very luminous pink. Temporarily paint the deepest shadows in a sanguine tone. Orange is used on perfectly defined areas of the leg, the forearm and the upper parts of the breasts. As we are not interested in defining the areas too much at the moment, the outline tones can be blended with the fingertips.*

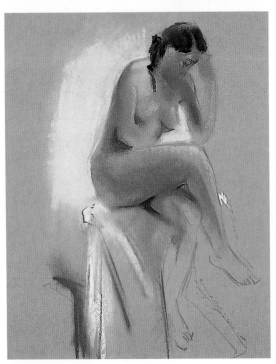

4. *Once the most important tones have been shaded and their edges blended, you can go on to define the forms of the model by increasing the tone contrasts. Paint the darkest areas, like the shadow beneath the arm, directly in black but do not accentuate the tone excessively. Do the more tenuous shadows in blue, which produces a dirty gray tone. Do not forget the shadow under the leg.*

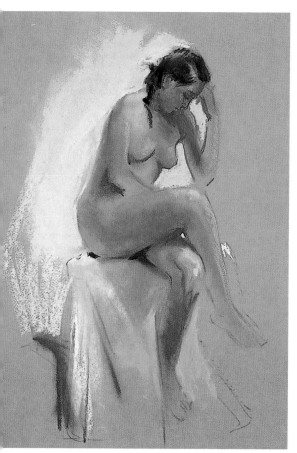

5. The medium tone shadows on the skin of the leg are of a different type. Paint them in burnt umber. However, do not completely cover the paper color. Now it is much easier to achieve the luminous tone of the leg. Outline the bright part down to the foot. It is important to place the first highlights around the knee: they are definitive and will be the light reference for the skin highlights.

6. The shadow under the arm still seems too contrasted so you will have to tone it down by gently flicking the pastel with your fingertips, without dragging all the pastel. The highlights on the knee are a guide when doing new luminous spots on the right shoulder of the model.

Depending on the brightness of the atmosphere, highlights on the skin are not worked in white because the skin filters light in its own special way.
The best approach is to use bright colors like Naples yellow.

7. *Outline the leg with pure white. If you do a few luminous tone strokes and then blend with the fingers, the color of the paper will be completely merged in this area. Adding a few more highlights, like the pink tone on the abdomen and on the knee, is enough to finish off this exercise. As you can see, when you go step by step, a good skin color needs a complete range of colors, including the color of the paper. If this were not the case the lighting and atmosphere would not be realistic. The colors used, although varied, tend to belong to the same color range, taking advantage of all the contrasts. This does not mean that additions in other harmonies are rejected. That is why blue plays an important role here.*

SUMMARY

The luminous tone painted around the figure allows the color of the paper to be integrated with the other tones.

The tones are established in accordance with the luminosity of each plane. For example, in the dark areas on the thigh and the arm the tone is the same.

A bright white outlines the leg and increases the contrast effect between the background and the figure.

Blend the color of the paper with the half shadows on the legs.

The way they painted

Degas
(Paris 1834-1917)

Ballerinas

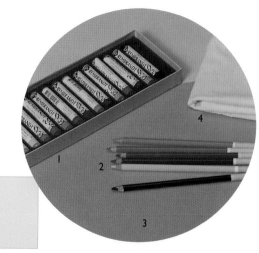

MATERIALS

Pastels (1), pastel crayon (2), clear brown colored paper (3), and a rag (4).

Degas was one of the most important impressionist artists, who is recognized for his drawings, paintings and sculptures. His first creative period was of marked historic significance and included meeting Manet, who introduced him to impressionism. The interest that he arouses in the plastic arts comes from the way he treated light and seemed able to freeze time. Highly subtle blendings are combined with expressive direct strokes. His style enabled him to work on artificial lighting and the textures that abound in theater.

Degas was especially keen on ballet dancers and musicals for two reasons: firstly, he could study the different effects of artificial light, and secondly, he could try to make time stand still. Degas was one of the most important pastel painters. If you study his work you can see how he used color to express light and forms, working in a direct and pure style. The light creates strong contrasts, although we can not define them as chiaroscuro because there are hardly any subtle changes between the tones. This characteristic of his painting is enhanced by the fact that pastel technique allows you to work with a direct style, superimposing light tones on top of dark ones.

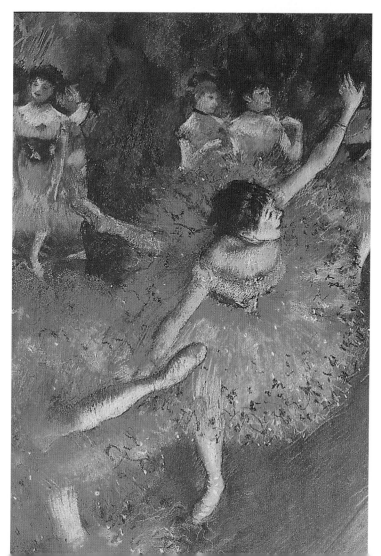

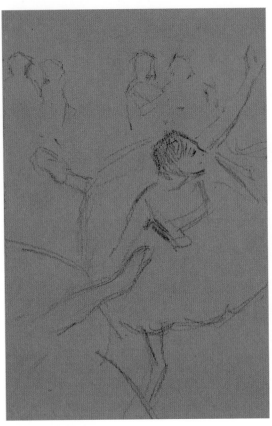

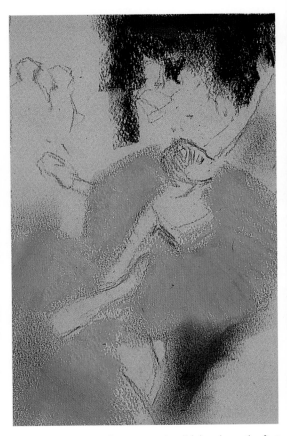

1. *The preliminary sketch is very important in this exercise, otherwise it would be impossible to position the different elements in the composition. As the drawing above shows, the first step is linear. Although you could do it in pencil, try using the tip of the pastel stick. What is important is that the line is pure and simple. You can tell that Degas approached the placing and the planning of the composition at the same time. Use a brisk stroke, suitable for figures in movement, to start the painting.*

2. *Just as the great artist did, lay down the first color shadings as a base for later colors and to outline the color of the paper. Once both the proportions and composition of the drawing are complete - this exercise is only a fragment of Degas' work - you can start to paint in the first color strokes. Firstly, do the areas that appear to be the least complicated, such as the dark background parts. Also you can paint the dancers' tutus moving around on their legs. The effect created is interesting because it is started in blue and then green is drawn over it to produce a luminous emerald green, like the original piece.*

The colors must be blended in a very controlled way to avoid mixing them. The slightly off tones can be alternated with bright areas.

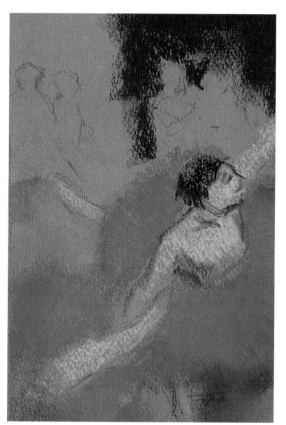

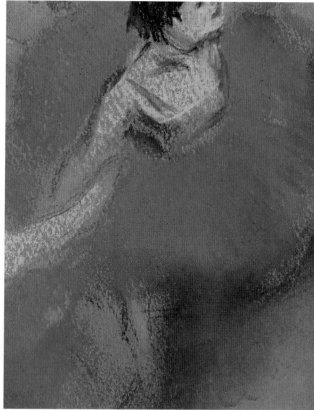

3. Degas used his vast knowledge of the technique to capture the moment. The combination of the striking color and the reserved background is effective. Where the paper grain has not been blocked out by the pressure exercised, its color optically interacts. Use this technique to paint the figures in a very luminous pink, flesh color. In the background, start work on the dresses of the ballerinas with loose orange strokes that you must blend later.

4. Paint all the lower right area in a slightly off color obtained by directly mixing blue and black on the paper with the fingers. Only stop when the pores are covered and the background color does not show through. Before doing impacting color strokes, Degas would blend some of the colors, for example on the tutus where the light is somewhat diffused. The off-gray in the foreground is allowed to penetrate into the outline of the tutu, making the form less defined.

> The color of the paper must show through the densest pastel strokes so as to give the special atmosphere created by Degas in all the picture.

STEP BY STEP: *Ballerinas* by Degas

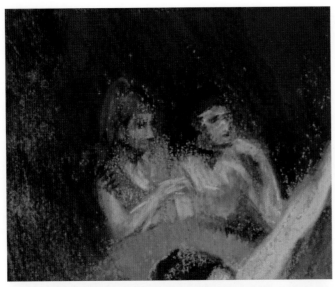

5. *One of Degas' great contributions to impressionism was the way he made light fall on the figures. Sometimes he simply depicted the distant ground with semi-blended shading. The brown color painted at the beginning outlined the two dancers hazily. Now, when the lighter flesh colors are applied, they become more defined. Due to the size of the drawing it is far simpler to do the colors with a pastel crayon. The stroke is somewhat harder and the tip will help you to do the fine, graphic details.*

Pastel crayons are delicate tools which must be treated carefully. When the point becomes blunt, do not use a pencil sharpener: a cutter works far better.

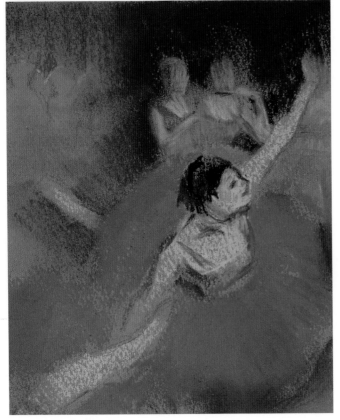

6. *Use two shades of green to define the background on the left behind the two figures. Keep the forms that are blended over the background very simple: it is the surrounding color that must insinuate them. Do not introduce the details yet.*

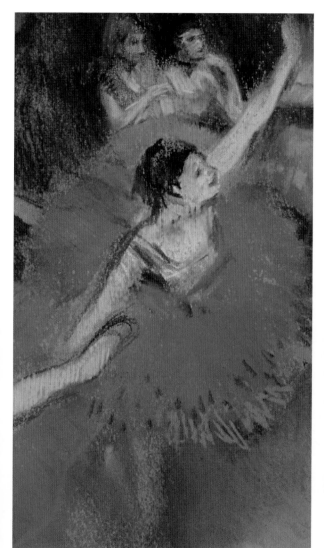

7. *Use a dark pastel crayon to start outlining the figures in the background. These small contrasts, together with the short marks, outline the heads and arms; they stand out for their luminosity, and define the features. You can produce a very characteristic texture as you are combining crayon strokes with the pastel stick. Shade in different directions in each area. With loose, bright strokes start to paint the adornments of the tutu.*

8. *When you paint the figures, the color of the paper begins to be more prominent in their out-line. Just a few touches with light colors and a few low definition blacks will give the figures the desired look. Paint the highlights almost white, without ever using pure white pastel tones.*

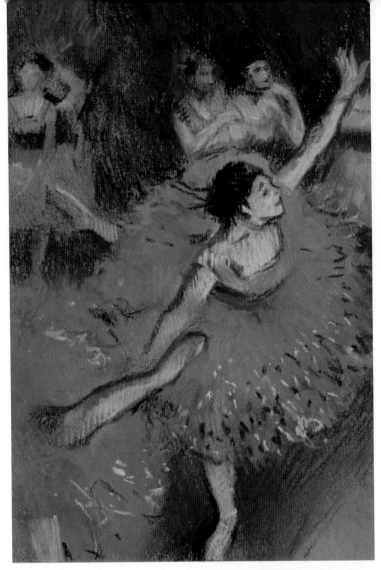

9. *It was in this final step that Degas showed his impressionist side by using pure colors that contrast with each other. Paint them with direct, superimposed strokes. The tutu is now made more luminous than before, this time using the pastel stick, which gives a much more expressive, impasted and direct stroke than the pencil. Outline the face of the lead ballerina and the body parts of the other dancers again. Use blue pastel to shade some areas on the dresses and the skin to reflect the colors of the ambience. Finally, use a bright, diagonal stroke to finish off the painting of the floor.*

SUMMARY

The contrast between the figures and the background which outlines them makes the background appear brighter.

The strokes of the leading ballerina's tutu are brilliant.

The flesh hue is very luminous. The color of the paper filters through.

Paint the tutu in two different colors to obtain emerald green. They do not have to be mixed excessively.

A diagonal stroke is used on the floor to give it texture.

Claude Monet
(Paris 1840-Giverny 1926)

Waterloo Bridge, London

Monet was one of the leading impressionst painters. The name of the movement comes from his painting "Impression; Dawn", 1872. He never tired of working and developing his impressionist concepts throughout his career: his understanding of light, especially moving and dancing on the surface of the water and reflecting color touches. Consequently, his work has been highly influential on every generation of painters that followed.

Pastel can be applied in as many different ways as there are forms of working with fine arts. It offers as great a painting capacity as oil or any other media or technique, but, as you can see in this quick sketch, it also allows you to do direct, free and spontaneous drawings. Moreover, pastel has another advantage: it has its own unique technical effects, like the overlaying of light tones over dark ones, and the blending of colors. Monet offers a fine display of the technique of simultaneous contrasts in this spectacular but straightforward exercise in light.

MATERIALS
Sienna-colored paper (1), pastels (2), and a rag (3).

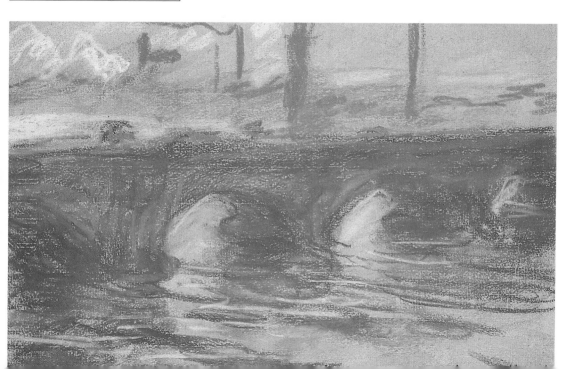

STEP BY STEP: *Waterloo Bridge, London* by Claude Monet

1. As pastel has a fresh stroke it can be used to draw just like other drawing media. This is a very quick preliminary sketch in which we will try to capture the essence of this famous bridge without focusing on the finer details. Although the bridge, amidst the London fog, appears simple, you must take a lot of care. Use loose strokes, superposing them but without defining the forms.

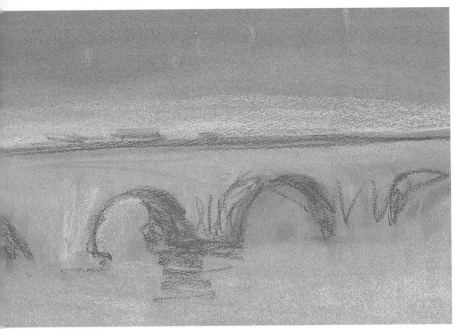

2. Monet worked on this painting with hardly any reference drawing, as can be seen here. The area where the Thames flows in the foreground can be shaded in white and then stumped. You must not press too hard on the stick because we do not want to cover the background color of the paper. The best approach is to use the stick flat and widthwise. Blend the tone immediately with the fingers. Paint the bridge in the same way that you have painted the water, using very luminous colors. Violet will give a clear tone under the bridge and can also be used on the right, but this time with a direct stroke.

3. In this painting, Monet aims to develop not so much the objects themselves but rather the luminosity. He achieved this with the contrasts produced by the light and by not excessively defining the forms. In this close up, you can observe how the reflections on the water have been done. Draw the bridge over the water with a rapid zigzag using the tip of the pastel stick. Reduce the pressure exerted as you work down. If the stroke is too obvious, gently rub it with a finger to blend it into the paper background.

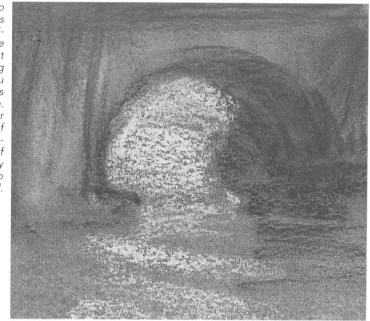

4. Using effects on top of each other is an ever present feature in the pastel technique. This meant that it was easier for Monet to use direct strokes of light to create simultaneous contrasts. On top of a layer which is immediately diffused, put down a direct and precise layer. With the same blue that was used to sketch out the bridge, mark out the more direct areas. The strokes must now be laid over the blended tone beneath, which will become the background color.

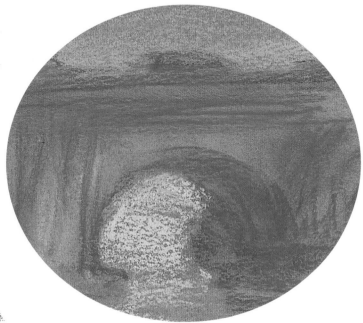

STEP BY STEP: *Waterloo Bridge, London* by Claude Monet

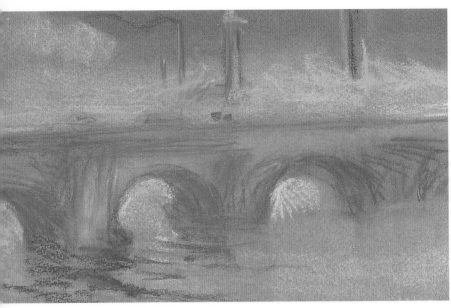

5. *Go over the arches of the bridge with a strong, blue contrast and increase the clarity of the light parts. As you are working on top of the color of the paper, paint until you almost block out the paper grain to ensure that the colors and tones are pure and luminous. Here the paper must not influence the shading by filtering through. Do as Monet did: leave the initial lay-out in place but allow the light effects to suggest the forms.*

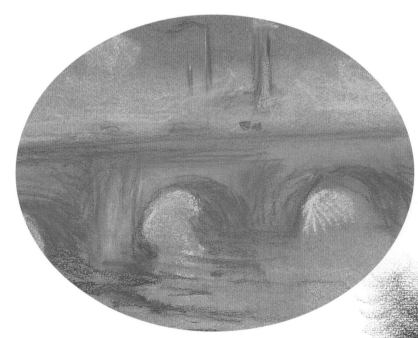

6. *The major part of the bridge is covered with rapid, gestural strokes. The pastel colors are vibrant when they come into contact with the background color. In the upper area, paint in very luminous tones, including light violet and ivory without over using white so that strong contrasts are not produced. Use your fingertips to blend some areas of the picture. This will give the picture a foggy look.*

7. In this step, the drawing is more evident than in the previous ones. Up until now the shading and the strokes have been used as a base. Some areas are intensely blended, others less so, but what counts is that we have deliberately avoided marking the contrasts of the forms. In this painting it is the contrasts between the different light planes that play the key role, although in some areas, like on the left-hand arch, you can observe volume effects. In these areas you must work more insistently so that the shadow is more noticeable. Intensify the highlights and the contrast with the dark areas at the same time. The painting style on the water is very graphic: use the tip of the pastel stick.

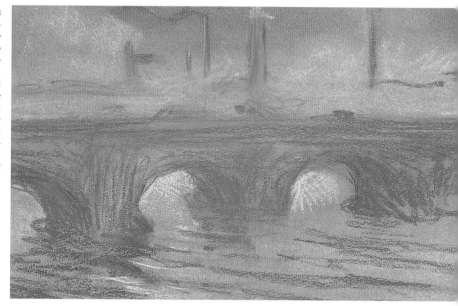

8. The areas where the highlights are most luminous need not stand out yet. Although pastel can be corrected at any moment, in this piece of quick work, where the nuances are blended into the background, it is important to know how to apply the lights in the right order. Be restrained in the way you paint the direct white strokes: the contrasts with the blue, and even with the background, are sure to be noticeable. Monet's main concern was to represent the effects of the light on the objects. Observe how the direct white strokes give the necessary depth to the atmosphere.

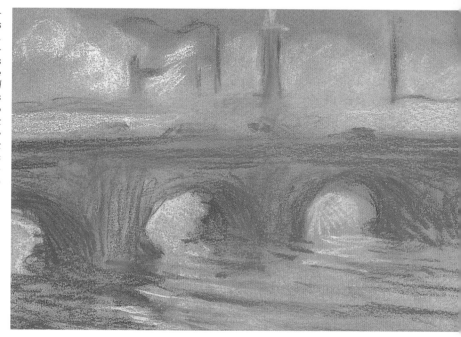

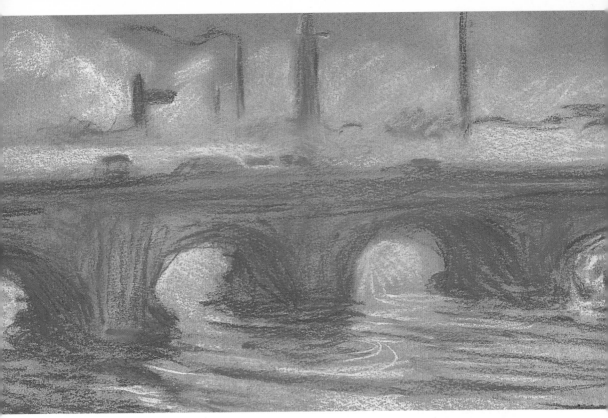

9. *The waves on the water require more luminous colors to make the contrasts between the blues and the light areas stand out more. Moreover, by doing so, the light coming through under the bridge is more real. The color of the paper is left reserved for the foggiest areas. Restate the areas in blue where you want to attract the viewer's eye, while the other areas can be left clouded in fog.*

SUMMARY

The drawing is direct so that it shows the different parts of the bridge. The strokes are not concrete; instead they aim at being vibrant.

The direct strokes on the bridge enable the background to be used like the other colors.

The water reflects part of the bridge in zigzagging strokes.

The boldest contrasts are the shadows under the arches and the light that comes through them.

The way they painted

Odilon Redon
(Bordeaux 1840-Paris 1926)

The Conch

Odilon Redon played an important role in the artistic vanguard of his generation. Together with Gustave Moureau he started the symbolist movement, which later led on to surrealism as practiced by Salvador Dalí, among others.

Owing to its blending properties and impacting color contrasts, pastel was probably Redon's favourite medium. He did the greater part of his work in pastel. The realism of his paintings contrasted strongly with elements that are barely insinuated. To appreciate his work, it is also important to note the emphasis given to integrating the color of the paper into the palette.

MATERIALS
Sienna-colored paper (1), pastels (2), and a rag (3).

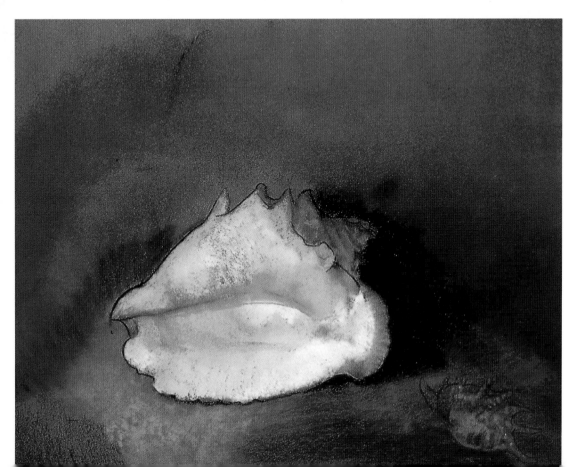

STEP BY STEP: *The Conch* by Odilon Redon

1. *One of the greatest merits of this piece is the perfect combination of shading and drawing pastel techniques. However, the drawing is not evident, nor continuous, in all areas of the picture. Instead, it appears and disappears, bestowing mystery and interest on this still life. Start the drawing with the tip of the pastel stick. Only the main lines and forms are suggested. Later on some, like the ones in the upper left corner, will be covered up by the paint.*

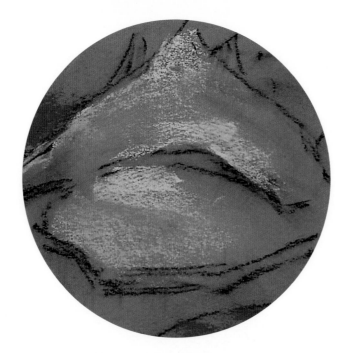

2. *How can you set about using the color? It seems that Odilon Redon preferred starting with the most evident contrasts, creating a base of both light and dark areas on which to work later. In this close up, you can see how a luminous pink color is integrated on top of the color of the paper, which will be used afterwards as the base for the pearly shell interior.*

You must be as careful when using light colors as you are with the dark ones. Working on colored paper means that both stand out strongly.

3. *Paint the background around the conch in slightly grayish green tones. When you pass your fingers over these color shadings, part of the color underneath, previously used as the initial drawing, is dragged away. The brightest areas of the conch are painted in ochre and then blended with the fingers. As can be seen, the color of the paper forms part of the picture.*

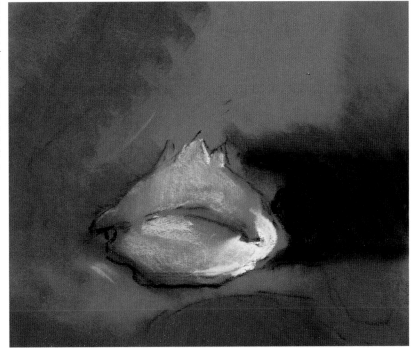

4. *It is important to carefully study the different effects of blending tones and superimposing layers. This close up is a good example of how an impasted area can just be blended at the edges with the color of the paper, leaving another area outlined against the background. Redon liked to combine blending some areas with outlining, creating an almost unreal atmosphere.*

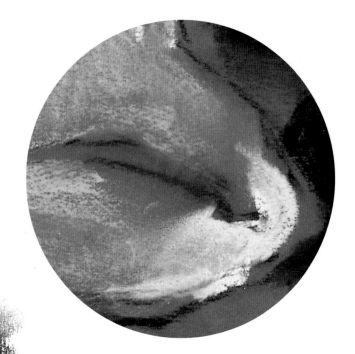

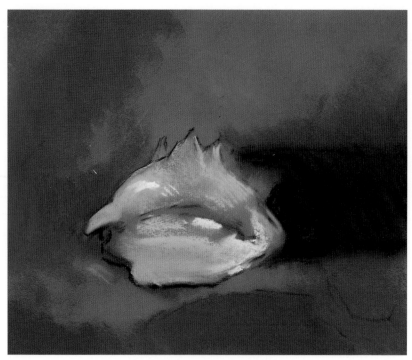

5. *Paint an intensely dark area on the right of the conch. This black tone, which is blended into the background with the fingertips, makes the conch more realistic, enhancing it with the effect of the light and dark contrast. All the background is stumped around the shading so the attention is focused on the main object, which will be painted with visible strokes throughout the exercise.*

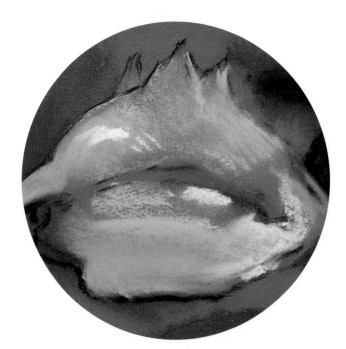

6. *Instead of allowing the stroke to disappear, make the edges more marked, increasing the impact of the contrast between the two styles. After diffusing the whitish tones, including pink and a bone-like color inside the conch, paint the left of the conch ochre. This addition is blended over the background before putting in a few new bone-colored touches. The edges of the inside of the conch are restated and then the lighter tones are diffused.*

7. *Pastel is easy to handle since it never has to dry on the paper. This permits you to merely wipe it quickly with a cloth to open up a clear space in which to redraw the small conch on the right. It is not a strong focal point, but it adds balance to the picture. If the black becomes too clogged when you wipe it, use the eraser. However, do not make the light space too bold.*

8. *Now the work is focused on the background around the conch. Paint it in blue tones, adding a little black and a color similar to the color of the paper. In this step you can appreciate how Redon approached the subtle blending of a great variety of pastel tints. Playing with the colors in this way creates a fascinating visual rhythm all over the picture. Inside the conch, diffuse any edges which are too hard with your fingertips.*

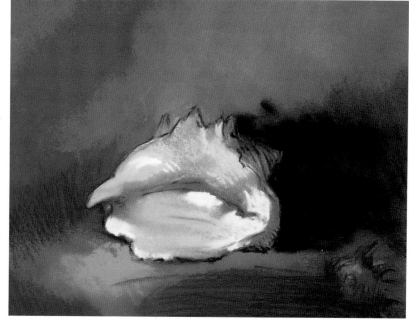

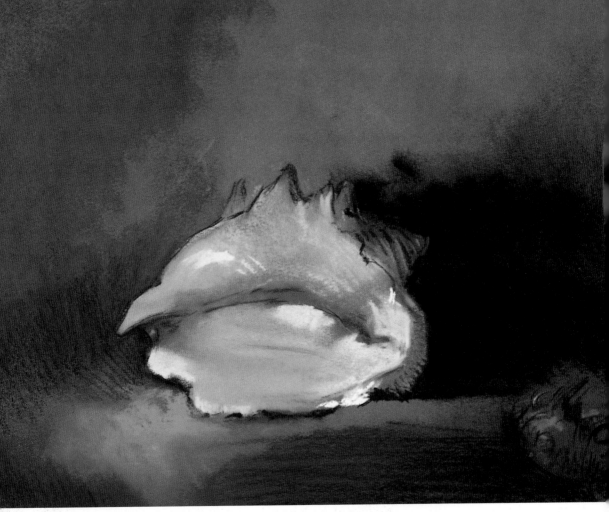

9. *Do the definitive contrasts for the whole picture. The background is painted again to avoid unnecessary mixes. Use black to darken the deepest shadows and sanguine colored pastel to paint the brightest parts,* *allowing the color of the paper to filter through. To increase the contrast of the conch in the lower part of the background, use a more orangy tone.*

SUMMARY

Do the drawing in black pastel. Some of the areas will later be covered by the background.

The edges of the conch are constantly restated, but let the stroke remain visible.

In the background there are colors that strongly contrast with the highlights on the conch.

Inside the conch the very luminous, diffused color is a base for other more varied and precise tones.

The way they painted

Joaquim Mir
(Barcelona 1873-1940)

Landscape

The origin of Mir's paintings lies in the natural brightness of the light in the Mediterranean countries. His original subjects are pictorial testimonies based on life in the neglected areas of towns and suburbs. The special color contrasts were in themselves worthy of interest. Symbolism and modernism heavily influenced his work making it more energetic and fantastic.

MATERIALS
Pastels (1), blue-colored paper (2), and a rag (3).

In this work Mir reveals his interest for the way light filters through the trees. Pastel enables him to apply light areas superimposed on top of dark areas, sometimes painting them and sometimes taking advantage of the color of the paper. This pastel landscape is a clear example of why it is regarded as a fresh and spontaneous way of painting, full of little dashes of color and impacts of light. You will be able to distinguish the different ways the paint has been treated. Some areas are clearly drawn and the line is visible. Other areas are informal shadings. What makes this piece difficult to do is that the composition of the picture is not based on planes, but rather on shadings which are not related to each other in an obvious way as in other more realist or figurative pieces. It is important to study the tones of the light and how the color of the paper shows through.

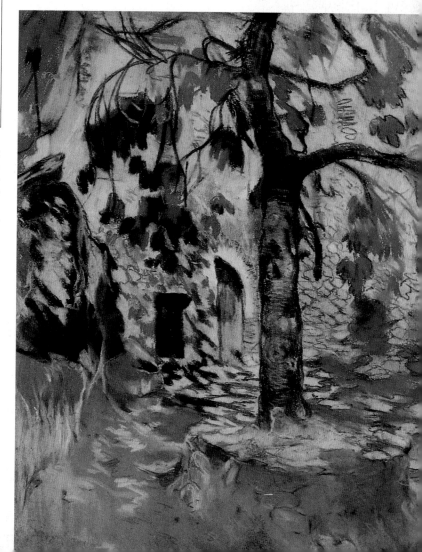

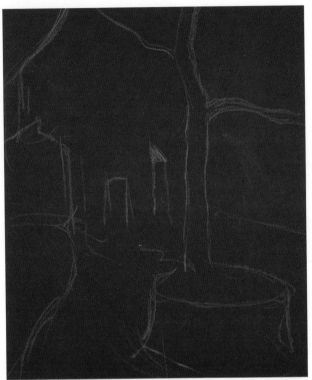

1. *You must always try to find the internal composition of the objects you are going to interpret. If you look for the principal lines you will be able to depict them much better. The first stage of the drawing will be done in a luminous blue color which gives a bold contrast and can later be easily integrated into the picture. It is probable that Mir did a preliminary sketch similar to this one since the final result is abstract and requires precise preliminary work.*

The composition layout should be done in tones similar to that of the paper, or in colors that can later be integrated.

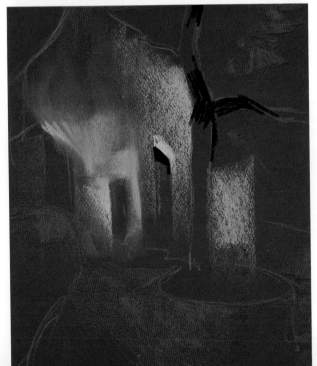

2. *It is necessery to finish the previous plan before going on to approach the first tones of the picture. Mir shaded the first light areas to isolate the forms on the paper, and to provoke an interaction between the background color and the rest of the colors in the picture. Later, you will be able to observe the progressive increase in the harmony of the paper color with the color and tonal theme. The first shading is done with the stick flat between the fingers. Rub the dirty white of the house with your fingertips so that the stroke mark is not noticeable.*

3. When Mir blended colors into the background, all of which belong to the cool color harmony, he excelled in their integration. The large shading in the lower part is painted in one color that hardly contrasts with the blue of the paper. However, the upper part is more diffused and here the green tone used below is deliberately mixed with Naples yellow.

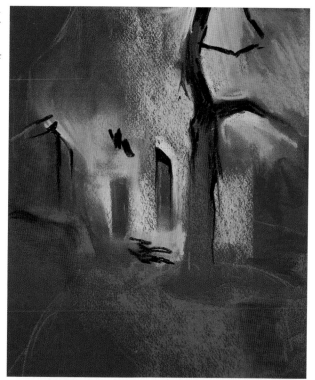

Blending the colors together must be combined with direct shading to enable you to outline the shapes against the background as if they had been painted.

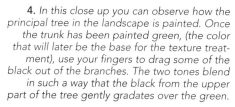

4. In this close up you can observe how the principal tree in the landscape is painted. Once the trunk has been painted green, (the color that will later be the base for the texture treatment), use your fingers to drag some of the black out of the branches. The two tones blend in such a way that the black from the upper part of the tree gently gradates over the green.

STEP BY STEP: *Landscape* by Joaquim Mir

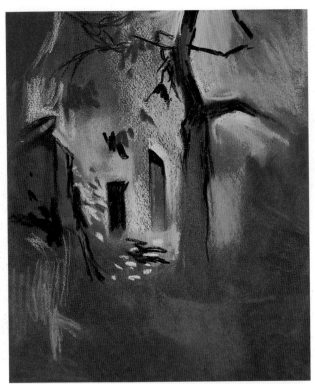

5. *The forms of the picture start to become clearer when you paint the first black contrasts in the doorway and in the shadow around the entrance on the right. Black integrates the color of the paper even more. At the same time, use white pastel to do luminous dashes on the ground. Use your fingertips to blend the colors where the flat strokes were visible before. Mir created the atmoshere of the light by using luminous colors combined with dark strokes and the color of the paper. The bright shading of the ground reveals the way the Spanish painter worked.*

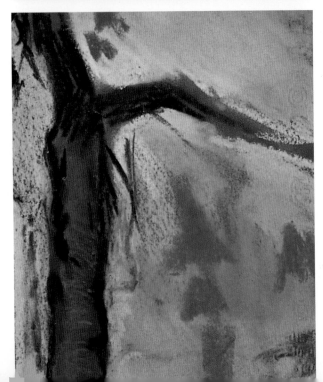

6. *The strokes on the main tree are made once the contrast against the background has been strengthened. The outline of the tree trunk must be blended by rubbing the finger inwards, towards the center. Paint on top of the bark in a blue which is very similar to the color of the paper. On top of this paint in green.*

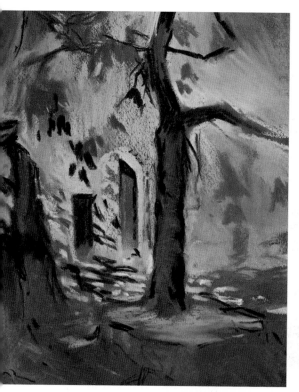
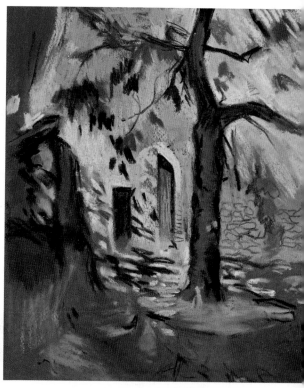

7. *Paint the white parts of the wall in an ivory white which allows the background to filter through in several places. These whitish tones are blended with the background so that the edges are not noticeable. Blue pastel is used to blend some of the shadow areas with the color of the paper. As well as these additions of blue, very direct strong contrasts are created by using pure white strokes, which are left unblended, and black dashes.*

8. *In the previous step you started to paint the walls white. Now, on top of these greenish white blendings do more shading, but this time with more direct strokes. The white strokes must be long and sloping, while the green is applied very directly with the tip of the stick. Mir blurred away the edges of the fallen leaves to attain the effect he desired. Use the tip of the stick to begin to outline some areas on the right, like the branches or the stone wall.*

The contrasts and the most detailed areas must be left until the end as they give the final shape to the objects painted over the shaded areas in the picture.

703

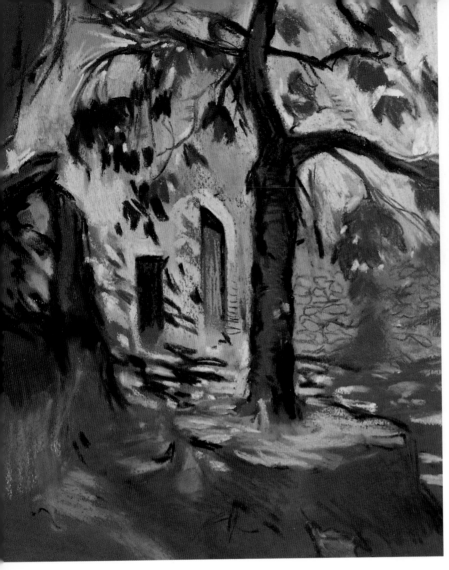

9. *To finish off this laborious pastel piece, paint some loose green strokes in the area of the branches. Blue is used to restate some shadows and to further integrate the color of the paper. In the lower left corner, work on the grass and the textures which are partly blended in with the first layers. Apply some direct lines over this base. Just doing a few more contrasts and direct color dashes is enough to round off this interpretation of Mir's work.*

SUMMARY

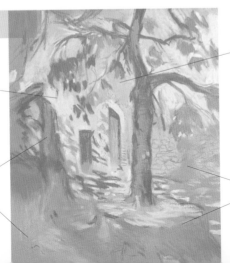

The first color marks are luminous. Blend them over the background to prepare a base for more direct colors.

The drawing is made in a bright color from the same chromatic range as the color of the paper. This means that when the other colors are painted they will cover up the lines.

The blue of the paper is always left filtering through and is integrated into the chromatic spectrum.

Adding blue to the shadow areas helps the paper to work in harmony with the color and tonal theme.